THE ORIGINS OF
MUSEUMS

THE ORIGINS OF MUSEUMS

THE CABINET OF CURIOSITIES IN SIXTEENTH- AND SEVENTEENTH-CENTURY EUROPE

EDITED BY

OLIVER IMPEY

AND

ARTHUR MACGREGOR

CLARENDON PRESS · OXFORD

1985

Oxford University Press, Walton Street, Oxford OX2 6DP

Oxford New York Toronto
Delhi Bombay Calcutta Madras Karachi
Kuala Lumpur Singapore Hong Kong Tokyo
Nairobi Dar es Salaam Cape Town
Melbourne Auckland

and associated companies in
Beirut Berlin Ibadan Nicosia

Oxford is a trade mark of Oxford University Press

Published in the United States
by Oxford University Press, New York

British Library Cataloguing in Publication Data
The Origins of museums: the cabinet of
curiosities in sixteenth and seventeenth
century Europe.
1. Collectors and collecting—Europe—History
2. Museums—Europe—History
I. Impey, Oliver II. MacGregor, Arthur
069'.094 AM342
ISBN 0-19-952108-5

Set by Wyvern Typesetting Ltd, Bristol
Printed in Great Britain
at the University Press, Oxford
by David Stanford
Printer to the University

FOREWORD

In 1983 the Ashmolean Museum of Art and Archaeology in the University of Oxford celebrated the tercentenary of its opening to the public in May 1683 by the then Duke of York (later King James II). The founding collections, with which Ashmole endowed his university, consisted very largely of the objects collected by the royal gardeners, the Tradescants, John the Elder and John the Younger; these were accumulated in the first half of the seventeenth century and constituted a prime example of the *Wunderkammer*, or cabinet of curiosities, a phenomenon which became fashionable throughout Europe in the sixteenth and seventeenth centuries.

The Tercentenary celebrations at the Ashmolean included a loan exhibition dedicated to the achievement of Elias Ashmole, with a catalogue and introductory essay by Michael Hunter. The occasion, however, focused attention on a hitherto somewhat neglected subject: the nature and development of such early collections, embryonic museums as they were, and their relationship to the early history of museums as they are now known. Accordingly, in July 1983, an international symposium was organized by Dr Oliver Impey and Mr Arthur MacGregor, of the Ashmolean Museum. This attracted a strong international response, and this volume offers a permanent record of the papers then delivered.

DAVID PIPER

EDITORS' PREFACE

The tercentenary of the Ashmolean Museum in 1983 provided the context for a week-long symposium held in Oxford on the subject of 'The Cabinet of Curiosities'.[1] The following chapters reproduce the substance of the papers delivered on that occasion, although contributors were encouraged both to condense their texts and to amend them as appropriate in the light of the fruitful discussion sessions which followed the formal presentations.

In drawing up the programme for the symposium, the organizers (the present editors) sought to provide a coverage of the subject which was as comprehensive as possible within the limits of the time available. Papers delivered on the first three days (chapters 1–20 in this publication) dealt with individual collections or with series of collections, demonstrating the various forms adopted by the cabinet of curiosities in the light of personal taste, academic purpose or regional location.[2] Contributions on the fourth day of the symposium (chapters 21–6) adopted a different viewpoint, examining various categories of material which were common to the majority of curiosity collections, while on the fifth day (chapters 27–33) the sources of exotic material in these early European collections were analysed according to their geographical derivation. By changing viewpoint in this way, it was sought to bring novel and useful perspectives to the study of these earliest museums and to present new insights into what was collected, whence it came and what its significance was perceived to be by those who collected.

Inevitably, there remain many aspects of the cabinet of curiosities to be explored. Interest in holding further symposia ran high at Oxford. The editors offer their gratitude to speakers and participators alike who brought success to the Ashmolean Tercentenary Symposium and dedicate this volume to those who may in the future carry forward the study of the origins of museums.

OLIVER IMPEY

ARTHUR MACGREGOR

[1] For notices of the Symposium see *Annals of Science* 41 (1984), pp. 168–9; *L'Ane* 13 (1983), pp. 37–9; *British Book News* (September 1983), pp. 531–2.

[2] Owing to last-minute organizational difficulties experienced by certain intending speakers, no contributions were offered on the important Brandenburg collections in Berlin nor on the general subject of collecting in France. The omission of the Brandenburg cabinet is rectified here by the inclusion of the chapter provided by Dr Theuerkauff, but France has had to remain largely unmentioned, a situation which belies the importance of the *cabinet de curiosités* in that country.

ACKNOWLEDGEMENTS

The symposium entitled 'The Cabinet of Curiosities', on which the present publication is based, was organized in Oxford in 1983 by the Editors with the sanction of the Visitors of the Ashmolean Museum. The Vice-Chancellor of the University of Oxford, Dr G. J. Warnock, and the Director of the Ashmolean Museum, Sir David Piper, welcomed the participants. The proceedings concluded with a formal summing-up from Professor Donald Lach of the University of Chicago.

Resident participants were accommodated in Balliol College, and formal lectures took place in the Playhouse Theatre. Evening receptions for participants were held at three Oxford Museums in addition to the Ashmolean – the University Museum of Natural History, the Museum of the History of Science, and the Oxford City Museum, by kind invitation of the Directors. At the conclusion of the symposium an expedition to Canterbury to view the Bargrave cabinet was led by Mr David Sturdy.

For advice and encouragement in the organization of the symposium and in the preparation of the publication the organizers thank Professor John Boardman, Mr T. H. Clarke, Professor F. A. Dreier, Professor Francis Haskell, the late John Hayward, Dr Thomas Heinemann, Mr John Rhodes and Dr Peter Whitehead; for translations and other help Miss Gertrud Seidmann; for continual assistance Mrs Jean Bagnall Smith, and for the daily running of the symposium three volunteer stewards – Miss Dora Thornton, Mr Edward Impey, and Mr Giles Mandelbrote. We would also like to thank Mr Keith Bennett, Mr Tim Crawford, Mrs Françoise Holt and an Anonymous Benefactor.

Financial assistance was generously provided by the Weatherhead Foundation, the Wellcome Trust, the British Academy, the British Council and the Metropolitan Centre for Far Eastern Art Studies. Contributions in kind from Basil Blackwell Ltd, Berry Brothers & Rudd Ltd, and Morrell's Brewery are gratefully acknowledged.

CONTENTS

LIST OF FIGURES

(at end)

INTRODUCTION

First, the collecting of a most perfect and general library, wherein whosoever the wit of man hath heretofore committed to books of worth . . . may be made contributory to your wisdom. Next, a spacious, wonderful garden, wherein whatsoever plant the sun of divers climate, or the earth out of divers moulds, either wild or by the culture of man brought forth, may be . . . set and cherished: this garden to be built about with rooms to stable in all rare beasts and to cage in all rare birds; with two lakes adjoining, the one of fresh water the other of salt, for like variety of fishes. And so you may have in small compass a model of the universal nature made private. The third, a goodly, huge cabinet, wherein whatsoever the hand of man by exquisite art or engine has made rare in stuff, form or motion; whatsoever singularity, chance, and the shuffle of things hath produced; whatsoever Nature has wrought in things that want life and may be kept; shall be sorted and included. The fourth such a still-house, so furnished with mills, instruments, furnaces, and vessels as may be a palace fit for a philosopher's stone.

Francis Bacon, *Gesta Grayorum* (1594)[1]

In his enumeration of the essential apparatus of the learned gentleman, Bacon neatly characterizes for us the nature of the museum (or 'cabinet') in the late sixteenth century and identifies the specific role it had to play in contemporary endeavours to comprehend and to encapsulate 'the universal nature'. With due allowance for the passage of years, no difficulty will be found in recognizing that, in terms of function, little has changed; along with libraries, botanical and zoological gardens, and research laboratories, museums are still in the business of 'keeping and sorting' the products of Man and Nature and in promoting understanding of their significance. Against the perspective of some four centuries of museum history, it is understandably easy to view these earliest collections as somewhat quaint. The terminology adopted in their description helps to further this attitude: the 'cabinet of curiosities', the 'closet of rarities', and the '*Wunderkammer*' all have an endearingly whimsical ring to them. The collectors' fondness for products of 'singularity, chance and the shuffle of things' provides easy reinforcement for this tendency. As an assessment of the basis on which such collections were assembled and were viewed by contemporary observers, however, it is both inadequate and misconceived. In reality, those very traits of diversity and miscellaneity which serve in our eyes to impair the serious intent of these collections were essential elements in a programme whose aim was nothing less than universality.

Interest in the natural world was a major preoccupation of Renaissance learning, and here collecting was to play an indispensable role. Reference collections were essential tools for the fundamental research undertaken by early naturalists such as Ulisse Aldrovandi and Conrad Gesner. Publications by such authors, through which the

[1] We are grateful to our colleague G. l'E. Turner for bringing this passage to our notice.

rudiments of a 'natural' approach to taxonomy were disseminated to a wider world, drew heavily on the contents of their own and their friends' collections. Scholars benefited instantly from the publication of specimens held by their contemporaries – an arrangement which retains equal importance today – and cross-references to each other's works became frequent.

In the desire to establish the position of mankind in the grand scheme of things, interest arose in the peoples of antiquity. As a complement to the revival of literary classical studies which lay at the root of Renaissance learning, the actual products of antiquity were eagerly gathered up by collectors. Roman coins, inscriptions, sculptures and utensils were particularly valued, as were figurines and mummies of ancient Egypt. The first steps in the emergence of the discipline of archaeology were taken in conjunction with the development of collections, as interest began to include the field monuments which hitherto had been little regarded or understood.

The discovery of the New World and the opening up of contacts with Africa, South-East Asia and the Far East revolutionized the way in which people saw the world and their own place within it. Polar bears, cassowaries, dodos – creatures hardly less fabulous than unicorns and basilisks – were displayed to an incredulous public in raree-shows, and were often, after their demise, acquired for display in museums. The human inhabitants of these exotic lands were less frequently (though not uncommonly) paraded before the public gaze, but items associated with them were among the most sought-after exhibits in early museums – tokens or emblems of societies whose very existence was a source of astonishment to the intensely parochial European public. Clothing, weapons and utensils of all sorts, often made of unfamiliar materials, found their way to collectors through the major ports and, in time, through dealers.

Perhaps in response to a growing awareness of the value of these exotic exhibits as representatives of the societies which produced them, collectors began to take an interest in the formerly unconsidered elements of their own surroundings. Obsolete tools, peasant costumes and other items of local produce began to appear in collections as if in comparison with objects of antique or exotic origin. Equally, scholars began to consider their own local natural history in terms other than those of the chase, and to describe and collect items where possible. Fossils, incomprehensible as yet, and stone implements, which were still regarded as of natural origin, were actively sought, along with dried flowers, beetles and bones. In the case of natural abnormalities, such as stags' heads with deformed antlers, collectors' enthusiasm and covetousness knew no bounds.

Amongst items from the man-made world, those displaying feats of technical virtuosity proved so irresistible to the collector that specially made pieces, often with no practical purpose, came to be produced specifically for the cabinet. Tremendous advances were made in the design of the lathe during the sixteenth century which allowed the manufacture of items of wood, ivory and horn of quite baffling complexity and perfection. Not infrequently the making of these things became a pastime for the rich and powerful. The production of miniscule carvings – scores of faces cut on a single cherrystone, dozens of miniature objects enclosed in a hazelnut – served as further testimonies to the ingenuity of the craftsman (and, no doubt, to the newly developed skill of the lens maker). In some

instances, most notably in the Electoral collection in Dresden, the skills involved were emphasized to the extent that manufacturing tools were displayed along with the products made with their aid, an allusion to human ingenuity which also found expression in the surgeons' instruments displayed there along with the names of those whom they had helped to cure.

Other distinct categories came to be recognized in the cabinet. Items associated with well-known historical characters were sought after by many collectors, whether personal belongings, medallic representations or painted portraits. The latter might be likenesses of the collector's family, or of patrons, influential friends or dependants, or they might be extensive series of 'portraits' of historical or even legendary personages with no obvious connection with the owner save respect, or through the inspired invention of the genealogist. In the case of princely collections, these would be by famous masters. And just as the work of certain painters was desirable, so were bronzes or marbles by certain favoured sculptors quick to achieve popularity, and an efficient industry producing replicas soon emerged.

This raises a problem: when were such things art and when were they simply curious? One collection called a *Wunderkammer* and another called a *Kunstkammer* would frequently have much in common, and many objects could be found in either type of collection. For instance, a Nautilus shell was a most desirable object for a *Wunderkammer*; were it to be engraved by Bellekin, it could be equally appropriately be kept in either; were it to be mounted in silver-gilt by Jamnitzer, it would probably belong in the *Kunstkammer*, or even in the treasury, the *Schatzkammer*. Time also affected classification of objects. The migration of objects from one type of collection to another might be connected with new-found knowledge, as in the case of the 'unicorn horns' which were recognized in the first half of the seventeenth century as coming from the narwhal, thereby losing much of their prestige and, incidentally, their monetary value. Or it could be due to an increase in the availability of an item imported from elsewhere: whereas in the early part of the sixteenth century porcelain would surely have been kept in the *Kunstkammer*, by the end of the century it was barely worthy of the *Wunderkammer*, having shifted into the household for decorative or even useful purposes. On the other hand, some objects made the reverse journey; a majolica service in Albrecht V's collection, dated 1576, does not appear in the inventories of the *Kunstkammer* until much later. This implies a later acceptance of the service as a work of art (or possibly an antique) as opposed to its former purely functional status. In spite of these comments, no reliance can be placed on contemporary terminology, as this, as much as the contents of the cabinets themselves was affected by matters of geography, chronology, social standing and personality.

Needless to say, it was only in princely courts that problems of this kind presented an issue. For the majority of collectors of more modest means, changes in fashionable terminology wrought few alterations in the cabinet, at least during the period considered here. One of the attractive features of the cabinet must have been the all-encompassing nature of its programme, which accommodated all manner of ambitions and a wide range of budgets. The costly, exotic and rare exhibits which formed an important feature of princely cabinets were quite beyond the grasp of collectors of more modest means, but

there were many more accessible categories of material – particularly from the natural world – whose curiosity value far outstripped their monetary worth. Not that economic factors could be ignored, for the cabinet was often a stimulus to research and exploration in such vital areas as mining, weaponry, time-keeping and navigation. Few cabinets lacked minerals (indicators for the identification of geological resources), or scientific instruments; princely cabinets rarely lacked an armoury. Later, of course, the ardent thematic collectors established high monetary values for rare types within a narrow range of specialization and these sometimes even produced a sort of boom market; tulips and seashells are among the best examples.

There are no difficulties in describing what might be found in a cabinet of curiosities, but the task of seizing and classifying the philosophical bonds which linked the aims of collectors all over Europe is more problematic, encompassing as they do the modest apothecary, the Tsar and the Emperor, and the Scientific Academy. Small wonder that no such attempt has been made since the appearance of Julius von Schlosser's classic *Die Kunst- und Wunderkammern der Spätrenaissance* in 1908. Since the publication of that survey, and particularly in the last few decades, a great deal of detailed groundwork has been carried out on certain collections and on particular aspects of such collections, as may be judged from the bibliography appended to this volume. A number of the following contributions specifically revise, amend or reject von Schlosser's conclusions, but our aim here is less all-embracing than his. The following essays adopt a variety of approaches to the elucidation of particular themes concerning the *Kunst-* and *Wunderkammern* of the sixteenth and seventeenth centuries; illuminating certain facets of them, but having no pretence to the encyclopaedic aims of those responsible for the beginnings of museums.

OLIVER IMPEY
ARTHUR MACGREGOR

SCIENCE-HONOUR-METAPHOR: ITALIAN CABINETS OF THE SIXTEENTH AND SEVENTEENTH CENTURIES

Giuseppe Olmi

In the space of a few pages, it is not easy to construct a complete picture of the nature and evolution of collections of natural objects in sixteenth- and seventeenth-century Italy. A major source of difficulty is the great diversity in both form and function which characterizes the numerous important collections formed during this period. It is my intention to concentrate here on private collections of the late sixteenth and seventeenth centuries, with only the briefest mention of the princely and aristocratic collections which form an essential point of reference and comparison against which to measure the diversity and the aims of many of the museums developed by private individuals during the second half of the sixteenth century.

As a starting point, it should be remembered that the collections of the Italian princes were largely characterized by an absence of specialization and by the juxtaposition of natural and artificial objects. With their marvellous appearance and encyclopaedic arrangement, they constitute an arena of competition between art and nature, and, more generally speaking, represent one of the most ambitious and spectacular responses of Mannerism to the crisis of values resulting from the breakdown of Renaissance certainty.

A *studiolo* such as that of Francesco I de' Medici can be seen as an attempt to reappropriate and reassemble all reality in miniature, to constitute a place from the centre of which the prince could symbolically reclaim dominion over the entire natural and artificial world. Therefore, although it is generally incorrect to speak of a didactic or scientific purpose in these collections, it is also inaccurate to claim that there was no principle of order informing them. The detailed project devised by Vincenzo Borghini for the Medici *studiolo* clearly illustrates how complicated the whole layout was.[1] It can therefore be said that order can be discerned in the princely collections, but it is primarily symbolic, and centres on man rather than on the natural world.

In parallel with these aristocratic collections, others, completely differing in purpose, content and organization, developed in Italy in the second half of the sixteenth century. Among the most famous were those of Francesco Calceolari in Verona, Ulisse Aldrovandi in Bologna, Michele Mercati in Rome, and Ferrante Imperato in Naples; all four collections are characterized by some definite area of specialization. Although some

[1] Borghini's project can be seen in Frey 1930, vol. 2, pp. 886–91. For the significance of the *studiolo* see Berti 1967, pp. 61–83; Lensi Orlandi 1978, pp. 109–35; Gandolfo 1978, pp. 263–311; Bolzoni 1980.

artificialia are included, almost all the objects are animal, plant or mineral in origin, and so we have here specifically scientific collections, or, more precisely, collections of natural objects.[2]

The shape of these collections was determined by two main factors: the social and economic status of the collectors, and, more importantly, their intellectual and professional interests. None of them belonged to the old aristocracy and none had stable relations with princely courts, except for Mercati who enjoyed papal patronage. They all studied medicine and botany at university and all entered professions which naturally followed from such studies. Calceolari and Imperato owned two of the most famous pharmacies in their respective cities; Mercati was a physician at the papal court and was also in charge of the botanic garden in the Vatican; Aldrovandi was professor of natural philosophy at the University of Bologna and director of the botanic garden there.

Sixteenth-century naturalists, while showing a general respect for the ancient authors, did not fail to perceive the inadequacies of most ancient descriptions of the natural world. It therefore became necessary to embark upon a thorough revision of all existing knowledge, to correct past errors and to take the species of the New World into consideration. This was not only an abstract exercise in classification: the use of plants, animals and minerals in medical therapy gave the whole task of identification a manifestly practical purpose. Throughout his life, Aldrovandi never tired of exhorting 'doctors and students of medicine' to apply themselves 'with all their powers' to the study of 'plants, animals and things discovered in the ground'.[3] For the Bolognese scholar, these studies had a twofold basis: theory and direct observation. The essentially practical purpose behind these scientists' museums and botanic gardens was that of providing opportunities for the first-hand observation of natural objects.[4]

Collecting natural objects therefore became a means of creating a didactic and professional resource. This second aspect is seen most clearly in the structure of Calceolari's museum (fig. 1), to which two separate catalogues were dedicated. The two are very different in character: the first was written by the doctor Giovanni Battista Olivi in 1584, and the second compiled by Benedetto Ceruti and Andrea Chiocco in 1622.[5] The latter appeared after Calceolari's death when the museum had probably been improved and transformed by his nephew Francesco, and already partly reflected the taste which we shall later see to be typical of seventeenth-century collectors. The earlier catalogue, however, clearly set out the practical aims of the museum, and in itself constituted a practical work of reference for physicians, pharmacists and botanists. The close, organic links between the museum and Calceolari's pharmacy are clearly delineated; it was as a result of the interdependence of the two that the museum took on the appearance and function of an actual laboratory and a well-furnished medical repository.

Another aspect heavily stressed in the 1584 catalogue is Calceolari's willingness to show his collection to his pupils, thus turning the three rooms of his museum into a place for study and comparison. Evidently, the specifically scientific function of museums like

[2] For example in 1597 Ferrante Imperato wrote a letter to Agostini saying explicitly 'my theatre of Nature consists of nothing but natural things, such as minerals, animals and plants' (quoted in Neviani 1936, p. 257).

[3] Biblioteca Universitaria, Bologna, MS Aldrovandi 70, c. 14.
[4] See Olmi 1977b.
[5] Olivi 1584 (another edition: Verona 1593); Ceruti and Chiocco 1622.

Calceolari's or Aldrovandi's and their being open to the public make them quite different in character from contemporary aristocratic collections or the intensely personal *studioli* of the princes. The museum is conceived of not as a symbolic place where all reality is reconstituted, but rather as an instrument for the comprehension and exploration of the natural world.

The criteria for the arrangement of the objects are therefore purely functional rather than symbolic. There is generally no trace in the scientists' private museums of complex systems of arrangement such as that devised by Borghini for Francesco I de' Medici, in which striking analogies with Giulio Camillo Delminio's *Teatro della memoria* have recently been detected.[6] Aldrovandi not only states explicitly that he found books on the art of memory useless, but also considers it quite vain and fruitless to attempt to form a coherent idea of reality by first superimposing artificial, abstract schemes upon it.[7] The cupboards filled with countless little drawers, which are to be found in Aldrovandi's museum – as in those of other naturalists – might at first sight recall those in the Medici *studiolo*, but in reality their function is quite different. In the *studiolo* the cupboards are concealed by panels depicting various subjects symbolically related to their contents, whereas in Aldrovandi's museum the two cupboards with 4,554 little drawers containing '*cose sotteranee, et conchilij et Ostreacei*' are conceived of and used as filing cabinets, with actual samples from the natural world taking the place of index cards. Of equal importance is the illustration (fig. 2; see also fig. 3) showing Mercati's *Metallotheca* in the Vatican.[8] The layout in general is far removed from that of the Medici *studiolo* with its nocturnal and saturnine atmosphere and its arcane arrangement which held meaning only for the Grand Duke and a few initiates. Instead, we have the orderly succession of numbered cupboards, each one bearing an inscription with details of the contents.

The tendency towards specialization and the adoption by many Italian scholars of an order of arrangement shaped by medical and pharmaceutical practice also contributed significantly towards modifying the concept of confrontation between art and nature in their museums. Aldrovandi's reflections on the meaning of the visual arts, and painting in particular, sprang directly from his desire to become more familiar with, and to catalogue, the natural world.[9] He considered pictorial representation primarily as a means of supplying deficiencies in the collection, pictures of exotic and unobtainable animals and plants being regarded as substitutes for the things themselves. In addition, illustrations inserted into a printed text helped to clarify the written description, making it more concrete and thus more comprehensible. It follows from this that there was no place in Aldrovandi's theories for the concept of man perfecting or transforming nature by art. Since art was conceived of simply as a means of accumulating scientific data, its functions were necessarily limited to an absolutely true and accurate portrayal of the natural world. It is not necessary to discuss here the actual level of realism attained by the numerous artists employed by Aldrovandi. It is sufficient to note that the scientist's desire to possess a complete documentation of nature led him not only to collect concrete objects but also to

[6] Bolzoni 1980.

[7] Olmi 1976, pp. 82–5.

[8] Mercati 1719. It should be noted that the engraving represents the ideal museum and that Mercati's *Metallotheca*

actually consisted of several separate rooms (see Accordi 1980, p. 4).

[9] Olmi 1977a; Olmi 1982.

undertake an enormous programme for the systematic illustration of the entire natural world.

By about 1595 Aldrovandi's museum contained approximately 8,000 tempera illustrations and fourteen cupboards containing the wood blocks which were used to illustrate his printed works from 1599 onwards. These were in addition to his 11,000 animals, fruits and minerals and 7,000 plants 'dried and pasted' into fifteen volumes. His programme can be viewed as an attempt to transfer the entire world of nature from the often inaccessible outdoors to the restricted interior of a museum.

Some scholars have been misled by this form of organization into anachronistically attributing functions to Aldrovandi's museum which in fact became typical only in late seventeenth- and eighteenth-century museums. There is no doubt that many new elements were to be found in these collections and it has already been said that these consisted particularly in specialization in the direction of natural history and in the definite rejection of any type of abstract symbolic systematization. But it is also evident that although museums like Aldrovandi's and Calceolari's were concrete expressions of that new scientific spirit which gave impetus to enquiry into the natural world, they also reflected some of the most characteristic and traditional traits of late Renaissance culture. Above all, it must be noted that the naturalists' attitude was not altogether neutral with regard to the objects placed in their museums. Their programme certainly provided an inventory of the natural world in all its manifold forms, and their scholarly research was also directed towards more common animals and plants, as can be seen in Aldrovandi's publication of a book on insects;[10] yet the love of rarity, the typically Mannerist taste for the bizarre and unusual object, although at odds with the original aims of the naturalists, reasserted itself in the new context of an exclusively natural-history collection.[11] It was the rare, outlandish piece which immediately conferred status on a collection and spread its fame beyond the scientific world. What attracted and astonished visitors was not only the great number of objects on show but also, perhaps above all, the display of objects unique to a particular collection. This was the reason behind the naturalists' marked preference for samples of exotic flora and fauna, animals of monstrous appearance, and plants and minerals endowed with extraordinary powers.

Another factor which lay behind the continuing popularity of exotic objects was the opening to the public of this type of museum, a development which naturally gave it a new dimension in addition to its didactic and scientific function. In the second half of the sixteenth century, a great change came about in the status of collections devoted exclusively to natural objects. With the enormous influx of strange and wonderful natural products resulting from new geographical discoveries, with improved communications and with the concomitant development of public interest in far-off mysterious lands, the natural history collection became for the first time a concrete means of enhancing fame and prestige. The countless visitors were not merely naturalists and students: these museums, and also the botanic gardens – those scientific institutions *par excellence* – were frequented for recreation and pleasure as well as instruction, because of the unusual and

[10] Aldrovandi 1602.

[11] For this aspect of collections in late Renaissance Italy, see Franchini *et al.* 1979.

wonderful objects on display.[12] This explains the fact that the arrangement of the products of nature within this setting was often determined by the desire for symmetry and a pleasing appearance. When late sixteenth-century naturalists speak proudly of the order in their collections, we should not, for the most part, take this as referring to a system of cataloguing objects based on the succession of complete series; instead we should imagine an arrangement based on aesthetic criteria. The imposed order was not one believed to exist in nature itself, but one calculated to appeal to the eye of the visitor.

Moving on from examining the general distribution of the collection to the individual pieces, and particularly to those from the animal kingdom, the question arises as to what precisely the late sixteenth-century naturalists saw and classified. As is well known, the zoological works of Aristotle, or rather some of them, inaugurated the main stream of Western thought which regarded the acquisition of rational and scientific knowledge of animals as being possible solely by means of dissection. The Greek philosopher thus severed the ancient bond of friendship between man and animal, and founded the classification of the latter on the anatomy of the corpse. However, immediately after Aristotle's death another type of approach was developed which emphasized the animal's affinity with man by concentrating on the study of the living creature, its character and intelligence. This alternative tradition began with Theophrastus, continued through the times of Antigony and Plutarch right up to Pliny and Elian, and there were still signs of it in the seventeenth century.[13] For the sixteenth-century naturalists, as for the authors of the medieval bestiaries, this notion was still very much alive. This can be attributed to the great influence still exerted during the Renaissance by the works of ancient authors such as Theophrastus and Pliny and also by those such as Æsop's *Fables* and Artemidoro's *The Interpretation of Dreams*, which emphasized affinities of conduct between man and animal. Having said this, I certainly do not wish to suggest that the sixteenth-century naturalists rejected all anatomical research, especially since we know, for example, that Aldrovandi carried out many accurate dissections. I simply wish to point out, in relation to the present subject, that some reasons which lay behind the internal organization of the museum also promoted the co-existence of a method of classification based on the living animal and its often amazing behaviour.

The great quantity of natural products from distant lands which increasingly flooded Europe during the sixteenth century has already been mentioned. Given the length of most voyages and the rudimentary methods of preservation, we may ask what actually remained of the specimens by the time they came into the hands of the naturalists? When they describe an animal in their works, they often claim to have it under direct observation in their museum, but if we look more carefully into the catalogues of these collections, we realize that we are dealing with an aspect of that fondness for the fragment and the quotation which historians of art and literature have identified as one of the characteristic traits of Mannerism. In most cases, in fact, they were dealing not with whole animals but with parts of them, often very small and insignificant parts such as

[12] An idea of the characteristics and functions of Italian botanic gardens is easily obtained from Biblioteca Nazionale, Florence, Targioni Tozzetti, 56² (*Agricoltura Sperimentale del Padre Agostino del Riccio* I) cc. 74v–75v; Porro 1591. See also Regione Toscana 1981 and Tongiorgi Tomasi 1983.

[13] Dierauer 1977; Vegetti 1979; Vegetti 1981. Some reference may also be found in Thomas 1983.

teeth, horns, tusks, nails, feathers, pieces of skin, or bones. Not only was the naturalist in no position to carry out anatomical dissection, therefore, but he could not even have had an overall conception of the appearance of the whole animal. Hence, in this context the fragment acted simply as a token of an exotic animal, concerning which wider ideas were extremely vague. In view of this ignorance concerning the physical appearance of the animal, the only possible way of writing about it was to describe its habits in accordance with ancient tradition. This led inevitably to the resuscitation of ancient ideas, to the revival of Pliny's treatise and the tradition which he upheld concerning the marvellous behaviour of animals, their intelligence – which was seen as being qualitatively very similar to man's – and their possible use as symbols. The influence of this tradition is apparent in the method of cataloguing. A surprising detail from the engraving of Imperato's museum indicates clearly that the reference is to the living animal and its symbolic significance rather than to the dead, anatomized one.[14] High on the right, amongst other birds, is a stuffed pelican in the act of opening its breast with its beak in order to resuscitate its dead young with its own blood (fig. 4). Such was the influence of secular tradition that the symbol of man's redemption through Christ's blood, taken straight from the pages of the *Physiologus*, appears in and is even classified within the natural history museum. The retention of such traditional elements, however, should not blind one to the objective signs of renewal in the scientists' collections, which put them on a completely different level from the princely *studioli*.

During the following century, notable changes in interests and style can be observed among the collectors. Signs of such changes were already apparent in the princely collections, particularly those of the Medici, at the end of the sixteenth century. Francesco I, now Grand Duke of Tuscany, began to reorganize all the family collections and embarked on a new cultural policy of which the highlight was the opening of the Uffizi Gallery. The new political demands connected with his succession to the throne led the man who had created a *studiolo* at the beginning of the 1570s, to dismantle it in 1584 and to transfer many objects to the Uffizi. It has often been observed that the motifs and complex symbolism present in the *studiolo* in large part blended together in the *Tribuna della Galleria*, but it is also obvious that in this new architectural setting they took on a new role and satisfied quite different requirements.[15] Indeed the *tribuna* and the whole *galleria* represented visually the polar opposite of the secret, nocturnal *studiolo*. All the rare and precious objects, which had once been destined for the private contemplation of the prince alone, were now on view to all in the *tribuna*. The need to legitimize the Grand Duke and his dynasty meant that the glorification of the prince, the celebration of his deeds and the power of his family had constantly to be exposed to the eyes of all and to be strongly impressed on the mind of every subject.

This transition from private to public also entailed a new arrangement of the collections. Works of art and antiquities gradually came to be seen as status symbols and instruments of propaganda, while grand-ducal policy increasingly brought scientific research under state patronage. The main effect of this was that the Uffizi Gallery took on the characteristics of an art museum, even if not in the strict modern sense of the term. It is

[14] Imperato 1599. [15] Heikamp 1963; Heikamp 1964.

true that there were scientific instruments and *naturalia* in the *tribuna*, but they were significantly fewer than those in the *studiolo* and were completely integrated with the works of art.

Specific places came to be devoted to scientific research. The Medici concentrated particularly on Pisa, the seat of the university. Ferdinando I oversaw the restructuring of the city's botanic garden and made it a centre for teaching and research, with the addition of a natural history museum.[16] The continuing regard in which scientific enquiry of all kinds was held by the Grand Dukes of Tuscany is illustrated by Cosimo I's summoning Galileo to Pisa and the later creation of the Accademia del Cimento.[17]

While there was a clear division between the arts and the sciences in collecting in the public sphere, the situation with regard to private collections was much more complex. Although it seems quite natural to assume that physicians and naturalists travelled the same road towards professional utilization of the museum for purposes of research and study, this certainly did not exclude the preference for curiosities which had been typical of the sixteenth-century museums, or the presence of some antiques or *objets d'art*. Nevertheless on the whole it is legitimate to see a distinct move towards natural history in collections of this kind. An example of this trend is the '*Museo di cose naturali*' belonging to the botanist Giacomo Zanoni, which appears to have been the most specialized amongst the Bolognese collections described by Paolo Boccone.[18] During the seventeenth century there was not much discussion of the naturalists' cabinets, or at least they were talked of only amongst the initiated. They certainly did not acquire fame on a scale such as that enjoyed by Aldrovandi's or Imperato's museums in the previous century. The reason for this, I believe, is that the ever-increasing importation of specimens from distant lands had shorn the *naturalia* in many collections of their novelty, rendering them somewhat commonplace and thus detracting from their public appeal.

Faced with this new situation, those collectors who were not professional scientists and who wished rather to use their collections as a means of enhancing their social standing had two alternatives: either they could turn back to antiquities and *objets d'art*, or they could employ every possible means to increase the marvellous, original and bizarre elements in their collections. Passing over the rather special case of Kircher's museum,[19] it seems that collectors in Rome, for example, preferred to take the first course.[20] The favourable state of the antiquities market, the continual presence of countless artists in the city (including numerous foreigners), and the considerable financial resources of the many great families and highly placed prelates, were undoubtedly some of the factors which guided the style and choice of the Roman collectors. Encyclopaedic collections were not completely absent, but they were very much in the minority. Examination of the list of approximately 150 collections in Rome left to us by Bellori reveals that more than 90 per cent of the owners preferred paintings, antiques, medals and cameos, while the products of nature were totally excluded.[21] On the other hand the structure of some celebrated private museums in the north of Italy was quite different, for they did contain

[16] Tongiorgi Tomasi 1980.
[17] For the general characteristics of Medici patronage of the sciences, see Galluzzi 1980.
[18] Boccone 1684, pp. 215–19.
[19] De Sepi 1678; Buonanni 1709.
[20] The fundamental source of information on seventeenth-century Roman collections remains Haskell 1963.
[21] [Bellori] 1664.

natural objects, ethnographical documents, scientific instruments and books, together with antiquities and works of art. I am referring to the museums of Manfredo Settala in Milan, Lodovico Moscardo in Verona and Ferdinando Cospi in Bologna, which owed their great fame partly to the publication of catalogues.[22] None of the three owners of these cabinets had studied science at university and, with the partial exception of Settala, neither had they shown any particular scientific interest of the sort which had stimulated so many private collectors in the second half of the sixteenth century. Personally, I am reluctant to share the opinion of those who have spoken of a distinct modern quality in these museums and who have unhesitatingly seen them as actual centres of research.[23] This seems to be an anachronistic approach, which ignores the social and cultural context of which the collections were an expression. Although the presence of individual objects may suggest new interests, it is dangerous to extrapolate from such evidence conclusions as to the general organization and the overall aims of the museums.[24] There is actually very little of the experimental method of the new science, or Galileo's school of thought, or Malpighi's biological research, underlying these museums.

Even the scientific interests of Settala, encouraged especially by his connections with Tuscany, were far from constituting an analytical survey of reality, for they ran in several different directions before converging on one great focal point: the curiosity. His activities as a constructor of scientific and mechanical instruments also fit well into this picture. Microscopes, telescopes, compasses and intricate clocks were seen not so much as working instruments but as precious objects, to be appreciated more from an aesthetic than a practical point of view. They were greatly sought after by noblemen because of their novel character and because in this age of new science they represented the most fashionable and unusual objects. Undoubtedly Settala's collection and his expertise with the lathe were aimed more at meeting this type of demand than at directly satisfying the requirements of scientific practice.

This type of analysis can be applied with even greater reason to the museums of Cospi and Moscardo, which were more obvious expressions of that new Baroque sensitivity which was also characteristic of the literature of the time. In fact, the interrelationship between eclectic collections and contemporary literature is so evident that one can speak of the former as visualized poetry and of some of the latter as imaginary museums. Through many private collections of the seventeenth century runs the same thread of surprise and wonder, typical of the poetics of Giambattista Marino; at the same time one finds evidence in the works of the latter of a taste for analytical inventory and the listing of all aspects of reality.[25]

Further information on the characteristics of these museums can be found in Emanuele Tesauro's *Cannocchiale aristotelico*, which was acclaimed throughout Italy. Many opinions and judgements of this writer from Turin could easily have been those of contemporary collectors; examples include his rather conservative attitude towards the new science and his regret for that sense of mystery which the discovery of the telescope had helped to

22 Terzago 1664; Scarabelli 1666; Moscardo 1656; Moscardo 1672; Legati 1677.
23 See, for example, Bedini 1965; Tavernari 1976.

24 This would also appear to be the opinion of Lightbown 1969, p. 265.
25 Getto 1969, pp. 13–57.

eliminate. Of even greater importance is the chapter dedicated to *Argutezze della natura* ('The wit of Nature') in which he maintains that all natural phenomena and products of nature constitute so many 'mysterious hieroglyphics', 'symbolic figures' in nature.[26] In short, Tesauro believed that in all things generated by nature there was an allusion to, and concrete image of, a concept. Such an idea was of the first importance where the museum was concerned. If nature speaks (*'fraseggia'*) through such metaphors, then the encyclopaedic collection, which is the sum of all possible metaphors, logically becomes the great metaphor of the world. Such an interpretation is confirmed by the fact that Tesauro, like Marino, was one of the authors used by compilers of museum catalogues.

Other aspects of seventeenth-century museums also make it difficult to justify the view of them as centres of scientific research. In the first place, one may cite the very reasons which the owners gave for forming their collections; these give the definite impression that the collection of diverse objects constituted more a commendable way of spending the time than a scientific activity. Cospi quite clearly defines his museum as 'a pastime of my youth',[27] and Moscardo similarly admits he became a collector to escape idleness by means of an honest occupation.[28] However, collecting on this scale can not have been a common pastime, open to all. In the preface to his catalogue, Moscardo, who had great ambitions to climb the social ladder, sought to dignify his thirty years of diligent collecting. Bearing in mind that the most important European princes had devoted themselves to creating museums, it seems evident that his real aim was to ennoble his own activity. Not only did the creation and enrichment of a museum constitute an occupation worthy of a nobleman; they were also a means of acquiring renown and prestige and of turning the owner's home into an almost obligatory sight for everyone. Nor was it just a question of attracting 'cavaliers and curious ladies' or countless travellers from England, Germany and France. The popularity of the cabinet of curiosities had for a time the effect of overturning rigid social hierarchies, giving the collector the unique opportunity of attracting important personages of royal blood to his own home and of guiding them through his museum. In his old age, Manfredo Settala was obliged to ask his servants to act as guides to his museum, although he would make exceptions for important visitors,[29] considering the effort of showing them round personally well repaid by the reflected glory.

Moreover, the collectors certainly publicized their museums as extensively as possible, emphasizing in particular the amazing objects on display in them. In the second half of the sixteenth century, when the natural collection had functioned as a professional instrument, most physicians and pharmacists had exchanged lists of their possessions among themselves with a view to close scientific collaboration. The printed catalogue, by contrast, is typical of the seventeenth century, an age in which, by a process of involution, Italian society and customs were taking on a Spanish quality which contributed towards an emphasis on external values. The catalogue combined its basic practical function with effective public propaganda. Cospi must have been well aware of this when he took pains to send complimentary copies of his museum catalogue to 'many Italian princes,

[26] Tesauro 1675, pp. 49–53.
[27] Archivio di Stato, Bologna, Fondo Ranuzzi-Cospi, *Vita del Sig. March.ᵉ Balì Ferdinando Cospi*, c. 490.
[28] Moscardo 1656, preface.
[29] See Settala's letter to Kircher quoted in Tavernari 1976, p. 57.

cardinals and knights of merit' before putting it on sale.[30] Similarly, the prestige which Moscardo acquired from his museum and its catalogue was not without concrete consequences, if it is indeed true that this Veronese collector received the title of *Conte* between the first and the second edition.[31]

Amongst all the seventeenth-century collections, Moscardo's is definitely the most encyclopaedic and the most confused. It contains antiques, mummies, paintings, clocks, musical instruments and natural products. Amongst the latter we find giants' teeth, shells which produce ducks and stones endowed with magic powers, and these were displayed not with scepticism but with pride.[32] Moreover, almost all the *naturalia* come from distant lands, supporting the idea that here the Mannerist style is recaptured and amplified by Baroque.

The Cospi museum also reveals characteristics typical of its time, which can be analysed by means of the 1677 catalogue. It is true that this catalogue was not actually written by Cospi himself but by Lorenzo Legati; however, I still believe it helps us to bring into focus the mentality of a certain type of collector in seventeenth-century Italy. The encyclopaedic quality is evident from the early pages of the introduction to the reader: Cospi's collection consists of 'peculiar manufactures of Art' and 'curious works of Nature'.[33] At this point it is not necessary to be reminded of how this juxtaposition of *naturalia* and *artificialia* resolves itself yet again into a continual confrontation between art and nature. It is more interesting to note that the natural-history section in the museum is organized in such a way as to exclude systematically all normality. Not only are the more common animals and plants, which would have been familiar to visitors, completely missing, but European flora and fauna in general are very poorly represented. Evidently, the fundamental aim of Cospi's museum was to provoke astonishment and wonder rather than analytically to reconstruct the whole natural world. This theory is borne out by the presence of only very few ordinary objects. In fact, he did not consider such things worth collecting unless they were either monstrous or had some bizarre peculiarity – the fly enclosed in amber, for example. The descriptions of individual pieces in the catalogue also show how outdated the natural history section of this collection was at this stage. There emerges clearly a feeling of nostalgia for a world full of portentous creatures and phenomena which had not yet been sifted out by scientific rationality. There is absolutely no form of anatomical investigation: animals and plants are described in the terms used by ancient and contemporary poets; their presence is recalled in emblems and medals. Above all, those beliefs in the habits and miraculous properties of animals which scientific research had by then shown to be unfounded, are still stubbornly reiterated. Evidently the results of scientific investigation could not be totally ignored; but the rational explanation (often taken from the works of Francesco Redi) is usually confined to a few grudging lines at the end of each description.[34] The effort to maintain the greatest possible sense of mystery and wonder is quite apparent. In the same town, and at the same time as Malpighi was subjecting the vegetable world to microscopic examination, it did not even

[30] Archivio di Stato, Bologna, Fondo Ranuzzi-Cospi, *Vita del Sig. March.ᵉ Balì Ferdinando Cospi*, c. 37.
[31] Franzoni 1979, p. 624.

[32] Moscardo 1656, pp. 122–3; 201–2.
[33] Legati 1677, preface.
[34] Ibid., for example pp. 11–12, 16, 25, 31, 135.

occur to Cospi to open up a dried Ethiopian fruit to discover the nature of its interior, although the catalogue notes that the fruit rattled when shaken.[35] He still clung to a method of enquiry based largely on vague supposition rather than dissection and empirical analysis.

I believe we now have sufficient evidence to state that museums such as Cospi's, Moscardo's and Settala's represent in some senses a retrogression when compared with the collections of the sixteenth-century naturalists. Julius von Schlosser was quite right when, almost eighty years ago, he detected some aspects of seventeenth-century Italian collections which were similar to those of the Nordic *Wunderkammer*.[36] Moreover, certain seventeenth-century documents would appear to support this interpretation. In his letters, the traveller Maximilian Misson declines to give a detailed description of the contents of Moscardo's museum in order to avoid repeating what he had already written about the Ambras collection.[37] He simply refers the reader to the description of what was possibly the most typical of the *Kunst- und Wunderkammern*, thus emphasizing the similarity between it and the Italian museum.

In addition to the three collections examined here in some detail, many others in Italy provide evidence of a taste for encyclopaedic arrangement. As late as the beginning of the eighteenth century, a Paduan physician, Alessandro Knips Macoppe, advises young physicians to form museums containing numerous tokens of the past as well as exotic and monstrous natural objects, as a means of enhancing prestige.[38] At the time Knips Macoppe was writing, however, signs of a marked and irreversible change were already beginning to show.

Only a few decades after the publication of the catalogues of the museums of Settala, Moscardo, and Cospi, other private collectors with no specific scientific training were giving a completely new slant to their collections. Luigi Ferdinando Marsili, for example, founded his collection of natural objects along strictly specialist lines.[39] Marsili firmly condemned the mixture of *naturalia* and *artificialia*, claiming that encyclopaedic collections 'serve more to delight young men and provoke the admiration of women and the ignorant, rather than teach scholars about nature'.[40] He saw his cabinet exclusively as an instrument for facilitating work and increasing knowledge in which, however, there had to be a true reflection of the natural order itself. This conception automatically makes Marsili introduce another great novelty into the realm of scientific collections: every product of nature, even the most common, had importance and worth, and therefore had to be represented in the museum. Thus the natural-history collection was no longer valued for its curiosities, bizarre objects, wonderful artefacts, or simply for the abundance of the pieces; now the orderly completeness of the natural series was valued because it was fundamentally useful.

The direction of specialization chosen by Marsili was also followed from the end of the seventeenth century by other collectors whose interests differ from those of the naturalists. Scipione Maffei organized a museum of epigraphy in Verona, with definite conservative

[35] Ibid., pp. 136–7.
[36] Schlosser 1908, pp. 108–9. The judgement of Schlosser concerns in particular Settala's museum.
[37] Misson 1743, vol. 1, p. 180.
[38] Knips Macoppe 1822, p. 93.
[39] See Spallanzani (forthcoming) and Olmi 1983.
[40] Quoted by Spallanzani (forthcoming).

and didactic aims.[41] Maffei's *lapidario* marked an important turning point in the history of Italian collections. It was not an encyclopaedic collection, nor did it attempt to incorporate the entire realm of antiquity. The Veronese scholar, concentrating his attention exclusively on inscriptions, which he classified with great precision, created a highly specialized collection. Another fundamental distinguishing feature of Maffei's *lapidario* is that, unlike the seventeenth-century collections which were created as pastimes and then opened to visitors in order to arouse wonder, it was envisaged from the beginning as a public institution.

Collections like those of Marsili and Maffei represent the earliest models which incorporated the new criteria governing the formation and arrangement of museums in the eighteenth century. Two of the most notable examples of the application of these criteria were to be the reorganization of the Uffizi Gallery in Florence by Pelli-Bencivenni and Lanzi, and the foundation of the Gabinetto di Fisica e di Storia Naturale under the direction of Felice Fontana.[42]

[41] Mariani Canova 1975–76; Franzoni 1975–76; Comune di Verona 1982; Sandrini 1982.

[42] Olmi 1983.

MUSEOGRAPHY AND ETHNOGRAPHICAL COLLECTIONS IN BOLOGNA DURING THE SIXTEENTH AND SEVENTEENTH CENTURIES

Laura Laurencich-Minelli

During the sixteenth century, Bologna was a museological centre of prime importance. It possessed two museums or *studi* of (for that period) a scientific type, one belonging to Ulisse Aldrovandi and the other to Antonio Giganti. As we learn from the Aldrovandian manuscripts, these two museums operated in a complementary manner to each other, both for the benefit of their respective proprietors and for other scholars, a function which was facilitated by their being housed close to one another in the same group of buildings.

Both museums are also of interest for the history of museography in that period for, while each can be seen as an expression of Italian Renaissance culture, they represent two distinct strands of it. The first, which was furnished also with a rich library, belonged to Ulisse Aldrovandi (1522–1605), the noted botanist, zoologist, and professor *de fossilibus, plantis et animalibus* at the University of Bologna; thus it was indirectly connected to the University.[1] The second museum under consideration belonged to the erudite Antonio Giganti (1535–98) who, although not himself a cleric, lived in close contact with the foremost exponents of the Church of Rome and its cultural environment. He was, in fact, secretary to two outstanding clerical personalities: the humanist Lodovico Beccadelli, from 1550 to his death in 1572,[2] and the Archbishop of Bologna, Cardinal Gabriele Paleotti, from 1580 to his death in 1597.[3] Monsignor Beccadelli's collection, which was rich in antiquities,[4] was gradually absorbed into the Giganti museum;[5] among the names of donors mentioned almost casually in the inventory of this museum, there appear those of personalities from the ecclesiastical world, and of those belonging to ecclesiastical orders of chivalry;[6] furthermore, Giganti, in his role as secretary successively to Beccadelli

[1] Aldrovandi himself, and not the university, created his museum; nevertheless, since he was Professor at Bologna University, we consider his museum connected to the university. For Aldrovandi's museum see Rodriquez 1956; for his ethnographical collections see Heikamp 1976, Laurencich-Minelli 1982a and 1983; for his scientific personality see Tugnoli-Pattaro 1977 and 1981; for his *naturalia* and his scientific personality see Olmi 1976 and 1977a.

[2] Monsignor Lodovico Beccadelli (born Bologna 1501, died Prato 1572). For his life see Giganti 1797; for his relations with Giganti's museum see Fragnito 1982 and Laurencich-Minelli 1984.

[3] Cardinal G. Paleotti (born Bologna 1522, died Rome 1597). For his life and personality see Prodi 1959–67; for his relations

with Giganti and his museum see Laurencich-Minelli 1984.

[4] Giganti 1797, p. 62.

[5] Giganti received many items from Beccadelli when the *Monsignore* was alive, and later, after his death, inherited the whole *studio* (Morandi 1797, pp. 158–63).

[6] Among the names of donors mentioned occasionally in Giganti's *Indice* (Biblioteca Ambrosiana, Milan, MS 85 sup.) are Ippolito Agostini, *balì* of the Order of S. Stefano (fol.252ʳ n°.[34]); Girolamo Geri, *cavaliere* of S. Sepolcro (fol.239ᵛ n°.1,2); Cardinal Giovanni Poggi (fol.248ᵛ, n°.[145]); Cardinal Gabriele Paleotti (fol.251ᵛ n°.[26]). (The numbers in parentheses were added in my transcription of the *Indice* (Laurencich-Minelli 1984, appendix), in order to facilitate identification of each item.)

and Paleotti, played an important part in the two small circles of intellectuals which gravitated around these high prelates, and he was also the 'spiritual son' of Beccadelli.[7] We may therefore conclude that Giganti's museum represented the cultural strand of ecclesiastical humanism in the Italian Renaissance during the long period spanning the Council of Trent (1545–63) and the years immediately following. This period appears to have been particularly favourable for the acquisition of ethnographical items, given that the Council itself, which acted internationally as a polarizing force amongst the high clergy, favoured exchanges and gifts of, among other things, items coming from recently discovered distant lands.

This museum, of which an inventory was drawn up by Giganti in 1586 together with a plan (fig. 5) and a vertical projection of one wall (fig. 6), has recently been the subject of detailed study.[8] These documents enable us to understand – almost to visualize – the organization of the display, and consequently to interpret more successfully that of Aldrovandi's museum. In addition, Giganti's *studio*, which was already in existence by 1563, was rich in ethnographical items including some from America, which may be linked with Aldrovandi and his museum.

Giganti's inventory shows that his was an encyclopaedic museum, embracing the picture gallery and collections of natural, ethnographical, archaeological and philological materials, as well as items pertaining to physics, particularly to optics. The ethnographical collections cover the East and West Indies as well as Middle Eastern (Turkish) items: they seem to have been considered both as exhibiting raw materials coming from distant lands and as demonstrating the utilization of such raw materials by non-European cultures. Exceptions were the palaeographical collections and the Turkish items, which were considered only for their cultural significance. The exceptional nature of several American items may be noted here, particularly a pre-Columbian map, two parts of a pre-Columbian codex, two feather head-dresses from Florida, and nine stone idols from the New World; the collection also included a 'stone knife with wooden handle with which they sacrificed', a stone axe, a series of bows and arrows and an obsidian razor, as well as a few items from colonial Mexico, including a small feather mosaic picture and a mitre.[9]

Since we have no written documents by Giganti, we can only speculate about his attitude towards the various categories distinguished in his display organization, basing our impressions on the quality, quantity and display arrangement of the individual groups of exhibits as they can be deduced from the inventory.

Aldrovandian manuscripts and publications dealing with the same subjects are extremely useful aids in this respect, given the close relationship which existed between the two scholars. However, we must not forget that the component parts into which we

[7] Giganti 1797, p. 1, n. 1.

[8] Biblioteca Ambrosiana, Milan, MS 85 sup. M, first mentioned by Rivolta (1914, p. 102, and 1939, p. 115). Fragnito (1982) wrote an interesting article giving the historical framework of the collection, mostly during Beccadelli's time, and a general interpretation of the museum. Laurencich-Minelli (1984), after considering Giganti's life in relation to his museum, attempts a reconstruction of the display and of his museographical conception on the basis of the *Indice*; a transcription of the manuscript is given in the appendix.

[9] See Laurencich-Minelli 1984, appendix fol.249^v, n°.[149]; fol.248^r, n°.[124]; fol.248^r n^os.[119], [120]; fol.241^v, n^os.48–55 and fol.246^r, n°.[54]; fol.245^v, n°.[23]; fol.245^r, n°.[24]; fol.247^v, n°.[109]; fol.241^v, n°.7; fol.248^r, n°.[118]; fol.249^v n°.[4].

have divided the museum in order to render it more clearly understandable are products of our own times and that Giganti, as a man of the Renaissance, conceived his collection (including the library) as a unity. '*Natura atque artis tot rerum millia in una*' was his museographical ideal, which he expressed in an epigraph on the Aldrovandian museum.[10] His museum and his library, while occupying two different though intercommunicating spaces (fig. 5), were unified to such an extent that the ceiling of the latter formed an exhibition space, and the former contained a table which formed a physical base for research, whether with books or with museum items.

From an examination of his *Indice*, it seems that in the matter of display organization Giganti had a strong desire to fill every space – making no distinction between *naturalia* and *artificialia* – and to achieve an effect of harmonious symmetry.[11] Two kinds of symmetry can be detected amongst the exhibits on the walls of the *studio*: the first, concerning the display of individual items, may be termed 'alternate microsymmetry', in which items of similar appearance are never displayed next to one another but invariably alternate with other, dissimilar objects;[12] the second system, which we may call 'repeating macrosymmetry', involved the arrangement of groups of items on a thematic basis.[13] This second feature is less easy to detect than the first, but if the alternating components involved in a microsymmetrical arrangement are examined, we find that they frequently form two series, each with some internal homogeneity, which suggests an attempt at thematic grouping. Moreover, one of the two components invariably comprises natural material, and each thematic group or *categoria* so detected is harmoniously displayed on more than one area of wall-space, in such a way as to achieve a repeating symmetry.

The desire for symmetry shown in the display organization,[14] the arrangement of the exhibits to allow maximum accessibility, and the atmosphere given to the whole museum and library by the constant presence of *naturalia*, all combine to suggest that this museum was conceived as a *theatrum naturae*, the walls of the *studio* being punctuated rhythmically by *naturalia* and the micro/macrosymmetry, alternating and repeating regularly, acting as a unifying framework for the very different categories of material exhibited. In short, we may say that in his museum Giganti sought to generate a harmonious vision which enabled a simultaneous evocation, or *ars memoriae*, of the whole of art and nature.[15]

Ulisse Aldrovandi's museum, although conceived on a similarly encyclopaedic basis, laid greater stress on the natural world. From the *Index alphabeticus rerum omnium naturalium*

[10] Giganti 1595, p. 115.

[11] The symmetry is very clear on façade A (fig. 6) and in the related inventory. It can also be inferred for the other three walls from the order of descriptions of each item in the inventory and from the plan (fig. 5).

[12] We use the term 'alternate microsymmetry' as it is concerned with the small (μικρόν) areas of the *studio* and involved the display of certain items in an arrangement in which they alternated with others of a different kind. This alternate microsymmetry is mostly displayed along horizontal lines which may be crossed by others running vertically. Examples of horizontal alternate microsymmetry are, in fig. 6, nos. 8, 9, 11 (portraits) and nos. 8, 10, 12 (starfish); examples of vertical microsymmetry are nos. 13, 15 (torpedo fish) and no. 14 (starfish different from those numbered 8, 10, 12).

[13] We use here the term 'repeating macrosymmetry' since it was concerned with the broader (μακρόν) areas of the *studio* and made an attempt at grouping a large number of items belonging to some kind of *categoria* and arranging them on the walls in repeating patterns: for example the group of *exotica* is divided between the two walls A and B and is symmetrically arranged between the door and the shelves of wall A and the shelves and the door of wall B.

[14] That is, microsymmetry within a broader macrosymmetry.

[15] Giganti expresses this idea of the museum as a place of simultaneous evocation of art and nature in a short poem which he dedicated to Aldrovandi's museum (Giganti 1595, p. 115).

in musaeo appensarum incipiendo a trabe prima of 1587,[16] we can see that although not ignoring antiquarian items – sculptures, paintings, plaster models of statuettes, clocks, burning glasses, distorting mirrors – his greatest interest was in animals, plants fossils and rocks. He was also interested in man and his various cultures, especially those of distant lands, and aimed to interpret and verify Hippocrates' thesis that the customs of populations are conditioned by their environment.[17] Ethnographical items enabled him to pursue the study of products of distant lands and to compare different methods of utilizing raw materials, as well as to examine different items with the same function.[18] It seems likely that he studied *exotica* in order to discover whether they had any useful contribution to make to his own world. In other words, Aldrovandi's ethnographical research as well as his zoological and botanical interests were characterized by very precise, practical, almost utilitarian aims in terms of *speziale*.

Aldrovandi and Giganti maintained a close relationship which hinged principally on the resources of their two museums. Aldrovandi often availed himself of Giganti's collection to describe or to write dissertations on items which he himself did not possess.[19] The fact that Aldrovandi, on 25 April 1588, made a partial list of only fifty-three of Giganti's items (that is, less than one tenth of Giganti's entire collection) suggests that he had free and continuous access to the whole museum.[20]

It seems from Giganti's *Indice* that Aldrovandi was also the most respected consultant for the natural material in Giganti's museum. We should not underestimate a certain methodological contribution made by Aldrovandi to Giganti's display arrangements, shown, for example, by the numerous gouaches of animals which carry into Giganti's *studio* the element of naturalistic reality conceived by Aldrovandi.[21]

Giganti was responsive to Aldrovandi's *desiderata*. In the list of noteworthy items observed in Giganti's museum (referred to above), Aldrovandi includes an Amazonian axe which we later find described in his own catalogue entitled *Musaeum Metallicum*, together with the information that it was donated by Giganti.[22] The two Mesoamerican knives described and drawn by Aldrovandi in the same catalogue may be recognized as Giganti's 'stone knife with wooden handle from the New World with which they sacrificed' and his 'stone razor from India'.[23] Indicative of another possible transfer from Giganti's to Aldrovandi's museum is the correspondence between the number of idols from the New World reproduced in *Musaeum Metallicum* and those listed in Giganti's *Indice*. The general description given by Giganti and the prominence which the idols enjoyed in his museum also support this hypothesis.[24] It is probable, too, that the head-dress of the '*Regina Insulae Floridae*', which Aldrovandi portrays in a gouache, is the head-dress from Florida made of 'small, fine, yellow, cunningly wrought' feathers of

[16] Biblioteca Universitaria, Bologna, Aldrovandi MS 26.

[17] Aldrovandi 1642, p. 93.

[18] Aldrovandi 1648, pp. 156–7; 541–51.

[19] Aldrovandi (Biblioteca Universitaria, Bologna, MS 21, IV, fols. 9–10r) describes a head-dress of red feathers of the Florida Indians which he did not possess, and writes on the nature of a shell which Giganti had obtained from Epidaurus (MS 6, II, fols. 210–13).

[20] Biblioteca Universitaria, Bologna, Aldrovandi MS 136, XII, fols.140–1.

[21] Olmi 1977a, pp. 105–18.

[22] Aldrovandi 1648, p. 157.

[23] Aldrovandi 1648, pp. 156–7; the knives correspond to those belonging to Giganti as described in his manuscript (see Laurencich-Minelli 1984, appendix fol.245v, n°.[23], fol.241v, n°.7; ibid. for discussion).

[24] See Laurencich-Minelli 1983, 1984; Aldrovandi 1648, pp. 541, 544.

Giganti's *Indice*.[25] It seems possible that Giganti, when retiring to Fossombrone in 1597, gave or sold these items to Aldrovandi.[26]

In spite of the impression given by the *Musaeum Metallicum* that Aldrovandi's museum was ordered according to comparative and functionalistic principles, an examination of the *Index alphabeticus rerum omnium naturalium* indicates that this was not the case.[27] Only rarely do related items occur together and, even when they do, they have irregular rather than consecutive numbering, as though they too had been displayed according to alternate symmetry, as in Giganti's museum.

We have here two museums which seem to conform to the same model, which we may call the Bolognese encyclopaedic conception of the *theatrum naturae*.[28] None the less, they are very different owing to the different personalities of their creators. On the one hand we have Giganti, who seems to have maintained a certain balance between the various subject categories of his collection without falling into the chaotic spread of his transalpine neighbours: on the contrary, he managed to make each subject sufficiently specialized to be able to offer a field for research, in spite of the fact that he felt no necessity to separate *artificialia* from *naturalia*. On the other hand we have Aldrovandi, who emphasized the natural characteristics of his collection to such a point that he could include in the *Index alphabeticus rerum omnium naturalium* even *artificialia*. Perhaps this was a kind of 'professional distortion' whereby he considered even works of art as expressions of natural reality or, more simply, perhaps it was because he had so few *artificialia* that they too were included in the general inventory of *naturalia*. Whatever the cause of this admixture, it indicates that Aldrovandi too felt it unnecessary to separate *artificialia* from *naturalia*.

Both these museums may be defined as 'scientific', since they were not only places of spiritual meditation and gratification but also research tools. Aldrovandi's zoological and botanical investigations are widely known, but we know hardly anything of Giganti's work in these spheres apart from the little which can be inferred from a few words here and there in the inventory of his museum or in Aldrovandi's writings. For example, when recording the gift of the Amazonian axe, Aldrovandi defines Giganti as '*rerum naturalium diligens perquisitor*'. This view is confirmed by the *Indice* where it appears that Giganti classified the *naturalia* himself.[29] It also seems clear from the *Indice* that he carried out experiments on the use of the lens with the camera obscura; that is to say, he may have contributed to the introduction of this type of experiment to Bologna.[30]

The quantity and quality of Giganti's archaeological specimens bear witness to his study of the classics, as do the archaeological drawings which carried the monuments of Roman civilization into his *studio*, and his own elegant Latin verse-writing in neo-classical

[25] See Laurencich-Minelli 1983, 1984; Aldrovandi *Tavole di Animali*, t. I, f. 75.

[26] Laurencich-Minelli 1984.

[27] Biblioteca Universitaria, Bologna, Aldrovandi MS 26.

[28] Lacking for the moment any evidence that this form of display as *theatrum naturae* had a wider currency than Bologna itself, we may call it 'Bologna style'.

[29] After publication of Giganti's *Indice*, it appears that in spite of the fact that Aldrovandi was his most respected consultant for natural items, Giganti preferred to classify his own *naturalia*, occasionally conflicting with Aldrovandi: while, for example, he believed that item n°. 56, fol.241^v was a 'horse-fish' (walrus) tooth, Aldrovandi identified it as a wart-hog tooth.

[30] We do not know when he began these experiments, but it must have been during that period between 1563, when we have the first reference to his *studio*, and 1586, the year when the *Indice* was drawn up. On the other hand Barbaro (1568) and Porta (1569) published writings on the possibility of using a lens with the camera obscura during those years. For further references see Laurencich-Minelli 1984.

style.[31] The fact that he collected documents and inscriptions in exotic languages (Chinese, Indian, Ancient Mexican), together with his interest in the Etruscan language, suggests that he also concerned himself with philological research into the original tongue of mankind as well as with Tuscany's Etruscan past.

During the seventeenth century an entirely new situation evolved among the Bolognese museums. Giganti's *studio* was already dispersed when, in 1603, Aldrovandi left his museum to the Senate of Bologna, together with his extensive library. In 1617 the whole collection was transferred to the Palazzo Pubblico, arranged in six rooms and given into the charge of the keeper who allowed access to the collections to scholars. This is perhaps the first example of a *theatrum naturae* open to the public.

In 1657 the Marchese Ferdinando Cospi's museum joined the Aldrovandi collection when it was transferred to 'one room with two small rooms' in the Palazzo Pubblico, being formally donated to the city in 1667.[32] No mention has been found of the fate of Cospi's library, which probably remained with his family. The Cospi museum is interesting as it represents, for Bolognese museography, a third element in addition to those of the sixteenth century. It came into being as 'a youthful pastime'; thus its initial formation can be considered as analogous to that of the *guardaroba* and collections of the high Italian nobility, notably those of the Medici.[33] Later, however, when Cospi decided to give his museum '*per servitio publico*', placing it alongside that of Aldrovandi, and when he chose for the preparation of the catalogues the learned doctor Lorenzo Legati,[34] he clearly wanted to invest his museum with a scientific character in the Aldrovandian mould.

We shall leave aside here the motives which might have prompted Cospi to make this donation, not the least of which may have been that of lending prestige to his branch of the Cospi family. Space is too limited here to describe fully the rich ethnographical collection of the Cospi museum; we may simply say that Legati's attitude towards its items was more cultural than naturalistic.[35] There is another point, however, on which we may dwell at greater length: the lack of correspondence in the Cospi collection between the display organization, as outlined in Legati's published catalogues, and the inventory.[36] From the division of the 1677 catalogue into books, we can deduce that the categories according to which Legati had ordered Cospi's collections were: (1) terrestrial and flying animals; (2) aquatic animals; (3) ancient and modern artificial devices; (4) ancient coins and medals; (5) figures of ancient gods. From the *Inventario Semplice* (1680) and from Mitelli's wood-cut of 1658,[37] however, we realize that the museum was not arranged according to the method of Legati's catalogue; furthermore, it showed a display organization which was actually contrary to Legati's subdivisions, most obviously in the admixture of *naturalia* and *artificialia*.

[31] Giganti 1595, 1598.

[32] *Supplica che il Marchese F. Cospi rivolse al Senato bolognese il 24 giugno 1660* (see Laurencich-Minelli and Filipetti 1981, p. 228). For the history of the Cospi collection, see also Laurencich-Minelli 1982a and 1982b.

[33] The quotation is from *Raggionamento del Sig. M.se Bali Ferdinando Cospi fatto in Senato nell'ultimo Regimento mentre era Gonfaloniere di Bologna . . .* (Laurencich-Minelli 1982b, p. 187). Thus, it can be considered as having had an initial formation analogous to that of the collections of the high Italian nobility and, in particular, to those of the Medici, to whom Ferdinando Cospi (1606–86) was related on his mother's side. He lived from the age of four to the age of eighteen at the court of Cosimo II.

[34] The quotation is from the *Supplica* mentioned in note 32. Lorenzo Legati came from the same scientific line as Aldrovandi, in whose works he had shown profound interest.

[35] For his attitude towards the ethnographical items, see Laurencich-Minelli and Filipetti 1983.

[36] Legati 1667, 1677; Anon. 1680.

[37] The Mitelli wood-cut, dated 1658, is in Legati 1677.

Bologna, therefore, offers an interesting area for the study of late Renaissance and Baroque museography, encompassing within a period of little more than a century three interlinked museums. Although they all derive from the standard model of the encyclopaedic collection, they represent three very different aspects of it: the first springs from the cultural world of the university, the second from that of the Church, and the third from that of the high nobility. These three museums, although very different from one another, none the less had something in common, namely the provision of a place for scientific documentation. None of them, however, was arranged in what, today, we would judge to be a scientifically based display, since the exhibits were not arranged in homogeneous groups. In addition, we have seen that it was not felt necessary to make the display organization coincide with that given in the corresponding catalogues. When catalogues do exist, they are seen to be independent exercises in scientific interpretation of the collections rather than true reflections of the actual, physical arrangement of the items. This would seem to contradict the idea of unity of knowledge which these collections ought otherwise to have represented. The donation of the collections to the city too, and their being opened to the public (which, in the case of the Cospi museum, seems to have been a determining factor in its transformation into a scientifically organized collection), seems anomalous with respect to other encyclopaedic collections in which that unity of knowledge was reserved for a select few.

In conclusion, it seems that this glimpse of Italian Renaissance-Baroque collecting offered by the Bolognese collections raises certain questions which prompt an examination of the subject in more detail, and over a larger number of collections in Italy. For the moment, we may content ourselves with the removal of the term '*Wunderkammer*' from the terminology of Italian museography. This word, borrowed from German museography, is entirely inappropriate for use in connection with Italian collecting. As substitutes we may propose the terms '*studio*', '*studiolo*', '*guardaroba*', '*museo*', which express more adequately the different degrees of research and documentation which these collections represent, and which were, with good reason, the words coined by those who actually founded the Italian collections.

TOWARDS A HISTORY OF COLLECTING IN MILAN IN THE LATE RENAISSANCE AND BAROQUE PERIODS

Antonio Aimi, Vincenzo de Michele, and Alessandro Morandotti

The administrative decentralization of Spanish rule in the state of Milan (1535–1713) and the autonomy allowed to the local political class in the government of the cities had evident repercussions on local collecting in this period.[1] Collecting was not determined by the cultural preferences of an artistically minded court, but rather was characterized by a plurality of interests and the social and territorial diversity of the collections. For these reasons, a study of collecting in Milan in the years following the imposition of Spanish rule ought not to omit analysis of the aims of individual collectors.

In the panorama of Milanese collections of this period, galleries of paintings were almost entirely the monopoly of the local patriciate, the noble class governing the city, and it may be assumed that the role of the galleries was one of social prestige and display.[2] By contrast, collections of antiquities, though exhibited in the gardens and palaces of the nobility only for decorative purposes, in certain cases acquired a scholarly value, serving as an essential complement to learned research into the city's history[3] or for other professional activities. Such a situation is documented by the collections of antique marbles and casts of such antiques owned by the sculptor Leone Leoni[4] and the painter Giovan Ambrogio Figino.[5]

However, a full and reliable survey of Milanese collections in the period under consideration is complicated by the marked tendency of local sources to favour collections of antiques and paintings. Girolamo Borsieri, well acquainted with cultural developments in late sixteenth- and early seventeenth-century Milan, does record some collections containing art objects and other items typical of encyclopaedic collections,[6] but this information is presented as being marginal to what was seen as the main content of such collections. This bias, which makes his information inaccurate and partial, is apparent from his description of, for instance, Federico Landi's collection, which we know contained a substantial nucleus of American ethnographical items,[7] or that of Giovan

[1] For the structure and organization of Spanish rule in Milan, see Bendiscioli 1957; Vismara 1959; Chabod 1961.

[2] Borsieri 1619, pp. 67–70 notes sixteen picture galleries in Milan, fourteen collected by members of the local government.

[3] This is the case for the collections of Giacomo Valeri (Borsieri 1619, p. 37; Motta 1892) and Giovan Ambrogio Biffi (Borsieri 1619, pp. 37–8), authors of learned studies on the history of Milan.

[4] For Leone Leoni's collection of casts of antique sculpture, see Boucher 1981.

[5] Morigia 1619, p. 558. We should not forget the connection between Figino's collection and his graphic records of antiquities: see Ciardi 1968, pp. 127–91.

[6] Borsieri 1619, p. 68.

[7] Scarabelli 1677, p. 169.

Battista Ardemanio, which contained two important sections of musical instruments and medicinal stones.[8]

As a whole, encyclopaedic collecting in Milan ranged far afield. The collections of physicians Gerolamo Cardano and (probably) Lodovico Settala,[9] rich in minerals and medicinal substances, can be taken as the only examples of working collections, while others, such as those of Gian Battista Clarici and Pietro Antonio Tolentino,[10] both of whom corresponded with Aldrovandi, were connected with non-professional research interests. Yet others, nearer to the typical *Wunderkammern*, displayed a predominant interest in works of art and craftsmanship as well as curiosities.

This last kind of collection had good reason to exist in Milan, one of the principal centres of production in later sixteenth-century Europe of objects for *Kunstkammern* and *Wunderkammern*. Local sources describe in detail the products of the Milanese workshops: items of wood, bone, ivory, jewellery, crystal and gemstones, arms and armour, miniatures, embroidery, and finally works of extreme technical virtuosity, such as minute objects turned on the lathe.[11]

It is interesting to note that dealings between these workshops and foreign patrons were often conducted through Milanese agents who, acting as intermediaries, followed the execution of the objects commissioned. The agents were often prominent members of the Milanese nobility. Italian and foreign courts commissioned works from the Milanese workshops through prominent citizens who were able to secure fair prices, to see that deadlines were observed, and to supervise the quality of the products.[12] One of these noble agents, Pirro I Visconti Borromeo (*c.* 1560–1604), collected the same kinds of objects as those which Duke Vincenzo I Gonzaga commissioned through him from the Milanese workshops.[13]

The Visconti Borromeo collection, formed at the end of the sixteenth century, was in fact similar to contemporary German *Wunderkammern*: paintings, marbles and works of art were mingled with mechanical instruments and zoological and ethnographical items; no scientific criterion was applied to the grouping of categories of related objects.[14] The Visconti Borromeo collection was displayed in eighteen rooms of a *nymphaeum*, a monumental artificial fountain constructed in the garden of the collector's suburban villa (fig. 7), where we find no zoological specimens hung on the walls as in contemporary *Wunderkammern*; but as proof of the interest in the natural world so typical of late Renaissance encyclopaedic collections, we find two rooms resembling grottoes (Fig. 8), constructed of travertine hewn from natural grottoes and decorated with compositions of shells and pietra dura. In this building, where natural phenomena were reproduced by artificial techniques (the formation of grottoes and waterfalls), four 'paintings of divers fruits' found a highly appropriate setting. They are the first independent still lifes ever recorded in a private collection.

[8] See (*Ardente etereo. Casinense inquieto*) *Tesoro delle Gioie* (Milan, 1619).

[9] Cardano 1663; Scarabelli 1677.

[10] Morandotti forthcoming; Scalesse 1982, pp. 134–6.

[11] Morigia 1619, pp. 468–97; Verga 1931, p. 235; Rosa 1957; Gamber and Thomas 1958; Distelberger 1975 and 1978.

[12] Interesting documentation of the relations between foreign courts, Milanese craftsmen and local nobility is provided by the letters of Gaspare and Prospero Visconti to Duke Albrecht V and to Prince Wilhelm of Bavaria (Simonsfeld 1902).

[13] Morandotti 1983b.

[14] Morandotti 1983a.

The material already collected by Lodovico Settala passed into the keeping of his son Manfredo (Fig. 9) early in the 1630s. Manfredo had already enriched it with a sizeable nucleus of ethnographic items and within a few years he transformed it into the most celebrated collection in the city and one of the most important in Italy, attracting admiring visits from scholars, travellers and crowned heads. The fame of the Settala collection (the printed catalogues went through no fewer than three editions,[15] the greatest editorial success of its kind), was clearly due to the quantity, variety and 'rarity' of its contents, but also to Manfredo's many-sided technical, scientific, and craft activities, ranging from the production of lathe-turned items to the construction of bizarre games in the Baroque taste, burning glasses, quasi-perpetual-motion devices, telescopes, and microscopes. It is unclear whether the collection was open to the public, but the attitude of Manfredo and those near to him suggests that it was neither private nor closed to those wishing to visit it, within the rigid barriers of class and culture in seventeenth-century Milan. The pomp surrounding Settala's funeral and the four commemorative volumes published immediately thereafter clearly show that the Settala museum had an important social function and was considered one of the city's leading cultural institutions.[16] Most of its exhibits were arranged in four (perhaps more) rooms in the family home in via Pantano, but others were situated in premises equipped as a workshop in the nearby cloister of the church of San Nazaro, of which Manfredo was canon.

Although it is difficult to provide a complete classification under regular headings, the following groups of materials can be identified in the Settala museum:

Mathematical and physical instruments, precision instruments: mirrors, lenses, telescopes, armillary spheres, astrolabes, timepieces, compasses, quasi-perpetual-motion devices, locks, automatons.

Rocks and minerals: quartz, metal ores, asbestos, gems, figured stones, magnets and lodestones, *pietra fungifera*.

Fossil remains: amber, shells, mammals.

Zoological remains: corals, molluscs, fish, reptiles, birds, mammals.

Products of the vegetable kingdom: seeds, woods, oils.

Ethnographic objects: clothes, ornaments and weapons from America, Asia, Africa.

Weapons: cross-bows, artillery.

Archaeological items: skeletons, urns, lamps.

European craft items, including those worked by Manfredo.

Musical instruments.

Books, prints, drawings, codices.

Paintings, statues, medals.

Since recent work by the authors and other members of the Gruppo di Ricerca sul Collezionismo, together with that of other scholars, has dealt with both the Settala museum as a whole and with particular sections of the collection,[17] it is unnecessary to

[15] Terzago 1664; Scarabelli 1666 and 1677.
[16] Alifer 1680; Pastorini 1680; Visconti 1680; Yrissarri 1681.
[17] Michele 1973; Tavernari 1976, 1979, 1980; Bassani 1977; Tomba 1978a and 1978b; Michele *et al.* 1983; Alberici 1983; Aimi 1983.

deal even summarily with these topics here. Instead we shall concentrate on certain aspects of Manfredo's activities which shed a new light on this collection, which has in the past been wrongly considered to be a *Wunderkammer* or at least the Italian collection closest to the German idea of a *Wunderkammer*.[18]

It should first be noted that we have adopted an interdisciplinary approach to the Settala museum and other encyclopaedic collections. This means that items in the different sections of the collection, their collocation and their function as museum-pieces, have been appraised by experts in the relevant disciplines, and have been related by them to the development of these disciplines in the sixteenth and seventeenth centuries. This strategy is not quite so obvious as it may seem, for in the case of the Settala museum not only has it never been done before, but there have been notable conflicts on the subject between art historians on the one hand and historians of science on the other.[19]

One outstanding, indeed essential, source for the study of the Settala museum is constituted by five illustrated codices in which about three hundred drawings illustrate the principal items, with manuscript notes by Settala himself.[20] These codices are extremely interesting, not so much for the quality of the temperas which reproduce the items in a markedly realistic style, but because they reveal a comparative treatment of the items themselves and concepts of classification which are much more advanced than those found in the printed catalogues. They are to be considered an authentic expression of Manfredo's scientific and museological principles, both because of their quality of 'work in progress' and their condemnation of a series of errors and wayward seventeenth-century notions; in this they are superior to any of the three printed catalogues, which should, for this very reason, be used with due caution.

Similarly, the engraving by Fiori (fig. 10), showing a large number of items on display in accordance with the classificatory criteria of neither the codices nor the printed catalogues, should be regarded as a stylized arrangement rather than a realistic depiction of the disposition of the objects. Moreover, no striking results have been produced by the attempt to deduce from the list of pieces in the museum significant differences between the Settala collection and a typical *Wunderkammer*, since the concepts apparent in the codices are expressed not so much in opposition to the tastes of the age as in the nature of a continuous technical exposition combined with a programme for the advancement and dissemination of scientific knowledge for which the collection served as a starting point. Examples of this were: Manfredo's promotion of a brief essay on the origin of fossils, in which explanations going back to the Bible or to Aristotle were rejected and the hypothesis advanced that subterranean interstitial passages linked mountains and the sea;[21] the invention of a ceramic paste which gave 'the appearance of Chinese porcelain', on which Tschirnhaus drew to 'give a start to European art porcelain';[22] participation in anatomical dissection;[23] Manfredo's skill in the construction of optical and mechanical instruments; and a continual search for information from experts or from the existing

[18] Schlosser 1908 (It. tr. 1974, p. 105).
[19] Giannessi 1958, pp. 432–5; Belloni 1958, pp. 628–41; Tea 1959, pp. 841–2.
[20] Biblioteca Ambrosiana, Milan, MS Z 387–9 and Biblioteca Estense, Modena, MSS Campori y H 1, 21–2.

[21] Quirino 1676.
[22] Tea 1959, pp. 841–2.
[23] Tavernari forthcoming.

literature concerning the ethnographical, archaeological and natural items in his possession.[24] Furthermore, to escape the isolation of an environment which he found intellectually unstimulating, he cultivated a wide range of contacts with figures such as Redi, Magliabechi, Oldenburg and Kircher.[25] As clearly appears, though Manfredo may not have devoted himself to these activities in the spirit of a scientist, his attitude was far from being that of the owner of a *Wunderkammer*.

[24] Fogolari 1900; Michele *et al.* 1983; Tavernari forthcoming; [25] Tavernari 1979 and forthcoming.
Aimi 1983; Aimi, de Michele and Morandotti 1984.

THE COLLECTION OF ARCHDUKE FERDINAND II AT SCHLOSS AMBRAS: ITS PURPOSE, COMPOSITION AND EVOLUTION

Elisabeth Scheicher

In 1564, on the death of his father, Emperor Ferdinand I,[1] Archduke Ferdinand II was appointed governor of Tyrol and the western attached territories, the so-called Vorlande. In the year of his appointment, Ferdinand, who had hitherto been in Bohemia since 1547 as governor on behalf of his father, started an extensive rebuilding of the Hochschloss, the Upper Castle at Ambras, a medieval fortification dating back to the eleventh century.[2] Chosen as a residence for Philippine Welser, the Archduke's first wife whom he married in secret, the castle was now modernized and the whole layout extended.

In 1566 the works were completed. Five years later, in 1571, construction work had begun on the Spanish Hall, a large banqueting hall richly decorated with paintings and stucco and with an inlaid wooden ceiling. At almost the same time, in 1573 Archduke Ferdinand II started a new building programme in the Lower Castle, known as Unterschloss, an arrangement of four large interconnected buildings. The main purpose of this spacious development was to house the Archduke's collection: three buildings were dedicated to the collection of arms and armour, one of Ferdinand's favourite fields of interest,[3] and the fourth to the *Kunstkammer*. Within this large complex, therefore, the *Kunstkammer* claimed only a small part, namely the wing which connected the third hall of arms and armour to the Kornschütt, a large building on two floors with a high trussed roof once used for storing corn.

Though the armoury and the *Kunstkammer* together represented one homogeneous museum, this present analysis is restricted to the *Kunstkammer*. Consequently, other problems, such as those arising from the portraits housed there, which can be considered only after further research on the inventory of the armoury, have been omitted here.

A visit to Archduke Ferdinand's museum was possible only by way of a circuit, starting with the first hall of armour, which contained equipment for tournaments, and ending with the library and the *Antiquarium* in the Kornschütt. Before entering the *Kunstkammer*, the visitor passed the so-called *Türkenkammerl*, the Turkish chamber, containing ethnographical objects, many of them trophies from the Turkish wars.

In the *Kunstkammer* the different pieces were housed in eighteen cupboards[4] placed back to back along the main axis of the room. In front of them stood two transverse cupboards,

[1] Hirn 1885–8.
[2] Scheicher 1982b, pp. 139–86.
[3] Luchner 1958; Kunsthistorisches Museum 1981.
[4] Kunsthistorisches Museum 1977.

called *Zwerchkästen*. The walls between the windows were covered with pictures from floor to ceiling. In the middle of the room there were various chests, partly filled with portraits and graphic works, and used to store pieces which were in the process of being studied.

For the fourth hall of armour, the so-called *Heldenrüstkammer*, Ferdinand started the publication of an illustrated catalogue,[5] the *Armamentarium Heroicum*, of which the Latin version appeared in Innsbruck in 1601. In contrast to this methodical approach to the collector's task, however, we have no indication that Ferdinand planned a catalogue or any other work of documentation for the *Kunstkammer*.

Our knowledge of the disposition of the rooms and of the display of the collection is based mainly on the inventory, drawn up immediately after the Archduke's death in 1596 and later published in the *Jahrbuch des Allerhöchsten Kaiserhauses* in 1888.[6] Greater accuracy and better descriptions of the individual pieces characterize the inventory of 1621, which is to be published in the same *Jahrbuch* series in 1985.[7] Since we have no inventory for the *Kunstkammer* going back to the Archduke's lifetime, the consequent lack of documentation for the years 1580–95 makes it impossible to know whether the two inalienable heirlooms of the House of Habsburg – the agate bowl and the unicorn horn – formed part of this display. After the death of Emperor Ferdinand I, his sons reached an agreement whereby these supremely valuable pieces would remain the property of the entire family, entrusted to the senior member of the household. Hence Archduke Ferdinand received them in 1577 after the death of his brother, Emperor Maximilian II, and it would be particularly interesting to know whether or not he separated the heirlooms from the items in the *Kunstkammer* to form some sort of treasury. After Ferdinand's death in 1595, Emperor Rudolf took them away immediately and we find the agate bowl mentioned in the inventory of his collection by 1607.[8]

Since the publication in 1908 of Julius von Schlosser's influential account of Renaissance *Kunst- und Wunderkammern*, Ambras has been mentioned in the literature fairly frequently, and a catalogue of the actual exhibition was published in 1977.[9] For this reason an examination of the *Kunstkammer* of Archduke Ferdinand and its relationship with other great European collections, if it is to be useful, cannot be restricted to the facts already well known. On the other hand, the need to compare exhibits and displays with contemporary collections elsewhere obliges the author to provide an account of the main characteristics, even if some of these are already common knowledge. Hence I shall adopt a middle course, concentrating on four major issues:

The display of the collection, its arrangement and its derivation.

Its programme and structure compared to that of the 'universal *Kunstkammer*'.

The reciprocal relationship between subject and display.

The particular character of the Ambras *Kunstkammer* as a result of Archduke Ferdinand's own acquisitions.

[5] Notzing 1601.
[6] Anon. 1888–9, vol. 7, p. ccxxii; vol. 10, pp. i–x.
[7] Inventory of Schloss Ambras dated 1621 (Sammlung für Plastik und Kunstgewerbe, Kunsthistorisches Museum, Vienna, inv. no. 6654.

[8] Bauer and Haupt 1976.
[9] Schlosser 1908; Lhotsky 1941–5; *idem* 1974; Scheicher 1979, pp. 76–135.

The basis of the arrangement of the Ambras *Kunstkammer* was primarily material, meaning that objects made of the same materials were grouped together in single cupboards. Following this system, the first cupboard contained the works in gold, the second silver, another bronze, and so on. This principle of the unity of materials was derived from Pliny's *Historia Naturalis*. It was Pliny who stressed the connection between the work of art and its raw material, but notwithstanding the general familiarity with his writings during the Renaissance, Pliny had no followers in the fifteenth and the first half of the sixteenth century.

The most important example of a collection displayed according to the concept of unity of materials is the *studiolo* of Francesco de' Medici in Florence.[10] Drawn up in about 1572 by various members of the Accademia del Disegno, the programme is explained by Vincenzo Borghini in his correspondence with Giorgio Vasari. In Borghini's own words, nature and art – meaning all matter within the hierarchy of the cosmos and works of art formed of this material – complement each other. The contents of each cupboard were shown in their appointed place within the universal system by means of painting and sculpture. An advantage of this form of display was that it gave the visitor a simple key through which to find the objects he sought. Borghini expressed this idea with the following words:[11] 'E'invenzione delle decorazioni dovene servire come per un segno et quasi inventario da ritrovar le cose.' Bearing in mind this interpretation, it is easy to find a plausible link between the programme of the Florentine *studiolo* and that of the Ambras *Kunstkammer*.

The assembling of common materials in individual cupboards remains, however, the only point in common between Florence and Ambras, the respective galleries being as different as is possible. The *studiolo*, a small room without windows, resembles more closely the interior of a precious cabinet than a museum. The doors of the cupboards are closed, the objects are invisible; their place in the universe can be discerned by the educated spectator, who is none the less denied all testimony of their material existence. At Ambras the situation was entirely different: here the collection was housed in a large hall without any decoration and lit from both sides: in this way, the interest of the visitor was directed without distraction to the objects in the cupboards, and the function of the room as a simple repository for the collection can easily be appreciated.

This particular emphasis on the work of art is expressed in the painting of the cupboards. The inventory of 1596[12] specifies colours for eight of the eighteen cupboards – blue being used for those containing gold, for example, and green for those housing silver – so that the background harmonizes with the pieces displayed against it. In addition to this attention to aesthetic considerations, the row of cupboards was assured of the best possible light by its position in the middle of the room in front of the windows.

The concept of displaying art so as to gratify the visitor's eye had been realized for the first time in the sculpture court of the Vatican palace.[13] Finished in 1506, the centre of the court was occupied by marble figures of the Tiber and the Nile represented as fountains, while the great marble sculptures were placed in painted and decorated niches in the four

[10] Berti 1967; Liebenwein 1977, pp. 154–9.
[11] Salerno 1963, p. 199; Frey 1930, vol. 2, pp. 522–30.
[12] Anon. 1888–9.
[13] Haskell and Penny 1981, pp. 7–10.

corners and in the centre of each enclosing wall. Thirteen antique masks were set in the walls, on a level with the upper part of the niches. The sculptures in the niches were placed as Pico della Mirandola describes, 'suis quaeque arulis super impositas'[14] – that is, like statues on an altar facing the visitor. It is important to appreciate that when the sculpture court was designed for Pope Julius II with at least five niches, the Pope was in possession of only a single statue which he considered worth placing there; hence the idea of having a collection and of this particular method of displaying it must have been conceived first, with the works of art which fulfilled the concept coming later.

The theoretical possibilities of this concept had already been grasped twenty years earlier by Leon Alberti.[15] In the fourth chapter of the ninth book on architecture, concerning private buildings, he describes the villa of Julius Caesar, where portrait sculptures of notable persons were displayed under the portico. In this context, Alberti criticizes any excess of pictorial or sculptural representation. He requires that the walls should be divided into panels where the sculptures or paintings should be placed, suggesting that this would be the best way to attract the visitor's attention.

There is a great difference, of course, between Alberti's concept of the sculpture court and the method of display adopted in the Ambras *Kunstkammer*. It is worth noting, however, that Archduke Ferdinand's solution to the problem of displaying his collection was not without precedent, nor was it as original as tended to be thought. More than three generations after Bramante, in the court of a prince who had already in his youth demonstrated independence and free will in his plan for the castle of Stern near Prague, the Ambras *Kunstkammer* seems not at all isolated within the evolution of the museum.

This displaying of the collection according to a method which was essentially practical but which also fulfilled aesthetic demands contrasts, however, with both the variety and the cosmological scale of the *Kunstkammer*. To treat the question of the relation between subject and display demands a definition of the contents of the *Kunstkammer* in terms of a universal scale as envisaged by Robert Fludd.[16] In the beginning there was nature, represented in the *Kunstkammer* by the *naturalia* in their raw form: plants, animals, bones, horns and minerals. Examples of this group are less numerous than they are significant: an antler enveloped within a growing tree, bought from the previous owner of the castle, reptiles, fishes, and – quantitatively the principal part of the collection – red and black corals, the latter grouped together with sponges to form decorative settings. There were also minerals, fossil fishes and 'giants' bones', deriving in fact from long-dead dinosaurs. What did all these things mean to Archduke Ferdinand? First, we have to recognize that there is no evidence of his making any attempt at a scientific assessment: there were no catalogues, nor were there any lists of the contents. On the other hand, it can be shown that in collecting the products of nature he took little account of their transcendent meaning: for example, he had not a single bezoar stone. Nevertheless, by displaying the corals together with sponges in a recreation of their environment, the group as a whole gained a didactic value. A similar intention is attested by payments from the Archduke to the painter Giorgio Liberale,[17] who was charged in 1565 with the task of making sketches

[14] Mirandola 1513; Ackerman 1954, pp. 45, 143.
[15] Alberti 1911, p. 485.
[16] Fludd 1617; Scheicher 1979, p. 12.
[17] *Jahrbuch des Allerhöchsten Kaiserhauses* 14 (1893), no. 10.423.

of plants and animals from the Adriatic Sea. Notwithstanding these signs of a certain interest in nature, it would be a mistake to ascribe to Archduke Ferdinand any pronounced ambition to document the environment in the sea. In common with his father Emperor Ferdinand I, and his uncle Emperor Karl V, the exploration of nature was for the Archduke a matter of representation, a facet of the normal activities of a princely collector, testifying to his universal interest.

Although he showed some interest in *naturalia* in their raw form, Ferdinand was more attracted by them as material for carvings, particularly those conserving something of the natural form of the original. Of principal interest in this field are the corals,[18] carved as mythological figures or beasts and mounted in cabinets (mostly in appropriate settings of marine shells and snails), partly gilded and populated with small animals of glass or bronze. Literary sources indicate that the carved corals were imported from Italy and later mounted in southern Germany or in Tyrol. Their mounting with nacre, glass, bronze and gold is in accordance with Borghini's own words:[19] 'Simil cose non sono tutte dello nature, ne dell' arte, ma vi hanno ambedue parte aiutando si l'una l'altra.'

The same ambiguity of status between art and nature can be distinguished in a group of objects once characterized by the term *stile rustique*.[20] To this group belong the casts made after nature in bronze or silver, as appear on a writing desk by Wenzel Jamnitzer,[21] now in the Kunsthistorisches Museum in Vienna. A peculiar preference for these reproductions of natural objects can be traced through all the cupboards of the Ambras *Kunstkammer*: quantitatively, the majority are represented by the *lapides manuales*, the hand-stones, a favourite field of interest of Ferdinand.[22] He brought most of them with him to Ambras from Bohemia, while others came from the Tyrolean silver mines at Schwaz. Apart from the true *lapides manuales*, he collected other pieces imitating their character, such as a miniature mountain of wood with a compass mounted under the lid.[23] Comparably small representations of mountains, covered with figures and animals in miniature, are found mounted on top of an ivory pavillion and in a wooden chest bearing the arms of Archduke Ferdinand and dated 1583.[24] Here a kind of hand-stone is represented by a little cage of glass[25] enclosing a mountain of paper, fixed with glass powder: the trunks of its trees are made of iron, the branches and the figures of glass. This piece originates from the same court workshop as the glass pictures made in Innsbruck by Venetian glass-blowers.

The antithesis of the *naturalia* and of the works occupying the ambiguous border-line between nature and art is represented by the *artefacta*, the products of man. Some of the rare pieces demonstrating man's ability to overcome the difficulties arising from the raw materials were turned works of wood and ivory,[26] probably originating from a Tyrolean or a Bavarian court workshop. In the inventory of 1596 they were specified as *Spill* (playthings), and indeed they performed no practical function.

A contrast to these anonymous artefacts is provided by the unrepeatable and unique creation represented by individual works of art. The most famous piece at Ambras is

[18] Kunsthistorisches Museum 1977, nos. 358, 360; Scheicher 1982.
[19] Salerno 1963, p. 199
[20] Kris 1926, pp. 137–208.
[21] Ibid., p. 155.
[22] Kunsthistorisches Museum 1977, no. 43.
[23] Ibid., no. 47.
[24] Ibid., no. 320.
[25] Ibid., no. 177.
[26] Ibid., nos. 137, 141–5, 158–61.

doubtless Benvenuto Cellini's *saliera*, one of the gifts given by King Charles IX of France to Archduke Ferdinand on the occasion of the King's wedding to Elizabeth, a daughter of Ferdinand's brother Maximilian.

An integral part of the 'universal *Kunstkammer*', testifying to man's ability to dominate nature, was the *scientifica*[27] – automatons, scientific instruments such as compasses and astrolabes, and clocks and watches – which filled a cupboard on their own, painted *leibfarben* (flesh-coloured).

While such instruments were collected mostly on a scientific basis, the contrary was true of another category within the *Kunstkammer*, namely the collection of *mirabilia*. This included everything beyond the normal and the commonplace – the particularly large, the particularly small, and the misshaped – as well as the miraculous. In consequence of Archduke Ferdinand's rational character, more stress was placed on material or formal divergence from the normal than on any derived meaning. Hence, as already mentioned, he had none of the bezoars so highly prized by his nephew Rudolf, but had instead the largest known bowl of wood, playing-cards for giants and dwarfs, and portraits of the crippled and the deformed.

The objects of *antiquitas*, in particular those of Greek or Roman origin, were of no attraction to Archduke Ferdinand. He placed not a single antique or sculpture in the *Kunstkammer*, and in the so-called *Antiquarium*, a small room next to the library, he had only casts of the heads of the Laocoon group,[28] apart from contemporary sculptures. This neglect of antiquity is not in conflict with the Archduke's enthusiasm for collecting armour and portraits of persons of historical importance, for the way in which Ferdinand was attracted by the past only serves to confirm the commonplace that the acquisition of antique sculptures was not dependent on any specifically historical interest on the part of the collector. Indeed, for Ferdinand, a portrait or a suit of armour gained most in value not from age or from aesthetic quality, but rather from association with some memorable event.

The most vivid historical evidence is that supplied by coins, and in large inlaid chests the Archduke housed one of the greatest numismatic collections in the history of his family.[29] During the eighteenth century the holdings were moved to Vienna where they were merged with the Imperial numismatic collection, which makes it impossible to reconstruct today what exactly could have been seen at Ambras in the sixteenth century. But descriptions, particularly the *Relation* of Dr Charles Patin dated 1673, proved that Ferdinand had one of the most important collections of his time. All these coins and medals were acquired in southern Tyrol. The already famous collection of his father was inherited by Ferdinand's brother, Maximilian II.

Of special attraction for a prince of the House of Habsburg must have been the *exotica* from overseas territories in North Africa, Asia and the New World. The most famous items were the pre-Columbian feather works,[30] testaments of the subjection of the New World. From one of these head-decorations the Archduke appropriated some feathers for his own helmet on the occasion of his second marriage in Innsbruck.

27 Scheicher 1979, p. 88.
28 Kunsthistorisches Museum 1977, nos. 408–9.
29 Lhotsky 1941–5, pp. 189–90.
30 Anders 1965.

All these *naturalia*, artefacts, scientific instruments, antiquities and *mirabilia* combined to form the character of the *Kunstkammer* as a mirror of the entire world and its various products. The concept of displaying them according to a system based on materials, a system which inevitably neglected the evolution of the universe, resulted in the collapse of the cosmological scale of the whole. As examples we may cite the placing together in single cupboards of both worked and unworked objects, *naturalia* and artefacts. Fidelity to this principle goes so far that in the cupboard designated 'bones' were housed not only turned objects of ivory but even, according to the inventory of 1596, the arm-bone of Duke Herman, a forefather of the House of Habsburg.

A particular character must be ascribed to the seventeenth cupboard, the so-called *Variokasten*,[31] and to the second small cupboard, the *Zwerchkasten*, in the eastern part of the hall. The *Variokasten*, placed deliberately at the end of the row, housed all those materials which were numerically too small to fill up a cupboard on their own and it contained many items characteristic of the universal *Kunstkammer* – playing-cards, trick items such as the so-called *Schüttelkasten* (shaking chest), works made of straw, European and North African textiles, and so on. While the disparate contents of the *Variokasten* were united for purely practical reasons, the character of the *Zwerchkasten* was more consciously affected by the individual pieces which it contained. All have now been lost, but the inventory of 1596 mentions a piece of the cord used by Judas in his suicide, and a cone from the cedar from which the temple of Solomon was built. Perhaps the Archduke wanted to separate the serious pieces from those of less weighty significance, and the method adopted for their display is proof of their inequality in the eyes of the collector. Hence a comparison of the programme of the universal *Kunstkammer* with the method of display adopted at Ambras produces an ambiguous result. The major part of the collection was arranged in a realistic manner and one which was, for everyday use, entirely practical. The *Zwerchkasten* ignores this approach, but perhaps we may arrive at the historical truth more readily by accepting this element of ambiguity, instead of demanding an austere classical uniformity.

The question of provenance may now be considered and, in particular, the contribution of the Archduke's own acquisitions to the specific character of the Ambras *Kunstkammer*. We must not forget that a great part of the collection came to Ambras by chance, as Ferdinand's inheritance from Maximilian I and from his father, Ferdinand I. In this necessarily short review I shall survey the cupboards by dividing their contents into three groups – gifts, heirlooms, and Ferdinand's deliberate acquisitions, the latter providing some testimony of the Archduke's own free will. The criteria for this separation are the following: markings on the pieces themselves, notes in the inventories, mostly concerning donations, and the rather rare pieces of independent information concerning acquisitions. This examination follows the sequence of the cupboards, starting with gold and silver.

In the first cupboard the category of gifts is represented on the highest level by the presents from King Charles IX of France,[32] – the *saliera*, the onyx jug and the goblets of St Michael and of Philip of Burgundy. Almost equivalent as testimonies of the Archduke's extraordinarily good taste concerning the aesthetic qualities of his acquisitions are the

[31] Scheicher 1979, pp. 123–30.

[32] Kris 1932, no. 33, pp. 21–3 and no. 35, pp. 24–8; Kris 1929, no. 469; Leithe-Jasper 1970, pp. 227–42.

great quantities of Milanese rock crystals. Mentioned in the inventory of 1596 and recently recognized by Distelberger,[33] they demonstrate how false it is to picture Archduke Ferdinand as a contributor only of strange and unusual objects, as these items are entirely characteristic of the *Wunderkammer*. One of these typical Ambras pieces is the bear as a hunter,[34] whose nearest relative is to be found in Munich. As we have no indication that it was a gift, we may assume that the Archduke bought it in Augsburg. In this first cupboard there was also a smaller quantity of vessels in semi-precious stone, among them one which was a gift from Emperor Rudolf. It is not now possible to identify this piece.

The largest group attributable to family inheritance is to be found in the second cupboard, containing works of silver. These included the *Natternzungerkredenz*,[35] and the goblet with the device 'AEIOU',[36] both from Emperor Friedrich III, as well as Emperor Maximilian's goblet and the Dürer goblet.[37] To this historical group the Archduke added the Jamnitzer writing-desk already mentioned and some amusing vessels in the form of naturalistic representations of animals or men.[38]

The hand-stones in the third cupboard were exclusively acquisitions, as were the musical instruments in the fourth.

A mixture of gift and acquisition, in the same way as the contents of the first cupboard, is found in cupboard no. 5, housing clocks and scientific instruments. The two automatons here,[39] the *Glockenturmautomat* and the *Trompeterautomat*, were gifts of Duke Wilhelm of Bavaria, brother-in-law of Ferdinand, and there are no signs of acquisitions of this kind by Ferdinand himself. This is not so with the clocks: despite a certain lack of variety, they demonstrate the collector's personal taste, not to mention his close knowledge of the subject. During his governorship in Prague, Ferdinand had already ordered works from Nikolaus Lanz,[40] and a description in the inventory raises the possibility that the famous table-clock of Jeremias Metzker[41] dated 1564 was in the Archduke's Ambras *Kunstkammer* at this time. In the same cupboard he had three so-called *Holzkastenuhren* ordered in Prague in the 1570s from Innsbruck.[42]

A single cupboard was dedicated to the bronzes. Identification of individual pieces from the short descriptions in the inventories[43] is in most cases difficult, even impossible. Although we have no proof of it, there is a likelihood that the collection represented a cross-section of European production rather than any special artistic preference on the part of the collector. Notwithstanding this variety, the Archduke included in his bronze cupboard veritable masterpieces like the Florentine Hercules,[44] now in the Kunsthistorisches Museum in Vienna.

A different situation entirely governs the groups comprising glass, coral, wood and ivory. To satisfy his demands for works of glass, Ferdinand supported his own court workshop,[45] the 'Glashütte' in Innsbruck, which produced the glass mountain, glass

[33] Distelberger 1975 and 1978.
[34] Kris 1932, no. 72; Kunsthistorisches Museum 1978, p. 210.
[35] Kunsthistorisches Museum 1964, no. 80.
[36] Ibid., no. 87.
[37] Kunsthistorisches Museum 1966, nos. 266–7.
[38] Kris 1932, nos. 73–4.
[39] Scheicher 1979, p. 102.

[40] *Jahrbuch des Allerhöchsten Kaiserhauses* vol. 2 (1890), no. 6977.
[41] Neumann 1961, pp. 89–122.
[42] Kunsthistorisches Museum 1966, nos. 333, 341.
[43] Anon. 1888–9, p. ccxcviii.
[44] Planiscig 1924, no. 233; Keutner 1958, p. 428; Kunsthistorisches Museum 1978, p. 179.
[45] Egg 1962.

goblets, and glass pictures with scenes from the Old and the New Testaments and mythological representations. Ferdinand hired craftsmen for his glassworks in Venice, but according to letters to his agents he placed more value on their technical ability than their artistic originality.

No documents survive concerning the origin of the turned items of wood and ivory. As Dr Seelig has commented,[46] mention is made of similar pieces in the Fickler inventory of the Bavarian collection in connection with Berchtesgaden, which was at this time an independent ecclesiastic territory.

The abundant contents of the cupboard containing iron-work must surely be related to the Archduke's own activities in this field.[47] Like other princes of his time, he practised various handicrafts, particularly glass-blowing and lathe-turning. The tools, instruments and even some of the locks housed in the iron cupboard can be compared with pieces in the great collection of the Historisches Museum in Dresden. It is uncertain whether Ferdinand bought these works from the same source or whether he received them from the Elector in Dresden; it may be noted in this context that in 1558 he acquired a suit of armour from the Saxon court armourer, Hans Rosenberg.[48] The chronological starting point of the collection lies in a chest lock of Emperor Maximilian I, bearing his own arms and those of his second wife, Bianca Maria Sforza. At a later time acquisitions from southern Germany were added, and also items made by Italian blacksmiths.

The great quantity of the cabinets themselves, mostly pieces produced in Augsburg, shows a particular interest of the collector.[49] There were also cases in which particularly small things of varying value were housed: bijoux, gems and also micro-carved works such as cherrystones, or historical memorabilia like the cover of the *Bulla Aurea*.

Although the Archduke's library was housed in twenty-two cupboards in a large hall on the first floor of the Kornschütt, there was in the *Kunstkammer* too one cupboard particularly designated for books. Like the silver cupboard, its contents were a *mixtum compositum* of acquisitions and heritage. The *Ambraser Liederbuch*, once in the possession of Emperor Maximilian I, and his autobiographies of Freydal, Theuerdank and Weiskunig were outweighed by a great stock of contemporary graphical works and a copy of the Roman *Historia* of Livy, which were Ferdinand's own acquisitions.[50]

Another heirloom from Maximilian I must have been the *Tödlein* of Hans Leinberger,[51] who was charged with the execution of the Emperor's tomb in the Hofkirche at Innsbruck. The sculpture was situated in the cupboard designated for wood, together with the little chest bearing Ferdinand's arms and the triple portrait showing his great-grandfather Maximilian, his father, and himself.[52]

Part of the inheritance from his father included the pre-Columbian feather-works in cupboard no. 9. This stock of *exotica*, which came to Ambras through fraternal exchange, stood next to a great mass of Chinese porcelain[53] and three silk paintings,[54] probably gifts from his cousin King Philip of Spain. According to the inventory of the Spanish

[46] Personal communication.
[47] Kunsthistorisches Museum 1977, nos. 198–219.
[48] Kunsthistorisches Museum 1981, p. 34.
[49] Kunsthistorisches Museum 1977, no. 341.
[50] Österreichisches Nationalbibliothek 1965.
[51] Kunsthistorisches Museum 1977, no. 309.
[52] Ibid., no. 320.
[53] Garner 1975.
[54] Whitfield 1976.

Kunstkammer, established in 1598,[55] the King must have owned the greatest collection of non-European art, which was, however, dispersed immediately after his death. It was probably through King Philip that Ferdinand received the cup made of rhinoceros-horn,[56] an Indo-Portuguese work; mentioned in the inventory of 1596, it was one of the first pieces to come to Europe after the conquest of Goa.

This brief survey of the *exotica* confirms the conclusions reached on the other sections of the collection, namely that the additions effected by the collector himself complemented the remainder of the collection in the sense of fulfilling the concept of the universal *Kunstkammer*. The balance between the individual elements of the universal *Kunstkammer* is one of the principal characteristics of Archduke Ferdinand's Ambras collection, offering a contrast to the Dresden *Kunstkammer*[57] in the 1580s, where, according to the inventory of 1587, the large stock of tools, instruments and turned items compared with a deficiency of objects of worked stone and jewellery. The advice addressed by Gabriel Kaldemarck in 1587 to Elector Christian I clearly identified this deficit (see p. 74).

A pronounced resemblance in terms of form and content can be observed between the Ambras *Kunstkammer* and the Bavarian collection[58] of Duke Wilhelm V, documented in the Fickler inventory of 1598.[59] In Munich, Ferdinand's brother-in-law owned an encyclopaedic collection of universal abundance where all categories were equally represented. The two collections had in common not only an overall concept, but also various groups and individual pieces related by a common origin. Examples of acquisition from the same artistic centres include carved corals, turned ivories (all the Munich pieces have been lost), vessels of rock crystal, and not least the figure of the bear as a hunter. This conformity, founded on dynastic relationships (Anna, the wife of Wilhelm V, was a sister of Archduke Ferdinand) and promoted by the geographical proximity of the two residences, was further advanced by the fact that the same persons were engaged in art affairs in Munich and Innsbruck. One of the most important was Jacopo da Strada, who had already worked for the Archduke during his time in Prague. A full estimation of the reciprocal relationship between Ambras and Munich must await publication of the Fickler inventory. We may content ourselves here by recognizing that a relationship did exist between the two collections. The concept adopted in displaying the two collections was, however, entirely different. As far as I could gather from a brief examination of the Fickler inventory, there was at Munich a particular rhythm in the presentation of remarkable pieces, such as the cabinets with carved corals, so that the visitor had the impression of a conscious arrangement. As there were no cupboards at Munich, however, the *Kunstkammer* was dominated by the richness and abundance of the whole collection.

In conclusion, the individuality of the Ambras *Kunstkammer* is based on the concept of displaying art in aesthetic terms in order to delight the eye of the beholder. This concept, based on prototypes of the Italian Renaissance, was novel and extraordinary in central Europe. It signified there the birth of the modern museum.

[55] *Jahrbuch des Allerhöchsten Kaiserhauses* 14 (1893), pp. i–lxx.
[56] Kunsthistorisches Museum 1977, no. 3.
[57] MS in Staatsarchiv, Dresden, loc. 9835; Menzhausen 1977.
[58] Hartig 1933b; Stockbauer 1874; Brunner 1970, pp. 7–26.
[59] Bayerische Staatsbibliothek, Munich, cgm 2133, 2134.

5

THE HABSBURG COLLECTIONS IN VIENNA DURING THE SEVENTEENTH CENTURY

Rudolf Distelberger

Literature attributes scarcely any specific character to the seventeenth-century Habsburgs of Vienna as collectors. So completely do the great collectors Archduke Ferdinand II (1529–95) and Emperor Rudolf II (1552–1612) overshadow the succeeding generation, that the seventeenth century came to be seen mainly as a time of consolidation rather than of acquisition, and it is certainly true that the Thirty Years War no longer permitted so intensive a dedication to art as that which Rudolf II had shown. The legacy of these two collectors forms even today the kernel of the Kunsthistorisches Museum's sculpture and decorative arts collection.

The Ambras Collection need not be considered here for it remained during the seventeenth century mainly at Schloss Ambras. The fate of Rudolf's collection, which he had amassed in the Hradschin Castle at Prague was different for part of it was brought to Vienna. The contents of his *Kunstkammer*, which formed only part of his total collection of art treasures, has been known since the publication in 1976 of the 1607–11 inventory.[1]

In Vienna there had been a *Kunstkammer* even before 1553 when it is mentioned for the first time but we hear almost nothing about it after Rudolf II caused the imperial residence to be moved from Vienna to Prague. The art treasures of its founder, Emperor Ferdinand I (1503–64), were divided among his sons: Emperor Maximilian II (1527–76), Archduke Ferdinand II, then Governor of Bohemia resident in Prague, and Archduke Karl II (1540–90), who established a *Kunstkammer* in Graz.[2] Emperor Maximilian II's collection, which met the highest aesthetic demands,[3] underwent the same fate: it was divided among his six sons, and it is likely that only Matthias's share remained for the Viennese *Kunstkammer*, which began to flourish again only after Rudolf died and the imperial residence was re-transferred to the banks of the Danube.

Rudolf II had wanted to prevent the dismembering of the collections which invariably followed the death of the collectors and he also wanted to avoid the selling off of treasuries to cover the debts which accompanied these bequests. Therefore he had striven for a joint central *Kunstkammer* and treasury for the whole family. After his death in January 1612, Matthias (1557–1619) tried to persuade his brothers that the collected treasures should be inherited by the eldest member of the family. In a letter to Maximilian III, dated September 1612, he justified his intention of setting up a central *Kunstkammer* and treasury

[1] Bauer and Haupt 1976.
[2] Lhotsky 1941–5, pp. 154–5. On the *Kunstkammer* in Graz, see ibid., pp. 203–12.

[3] Ibid., pp. 157–78.

in two ways: on the one hand he referred to the intentions of the late emperor, and on the other he envisaged the institution as furthering the fame and glory of the House of Austria.[4] With this principle in mind, the new treasury was founded and only with this knowledge can we understand why the *Kunstkammer* was renamed the *Schatzkammer* (treasury) and why it developed differently to other comparable collections of the seventeenth century.

For Matthias it was a matter of ensuring that Rudolf's immeasurable artistic treasures were not dispersed. The *Kunstkammer* of Archduke Maximilian III (1558–1618) and Albrecht VII (1559–1621), as well as those in Ambras, Graz, and Prague, remained intact. Matthias transferred only extremely valuable, personally selected objects from Prague to Vienna, in order to incorporate them into the *Schatzkammer*, making them the centre-piece of the Habsburg collections. This Viennese treasury was designed not so much to satisfy the encyclopaedic demands of its collector, but rather to stress the glory of the House of Habsburg. Scientific ambitions were completely absent. These devolved upon the court library, which also administered the coin collection. The collection of weapons had been set up in the upper storey of the so-called Stallburg since the end of the sixteenth century, and it remained there until 1750. Matthias's 1619 inventories[5] and the 1750 *Schatzkammer* inventory[6] represent two corner-stones for judging the development of the Vienna *Kunstkammer* in the seventeenth century.

Emperor Ferdinand II (1578–1637) made a considerable step towards bringing together the family treasure by means of the so-called *Majoratsstiftung* (institution of the right of primogeniture) of 1621 and 1635, according to which the collected family jewels and art treasures, including those in Ambras and Prague, were to pass to the eldest son while remaining the inalienable property of the family. In other words, they did not belong to the state nor to the people.[7]

This is an instance of the budding absolutism of the seventeenth century which followed the Counter-Reformation and religious wars, and which, particularly in Vienna, coloured the setting up and arrangement of the collections, where many objects were admitted which served exclusively to glorify the person of the emperor. On the other hand, the Jesuit-educated Ferdinand II and Ferdinand III had no interest in the countless objects based on mythological-erotic themes amongst Rudolf's art treasures. This is why, for example, Correggio's 'Danae and Leda', to obtain which Rudolf had gone to considerable lengths, remained unnoticed in Prague and ultimately fell into the hands of the Swedes. Albrecht Dürer, however, was raised to the rank of universal artist, and countless small wood-carvings were attributed to him, all supposedly of enormous value.

Unfortunately, the seventeenth-century Vienna inventories are lost, and we are forced to turn to the descriptions of divers foreign visitors to find out more about the arrangement of the Vienna treasury. Ferdinand III (1608–57) had new rooms built on to the Hofburg between 1640 and 1642 to house the treasury, and here a definitive exhibition

[4] Zimmermann 1888, p. lxii, Register 4701; Lhotsky 1941–5, p. 302.

[5] Published by Voltelini 1899, Register 17408, pp. xlix–lxiv (books) and lxv–cxxii (*Kunstkammer*), and by Köhler 1906–7, Register 19446–55, pp. i–xx

[6] Published by Zimmermann 1889, Register 6253, pp. ccli–cccxxiv.

[7] Lhotsky 1941–5, p. 332.

was set up which remained largely unchanged for the rest of the century. The first piece of information we have concerning the appearance of the treasury comes from Conte Guglielmo Codebò, the ambassador for Modena at the court of Emperor Leopold I (1640–1705); he described it in a long report to Duke Alfonso IV, dated 16 August 1659.[8] The second description is to be found in the travel-diary of the chancellor of the legation of Saxony and Weimar, named Müller, which was first published by his son, Johann Joachim Müller, in 1714 in Jena. Müller visited the treasury in June 1660.[9] During 1668–9 an Englishman, Edward Brown, travelled around Austria and south-east Europe and in 1677 published in London his impressions of what he had seen.[10] Although the description of the treasury contained in his book is not very detailed, it nevertheless offers us interesting perspectives. An anonymous description of the treasury of 1677 was brought out by Arnold Luschin von Ebengreuth in 1899.[11] A variant, from the same time, exists in private hands in Vienna as an unpublished manuscript.

In what follows I shall attempt, on the basis of these reports, to give an idea of the Vienna treasury of the seventeenth century. The visitor entered first a gallery sixty-two paces long and seventeen wide, on the right-hand wall of which, opposite the windows and under a series of arches, stood thirteen tall wooden cupboards. Each cupboard was decorated with beautiful paintings framed in ebonized wood, had double doors, and was crowned with a gilded eagle bearing the monogram of Ferdinand III on the breast. Upon the cupboards stood pagan busts, and on the walls between them hung pictures.[12] Tables stood against the wall with the windows, and on these tables were finely wrought cabinets containing sundry rare objects. Beneath the windows was a row of imperial portraits.

In the first cupboard, turned pieces in ivory predominated.[13] In addition there were pieces of rhinoceros-horn, mother-of-pearl, and a casket of agate, and on the lower shelf was coral work.

Turned ivory pieces were also to be found in the second chest, which in addition contained ivory statuettes and reliefs, as well as a round box with a carving of the Birth of Christ, supposedly 'by the consumate Master Albrecht Dürer, who has excelled in all arts', and which 'is valued at 30,000 Reichstaler'.[14] Here we see how extraordinarily highly regarded Dürer was at this time – a phenomenon which has only very recently gained scientific respectability thanks to the Frankfurt exhibition in 1981–2 entitled *Dürers Verwandlung in der Skulptur zwischen Renaissance und Barock*.[15]

The first two cupboards housed objects which were almost exclusively from the seventeenth century, having been acquired since the time of Ferdinand II, whilst in the

[8] Published in Campori 1866, pp. 112–17. It has remained unnoticed by researchers, perhaps because Campori's book appeared in only 250 copies.

[9] Müller 1714, esp. pp. 83–341 (*Reise-Diarium bey kayserlicher Belehnung des Chur- und Fürstlichen Hauses Sachsen*) §112 and pp. 267–84 (*Kayserliche Schatz-Cammer*). This description too was overlooked by Lhotsky in his excellent history of the collections.

[10] Brown 1677. Brown was a Fellow of the College of Physicians of London and of the Royal Society. The account of his German journeys is usually bound together with *A brief account of some Travels in Hungaria, Servia, Bulgaria, Macedonia, Thessaly, Austria, Syria, Carinthia, Carniola and Friuli* (London, 1673), forming pp. 95–100.

[11] Luschin von Ebengreuth 1899, Register 18307, pp. cxc–cxcvi.

[12] The sequence of the cupboards is not always identical in the four reports. Either the contents of some of the chests were rearranged or the authors were guilty of some slips of the memory.

[13] Including two tankards, which Ferdinand III and Leopold I had made themselves.

[14] Report from 1677.

[15] Beck and Decker 1981. The exhibition took place in the Liebieghaus, Frankfurt, from 1 November to 17 January 1982.

third and fourth cupboards stood clocks and automatons, most of which came from older collections.[16] On the door of the third chest hung pictures, among which were two portraits supposedly by Dürer. The doors were consequently not glazed.

In the fifth cupboard was silver work – unspecified ewers and basins, among which were certainly to be found the pieces inherited from Rudolf II's *Kunstkammer* – and some filigree work; in particular, a fine handkerchief made by Indians excited great admiration. These articles of filigree had been brought from Spain by Empress Margaretha Theresa, Leopold I's first wife. Their value was estimated at 7,000 silver crowns.

In the sixth cupboard, antique and modern cameos and intaglios, as well as pietra-dura pictures, precious stones and vessels of agate and jasper, lay on eight shelves. Of special note are the famous Ptolemy cameo and the *'Gemma Augustea'*.[17]

In the seventh cupboard was more silver work. The reports on these draw special attention to the pieces with mother-of-pearl, which must have included the nautilus-shell cups which were then in vogue.

The next cupboard showed gold objects, some ornamented with precious stones and pearls. There were five gold ewers and basins, four of which have gone missing. Several Turkish sabres and daggers are mentioned, which were set with emeralds, sapphires, turquoises and rubies; also three gold dog-collars which, together with the dogs, were a present from 'the English queen', as well as gold work with corals.

In the ninth and tenth cupboards stood precious stone vessels, among them many works by Dionysio Miseroni.[18]

The eleventh and twelfth chests were reserved for rock-crystal vessels. Among these Dionysio Miseroni's 115 cm.-tall pyramid, made in 1653, was regarded as a miracle, for it is cut from one large block of crystal, such that the four upper vases are successively cut from the lower vase. It was valued at 20,000 Reichstaler. This piece is really a monument to Emperor Ferdinand III, whose monogram is engraved on the vessel. The imperial eagle crowns the pyramid.

The thirteenth cupboard surpassed all the others, for it housed the private crown of Rudolf II, the so-called Imperial Dynastic Crown, which later (1804) became the official crown of the Empire of Austria, along with Matthias's sceptre and orb and four further crowns. Rudolf did not keep the imperial insignia in the *Kunstkammer*. This elevation of the new *Schatzkammer* by the insignia is an indication of how it was conceived as an expression of absolutist power. In the same chest, next to the imperial jewellery consisting of chains, precious stones, giant pearls and the collection of diamond- and ruby-studded Turkish sabres stood the priceless emerald vessel which Dionysio Miseroni had cut in 1641 and 'the like of which no potentate shall have'.[19] The dark green Columbian emerald weighed 2,680 carats. The uniqueness of this and other pieces corresponded to the unique position of the emperor.

Along the short wall stood a large cupboard which took up the whole width of the room,

[16] For example the musical box in the form of a ship by Hans Schlottheim, or the automaton depicting the triumph of Bacchus from Rudolf II's collection (Bauer and Haupt 1976, pls. 92, 94).

[17] Eichler and Kris 1927, no. 3, pl. 1 and no. 7, pl. 4.

[18] For example the citrine flower vase, made in 1647, the lapis-lazuli ewer and basin of 1652, and the garnet vessels. See Distelberger 1979, pp. 109–88, figs. 104, 115–18. The pyramid from the next chest is shown in fig. 127.

[19] Report of 1677. Cf. Distelberger 1979, fig. 102.

containing precious Turkish gifts and booty, such as saddles, stirrups, shabracks, sabres, and seventy-two gilded sweetmeat dishes.

The tables against the wall with the windows were partly inlaid with Florentine mosaics or *scagliola*, partly with ivory and mother-of-pearl. On one table lay the (now missing) inventory, bound in red velvet. The cabinets on the tables contained miniature wax reliefs and statuettes, pictures composed of feathers from the New World, Turkish gifts, 'adders' tongues' (fossilized sharks' teeth), bezoars, pieces of amber, coral figurines, etc. Once again we encounter fine wood-carvings attributed to Dürer, and next to the fifth window lay the gaming-board made in 1537 which is signed by Hans Kels and which, together with the carved pieces, was nevertheless revered as Dürer's work. Even the keys to the emperors' coffins in the Capuchin monastery lay neatly marked and locked in a casket. By the seventh window stood the bronze bust of Emperor Ferdinand III, made by Georg Schweigger in 1655.[20] In addition, articles of great value are referred to, such as two golden gaming-boards with pieces studded with precious stones, and a medicine chest dating from about 1670 with forty-six rock-crystal vessels in a cabinet of gilded bronze with rock-crystal columns and sides.[21] On the last table was the great, late Antique agate bowl – the largest of its kind – which has a diameter of 75 cm.; the sons of Ferdinand I had in 1564 proclaimed this item to be an inalienable heirloom of the House of Habsburg and it was regarded as priceless.[22]

The sequence of the cupboards and tables thus culminated with the insignia and the most precious objects.

As for *mirabilia*, there was a bowl (or chalice) from Solomon's Temple, a horn which belonged to the Magi, 'unicorns' (narwhal tusks), an ivory chair, and a few curious natural growths. On the wall with the windows hung pictures.

Adjoining this, the main room of the treasury, were two more rooms each thirteen paces long and ten wide, in which objects brought from Ambras were also to be found, along with the many pictures which adorned the walls. Noteworthy is the *Martyrdom of the Ten Thousand* by Dürer from Rudolf II's collection, though as far as the remaining pieces are concerned, it was the historical aspect which predominated.[23]

Just next to the treasury, an ecclesiastical treasury had been set up, something quite unheard of in the domain of imperial collections. The room was twenty-four paces long and twelve wide and housed a wealth of precious paraments, monstrances, chalices and other devotional objects, as well as reliquaries.[24] Not to be overlooked, of course, were works by Dürer, to whom were attributed a wooden cross, a Saint Sebastian and a painted wood panel with six wings, upon which all Sunday and festival day gospels were inscribed and illustrated with pictures.

[20] The sculptor Schweigger from Nürnberg was never a court artist but his retrospective art, which harked back to Dürer's time, was highly prized in Vienna and many of his small-scale works found their way into the collection.

[21] This cabinet has been preserved, but never published.

[22] Leithe-Jasper and Distelberger 1982, fig. on p. 29.

[23] In one cupboard was King Philip II of Spain's silver-gilt armour, on which an embossed and realistically painted model of his head made by Pompeo Leoni was placed so that the complete figure of the king was visible. King Gustavus Adolphus of Sweden's leather jerkin, which he had worn at the battle of Lützen, was also here and the holes from the shots which caused his death were to be seen; in addition General Tilly's dagger, General Aldringen's hat (which had been shot through), and other such articles were on display.

[24] Most notable were the relics of Christ, such as a reliquary in the form of a small altar with a thorn from the crown of thorns, and an ostensory with a nail from the Holy Cross: see Leithe-Jasper and Distelberger 1982, figs. on pp. 45–6.

The reports quoted omit, of course, many objects which were to be found during the seventeenth century in the imperial collections, and of whose existence we know from other sources. In about 1660 Leopold I summoned to Vienna several Milanese craftsmen who specialized in cutting precious stones, and their ateliers continued to work for the court into the eighteenth century; many of their rock-crystal and agate works have been preserved. Matthias Steinl carved in 1693 the well-known ivory statuettes of Leopold I on horse-back, showing him as victor over the Turks and of Josef I as victor over the demon of evil.[25] The artistry and technical mastery of the material shown by these carvings is in the tradition of the virtuoso pieces of the *Kunstkammer*, but they are first and foremost political monuments. A similar monument showing the Baroque apotheosis of the ruler was made by Christoph Maucher in 1700. It commemorates the enthroned Emperor Leopold I and the young Josef I, victorious over the Turks.[26]

These last-named objects make clearer still the impression which we have hitherto gained of the character of the Vienna treasury: it served primarily to deify the Emperor and the whole House of Austria, and pursued no didactic or intellectual ideal. Above all we find there objects of precious materials: gold, silver, precious stones, pearls, coral, ivory, and some *mirabilia*. It was designed less for the connoisseur than for the admirer. Classical antiquity was represented only in the form of valuable cameos. There were no small bronzes, exotica or *naturalia*.[27] Ostentatious objects from the empire of the Turkish arch-enemy made a strong impression on the visitor to the treasury, for these objects brought home the duel for power, the constant threat from the east, and the changing fate of the two powers.

The foundation of the ecclesiastical treasury had also a religio-political significance: the emperors at the time of the Counter-Reformation wanted to prove themselves as militant defenders of the true faith and this is how we should understand the striking reverence in which Dürer was held, as Bernhard Decker has shown in great detail in the catalogue of the already mentioned Frankfurt exhibition of 1981–2.[28] The Council of Trent had recommended artists to take Dürer as the example for their religious pictures, thereby giving the art of the great master a religious dimension.

Many pieces in the treasury were princely or diplomatic gifts. They vividly reflect the increasing centralization of power in Vienna and the growth of absolutism. The *domus Austriae*, threatened in the west by Louis XIV, and in the east by the Turks, was more and more identified with the Holy Roman Empire. Austria, in her distress, emerged at this time as a great European power.

The treasury retained its representative character and political background throughout the following centuries. It was no longer a *Kunstkammer* in the sixteenth-century sense and was rightly renamed *Schatzkammer*. We can see in it a form of the specialization of collecting which characterizes the seventeenth century.

Our picture of the Habsburgs' ideas on collecting would be inaccurate and incomplete if, on the basis of the particular structure of the treasury as one of the successors of the

[25] Pühringer-Zwanowetz 1966, pp. 43 ff. and 209, figs. 78–95.

[26] Theuerkauff 1963, pp. 60–83.

[27] The natural history collection was first established in Vienna in 1748 by Emperor Franz I of Austria (Franz Stephan of Lorrain), when he bought the scientifically arranged collection of Ritter Johann von Baillou.

[28] Beck and Decker 1981, pp. 385–488 and especially pp. 433–82.

Kunstkammer, we were to think of the seventeenth-century Habsburgs as having had no scientific interests in mind. Ferdinand III, who was master of seven languages, not only furthered countless scientific publications, but was himself conversant with philosophy and natural and applied sciences.[29] In 1655 Ferdinand III acquired almost 14,000 prints and manuscripts of the Fugger family. In Leopold I's time the aforementioned Edward Brown regarded the court library as rivalling the Bibliotheca Vaticana and the Bodleian Library. Ferdinand's particular love, however, was music and, like Leopold I, he was a passionate composer.

The Vienna collections, and in particular the picture gallery, were significantly enriched in the middle of the seventeenth century by the greatest collector in the Habsburg family at this time, Archduke Leopold Wilhelm (1614–62). He may be regarded as the father of the picture gallery.[30] From 1647 to 1656 he was the Spanish governor of the Netherlands, which were then an important art-dealing centre. The birth and fate of his picture gallery has been closely described by Klara Garas,[31] so I need only mention a few items of particular interest.

When Leopold Wilhelm returned to Vienna, he had his *Kunstkammer* set up in the Stallburg and in 1659 he instructed Jan Anton van der Baren, canon of his court and a painter of some skill, to compile an inventory; the result was an outstanding work in terms of its excellent descriptions of the objects catalogued.[32] It contains 517 Italian and 880 German and Dutch paintings, 542 sculptures and 343 drawings. Over 600 paintings have been identified, and more than 500 can be found in the Vienna gallery. As far as his acquisitions were concerned, Leopold Wilhelm was aided by the collapse of the English monarchy. Many paintings came from King Charles I's collection. The collection of the Venetian Bartolomeo della Nave, to obtain which Charles had gone to considerable trouble, he acquired from the Marquess of Hamilton. In this way he obtained count-less Venetian pictures: Bellinis, Giorgones, Lottos, Titians, Veroneses and Tintorettos. The Archduke's great connoisseurship is further revealed by his interest in the old Dutch Masters and he acquired pictures by van Eyck, van der Goes, Geertgen, Massys, Patenier and others. Rubens and his school are, of course, also richly represented in his gallery.[33]

Archduke Leopold Wilhelm's collection did not consist of just a gallery however, for he calls it, instead, a '*Kunstkammer*'. We find there marble sculptures, bronzes, plaquettes, wood-carvings, ivory and wax statuettes and reliefs, and goldsmith's models in wood. Of the 542 pieces, a little more than sixty can be identified in the present collection of sculpture and decorative arts. Most interesting are the countless bronzes. The Archduke owned several works by Pier Jacopo Alari Buonacolsi, called Antico, Jacopo Sansovino,

[29] The Viennese court mathematician and goldsmith Johann Melchior Volckmair made for Ferdinand III in 1637–42 a complete set of scientific instruments, which contain mathematical tables, proportional circles, maps, measuring instruments, a sundial, etc.

[30] As the younger son of Emperor Ferdinand II he was destined for the Church, and at the age of eleven he became Bishop of Passau and Strasbourg, at fourteen Bishop of Magdeburg, and in 1642 Grand Master of the *Deutsche Ritterorden*.

[31] Garas 1967, pp. 39–80; 1968, pp. 181–278. The gallery paintings by David Teniers, Leopold Wilhelm's court-painter, are well known and these give us an idea of his Brussels collection.

[32] Published by Berger 1883, pp. lxxxvi–clxxvii.

[33] Cf. Prohaska 1984, p. 3. After the 1648 sacking Leopold Wilhelm also filled the Prague gallery with masterpieces, such as Titian's *Ecce homo* and Rubens's *Festival of Venus* and *The Four Continents*, which are housed today in Vienna.

Danese Cattaneo and others. Equally well represented in the collection was German wood carving of Dürer's time.

No *mirabilia* are to be found in this *Kunstkammer*, no goldsmith's work and no superficially showy pieces. The collector looked for works of art with the highest aesthetic standards in mind, and showed for his time an uncommon historical interest in the older works of the fifteenth and early sixteenth centuries. Even Leopold Wilhelm's so-called *Kunstkammer* was a modern specialized collection, which had already left behind the older form of the *Kunstkammer*.

It is interesting that, in addition, Leopold Wilhelm owned a '*Schatzkammer*'. Inventories of this treasury were compiled in 1647 and 1660.[34] The *Schatzkammer* was subdivided into an ecclesiastical treasury which consisted mainly of reliquaries and religious objects, and a secular treasury. In the latter the usual goldsmith's works, precious-stone vessels, clocks, scientific instruments and a few weapons were to be found. We do not know where this treasury was set up originally, but it suffered a different fate to the *Kunstkammer*, and only a few objects from it can be identified today in the Vienna collections.

The Archduke's *Kunstkammer* was united with the other painting collections of the Habsburgs in the eighteenth century, which were scattered throughout the various imperial residences, and Emperor Karl VI (1685–1740) set up a splendid new exhibition in the Stallburg between 1720 and 1728. The House of Austria was at the height of its power and, in keeping with the hierarchical absolutist idea of the subordination of the individual to the whole, the pictures were displayed in a decorative system symmetrical in size as well as layout, and set in a carved gilt wainscoting.[35] For all these reasons the pictures were, when necessary, cut or enlarged. The three volumes of the picture inventory, which Karl VI had compiled and painted by Ferdinand Astorffer between 1720 and 1733 give a good idea of this gallery. In one corner-room, small statuettes from Leopold Wilhelm's collection were placed close together behind glass. The collection was complete as far as Karl VI was concerned, for the arrangement of the pieces allowed no possibility of introducing new acquisitions.

In a memorial painting by Francesco Solimena, which was painted for the gallery in 1728, the director of the imperial palaces, Count Gundaker Althann, presents the inventory of the collection to the Emperor. The goddess Fama announces the Emperor's artistic taste to the whole world. This picture was hung in the fifth room in a richly ornamented frame, crowned with an eagle and the imperial insignia. Like the treasury, this collection, too, finally served to glorify the emperor.

[34] Published by Mraz and Haupt 1981, pp. i–xlvi, and by Zimmermann 1888, Register 4717, pp. lxvii–lxxxiv (*Inventar der Schatzkammer der Erzherzogs Leopold Wilhelm*).

[35] Prohaska 1984, p. 3.

THE COLLECTION OF RUDOLF II AT PRAGUE: CABINET OF CURIOSITIES OR SCIENTIFIC MUSEUM?

Eliška Fučíková

Art historians warmly welcomed the publication in 1976 of the inventory of Rudolf II's *Kunstkammer* dating from 1607 to 1611.[1] At last we may all form an impression of the character, the magnitude, and the quality of that part of the Emperor's collection which contained both *naturalia* and *artificialia*. The time has now arrived for a detailed study of various parts of Rudolf's collection, for the identification through the inventory of the objects which it contained and, foremost, for the evaluation of the overall nature and character of this remarkable collection. Rudolf II collected not only excellent pictures, sculptures, and objects of western craftsmanship: his collection contained also a great number of artefacts and objects of everyday use from India, Persia, Turkey, Siam, China, and other countries of the East as well as from the Americas. The inventory gives not only a reasonably good description of individual specimens, but it also details their dimensions and describes the techniques of their manufacture and decoration. It should, then, not be difficult to check the entries of the inventory against the sixteenth-century ethnographic specimens in the major museums of the world, enabling us, perhaps, to discover whether some of them in fact originated in Rudolf's collection. From among the *naturalia*, the extraordinary collection of humming-birds, crabs, lobsters, shells, and conches certainly merits systematic attention; their inventory often refers to the relevant contemporary scientific literature. Data can be found in the inventory of interest to archaeologists – Rudolf's collection contained, for example, archaeological objects from the Hallstatt area[2] – and even to palaeontologists: for instance, the Emperor possessed a mammoth tusk found near Prague[3] and a number of fossils.

Systematic reading of the inventory taxes one's memory and can often be a demanding exercise; it is, nevertheless, an exciting and indeed indispensable undertaking for the evaluation of the collection as a whole. The fact that the inventory lists individual specimens according to type and frequently refers to the location of the specimens clearly indicates that the collection was ordered and systematic. The location of particular objects within the collection was not haphazard and their register evidently functioned well since changes in the collection were immediately noted in the inventory.

Once the contents of the *Kunstkammer* are known, we should be able to concern ourselves

[1] Bauer and Haupt 1976.
[2] Bauer and Haupt 1976, p. 103, no. 1161.
[3] Morávek 1933, p. 88.

with its physical appearance; that is to say, it should be possible to discover in which rooms it was housed, how the specimens were displayed, and so on. As far as I know, nobody so far has paid any detailed attention to these questions, although their investigation may lead to interesting discoveries. I have attempted here to construct a hypothesis concerning the nature and character of Rudolf's collection. This hypothesis is not, however, based on a study of original specimens: it is formulated on the basis of comparison of the 1607–11 inventory, compiled during the Emperor's lifetime, with later catalogues compiled in 1619[4] and 1621.[5] These later inventories no longer refer to specimens inherited by the Emperor's relatives or to those removed to Vienna, but in comparison with the original inventory they are more specific in their references to the location of individual pieces. Comparison has revealed that only slight changes occurred in the arrangement of the collection; although the most valuable pieces disappeared and the contents of some cupboards and chests changed somewhat, the contents of most of them remained unchanged. This means that as late as 1621 the *Kunstkammer* of Rudolf II retained in outline the appearance it had displayed during the Emperor's lifetime. What then was the nature and character of the collection and where was it housed?

The Emperor settled in Prague in the early 1580s. Several years earlier, he had already ordered the restoration of the living quarters of the palace located in the southern wing of the Hradschin Castle. As these quarters were inappropriate for the grand scale of the social life during the Emperor's permanent residence in Prague, work was begun in 1587 on the building of the so-called *Sommerpalast*.[6] This palace contained reception rooms in a separate building adjoining the Emperor's private quarters and served for many years as a temporary home for his collections. Two years later, in 1589, Rudolf issued orders for the building of the so-called *Gangbau* – a narrow, long, two-storey structure built against the original Romanesque fortifications of the castle. The construction of extensive stables began in the same year. A spacious room, known as the Spanish Room and destined to be the Emperor's picture gallery, was built above them. The *Gangbau* was thus a vast corridor which connected the palace with the gallery. Although the construction of these buildings proceeded quite rapidly, the work still took several years. The Spanish Room was paved in 1596; a year later the panelling of the ceiling was completed and at the same time Paul Vredeman de Vries and his son Jan started decorating it. The construction of the *Gangbau* took even longer; the builder's books still exist from the years 1600–1605. The work was apparently slowed down by the commencement of another project, the construction of the so-called *Neubau*. This was about twice as wide as the Spanish Room and apart from stables on two floors, it contained also the large 'New Room'. Construction work was completed in 1606, shortly after the completion of the connecting corridor. These structures completed the western wing of the castle, which consisted mainly of reception rooms but whose principal function was to house the Emperor's collection. When the Frenchman Esprinchard viewed the collection in 1597, it was still housed in the three rooms of the southern wing, which were apparently too small and

4 Morávek 1932–3, 1933, 1934–5.
5 Zimmermann 1905.

6 For the building activity at the Prague castle under Rudolf II, see Muchka 1969; Krčálová 1975, 1979, 1982.

unsuitable for it.[7] The collection was moved into the new rooms perhaps as late as 1605 or 1606 when the construction work ended at last. Although the original plans for the rooms built by Rudolf for himself and for his collection no longer exist (and the rooms themselves were rebuilt during a later reconstruction of the castle), we know from the entries in the inventories of 1619 and 1621 that the collection of *naturalia* and *artificialia* was housed in the *Kunstkammer*. This consisted of three vaulted chambers forming the *vordere* (front) *Kunstkammer*, each about five and a half metres wide, a little over three metres high and altogether about sixty metres long; the block of the 'Mathematical Tower' separated these rooms from the principal chamber of the *Kunstkammer*, which was apparently a room with a flat ceiling equal in width and height to the *vordere Kunstkammer* and with a length of some thirty-three metres. Access to the *Kunstkammer* was via the Spanish Room and, by way of a narrow corridor, through the New Room. On the floor above the *Kunstkammer* was the gallery, also divided into two parts by the Mathematical Tower. The first gallery, the *vorderer Gang*, lay to one side of the Emperor's palace from which there was an entry to it. This part of the gallery is also described as the *langer Gang* (Long Corridor) in the entries of some inventories,[8] a name which derives from the fact that it extended undivided over the three rooms on the floor below it. The Long Corridor was higher than the spaces below, being approximately five metres in height to accommodate the paintings which hung on its walls in three rows. A narrow passage in the Mathematical Tower, in which there were also pictures, connected the Long Corridor with the second one, also referred to as a gallery, arranged as the first one.

It is possible to reconstruct the appearance of the *Kunstkammer* and the *vordere Kunstkammer* from the inventories of 1619 and 1621. Along the solid wall stood single and double cupboards, both open and with doors. Globes, sculptures, large vessels and various antlers stood on the cupboards, while other antlers hung on the wall between them. Tables, chests and cases stood along the opposite wall between the windows; globes, sculptures, mirrors, small chests, writing desks, and so on stood on them or below the tables. A long green table stood in the middle of the *Kunstkammer*; clocks, musical instruments, automatons, vessels of precious stone, and so on were placed on it. There was no empty space even around the table. It was surrounded by chests, small tables and display cabinets. In the three rooms of the *vordere Kunstkammer*, the specimens were in cupboards, chests and desks along the walls, and of course again also on them. Inventories from 1619 and 1621 both mention, and those from 1607–11 confirm that the room called the *Kunstkammer* contained twenty cupboards. The information about the three rooms of the *vordere Kunstkammer* is available only from later inventories; the *vordere Kunstkammer* contained seventeen cupboards – six of them were in the first room (*erstes Gewölbe*), five in the second one (*zweites Gewölbe*) and six in the third one (*drittes Gewölbe*).

The number of twenty cupboards in the *Kunstkammer* is extremely important because it suggests a hitherto unrecognized fact, namely that the inventory of Rudolf II's *Kunstkammer* for 1607–11 lists only those specimens which were placed in the room called

[7] Janáček 1962, p. 85.

[8] For example in the list of paintings sold to Daniel de Briers – see Zimmermann 1905, p. li.

by this name. When we create our own list of locations on the basis of information from the inventory compiled during the Emperor's life, we arrive at twenty cupboards consecutively numbered. However, we do not obtain the same result if we perform the same exercise for the table and chests, although these too were consecutively numbered. This can be best explained by suggesting that the cupboards were probably made specifically for the new rooms and were, therefore, consecutively numbered.[9] On the other hand, the numbering of the tables, chests and cabinets must have originated from their previous placement in the *Sommerpalast*, the numbers being assigned to them in an older inventory of Rudolf's collection. This means that the tables and chests unaccounted for must have been located elsewhere. The 1607–11 inventory also does not list the contents of the seventeen cupboards which were still in their original place in the *vordere Kunstkammer* in 1619 and 1621. What has always been surprising about the inventory from 1607–11 is the fact that it does not list a number of craft products which are known to have been either acquired or manufactured at the Emperor's behest. The explanation so far suggested is that these objects were located in the Emperor's living quarters or possibly in the Spanish or the New Room. But they were also located in the *vordere Kunstkammer*: for example, it was here that the famous sets of Italian and French faience were housed. Their 178 pieces were still kept in 1621 on six shelves of cupboard no. 2 in the first room of the *vordere Kunstkammer*.[10] Cupboards nos. 1, 3 and 5 contained a part of the library, and nos. 7 and 8 enclosed 141 small pictures of varying subject matter on wood, copper, and stone. Furthermore, the objects listed in the *Kunstkammer* do not include, for example, the Turkish and Hungarian horse-harnesses, which were kept in cupboard no. 6, nor the captured Turkish regimental colours and Turkish and Hungarian costumes which were in no. 11. The 1607–11 inventory makes no mention of two other cupboards nor of some chests full of large natural gemstones.

All this indicates that the *vordere Kunstkammer* had its own inventory and that the paintings and objects located in the Spanish and New Rooms were also separately listed. The inventory of 1607–11 was drawn up probably shortly after the Emperor's collection had been moved into the new rooms, at which point the older lists, to which there are several references in the inventory, lost their relevance.[11]

It is difficult to say whether location catalogues existed. It seems, however, that they would have been redundant as Rudolf's collection was in principle arranged thematically. Location needed to be indicated and appears in the inventory only when objects of different classes or of different territorial origin were brought together, as for example when some Indian gold and silverware was stored with European items: a reference to their location appears in the catalogues both of Indian objects and of silverware.[12] It appears from the entries in the inventory that there were separate catalogues of miniature objects, small chests and escritoires.[13] Location was also indicated in cases where the objects were moved from one place to another; some of these

[9] As has been pointed out by Bauer and Haupt 1976, pp. xxvii–xxix, their contents as given are essentially identical to the inventories of 1607–11, 1619 and 1621.

[10] Morávek 1933, p. 89; Zimmermann 1905, p. xxxiii.

[11] Bauer and Haupt 1976, p. 11, no. 168; p. 65, no. 1191; p. 12, no. 177.

[12] Bauer and Haupt 1976, p. 43, nos. 760–3, 766.

[13] Bauer and Haupt 1976, p. 81, no. 1508; p. 127, nos. 2455–68; pp. 127–9, nos. 2469–539.

examples again clearly suggest the existence of separate inventories of the *Kunstkammer* and the *vordere Kunstkammer*.[14] Some sculptures and reliefs by Adrian de Vries, G. B. Quadri and A. Abondio were moved from the *Kunstkammer* to the first, second or third rooms of the *vordere Kunstkammer*. These are the only instances in which these rooms are specifically mentioned in the inventory of 1607–11.[15]

The conclusion that the inventory of 1607–11 is the catalogue merely of one part of the Emperor's collection which was located in one specific room, i.e. the *Kunstkammer*, is less important for gaining an impression of its contents than for estimating its size. In the absence of a similar catalogue of objects in the *vordere Kunstkammer*, it is possible only to estimate that Rudolf's whole collection of *naturalia* and *artificialia* was approximately twice the size of the collection recorded in the published inventory of the *Kunstkammer* dating from 1607–11. Rudolf's collection of *naturalia* and *artificialia* must therefore have been of a size equal to that of his breathtaking collection of paintings.

Erwin Neumann proved in 1966 on the basis of the newly discovered inventory that Rudolf's collection at Prague castle was not a mere cabinet of curiosities: rather 'it represented a consistently systematic collection of various objects from the different realms of nature, human arts and human knowledge, founded on an encyclopaedic principle; it was thus a Mannerist museum.'[16] In his 'Remarks on the collections of Rudolf II: the *Kunstkammer* as a form of *representatio*', Thomas DaCosta Kaufmann later suggested that 'Rudolf's *Kunstkammer* had a role in diplomacy that was stressed by its stately setting. It had a carefully organized content based on the system of correspondences.' He is of the opinion that 'we may also consider Rudolf's possession of the world in microcosm in his *Kunstkammer* an expression of his symbolic mastery of the greater world.'[17]

I would like to point out a few more important aspects of such collections. Their arrangement resembles most of all that of a universal museum of the type which became established in the nineteenth century and which has occasionally survived in provincial towns and villages until now. In these there were assembled samples of all kinds of things which made up the world inhabited by man – manufactured objects as well as those which only nature could provide; natural products as well as things prodigious. In the absence of any rules of selection, there was on view everything the museum chanced to acquire, including at times several identical versions of the same exhibit, secondary examples thus being accorded the same rank as primary specimens. Even if the museum holdings were arranged according to certain principles, most visitors were oblivious to them and passed through the exhibition seeing only successive individual facets of an ever-changing image. The same can probably be said of Rudolf's collections: though they were arranged systematically, with the contents of all cupboards, tables and chests marked by a certain consistency, for a modern scholar it is very difficult to identify the principles of this or that arrangement. Next to a cupboard containing Turkish vessels was another one full of objects originating in India, and yet a third in which *naturalia* of various sorts could be found. Next to one cupboard stuffed with shells and conches, was another containing

[14] Bauer and Haupt 1976, p. 110, no. 2147; p. 111, no. 2149.
[15] Bauer and Haupt 1976, p. 97, nos. 1832–5; p. 98, nos. 1846–7; p. 103, nos. 1975–6.
[16] Neumann 1966, p. 264.
[17] Kaufmann 1978, p. 27.

mirrors, statuettes, and objects made of wax, plaster, or terracotta, and again a third full of objects turned from ivory or amber. Some cupboards were open and some were closed; in neither instance, however, can the objects in them be said to have been spectacularly displayed. There can be no doubt that Rudolf's collection was never destined for a wider public, but was limited to those few initiates who knew how to use it.

Even though the Emperor's collection was not a cabinet of curiosities as characterized by Julius von Schlosser,[18] rarities of various kinds formed an inseparable part of it, just as they did in the museums mentioned above. I remember one extraordinary exhibit in a small provincial museum in southern Bohemia: a bowl containing a heap of small iron objects. The label read: 'What a hen pecked and swallowed in the yard of a master engineer.' This label amused the visitors; the contents of the bowl surprised and astonished them. I suppose that the various curiosities in Rudolf's collection played a similar role; they were there to entertain and to amuse. At the same time, they functioned as examples of divine or satanic will and 'creativity' in this *theatrum mundi*.

Rudolf's collection undoubtedly expressed his political and governmental aspirations, but it also reflected his personal interests. This may be demonstrated by the collection of antlers: some of these were in the nature of rarities, like the antlers of two stags locked together or others deformed by disease, the horns of numerous exotic animals, and so on; the remainder, however, were trophies of animals shot by the Emperor himself. Besides his interest in the arts, hunting was another of Rudolf's great passions.[19] Hence he displayed the proof of his hunting prowess next to the pieces of art which he had acquired for his collection.

Rudolf's collection was not merely a static display to please the eye of the onlooker; it was a living organism and a fascinating resource. Various ores, natural gemstones, shells, horns, rare nuts, and the like were deposited in it not merely because of their unusual shape, the rarity of their material or their origin in distant lands: they represented a store serving the craft workshops of the court, to which exotic or precious raw materials were dispatched only to return to the *Kunstkammer* in the form of artefacts. But even the remnants of raw materials left after the artefact had been produced were returned to the *Kunstkammer* to await some possible future use.[20] I do not know whether the belief in the magical power of hippopotamus teeth existed in Rudolf's days; when he took some of these from the *Kunstkammer* to his rooms, it could simply have been with the intention of using them in lathe-turning, an inherited family passion and his way of self-realization through artistic creativity.[21] Even unfinished craft objects were returned to the *Kunstkammer*, probably because the craftsman had died; there they waited until the Emperor found a new and skilful master to complete the work.[22] One may mention by way of example Schweinberger's gilded basin to match his famous Seychelles nut ewer.[23] Gemstone vessels or decoratively cut nuts which came into the collection as partially manufactured products were handed over to goldsmiths for elaborate mounting. Lenses

[18] Schlosser 1908, p. 78.
[19] Lhotsky 1941–5, p. 237.
[20] Bauer and Haupt 1976, p. 121, no. 2352; p. 122, nos. 2363–4, 2368–9.
[21] Bauer and Haupt 1976, p. 8, no. 97.
[22] Bauer and Haupt 1976, p. 80, no. 1504; p. 81, nos. 1509–10; pp. 111–12, no. 2463.
[23] Bauer and Haupt 1976, p. 84, no. 1556.

ordered for the Emperor from Venice also waited in the collection to be fitted later into telescopes.[24]

The Emperor's collection was a source of learning and inspiration and it represented an important resource for court artists. Landscape painters studied here the work of Dürer, Bruegel, Clerck and Bols.[25] Painters of religious and mythological pictures scrutinized drawings and prints of famous masters of the Italian Renaissance and of Mannerism. They studied the compendia of classical art and various iconographical handbooks. When Adrian de Vries had been contracted to create a portrait of Rudolf II, he took over the schema of the bust of Charles V by Leoni which was deposited in the Emperor's collection.[26] Examples like these could be presented many times over.

I have no wish to suggest that Rudolf's *Kunstkammer* and gallery were freely accessible. The Emperor certainly spent a great amount of his time there. He had his desk there and he probably would not have tolerated any disturbance from strangers. But artistically inspired guests of the Emperor who were able to appreciate the collection were most certainly not barred from it. For the court artists, the collection was a genuine paradise which they visited not only to seek inspiration but also to find material suitable for their own work. They probably brought along colleagues who were drawn to Prague by the fame of the Emperor's residence and by Rudolf's patronage. For the Emperor himself, the collection must have been the source of unceasing joy; it was a kingdom which never failed or disappointed him. Here he could decide the destiny of individual pieces, inspire his artists, enforce his will and grant free rein to artistic creativity and fantasy. Even though Rudolf's collection and the Emperor's court had their predecessors – one need mention only Lorenzo de' Medici and his collections – in magnitude, quality and diversity Rudolf's collections were without equal, not only in their time but for centuries to come.

[24] Bauer and Haupt 1976, p. 70, no. 1292.
[25] Fučíková 1972; Gerszi 1975, 1982; Spicer 1970; Zwollo 1968; Zimmer 1971; Larsson 1967.
[26] Larsson 1967, pp. 36–8.

'HIS MAJESTY'S CABINET' AND PETER I's
KUNSTKAMMER

Oleg Neverov
Translated by Gertrud Seidmann

Seventeenth-century Russia did not remain unaffected by that typical manifestation of Baroque culture, then mushrooming in cities all over Europe, the cabinet of rarities or *Kunstkammer*. Once contacts had been re-established, after a long period of isolation, the desire arose to amass tangible evidence of all the exciting, new, and hitherto unsuspected discoveries being made all over the world in that dynamic age. Exotic animals and plants, strange clothes and tools, ritual objects from distant tribes or from neighbours closer to home – all became objects of fascination and interest to collectors.

In Russia, the earliest collections of this kind are traceable to the sixteenth century, to Tsar Ivan the Terrible (1530–84) and later, in the seventeenth century, to Tsar Alexius (reigned 1654–76). In the eighteenth century, Princess Dashkov owned a pair of Greek gold ear-rings previously in Tsar Ivan's collection.[1] Tsar Alexius is reported to have paid 100 gold tchervonzy (ducats) to a Dutch traveller who was able to prove to him conclusively that the so-called 'sea-unicorn's horn' with which he had been presented came not from a fish but from a marine mammal.[2] This exhibit from Tsar Alexius's collection of rarities was later transferred from Moscow to St. Petersburg by his son, Peter the Great. Another object which eventually reached St. Petersburg was a Gothic silver reliquary which had belonged to Ivan the Terrible; it had been part of the booty taken by the Tsar at the capture of the Estonian city of Dorpat.[3]

But it was Peter the Great, whose unceasing thirst for knowledge sought to penetrate every sphere of human endeavour, who brought a new vigour to the making of his own collection of rarities. Nothing is more characteristic of him than the motto displayed on his private seal in the 1690s: there he was depicted as a young shipwright with his tools, and round the portrait ran the inscription: 'For I am one of those who are taught, and I seek those who will teach me.'[4]

Peter I's interest in rarities of nature and art manifested itself during his first journey abroad in 1697–8. Typically, he set down on paper his impressions of the curiosities which had caught his attention, in his letters home to Andrei Vinius whom he had appointed

[1] Scarisbrick 1981, p. 77.
[2] Beljaev 1800, vol. 2, p. 143.
[3] Now in the Hermitage Museum, Leningrad. See *Musei Imperialis Petropolitani* vol. 2, pt. 1, p. 202, no. i: 'Hierotheca ex argento inaurato, secundum regulas architecturae Gotticae efficta, in qua panis, seu hostia sacra reponitur. Tzar Ioan Wasiljewicz Dorpato expugnato, illam inter alia spolia abstulit.'
[4] *Pis'ma i bumagi imperatora Petra Velikogo* 1 (St. Petersburg, 1887), pp. 522, 622, 649 ff.

Royal Apothecary in Moscow. He wrote to him from Libau, where he had called on the local apothecary, on 24 April 1697: 'Here I have seen a great marvel which at home they used to say was a lie: a man here has in his apothecary's shop in a jar of spirits a salamander which I took out and held in my own hands: this is word for word exactly as has been written.'[5] Again, in the account books of the Great Embassy there is the following entry, dated 9 April 1698: 'Bought at Amsterdam from the merchant Bartholomew Vorhagen, a marine animal, a "Korkodil", also a sea fish called Swertfish, for his Highness the Tsar's personal household, and the animal and the fish have been handed to bombardier Ivan Hummer for taking to Moscow.'[6]

In England, the Tsar wrote from Deptford on 1 March 1698 to Vinius as follows: 'I have never seen such Chinese things in Moscow as I have here!'[7] In the Tower of London, the Tsar was delighted by the collection of arms which reminded him of Moscow's Armoury, and at Oxford he was interested to see Ivan the Terrible's diplomatic correspondence. In Amsterdam, Leiden and Utrecht, he assiduously viewed not only the private cabinets of such collectors as Jacob de Wilde, Frederic Ruysch and Nicolas Chevalier, but also the collections in Leiden University's anatomy theatre and in the city's Hortus Medicus. Of the few days Peter spent in Dresden in June 1698, three were passed in detailed study of the Elector of Saxony's *Kunstkammer*.

The Tsar established his first natural history collection in the Moscow Apothecary's Department and appointed his personal physician Aryeskin as its Keeper. The collections of arms were kept together with the ethnographic and artistic rarities in the Kremlin.

Initially, 'His Majesty's Cabinet' was essentially private. Johann Schumacher, appointed Librarian and Keeper of Rarities, many years later reminded the Tsar of this early period in the history of the collections: 'I know your Imperial Highness's Cabinet intimately, for I was in charge of it at its beginning, with a few animals and some Lapp sleighs.'[8] At that time, Peter's collections consisted of exotic animals, physical monstrosities, anatomical specimens, arms, ambassadors' gifts and ethnographic rarities.

After 1714, when the capital was transferred from Moscow to St. Petersburg, His Majesty's Cabinet was housed in Peter's Summer Palace. In 1715, it was greatly increased by the gift of the famous 'Siberian collection' of Scythian gold objects which had been presented to Catherine I, Peter's consort, by Nikita Demidov, the owner of the Tagil mines; this collection was further augmented in the following year, 1716, when Matthew Gagarin, the governor of Siberia, presented a hundred similar objects.

But in 1714 Peter had also established Russia's first *public* museum, the St. Petersburg *Kunstkammer*. 'I want people to look and learn' – with these words, the founder is reported to have laid down the didactic function of the museum.[9] Not many of Peter's contemporaries understood at the time that, in collecting such rarities, the Tsar was laying the foundations for the country's scientific development. The German philosopher Leibniz had outlined the desirability of such a plan in a memorandum written for Peter some years before in 1708: 'Concerning the Museum and the cabinets and *Kunstkammern*

[5] Ibid., p. 149.
[6] Baklanova 1947, p. 20.
[7] *Pis'ma i bumagi imperatora Petra Velikogo* 1, p. 240.

[8] Pekarskij 1862, p. 553.
[9] Schtelin 1787, p. 76

pertaining to it, it is absolutely essential that they should be such as to serve not only as objects of general curiosity, but also as means to the perfection of the arts and sciences.'[10]

The solemn, official opening of the *Kunstkammer* took place in 1719. It was originally housed near the Smolny Palace in the Kikin mansion, which had been confiscated from a disgraced courtier. For his new museum, the Tsar had brought back from his second journey abroad, undertaken in 1716–17, entire collections which he had managed to purchase in Holland and Germany. These were the Amsterdam collections of the apothecary Albert Seba and the anatomist Frederic Ruysch, as well as the cabinet of the Danzig physician Gottwald.[11] In 1718, Daniel Messerschmidt had been sent on an expedition to Siberia 'to seek out curiosities and various rarities',[12] and everything he collected entered the *Kunstkammer*.[13] In 1711, Peter sent his librarian Johann Schumacher to do the rounds of Europe's major cities; what his instructions were, we know from the report which Schumacher wrote on his return. He had been instructed, he writes, 'to visit the museums of learned men, both public and private, and there to observe how Your Majesty's museum differs from theirs; and if there is anything lacking in Your Majesty's museum, to strive to fill this gap.'[14] Among the objects Schumacher acquired on this journey, one may single out the ancient lamps (fig. 19), gems and engraved shells which he purchased at Utrecht from Nicolas Chevalier.[15]

Meanwhile, in 1718, the foundations had been laid for an edifice for the new *Kunstkammer*; this was on the Wassiliewsky Island, near the principal government buildings. On arriving at the site of the future museum, accompanied by the architect Domenico Tresini, Peter is reported to have pointed to one of the strangely misshapen pine trees growing there, to have exclaimed 'Oh monstrous tree, miraculous tree!' and, turning to his suite, to have given the order 'Let the new *Kunstkammer* be erected on this spot.' A branch from this tree, curiously intertwined with its trunk, was preserved as an exhibit in the new museum, in memory of this event.[16]

By 1728, all the *Kunstkammer* collections had been transferred to the new building and the rarities, which in the Tsar's lifetime had been kept in his own cabinet, also came to join them here, though the building was not completed until 1734. In fact, Peter's plans for the sculptural embellishment of the façade were never executed. The empty niches were to have held statues, whose designs, approved by Schumacher, are preserved in the Russian Museum. Their didactic programme is characteristic; they were to have represented Science, Patriotism and Humanitarian Sentiment.[17]

At some time in the 1730s, preparations were set afoot for the publication of a complete and fully illustrated catalogue of the *Kunstkammer* collections (whence come figs. 19–20, 22–3). Many hundreds of detailed watercolours of the exhibits were drawn by artists, members of the Academy of Engraving. Eventually, in 1741, a two-volume catalogue in Latin appeared, but without illustrations. This was followed by an album of architectural

[10] Gerje 1871, p. 76.
[11] From the collection of Albert Seba: see *Materialy dlja istorii imperatorskoj Akademii Nauk* 7 (St. Petersburg, 1895), p. 300; *Monumenta Sibirica*, tab. i, fig. 5; Hermitage Library, no. 20005.
[12] *Materialy dlja istorii imperatorskoj Akademii Nauk* 1 (St. Petersburg, 1885), p. 293.
[13] Neverov 1977, pp. 40–1.

[14] Pekarskij 1862, p. 534.
[15] Neverov 1977, p. 40. *Musei Imperialis Petropolitani* vol. 2, pt. i, p. 207; Central Archive of Ancient Acts, fond ix, list 2, bk. 62, p. 227[v].
[16] Beljaev 1800, vol. 1, p. 190.
[17] Russian Museum, Drawings Section, no. P.38001–2: *Sapientia, Cura pro Patria, Humanitas*.

prints depicting the 'Palace of the Academy of Sciences', originally dedicated by the versatile Schumacher to Anna Leopoldovna (mother of the short-lived Tsar Ivan VI) and swiftly rededicated to the Empress Elisabeth, following the palace coup which took place while it was in the press. A start was also made on printing the plates for the illustrated edition of the catalogue, but a devastating fire which broke out in the *Kunstkammer* on 5 December 1747 destroyed not only many sheets of drawings and engravings, but also some of the completed copper-plates. Peter's museum suffered frightful losses; but those watercolours and proofs which have survived and are now to be found in various Leningrad museums, enable us to form an almost complete picture of those now missing rarities which either perished in the fire or disappeared at later dates.[18]

Among them was a memento of Peter's journey to Copenhagen in the spring of 1716, a gift from the King of Denmark. This was a gold cup set with cameos, which eventually came to the *Kunstkammer* after the Tsar's death. Many years later, this magnificent cup was given to Catherine II as a New Year's gift for 1785, for the enrichment of her celebrated *dactyliothèque* – a step towards the despoliation of Peter's collection taken by Princess Dashkov, recently appointed Director of the Academy of Sciences. Catherine in return presented Professor Laxman's mineral collection, which had been a gift to herself. On the Empress's orders, the cameos which embellished Peter's cup were ripped off and the gold melted down; thereafter the stones sank from sight into that enormous collection of engraved gems which Catherine herself jokingly called a 'bottomless pit', but from a watercolour by Otto Elliger and the engraving after it, both now in the Hermitage collection, we can reconstruct the appearance of this vanished relic of Peter the Great.[19]

The fire of 1747 also destroyed objects which Peter himself had turned on the lathe – medallions with the figures of Diana and of St. Andrew the Apostle – but their designs have been preserved (now in the Russian Museum) as well as the drawing of a compass case, turned by the Tsar from an elephant's tusk.[20] A statue of Priapus, now in Dresden, aroused Peter I's interest during his visit to the Berlin *Kunstkammer*. According to the Margravine Wilhelmina of Bayreuth, the Tsar, entranced by this work and quite unperturbed by the presence of numerous bystanders, ordered his consort Catherine I to embrace this indelicate piece of sculpture and, to overcome her reluctance, jokingly threatened to chop off her head. King Friedrich I of Prussia presented the statue to the Tsar and it stood in the *Kunstkammer* for almost five years; later, however, it was given to the King of Denmark, who in turn gave it to the Elector of Saxony in exchange for a regiment of giant dragoons.[21]

A separate section of the *Kunstkammer* contained mementoes relating to Peter himself. These had been transferred from His Majesty's Cabinet, some during his own lifetime but the greater part after his death, in the years 1725, 1727 and 1728. In 1723, the Tsar's secretary Makarov gave a silver key which had been presented to Peter by the Governor of the captured city of Derbent.[22] From his personal physician Aryeskin came a coconut cup

[18] Parts of these drawings are in the archives of the Academy (Rasdel ix, Opis' 4,11. 1–758), in the Russian Museum, Drawings Section (nos. P.38034–102) and in the Hermitage Museum, Section of Numismatics and Section of Russian Culture (nos. P.7057–171).

[19] Kagan and Neverov 1982, pp. 13–17.
[20] Russian Museum, nos. P.38054, 38062.
[21] Heres 1977, p. 105.
[22] *Materialy dlja istorii imperatorskoj Akademii Nauk* vol. 7, p. 315; *Monumenta Sibirica*, tab. xxxiv.

which, before Peter's lifetime, had belonged to a vassal of his father's, as witnessed by its inscription: 'The tankard [*bratina*] of Michael Tyomkin of Rostov. Drink from it and be healthy.'[23] In 1725, the Court Intendant Peter Moshkov gave a cup carved from a shell, which the Tsar had used to carry on his travels.[24] The same donor also gave to the *Kunstkammer* a Renaissance parade dagger[25] and a walnut snuffbox in the shape of a ship which had accompanied Peter on his first journey abroad.[26] A gold snuffbox with a miniature of Countess Kosel and an erotic scene 'in the manner of Aretino' had been a gift from Augustus II, King of Poland.[27]

One of the water-colours now in the Russian Museum depicts a memento typical of Peter's *Kunstkammer* (fig. 20), described in the 1741 Catalogue as 'a head of Peter I together with seven others, formerly his companions on the journey into Belgium in the Year of our Lord 1698. In wax.'[28] Of the three men depicted in line with Peter, François Lefort and Prince Alexander Menshikov (at the time of the Tsar's journey his personal treasurer) are clearly recognizable.

But the *Kunstkammer* at one time held much stranger exhibits. At some time in the 1780s, Princess Dashkov came all of a sudden upon two glass jars which, she discovered, held, preserved in spirits, the heads of the executed lovers of Peter I and his consort, Mary Hamilton and William Mons. Peter, not content with forcing Catherine to be present at her lover's execution, apparently ordered the jar with his head to be placed in her apartments. Princess Dashkov and Catherine remarked on the wonderful preservation of the two beautiful young faces, still striking after the passage of fifty years. The Empress ordered the jars to be buried.[29]

Two of the *Kunstkammer* galleries housed 'portraits, statues, reliefs and other objects in wax, lead, bronze and plaster'. Here were to be found the series of large medallions of Roman emperors and ancient notables such as Solon, Cicero and Seneca, and portraits of Peter's contemporaries – Pope Clement XI, Queen Maria Sobieska, Jacob Brüss, Count Ostermann, the soldier Buchvastov, the giant Bourgeois, and others.[30] A large number of the objects listed in this section can be securely identified with bronze and lead plaquettes now in the Hermitage Museum (fig. 21).[31]

The gallery known as 'the Emperor's Workshop' was mostly taken up with Peter I's lathes and with cases containing his 'works of the chisel' (cabinets 4–6) and 'turned work' (7–8). Among the former there was a curious shell 'on which is carved in relief the story of the Crucifixion, with a pearl of unusual size in the centre'.[32] Ivory reliefs depicted Aeneas carrying his father away from burning Troy, the martyrdom of a Christian saint, and a scene of Joseph with the wife of Potiphar; there were also portraits of King Ladislaus of Poland and his Queen.[33] There was a heart-shaped amber pendant depicting an unknown

[23] Ibid., p. 314; tab. vii, fig. 1.
[24] Ibid., p. 314; tab. iii.
[25] Ibid., p. 300; tab. i, fig. 4.
[26] Russian Museum, no. P.38071; Hermitage Museum, no. E 2000.
[27] Russian Museum, no. P.38054.
[28] Russian Museum, no. P.38090; *Musei Imperialis Petropolitani* vol. 2, pt. i, p. 83.
[29] Helbig 1900, p. 100.

[30] *Musei Imperialis Petropolitani* vol. 2, pt. i, pp. 75–85.
[31] Hermitage Museum, nos. E 9839, 9846, 9851, 9900, 9924, 13430, 13431, 14131; *Zapadnoevropejskie plaketki xv–xvii vekov. Sobranie Ermitaga. Katalog vystavki* (Leningrad, 1976), nos. 63–5, 121–2, 147, 149, 155–6, 163–4, 172.
[32] Russian Museum, nos. P.38053; *Musei Imperialis Petropolitani* vol. 2, pt. i, p. 86, no. 18.
[33] Russian Museum, nos. P.38056, 38053, 38088; *Musei Imperialis Petropolitani* vol. 2, pt. i, p. 86.

couple.[34] Among sculpture in the round, one may single out a figure of Juno with her peacock, an ivory group of Hercules and Omphale by Balthasar Permoser, and ivory and wooden statuettes of the Madonna and Child.[35] Among the turned work, apart from many objects from Peter's own hand, were a large number of *Kunststücke* – displays of virtuosity – such as ivory and wooden 'spheres within spheres', and a hundred beakers fitting one into the other.[36]

The most original part of Peter's collection consisted of archaeological treasures dug up by order of the Tsar from ancient burial grounds. Many of these objects, which were found in Siberia, in the steppes of the Caspian sea-coast, on the Don and in the Volga delta, became known to eighteenth-century savants through Montfaucon, who heard about them in 1721 from Schumacher.[37]

Objects of precious metal and stones, engraved gems and coins were placed in a special section of the *Kunstkammer*. Its pride was the coin collection formerly belonging to the celebrated Hamburg collector Johann Lüders. Schumacher had bought the gold and silver coins from his heirs in 1721, but in 1738, during the reign of the Empress Anna, the bronze coins from the Lüders collection were added. The systematic catalogue by the numismatist Capello, acquired together with the collection, shows that the most celebrated collector among the rulers of the generation before Peter's, Queen Christina of Sweden, had been trying to obtain a number of rarities from this collection from Lüders himself.[38]

From 1724 onwards, the *Kunstkammer* came under the direction of the St. Petersburg Academy of Sciences; hence it is not surprising that the systematic arrangement of the collections conformed to the state of scientific knowledge of the early eighteenth century. There were separate divisions for rarities of nature (*naturalia*), 'rarities executed by art' and antiquities.

The 1741 catalogue lists also many volumes of drawings which recorded the entire *Kunstkammer* collections. These were executed between 1732 and 1739 but, as we have seen, did not survive in full. However, even the list in the catalogue gives a good idea of the systematic arrangement of the collections, starting with anatomical specimens and casts, illustrations of embryos, freaks, animals divided into classes, plants and minerals. Next, in the section for man-made objects, there were tools, craftsmen's apparatus, and ethnographic collections, among them a large display of 'wares from China', and finally the section containing objects of gold and silver, gems and coins. A separate section was devoted to 'pictures in colours thinned with oil', they in their turn being subdivided into 'representations of faces', 'representations of single figures', 'groups', 'symbolic' paintings, landscapes, and what we should now call still-life. There were subdivisions for gouaches, water-colours, and the drawings of Sybilla Merian.[39]

An artist, Mary Gsell, was evidently responsible for the decorative arrangement of the exhibits in Peter's museum: she provided tracings, parchments, dried flowers and so on

[34] Russian Museum, nos. P.38088; *Musei Imperialis Petropolitani* vol. 2, pt. i, p. 86.

[35] Russian Museum, nos. P. 38066, 38091. *Musei Imperialis Petropolitani* vol. 2, pt. i, p. 87, nos. 40, 45–6.

[36] Russian Museum, nos. P.38044, 38051, 38057, 38060; *Musei Imperialis Petropolitani* vol. 1, pt. ii, p. 89.

[37] Montfaucon 1724, pl. 71.

[38] Neverov 1977, p. 42.

[39] *Musei Imperialis Petropolitani* vol. 2, pt. i, pp. 176–7.

for the natural history section. The anatomical exhibits were distinguished by a specially odd display deriving from that of the original Amsterdam owner, Frederick Ruysch; one of these, for instance, showed the skeleton of a child wiping his tears with a specimen of brain membrane.[40] Daring juxtapositions of skulls, monsters and all kinds of animals were intended to lay even greater stress on the extraordinary and the wonderful in the world of the *Kunstkammer*.

One speciality of Peter's museum was the presence of *live* exhibits, such as a young hermaphrodite (who later escaped from the *Kunstkammer*), and the monsters Foma, Jakob and Stepan, who also served as stokers. Foma, the son of a peasant from Irkutsk province, had only two digits on each hand and foot (fig. 22). After his death, Peter had him stuffed and exhibited in the *Kunstkammer*, next to the skeleton of the giant Bourgeois.[41]

A special gallery held not only the wax 'personage' of the Tsar, placed there after his death by Bartolommeo Rastrelli, but also his dog and his horse Lisetta, specimens of the taxidermist's art. At the end of the eighteenth century, Osip Beljaev was able to describe the horse as 'a stallion of Persian stock'.[42]

We must not be too severe with the assiduous eighteenth-century Keeper of the *Kunstkammer* who, painstakingly copying the opinions of Peter's academicians, sincerely believed a Graeco-Bactrian gold goblet to be an item of head-gear: 'two gold caps [*skuf'i*], as worn by the Buchars for helmets'.[43] Similarly, it was easy enough, in 1741, to take a circular plaque depicting the Bactrian goddess Khvaninda (fig. 23) for the 'figure of an angel holding a heart in his right hand'.[44]

Like all similar collections dating back to the seventeenth and eighteenth centuries, those of Peter's *Kunstkammer* were not to survive in their original state. What can now be found in the galleries of the Ethnographical Museum of the USSR Academy of Science are only a few ethnographic and natural history objects from the early eighteenth century. With the ethnographic collections in particular, the unpredictable fancies of the Empress Anna wrought havoc, as when she wished to show a 'pageant of the nations' among these unique exhibits on the occasion of the mock marriage of her court fools on 6 February 1740. At the end of these festivities, many costumes, vessels, carriages, weapons and implements were carried off as souvenirs by her courtiers. We have already seen how Catherine II, although always professing a cult of the memory of Peter, did not hesitate to destroy a relic of his at one stroke, when faced with the temptation of enriching her gem collection. Although an eager collector of works of art, Catherine evidently had no sympathy for the 'universal' type of museum, which seemed to her an anachronism. She apparently said of Gregory Orlov's addiction to this kind of museum, 'I often quarrelled with him about his wish to enclose Nature in a Cabinet – even a huge palace could not hold her.'[45]

During the nineteenth century, many of the *Kunstkammer* objects were transferred to the

[40] Stanjukovitch 1953, p. 43. On Ruysch's preparations, see also pp. 119–20 below.

[41] Beljaev 1800, vol. 1, p. 192.

[42] Ibid., vol. 1, p. 183.

[43] Ibid., vol. 3, p. 6.

[44] *Musei Imperialis Petropolitani* vol. 2, pt. i, p. 200, no. 23.

[45] *Sbornik Russkogo Istoricheskogo Obschestva* vol. 13 (St Petersburg, 1874), p. 258 (letter of Catherine II to Mrs Bjelke, 4.1.1772).

Tsárskoye Seló arsenal (in 1851) and to the Hermitage (in 1857, 1859, and 1894). But the illustrations which have survived, together with the manuscript descriptions dating back to the time of Peter the Great and the 1741 printed catalogue, make it possible to reconstruct every detail of Russia's first universal museum, heir to the Tsar's seventeenth-century cabinet of rarities.

THE BASLE CABINETS OF ART AND CURIOSITIES IN THE SIXTEENTH AND SEVENTEENTH CENTURIES

Hans Christoph Ackermann

My aim here is to offer a brief survey of the humanistically oriented bourgeois collections of art and curiosities which sprang up in Basle during the sixteenth and seventeenth centuries.[1] The impetus to assemble art and curiosity cabinets in Basle came quite definitely from the circle of humanists around Erasmus of Rotterdam. Yet when he died in Basle in 1536, Erasmus could have had no idea that his legacy would form the foundation of twenty-three of today's museums. His heir was Bonifacius Amerbach (1495–1562), a lawyer at Basle University, legal adviser to various European noble houses and son of the Basle printer Johannes Amerbach (1430–1513). Johannes Amerbach was the forerunner of the renowned Johann Frobenius, the printer of Erasmus's works in Basle. Bonifacius Amerbach was a fine man, endowed with humanistic qualities through his association with Erasmus, yet he himself possessed no collecting spirit. From his father, who came to Basle from Venice, he had inherited a series of Italian prints. He had also probably inherited some sketches by Albrecht Dürer, intended by Johannes Amerbach as illustrations for a publication of Terentius; these had been drawn on to wooden blocks, some of which were already partially carved. A magnificent dagger belonging to Johannes Amerbach, with its chalcedony handle in a gilded silver setting, is extant to this day. To this paternal inheritance was added in 1536 the surprisingly extensive legacy from Erasmus.[2] It included parts of Erasmus's library, some silver drinking vessels (from an original total of forty silver and gilded objects), coins and medals presented to Erasmus by important personages, his signet ring and seal, his table-knife, hour-glass and numerous other objects. Amongst these was probably also the lovely drawing by Hans Holbein of Erasmus's friend Sir Thomas More with his family.

In order to preserve this legacy in a manner worthy of it, Bonifacius Amerbach had a cabinet made in 1539 (fig. 24), which – as with most of the other objects mentioned – is kept today in the Historisches Museum at Basle, and which represents in effect the nucleus of the Basle museums.[3] Bonifacius Amerbach may have confined his collecting activities merely to the preservation of this honoured legacy, although his interest in art went as far as to have his portrait painted by the young Hans Holbein in 1519. A brief look

[1] I have to thank Dr Elisabeth Landolt for most valuable information on the theme of this paper. A good survey of early collecting in Basle is to be found in Fischer 1936. More recent research is published in Landolt 1978. On early numismatic collections see Reinhardt 1945.

[2] Cf. Major 1926.

[3] Reindl 1973, pp. 54–6.

at this painting, which is today in the Kunstmuseum at Basle, confirms the character traits suggested already.

The actual collector and founder of the so-called 'Amerbach cabinet' was Bonifacius's son, Basilius (1533–91).[4] Basilius, like his father before him, studied jurisprudence in Basle, Tübingen, Padua and Bologna, where he earned his doctorate in law. From Bologna he undertook journeys throughout the whole of Italy – to Venice and to northern Italy, but also to Rome and Naples, where he was strongly influenced by the Roman antiquities. Following travels in France and Germany, he returned to Basle in 1560. In 1562, he became Professor to the Corpus Juris and in 1564 Professor for the Pandects, receiving also the position of town counsel and syndic. Like his father, he was Chancellor of the University of Basle five times and legal adviser to noble houses abroad. In 1561, he married Ester Rüedin, the daughter of the Guild Master General of Basle. When his wife and little son, Basiliolus, died in 1562, he seemed to transfer his whole passion into the assembling of a cabinet of art and curiosities. On the death of his father, he inherited about a hundred objects worthy of an art cabinet. In the earliest inventory of his to survive,[5] he had already entered 4,103 items. This shows the huge passion for collecting which must have possessed him. A further inventory of 1586[6] lists sixty-seven paintings, 1,900 drawings, 3,900 woodcuts and engravings, over 2,000 coins and medals and an extensive library; numerous other objects are also mentioned, among them musical instruments and 770 goldsmith's models alone. Basilius Amerbach kept an exact account of his acquisitions, so that today, on the basis of a record left by his nephew and heir Ludwig Iselin, we can follow year by year the expenses incurred by the collection from 1563 to Basilius's death in 1591. In total, during the thirty years Amerbach devoted to collecting, he spent over £2,300, of which over £700 was expended in the years 1576 to 1578 alone. Amerbach was particularly interested in acquiring whole workshops and their assets, which accounts for the enormous wealth of goldsmith's models and designs.[7] These purchases were made possible by several plague epidemics which swept through Basle during Amerbach's lifetime. His interest in handicraft was so strong that he even tried his hand at taking casts of some of his objects.[8]

In 1562, after his father's death, Amerbach took up residence in the family house, 'zum Kaiserstuhl', in lesser Basle, on the right bank of the Rhine. In the years around 1580 he had a vaulted chamber for the collection built on to the back of the house, executed by the famous builder Daniel Heintz.[9] New cabinets were made according to his exact specifications by the Basle cabinet-maker Mathis Giger I. One large cabinet is to be seen today at the Historisches Museum at Basle, together with a small cabinet, intended primarily for parts of the coin collection but incorporating on one side three arcades in which, according to the inventory, stood three bronze statuettes. On the walls of the room hung forty-nine paintings, amongst them Holbein's family portrait of 1528 and Albrecht

[4] Ganz and Major 1907. An important published source on Amerbach is the correspondence published in (to date) nine volumes by Hartmann and Jenny (1942–82).

[5] Inventory A: Ganz and Major 1907, pp. 12–17, 31–4.

[6] Inventory D: Ganz and Major 1907, pp. 18–19, 28–30, 40–54.

[7] The importance of this part of the collection was appreciated by Jacob Burckhardt (1864). See also Falk 1979, pp. 116–63 and pls. 89–147.

[8] On casts of other works of art in the Amerbach cabinet, see Reinhardt 1958.

[9] Landolt 1978, pp. 315–17.

Altdorfer's *Resurrection* of 1527. In chests in this room were preserved, rolled-up, the *Tüchlin* painted on canvas by the Bernese politician and painter Niklaus Manuel Deutsch.

Basilius Amerbach's art collection is distinguished by his systematic collecting and by the high quality of his inventory. For example, as regards drawings alone, there are 160 drawings by Urs Graf, fifty-six drawings and the two famous sketch-books by Hans Holbein the Elder, 104 drawings by Hans Holbein the Younger, and eighty-four drawings and two sketch-books by Niklaus Manuel Deutsch.[10] From the property and estate of Ludovic Demoulin de Rochefort, the former personal physician to Marguerite de Valois and later to the Duke of Savoy, who spent the evening of his life in Basle,[11] Amerbach acquired an important series of medals of the late Italian Renaissance, amongst them the portrait-medal of Ludovic de Rochefort by Ludovico Leoni. As in every humanistic collection of art and curiosities, natural wonders such as fossils, precious stones and amber are present.

Besides his own collecting, Basilius Amerbach was also active in excavating amongst the Roman ruins at Augst, near Basle, together with Andreas Ryff, of whom we shall hear more later. As evidence of this activity there are still preserved at the Basle University Library a ground-plan of the theatre at Augst, with a handwritten commentary by Basilius Amerbach, and also other views of the same theatre painted for him by the Basle painter Hans Bock.

After the death of Basilius Amerbach, the collection passed to the Iselin family. In 1661, the Amerbach cabinet, now rather well known and much visited by travellers, was in danger of being sold abroad. At the instigation of the lawyer and collector Remigius Faesch, and of the mayor of Basle Johann Rudolf Wettstein – to whom, by the way, Switzerland owes its formal independence from the Empire on the occasion of the Westphalian Peace of 1648 – the Basle Council decided, on 20 November 1661, to buy the Amerbach cabinet for 9,000 thalers, and to make it accessible to the public as university property. In this way originated the first public collection – to our knowledge – to be bought by a city and whose origins cannot be traced back to a princely collection. Together with the library, it was installed in the house 'zur Mücke' near the cathedral, where it remained until the opening of the Museum at the Augustinergasse in 1849.

The collecting activities of Basilius Amerbach in the second half of the sixteenth century were not carried out in isolation, but were accompanied by a spate of similar enterprises by a number of collectors friendly with Amerbach. I have already mentioned Ludovic de Rochefort, who came to Basle from Savoy, and some of whose collection has been handed down to us through the Amerbach cabinet. Unfortunately, exceptionally little remains from the other collections: however, we know quite a lot about other Basle collections of the sixteenth century (some of which were the equal of the Amerbach cabinet) through reports from travellers and through the personal notes of the collectors themselves.

Next to the Amerbach cabinet, the most important collection was certainly that of the

[10] Cf. the exhibition catalogue *Meisterzeichnungen aus dem Amerbach-Kabinett* (Kupferstichkabinett der Oeffentlichen Kunstsammlung Basel, 1962) and Falk 1979, pp. 11–23.

[11] Burckhardt 1917, pp. 29–60.

Basle physician Felix Platter (1536–1614).[12] His larger-than-life portrait, painted in 1584 by Hans Bock, shows an elegant, self-assured and clever man surrounded by the objects which were of value to him. The book beneath his right hand is an anatomical work published by Froben in 1583, the *De corporis humani structura et usu libri tres*. The lemon, the cut-open bitter orange and the twig from a kind of potato plant (*Solanum*) displayed on the table, as well as the orange tree on the right, come from Platter's famous botanical garden. The ruins in the background are a reference to the excavations at Augst, which had been carried out in collaboration with Amerbach and Ryff. The rich contents of Platter's cabinet of natural curiosities had been amassed on his extensive travels and through exchanges with other scholars. In this manner he acquired part of the estate of Conrad Gesner of Zurich, whose drawings, most of which had been coloured, he annotated personally. In the Basle University library are two volumes of these paintings, which were unfortunately cut out in the eighteenth century and stuck into collector's albums.

In addition to natural curiosities, Platter also collected coins, art objects both antique and contemporary (he owned, for example, eighty-eight large paintings in comparison with the sixty-seven owned by Amerbach), and exotica (particularly North American Indian clothes and artefacts), but he took care to include also curiosities such as mandrakes, freaks and living animals. Platter was also a talented musician and collector of musical instruments, known to his fellow-students in Montpellier as 'l'allemand du Luth'. His collection was installed in his large house 'zum Samson', described by Michel de Montaigne in 1580 as 'la maison la plus pinte et enrichie de mignardises à la Françoise qu'il est possible de voir; laquelle le dit medecin a batie fort grande, ample et somptueuse.'

Two embroideries sewn by Platter's wife and a statue by the sculptor Hans Michel, showing Samson fighting a Philistine, are preserved in the Historisches Museum at Basle, as well as a Renaissance bronze statuette of Jupiter which Platter gave to Basilius Amerbach.

Another important cabinet, about which we know almost nothing, however, is that owned by Basilius Amerbach's brother-in-law, Theodor Zwinger (1532–88).[13] He was Professor of Greek, Ethics and finally of Medicine at Basle University. It was thanks to him and to Felix Platter that Basle possessed already in the sixteenth century an anatomical theatre. His likeness, also painted by Hans Bock, who was much in demand at that time, is preserved at the Basle Kunstmuseum. About his collection we know only that in 1706 his descendants still owned a collection of 1,600 engravings and drawings. There is also in the Amerbach cabinet a Romanesque dragon which Amerbach received from Zwinger.

Zwinger had his house decorated with murals, again by Hans Bock. The designs for these murals, which were in the tradition of Hans Holbein's paintings on the house 'zum Tanz', have survived, but the paintings themselves unfortunately have not.

The last collector of the sixteenth century whom I would like to mention briefly is the Basle silk-merchant and statesman Andreas Ryff (1550–1603),[14] who is perhaps

[12] See Landolt 1972, pp. 245–306, and also an unpublished manuscript by the same author, 'Der Stadtarzt Felix Platter und seine Beziehungen zu den Basler Kunstlern'. See also Fischer 1936, pp. 22–5.

[13] See Fischer 1936, pp. 21–2, and Gilly 1977–9.

[14] Meyer 1966, pp. 5–31; 1972, pp. 5–135.

best-known for his role in the so-called *Rappenkrieg* (War of the Pennies) between the town and the surrounding dependant areas. He wrote a history of the Swiss Confederation and a series of other works. Particularly charming is his little travel book, the title page of which shows a miniature by Hieronymus Vischer, whereas his own drawings on his journey to Italy show, for example, the almost modern-looking representation of the bay of Santa Margherita on the Ligurian coast. After the *Rappenkrieg*, Ryff had a medal struck with his likeness, but he had to cancel the striking at the behest of the Basle city council. One of these medals is on display at the Basle Historisches Museum. Unfortunately, of his entire art collection, nothing remains except a cabinet dated 1592 (fig. 25), which is likewise to be seen today at the Basle Historisches Museum. As has already been mentioned, Ryff also collaborated in the excavations at Augst and was perhaps even their initiator. Finally, he had a great interest in mining and in the minting of coins.

From the seventeenth century I would like to introduce just one cabinet – or 'Museum' as its owner called it – that belonging to the lawyer Remigius Faesch (1595–1667).[15] The Faesch museum is as important to the Basle museums as the Amerbach cabinet because, in accordance with the last will of its founder, it has been integrated into the collections since 1823 and so is still available to us today. Remigius Faesch belonged to one of the most important Basle families, one which has given the town several mayors, but also well-known goldsmiths and stone-masons. One of his ancestors was the Basle mayor Jakob Meyer zum Hasen, who was one of the first to support the young Hans Holbein and had his portrait painted by him several times: examples are the early double likeness with his wife, Dorothea Kannengiesser, in 1516, and later in the famous *DarmstädterMadonna*, as donor, with his family.

Remigius Faesch studied jurisprudence in Basle, Geneva, Bourges, Paris, Marburg and Kassel, eventually earning his doctorate in Basle. In 1620–1, he undertook a journey to Italy, which certainly quickened his interest in the classical world. After his return, at the age of twenty-six, he had his portrait painted by Bartholomäus Sarburgh. In 1629, Faesch was appointed Professor in the Law Faculty, a position he continued to occupy until his death. As a successful lawyer he became legal consultant to the Duke of Württemberg and to the Margrave of Baden. But since he showed no political ambition, and since he remained unmarried, he could endulge completely his passion for collecting.

Remigius Faesch was above all interested in the pictorial arts. He compiled a folio volume entitled *Humanae Industriae Monumenta*, which contained all he could discover about the arts and which is still to be found in Basle University library. The individual chapters are headed 'Pictoria', 'Plastice', 'Statuaria', 'Sculptoria', and 'Architectonica', with an appendix on 'varia supellex Antique' with 'Urnae', 'Vascula', 'Lucernae', 'Claves', 'Annuli', and so on. Faesch continued this compendium until his death. He quotes in it 160 authors involved in the arts, from classical times until his own period. Aside from general mention of the most famous artists of all times, Faesch devoted himself above all to the German school of painting, with which he himself had been almost professionally engaged. For example, he firstly compiled a catalogue of all the works known at that time of Hans Holbein the Younger, but we also learn important facts about

[15] Major 1908, pp. 1–69; Fischer 1936, pp. 34–40.

Martin Schongauer or Hans Baldung Grien which would not otherwise have been passed down to us.

Faesch was an exceedingly keen collector of the graphic arts. We have two inventories of his graphic collection, from 1641 and 1648, as well as four catalogues of artists and their monograms. In the 1648 inventory, for example, Faesch lists 191 woodcuts, engravings and etchings by Albrecht Dürer. Faesch's coin and medal collection was equally comprehensive. He began a *Thesaurus rei numariae*, according to which his coin collection comprised 3,400 pieces. When the Faesch Museum became university property in 1823, there were 8,322 pieces. Even applied art was not excluded from his collection, and to complete the picture of the coin collection one might mention a gilded dish dated 1571 with antique coins sunk into it, all the more interesting as it incorporates an example from the goldsmith's model collection, used as a handle to the dish. This goldsmith's model may have come from the workshop of Remigius Faesch's ancestors.

As well as works from the classical period, such as an Argive bronze from the fifth century BC showing Heracles resting, or a late Hellenistic finger-ring with a cameo showing the head of an African, the Faesch collection also includes Romanesque and Gothic works of art, such as a sleeping St. Peter from a Mount of Olives group. To the sixteenth century belongs a group of modelled wax profiles, brought to Basle from Berlin by the Basle physician and alchemist Leonhard Thurneysser.[16] They are by Heinrich Rappusch the Elder, and include the likenesses of the Margrave Johann Georg of Brandenburg with his third wife Elisabeth von Anhalt (fig. 26), and one of his son Johann Friedrich, Margrave of Brandenburg, with his wife Katharina, Margravine of Brandenburg. The splendid agate goblet with a gold and enamel setting by Hans Kobenhaupt brings us up to the seventeenth century, as do the pieces of turner's work in ivory and wood in the Mannerist style. Faesch kept some of these valuable objects in a display cabinet which has been preserved (fig. 27). Its Mannerist shape presents the greatest contrast imaginable to the cupboards of the Amerbach cabinet. This piece of furniture was made in 1619 in Basle by the prolific carpenter and woodcarver François Parregod.

The Faesch Museum occupied a large house on the Petersplatz, very near to the Platter residence already mentioned. The library was on the ground floor while the cabinet was housed on the first floor. In a detailed inventory of 1772, there is an exact description of the cabinet, in which, as well as the works of art referred to above, there were also natural wonders or, more precisely, curiosities. Sandrart wrote of this Museum that the owner lived like a prince and that the house was a palace 'as if Minerva had made her home in it'.[17]

Faesch, who had been heavily involved in 1661 in the acquisition of the Amerbach cabinet, wanted to ensure that his museum did not meet with a similar fate; he wanted it to remain as a *monumentum aere perennius* to himself and to his family. In his will, he left it to his family, for as long as there should be lawyers in the family; otherwise, it should go to the university and be united with the Amerbach cabinet. In 1817 this eventuality arose as

[16] An important personality for our subject in the sixteenth century, but living most of his life abroad: see Boerlin 1976.

[17] Peltzer 1925, p. 322.

the last of a long, unbroken line of lawyers in the Faesch family died. After a long court-case, the Faesch Museum finally did go to the university and was, in accordance with Remigius Faesch's will, united with the Amerbach cabinet.

In this paper I have attempted to provide a brief, though necessarily superficial, overview of collecting activity in Basle during the sixteenth and seventeenth centuries. I have given priority to showing that the various collections should not be seen as individual phenomena, but rather as part of the humanistic tradition, which at that time was strong enough amongst the Basle bourgeoisie to support the establishment of so many cabinets of art and curiosities. It was this outlook alone which enabled the purchase of the Amerbach cabinet in 1661 and the opening of the first modern museum to be supported actively by a civic community. Similar developments took place in many other towns of the German-speaking world, notably at Augsburg and at Nürnberg, but we are lucky in Basle to have surviving until the present day both the objects and the inventories of some of these sixteenth- and seventeenth-century collections.

ELECTOR AUGUSTUS'S *KUNSTKAMMER*: AN ANALYSIS OF THE INVENTORY OF 1587

Joachim Menzhausen

The *Kunstkammer* in Dresden was apparently the second foundation of its kind north of the Alps. We are informed by Dr Scheicher's basic publication on the Habsburg *Kunstkammern*[1] that there was already by 1550 a collection by this name in Vienna, though there exists neither an inventory nor any idea of where it was or how it was arranged. By contrast, we know a great deal about the contents, order and location of the *Kunstkammer* in Dresden. It was situated on the fourth floor of the western wing of the *Residenz*, directly over the electoral living-rooms. It is believed to have been founded in 1560, but this information was mentioned for the first time only in 1671, when the keeper (*Kunstkämmerer*) Tobias Beutel published a guide for foreign visitors.[2] His source remains unknown, but the date has never been doubted. The reason may be that the sheer mass of material makes us believe it. Elector Augustus's reign began in 1553 when he was twenty-seven years old. The first inventory of his collection was drawn up in 1587, the year after his death (figs 28–9). It contains around 10,000 entries, for which twenty-five years of collecting seems credible. In fact, the aforementioned number is an underestimate: there are exactly 9,586 entries, but among the books, which formed a small department in the *Kunstkammer*, we find a number of volumes containing engravings of different origins and subjects. Since these seem to have constituted a considerable stock, we may conjecture that the total of objects amounted to 10,000 at the very least.

To give an idea of the original significance of this *Kunstkammer*, it will be necessary to throw some light on the other electoral collections existing alongside it. Augustus enlarged the cabinet of coins and medals, the silver chamber and, being an enthusiastic jouster, he founded an armoury. Moreover, he established an *Anatomie-Kammer*, exhibiting human and animal skeletons, abnormalities, and fossils, a treasury chamber, and the then famous library. Together with the *Kunstkammer* they formed a system of mutually exclusive but interconnected collections. The system itself explains why some so-called 'typical *Kunstkammer*-pieces' in Dresden were to be found outside the *Kunstkammer* in the treasury chamber and in the anatomy chamber. But the connecting links are also significant. One of these was formed by books, the greater number of which were of course in the library, but 288 volumes were kept in the *Kunstkammer*. We may conclude that this arrangement was dictated by their special character. In the inventory, the section on books is entitled 'An astronomischen, astrologischen, geometrischen,

[1] Scheicher 1979. [2] Beutel 1671.

perspectivischen, arithmetischen und anderen Kunstbüchern'. The last part of the title comprises books on architecture, iconography, history (particularly illustrated works), geography and the above-mentioned volumes filled with engravings. Philosophy, theology, and poetry are missing. Hence we may say that this was the scientific part of Augustus's collection of books, and may assume that astrology, architecture, and the fine arts were then included among the sciences. This conclusion is dictated by the arrangement itself, and is of striking importance to my subject.

Elector Augustus's *Kunstkammer* consisted of seven rooms. Some had sloping walls, since they occupied the floor directly under the roof. The last two rooms contained items of little importance – a large number of cases, for example – and will not be considered here, although apparently they did belong to the system of display, for there is a decline in general importance throughout the sequence of rooms. So the first room was the most interesting, and it was the only one to exhibit (in exception to the rule) some rare and precious items, such as a unicorn horn, the famous Columbian ore with emeralds – now in the Green Vaults – and a few rock-crystal pieces from Milan, including a crystal ball for divining the future, similar to (but somewhat larger than) that used by Queen Elizabeth I of England. All the vessels of rock-crystal and other semi-precious stones, however, and even most of the items of Saxon serpentine, were kept in the treasury chamber.

In this first room one could also see pictures and sculptures. Italian miniature copies in marble after Michelangelo and small bronzes by Giovanni da Bologna. The last-mentioned were gifts made by the Grand Duke of Florence in 1584 to Duke Christian, Elector Augustus's successor. Their presence in the premier room may indicate how highly they were regarded, but we cannot be sure whether they were already displayed by Augustus himself.

The pictures were mostly portraits, beginning with twelve Roman emperors, followed by representations of Augustus and his wife, and ending with contemporary rulers. There were also some religious paintings, but the only significant group is a series of tiny water-colours by Hans Bol, from which we can perhaps perceive something of the Elector's taste. The *Kunstkämmerer* David Uslaub added to an entry in the inventory that they were acquired by order of Augustus, and they are what we today would call realistic, because of the meticulously executed landscapes shown in the background. Paintings were spread over all five rooms. They numbered about ninety, but were mostly portraits of princes, pictures of spectacularly large animals killed in the hunt, and representations of famous fortresses and sieges. Only the little pictures by Bol allow us to recognize an artistic inclination, the others being little more than records. Though a total of about 130 pictures and sculptures of widely varying quality may have contributed impressively to the appearance of the Saxon *Kunstkammer*, in quantity they represented hardly 1.5 per cent of its stock.

Only in this first room did Augustus display some natural objects, numbering altogether not more than eighteen pieces. Most of these were sea shells and snail-shells, but there was also a dried octopus described as a 'miraculous creature', and what was called a 'paradise bird'.

All these exhibits were marginal, however, when compared with a group which

embodied the very character of Augustus's *Kunstkammer* – the tools (e.g. figs. 30–1). These numbered 7,353, almost 75 per cent. They were to be found in every room, generally ordered according to the professions for which they were made. Most of them lay in the drawers of writing-desks, caskets and cabinets. Large ones hung on the walls or lay on tables. Hence such pieces of furniture were also distributed throughout all the rooms, and not only were writing-desks and writing-caskets to hand, but also the instruments for writing and drawing were available in practically every corner. Needless to say, the tools and furniture were normally made by well-known craftsmen to princely order; many of them bear the Saxon arms within splendid ornamental settings.

The collection of tools did not cover all contemporary crafts and professions. Its composition seems to have been determined by a mixture of personal inclination and professional interest – the latter in terms of the elector as ruler of a highly developed industrial country. Basic crafts were represented by sets of tools for cabinet-makers, locksmiths, gardeners, turners and gunsmiths. Great attention was paid to surgical instruments, many of which were distributed in the first and the third rooms. The same was the case with geodesy: its tools and instruments occupied prominent places in the first and second rooms, and many route-maps, plans and charts, particularly of Saxon territories, hung in all the rooms. Geodesy was an important science for a country whose industry was based on water-power and whose ruler had an interest in the continuing discovery of new natural resources.

Gunnery featured prominently in the collection. There were many tools and instruments associated with it, as well as plans and pictures of fortresses and sieges in the second room. Objects of even greater variety represented various aspects of hunting: there were special arms, whistles, pictures, trophies, plaster-casts of tracks of domestic and wild animals, and a collection of fishing-rods. The characteristic mixture of personal engagement and the economic necessities of a great princely court can again be detected, for meat from hunted animals contributed fundamentally to the diet of the court, for which the elector bore ultimate responsibility. Moreover, we can recognize in this field that tools and instruments were often placed together with their products. So we find cast letters and stamps near books, or lathes and the corresponding tools beside a respectable stock of turned ivory pieces. Augustus himself was a highly trained ivory-turner, and the craft was included in the educational curriculum of his sons. The court turner's shop lay nearby the *Kunstkammer*, turning being then closely related to mathematics and geometry, and to the understanding of perspective. Numerous geometry-sets and the famous books on perspective by Jamnitzer[3] and Lencker[4] were kept in this second room, and Lencker himself was for some years the princes' tutor. Familiarity with these fields of study was of prime significance for Saxony's rulers, since they bore responsibility for basic decisions in the province's mining industry, where Europe's biggest and most advanced machines were pumping water and smashing ores.

There were also to be found in the *Kunstkammer* smaller groups of objects such as games, musical instruments, Saxon minerals and a small number of vessels of Saxon alabaster and serpentine. But the biggest group next to the tools was formed by scientific

[3] Jamnitzer 1568. [4] Lencker 1567.

instruments, including clocks. It contained 442 pieces, about 4.5 per cent of the total.[5] The mass of quadrants, spheres, globes, astronomical clocks, astrolabes, compasses, hour-glasses, geometry-sets and measuring instruments of all kinds, standing on tables, desks and cabinets, must have been striking. Astronomy and astrology belonged to the elector's favourite fields of interest.

Many of the tools were arranged in cases and drawers and were not immediately visible. Many of them were small, but nevertheless they contributed essentially to the overall impression of Augustus's *Kunstkammer*, along with the instruments, desks, cabinets, busts and pictures of princes.

The most significant groups of items are as follows:

Tools (7,353)	*c.* 75%
Scientific instruments and clocks (442)	*c.* 4.5%
Books (288)	*c.*. 3%
Turned ivories (271)	*c.* 2.5%
Pictures and sculptures (135)	*c.* 1.5%
Naturalia (trophies, corals, shells, samples of exotic wood) (100)	*c.* 1%
Furniture (80)	*c.* 1%

These most prominent groups cover almost 90 per cent of the total stock.

If Elector Augustus's *Kunstkammer* is compared with other collections, it appears markedly different, even innovative. I shall attempt to explain the reasons which may have lain behind the development of such a special type of collection, unique in its period. The Electorate of Saxony was at the time double the size of the Kingdom of Saxony in the nineteenth century, by which time it had suffered defeat in 1815 along with France, and almost half of its territory had been lost to Prussia. In the sixteenth century, Saxony was the most powerful German princedom, not only because of its size and not only because it became the principal state in the Protestant hegemony in Northern Europe: it was no accident that Hamlet studied at Wittenberg, for Saxony owned the biggest industrial complex in Central Europe. Silver, tin, copper, iron, bismuth, antimony and cobalt were mined in its mountainous southern territories. Semi-precious stones and marble were found. A great number of small but wealthy manufacturing towns and villages developed, producing metal-ware, glass and cloth. Leipzig became the domestic distribution centre.

It was from this base that Duke Moritz tried to influence the policies of the German *Reich*. It was he who won, at the battle of Mühlberg, the electoral dignity on which the development of Dresden as the new capital was based. But Moritz was killed in the battle of Sievershausen in 1553 and his brother Augustus succeeded him. He followed the opposite path, strengthening the country after the preceding wars and developing its

[5] The fine arts may have been slightly more strongly represented, but due to the uncertainty as to the numbers of engravings contained in the albums, it is impossible to be sure.

internal administrative and economic structures. It is against this background that we have to consider Augustus's newly founded *Kunstkammer*.

From the very beginning, it was not a museum in the sense of an exclusive exhibition; it was a working collection. Not only were there places to work practically everywhere, but there were also numerous products, especially turned items, by the Elector himself and his son. Moreover, we are informed by Victor Hantzsch, who published the first important article on our subject in 1902,[6] that artists and craftsmen were loaned tools, instruments and books especially for works ordered by the prince. The record describes loans made after Augustus's death, but it is evident that such a practice was of long standing. We may safely conclude that the collection should be numbered among the stabilizing measures promoted by Augustus, helping to encourage education within the princely family and improving the arts and crafts in the state. In time, the Elector's endeavours did indeed lead to a flourishing of sciences and crafts in Saxony. On the other hand, this utilitarian function of the *Kunstkammer* could not but turn it into a public collection, a feature which remained a peculiarity of all the Dresden collections. How else could an unknown librarian named Winckelmann and an unknown student named Goethe have visited the Dresden picture-gallery around the middle of the eighteenth century?

Unfortunately, the guest-books of the *Kunstkämmerer* fell victim to the 1945 air-raid, but we are informed by a short article published in 1915[7] that craftsmen, students, scholars – even citizens with their guests – were visitors to the *Kunstkammer*. Moreover, we in Dresden have recently acquired from a private Irish collection a copy of the widely read *Hauspostille* by Martin Luther which belonged to the first *Kunstkämmerer* David Uslaub; it contains many entries and signatures by members of princely families, who were the Electors' guests and who visited the famous *Kunstkammer*.

The peculiarity of the *Kunstkammer* had yet another consequence. All scholars who have studied it in the past have been astonished at the lack of general order. This seemed to be in contradiction to Augustus's character. He was an efficient householder, a gifted administrator and a skilled economist. Our expectations, however, probably do not match the prince's intentions. We have classed it with the usual type of *Kunstkammer*, mirroring the universe as Quiccheberg taught,[8] forming a microcosm around the central figure of the prince. However, this early Saxon collection was unlike all the others: it was rational in terms of contemporary understanding and without mysticism; it was a working collection, made for the use of clear-headed practical men. We have seen that there was a loose order to it: the decline of importance from beginning to end; the connecting of tool, instrument and product; the concentration wherever possible of items serving one purpose or profession. This, apparently, was order enough; more would have been superfluous.

Shortly after the founder's death, in that very year – 1587 – in which the first inventory was written by the keeper David Uslaub, an opponent of this type of a *Kunstkammer* arose. He was Gabriel Kaldemarck, a widely travelled artist and a consultant of Augustus's

[6] Hantzsch 1902.
[7] Heym 1913.

[8] Quiccheberg 1565.

successor, Elector Christian I. Kaldemarck wrote a detailed report to him,[9] proposing the establishment of a *Kunstkammer* of (as I see it) an Italian princely type with a dominating art collection. The text belongs to the essential theoretical tracts on the *Kunstkammer*, but in terms of the Dresden collection, it came as something like an anti-*Kunstkammer* manifesto. Kaldemarck simply did not acknowledge the existence of a *Kunstkammer*, although he certainly knew of it. He even attacked it, giving us in this way a contemporary characterization:

> '. . . das die Instrumenta zur Musica, Astronomia, Geometria, Item probir, Goldschmidt, Bildhauer, Tischer, Dressler, Balbier und andere werckgezeuge, von der Kunstcammer abzusondern, dann weil solche nicht das Werck, sondern nur Instrumenta und gezeugk, damit mererley werck gemacht werden mögen.
>
> ('. . . that the instruments for music, astronomy, geometry, and the tools for the analysis of materials, for goldsmiths, sculptors, cabinet-makers, turners, surgeons and others are to be removed from the *Kunstkammer*, because they are not works, but mere instruments and tools, to produce different works.')

The wording of the enumeration proves that he knew the late Augustus's foundation, since he names precisely the principal groups, essentially characteristic of the *Kunstkammer*. His proposal was in vain. The young and highly gifted elector died four years later, and the character of the Saxon *Kunstkammer* was thereafter changed by the acquisition of numerous so-called 'typical *Kunstkammer* pieces', meaning precious items, antiquities, curiosities and automatons. Thus it became less scientific and more characteristically representative for the ruler of an important and wealthy princedom. In the second half of the seventeenth century, when Lutheran reserve against the Italian (i.e. Catholic) domination of the fine arts disappeared, the paintings and sculptures were significantly augmented. However, something of the scientific and technical character of this *Kunstkammer* must have survived up to its final dissolution, for when the remains were sold in 1835, the director of the Dresden *Technische Lehranstalt*, the predecessor of today's Technical University, protested against the sale. In the period of romanticism with its overestimation of the fine arts, he still recognized the significance of the collection for the history of science and technology. His objections were in vain, however, and so it was that Augustus's machines for drawing wires and turning ivories came to be transferred to the Musée de Cluny and the Musée Carnavalet in Paris.

Let me finally try to fix the position of Augustus's *Kunstkammer* within the genesis of our museums. If the recent literature is examined there will often be found no distinction between treasury and *Kunstkammer*. This indeed seemed to be the case in the famous early French collections and in the Austrian *Kunstkammern* which were to follow them. The line of development constructed by Dr Scheicher[10] is convincing, all the more so as this type was to become general around 1600. But the Dresden system of collections in the 1560s, as established by Elector Augustus, was something special. I see it as the origin of a new line, in which the prince apparently turned disadvantage to advantage. I refer to the fact that the Lutheran party in the German *Reich* of this time fell into cultural self-isolation. Despite

[9] Staatsarchiv, Dresden, loc. 9835. [10] Scheicher 1979.

relationships with Prague, Innsbruck and Florence, the difference in thinking and feeling was as total as the difference in religious practices between the Catholic and the Protestant communities, particularly so in Martin Luther's own land. The cultural effect is still visible, and even still alive. Saxony now had to adapt her whole culture to the new circumstances — the church service, iconography, all the arts, education. Why not collecting and collections? The beginnings of diversification can be detected in the museums in this period. The special interests of collectors and the special conditions prevailing in different countries led to a variety of collections, from those of arms in Russia to art collections in Italy, for example. We find the establishment of treasuries in addition to the silver chambers, and in Munich even a special building for Roman antiquities. But in Dresden there was immediately an astonishingly comprehensive reaction. Augustus's advanced system of collections, unparalleled in his time, can be seen as a consequence of this situation. It was independent and it was rational. It seems logical that in later years the rational and scientific character of his *Kunstkammer* gave way, step by step, to the international type, in the same way in which the parties themselves drew nearer to each other. On the other hand, in the course of the seventeenth century many *Kunstkammern* were founded which perpetuated the scientific type: examples include the Museum Kircherianum in Rome, the Museum Wormianum in Copenhagen, the *Kunstkammer* in St. Petersburg, and, last but not least, the Tradescant collection, precursor of the Ashmolean Museum. The Dresden *Kunstkammer* of Elector Augustus may not have been their model, but it was, I submit, in respect of its special character, the forerunner of the scientific-technical museum.

THE MUNICH *KUNSTKAMMER*, 1565–1807

Lorenz Seelig

The sixth decade of the sixteenth century – more precisely the year 1565 – was decisive for the Munich *Schatzkammer* as well as for the *Kunstkammer*. The decrees drafted in that year by Duke Albrecht V and his wife Anna do not by any means signify the foundation of a *Schatzkammer* in the narrower sense of the word. Rather, the document declares nineteen valuables[1] as being inalienable heirlooms of the princely household, to be handed down to the successive rulers forever. This was in line with the developing principles of the modern princely state,[2] which tended towards the concentration and continuity of sovereignty and property within the dynasty: in 1530, Francis I of France had issued a similar decree.[3] The inspiring model for the Bavarian Wittelsbach document was probably an agreement of 1564 between the sons of Emperor Ferdinand I – Duchess Anna's brothers – which pronounced the agate bowl and the unicorn horn as inalienable property of the Austrian imperial household.[4] With regard to safekeeping, Albrecht V's document merely states that the pieces were to remain 'bei unnserm fürstlichen haus der neuen veest',[5] that is, doubtless in the *Silberturm* of the *Neuveste*, which also housed the other state and silver treasures.[6] Albrecht V's inalienable treasures were not historical objects of the reigning dynasty, such as insignia, but were instead contemporary pieces of jewellery and goldsmiths' works set with precious stones of a high material value, mainly commissioned by Albrecht himself.

In a period of political consolidation,[7] Albrecht's decree concerning the treasure represented a successful attempt at retaining those valuables for the future of the dynasty. The Munich *Kunstkammer* stood in marked contrast to this.[8] It was likewise mentioned for the first time in 1565 under the name *Theatrum* or *Theatrum Sapientiae*; this was not, however, in a legal document, but in the writings of Samuel Quiccheberg, Albrecht V's Flemish adviser on matters artistic.[9] In contrast to the treasures of the ducal household itself, the *Kunstkammer* collection was of decidedly wide range and far-reaching historical

[1] The nineteen objects were listed under seventeen locations, no. 12 being occupied by three rings. Between 1565 and 1579 a further ten items were added to the list (Thoma and Brunner 1970, pp. 7–18). See also Brunner 1977, pp. 127–48.

[2] Kunisch 1982.

[3] Bapst 1889, p. 3; Somers Cocks 1980, p. 3.

[4] Voltelini 1928; Lhotsky 1941–5, pp. 154–5. Cf. also analogous regulations in Saxony and Württemberg (Menzhausen 1977, p. 13; Fleischhauer 1976, pp. 8, 19, 86.)

[5] Thoma and Brunner 1970, p. 13.

[6] Brunner 1977, p. 127. See also Frankenburger 1923, p. 3; Meitinger 1970, pp. 22–3, 38.

[7] Albrecht V carried through the Counter-Reformation in Bavaria from 1564, restricted the power of the Estates by the Treaty of Ingolstadt in 1563, and crushed a so-called revolt by Protestant noblemen in 1564.

[8] Stockbauer 1874, pp. 9–18; Zimmermann 1895, pp. 26–9; Schlosser 1908, pp. 72–6; Hartig 1917, pp. 49, 93–6; Klinckowstroem 1922, pp. 14–18; Berliner 1926, pp. xvi–xvii; Hartig 1933b, pp. 200–11; Balsiger 1970, pp. 59–60; Brunner 1977, pp. 17–23; Krempel 1978, pp. 142–50; Scheicher 1979, pp. 191–4; Diemer 1980, pp. 133–4, 156. On the paintings in the Munich *Kunstkammer*, see nn. 57, 117, 119 below.

[9] See n. 139. The expression *Theatrum Sapientiae* is also found (referring to the Munich *Kunstkammer*) in Quiccheberg's dedication to Albrecht V in his commentary on the penitential psalms of Orlande de Lassus, completed in 1565 (Bayerische Staatsbibliothek, Munich, Mus. MS A I, Kommentarband 1.)

and geographical scope, and was to be made accessible to a selected public in a suitable building, begun in 1563. In 1568, Albrecht started on a further, doubtless more important building for his collections: this was the *Antiquarium*,[10] situated between the *Neuveste* and the *Kunstkammer*, whose gallery-like ground floor served almost exclusively for the accommodation of antique and pseudo-antique sculptures, in particular busts and statues clearly named and of the highest quality. The upper floor of the building, completed as early as 1571, accommodated the court library, which Albrecht had recently founded.[11] Thus by this time the four complexes of princely art possessions were already established in Munich and all were cited in Albrecht's wills drawn up in 1572 and 1578 – the inalienable household treasures, the *Kunstkammer*, the *Antiquarium*, and the library. By means of legal dispositions and binding testaments, the four collections were also assured of continuity after Albrecht V's death. Each of these four separate units had unmistakable functions and were situated in special premises inside or near the *Residenz*, or assigned to a building which was specially designed to house a collection.

The building intended for the *Kunstkammer*,[12] above the stables on the ground floor,[13] lay between the *Alter Hof* and the *Neuveste*. It was Munich's first Renaissance building, which by virtue of its scale, regularity and independence, stands out in the town model of Munich designed by Jakob Sandtner and completed in 1570.[14] A special feature of the four-winged structure is the arcaded courtyard, alluded to in 1565 by Quiccheberg, who, in reference to the desirable characteristics of a building for a collection, mentions 'a formation of cloister-like ambulatories, which, with four wings comprising several floors, surround a courtyard', 'ita enim Bavaricum theatrum artificiosarum rerum spectatur.'[15] Probably with the intention of examining the objects and with the possibilities of future exhibition in the mind, the contents of the *Kunstkammer* stored in Landshut were transferred to Munich as early as 1566.[16] In the autumn of 1567, it was considered whether to place a smaller number of antiquities in the area of the *Kunstkammer*,[17] but only in 1575 were payments made specifically for pedestals, which were presumably part of the museum's interior decoration.[18] Finally, by 1578, completion of the building seemed imminent.[19]

During those years, the *Kunstkammer* could at least be visited. On the recommendation of the merchant Marx Fugger and the numismatic specialist Adolf Occo (who, as he wrote in 1579, had personally inspected the coin collection of the *Kunstkammer*, 'quae in speciosissimo illo theatro, omnium admirandaram rerum copia et abundantia refertum conspiciuntur'),[20] the geographer Abraham Ortelius and the painter Georg Hoefnagel were granted admission to the *Kunstkammer*.[21] In 1578, Albrecht's Milanese agent Prospero Visconti visited the *Kunstkammer* for two days, and in his letter of thanks to Albrecht V praised it as a 'museum non solum rarum, sed unicum in tota Europa'.[22] Thus

[10] Frosien-Leinz 1980, pp. 310–21.

[11] Hartig 1917.

[12] Klein 1977, pp. 226–34; exhibition catalogue Stadtmuseum, Munich 1980, pp. 280–4, no. 66 (Birgit Rehfus).

[13] On the architectural affinities of the *Marstall* building, see Götz 1964, p. 15.

[14] On the model (in the Bayerisches Nationalmuseum) see Reitzenstein 1967, pp. 1–28, esp. p. 18, and illustration on p. 43.

[15] Quiccheberg 1565, fol. following Diii[v].

[16] Hartig 1931, p. 342; 1933b, p. 204.

[17] Hartig 1933b, p. 220; Busch 1973, pp. 105–7.

[18] Hartig 1931, pp. 369, 373; Busch 1973, p. 323, n. 265.

[19] Stockbauer 1874, p. 12.

[20] Occo 1579, [unpaginated].

[21] Hartig 1917, pp. 350–1; Busch 1973, pp. 138, 304 n. 134.

[22] Simonsfeld 1902, pp. 390, 487.

the Duke opened his *Kunstkammer* not only to princes[23] and ambassadors, but also to interested artists and academics. This practice continued under Wilhelm V, Albrecht's son, so that in the passage devoted to Munich in Braun-Hogenberg's *Civitas Orbis Terrarum* of 1586, we read that whoever was curious could visit the *Kunstkammer*.[24] It was the usual practice for the visitor to show his appreciation in the form of an object donated to the collection.[25] By 1611, however, according to Philipp Hainhofer, various things had gone missing from the *Kunstkammer* and admission was therefore curtailed.[26]

How, then, was the *Kunstkammer* collection housed and exhibited in Albrecht V's and Wilhelm V's time? As no older ground-plans are known, indications of earlier room allocation can be inferred solely from plans completed in 1807 on the occasion of the conversion of the building for the Royal Mint.[27] In one version the alterations made in the early nineteenth century, limited almost exclusively to the interior, are rendered in a different colour to those parts which were incorporated from the sixteenth century. Thus we can easily identify the Renaissance elements. Usually, the first floor is designated as having been the exhibition area,[28] but one finds here spatial divisions from the sixteenth century which can hardly be reconciled with the interior design of the *Kunstkammer*. In addition to this, the first floor had very low ceilings, whereas the second floor, subdivided by the insertion of a false ceiling in 1807, was much taller[29] and would therefore alone have been suitable for the accommodation of the collections. Only here does Sandtner's model, too, show very large windows.

According to the details of the *Kunstkammer* inventory compiled by the lawyer Johann Baptist Fickler in 1598,[30] which names well over 6,000 objects (without the doll's house[31] and the coins) in 3,400 locations on about sixty tables, and also according to the description written by Philipp Hainhofer in 1611,[32] the visitor's 'round tour' began in the north-west corner,[33] which princely visitors could also reach directly via the gallery leading from the *Neuveste*. Facing the arcaded courtyard, a small gallery leading through

[23] For example, on the visit of Herzog Augustus the younger of Braunschweig-Lüneburg in 1598: see Gobiet 1984, p. 9.

[24] Braun and Hogenberg 1965, pt. 4, no. 43 (the section relating to Munich in pt. 4, which seems to have first appeared in 1588, was probably written by Anselm Stöckl). See also Hartig 1917, p. 93 n. 5.

[25] Sebastian Preu, chancellor and toll-gatherer of Straubing, after visiting the Munich *Kunstkammer* in 1580 accompanied by the Duke in person, presented a rosary 'because everyone who is shown graciousness, according to traditional custom, has to present something to the above-mentioned *Kunstkammer*' (Stockbauer 1874, p. 120).

[26] Haeutle 1881, p. 105; cf. Diemer 1980, p. 138.

[27] Landbauamt, Munich, unregistered. See also Stadtmuseum, Munich 1980, p. 283, no. 66.1–4.

[28] See, for example, Klein 1977, p. 229.

[29] According to the plans of 1870, which give data for the earlier dimensions, the rooms on the first floor were *c.*3.25m. high and on the second floor at least *c.*5m. high. When the intermediate ceiling was inserted and the façade was refashioned with four rows of windows, an attic storey was built above the balustrade (see the building records in the Hauptstaatsarchiv, Munich, MF 55794/2).

[30] Staatsbibliothek, Munich cgm 2133 and 2134, with different numbering (cited here as 'F', according to cgm 2134); Fickler's

attempt at an inventory was prompted by Wilhelm V's expressed desire (Busch 1973, p. 173); see Steinruck 1965, pp. 149, 155–7, 159–60, 253, 297–8, nos. 34–6; *Neue Deutsche Biographie* vol. 5 (Berlin), 1961, p. 136 (Friedrich Merzbacher); Staatliche Münzsammlung, Munich 1982, pp. 14, 16–17.

[31] On the doll's house in the Munich *Kunstkammer*, see Wilckens 1978, pp. 7 ff.

[32] Haeutle 1881, pp. 84–105. On Hainhofer's relations with Munich, see Volk-Knüttel 1980. Although Haeutle (1881) in his notes refers several times to entries in Fickler's inventory corresponding to Hainhofer's notes (without quoting the numbers), no attempt has so far been made at a systematic concordance between the Fickler inventory and Hainhofer's descriptions, nor has anyone attempted to relate these two sources to the actual *Kunstkammer* building.

[33] The exact position of the staircase leading to the *Kunstkammer* is not known. Possibly the main staircase was in the middle of the western wing, which has a large gable on Sandtner's model, and where, in 1808–9, a completely new staircase was constructed. It is equally uncertain whether the narrow staircase above the *porte cochère* in the western half of the north wing was present before the nineteenth century. The north-western corner of the *Kunstkammer* has been reconstructed in the plan on very slender evidence and must be considered very hypothetical.

all four wings was separated from the exhibition rooms by a partition, probably interspersed with windows or broken by a *Gätter* (trellis).[34] The gallery also housed a series of art works of lesser rank, such as portraits of court fools.[35] After passing through the antechamber,[36] one entered the north-west corner of the exhibition rooms, housing a grey-painted case where certain books were stored, that is, valuable volumes often containing drawings or engraved illustrations.[37] These were not kept in the court library since in the first place they were regarded as works of art, and secondly their artistic, antiquarian and numismatic content was relevant to the objects in the *Kunstkammer*. Next to this book-case stood a longer chest with seventy-four shallow drawers, containing only graphic works.[38]

The opposite (north-east) corner room was, as Hainhofer says, 'an enclosed room with windows on two sides because it is in a corner of the *Kunstkammer*'.[39] There were two cupboards (*Kredenzen*), each with tiered tops of four steps, upon which contemporary goldsmiths' works were placed without protective cases. The more richly endowed cupboards on the north side[40] displayed exclusively silver-gilt flasks, beakers, *tazze* and basins, two of which are preserved today in the *Schatzkammer*.[41] By way of contrast, there were smaller-scale, ungilded silver works on the eastern cupboard.[42] Furthermore, three ornate tables with stone marquetry tops were positioned here, the slab of the central octagonal table being a Florentine *pietra dura* work.[43] On each of the outer square tables was placed a Sinhalese ivory casket,[44] acquired by Albrecht in 1566, containing amongst other things numerous rings and cameos.[45] Next to these lay a few rare pieces, such as the 'Golden Tablet' now in the *Schatzkammer*.[46] A longer rectangular table of simple appearance[47] standing in the corner displayed rock-crystal and semi-precious stones, as well as goldsmiths' works such as the ambergris bear now in the *Schatzkammer*.[48] Hanging on the walls of the corner room were a few selected objects such as a valuable set of weapons of allegedly Persian origin,[49] and a large ornate mirror,[50] possibly identical with the one about which Hainhofer wrote in 1611, 'in which you can see everything in the *Kunstkammer*, including yourself and several other things'.[51] Thus, on account of the preciousness of the choice objects and the magnificence of the repositories, the north-east corner room was a veritable treasure-house, although the material value could not of course be compared with those pieces under lock and key in the treasure vault in the

[34] Haeutle 1881, p. 84.

[35] Staatsbibliothek, Munich, F.3342–9 and 3268–75; Haeutle 1881, pp. 84–5.

[36] Staatsbibliothek, Munich, F.3334 (table with paintings by Melchior Bocksberger); Haeutle 1881, p. 85.

[37] Staatsbibliothek, Munich, F.1–118; Haeutle 1881, p. 85. On the books in the *Kunstkammer*, see also Hartig 1917, pp. 93–6, 119–22.

[38] Staatsbibliothek, Munich, F.119; Haeutle 1881, p. 85. On the drawings in the *Kunstkammer* see Parshall 1982, p. 142.

[39] Haeutle 1881, pp. 94, 96.

[40] Staatsbibliothek, Munich, F.790–824.

[41] Ibid., 792 ff.; Thoma and Brunner 1970, nos. 589–90; Seling 1980, vol. 1, p. 67 (ascribed to Andreas Attemstett and Cornelius Erb).

[42] Staatsbibliothek, Munich, F.920–36. For a surviving writ-ing box and accessories by Hans and Elias Lencker, see Thoma and Brunner 1970, nos. 579–83.

[43] Staatsbibliothek, Munich, F.825, 911, 916

[44] Ibid., F.826, 918; Haeutle 1881, p. 95; Thoma and Brunner 1970, nos. 1241–2.

[45] Staatsbibliothek, Munich, F.829, 833–4, 837–8, 840–1, 843, 848, 859; Thoma and Brunner 1970, nos. 1, 14, 21, 52, 55, 175, 639, 641, 647, 1222, 1257; see also Nickel 1983, pp. 39–43.

[46] Staatsbibliothek, Munich, F.917; Haeutle 1881, p. 92; Thoma and Brunner 1970, no. 12a.

[47] Staatsbibliothek, Munich, after F.864 (table A).

[48] Ibid., 891, 865, 868, 872, 880; Thoma and Brunner 1970, nos. 22, 504(?), 505, 507, 617.

[49] Staatsbibliothek, Munich, F.913; Haeutle 1881, p. 95.

[50] Staatsbibliothek, Munich, F.915.

[51] Haeutle, 1881, p. 95.

Silberturm. The coin collection was also kept in the immediate vicinity of the north-east corner room.[52]

The contents of the collection exhibited in the north wing, in a room approximately 6.5 metres wide by 35 metres long, followed a very strict pattern. Twelve tables, square in shape and usually painted an ash-grey colour,[53] stood by the windows. (In the reconstruction, the twelve tables are tentatively aligned with the central window axes.) There were mountains of coral protected by glass covers on the tables.[54] Exhibits related thematically to the surrounding repositories could also lie underneath the tables, as the *Tischl* usually had four legs. On the north side, a further twelve longer tables, painted ash-grey and described as *Tafeln*, stood in alignment with the wall sections between the windows, probably in the middle of the room. As a rule, between twenty and 120 pieces were to be found either on or underneath these exhibition *Tafeln*. Trunks, chests, cases and glass covers helped to protect the more fragile or valuable objects. A carpet, usually oriental, might distinguish individual *Tafeln*. In addition, lead casts, plaquettes and medallions, and also occasionally textiles, were to be found in the shallow drawers of the tables.

On the window side, the decoration of the walls also corresponded to the general axial-based arrangement. Thus, in the sections between the windows, one found finely turned wooden structures, on which hunting trophies were mounted,[55] similar to those which have survived at Ambras.[56] Numerous paintings and reliefs, following a strict systematic arrangement, were also hung on the walls on the window side.[57] On two shelves which ran around the upper wall-zones of the exhibition room were many antique (or allegedly antique) as well as modern vessels and sculptures, particularly statuettes and busts, mainly bronze.[58] Larger terracotta busts stood on the floor by the windows.[59] In addition to these, a few stuffed animals hung from the ceiling.[60]

As the longest of the four wings, the north wing gives the best idea of the criteria employed in exhibiting the Munich *Kunstkammer*. It was not by chance that the north gallery, which looked out onto the ruler's palace, the *Neuveste* and the *Antiquarium*, accommodated series of painted portraits of antique and later rulers. Furthermore, it contained probably the most prominent *Kunstkammer* objects as far as rank and value are concerned.

The actual layout of the Munich collection corresponded in principle to basic criteria

[52] Staatsbibliothek, Munich, F.788; part of the description of the coin cabinet on table 13 is at the end of cgm 2134 (fol. 260ʳ–264ᵛ).

[53] There were also a number of elaborate tables which also served to give prominence to particularly precious objects; a pair of such tables from the *Kunstkammer* are in the Bayerisches Nationalmuseum (nos. R 910–11); (Bachtler, Diemer and Erichsen 1980, p. 215, no. viii, 6).

[54] Scheicher 1982a.

[55] The trophies of arms complete with Bavarian and (in the case of F.186) Austrian coats of arms, and hence probably referring to Albrecht V and his consort Anna, in the case of F.186 described as 'similar to Berchtesgaden work', are mounted on pillars 2–5 and 7 (F.18, 228, 288, 317, 281¹), while Hainhofer calls them 'woodcarvings from Amberg and Fuessen' (Haeutle 1881,

p. 86). On pillars 8 and 9 there were two 'wooden clock-cases painted white, probably a pair' (F.336 and 404).

[56] Kunsthistorisches Museum 1977, p. 70, no. 144; cf. also p. 75, no. 159, and Scheicher 1979, illustration on p. 133.

[57] On the series of Roman emperors and on their appended histories, see particularly Hartt 1958, vol. 1, pp. 170–6.

[58] See the bronzes in the Bayerisches Nationalmuseum which were probably (in some cases certainly) produced for the *Kunstkammer* (Weihrauch 1956, nos. 21, 90, 92, 100, 151; Staatsbibliothek, Munich, F.2252, 2275, 2292, 2310, 2454).

[59] See, for example, Staatsbibliothek, Munich, F.1145, 1271, 1276 (all showing men and women) and 1228 (Charles V).

[60] Staatsbibliothek, Munich, F.3328–9 (crocodiles and tortoises).

also followed in other *Kunstkammern*,[61], as in the displaying of numerous objects on long plain *Tafeln* (contrasting with the *Tischl* with valuable individual pieces), in the setting of statuettes and so forth on the surrounding shelves, and in the hanging of paintings on the upper areas of the walls. In Munich on the other hand, there was a decided absence of cupboards as found at Ambras[62] and Prague[63]. Likewise in Munich, there was no attempt at spatial economy as in the Dresden *Kunstkammer*, where numerous objects were placed on numbered walls.[64] In Munich, the guiding principle was to strive against a mere conglomeration of objects and to create instead a sumptuous display of the heterogeneous and wide-ranging contents. On entering the princely *Kunstkammer*, the visitor was to obtain an overall impression of the objects, which were distributed in lavish abundance. The specific character of the *Kunstkammer* is confirmed by the report of the Bohemian traveller Friedrich von Dohna who wrote in 1592–3: 'In this house you can circulate everywhere as there are no separating walls.'[65]

In its time, the four-winged structure of the free-standing building was doubtless the largest building specifically intended to house a collection, which was wholly contained within the rather simple interior.[66] Thus, here as with the *Antiquarium*, Albrecht V went beyond the courts of Dresden[67] and Vienna,[68] whose *Kunstkammern*, founded slightly earlier, were at that time accommodated in less suitably adapted buildings. The special room for the *Kunstkammer* which Archduke Ferdinand created at Ambras was noticeably much smaller.[69] It is not suprising, therefore, that in 1615 when Hainhofer was writing his recommendations to Philipp II of Pomerania for the building and interior design of a representative princely *Kunstkammer*, he had the free-standing Munich *Kunstkammer* specifically in mind, with its four wings, lit by large windows: hence he advised that 'The *Kunstkammer* should have not only square and oblong tables by the windows but also rectangular tables in the middle with locking chests underneath.'[70]

What, then, were the contents of the Munich collection? As in other princely *Kunstkammern* of the sixteenth century, purely natural products, which could not be considered in the categories of the miraculous or abnormal, play a relatively small role at Munich. Fossils, especially in Kelheim and Eichstätt limestone and Mansfeld copper-slate,[71] so-called *Meergewächse* (marine plants)[72] and shells,[73] are all present in significant numbers. However, in 1611 Hainhofer wrote that these were nothing special and that he would not care to exchange them for his own. There is also a certain preference for animal horns, teeth, claws and bones.[74] The unicorn horns owned by the

[61] See Hainhofer's description of the Stuttgart *Kunstkammer* (Oechelhäuser 1891, esp. pp. 308–9).

[62] Kunsthistorisches Museum 1977, pp. 14–15; Scheicher 1979, p. 81.

[63] Bauer and Haupt 1976, p. xxvii.

[64] Hantzsch 1902, p. 229; Menzhausen 1977, fig. 6. See also the custom followed in the Florentine *Tribuna* for the decorative arrangement of pendant objects as trophies (Heikamp 1963, p. 205)

[65] Müller 1976, p. 307: we have here the first, though brief description of the Munich *Kunstkammer*.

[66] The architecture of the Munich *Kunstkammer* (because it is closely related to that of the *Marstall*) is surprisingly ignored in the literature concerned with museum buildings: see Seling 1953,

pp. 16–18; Pevsner 1979, p. 114; Liebenwein 1982, esp. pp. 487–9, 493.

[67] See nn. 4 and 64 above.

[68] Lhotsky 1941–5, pt. 1, pp. 144–6; Scheicher 1979, pp. 65–7.

[69] Scheicher 1979, p. 80.

[70] Doering 1896, p. 273.

[71] Staatsbibliothek, Munich, F.1895, 1905; Haeutle 1881, pp. 101–2.

[72] Staatsbibliothek, Munich, F.1899–1904.

[73] Ibid., F.1114–9; Haeutle 1881.

[74] Staatsbibliothek, Munich, F.480, 513–15, 987–1002, tables 10, 15; Haeutle 1881, p. 96; see also Volk 1980, pp. 175–6. For mention by Hainhofer of a black gazelle horn in the Munich *Kunstkammer*, see Doering 1896, pp. 140, 166.

Bavarian dukes are not mentioned in the *Kunstkammer*;[75] there were some in the *Schatzkammer*, however, where in 1667 three examples are mentioned.[76] Equally relevant in the 'medico-magical' sense, is a selection of bezoars which lay together in a group on one *Tafel*.[77] There were also large numbers of natural products which deviated from the norm, mainly originals, but also some represented as casts and graphic reproductions.

Occupying a position of higher rank in the Munich *Kunstkammer* were those natural specimens which retained their original form but which were assembled into artificial formations, such as the previously mentioned coral mountains.[78] Similar treatment was accorded to the *lapides manuales*, visibly displayed under glass covers and kept together with unmounted minerals in four cases, placed symmetrically in the middle of the west wing,[79] but not systematically selected and classified as they were in Dresden.

What dominated the collection was the large number of artefacts, but here, however, we need to differentiate. The number of scientific objects was remarkably small, the scientific and drawing instruments being concentrated solely on two *Tafeln* and a neighbouring table.[80] There were hardly any mechanical clocks.[81] Under the heading 'ironwork' one finds tools, locks and torture instruments, as well as printing blocks.[82] By way of contrast, one might recall the importance placed on such objects in the Dresden *Kunstkammer* of the Elector Augustus.[83]

On the other hand, there was a great variety of objects which, by virtue of their material and by the way they were treated, tended to assume a somewhat 'artificial' character, denying any practical usage. Amongst other things, there were various boxes and vessels, mainly classified by material, including twenty-six pieces in majolica[84] and about 195 porcelain items.[85] In addition, there were many goldsmiths' works, enamelled copper in the manner of Limousin enamel,[86] and glass.[87] Other objects of this kind, classified by types included cutlery,[88] swords,[89] walking-sticks,[90] rosary beads,[91] calendars[92] and

[75] Staatsbibliothek, Munich, F.283¹, mentions a 'Stangen in form eines Ainkhirns geschnitten': this is probably not a narwhal tusk but rather a piece of ivory with a spiral shape (see also the painting F.2694, showing a unicorn given to Wilhelm in 1591). On the sale of so-called unicorn horns, see Stockbauer 1874, pp. 115–16.

[76] Pallavicino 1667, p. 124.

[77] Staatsbibliothek, Munich, F.485–93, fig. 10; Haeutle 1881, p. 92. See also Stockbauer 1874, p. 96.

[78] Cf. n. 54. Albrecht V had bought so many coral pieces of this kind that after 1581 his son Wilhelm V declined to make further purchases (Stockbauer 1874, p. 114).

[79] Staatsbibliothek, Munich, F.1263, 1908–11, 1971–95; four chests on tables 39–40, F.1923–70; Haeutle 1881, p. 102. Albrecht V particularly loved presents of *Handsteine* (Stockbauer 1874, pp. 115–16).

[80] Staatsbibliothek, Munich, table after table 34 (F.1791–826) ('allerley mathematische Instrumenta von Messing, Eysen und Holz'), tables 33 (F.1691–735) and 34 (F.1776–89); altogether 115 objects are mentioned.

[81] Maurice 1976, vol. I, p. 135.

[82] Staatsbibliothek, Munich, F.1020–46, table 16; Haeutle 1881, p. 96.

[83] Hantzsch 1902, pp. 222–3, 227–33; Menzhausen 1977, pp. 23, 79.

[84] Staatsbibliothek, Munich, F.1213–27, table 20, below; cf. Brunner 1977, pp. 211–14. Albrecht V's majolica service dated 1576 (Brunner 1977, pp. 211–14), which is not mentioned in the Fickler inventory, may still have been in use at that time, so that it would have belonged in the kitchen.

[85] Staatsbibliothek, Munich, F.1053–69; Haeutle 1881, p. 96. Hainhofer mentions 'in another room . . . a cupboard with very beautiful porcelain dishes and bowls' (Haeutle 1881, p. 97), which clearly were not there in 1598 but came later under Maximilian I: see Brunner 1966, p. 4; 1977, p. 215.

[86] Staatsbibliothek, Munich, F.2092–6.

[87] Ibid., 1305–6, 1312–22, table 22; F.1335, 1340–4, table 23; F.2088–91, table 43. Haeutle 1881, p. 98. See also Rückert 1982, vol. I, pp. 18–19.

[88] Staatsbibliothek, Munich, F.410–29, fig. 10.

[89] Ibid., 339–91, table 9 above; Haeutle 1881, pp. 90–1; Thoma and Brunner 1970, no. 233 (the sword of Christoph of Bavaria).

[90] Staatsbibliothek, Munich, F.393–9, table 9, below; Haeutle 1881, p. 91. See also Thoma and Brunner 1970, no. 560 (the so-called staff of Albrecht V, of ivory).

[91] Staatsbibliothek, Munich, F.430, 654, 707–9, 1295–303, 1892; Haeutle 1881, p. 98.

[92] Staatsbibliothek, Munich, F.505–8. For the form of the *Mandlkalender*, see Kunsthistorisches Museum 1977, p. 85, no. 187.

games.[93] On the other hand, European musical instruments are not mentioned as being in the *Kunstkammer*.[94]

Of great importance here are the non-European objects, which in Fickler's inventory are usually recorded under the rubric 'Indian' or 'Turkish'. They came to Munich by way of purchase, for instance via the Fuggers and their foreign trading-posts, or were presents, especially from the Medici: in 1572, Cosimo I sent to Munich part of the exotic cargo from a ship newly berthed at Livorno.[95]

In terms of quantity, the cultures of Latin America and especially Mexico were strongly represented.[96] Objects from Africa cannot easily be identified from Fickler's descriptions. However, a West African ivory horn which derives from the *Kunstkammer* is today preserved in the Staatliches Museum für Völkerkunde at Munich.[97] The Augsburg merchant Ludwig Welser brought back a series of textiles from Tunisia, belonging to the culture of Islamic North Africa.[98] This leads us to those pieces usually described by Fickler as 'Moresque', 'Persian', 'Barbarian', 'African', or 'Mauretanian', which are to be found in large numbers in the *Kunstkammer*. Here one might mention arms, including many daggers, as well as metal and leather work, clothing and carpets.[99] The two ivory caskets mentioned earlier are from Ceylon and were brought to Munich via Lisbon following negotiations by the Fuggers in 1566. From the Far East came some porcelain and lacquered wooden bowls which possibly stem from Japan.[100] A representative of Jewish culture is the so-called wedding ring in the *Schatzkammer*.[101] The metalwork, then classified as antique and also thought to be of Jewish origin,[102] is considered now to be Syrian or Persian.[103] The term 'moskowitisch', used to describe articles of clothing and woodwork,[104] points toward eastern Europe. It is worth mentioning that in 1576, on the occasion of the Regensburg Imperial Diet, an archimandrite from Moscow presented gifts to Albrecht V. The kayak given to Wilhelm V, also in the Staatliches Museum für Völkerkunde,[105] is definitely from Greenland. Some of the shoes apparently originate from Lapland.[106]

The Bavarian territories themselves played a vital role in the Munich *Kunstkammer* (a fact which certainly differentiates it from the collections in Ambras and Prague). The

[93] Staatsbibliothek, Munich, F.1872–4, 2056–75. For a set of playing cards dating from *c.*1430–5 (F.1872) and still to be found in the Württembergisches Landesmuseum, see Fleischhauer 1976, pp. 54–5, figs. II–III.

[94] Musical instruments were probably in a special music cabinet. See the sale register of Raimund Fugger's musical instruments (Stockbauer 1874, pp. 81–4).

[95] Bayerisches Hauptstaatsarchiv, Munich, Kurbaiern Äusseres Archiv 4853 (Libri Antiquitatum III, fols. 267 ff.) See Stockbauer 1874, p. 76; Heikamp 1970a, p. 207.

[96] Heikamp 1970a

[97] Staatsbibliothek, Munich, F.725; Staatliches Museum für Völkerkunde, Munich, 1980, p. 48, no. 97. A second ivory trumpet, which was probably once in the Munich *Kunstkammer* and which bears the inscription 'Da pacē Dñe in Diebus nr̄', is listed as F.725; it may be compared with other examples in Dresden and Paris (Mr Ezio Bassani, personal communication).

[98] Staatsbibliothek, Munich, F.1827–49, table after table 34. For Ludwig Welser, see Bayerisches Hauptstaatsarchiv, Munich, Kurbaiern Äusseres Archiv 4853 (Libri Antiquitatum III, fol. 297); cf. Stockbauer 1874, p. 81.

[99] Staatsbibliothek, Munich, F.963–70, 1407 ff., 1539–45, 1585 ff., 1748–75, 1845–7, 1853.

[100] Ibid., 247–56; cf. Kunsthistorisches Museum 1977, pp. 107, 109, nos. 267–8, 276, and Scheicher 1979, p. 117, illustration on p. 32.

[101] Staatsbibliothek, Munich, F.841; Thoma and Brunner 1970, no. 52.

[102] Staatsbibliothek, Munich, F.198–226, table 3.

[103] Spallanzani 1980b.

[104] Staatsbibliothek, Munich, F.322¹ and 326¹, table 8, below; F.890, 895, table A; F.301–2, table 5. The wooden drinking-vessel described under F.302 was presented to Albrecht V at the Diet of Regensburg (1576) by a legation from Moscow, which included the archimandrite shown in a portrait, F.3117.

[105] The kayak, which was not mentioned in the Fickler inventory but which was certainly in Munich at that time, was transferred from the *Kunstkammer* to the armoury in 1637 (Stöcklein 1911, p. 513; Museum für Völkerkunde, Munich 1980, p. 15).

[106] Staatsbibliothek, Munich, F.1549.

town models built by the cabinet-maker Jacob Sandtner in 1568–1574[107] exactly filled the south-west corner of the *Kunstkammer*. Here the topographical presentation of the Duchy's five largest towns stood in the foreground. The printing blocks of the Bavarian map by Philipp Apian, of 1568,[108] which stood directly alongside the town models, formed an important testimony to the first large-scale cartographic recording of Bavaria. Also present here were printing blocks of the arms of Bavarian towns, monasteries and aristocratic families.[109] One may further count amongst the items from the princedom finds from prehistoric and provincial Roman times,[110] which came to the Munich *Kunstkammer* as presents or through sovereign rights.

With the mention of objects from antiquity, we approach a further important aspect of the *Kunstkammer* – the historical dimension. History manifested itself extensively within the *Kunstkammer* through individuals, who might be represented by way of a portrait or a commemorative object such as clothing, armour or arms.[111] This is true for famous as well as for infamous persons, who can all be listed under the heading 'celebrities'.[112] Some of the more curious objects included the huge boots belonging to the deformed Duke Johann Friedrich II of Sachsen-Coburg[113] and the enormous doublet of the provost of Altötting.[114] Anecdotal comments often became attached to various pieces, as in the case of the sheath of Hans von Fraunberg's sword, covered with human skin, which is cited later in some legal history books.[115] Claiming especially high rank here were the commemorative pieces from the Wittelsbach dynasty, such as the wedding ring supposed to be that of Albrecht V.[116] Portraits inevitably played an important role in the collection and, in contrast to the commemorative pieces, enabled the compilation of a comprehensive collection of personalities, if necessary augmented by copies.[117]

Finally, a few further points may be touched upon. According to Samuel Quiccheberg's distinction between 'miraculosarum rerum promptuarium [*Wunderkammer*]' and 'artificiosarum rerum conclave [*Kunstkammer*]',[118] the collection contained a remarkable number of paintings[119] and sculptures[120] (in addition to the works of artist-craftsmen), which do not belong to the category of pure documentation. Many objects, on the other hand, were typical *Kunstkammer* pieces, distinguished through their extraordinarily subtle

[107] Ibid., 1859–46; cf. n. 14.

[108] Staatsbibliothek, Munich, F.1870; Haeutle 1881, p. 101; Traudl Seifert in Bayerische Staatsbibliothek, Munich, 1979, pp. 32–4, no. 26. See also Bayerisches Nationalmuseum 1909, p. 37, no. 360.

[109] Staatsbibliothek, Munich, F.1870.

[110] Staatsbibliothek, Munich, F.2251, 2532.

[111] Ibid., 287¹, 294, 318–20, 339–41, 382–3, 1547, 1850–1.

[112] Lhotsky 1941–5, pt. 1, p. 186.

[113] Staatsbibliothek, Munich, F.230; Haeutle 1881, p.87.

[114] Staatsbibliothek, Munich, F.1852; Haeutle 1881, p. 104. The portrait of the provost is mentioned under F.3118.

[115] Staatsbibliothek, Munich, F.339; Haeutle 1881, p. 90; Doeplerus 1697, pt. 2, p. 51; *Monatliche Unterredungen* 1697, p. 501; Rabiosus 1778, p. 55.

[116] Staatsbibliothek, Munich, F.838. Contrary to the statement in Thoma and Brunner (1970, p. 70, no. 55) Fickler's enumeration of the Bavarian dukes named Albrecht corresponds to our present numbering, i.e. Fickler does in fact refer to

Albrecht IV. The dating to the early sixteenth century is supported by the late Gothic appearance of the hoop and the particular form of the diamond rosette. Albrecht V's ring would hardly have entered the *Kunstkammer*, as Fickler realized when he called it Albrecht IV's.

[117] Bayerische Akademie 1893, pp. 2–56; see also Simonsfeld 1902, pp. 524–8.

[118] Quiccheberg 1565, fol. following fol. Giiiᵛ; see also Berliner 1928, p. 330.

[119] See nn. 57 and 117 above. See also Reber 1892a; 1892b, p. 10; Diemer 1980, pp. 129–34, 146–7.

[120] See (apart from the bronzes mentioned in n. 58) the following sculptures deriving from the *Kunstkammer*: a relief panel in wood of Philipp von Freising by Friedrich Hagenauer (Staatsbibliothek, Munich, F.1858; Metz *et al.* 1966 p. 119, no. 697); relief panel in stone of the *Judgement of Paris* by Hans Aesslinger (F.1665; Krempel 1978, fig. 97); stone model of the tomb of Ludwig the Bearded by Hans Multscher (F.1679; Bayerisches Nationalmuseum 1955, pp. 5, 44, fig. 31).

workmanship, as for instance in fine textiles[121] or in micro-carvings,[122] including the obligatory cherrystone with numerous faces.[123] Works of art personally executed by princely persons also formed an indispensable category in the ducal *Kunstkammer*.[124]

This broad outline of the appearance of the *Kunstkammer* is based on Fickler's inventory of 1598. One can assume that the *Kunstkammer*, in the state which Fickler described, mainly dated back to Albrecht V. The collection was indeed enlarged under his son Wilhelm V, but was not fundamentally altered in character. We know that Wilhelm had an obligation towards the provincial diets – which themselves pressed for the sale of a portion of the ducal collection – to curtail further acquisitions.[125] Of course, Wilhelm still received numerous presents and had also added his own so-called *Junge Kunstkammer*.[126] Nevertheless, we may regard Albrecht V as the authoritative creator of the *Kunstkammer*. From Albrecht's correspondence on art contained in the *libri antiquitatum*,[127] we learn that he was especially interested in remains from classical antiquity, which he collected consistently. He had always been systematic in the area of portrait series and was passionately fond of commissioning goldsmiths' works, jewellery and precious stones.[128] As far as the objects in the *Kunstkammer* are concerned, however, much came by way of donations and presents, that is to say, by chance. Albrecht V even wrote numerous letters pleading for gifts, as for example when he wrote to the Queen of Philip II of Spain, requesting exotic objects.[129] The activities of Albrecht as founder of the *Kunstkammer* were specifically mentioned in his burial orations of 1579. Here the connection between 'ars' and 'natura', under the common heading 'insolitum, bellum, mirabile, rarum', is looked upon as the characteristic of the *Kunstkammer*.[130] Also met with is the commonplace that the *Kunstkammer* combines the riches of the world in miniature[131] and that it is nature's rival, 'aemula'.[132]

How are we to see the acclaimed Munich *Kunstkammer* in relation to the other princely *Kunstkammern* during the second half of the sixteenth century? In the first place, it is one of the earliest examples of its type. Chronologically, it follows that of Ferdinand I in Vienna and it succeeds that at Dresden by only a few years. It slightly precedes the setting up of the two great Habsburg *Kunstkammern* in Ambras and Prague.[133] Since, in the first few years of its existence, the Dresden *Kunstkammer* was orientated primarily towards the collecting of instruments and minerals, the Munich collection can be regarded as the first to realize the encyclopaedic ideal to a significant degree. To be sure, the extraordinary

[121] Volk-Knüttel 1981, p. 238.

[122] Staatsbibliothek, Munich, F.268¹–71¹, 475, 654–6, 664–703; Thoma and Brunner 1970, nos. 28–9, 214.

[123] Staatsbibliothek, Munich, F.669; Haeutle 1881, p. 103. Cf. also F.672, 681.

[124] Staatsbibliothek, Munich, F.745–6, 1347, 1349, 1378, 1489; Haeutle 1881, pp. 93, 99 (lathe-turned, plaster and wax works.)

[125] Stockbauer 1874, p. 19.

[126] Baader 1943, p. 238.

[127] Bayerisches Hauptstaatsarchiv, Munich, Kurbaiern Äusseres Archiv, 4851 ff.

[128] Krempel 1967, pp. 111–86.

[129] Bayerisches Hauptstaatsarchiv, Munich, Kurbaiern Äusseres Archiv, 4853, fols. 314–15: Albrecht V to Elisabeth de Valois, 24 May 1575, concerning 'selzamen und hir Landes fernen Sachen'.

[130] Menzelius 1579, p. 10; Boscius 1580, p. 29.

[131] Menzelius 1579, p. 10.

[132] See the Tetrastichon of Erasmus Fend reproduced by Brunner (1977, p. 17) and first quoted by Quiccheberg (1565, fol. Hiiiᵛ) who calls it 'aemula natura', while Daniel Wilhelm Moller (1704, p. 246) calls it more properly 'aemula naturae'. See also the description of the Munich *Kunstkammer* in Gorlaeus 1601, fol.*2, as well as the brief mention of certain items in the travel journal of Henri I, Duc de Rohan, dated 1599 (Richter 1880, p. 229).

[133] On the *Kunstkammern* in Dresden, Vienna, Ambras, and Prague, see nn. 4, 62–4, 68 above.

consistency with which the grouping of objects is pursued at Ambras was lacking in Munich and yet there were occasional conformities. Here and there the cases or *Tafeln* are partly ordered according to the materials or genres and types of objects which they contained, making the Munich *Kunstkammer* most readily comparable to that at Ambras. In both collections, for example, there are individual groups of gilded and ungilded silver, and numerous alabaster objects, as well as local alpine objects including woodwork. Through the very sequence of cupboards in Ambras, a certain system is recognizable, whereas in Munich there were only occasional connections from *Tafel* to *Tafel*. Some *Tafeln* had no specific theme and often different groups of objects and materials were dispersed at random over several repositories. Beyond this, the framework in Munich was so wide as to embrace antiques of all kinds,[134] not to mention paintings on religious, mythological and historical themes. Yet at the same time, it is the variety of choice at Munich which differentiates the collection from that of Rudolf II at Prague: in Prague the paintings formed a separate collection and a much stricter standard of quality was applied.

To conclude this discussion of Albrecht V's and Wilhelm V's time, I shall raise the possible relationship of Samuel Quiccheberg's *Inscriptiones vel tituli theatri amplissimi* with the Munich *Kunstkammer*.[135] The Flemish doctor should be regarded as an artistic adviser, not as an art authority (like Hans Jakob Fugger) nor as an antiquary and negotiator (like Jacopo Strada). Quiccheberg became an important figure in the history of collecting not through his practical activities, but because of his book, published in Munich in 1565 and rightly regarded as the first purely museological tract. In the first instance, Quiccheberg's work offers guide-lines for the setting up of an all-embracing collection, such as were emerging in many places during those years. Quiccheberg's declared aim was to promote their founding and enlargement, according to the different means of individual collectors. Thus his writings contain not only a detailed classification system but also an abundance of practical instructions. Special advice is given, for example, on the installation of a private collection within a limited space. In contrast to this, collections with a far greater wall-area and with spacious display tables are also discussed.[136] Here one recalls the Munich *Kunstkammer*, which Quiccheberg praises for its generous architectural layout.[137] However, at no point in the *Inscriptiones* can there be found any suggestion that the work was intended specifically as an introduction to the Munich collection. This does not contradict the fact that in his tract Quiccheberg clearly formulated certain passages with regard to the Munich collection and to the patronage of the Bavarian Duke. Quiccheberg did not see the *Kunstkammer* at Munich (as Gabriel Kaldemarck later did in Dresden)[138] as a pure art collection, but rather as an encyclopaedic collection on which he conferred the

[134] On the antiques in the *Kunstkammer*, see, for example, Christ 1866, pp. 373, 378, 396 and Busch 1973, p. 145.

[135] On Quiccheberg and his writings see Pantaleon 1570, pt. 3, p. 560; Klemm 1837, pp. 195–201; Murray 1904, vol. 1, p. 28; *Biographie Nationale de Belgique* 18 (Brussels, 1905), cols. 499–501 (Fernand Donnet); Schlosser 1908, pp. 72–6; Volbehr 1909; Habich 1913; Hartig 1917, index; Bayerische Akademie 1921, p. 15 (Otto Hartig); Berliner 1928, pp. 328–31; Hartig 1933a; 1933b, pp. 172, 200–4; Hajós 1958, 1963; Klemm 1973; Mundt 1974, pp. 92–3; Scheicher 1979, p. 68; Biblioteca del Cinquecento

1979, p. 84; Bolzoni 1980; Liebenwein 1982, pp. 501–2; Bayerische Staatsbibliothek 1982, p. 173; Parshall 1982, pp. 142, 182–3; Lugli 1983, pp. 84–5, 133–4.

[136] Quiccheberg 1565, fol. Dii^r.

[137] Ibid., fol. following Diii^r.

[138] Menzhausen 1977, pp. 16–25; Scheicher 1979, pp. 70–1. Also the paper on Kaldemarck delivered by Wolfgang Lieben-wein to the colloquium on the Munich *Antiquarium* in 1979 and currently being prepared for publication.

title *Theatrum* or *Theatrum Sapientiae*, probably referring to Giulio Camillo's *Idea del Teatro*;[139] in contrast, the terms *promptuarium* or *museum* were reserved by Quiccheberg for specialized collections. Perhaps the influence of Quiccheberg, who died in 1567, is reflected in certain features of the Munich *Kunstkammer*, as for example in the strong representation of the prince and his realm, and in the importance of graphics and casts for documentary purposes.

The first step in drastically reducing the *Kunstkammer* was taken before 1606, when Maximilian I set up his own *Kammergalerie* and removed the highest-quality works from the *Kunstkammer*.[140] The Duke justified these withdrawals by arguing that the objects in the *Kunstkammer* were not sufficiently protected against dust and dirt or fire-hazards, nor were they sufficiently well guarded. Furthermore, such huge rooms, set apart from the *Residenz* above the stables, made it difficult to control withdrawals by loan, or thefts.[141] Ultimately, however, there lay behind the transferral the wish of the reigning prince, in accordance with the principles of early absolutism, to withdraw the treasures in the *Kunstkammer* from public view and to convey them to an area reserved wholly for the sovereign.[142] The most select art possessions were thus – like the treasures – treated as 'arcanum',[143] about whose 'secret' contents only the ruler was informed and over which only he could dispose. Contemporary connoisseurs, including the persevering Hainhofer, had no admission to the *Kammergalerie*, which was situated in Maximilian I's own apartments in the *Residenz*. Here the objects were stored in locked cabinets and served exclusively for the prince's own 'recreation'. For the *Kammergalerie*, which belonged to the type of the *studiolo*[144] and no longer emphasized universal claims, Maximilian I took from the *Kunstkammer* only certain objects from different categories (but excluding natural specimens) which were distinguished by their extraordinary quality of material and workmanship.[145] The Bavarian Duke's own high standards as a collector, incidentally, were probably stimulated by a visit to Rudolf II's collection in Prague in 1593.[146]

The *Kunstkammer*, bereft of its valuables and further diminished by the transfer of the coin collection to the *Antiquarium* in 1603, now slipped to the ranks of a mere secondary collection. Historical and ethnological objects of little artistic value were all that remained. The most devastating blow was struck when the Swedes and their allies plundered the *Kunstkammer* in 1632, destroying especially the coral mountains.[147] The pieces which had previously given the *Kunstkammer* its specific character and aesthetic appearance were no longer present. The essence of the *Kunstkammer* was lost and, being already out of date, it was never restored to its earlier level.

After 1632 the contents of the *Kunstkammer* were further despoiled in favour of other Munich collections. In 1637, Maximilian I transferred various prominent natural specimens (including Emperor Maximilian II's stuffed elephant) along with the

[139] Hajós 1963, pp. 207–11.
[140] Diemer 1980, pp. 129–38.
[141] Thoma and Brunner 1970, p. 22; Diemer 1980, p. 129.
[142] Diemer 1980, p. 144.
[143] Dollinger 1968, pp. 170–4.
[144] Liebenwein 1977, pp. 142–64. The Florentine *Tribuna* (see

n. 64) was comparable in variety but not in the presentation of the exhibits.
[145] Bachtler, Diemer and Erichsen 1980, pp. 191–252.
[146] Diemer 1980, p. 135.
[147] Ibid., pp. 140–1; see also Hainhofer's report in Gobiet 1984, p. 614, no. 1168, pp. 617–18, no. 1172.

afore-mentioned kayak, to the armoury.[148] This was a set-back in the history of the collection since removed from their thematic context, the pieces now became mere curiosities.

In 1655, we learn, the textile and furniture depositories, the *Gardemeuble*, were accommodated in the *Marstall* building, where the *Kunstkammer* used to be.[149] From here onwards, the *Kunstkammer* takes on a sort of phantom existence. Hainhofer's manuscript record of 1611, i.e. a good twenty years before the Swedes plundered the *Kunstkammer* in 1632, was finally published between 1640 and 1705, with few alterations, as an allegedly up-to-date account of the state of the collection.[150] The *Kunstkammer* is not mentioned in several descriptions of the *Residenz* and of Munich, which, however, give for the first time comprehensive reports on the adjacent twin collections of the *Schatzkammer* and *Kammergalerie*.[151]

Whereas many scientifically orientated collections came into existence elsewhere during the seventeenth century, in Bavaria the opportunity of using the remaining contents of the *Kunstkammer* as illustrative material for natural science or ethnology was neglected. Science and research found practically no support under the electors Ferdinand Maria, Max Emanuel and Karl Albrecht,[152] all of whose interests were directed towards their palaces. Interest in such objects came only from the church and from the Bavarian Jesuit university in Ingolstadt, where the priest Ferdinand Orban set up a cabinet, similar to a museum.[153] The ducal court itself did not, however, follow the contemporary trend of founding specialist collections or spatially differentiating between the existing contents as was the case in Dresden and Berlin. Instead, in 1730, Karl Albrecht created a new room for his treasure – a single room in the style of a mirror cabinet – which, by way of its position at the end of the Wittelsbach ancestral gallery, played a practical role in political-dynastic propaganda.[154] Significantly, neither the Munich *Schatzkammer* nor the *Kunstkammer* played any role in the theoretical debate on the nature of collecting during the seventeenth and eighteenth centuries.[155]

A last inventory describes the markedly reduced *Kunstkammer*[156] in its old location in the *Marstall* building in the year 1807,[157] just before the building was vacated, destined to

[148] Stöcklein 1911, pp. 513–14.

[149] Volk-Knüttel 1976, p. 93, n. 326.

[150] Zeiller 1640, pp. 283–9; Roden 1690, pp. 839–44; Ertl 1703, pp. 252–62; Krempel (1978, pp. 149–50) erroneously supposes that Ertl's description (taken from Hainhofer and Zeiller) reproduces the actual state of the *Kunstkammer* at the beginning of the eighteenth century.

[151] Monconys 1665–6, pt. 2, pp. 351–4; Pallavicino 1667, pp. 123–35; Misson 1702, vol. 1, pp. 117–25; Patin 1695, pp. 83–9.

[152] Hammermayer 1976.

[153] Krempel 1968.

[154] Seelig 1980, p. 268.

[155] See the brief mentions of the Munich *Kunstkammer* in a few works of *Kunstkammer* literature: *Monatliche Unterredungen* 1696, pp. 122 ff.; Sturm 1697, pp. 166–7; Neickel 1727, p. 73; Köhler 1788, pt. 2, pp. 891, 912.

[156] In 1758 Elector Maximilian III Joseph had ordered that one half of the so-called *Kunstkammer* was to make room for the court library (Geheimes Hausarchiv, Munich, Korr.-Akt. 1712 P

I 3): to what extent this intention was realized is, however, unclear. The *Kunstkammer* probably was augmented after the Bavarian and Palatine branches of the House of Wittelsbach were united in 1777 when a number of objects from the Munich *Residenz* were transferred there, as appears from an inventory of 1778 (Bayerisches Hauptstaatarchiv, Munich, HR 23/62). This *Kunstkammer* inventory mentions numerous items which are not present in the previous inventories dated 1734, 1750, 1763 and 1772 (Bayerische Verwaltung der staatlichen Schlösser, Gärten und Seen, Museumsabteilung, inv. no. 128–34). Krempel (1978, p. 150) (perhaps referring to Rittershausen 1788, p. 150) and Berliner (1926, pp. xx ff.) referred to the establishment of a new *Kunstkammer* in the *Kölnischen* (i.e. Trier) *Zimmer* in the Munich *Residenz*; at any rate during the 1770s various cabinets and collectors' pieces must have been placed here on a temporary basis and were later dispersed.

[157] Bayerische Verwaltung der staatlichen Schlösser, Gärten und Seen, Museumsabteilung, inv. no. 3.

become the Royal Mint. Surprisingly, we find still portraits and objects of a historical nature as originally described in Fickler's inventory.[158]

[158] See, for example, the medallion of a Knight of the Golden Fleece (Staatsbibliothek, Munich, F.525; Thoma and Brunner 1970, no. 19) and the woven miniature portraits of Maximilian I and his sister Christierna (F.649; Bayerisches Nationalmuseum no. R1554; Volk-Knüttel 1981, pp. 238–42). For the later history of the Munich collections, see particularly Berliner 1926, pp. xxvi–xxix; Bayerisches Nationalmuseum 1955, pp. 7–33, Frosien-Leinz 1980, p. 318.

This brief text has been able to deal with only a few of the numerous questions relating to the Munich *Kunstkammer*, which have hitherto lacked comprehensive treatment. More detailed treatment must be reserved for a future history, which will have to start with Fickler's inventory and will have to consider a great many further archival sources.

For important questions and references I am grateful to Dr Peter Diemer, Dr Johannes Erichsen, Dr Eliška Fučíková, Dr Thomas Lersch, Dr Elisabeth Scheicher, Mr Fridolin Stumpf, Dr Brigitte Volk-Knüttel and Dr Peter Volk. I should also like to thank Miss Gertrud Seidmann for revision of my text, which was translated by Miss Julie Seddon-Jones.

PHILIPP HAINHOFER AND GUSTAVUS ADOLPHUS'S *KUNSTSCHRANK* IN UPPSALA

Hans-Olof Boström

In a letter of July 1607, Duke Wilhelm V of Bavaria informed his son, the reigning Duke Maximilian I, of 'a citizen of Augsburg whom, apart from his religion, I hold to be an honourable and intelligent young man, who is learned as well as being a merchant and in whose house I saw all kinds of foreign and strange things as well as almost an entire *Kunstkammer*'.[1]

The man described thus was the merchant Philipp Hainhofer (fig. 33), twenty-nine years old at the time.[2] The Duke had made his acquaintance a year before when visiting the *Kunstkammer* which he mentions.[3] Hainhofer had laid its foundations in 1604 and it was soon to become one of the objects of interest in Augsburg which no distinguished traveller neglected to visit.

Hainhofer was already a rather important man in his home town when Duke Wilhelm met him. He belonged to an old merchant family which had been ennobled by Emperor Rudolf II and which had married into the so-called *Mehrergesellschaft* in Augsburg, a political group uniting the patricians on the one hand and the merchants' guild on the other.[4] In 1605 he had been elected to the city's Greater Council and in 1607 he succeeded his uncle, Hieronymus Hörmann, as political agent to Henry IV of France. That signalled the beginning of his diplomatic career. Soon he was agent to several German princes, conveying political and cultural information from France and Italy in particular and representing his patrons at princely ceremonies (baptisms, marriages, funerals) as well as at political gatherings.

Hainhofer was well suited to such missions. During his years of study in Italy and, later, in Cologne and Holland, he had acquired an extensive knowledge of languages and a profound humanist education. His chief subject of study was law, but throughout his life he also took a lively interest in theology. A convinced Lutheran (hence Duke Wilhelm's one reservation), he displayed great tolerance towards religious opponents; this was, in any case, a condition of his successful business with Catholic princes. For example, he did not hesitate to procure relics from North-German princes for the fervent Catholic Wilhelm V.[5]

To begin with, Hainhofer's trade was mainly in Italian silk, but it soon came to include

[1] Volk-Knüttel 1980, pp. 84; 121, n. 21.
[2] For the biography of Hainhofer, see Stetten 1778, pp. 269–88; *Baltische Studien* 1834, pp. xi–xxxii; Doering 1904; Böttiger 1909–10, vol. 1; 1923; Blendinger 1966. The work of Gobiet (1984) was published after this paper went to press.
[3] *Baltische Studien* 1834, p. xxii.
[4] Cf. Rieber 1968, p. 309; Bátori 1969, pp. 21–2.
[5] Haeutle 1881, pp. 143–4; Böttiger 1909–10, vol. 1, p. 15; Böttiger 1923, pp. 6–7.

objects of art and luxury articles of all kinds. Increased dealings with princely patrons expanded his field of enterprise still further. He might be commissioned to obtain English sheep for Duke Maximilian I of Bavaria,[6] a stallion or pet dog for Archduke Leopold II of Austria,[7] horses, dogs, clocks, musicians, domestic servants, spices, provisions and, above all, books for Duke Augustus the Younger of Brunswick-Lüneburg, the foremost German book-collector of his time[8] – in fact, anything suitable for the court of a prince.

His *Kunstkammer*, too, played a part in his commercial activities. Its exhibits might be exchanged or sold and hence it was in a continual state of flux and expansion. Unfortunately, we possess no inventory of the collection: it is only from Hainhofer's letters that we can gain a rough idea of its contents.[9] At first, it seems to have consisted mainly of *conchylia* and *ethnographica*, objects which Hainhofer bought for the most part from Dutch merchants on his regular visits to the Lent and Autumn fairs at Frankfurt.[10] The *Kunstkammer* rapidly expanded to include a large number of coins and medals as well as antiquities. Hainhofer maintained a network of what he calls 'representatives and friends' in several European cities.[11] They provided him with the articles necessary for his trade as well as with pieces for his collection and supplied him with the information he communicated to his patrons. The widespread Italian Lumaga family occupied an important place in Hainhofer's commercial activities: it had branches in Nürnberg, Paris, Lyon, Genoa and Turin.[12] In Florence, his brother Christoph was his most important business contact until the latter's death in 1616. It is likely that Hainhofer also utilized the services of the great commercial firms of his native city. The Fugger company, for instance, had branches throughout Europe, that in Lisbon possibly providing Hainhofer with the South American items in his collection. Furthermore, he was, of course, visited by the many foreign merchants who passed through Augsburg.

Hainhofer was very proud of his *Kunstkammer*, especially its shells. Once he tells us that 'no one here has such fine shells as I'[13] and, after seeing the 'shells and sea fauna' in the ducal *Kunstkammer* at Munich, he says 'I should not wish to exchange mine for these.'[14] How dear to his heart his collection was is demonstrated by the statement that 'when someone presents me with a foreign object for my *Kunstkammer*, whether it be of *rebus naturalibus* or *artificialibus*, I experience more pleasure than if he had given me cash.'[15]

Hainhofer was naturally eager to see other *Kunstkammern* and visited several of the great princely collections of the age: that at Munich in 1603 and 1611, the Duke of Württemberg's at Stuttgart in 1616, that of the Saxon elector at Dresden in 1617 and 1629 and Archduke Ferdinand II's at Ambras in 1628.[16] The most famous one – the Emperor Rudolf II's – he never saw but was well informed about it from his correspondence with

[6] Volk-Knüttel 1980, pp. 84, 121 n. 11.

[7] Böttiger 1909–10, vol. 1, pp. 19, 60; Böttiger 1923, p. 6.

[8] *Sammler, Fürst, Gelehrter* 1979, pp. 79, 80, 163, 173, 315–19; Fink 1955, pp. 323–4.

[9] Doering 1901, pp. 251–89.

[10] Böttiger 1909–10, vol. 1, pp. 3, 5, 38.

[11] '. . . factorn vnd amicis' Doering 1894, p. 9.

[12] For correspondence with members of the Lumaga family,

see Herzog August Bibliothek, Wolfenbüttel, Cod. Guelf. 17.27 Aug. 4°, *passim*. Cf. Heikamp 1966b, p. 92; Volk-Knüttel 1980, p. 122, n. 37.

[13] Doering 1894, p. 93.

[14] Haeutle 1881, p. 96.

[15] Doering 1901, p. 252.

[16] Hartig 1924; Haeutle 1881, pp. 55–148; Oechelhäuser 1891; *Baltische Studien* 1834, pp. 134–5; Doering 1901, pp. 84–8, 157–79.

artists and friends in Prague, among them his cousin Melchior Hainhofer who in 1610 was raised to Imperial Court Councillor.[17]

In his travel-reports Hainhofer often gives expression to his enthusiasm for what he has seen. On being allowed to visit the *Kunstkammer* in Stuttgart he exclaims, 'I hold this to be a greater act of grace than any that has ever been accorded me and the news has given me more pleasure than anything else I can imagine.'[18] During his stay in Munich in 1611, he visited the *Kunstkammer* three times, but believed that 'to see everything properly not even two or three days are sufficient, rather as many months or more.'[19] And at Ambras in 1628, he complained when dinner was to be served: 'I should much rather have visited the *Kunstkammer* than eat the finest meal.'[20]

In his *curriculum vitae* Hainhofer lists the distinguished visitors to his own *Kunstkammer*. They include, besides a large number of German princes, King Christian IV of Denmark, Archduke Leopold V of Austria, Gustavus Adolphus of Sweden and the unfortunate Elector Palatine Frederic V, the former *Winterkönig* (both shortly before their deaths in 1632), some Medici princes and a few travelling English aristocrats.[21] Among the latter was the most distinguished English collector of the time, Thomas Howard, second Earl of Arundel. On his diplomatic mission to Emperor Ferdinand II in 1636 Lord Arundel spent a week in Augsburg towards the end of July. In the diary kept by William Crowne during the mission no mention is made of a visit to Hainhofer, but Hainhofer himself proudly records that the Earl 'came to see my curiosities'.[22] As early as 1626 Hainhofer had asked the German poet Georg Rudolph Weckherlin, at that time Under-Secretary of State to Charles I, to 'bring me into contact with that lover of painting the Earl of Arundel'.[23]

Many of Hainhofer's social equals – patricians, merchants, scholars – had *Kunstkammern* of their own: his truly original achievement lies in his pieces of multi-purpose furniture, especially his great *Kunstschränke*. These *Mehrzweckmöbel*, manufactured under his supervision by dozens of artists and craftsmen from various guilds, are, or were at least intended to be, miniature *Kunstkammern*. This is true of the cabinets now in Uppsala and Florence as well as of the one now lost which was sold to Duke Augustus the Younger of Brunswick in 1647. The case of the Pomeranian *Kunstschrank*, destroyed in the Second World War, is somewhat different. Unlike the other cabinets I have mentioned, it did not contain collections of *naturalia* and *artificialia*, but instead included a set of instruments and tools for virtually every human occupation. This difference is probably due to the fact that the cabinet was meant to form only a part of the *Kunstkammer* in the ducal castle at Stettin, for which Hainhofer delivered a plan in 1615.[24]

The Pomeranian *Kunstschrank* was begun first (in 1610), but constant expansion of the

[17] Staats- und Stadtbibliothek, Augsburg, Cim. 66, fol. 58ʳ. Letters from Philipp Hainhofer to his cousin Melchior are to be found in Herzog August Bibliothek, Wolfenbüttel, Cod. Guelf. 17.23 Aug. 4°, fols. 22ʳ–22ᵛ, 26ᵛ–30ᵛ, 111ʳ–112ʳ; Cod. Guelf. 17.24 Aug. 4°, fols. 4ᵛ–5ᵛ, 91ᵛ–93ʳ, 124ᵛ–126ʳ, 153ᵛ–154ᵛ. Cf. Cod. Guelf. 17.23 Aug 4°, fol. 264ʳ.

[18] Oechelhäuser 1891, p. 306.

[19] Haeutle 1881, p. 105.

[20] Reidemeister 1935, p. 111.

[21] Staats- und Stadtbibliothek, Augsburg, Cim. 66, fol. 62ᵛ, 63ʳ, 89ᵛ; Herzog August Bibliothek, Wolfenbüttel, Cod. Guelf.

60.9 Aug. 2°, fols. 3ᵛ, 7ᵛ, 8ʳ, 10ʳ, 11ᵛ, 13ʳ, 13ᵛ, 14ʳ, 14ᵛ, 15ʳ; *Baltische Studien* 1834, pp. xxii, xxv, xxvi, xxviii, xxix, xxx.

[22] Staats- und Stadtbibliothek, Augsburg, Cim. 66, fol. 87ʳ; Herzog August Bibliothek, Wolfenbüttel, Cod. Guelf. 60.9 Aug. 2°, fol. 13ʳ; *Baltische Studien* 1834, p. xxix. Cf. Springell 1963, pp. 77–8; 125, nn. 165–6.

[23] Herzog August Bibliothek, Wolfenbüttel, Cod. Guelf. 17.27 Aug. 4°, fol. 78ᵛ.

[24] Doering 1894, pp. 272–6; Lessing and Brüning 1905, p. 8. Cf. Heikamp 1963, pp. 230–1.

not particularly extensive original project delayed its completion until 1617.[25] In the meantime, another cabinet, smaller but otherwise closely related to the Pomeranian one, had been delivered to the Grand Duchess Maria Magdalena of Tuscany in 1613.[26] It is not known to have survived.

But these cabinets were made to commission. The other three which I have mentioned were manufactured at Hainhofer's own risk and expense. His untiring efforts to sell them make for amusing reading in John Böttiger's monograph on the *Kunstschrank* given to Gustavus Adolphus. He dispatched letters to princes all over Europe, enclosing descriptions of the cabinets in Latin, English, French, Italian or German. Among those approached – usually via business contacts – were the kings of Denmark, Poland, Spain and England, the Queen of France, Emperor Ferdinand II, Empress Maria Anna, the Duke of Orléans and the *Signoria* of Genoa.[27]

Such offers might also concern smaller projects which Hainhofer had in manufacture. For instance, in December 1632 he wrote to Georg Rudolph Weckherlin in London asking him to find some noble, or perhaps the king or queen, to buy 'a fine table', the drawers of which contained 'medicinal and toilet articles, all kinds of playthings, a musical instrument and many other fine objects'.[28] Hainhofer probably got to know Weckherlin in 1616 in the latter's home town of Stuttgart while both were taking part in the splendid ceremonies surrounding the princely baptism in March of that year.[29] This is just one of many examples of Hainhofer's ability to use casual acquaintances to promote his affairs.

The *Kunstschrank* in Florence – or *stipo tedesco* as it is usually called – was made between 1619 and 1626, and by 1628 Hainhofer had already succeeded in selling it to Archduke Leopold V of Austria, who in turn presented it to his wife's nephew, Grand Duke Ferdinand II of Tuscany.[30] It now has its place in the Museo degli Argenti in the Pitti Palace.

Before concentrating on Gustavus Adolphus's *Kunstschrank*, I should like to say a few words about three further, less well-known cabinets, one of which has not survived. The first, a small one now belonging to the Rijksmuseum in Amsterdam, was made at the end of the 1620s. On his own initiative Hainhofer sent it in 1631 to Duke Augustus of Brunswick, advising him that it would make a suitable gift for 'the King of Sweden's wife', Queen Maria Eleonora. The Duke, however, was not interested in acquiring it but did promise to try to find a buyer.[31] Perhaps it was purchased by a member of the Orange dynasty and reached Holland in this way. According to Hainhofer the greater part of its contents was lost during transportation to Duke Augustus.

A little *Kunstschrank* in the Kunsthistorisches Museum, Vienna, shows a certain similarity with the Amsterdam cabinet, while its crown of minerals and shells finds its counterpart in the 'mountain' at the top of the Uppsala *Kunstschrank*. These correspondences make it reasonable to date the Viennese cabinet to the 1620s: its

[25] Lessing and Brüning 1905; Hausmann 1959; Alfter 1981, pp. 76–87; Pechstein 1983, pp. 44–7.
[26] Volk-Knüttel 1980, pp. 88–9. Cf. Himmelheber 1975, p. 114.
[27] Böttiger 1909–10, vol. 1, pp. 49, 51, 57–60, 62–4.
[28] Herzog August Bibliothek, Wolfenbüttel, Cod. Guelf. 17.27 Aug. 4°, fols. 383ʳ–384ʳ.

[29] Oechelhäuser 1891; Forster 1944, pp. 27–31, 60.
[30] Heikamp 1963; Piacenti Aschengreen 1968, pp. 19, 174; Alfter 1981, pp. 96–101.
[31] Himmelheber 1980; Rijksmuseum, Amsterdam 1952, pp. 356–60; Alfter 1981, pp. 112–14.

traditional description as 'Rudolf II's *Kunstschrank*' must therefore be false. No documents connect it with Hainhofer, but the affinities with his other *Kunstschränke* are so striking that I see no reason to question that he was its creator.[32]

A third cabinet, made between 1631 and 1634, was bought by Duke Augustus of Brunswick, but not until 1647, immediately before Hainhofer's death – on the very day he died as contemporary sources have it.[33] Its history thus far has been traced in documents by Detlef Heikamp.[34] Recently a Swedish historian of ideas, Arne Losman, has succeeded in pursuing the story a little further.[35] Directly following its purchase, the Duke presented it to Field Marshal Carl Gustaf Wrangel, then supreme commander of the Swedish army in Germany. The gift's purpose was apparently to facilitate the flow of Swedish subsidies. It was a valuable gift: the Duke had paid 6,000 thalers for it, equivalent to the price of 230 ordinary saddle-horses. The *Kunstschrank* seems to have reached Sweden, but then we lose all trace of it.

We are better informed about the *Kunstschrank* of Gustavus Adolphus (fig. 34).[36] It was manufactured between 1625 and 1631, remaining in Hainhofer's house until the Swedish king's troops entered Augsburg in April 1632. The Lutheran councillors, who were reinstated by Gustavus Adolphus, wished to welcome the king with a magnificent gift, so the council bought the cabinet from Hainhofer for 6,500 thalers (though he received only 6,000 gulden). The presentation ceremony took place in the Fugger palace, with Hainhofer demonstrating it for the king, whom he describes as 'versed in all sciences and a master of all arts'.[37]

Hainhofer had played an important role as mediator between Catholics and Lutherans prior to the surrender of Augsburg; as a reward for this and other services, his was among seventeen Lutheran families elevated to the rank of patrician (the so-called *Schwedengeschlechter*).[38] He was also appointed one of the council's three building inspectors supervising public building in Augsburg. Furthermore, he was even granted some Swabian villages which, however, he was politically shrewd enough not to accept.[39] Following the conquest of Augsburg by imperial troops in 1635, Hainhofer lost both his patrician status and his seat on the council.

Little more than six months after receiving the *Kunstschrank*, Gustavus Adolphus died, and not until the following year was it transported to Sweden.[40] First it was placed in the royal castle of Svartsjö, but was later transferred to that at Uppsala. In 1694 Carl XI donated it to Uppsala University; today it stands in the most splendid room of the university's main building, the Chancellor's room.

The *Kunstschrank* was deprived at an early date of its huge collection of coins and medals, which became part of the university's numismatic museum. In the course of the eighteenth century its minerals were also removed and transferred to the Department of Chemistry. With these exceptions the contents of the cabinet have survived almost intact.

[32] Fock 1982 is of the same opinion. Cf. Alfter 1981, pp. 137–9.
[33] *Baltische Studien* 1834, p. xxxii. Cf. Andreae 1649, p. 267; Sporhan-Krempel 1970, p. 737.
[34] Heikamp 1963, pp. 233–4.
[35] Losman 1980, pp. 64–71.
[36] Böttiger 1909–10; Alfter 1981, pp. 1–8, 102–9; Boström 1982.

[37] Böttiger 1909–10, vol. 1, p. 69.
[38] *Baltische Studien* 1834, p. xxviii; cf. *Welt im Umbruch* 1980, vol. 1, p. 401.
[39] Herzog August Bibliothek, Wolfenbüttel, Cod. Guelf. 60.9 Aug. 2°, fols. 12^r–12^v.
[40] Böttiger 1909–10, vol. 1, pp. 71–4; 1913.

Unfortunately, the description is lost which, like those of the other *Kunstschränke*, certainly belonged with it. Thus it is difficult to comprehend fully the system behind the collection of objects. However, considerable help is provided by the inventory of contents intended to accompany the *stipo tedesco* but never delivered with it.[41] This exhibits similarities with the contents of the Uppsala cabinet; indeed, many items would seem to be identical.[42] It is certain that Hainhofer's own *Kunstkammer* provided the greater part of the hundreds of objects in the *Kunstschrank* in Uppsala. Of the planned content of the Florentine cabinet, he says that it was 'brought together over a period of twenty years'.[43]

Hainhofer calls the *stipo tedesco* 'a small *Kunstkammer*' and both the composition of the contents listed in the inventory and the items in the Uppsala cabinet do in fact represent small-scale versions of princely *Kunstkammern*.[44] The inventory divides the objects into two main categories: *naturalia* and *artificialia*. Natural products worked by human hand are reckoned among the *naturalia* – for instance, carved precious stones, rosaries, a knife, fork and spoon of amber, and bowls of *terra sigillata* or serpentine. This system of classification has its counterpart in princely *Kunstkammern* and perhaps derives from the arrangement of the elder Pliny's *Naturalis historia*.[45] Within these two main sections the objects are grouped according to material and function, geographical and chronological criteria scarcely playing any part at all. This, too, accords with the *Kunstkammern*. Like many of them, Hainhofer's *Kunstschränke* give expression to the desire for an all-embracing documentation of the world and of human activities. In the Uppsala cabinet the animal, plant and mineral kingdoms are represented, the four continents known at that time and every historical period from antiquity up to Hainhofer's own day. Instruments fulfilling the needs of practical everyday life, of work and study, stand alongside those supplying pastimes and aesthetic pleasure. As with the *Kunstkammern*, this quest for universality is modified by a focus on the rare, the peculiar, the precious and, in the case of artefacts, on objects characterized by artistic refinement, a high level of craftsmanship and the surmounting of technical difficulties.

The same encyclopaedic intention finds expression in the pictorial programme of the *Kunstschrank*. It is more extensive than in Hainhofer's earlier cabinets and may in part be understood as a combination of those of the Pomeranian and Florentine *Kunstschränke*. If the iconographical content of the former may be summarized as the triumph of Art and Science – of civilization – over Nature, then that of the latter is, in Hainhofer's own words, 'a compendium of all Holy Scripture'.[46]

The biblical component in the iconography of Gustavus Adolphus's cabinet is represented by hundreds of pictures, ranging from Genesis to Revelations. Also present are the traditional allegories of the four elements, the five senses, of virtues and of time and place. One feature does not appear in Hainhofer's other cabinets: the large number of allegories of love, the prelude to which is to be seen in the crowning statuette of Venus. Hidden among depictions of the glory and richness of life on earth there are also some *vanitas* pictures, reminding the beholder of Death's presence and the transitoriness of all

[41] Doering 1901, pp. 131–8.
[42] Böttiger 1909–10, vol. 1, p. 65; Boström 1982, p. 40.
[43] Böttiger 1909–10, vol. 1, p. 59.
[44] Böttiger 1909–10, vol. 1, p. 59. Cf. Heikamp 1963, pp. 234, 256.
[45] Cf. Scheicher 1979, p. 43; Bredekamp 1982, p. 515.
[46] Böttiger 1909–10, vol. 1, pp. 41, 59.

things. Finally, in the central section, wooden intarsias depict Augsburg at the outbreak of the Thirty Years War with the newly erected town hall and arsenal by Elias Holl.[47]

I shall neither examine more closely the pictures in this vast programme nor list the various groups of items contained in the cabinet. Instead, I should like to concentrate on certain aspects which may be considered important and which hitherto have not attracted much attention.

Firstly: was the *Kunstschrank* intended to be of any practical use? In an article on the Pomeranian cabinet Tjark Hausmann maintains that all tools and instruments belonging to it (they are still preserved in Berlin) were not intended for actual use but had a purely symbolic significance.[48] Even if they do 'work perfectly', they are in fact miniature tools which, in their capacity of 'things of diverse significance operating on many levels and in different directions', are meant to encourage meditation on the part of the beholder.[49]

I cannot agree entirely with this interpretation. To begin with, I consider the tools and instruments no more miniatures than are the writing utensils, the mathematical and astronomical instruments, the medicine cabinet, the 'barber's shop' and the surgical instruments in the Uppsala *Kunstschrank*. There are genuine miniature objects in that cabinet, a great number in fact: for example, there are twelve agricultural implements made of sewing needles. Such things may indeed be labelled 'playthings' but not those I mentioned previously. Here it is instructive to compare Hainhofer's *Kunstschränke* with the other types of multi-purpose furniture he had manufactured, e.g. portable tables and beds, chests for women at childbirth, and mirror cabinets.

Of a childbirth chest he had invented for the Duchess of Brunswick he says it is intended for 'the most necessary daily use';[50] the *stipo tedesco* he describes as being of 'use and service';[51] and the cabinet bought in 1647 by Duke Augustus of Brunswick he calls 'an astonishing *Kunstkammer* as well as a household article'.[52] Such statements by Hainhofer are corroborated by the demand of Duke Maximilian I of Bavaria when, in 1613, Hainhofer tried to induce him to order a *Kunstschrank*: it ought to be 'of some use and not just stand about pointlessly'.[53]

In the course of the restoration of the Uppsala *Kunstschrank* some years ago, the velvet linings of its medicine cabinet were found to be badly worn and the movable board on the same side to be severely damaged by water. It would seem that the basin and ewer, actually intended for use at mealtimes, had frequently been used as toilet articles. Since it came into the possession of the university, the cabinet has never been in practical use, so one must assume the damage to date from its time in a tower-chamber of the royal castle at Uppsala. Perhaps it was Queen Christina who used it in this manner.

The magical or medicinal properties ascribed to many of the objects in the Uppsala *Kunstschrank* constitute an important aspect of its function. The ewer of coco-de-mer or Seychelles nut crowning the cabinet (fig. 35) may be easily detached and used as a wine ewer – Hainhofer mentions at one point that it holds 'one quart of wine'.[54] The Seychelles nut was thought to be an exceptionally effective antidote for poison. In addition, the ewer

[47] Cf. Alfter 1981, pp. 1–8.
[48] Hausmann 1959, pp. 347–50.
[49] Hausmann 1959, p. 350.
[50] Doering 1901, p. 301.

[51] Doering 1901, p. 131.
[52] Heikamp 1963, pp. 234, 256.
[53] Volk-Knüttel 1980, pp. 89, 108.
[54] Böttiger 1909–10, vol. 1, p. 45.

was probably considered one of the most valuable objects in the cabinet, Seychelles nuts being of the utmost rarity in Europe. It was not until 1768 that their sole place of origin, two small islands in the Seychelles, was discovered.[55]

The 'mountain' on which the ewer stands contains black, white and red coral twigs. Apotropeic properties – in particular against the Evil Eye – were attributed to coral, an effect increased here by carving the tops of a couple of coral twigs in the shape of a hand in the so-called *fica* gesture: with the thumb between the index finger and the next, this gesture was thought to avert all kinds of evil.[56]

The cabinet contains, further, a large number of objects supposedly possessing prophylactic or medicinal properties or considered effective as aphrodisiacs: bezoars, a *pomambra*, a musk pouch, cups of *lignum Guaiacum*, a bowl and mug of *terra sigillata*, and so on.[57] The minerals originally belonging to the cabinet were also, perhaps, selected with regard to the magical properties associated with the various stones.

Hainhofer often states that his *Kunstschränke*, which he calls 'tables' (*Tische*) or 'desks' (*Schreibtische*), also had to satisfy the demand for *Kurzweil* (i.e. for pastimes or diversions) and says of the *stipo tedesco* that a 'more practical and diverting table' had never been made.[58] To this category of objects in the Uppsala cabinet belong the chess set and other parlour games as well as the sets of playing cards, on the backs of which are noted the tunes of thirteen popular songs.

Beneath the 'mountain' is a virginal (fig. 36), which may be played in a number of ways. Firstly, a drawer can be taken out of the cabinet's pedestal and, by a simple manipulation, converted into steps granting access to the keyboard. Conversely, the virginal can be taken out of the cabinet and placed on the folding table likewise to be found in the pedestal. Finally, the virginal is equipped with a mechanism which allows three compositions to be played automatically. Originally the virginal was linked mechanically to a clock hidden in the 'mountain', thus enabling it to be played automatically at a predetermined moment in time. When adjusted accordingly, it also played automatically when the doors of its compartment were opened.[59]

Several objects in the cabinet aim at similar surprise effects, especially those intended 'for vexation'.[60] There are vexing mirrors distorting the reflected image, vexing spectacles breaking up reality into facets, artificial eggs, fruit and bread cheating those who take hold of them, halves of nuts with illusionistic wire insects, wooden spoons with two handles or bowls, a mug one cannot drink from and, finally, two pairs of vexing gloves one cannot put on since they are sewn together. Such practical jokes were immensely popular in the Mannerist and Baroque periods – one thinks, for example, of the Archduke Ferdinand II's iron chair at Ambras which held anyone captive who sat down in it or of the surprise jets of water which soaked strollers in the palace parks of the time.

[55] Kris 1932, pp. 49–51; Philippovich 1966, pp. 499–502. Cf. Hayward 1976, p. 394; Seling 1980, pp. 60–1, 257; Tait 1981, p. 71.

[56] Rettenbeck 1955; Hansmann and Kriss-Rettenbeck 1966, pp. 42, 67–9; Philippovich 1966, p. 122.

[57] Böttiger 1909–10, vol. 3, pp. 50–3, 91–4; cf. Philippovich 1966, pp. 264–6, 419–23; for *terra sigillata* cf. Zedler 1962, cols. 1074–6.

[58] Doering 1901, p. 22.

[59] *Welt im Umbruch* 1980, vol. 2, pp. 477–8; see also MS by F. Hellwig in Germanisches Nationalmuseum, Nürnberg, entitled 'Bericht über die Untersuchung von Uhr und Automatenvirginal des Augsburger Kunstschrankes im Kunstmuseum der Universität Uppsala' (1981).

[60] Böttiger 1909–10, vol. 1, pp. 31–3; vol. 2, pp. 59–60; vol. 3, pp. 17–18, 34, 70, 88.

The cabinet's anamorphoses may also be placed in this 'amusement' category. They surprise the beholder in a way similar to the objects already mentioned, giving him an 'Aha!' experience as the distorted picture regains its correct proportions. Two of them are so-called perspective anamorphoses, the third a mirror anamorphosis with a painting on copper of an elegant gentleman. The mirror anamorphosis can be perceived correctly only with the aid of a cylindrical or conical mirror and it was, at the time Hainhofer included one in his cabinet, a recent invention. The first known representation of a functioning mirror anamorphosis is an engraving of about 1625 by Hans Tröschel of Nürnberg, executed in Rome after a model by Simon Vouet, who seems to have played an important role in the development and dissemination of mirror anamorphoses. Its principles were first described in writing in a publication of 1630, *Perspective cylindrique et conique* by the French mathematician Sieur de Vaulezard.[61]

The mirror anamorphosis in the Uppsala cabinet is just one example of Hainhofer's insatiable appetite for novelties. Another is his inclusion of a telescope in the Pomeranian *Kunstschrank* in 1617, less than ten years after its invention.

In this connection I should like to mention some so-called *Verkehrbilder*, small paintings on ivory at two of the corners of the Uppsala cabinet. Two of these represent the beautiful faces of a man and woman respectively which, when turned upside down, change into grinning skulls. They are thus *vanitas* pictures. Another depicts a landscape which, when rotated through ninety degrees, becomes a man's head in profile. A further composition shows a head made up of the heads of two men, a horse and a ram. Similar to these are four allegories of the seasons represented in the manner of Arcimboldo, i.e. as heads comprised of flowers, fruits, leafless branches, and so on. Related to these paintings is an automaton hidden in the 'mountain': moving figures perform the story of Apollo and Cyparissus from the tenth book of Ovid's *Metamorphoses*, the beholder being able to watch Cyparissus change into a cypress tree after shooting the stag.

The pictures and automaton which I have mentioned are instances of a concern with the concept of metamorphosis which pervades a good deal of the cabinet's pictorial programme. Hainhofer shared with many others of his time an interest in the visualization of the transition from life to death, Man to animal, Man to Nature and Nature to Art. The same interest is expressed in the many casts from nature found among the contents of the *Kunstschrank*: a snake, lizard and frog in lead, and lizards and beetles in silver. These are objects summed up in the term *stil rustique* introduced by Ernst Kris.[62]

Hainhofer often expressed his enthusiasm for things exhibiting this gradual transition from Nature to Art, objects in which Nature seems to work like an artist and the artist in the manner of Nature. In particular he admired 'ruin marble' or 'landscape stone' with, as he puts it, 'self-made landscapes and buildings'.[63] He imported slabs of this stone from Florence, either already decorated or, more frequently, unpainted stones which 'with paint can be helped a little to represent something'.[64] Landscape stones are often used in the Uppsala *Kunstschrank*, above all in its folding table and desk. To this category of

[61] Baltrušaitis 1956; 1969, pp. 135–7, 151; Leeman, Elffers and Schuyt 1975, p. 133.
[62] Kris 1926.
[63] Doering 1901, p. 44. Cf. Herzog August Bibliothek, Wolfenbüttel, Cod. Guelf. 83 Extrav. 2°, fol. 315ʳ. Cf. also Bredekamp 1982, p. 515.
[64] Volk-Knüttel 1980, p. 107.

pictures belongs, too, the large alabaster slab painted by Johann König with depictions of the *Israelites Crossing the Red Sea* on one side and the *Last Judgement* on the other. The artist has been very skilful in using the texture of the stone to give the illusion of clouds, rocks and mighty cascades. In works of art of this kind one may perceive how, as Hainhofer describes it, 'Art and Nature play with one another'.[65] He was also fond of vases of rock crystal, which he calls 'a great pleasure for princes, since they have Nature and Art side by side'.[66]

This conception of Art and Nature as working side by side with similar means or in symbiosis with each other was by no means new to Hainhofer. He had had opportunities to see comparable works of art on his youthful journeys of study – for example during a three-week stay in Florence. Francesco I's *studiolo* in the Palazzo Vecchio, the grotto in the Boboli gardens and the grottoes and fountains in the park of the Medici villa at Pratolino (which Hainhofer describes in his diary) betray the same attitude towards Art and Nature.[67] He surely also visited the *Opificio delle pietre dure*, founded some ten years previously, where he could see how slabs of landscape stone were 'helped a little' to become works of art and how *pietre dure* were put together to form still lifes of birds and flowers.[68] From the same workshop he later imported the *pietra dura* and some of the ruin marble which adorn the cabinet in Uppsala.[69]

But comparable objects were to be found nearer Augsburg than that: the grotto in the Munich *Residenz*, for example, or the writing utensils and caskets by the Nürnberg silversmith Wenzel Jamnitzer with their animals and plants cast from nature and their crowning configurations of sand and stone. In fact, the latter are probably the prototypes of the 'mountains' in Hainhofer's *Kunstschränke* in Uppsala and Vienna.[70] Of course, Hainhofer could also have studied many phenomena exhibiting a symbiotic relationship between Art and Nature in the great *Kunstkammer* at Ambras, which, however, he did not visit until 1628.[71]

Hainhofer hardly possessed a logically thought-out conception of art. There are passages in his writings which seem to contradict the conception I have tried to outline. When visiting Dresden in 1629, Hainhofer falls to admiring a tombstone in which the figures are represented so illusionistically that they seem 'to stand there in person'.[72] In subsequent passages of his diary Hainhofer refers to the anecdote about Apelles and the horse of Alexander the Great. From one of his letters to Duke Philipp II of Pomerania we know that he had seen Gian Paolo Lomazzo's *Trattato dell'arte della Pittura* where, at the start of the first chapter, he could read that painting is 'come a dire simia della natura'.[73] This ancient, but no longer particularly strong, doctrine of Art as the ape of Nature is thus

[65] Doering 1901, p. 117.

[66] Doering 1894, p. 102.

[67] Herzog August Bibliothek, Wolfenbüttel, Cod. Guelf. 60. 22 Aug. 4°, fols. 231–2. For Pratolino, see Zangheri 1979; cf. Heikamp 1969.

[68] Giusti, Mazzoni and Pampaloni Martelli 1978; Rossi 1969, pp. 117–79.

[69] The slab with a representation of a naval battle with Jonah and the whale on the writing-desk of the Uppsala cabinet is very similar to a painting on landscape stone in the Museo delle Pietre Dure in Florence, which is attributed to the circle of Filippo

Napoletano (another similar painting belongs to Rudolf II's *Kunstschrank* in Vienna). Also other representations on the Uppsala desk are very close to paintings from the Napoletano circle. Cf. Böttiger 1909–10, vol. 2, p. 54; Giusti, Mazzoni and Pampaloni Martelli 1978, p. 345 and pls. 546, 551.

[70] Cf. Menzhausen 1977, pp. 39–40; Hayward 1976, pp. 208–11; Hernmarck 1977, pp. 281–2.

[71] Doering 1901, pp. 84–8; cf. Scheicher 1979, pp. 73–136.

[72] Doering 1901, p. 229.

[73] Lomazzo 1584, p. 19; cf. Doering 1894, p. 180; Janson 1952, pp. 301–4.

shared by the philosopher of art Lomazzo and the layman Hainhofer. However, I should point out that Lomazzo, too, was inconsistent in his conception of art, for at other times he says that Art works in the same way as Nature.[74]

When one is speaking of *Kunstkammern*, the name of the Oxford doctor Robert Fludd is bound to occur sooner or later. The model of the cosmos in the first part of his *Utriusque cosmi historia* does in fact show similarities with the organization of both *Kunstkammern* and *Kunstschränke*, even if it is difficult or impossible to prove any direct connection.[75] In the plate depicting the model of the universe at the beginning of the first volume of his work, the ape recurs as symbol of the arts, held in chain by Nature who in turn is guided by God. The volume was published in Oppenheim in 1617 and of course it is not impossible that Hainhofer studied this well-known book. He was by no means uninterested in occult sciences of the type practised by Fludd. This is evident from the book *Cabala, Spiegel der Kunst und Natur: in Alchymia* by the Tyrolese doctor Stephan Michelspacher, which was published in Augsburg in 1615 with a dedication to Hainhofer.[76] Moreover, Hainhofer was a friend of the Lutheran theologian Johann Valentin Andreae who in his youth seems to have been one of the driving forces behind the Rosicrucian movement.[77] This movement had been defended by Fludd, but he never seems to have come into personal contact with Andreae who, for theological reasons, soon renounced all connections with the Rosicrucians.[78]

If one seeks connections between Fludd's model of the universe and the microcosms that are Hainhofer's cabinets, then these are closer in the Uppsala cabinet, which was made after the appearance of *Utriusque cosmi historia*, than in the Pomeranian one, which was finished in the year of the book's publication. As I have pointed out, the Pomeranian cabinet lacks collections of *naturalia* and *artificialia* and is thus, unlike that in Uppsala, no microcosm. As in Fludd's model the animal, vegetable, and mineral kingdoms are included in the Uppsala cabinet and there are representations of the four elements in it as well as in Fludd. The tools and instruments are attributes of the *artes liberales*, four of which – arithmetic, geometry, astronomy and music – are depicted in silver inlays in the cabinet's desk. These are the traditional *quadrivium* of the *artes liberales* and also appear among the *Artes Liberaliores* in Fludd's model. However, some *artes mechanicae* are also present in the desk: tailoring, minting, printing, goldsmithing, watchmaking, painting and the art of perspective. The last three are also included among Fludd's *Artes Liberaliores*. A comparison with the silver inlays in the desk of the Pomeranian cabinet is instructive. They depict study, printing, painting and mathematics. These are occupations connected in one way or another with the actual function of the desk and are thus quite different from the fusion of the conventional seven *artes liberales* with *artes mechanicae* found in Fludd and in the desk of the Uppsala *Kunstschrank*. Instead, the seven *artes liberales* adorn the sides and top of the Pomeranian cabinet.

[74] Cf. Nyholm 1977, pp. 141–68, 216.

[75] Fludd 1617, pp. 4–5; Janson 1952, pp. 304–5; Hutin 1971; Godwin 1979; Fludd 1979, pp. 1–21; Yates 1969, pp. 42–79; 1972b, pp. 70–90; Kemp 1973, pp. 88–101; Heninger 1977, pp. 27–9, 82–4, 144–5. Cf. Salerno 1963, pp. 195–6.

[76] Michelspacher 1615. Cf. Jöcher 1751, vol. 3, col. 521.

[77] Andreae 1649, pp. 267–70; cf. Kienast 1926; Hutin 1971, pp. 23–9; Montgomery 1973; Dülmen 1978, pp. 153–4; 249, nn. 37–8; 251, n. 52; Godwin 1979, pp. 10–11; Yates 1972b, pp. 30–3, 50, 59–69, 91–3, 140–55.

[78] Yates 1969, pp. 68–9; 1972b, pp. 70–90.

Anyone who has read *The Art of Memory* and other publications by the late Dame Frances Yates knows what an important role that concept plays in Robert Fludd's *Utriusque cosmi historia*.[79] Arne Losman has recently suggested that Hainhofer's *Kunstschränke* may be interpreted as *theatri memoriae*.[80] I was disinclined to believe this until I discovered a little brochure entitled *Exemplum speciminis artis memoriae*, published in Augsburg in 1614.[81] From it we learn that on 17 June of that year some learned gentlemen, among them Hainhofer, assembled to hear Lambert Schenkel from 's Hertogenbosch. This Dutch pedagogue was, together with Fludd, one of the leading authorities on the art of memory.[82] Hainhofer apparently knew him already, because in his report of the baptism in Stuttgart two years later he calls him 'my preceptor', which seems to point to more than just a single casual meeting in Augsburg.[83] Schenkel was probably Hainhofer's teacher during his studies in Holland.

These considerations cannot, of course, prove that the *Kunstschrank* of Gustavus Adolphus really was intended to serve as a *theatrum memoriae*, with innumerable pictures and objects in fixed places in compartments and drawers helping the beholder to understand God's creation. It is likewise impossible to establish whether Fludd's model of the cosmos and his theories of macrocosm/microcosm did in fact form the basis of the microcosm represented by the *Kunstschrank*. The Uppsala cabinet is so multifarious in its iconography and contents that it will probably never cease to pose problems and give rise to fresh modes of interpretation. Philipp Hainhofer once said of this *Kunstschrank* that 'many hold it to be the eighth wonder of the world'.[84] I expect that those who have seen the cabinet will not consider this exaggeration to be wholly unfounded.[85]

[79] Yates 1972a, pp. 320–41.
[80] Losman 1982.
[81] Schenckelius 1614.
[82] Jöcher 1751, vol. 4, cols. 252–3; Yates 1972a, pp. 299–301.

[83] Oechelhäuser 1891, p. 300; cf. p. 327, n. 5.
[84] Böttiger 1909–10, vol. 1, pp. 64, 68.
[85] I wish to thank Mr Michael Foster for revising my English text.

THE *KUNSTKAMMER* OF THE HESSIAN LANDGRAVES IN KASSEL

Franz Adrian Dreier

The *Kunstkammer* of the Landgraves of Hesse-Kassel presents a good example of a princely collection which developed into a public museum. Since numerous works of art, natural history and ethnology have survived as evidence of this process, and since the three buildings representing its architectural manifestation still exist today, Kassel belongs amongst those few places where the genesis of a public museum can be studied by means other than literary sources.[1]

The germ of its development, even if not its actual beginning, lay in the medieval treasury of the landgraves, which typically accumulated anything worthy of preservation whether by virtue of its precious material, magical power or rarity. Together with examples of European arts and crafts, it encompassed also works of oriental origin, witnesses of a period which combined an extraordinary mixture of piety and a striving for power and luxury with a thirst for adventure, and which quenched its longing for distant, legendary lands in crusades against the infidel.

Two thirteenth-century enamelled beakers belonging to the Aleppo group, one of them decorated with musicians and the other with hunting scenes, and a large fourteenth-century Syrian enamelled glass vessel shaped like a bucket, must have been brought to Hesse by a crusader or a princely pilgrim.[2] A Fatimid bronze lion probably arrived in Hesse by similar means,[3] as did the so-called sword of Boabdil, the last ruler of Granada.[4] The famous celadon bowl (fig. 37), the earliest example of Chinese pottery whose arrival in Europe is documented, may have been brought by Philipp, the last Count of Katzenelnbogen, from an eastern journey. The bowl seems to have come into the possession of the House of Hesse through Anna, Philipp's daughter and heiress. From the same source as the celadon bowl comes a ceremonial wine jug of gilded silver, with rich engraved decoration (fig. 38). It is known as the *Katzenelnbogische Willkomm* and was by no means unique in its time: similar jugs were registered in Hessian inventories of the *Silberkammer* drawn up in the years 1500, 1502, 1504 and 1525.[5] A large ring of gilt bronze was probably given by Ferdinando of Aragon to Wilhelm the Elder on his visit to Naples in 1491, when he was invested with the Order of the Griffon. Pope Innocent VIII gave him a large ceremonial sword, which also is preserved.[6]

[1] A comprehensive monograph on the *Kunstkammer* in Kassel, including the *Kunsthaus* of the Landgrave Carl, has not yet been written. For short summaries see Dreier 1961 and Link 1975.

[2] Lamm 1930, p. 304, no. 4; p. 329, no. 3; p. 414, no. 3; Fuchs 1959, p. 8; Schlosser 1908, pp. 112–13.

[3] Hallo 1983b; Meyer 1959.

[4] Kühnel 1924, p. 73, fig. 122.

[5] Drach 1888, pp. 3–6; Demiandt 1939.

[6] See n. 3.

As in the other collections in Kassel, objects to which magical powers were attributed were preserved in the treasury. Some of these are now in the Naturkundemuseum[7] – some horns of the unicorn, for instance, the distinguishing feature of the fabulous creature associated with the Virgin, which in reality comes from the narwhal. Ostrich eggs were also present, as were coconuts and nautilus shells (fig. 39), the latter formerly recorded in the treasuries of Hellenistic temples and familiar to ancient authors such as Aristotle, Athenaeus, Pliny, Oppianus and Allianus.

The first art collector of importance in the House of Hesse was Wilhelm IV, known as the Wise. During his reign, from 1567 to 1592, the transformation of the medieval treasury into a collection in the style of the Renaissance took place. Although belonging to the opposite camp as far as political party and religious belief were concerned, he proved to be similar in spirit to the Archduke of Tyrol, though the focus of his interest was somewhat different. Wilhelm was one of the most important astronomers of his time, who calibrated and designed astronomical clocks and instruments. He secured for his observatory in the attic of his palace the Swiss mathematician and mechanic Jost Bürgi,[8] who also worked for the Emperor Rudolf II and who developed among several important inventions a system of logarithms invented in 1588 independently from those of John Napier. Among the many astronomers and scientists who visited Kassel, the greatest was Tycho Brahe.

It is known from surviving letters that Wilhelm was also interested in the field of arts and crafts and had precise ideas about what represented good taste. He gave detailed instructions to artists or their agents and sometimes added a little sketch.[9] He was a man of some experience in using different artistic techniques: for example, he instructed, Duke Johann Moritz of Anhalt in the method of burnishing gilded metal.[10] He laid the foundation of an important library and, like many of his humanist contemporaries (including Ferdinand), he established a collection of portraits.

It may have been the demands of the guiding principle of a *vera effigies* that restricted Wilhelm in his collecting to portraits of rulers living between 1530 and 1580.[11] The paintings were shown in the *Gülden Saal* of the palace, which was totally destroyed by fire in 1811. We know the identities of all the subjects from an inventory drawn up in 1718, which also mentions life-sized busts of the Landgrave's family displayed in niches in the window pillars. Over the door was incised in stone the inscription 'Effigies omnium Imperatorum, Regum etc. qui ab anno MDXXX usque ad annum MDXXXI Reipublicae Christianae ditionibus praefuerunt'. On the door was shown Jesus Christ, 'Rex Regum et Dominus Dominatium'. Opposite the entrance, the following words of exhortation were to be read: 'At super hos omnes hic cuius imago videtur – Rex Regum spatium, limite, fine caret.' The portraits were executed by the two court painters, Caspar van der Borcht and Jost vom Hoff, who were sent on travels to portray other European rulers or to copy originals in their possession. Paramount in importance to their employer was probably not the artistic quality of the portrait, however high that might have been, but rather the historical significance of the person depicted. His demands for authenticity

[7] The ethnological objects are preserved in Schloss Witzenhausen.

[8] Mackensen 1982.

[9] Drach 1888, p. 18.

[10] Rommel 1828–58, vol. 5, p. 738.

[11] Schwindratzheim 1937. See also Rave 1959.

and verisimilitude also favoured modelling in wax, which was well suited to portraiture. Hence we find a considerable number of wax reliefs and wax figures in Kassel, among them a portrait of the Landgrave which shows every detail of his physiognomy modelled with ruthless accuracy. As early as the fifteenth century, rulers and famous persons were modelled life-size in wax. A well-known example is in the church of Santissima Annunciata in Florence.[12] We shall see that this idea was alive in Kassel up to the second half of the eighteenth century.

The founding of a Venetian glass house in Kassel was an important – though short-lived – episode. Wilhelm obtained as collaborator in his enterprise the glass-maker Francesco Warisco, who previously had been working in Herrisvad in Sweden.[13] Not without some difficulty, he managed to attract other assistance from the Low Countries. Practical problems soon became apparent and personal conflicts developed between the Landgrave's own men and the Italians. Production of glass began on 22 June 1583, the Landgrave's birthday, and in August of the following year, at their own request, the workers were dismissed. Some testimonies of their skills were left in the Landgrave's *Kunstkammer*, among them the first glass produced on 22 June, a fine goblet with white threads inlaid *a ritorti*. The *Imperial Gläser* mentioned in a list may be identical with some of the *Flügelgläser (verres à serpent)*, also preserved in the *Kunstkammer*.

Wilhelm's son, Moritz the Learned, was likewise a versatile man. In his case the father's love of astronomy was replaced by a passionate interest in alchemy. He was a skilled musician and mastered many stringed instruments, as well as the organ and piano. He composed, spoke ten languages fluently, and brought English actors to Kassel to the first German theatre, named the Ottoneum after his prematurely deceased son. He even acted himself. An interesting parallel to the art collections of Ferdinand of Tyrol lies in the fact that Wilhelm had planned to house his collections in a new stable building, begun one year before he died in 1592 – a plan later carried out by Moritz, although with alterations.[14]

The building was finished in 1593 by Hans and Hieronymus Müller, and lay to the north of the Landgrave's palace. It was composed of four two-storeyed wings around a rectangular courtyard. Lupold von Wedel,[15] a travelling nobleman from Pomerania who visited Kassel in May 1606, compared it with a 'little palace'. In the upper storey of the fourth wing, which was also destined to house several other collections as well as a laboratory and an important library, he mentions 'eine Kunstkammer', but makes no comment on the objects shown in it. Perhaps they had not been transferred at that time from the palace to the new house. This possible explanation is suggested by the fact that in his description Wedel tells us how he came to the printing works and the mint after having visited the Landgrave's maze, but makes no mention of them being in the stable building which, as we learn from an inventory, housed these two workshops by 1612 at the latest. He refers to the *Kunstkammer* in the stable when arriving at the new building after having passed the *Baumgarten*. Unfortunately, it cannot be decided with certainty whether 'die Kunstkammer', to which he dedicates a rather summary description some pages earlier,

[12] Schlosser 1908, pp. 16–18, fig. 6.
[13] Drach 1893; Killing 1927, pp. 70–8; Dreier 1968, ch. III.
[14] Holtmeyer 1923, text 2, pp. 302–6.
[15] Bär 1895; Girgensohn 1912.

is identical with that in the stable building. Wedel mentions in the first of these passages that he was 'guided to the fortress, also into the Landgrave's *Kunst-Kammer*'. The fortifications, however, enclosed both the palace and the stable building. Of some relevance to this problem is a letter of 1605, in which the Landgrave orders that the 'alterations' be postponed to the following year. Other documents prove that the building was not yet completely furnished in 1608. We know that a large armoury had been established just after Moritz's accession to the throne in 1592, but other collections are mentioned for the first time in the inventory drawn up in 1612.[16] There were, of course, rooms in the old palace to house the collections before the objects were transferred to the stable building, but in no document is any reference made to a room designated *Kunstkammer*, unless one assumes that the Pomeranian traveller is reporting upon it in his description. It is, however, not clear from Wedel's report, whether there were one or two *Kunstkammern* in the year of his visit. After Moritz's time the old room in the palace must have been used for other purposes: Johann Just Winkelmann, the chronicler of Hesse and Hersfeld, in his fairly detailed description published in 1697, mentions only the *Kunstkammer* in the stable buildings.[17]

Very little information about the *Kunstkammer* is given by Lupold von Wedel. He saw 'many excellent things . . . which would take a long time to enumerate', but mentions only 'many unicorns' and refers to a 'gunbarrel made of wood, which shoots leaden bullets without powder' and to a 'sheepskin from India', which felt soft like silk. He was accompanied on his visit by Bernhard Paludanus (p. 125). Wedel mentions that Paludanus sent the Landgrave 'many strange things, which he got beyond the sea'. It may be of interest that in 1602 Paludanus also supplied the *Kunstkammer* of Duke Philipp Julius of Pomerania-Wolgast, cousin of Philipp II of Pomerania-Stettin, who ordered the *Kunstschrank* by Philipp Hainhofer in Augsburg.[18] We learn from the inventory of 1612 that the upper storey of the stable building housed the *Kunstkammer*, a *Schneiderei* for tailoring and dressmaking, a so-called *Inventionskammer*, in which all possible objects needed by Moritz for his theatrical activities and for masques and tournaments were kept, the printing works, and the old mint. There was also a *Kleiderkammer* with costumes from all over the world. The armoury contained an important collection of valuable weapons. Objects of art, natural history and curiosity were shown in the *Kunstkammer*. Winkelmann refers to some of them, and also mentions astronomical clocks, astrolabes and other scientific instruments, among them the famous planetarium made in 1560–1 by Wilhelm IV and his collaborators E. Baldewein, Hans Bucher and E. Diepel.[19] It is important to note that a number of ancient works of art were acquired in Moritz's time. There are references to 'vestal lamps' and in 1603 the Councillor of Württemberg, Johann Henne, acquired 'Roman antiquities' for Moritz in France.[20] Three years earlier a Persian embassy had presented Moritz with some paintings. He abdicated in 1627 in favour of his

[16] Mentioned in Holtmeyer 1923, p. 302 (without a bibliographical reference).

[17] Winkelmann 1697, p. 281.

[18] Bär 1895, p. 574; Bethe 1937, pp. 107–10; *Allgemeine Deutsche Biographie* vol. 26 (1888), pp. 37–43. See also Lessing and Brüning 1905.

[19] Winkelmann 1697, p. 281. See also Kirchvogel 1953, pp. 12–18; Zinner 1956, pp. 242–3, 267; Lloyd 1958, p. 46, pls. 52–7; Heuser 1961.

[20] Rommel 1828–58, vol. 6, p. 417.

son Wilhelm V. One year after his death in 1632, the library was transferred to the new building.

In view of their acute and critical understanding, and the high level of education of both Wilhelm and Moritz, we may assume that in their collections the scientific character was predominant and that the freakish nature of some contemporary collections was less emphasized. Even in Wilhelm's time Samuel von Quiccheberg in his *Theatrum Sapientiae* divided the contents of an art and curiosity cabinet into a system of three parts: the first is the art collection, in which are to be found not only paintings and sculpture, but also mechanical works and scientific instruments, glass, ceramics, and works of materials such as mother-of-pearl, amber, ivory, wood, and so on; then comes the natural history collection, and finally, the 'rarity cabinet' containing curiosities of all kinds. Wilhelm and Moritz certainly knew this publication, but there is no evidence in the documents of any systematic division being applied at Kassel, in the case of the rooms mentioned earlier.

Kassel was spared from the ravages of the Thirty Years War. The collections also increased in the reign of Moritz's successors Wilhelm V, known as the Constant (1627–37), Wilhelm VI (1637–63) and his consort Hedwig Sophie of Brandenburg, who was regent for her minor son Carl until 1677. Under his rule, which lasted until 1730, Kassel acquired a new face. Carl, who was as highly gifted as his predecessors and who favoured a liberal absolutism, enriched his residence, as was customary of his period, with a number of important buildings. Under his aegis the architect Guerniero created the series of cascades running down from the giant castle at the summit of the Habichtswald, which dominates the town of Kassel. The castle is surmounted by an obelisk bearing the 9 metre-high bronze copy of the Farnese Hercules, who greets the visitor from afar as the symbol of the town. In addition, Carl built the Orangery, linked with a generously planned Baroque garden, and the Menagerie. He brought French refugees to Kassel and created for them the upper new town. He founded a faience manufactory and by the moat of the old castle he established a gem-cutting workshop with German and Italian craftsmen, some of whom were recruited in Florence during his 'grand tour' in 1699. The most important artist there was undoubtedly the Swiss Christoph Labhardt the Elder, born in Steckborn in the canton of Turgau, who was called to Kassel in 1680 and founded a whole family of craftsmen there. Two years later Franz Gondelach, the man who was destined to lead German glass-engraving to its zenith, entered the Landgrave's service.[21]

Carl's personal passion was for the most princely of all crafts, the art of turning ivory. Sometimes he presented his works to friendly rulers possessed of the same passion as himself, and received presents in return; among these was a medallion with an allegorical representation, in which Tsar Peter the Great of Russia immortalized himself by his own hand. The Landgrave noted on the back that a colonel of the artillery named Henning had brought him this personal present from Peter. Carl himself turned at his lathe a medallion featuring Fortuna after a statuette by Leonhard Kern, transforming in this way a full figure in the round into a reduced high relief. Statuettes by Leonhard Kern who, to all appearances, did not work for the Hessian court but made a number of works for the Great Elector of Brandenburg, may have been brought to Kassel by Hedwig Sophie as

[21] Hallo 1983a (see also *Alteskunsthandwerk* vol. 1, no. 5 (1927), pp. 181–204); Dreier 1968, ch. v; 1970.

probably were some works of amber, among them a case with the figures of the elector and his first consort Louise Henriette of Orange, probably by Jacob Heise after a painting by Matthias Czwiczik.[22] During Carl's reign many ivories came into the collections, including works by Ignaz Elhafen, Magnus Berg, Jean Cavalier and other artists well known and appreciated in their time. In 1716 Jacob Dobberman arrived in Kassel and produced there a great number of reliefs and figures. He also chose amber as his material, as the great Christoph Labhardt had done on occasion.

The growing lack of space in the rooms of the stable led Carl to the decision to create a unique institution – the so-called *Kunsthaus* (fig. 40). It was, however, no new construction which took its form from the function it was intended to fulfil, but originated in the adaption of an already existing building, the Ottoneum, the theatre building already mentioned in connection with Moritz. Considerable alterations were carried out by Paul du Ry.[23] Inside the building it is apparent that his intention was to combine the art and curiosity cabinets, the material being divided according to subject matter, with each group being as far as possible provided with its own room.

The organization in Carl's *Kunsthaus* has sadly not been recorded in any illustration, but its major divisions are made clear by contemporary reports of scholars and travellers. In 1709, the year of its inauguration, Zacharias Conrad von Uffenbach visited the *Kunsthaus*. He praised among other objects of interest the collection of astronomical and physical instruments.[24] Michael Valentini in his *Museum Museorum*, published from 1704 to 1714, also favoured the objects of natural history and science rather than the works of art.[25] Friedrich Christoph Schminke in his book *Attempt at an exact and thorough description of the princely Hessian residence and capital Kassel*, published in 1767,[26] gives us the clearest and most detailed description. He mentions the *Stein- oder Sculpturzimmer* (stone or sculpture room). Then follows the *Mineralienzimmer* (mineral room) with specimens of ores, fossils and so on. Stairs led up to the *Medaillenzimmer* (medal room). A special room was reserved for *geschnittene Steine* (gems and cameos), and also ancient jewellery, silver work, ivory and amber. A further room contained *Altertümer und andere Sachen* – Greek and Roman antiquities as well as prehistoric pottery and weapons, the result of an excavation carried out on Carl's initiative on the so-called Maderheide, a heath near Kassel. In another room was exhibited Chinese porcelain. The *Uhrkammer* housed the clock collection, and two *Physicalische Zimmern* – an *Optisches Zimmer* and the *Mathematisches Zimmer* – contained physical, optical and mathematical instruments and apparatus. In the second storey was a room full of stuffed animals, costumes (among them Chinese, Laplandish and Turkish specimens), glasses, weapons and musical instruments. Nearby in the *Mechanisches Zimmer* were exhibited mechanical, hydraulic and hydrostatic models.

The *Kunsthaus* contained more than a hundred paintings. On the top floor was the *Anatomiekammer*, with surgical instruments, preparations of different kinds, Indian and Egyptian mummies, human and animal abnormalities. There also was the *Auditorium Carolinum*, with a case in which skeletons and further preparations were preserved. On the

22 Dreier 1964; Rohde 1937, pp. 42–3, fig. 20.
23 Holtmeyer 1923, text 2, pp. 534–42.
24 Uffenbach 1753–4, vol. 1, pp. 1–72.
25 Valentini 1704–14, appendix v, pp. 14–16.
26 Schminke 1767, pp. 135–94.

upper floor of the *Kunsthaus* Carl had his turning workshop, the *Drehkammer*, where he passed his leisure hours. On the roof was a platform with the observatory. Since 1711 the models of important buildings and technical works were shown in a second building, the *Modellhaus*, among them a model of the waterworks supplying the cascades and fountain of the Carlsberg.

The *Kunsthaus* of the Landgrave Carl was, undoubtedly, a gigantic *Kunstkammer*. The idea of the art and curiosity cabinet still lived on in this building. By whom was it visited? In Kassel Moritz the Learned had already opened his library to the students of his foundation, the Collegium Mauritianum, a preparatory school of the type of the *Gymnasium illustre*. Carl affiliated the *Kunsthaus* as a display and teaching-collection to his foundation, the Collegium Carolinum. It is clear from the travel reports of the time that any interested person furnished with a recommendation could obtain entry without difficulty. Scholars, princes, noblemen and the educated upper middle classes formed a privileged group of museum visitors, representing the public at large.[27]

The idea of unrestricted entry was fulfilled to a rather higher degree by the Museum Fridericianum (fig. 41). It was open daily from 9 to 10 a.m. and from 2 to 3 p.m. By order of the Oberhof-marschall Veltheim dated 29 June 1795, however, the times of opening were restricted to a certain extent to give the inspector (named Doering) the opportunity to work on the collections on specific days without being disturbed. The sculptures, models of cork, mosaics, scientific instruments, wax figures, weapons and *Kunstsachen* were furthermore accessible daily, whilst the jewellery, gems, cameos, coins and other antiquities, as well as the clocks and the library, henceforth were shown only on Mondays, Thursdays, and Saturdays. We learn from a document dated 1789 that the room in which the clocks were exhibited could be visited only in smaller groups guided by the inspector Doering.

The Museum Fridericianum was the first museum of the eighteenth century to be housed in a building destined from the beginning to hold the collections, since the Count Algarotti's plan for a museum in Dresden, designed in 1742, had not been realized.[28] Two considerations moved Friedrich II, Landgrave of Hesse, son of Wilhelm VIII, who founded the gallery of paintings, to build up his new museum. The first was the growth of the library, for which Wilhelm IV had prepared the ground, and the second was the increasing shortage of space in his grandfather's *Kunsthaus*. Simon Louis du Ry, son of Paul du Ry, who had been responsible for the alterations to the *Kunsthaus*, was entrusted with the erection of the building. In 1769 the foundation stone was laid, but it was ten years before the building was completed since the sloping terrain necessitated a considerable amount of levelling. In 1779 the books and the collections were finally moved in.

The plan for a museum building was part of a radical extension of the town begun

[27] The story of a farmer who met the Landgrave working at his lathe in the *Kunsthaus* has been handed down to posterity. Carl is said to have taken an order from him to turn a new handle for his walking-stick. On finishing the handle, the prince received an albus. Even this anecdote seems to me to demonstrate that the peasantry did not form a frequent group of visitors (cf. Rommel 1828–58, vol. 10. p. 2).

[28] Seling 1967. For the Museum Fridericianum, see Holtmeyer 1923, text 2, pp. 546–60; Seling 1950, pp. 175–89; Gerland 1895, pp. 71, 112. For travel reports, see Günderode 1781, pp. 108–28; Hassencamp 1783, pp. 52–5; Casparson 1785.

under Friedrich after the dismantling of the old fortifications. The new building replaced a bastion, and it is interesting to note that an old medieval tower, the Zwehrenturm, was deliberately allowed to stand and was connected to the new museum by a narrow passage – an early instance of 'gothic revival' in Germany. Externally, the Museum Fridericianum was by German standards an early example of the Palladian style. The regular series of Ionic pilasters and the continuous cornice are broken only in the centre of the façade by a monumental columned portico. Six columns at the top of a flight of steps bear the projecting entablature and a shallow pediment. The façade is terminated vertically by a balustrade with vases over the pilaster axes. Behind the pediment the balustrade is broken up by a plain blind wall on which have been set allegorical figures. The ground-plan still shows the traditional system of three wings, known from the architecture of Baroque palaces. The building has two storeys: on the ground floor with its square entrance hall were exhibited the museum collections, while the upper storey housed the library. It is unnecessary to describe in detail the succession of rooms in the Museum Fridericianum as we did for the *Kunsthaus*, for the collections were the same and the principle guiding their arrangement corresponded closely with that of the *Kunsthaus*. It differed in the absence of paintings, however, which from 1751 onwards were shown in the gallery planned by François Cuvilliès for Wilhelm VII. A new accent is given by Friedrich's collection of antiquities. It was, however, assembled too late to influence the form of the museum.

Friedrich's museum was built in a period of transition. The pediment still bears the name of the founder in golden letters in accordance with a custom dating from the late sixteenth century. Inside the building, however, with the exception of a marble bust in the library, there were no further allusions to the prince. Friedrich set aside only a study in which he held meetings with the learned members of the *Société des Antiques*. In it he appeared as an equal among equals. Nevertheless, the same prince, who was an enthusiastic supporter of antiquity and who paid homage to the ideas of enlightenment, formed, together with his sculptor Johann Wilhelm Kirchner, a collection of life-sized wax figures of all landgraves and landgravines, including himself, dressed in original costumes and wigs – a last concession to the departing era of art and curiosity cabinets.[29]

29 Günderode 1781, pp. 118f.

THE BRANDENBURG *KUNSTKAMMER* IN BERLIN[1]

Christian Theuerkauff

It was the Elector Joachim II of Brandenburg (reigned 1535–71) who is first reported to have had curiosities specially created or purchased for him abroad.[2] His successors, especially the Elector Joachim Friedrich (reigned 1598–1608) enlarged the collections of the 'Churfürstliche Kunstkammer' as it is called in the earliest preserved inventory of 1603 (an earlier one of 1599, perhaps the first, had disappeared by 1930). These collections were kept in the Schloss at Berlin (at that time still known as 'Cölln an der Spree') in what was described as the 'Kunstkammer im Gewölbe', in the charge of a *Kammermeister* who also supervised the Wardrobe. A *Kammermeister* Johann Fritz helped the Elector Johann Sigismund on 1 April 1607 to select presents here for his wife, a custom which lasted into the eighteenth century. Besides the *Kunstkammer*, other rooms in the Schloss housed the Cathedral Treasury, the Armoury and, since 1465, the silver plate, although services for practical use were also to be found in the *Kunstkammer*.

The Elector Georg Wilhelm (reigned 1619–40), anxious that no harm should come to the *Kunstkammer* collections during the Thirty Years War, had a new inventory made in 1626 and the collections removed to Küstrin, but they appear to have been lost or destroyed during the War;[3] among the very few objects dating from before 1610 is a gem of Jupiter Serapis in the Berlin Antikenmuseum.

Friedrich Wilhelm of Brandenburg (reigned 1640–88) hence had to make a new start;[4] fired by an enthusiasm for classical antiquity, he was also keenly interested in his library and he used his friendly relations with the Netherlands for help in establishing and continually increasing the art collections in his 'antiquitättsstube', the *Kunstkammer*. He had witnessed the excavations of Roman artefacts during his temporary residence at Cleves on the Rhine. In 1642 he bought his first complete collection, that of Erasmus Seidel, and in 1649 ordered a first inventory of his coin collection, then numbering more than 4,900 items, with an appendix listing his gems, bronze figures and vessels, ceramics and glass. In 1663 the 'Antiquarius' Christian Heinrich von Heimbach was put in charge of the 'Antiken-, Kunst- und Naturalienkammer'. His first inventory of 1672 includes the first antiquities to have reached Berlin, the sculptures from the collection of Gerard and Jan Reynst, bought in Amsterdam but partly of Venetian origin.

From 1671 onward, there is documentation of purchases of *naturalia*, oriental weapons and art objects such as porcelain, Indian manuscripts and so on, mostly from the Dutch

[1] This chapter adapted by Gertrud Seidmann from Theuerkauff 1981.
[2] Nicolai 1769, 1786.
[3] Ledebur 1831.
[4] Nicolai 1769.

East India Company. On 8 October 1674 the Elector even took the trouble to write from camp at Bleissheim to acknowledge the receipt of rare seaplants and 'indianisch' arms from Batavia and to ask for more. In 1680 Brandenburg ships under Admiral Raule brought back rarities from an African expedition.

Patin's *Relations historiques et curieuses de voyages en Allemagne* (1676) mentions the 'Cabinet des médailles' in the Library as well worth a visit: it was not until 1680 that the coins and medals were relocated in the *Kunstkammer*, where they were joined by antiquities collected by the Xanten pastor Hermann Ewich, whose remarkable collection of manuscripts, now in the Staatsbibliothek Preussischer Kulturbesitz, bears testimony to Friedrich Wilhelm's collector's zeal to this day.

His interests were not limited to classical antiquity; he also collected Renaissance works of art, such as drawings by Dürer, C. Meit's bust of Philibert of Savoy, Netherlandish paintings and – of great importance for the *Kunstkammer* proper – contemporary sculpture. The many ivories by Leonhard Kern which had probably reached Berlin long before 1688 were joined by numerous works by many artists including Christian Gottfried Leygebe, who was salaried and lodged as a court artist from 1668.

On 25 April 1685 Christian Albrecht Kunckel succeeded von Heimbach as 'Overseer of Our Cabinet of Arts and Rarities': in his charge were 'all the antiquities, rarities, *Indianisch* objects, gold, silver and copper Roman and Greek coins and medals, watches' and other objects, such as *naturalia*, mathematical instruments and models; he was to make inventories and keep proper order and see to it that nothing was stolen, broken or neglected. He received 200 thalers a year, and it was his duty to keep proper registers of new acquisitions and their locations so that they could be easily found. Similar orders were issued to the Swiss Christoph Ungelter who succeeded him on 29 June 1688, shortly after the accession of the Elector Friedrich III of Brandenburg (reigned 1688–1713), the greatest patron of the arts and sciences of his House, during whose reign all the collections, including the *Kunst-* and *Naturalienkammer*, greatly increased in size and importance. The document which ratified Christoph Ungelter's appointment shows that the collection, named alternatively *Raritätenkammer* and *Kunstkammer*, contained a great diversity of objects. According to Ledebur (1831) there existed a 'specification' of the rarities handed over by Kunckel to Ungelter which apparently listed 320 items under the following headings: (1) turnery; (2) *naturalia*; (3) statues; (4) objects of vertue and rarities; (5) architectural plans and paintings (6) Oriental weapons; (7) minerals; (8) mechanical models.

However, it was Lorenz Beger (1653–1705) of Heidelberg, formerly Antiquary and Librarian at the Court of the Electors Palatine and author of the *Thesaurus ex thesauro Palatino selectus* (1685) (in which he had published the Heidelberg gems and coins), who was to play the most important role for Friedrich III's collections. From his appointment as 'Counsellor and Librarian to the Elector' in 1686 to his early death in 1705, he was primarily concerned with the antiquities, but also with the *Kunstkammer*. It was he who had in 1686 personally brought to Cleves the coins, medals and antiquities numbering more than 12,000 which came to Brandenburg by inheritance.

Nominally serving under Christoph Ungelter, Beger was evidently put in charge of the

'Antiquitäten-Cammer' in the spring of 1688 by Friedrich III's special wish; the journal of the collection was begun on 12 May, only three days after the Great Elector's death, with entries for new acquisitions. It was not until after Ungelter's death, in July 1693, that Beger was placed officially in charge of almost all the collections, the Cabinet of Coins and Antiquities, the Library and the *Kunst- und Raritätenkammer*, with the title of 'Serenissimi Electoris Brandenburgici consiliarius ab Antiquitatibus et Bibliotheca', assisted in the *Kunst- und Naturalienkammer* by Johann Casimir Philippi (died 1735).

Lorenz Beger was bent on increasing the collections of the *Kunstkammer* and particularly the classical antiquities, which included Egyptian antiquities and finds from excavations in Germany, and to arrange them in orderly fashion. Friedrich III's minister Eberhard von Danckelmann had issued a decree as early as 1 March 1689, demanding concentration of the collections in one place, and mentioning that 'divers rarities and *naturalia*' collected by Friedrich's father had never been put in their proper places but were dispersed in various locations, including the houses of private individuals. Such objects, their categories listed in detail, were without fail to be handed over to Christoph Ungelter together with lists, and non-compliance was threatened with punishment. Meanwhile the *Kunstkammer* collections grew apace, through purchases, inheritance and presentations. In 1689 François Duquesnoy's 'Cupid carving a bow' and a silver automaton in the form of Diana, the latter a present from the principality of Minden, had joined the collection; the *Pommersche Kunstschrank*, inherited in 1684, was there by the end of the 1680s, and part of the *Naturalienkammer* of the late Christian Lorentzen von Adlersheim of Leipzig by 1687.

In 1692 mathematical, optical and physical instruments were bought from the heirs of the Halle professor Johann Jacob Spener; a number of rarities and *naturalia* from the collection of the late Dr Elsholtz, including 'six pieces of worked amber enclosing diverse animals as though grown there naturally', crystals, a microscope, ostrich eggs, 'Indian salt in a glass' and 'an ancient seal of metal with the Hohenzollern coat of arms on it' reached the collections before 1693. But there were losses, too: thus, by a decree of 3 December 1689 the architectural plans were handed over to Johann Arnold Nering, supervisory engineer and all the sea-shells and snails – approximately 6,000 of them – which were not part of the rarities or in the cabinets, to the Italian Francesco Baratta who was in charge of the garden grottoes. Furthermore, all the firearms were transferred to the Armoury.

After J. C. Philippi's appointment in 1693, Beger evidently wished to concentrate on his scholarly writings and on the antiquities. This is clear from his letter to von Danckelmann of 30 August 1693, that is to say written before his official appointment as 'Erster Kunst-Kämmerer', in which he indicates that he wishes Philippi to look after the administration of the *Kunstkammer*, the keeping of catalogues, and all practical matters, while he himself asks to be put in charge of increasing the collections, improving their order, researching the nature and origin of the objects, and keeping a general overview over their preservation and proper cataloguing.

A set of cutlery bent out of true – a souvenir of a hunting accident suffered by Friedrich III near Potsdam – came to the *Kunstkammer* as a 'historical curiosity' on 21 December

1695, where it joined Christoph Jamnitzer's silver elephant, obtained the previous year, and a bowl depicting the battle of Zama (now lost, published by Beger in 1704).[5] Duplicates from the collection of *naturalia* had to be passed over to August Hermann Francke's orphanage at Halle, for the teaching of natural science.

Meanwhile the court artists Elias Terwesten and Theodor Guericke had been endeavouring since 1694 to obtain plaster casts of antique statuary in Rome; these were placed in the Berlin Academy of Arts, founded in 1696, the third in Europe after Rome and Paris. Elias Terwesten had also acted as middleman in the purchase (suggested by Beger) of the vast collection of antiquities belonging to the Roman archaeologist Giovanni Pietro Bellori (died 1696); anxiously awaited, the collection of more than 232 objects finally arrived in Berlin on 4 May 1698.[6] But Beger's *magnum opus*, which enjoyed the special patronage of Spanheim and Danckelmann, was the *Thesaurus Brandenburgicus* in three volumes,[7] the last of which included objects from the Bellori Collection, previously published separately by Beger in 1698. Significantly Beger – surely with Friedrich III's approval – sent the first two volumes to Louis XIV who rewarded him with the gift of a valuable gold chain and medal, sent through E. Spanheim, Ambassador in Paris 1689–1701. As far as the collections are concerned, Beger's publication signals the definitive separation of the Cabinet of Antiquities and Medals from the *Kunst- und Naturalienkammer*, while at the same time he repeatedly expresses the hope that these will be made more accessible to the public.

The Cabinet of Antiquities and Medals, a part of Friedrich's collection particularly furthered by the enthusiasm of Ezechiel Spanheim and Samuel Pufendorf, contained ancient and modern coins, engraved gems and medals; among them, according to F. E. Brückmann,[8] was the series of the 'Histoire Métallique' of Louis XIV, who was admired by the ruler of Brandenburg-Prussia despite his political allegiance to the Emperor. It is significant for the relations between Berlin and Paris, and their common interest in antiquities, that Spanheim followed the French example in instituting conferences on the lives and coinages of the Roman emperors in Berlin. Friedrich III and I's own medallist Raimund Faltz, who had learned his craft in Paris, in 1703 bequeathed his collection of medals, impressions, wax models and plasters – only partly his own work, and valued at 20,000 thalers – to Friedrich I. As late as 1795, when J. Henry took over the direction of the Cabinet of Medals, this legacy was housed in a separate cabinet with its own inventory.

It is not known whether delicately worked ivory medallions by Faltz, such as those of Sophie Charlotte or the itinerant French artist Jean Cavalier, were kept in the Coin Cabinet or in the *Kunstkammer* proper. There were a great number of portraits in enamel, portrait-miniatures on diamond-encrusted boxes, and others in amber, wax, bronze or ivory – further proof of the importance of the *Kunstkammer* as a repository of works of art and rarities relating to the ruling family. Even a small cane handle of ivory carved by the court sculptor Johann Michael Döbel (Däbeler), with the insignia of the Elector and the British Order of the Garter, is mentioned in every description of the *Kunstkammer* right

[5] Kugler 1838, p. 162.
[6] Heres 1977.

[7] Beger 1696–1701. See also Budde 1981; Gröschel 1981.
[8] Brückmann 1747.

down to Küster's in 1756 and Kugler's in 1838.[9] Such objects as the group of Venus and Amor – a New Year's present from Prince Friedrich Wilhelm to his father – the glass from which the Emperor Peter I of Russia and King Friedrich I of Prussia had drunk to their friendship, or the Emperor Rudolf's Cup of the Universe – a present from the Jews of Halberstadt – which joined the *Kunstkammer* as 'souvenirs' in 1703, 1697 and 1703 respectively, as well as the numerous ivory statuettes of Hercules, perhaps show a conscious harking back to antique prototypes present in Berlin or known from books; they also reflect Friedrich III and I's pretensions at rivalry with the Sun King, testifying to his claims to power. It is interesting to note in this context the presents given for New Year 1701 by Field Marshal Alexander Hermann, Count of Wartensleben (a nautilus cup), and General von Thüngen in 1705 (the Marburg University Cup).

From 1702, Beger's son-in-law Johann Carl Schott, later *Hofrat* and Antiquary (died 1717), who had provided drawings for the *Thesaurus*, acted as his assistant and from 1703 inventoried new accessions to the Cabinet of Antiquities. After Beger's death on 20 February 1705, Schott succeeded him as director of the Cabinet of Antiquities, Coins and Medals, now quite separate from the *Kunst- und Naturalienkammer* which continued to be direct by Philippi. By royal decree of 3 August 1703, the *Kunstkammer* was transferred to the 'new building and the rooms appointed for it', namely the Berlin Schloss which had been under construction since 1698 under the direction of Andreas Schlüter, though its exact location is a problem not yet entirely solved.[10]

[9] Küster 1756; Kugler 1838.

[10] In addition to the sources cited above, the following are of importance for the history of the Brandenburg *Kunstkammer*: Henry 1805; Heres 1980; König 1793–8; Ledebur 1833, 1844, 1871, 1875.

EARLY DUTCH CABINETS OF CURIOSITIES

Th.H. Lunsingh Scheurleer

The concept of the universe as visualized in the late sixteenth century was most imaginatively depicted in an engraving by the Dutch artist Crispin de Passe the Elder. The concept as such goes back to the now forgotten scholar Theodorus Graminaeus (fig. 46). This engraving was analysed in great detail by Dr Ilja Veldman and in what follows I have leaned heavily on her interpretation.[1] The engraving formed the title-page of a series representing the seven planets and entitled *Catena aurea Platonis*, 'Plato's Golden Chain'. We are confronted with a heavy chain forming an oval with man at the centre and with radial connections to the elements, flora and fauna. The planets appear in the upper zone on banners held by archangels with the Creator at the top. In the middle, at a short distance from man, appears the moon. Below the symbolic depiction of flora and fauna a poetically conceived representation of stones and metals has been prominently suspended, in the form of a medallion. The underlying principles of this concept go back to Plato's *Timaeus*.

The point, then, of introducing my contribution with this particular engraving is precisely the prominence given to the individual details and their connections with the other component parts. Indeed, this illustration may well be considered a key to the origin of many collections and cabinets of curiosities as they came into being in the Low Countries in this period.[2]

In a country 'lacking a head', as Queen Elizabeth put it – that is to say without a monarch – the urge felt by the educated to surround themselves with tangible objects mirroring the cosmology of the time necessarily found expression among the well-to-do burghers and the odd country squire. Needless to say, these could not afford to collect on a large scale and therefore limited themselves to narrower areas of interest. Thus, from an early date, the collecting of shells became very popular. As an illustration of this interest, a long and somewhat boring poem by Philibert van Borsselen, 'Strande', published in 1611, may be cited.[3] The poet presents the reader with an enumeration of what can be observed on the sandy beaches of his native country, focusing his attention on the great number of shells. These are compared to marble and agate, and their purple and azure are said to be almost inimitable even by the best of artists. The poet quotes classical authors in his copious footnotes, though the spirit of the whole is clearly marked by a profoundly religious attitude. The poem, in other words, was written in praise of the Creator of the universe. It was dedicated to van Borsselen's brother-in-law, Cornelis van Bleyenburgh,

[1] Veldman 1983, p. 21.
[2] For Dutch zoological collections in general, see Engel 1939.
[3] Muller 1937, p. 13.

the owner of a country mansion at Rijswijk. This gentleman owned a collection of shells which evidently fulfilled an important function in his life, since he is known to have regularly spent hours in a closet in one of his turrets, lost in a contemplation inspired equally by elevating reading matter and the wonders of his collection.[4] In this way collecting natural objects became almost an act of piety.

Van Borsselen's poem was dedicated not only to this curious collector but to all his fellow 'shellists'. Another such collector was a certain Jan Govertsen of Haarlem, a character of whom no less then eight portraits are extant.[5] One of these, painted by Hendrick Goltzius, represents him at the age of fifty-eight with a number of shells before him. Dr Reznicek has suggested that the picture is reminiscent of Dürer's portrait of Pirckheimer, of whose costume the viewer is reminded by Goltzius. The sitter cannot be denied a measure of arrogance, to put it mildly. Very little is known about this worthy, but what can hardly be doubted is that he must have played a role in the world of the arts at Haarlem, for he occurs again (together with his shells) in a picture – seemingly of 1607 by Cornelis van Haarlem and presently at Knole – which represents an allegory of the arts and sciences. Govertsen died *c.* 1618; what happened to his collection is as mysterious as is the fate of those of van Bleyenburgh and many other 'shellists'.

But Netherlanders did not merely collect shells; they were also collectors of coins and medals. For their sake Hubert Goltz of Venlo produced a series of monumental tomes with monochrome woodcuts in various editions, each in a different language. In 1574, for instance, there appeared his volume on Augustan coinage with a skilfully engraved title-page justifying the publication on somewhat curious grounds: the Emperor's age was to be seen not only as the golden age of antiquity, but at the same time as the age marked by the life and death of our Saviour.[6] In another no less impressive tome he reviewed the coins and medals of all the other Roman emperors and their medieval and Renaissance successors, practically up to the moment of publication.[7] In this case, his motivation was slightly different: the portrait of each ruler was provided with an edifying maxim, though any connection between it and the sitter was purely coincidental. In this way the Emperor Marcus Aurelius is given the caption: 'It is better that I govern myself according to the advice of various great persons than that these govern themselves according to mine.'[8] This spirit is characteristic of the entire enterprise.

Another variation on the theme is represented by the collection of Abraham Gorlaeus, Councillor of the Count of Nieuwenaar and Meurs in the province of Utrecht. After 1595 he lived at Delft in comfortable retirement. He owned a collection of rings set with precious stones which he published in his *Dactyliotheca*.[9] It was subsequently acquired by Prince Henry Stuart and in this way passed into the British Royal Collection. In the introduction to the *Dactyliotheca* he informs the reader that even at an early age he devoted much time to acquiring a knowledge of history and antiquity, without which (he added) our life would be mere darkness, more so even than that of the Cimmerians on whom the

[4] Ibid., p. 63, lines 1830–3.
[5] Reznicek 1983, p. 209.
[6] Goltz 1574.
[7] Goltz 1557.

[8] I have been unable to trace this maxim (which appears in Goltz 1557, pl. xviii) in the *Meditations* of Marcus Aurelius (Staniforth 1982).
[9] Gorlaeus 1601. For his other numismatic works, see *Nieuw Niederlandsch Biografisch Woordenboek* 5 (Leiden, 1921), cols. 208–9.

sun never looks, as Homer put it. The *Dactyliotheca* boasted a portrait of the author, one of the rare likenesses of early seventeenth-century collectors.

One of the most important collections of the period was undoubtedly that of the brothers Jan and Gerard Reynst recently described in a monograph by Anne-Marie Logan.[10] The collection was made up not only of *naturalia* but also of antique sculptures, vases and Egyptian objects. It contained furthermore an important group of Italian pictures. Several items were bought by the States of Holland in 1660 in order to be included in the so-called 'Dutch Gift' to Charles II at the Restoration, still largely extant in the Royal Collection. The moving force behind the Reynst collection was Jan Reynst, domiciled in Venice where he belonged to the international coterie of great merchants. His elder brother lived in Amsterdam where he in turn contributed to the growth of their collection. Jan's first purchases consisted of the Andrea Vendramin collection of both *artefacta* and *naturalia*. After Jan's death in 1646 the two parts of the collection were united in the Amsterdam town-house of Gerard, where the latter ordered engravings to be made of both the pictures and the antique sculptures. After his death a selection of these was published in two large volumes by his heirs. It is worth noting that as much attention was lavished on the antique sculptures as on the pictures. For in the period concerned the components of such a collection served not only the purpose of providing excellent models for artists, but also gave food for thought to those interested in the message of classical history. In fact, as such they were often valued much more highly than any number of manuscript texts, which were on the whole available only in mutilated form.[11] Viewed from this angle, the title-page of the book on antique sculptures by Gerard Lairesse[12] (fig. 47) acquires a special significance: it shows Father Time about to destroy antique sculptures, but being prevented by Prudence. Prudence, according to Ripa, has the gift to judge the Past, bring order into the Present, and foresee the Future – a singularly suitable emblem for any collector of antiques. It should not be overlooked, of course, that the owners of a collection of this size would have been very well aware of its value as an investment. It would have tallied with their social status and been recognized as suitable for the genuine *mercator sapiens*.

In the seventeenth century, with its ever closer ties between the eastern and western worlds, the exotic element achieved a more and more prominent place in Dutch collections. The objects concerned hailed mostly from Asia and South America; those from Asia consisted primarily of Chinese and Japanese porcelain and lacquerwork, those from South America of various articles of dress made of multi-coloured feathers. The dwellings of the Stadtholder Frederick Henry and his spouse Amalia van Solms reflect this development to a considerable extent. They possessed extensive collections of curiously wrought items of rock-crystal, carnelian, and jasper mounted in gold, and of amber, ivory and mother-of-pearl. The collection was clearly conceived as a *Schatzkammer*, but its *exotica* certainly exceeded in number and variety what was usually found in other European countries. In the United Provinces large collections of Chinese porcelain distinguished the various dwellings of the Princes of Orange in 'De Oude Hof' at The

[10] Logan 1979.
[11] Haskell and Penny 1981, p. 45.
[12] Logan 1979, pp. 46–7, pl. 9.

Hague. The Chinese material was, as we learn from an inventory of 1632,[13] set out in tiers on shelves fixed to the walls, together with items from Avon near Fontainebleau. This was the customary arrangement, and was also to be seen in Rembrandt's house in Amsterdam.[14] Japanese lacquerwork, particularly after the Dutch had been granted the only European trading-post in the Empire of the Rising Sun, likewise enjoyed a considerable vogue. Accordingly balusters of black and gold lacquer decorated with mother-of-pearl, intended to separate the bed from the rest of the princely bedchamber, were specially ordered in Japan and eventually placed in 'Het Huis ten Bosch' near The Hague.[15]

Dr Schepelern has left us a fascinating record of the rich and varied collection of the physician Paludanus at Enkhuizen in the early seventeenth century.[16] It too contained Americana, such as feathers and native clubs. In fact, the collecting of objects from South America received an entirely new impulse after the appointment of Johan Maurits of Nassau as Governor-General of Brazil by the Dutch West-India Company in 1636. Painters such as Frans Post, who depicted the Brazilian landscape, and Albert Eckhout, who painted representations of native tribes, were in his suite; so were Willem Piso, the physician, and the biologist and astronomer Georg Markgraf.[17] Johan Maurits gathered an important collection of *naturalia* which was placed in a museum in Mauritsstad, probably one of the oldest 'treasure houses' of the southern hemisphere.[18] In 1644 its contents were removed to the recently completed 'Mauritshuis' at The Hague, where many items changed hands. The not inconsiderable remainder was described shortly after the death of its owner by Jacob de Hennin.[19] Much attention was paid to the frescoes on the central staircase, showing 'lifelike all the heathen and barbaric nations, male and female, moors, negroes, Brazilians, wild Papouyas, Hottentots and other savage nations, who are all God's creatures.' The writer also mentions beautiful scimitars, assegais, firearms, drums and trumpets, in addition to valuable lacquerwork and beautifully woven baskets from Africa and the fine American head-dresses, shields and fans, made of many-coloured feathers. He also mentions many animals, such as small tortoises, a crocodile, a stuffed rhinoceros, a small elephant, an ostrich, a cockatoo, parrots and a bird of paradise, as well as a tarantula which showed all manner of colours in the sun, peacocks and geese. The collection also contained shells, gold and gold dust, and silver ore, as well as lead, mercury, copper, iron and a collection of precious stones. What is particularly characteristic, though, is that the entire enumeration forms an integral part of a chapter on 'Sight', in which the transitoriness of all earthly things is emphasized and which culminates in a description of a picture of the Last Judgement.

As Caspar Barlaeus tells us, Johan Maurits was very much aware of the fragility of all the 'natural curiosities' which he had collected. In order to preserve their memory,

[13] Drossaers and Lunsingh Scheurleer 1972, pp. xxiv, 204, 300–17.

[14] Scheller 1969, p. 127, fig. 26. The classic example of this way of exhibiting smaller objects was, of course, the *Tribuna* at Florence: see Heikamp 1963; Haskell and Penny 1981, p. 54.

[15] Lunsingh Scheurleer 1969, pp. 48–9. For a cabinet panelled with Japanese lacquer and mother-of-pearl, see pp. 55–6.

[16] Schepelern 1981. See also pp. 125–6, below.

[17] Lunsingh Scheurleer 1979, pp. 144–5, 182–3. See also contributions in the same volume by H. Honour, J. D. North and P. J. P. Whitehead.

[18] Lunsingh Scheurleer 1979, p. 182 and n. 49. Caspar Barlaeus speaks of it as a 'cimeliarchium', literally 'treasury'. Mauritsstad was founded by Johan Maurits of Nassau in Brazil and now forms part of the town of Recife.

[19] Hennin 1681, pp. 110 ff.

therefore, he had them painted by Albert Eckhout and a number of other artists.[20] The results of his astuteness as a collector can be gauged from a picture of *c.*1650 ascribed to Jacob van Campen in the Central Hall of the Huis ten Bosch, commissioned in homage to the Stadtholder Frederick Henry (fig. 48). At the top the picture is dominated by a Japanese helmet and armour, to the left and right of which two American feather-shields are depicted flanking a parrot and a Japanese shield with crossed spears. In the middle of the picture is a Chinese vase and a woman carrying fruit in two African baskets, and at the bottom we are offered other women of whom one is wearing a feather cloak.[21] In this way the treasures of East and West are shown as paying their respects to the late lamented Stadtholder.

In Amsterdam at the end of the seventeenth century, one of the most impressive anatomical collections was that gathered by Frederick Ruysch. Ruysch was born in The Hague in 1638. Originally apprenticed to an apothecary, he subsequently read medicine and took his degree in 1664. He had been deeply impressed by the new injection technique which his teachers described in the *Bibliotheca Anatomica* of Mangetus. The introduction of elixir of vitriol into the vascular system caused the blood to coagulate in the vessels. This was the starting-point for Ruysch's remarkable achievement, a collection needing for its display no fewer than five rooms of his private house in Amsterdam, where he had been appointed Professor of Anatomy in 1685. This collection of human and anatomical material alone filled ten cabinets. A special item consisted of two intricate groups of anatomical preparations of human organs flanked and crowned by the skeletons of little children and meant to represent allegories of death. Of these three-dimensional *vanitas mundi* emblems, Ruysch ordered engravings to be made which were also included in his *Opera Omnia*. It was Dr Antonie Luyendijk-Elshout, Professor of the History of Medicine in the University of Leiden, who succeeded in fully analysing these compositions on the strength of Ruysch's own texts.[22] From this analysis may be quoted the description of one group (fig. 49), as engraved by C. Huyberts, which reads as follows:

With eye sockets turned heavenward the central skeleton – a foetus of about four months – chants a lament on the misery of life. 'Ah Fate, ah bitter Fate!' it sings, accompanying itself on a violin, made of an osteomyelitic sequester with a dried artery for a bow. At its right, a tiny skeleton conducts the music with a baton, set with minute kidney stones. In the right foreground a stiff little skeleton girdles its hips with injected sheep intestines, its right hand grasping a spear made of the hardened vas deferens of an adult man, grimly conveying the message that its first hour was also its last. On the left, behind a handsome vase made of the inflated tunica albuginea of the testis, poses an elegant little skeleton with a feather on its skull and a stone coughed up from the lungs hanging from its hand. In all likelihood the feather is intended to draw attention to the ossification of the cranium. For the little horizontal skeleton in the foreground with the familiar mayfly on its delicate hand, Ruysch chose a quotation from the Roman poet Plautus, one of the favorite authors of this period, to the effect that its lifespan had been as brief as that of young grass felled by the scythe so soon after sprouting.

[20] Lunsingh Scheurleer 1979, p. 173.
[21] Brenninkmeyer-de Rooij 1982, p. 156, fig. 38. For the Chinese vase, see Lunsingh Scheurleer 1981–2.

[22] Luyendijk-Elshout 1970, p. 121.

Together with many of his other preparations, each of which carried a moralizing message, these almost artistically inspired compositions represent a late and bizarre culmination of what André Chastel has called the *anatomie moralisée*.[23] Ruysch designed his compositions with utmost care and, as Dr Luyendijk-Elshout has pointed out, he never failed to indicate the scientific importance of his preparations.

A considerable part of the Ruysch collection was bought by Tsar Peter of all the Russians and is still to be seen in the gallery of the *Kunstkammer* in Leningrad.

At one time collecting was the exclusive province of the monarch, but in the Republic of the United Provinces it was pursued by citizens of the most diverse social strata. Some of these, such as the Princes of Orange and Johan Maurits of Nassau, represented the high nobility; others, such as Gorlaeus and the brothers Reynst, belonged to the upper classes; whereas a man like Ruysch was characteristically possessed of a scientific urge, no matter how curiously surrealist its expression.

From contemporary writings on seventeenth-century *naturalia*, the notion very clearly transpires that the collector's underlying principle was in every instance the emblematic ordering of one particular part of God's creation. The extreme form taken by the moralizing impulse in the case of Frederick Ruysch is an exception. The impulse as such was, it seems to me, shared by all. In their motivation the collectors fell back on biblical texts and classical maxims. Their deepest feelings were perhaps best expressed by Jan Swammerdam, the Amsterdam scientist and collector, to the Parisian Maecenas Melchisédec Thévenot, in the dedication of his study of the louse (April 1678):[24]

I present to you herewith the Almighty Finger of God[25] in the anatomy of a louse; in which you will find wonder piled upon wonder and God's Wisdom clearly exposed in one minute particle.[26]

The lines of Apelles[27] bring all the world to admiration, but here you will see in a fragment of a line the entire structure of the most ingeniously created animals of the whole universe, as if compressed into an abstract. Which [ordinary] persons, Sir, are capable of grasping this? But which artist, save God, can there be who could in any way trace and express it?

This is why it is but by His Spirit and Grace, which he has bestowed on mankind, that they can investigate these high and hidden wonders and for the benefit of other men display the same.[28]

[23] Chastel 1978, p. 218. The theme was fully developed in the early seventeenth century in the Leiden Anatomy Theatre: see Lunsingh Scheurleer 1975.

[24] Swammerdam 1737, p. 67; Lindeboom 1975b, p. 104, letter no. 19a (fragment), April 1678; Schierbeek 1947, p. 66.

[25] In the sequel to his letter Swammerdam refers to Exodus 8: 16–19, in which Aaron, by 'smiting the dust of the land' with his rod, caused lice to appear at the command of God. The inability of the Egyptian magicians to do likewise was justified by them as being brought about by the Finger of God.

[26] In Pliny the identical sentiment occurs as: 'Eminet in minimis maximus ille deus.'

[27] Waal 1967.

[28] I gratefully acknowledge the stimulating exchange of ideas with my friend and colleague A. G. H. Bachrach, which led to the English translation of this contribution.

NATURAL PHILOSOPHERS AND PRINCELY COLLECTORS: WORM, PALUDANUS AND THE GOTTORP AND COPENHAGEN COLLECTIONS

H. D. Schepelern

Before the seventeenth century, scholars and collectors had little reason to visit 'ultima Thule', but if anyone did go so far, he would as often as not have to spend some days or weeks in Denmark, whether he came by sea round the northern tip of Jutland to Elsinore and Copenhagen or overland by way of Hamburg and the Danish islands.

Certainly, since the late fifteenth century, there were universities both in Copenhagen and Uppsala – Uppsala being founded earlier than Copenhagen by a few years – but they came to international importance only during the Thirty Years War when German universities and princely collections were liable to fall victim at any moment to violence. Far from being inviolate sanctuaries, such establishments, like other cultural property, were dealt with as small coin in political bargains, if not as legitimate booty of the conqueror. In 1622 the Spanish plundered Heidelberg, whence the famous Bibliotheca Palatina was taken to Rome. The Swedish booty from Prague in 1648 went to the far north, where specimens can still be traced in Swedish public and private collections.

Christian IV of Denmark (reigned 1588–1648) would hardly have behaved better, had not his active participation in the war from 1625 resulted in a defeat and an unprofitable conclusion of peace in 1629. If he did happen to cherish a desire to fulfil the Rosicrucian prophecy of a 'Lion from the North',[1] his hopes were soon dashed, but a few years later the Protestant cause found new support in Gustavus Adolphus of Sweden who, before his heroic death at Lutzen in 1632, received the Augsburg *Kunstschrank*, now in Uppsala (see pp. 90–101) as a palpable symbol of the future predominance of Sweden.

Throughout the rest of the century, Copenhagen could none the less boast of a university with a respectable international status, being the nearest point of escape for scholars from the universities of northern Germany which were constantly menaced by the troubles of war. The university of Copenhagen had been re-established after the Lutheran reformation in 1536, but theology was far from quenching medicine and natural science, represented there by scholars such as the astronomer Tycho Brahe, the iatrochemist Petrus Severinus, the anatomist Caspar Bartholin and his learned sons.

[1] Yates 1972b, p. 255.

As to collections, there was not yet a royal *Kunstkammer*, but in the 1620s the medical professor Olaus Worm (1588–1654) (fig. 50) had founded a private collection of natural objects. He represents an early example of the university teacher who makes use of demonstrative material from his collection for the benefit of students in natural philosophy, as had been the case with Ulisse Aldrovandi in Bologna (pp. 17–23).

Natural philosophy formed part of a full university course, which still reflected the tradition of the seven liberal arts. The baccalaureate required familiarity with the four elements (earth, water, fire and air) of the macrocosmos, and with the corresponding four humours of the microcosmos (the sanguinary, bilious, phlegmatic or melancholic dispositions of man). A more advanced stage of natural knowledge was attained only by those who continued the preliminary course and studied medicine, which had made enormous progress during the sixteenth and seventeenth centuries, especially in anatomy. William Harvey's discovery of the circulation of blood in 1628 was too revolutionary to be accepted at once, but about the middle of the century it came to be generally acknowledged; soon after, there followed the identification of the thoracic duct, which the Swede Olof Rudbeck and the Dane Thomas Bartholin each claimed to have discovered first. In the 1660s and 1670s followed the Dane Nicolaus Steno, who demonstrated the parotid glands and went on to become the founder of modern geology.

Anatomy was concerned with the microcosmos, the human body, but for the advanced physician observations were also to be made in the macrocosmos. Much had been added to ancient knowledge through plants and animals unknown to Pliny and Theophrastus, brought from newly discovered parts of the world. Experience gained by miners, goldsmiths, apothecaries and alchemists might also prove useful to science. In the sixteenth century, the adventurous figure of Paracelsus had tried to break the dominance of the four elements, replacing them with three others (salt, sulphur and mercury), in his attempt to explain the principles of growth and variation in nature. He eagerly recommended direct observation. From his numerous – often confused – books, it is possible to catch a glimpse of new guide-lines for medical practice, especially in the field of drugs where he could take advantage of any of nature's products, including metals and stones. Modern medicine is likely to condemn the majority of his prescriptions; many of these were taken over by the iatrochemists of the seventeenth century, who may have killed many prominent patients when using lead- and mercury-based internal remedies to treat, for instance, venereal disease, in the belief that experience seemed to have proved them beneficial in healing external symptoms.

Worm had studied for many years abroad. He took his medical degree in Basle, where botany and the collecting of natural objects had developed in the footsteps of Conrad Gesner (p. 65). He had visited Ferrante Imperato in Naples and he had been in Bologna after the death of Aldrovandi, whose collections were at that time in temporary storage, but in his later writing Worm often quotes Aldrovandi's works along with Gesner's animal history and the catalogues of Imperato's and Calceolari's collections. He had attended Hartmann's chemical lectures in Marburg and lived for some time in Kassel, making experiments in the laboratory of Moritz the Learned. In spite of this, Worm kept

clear of all the mysteries of alchemy. He was not very speculative by nature and never became a true iatrochemist. At an early date he had sworn allegiance to J. C. Scaliger and to the principles of the Lincei Academy in Rome,[2] performing autopsies and making direct observations – the leading principles of progress – instead of relying on syllogisms and mere book-learning. But like all prominent scholars of that period, Worm was a formidable philologist with an extensive reading in the classics and the whole tradition which was revived in the Renaissance. On his return to Denmark in 1613, he took over the chairs of Latin and Greek and soon won fame as the founder of Nordic archaeology, one of his most imposing achievements being a great edition of all the Danish runic stones.[3] Here, however, we must limit ourselves to his collecting activities, which started about 1620 when he was appointed Professor in Natural Philosophy. Not until 1624 did he obtain a chair in medicine.

Worm's collection took shape between 1620 and his death in 1654. His last great work was the folio volume *Museum Wormianum*[4] printed in Leiden and Amsterdam and issued the year after his death. It has secured his name as one of the founders not only of Danish but of European museums. The typographical model of the book was Piso and Markgraf's publication of the *Historia Naturalis Brasiliae*,[5] from which some of the illustrations were also taken. Others came from the works of Gesner, Aldrovandi and Rondelet, but the best of them were made in Copenhagen from drawings made under his own supervision. This is true of the frontispiece showing the interior of his museum (fig. 51), from which many single objects are still identifiable. The arrangement of the material followed the principles of Imperato and Calceolari.

Museum Wormianum is not merely a catalogue but a true history of natural and artificial objects. In four books Worm deals with the kingdoms of nature and art, starting with the lowest, namely stones and minerals, then proceeding upwards to plants, lower and higher animals, and including human anatomy which, however, is represented only by an embryo and some skulls and bones. In this field he could draw upon more ample material for demonstration in the anatomy theatre of the university, founded in 1642. The fourth book gives a survey of Worm's artificial objects, arranged according to materials. This part of his museum had developed incidentally as an adjunct to the natural objects, but in Worm's later years his fame as an antiquary meant it tended to predominate.

Worm did not pretend to give a complete survey of all known natural objects but explicitly proclaimed his intention to limit himself to objects found in his own collection. The text is somewhat heterogeneous. To some extent it is clear that he made use of the manuscript notes from his university lectures, but sometimes, as in the chapters on botany, he simply gives a list of names in alphabetical order. At his best, however, he gives marvellous descriptions stamped by his total command of the Latin language and of the terminology found in ancient and more recent literary sources.[6]

[2] Gabrieli 1938–42, p. 1011: '... alla construzione della nuove basi della scienze sull' osservazione diretta, lo studio cioè della natura: il primo, il vero, il grande e sempre aperto libro di Dio.'

[3] Worm 1643.

[4] Worm 1655; Schepelern 1971.

[5] Laet 1648.

[6] During the preparation of an exhibition in the Museum of Applied Arts, Copenhagen, entitled *Conch and Man* (see Woldbye and Meyenburg 1983) I took the opportunity of translating the ten pages (251–61) dealing with shells in Worm's collection. In most cases his descriptions proved to be so exact that a modern conchologist would be able to identify most of them in spite of changes in terminology.

Private collections, on the whole, seldom had space for aesthetic arrangement, which was a privilege rather of great princely cabinets. Worm's shells, for instance, were stowed together in boxes labelled with their classifications (turbinati, univalves, bivalves). In the illustration of his museum interior (fig. 51) the reader will be able to discern, in the window recess, the skull of a narwhal with its spiral tooth. Worm's name for it, *unicornu marinum*, is connected with his definite statement of its being not a unicorn's horn: he had first published this refutation in a special treatise in 1638, referring to Mercator's *Atlas* of 1595, where it was reported that such horns were often found on northern coasts and most probably originated from a marine animal rather than from a fabulous quadruped. The text of his museum history[7] is a reprint of his treatise with a few alterations.

Like many other advisers to collecting princes, Worm was a medical man. In his museum history the descriptions of natural objects are very often accompanied by prescriptions for their use in medicine. He was at the King's bedside when Christian IV died in 1648 in his dear Rosenborg in Copenhagen, where the royal treasures and the crown jewels are kept today. The old king had not been a collector like his English cousin Charles I, but he had – until his unlucky meddling in the Thirty Years War – been one of the wealthiest princes in northern Europe and a great builder. As a warrior he was not Fortune's favourite like his Nordic rival Gustavus Adolphus of Sweden, but he was able to command his own fleet, as he did in 1644 when he lost his right eye in a naval battle and won fame as the most outstanding Danish monarch since Canute the Great. His son and successor, Frederik III (reigned 1648–70), founded the royal *Kunstkammer* in Copenhagen in 1650 (pp. 129–32). Until 1654 he kept close contact with Worm, whose museum he acquired to incorporate into the *Kunstkammer*. Later inventories reveal the fact that Worm's strict systematic arrangement was soon abandoned in favour of artistic and historical principles. It is less important that, in the printed catalogues of the *Kunstkammer* from 1696 and 1710, the three kingdoms of nature are registered in inverse order, starting with human beings and quadrupeds and finishing with stones and metals: the shift to more historical aspects is symptomatic, however, when, in the 1710 edition, the collection of coins and medals occupies more than 60 per cent of the printed text.

The kingdom of Denmark comprised Denmark proper – including, until 1660, what was to become the southern part of Sweden – Norway (until 1814), and the Duchies of Schleswig and Holstein (until 1864). The Sound was under Danish control on both sides and Copenhagen was the principal port of southern Scandinavia, at least until after 1660 when Sweden's predominance allowed Gothenburg to develop into a prospering rival town. The first traces of the decline to come were manifested before the death of Christian IV and the situation aggravated by the fact that the dukes of Schleswig and Holstein – the king's vassals belonging to a collateral line of the royal family – pursued their own policy. Their economy prospered from fertile homelands and from the flourishing overseas trade through Hamburg. Hence the ducal court at Gottorp in Schleswig managed to establish a cultural centre under the Dukes Frederik III (reigned 1616–59) and Christian Albrecht (reigned 1659–94), the latter founding the University of Kiel in 1665. With the learned

[7] Worm 1655, pp. 282–7.

mathematician Adam Olearius (1603–71) as his adviser, the Duke collected a cabinet of curiosities at Gottorp, drawing upon material from two political and scientific embassies to Russia and Persia in the 1630s. An illustrated guide to the collection was published by Olearius in 1666 (fig. 52).[8]

No doubt, the challenge from Gottorp was a stimulus to Frederik III when founding his *Kunstkammer* in Copenhagen. In many respects the two princely collections show a parallel development. The King in Copenhagen enlarged his collection through the acquisition of Worm's museum in 1655, and in 1651 the Duke, in a similar way, had bought a famous Dutch collection left by the town physician of Enkhuizen, Berhard Paludanus (1550–1633) (fig. 53). Under more favourable military and political conditions at the beginning of the eighteenth century, the Danish king at last got the upper hand over the Duke of Gottorp. He annexed his part of Schleswig to Denmark and forced the Duke to cede his cabinet of curiosities to the crown. In the middle of the century it was eventually brought to Copenhagen and absorbed into the royal *Kunstkammer*.

The inventory of Paludanus's collection, drawn up in 1617–18 in his own hand, is now in the Royal Library of Copenhagen. Recently I decided to carry through a closer examination of the manuscript, the content of which was little known.[9] A number of Paludanus's ethnographical objects proved to be identifiable as still surviving in the Nationalmuseum at Copenhagen, and it transpired from the exercise that there were both similarities and dissimilarities between Worm and Paludanus. Both were medical men, but Worm probably had a more thorough learning: Worm was a true polyhistor who extended his activities to a great variety of fields, the collecting of natural objects being only one of them, whereas Paludanus limited himself to collecting and to medical practice. Worm's folio gives us a 'history' and is thus superior to Paludanus's inventory which is a mere list of objects, roughly described, first in Latin then in an odd mixture of German and Dutch. He does not systematize very much, and his artificial objects (mainly costly gifts from princely supporters) are inserted at random between the natural and the ethnographical. Only part of the scientific material – but none of Paludanus's real valuables – is identifiable today, so the latter are likely to have been disposed of before the collection was sold by his heirs to the Duke of Gottorp.

Paludanus's collecting activities seem to fall within two periods. In 1581 he returned to his fatherland after many years of travelling in Europe and the Near East, whence he brought home a considerable number of scientific objects acquired by himself throughout his journey. This collection, the first stage, was partly published in German in 1604 in a description[10] by Jacob Rathgeber who, in 1592, had accompanied Duke Friedrich of Württemberg-Teck (1557–1608) when visiting Paludanus in Enkhuizen. The main part of this printed inventory is in tabular form, and the provenance of several objects is inserted, testifying that most of them came from countries visited by Paludanus himself, that is to say, from Europe and the Near East. I venture the suggestion that the printed list may have been a document drawn up in connection with the bargain struck between Paludanus and the Duke when the latter bought Paludanus's collection to form the basis

[8] Olearius 1666.
[9] Schepelern 1981.
[10] Rathgeber and Horrenberg 1603–4.

of the cabinet of curiosities which is still to be found in the Württembergisches Landesmuseum at Stuttgart.[11]

A comparison between the printed inventory of 1604 and the written version of 1617 reveals an essential difference – the latter comprises a majority of objects from the Far East (China, Japan and, especially, India). The title-page, mentioning that the collection was formed in the years after 1600, seems to favour my hypothesis of two periods. The change in the contents of the collection I attribute to the collaboration between Paludanus and the famous Dutch traveller Jan Huygens van Linschoten (1563–1611) who, in 1592, after fourteen years of travelling (he lived in Goa from 1583 until 1589) had settled down in Enkhuizen. In the well-known description of his travels[12] Linschoten often mentions Paludanus, whose medical commentaries to many of the natural objects are inserted into the text in a special typeface and have his name appended. No wonder that Linschoten's itinerary feels almost like a running commentary to Paludanus's catalogue. It seems probable that a good deal of the exotic natural and ethnographical objects acquired by Paludanus after 1600 and later sold to the Duke of Gottorp, were brought to Europe by Linschoten and are now to be sought in Copenhagen where the princely collections from Gottorp were eventually united with the royal *Kunstkammer*.[13]

Written sources and our own imagination give us only vague notions of what was really going on at the courts of the great princely collectors. We know that there were artists' and artisans' workshops in Florence, Prague, Kassel, Dresden and elsewhere. Sometimes there were also alchemical laboratories, but in my opinion alchemy, astrology, and mystic enlightenment should be considered as secondary phenomena rather than as indispensable elements of collecting activities. Too many of the natural philosophers engaged in collecting were sober observers of nature and maintained a critical attitude towards mysticism. This is true in the case of Worm, whom I know best, and Paludanus seems likewise to have taken little interest in such problems. Kings and princes, on the other hand, would often be open to the temptations of gold-makers, but although chemistry – in the modern sense of the word – remained an unborn science until well into the eighteenth century, it should not at this period be in every case equated with alchemy. In Copenhagen, Christian IV had established a chemical laboratory near Rosenborg as early as in 1609. Its first head was the Schleswig physician Peter Payngk, who had worked in Prague at the court of Rudolf II, but he was more an iatrochemist than a real alchemist. When silver ore was found in Norway in 1623, the laboratory was given the practical task of analysing the metal, an activity continued under Frederik III who was, on the other hand, personally interested in gold-making and was taken in by the Italian charlatan Guiseppe Borri (1627–95), who died a life-prisoner in Castel San Angelo in Rome.

As to the distinction between cabinets of curiosities and *Kunst- und Wunderkammern*, I

[11] The museum at Stuttgart was not mentioned by Schlosser (1908). See Fleischhauer 1976, p. 3: 'Aus der Wunderkammer des berühmten Naturwissenschaftlers und Reisenden Bernhardus Paludanus (1550–1633) in Enkhuyzen unweit Amsterdam, die er 1592 auf der Rückreise von England besuchte, wählte er . . . zu etlichen Hunderten . . . allerlei Kleidungen und fremde Sachen aus Cyria, Persien, Armenien, Ost- und Westindien, Türkei, Arabia, Muskovien etc. aus, die er sich zusenden liess.'

[12] Linschoten 1596; 1599 (dedicated to the Landgrave Moritz of Hesse).

[13] I have analysed the material exhibited in 1979 in the ethnographical collections of the National Museum, Copenhagen (Dam-Mikkelsen and Lundbæk 1980), identifying seventeen oriental objects which probably came from Paludanus's collection. See also Schepelern 1981.

cannot agree with Julius von Schlosser[14] who sought to find a difference in mentality north and south of the Alps. Collecting principles, on the whole, were the same everywhere, but a natural philosopher and a princely collector would have differing views, the prince aiming at totality and arranging his cabinet according to more aesthetic principles.[15] To him it would make little difference whether a beautiful vessel was turned in ivory by an artist or was shaped in the form of a conch shell by God the Almighty, the greatest artist of all. The philosophers had adopted their views upon the physical relations of nature from traditional natural philosophy, and Aldrovandi in Bologna, Kircher in Rome, Quiccheberg in Munich and Worm in Copenhagen would systematize in the same way. This is a fact which must be recognized by those of us today who so easily forget the original strict system of the natural collections, often because the objects which survive tend to be oddities like the malformed child or the skull of a horned hare. The artists' works, often imitating nature, have survived and are estimated now in their own right, in a period when the old natural philosophy is forgotten, stifled by modern science.

[14] Schlosser (1908) contrasts 'den Freuden am Künstlichen und Kuriosen' of the Germans with 'das Streben nach künstlicher und monumentaler Gesamthaltung' of the Italian collectors.

[15] Putscher 1974, pp. 256–77.

FROM THE ROYAL *KUNSTKAMMER* TO THE MODERN MUSEUMS OF COPENHAGEN

Bente Gundestrup

This account of the Royal Danish *Kunstkammer* falls into three parts. The first deals with the early collections of the Danish kings and the founder of the *Kunstkammer*, King Frederik III (fig. 54): his background is examined, particularly his education, the offices which he held and the influences which he may have absorbed in the years before he became King of Denmark. The second part concentrates on the history of the *Kunstkammer* – its physical limits, its accessions and the methods of classification and registration used in the collection. The third and last part will trace the developments from the 1820s (when the *Kunstkammer* collection was dispersed) to the modern museums in Copenhagen; at the same time it outlines the background to the research presently taking place mainly at the National Museum and the Rosenborg collection, shortly to be extended to other public museums in Copenhagen.

EARLY COLLECTIONS

At the beginning of his reign Frederik II of Denmark (1559–88), planned to install a *Drehezimmer* or *Wunderkammer* in the castle of Krogen (now Kronborg Castle). Nothing became of this project, but it illustrates how *Kunstkammer* objects, and therefore the rise of *Kunstkamre*, became associated with the *Drehezimmer* in the palaces. The art of turnery was a favourite pastime for generations of Danish kings: the *Drehezimmer* was supervised by the royal turner, who held a position of trust, and access was gained only with permission from the king himself. It was therefore natural that this room should be used for the storage of art objects, jewels, ceremonial arms, and so on.[1]

Other rooms besides the *Drehezimmer* could be designated as *Kunstkamre*. Christian IV (1588–1648), the son and successor of Frederik II, had a large collection of rare and valuable arms in his private lodge at Frederiksborg Castle. Some of these arms were so remarkable that the rooms in which they were kept were actually referred to as *Kunstkamre*. An account of a collection of *Kunstkammer* material at Rosenborg Castle was left by a visitor to Copenhagen in 1623, Prince Christian the Younger of Anhalt: he noted in his diary that Rosenborg contained 'a small cabinet in which are some Japanese swords, knives and tapestries, also paintings and pictures'.[2]

What is now called Det kongelige danske Kunstkammer (Royal Danish *Kunstkammer*)

[1] Liisberg 1897, pp. 8–13. [2] Hermansen 1951, pp. 20–1.

did not exist until after Christian IV died in 1648, to be succeeded by his second son, Duke Frederik, his eldest son and heir presumptive having died the previous year. Thus Frederik's education had not been geared directly to his succession to the throne. Indeed, his father had from 1616 attempted to have him appointed Archbishop of Bremen. He had also striven to educate his son as a man of the world and a versatile scholar.

Travelling abroad was a natural part of a prince's education as it was for other young noblemen of the time. In the years 1628–30 Duke Frederik journeyed in Holland and France. His interest in art, antiquities, ethnographical items and such like was probably stimulated as he became acquainted in this way with the widespread enthusiasm for collecting. No doubt his interest developed further in the decade from 1634 to 1644, which he spent in Bremen as secular Archbishop: Bremen is no distance from the Dutch ports, where a great amount of ethnographical material was disembarked. From there, these exotic objects and knowledge of them were spread all over Europe.[3]

As a consequence of the war of 1643–5 between Denmark and Sweden, Frederik lost his office in Bremen. He then settled in Flensburg, where he was installed by his father as governor of the duchies of Schleswig and Holstein. Here he was situated close to one of the influential cultural centres of his time, for at Schloss Gottorp in Schleswig the third Duke of Gottorp, Frederik's cousin Friedrich, was planning to found a *Kunstkammer*. The prime mover of this project was Adam Olearius who, in 1649, was appointed keeper of the Library and *Kunstkammer* at Gottorp. Two years later he brought the famous collection of Bernhard Paludanus from Enkhuizen to Gottorp.[4]

FREDERIK III'S *KUNSTKAMMER*

In 1648, when Frederik was elected King, he took up residence at the Castle of Copenhagen (fig. 56). Whether he brought a collection with him to the capital and what any such collection may have consisted of remains unknown, but it is certain that the *Drehezimmer* at the Castle soon held a collection of some size.

Two reasons may be given for this conclusion. Firstly, from the spring of 1650 at the latest, the first *Kunstkammer* employee was registered on the royal payroll, and from that time the *Kunstkammer* was considered an established institution.[5] Secondly, the *Drehezimmer* very soon became too small: in 1653, only five years after the King's arrival in Copenhagen, more than half of the eight rooms newly designated for the *Kunstkammer* in the south wing of the Castle were occupied.[6]

The King's collections (his Library as well as his *Kunstkammer*) were enriched by numerous accessions in the following years, and again more room was needed, especially for the Library. Plans were made, therefore, to erect a special building for these two large collections, and in 1665 the foundation stone was laid for the Library and *Kunstkammer* building. It was placed next to the King's residence and survived two great fires in the neighbouring Castle. The building still stands today, containing the Rigsarkiv (Danish National Archives).

[3] Liisberg 1897, pp. 14–17; Hermansen 1951, pp. 26–7.
[4] Schlee 1965, pp. 280–90.
[5] Hermansen 1951, p. 28.
[6] Liisberg 1897, pp. 17–25.

The *Kunstkammer* building was not completed until the end of the 1670s and, according to tradition, the transfer of the *Kunstkammer* collection from the Castle to the new premises was not finished until 1680. Thus Frederik III, who died in 1670, did not live to see his beloved collections in their new purpose-built surroundings. For almost the whole of the next one and half centuries – that is, until it was dispersed – the collection remained in this building (fig. 55).[7]

ACCESSIONS TO THE *KUNSTKAMMER*

There were various ways in which the King could enlarge the collection. The exchange of gifts between sovereigns and princes was one such way. An example of this process is a famous donation received by Frederik III from the Dutch prince Johan Maurits of Nassau, former governor and colonizer of Brazil. Around 1640 Johan Maurits embarked for Brazil along with a team of scientists, artists and tradesmen, whose task it was to study and describe the natural resources and the native peoples of the Dutch possessions in Africa and South America. Among these was the Dutch painter, Albert Eckhout: from his hand came some of the oldest surviving ethnographical paintings, sent by Johan Maurits to Frederik in 1654. The donation originally consisted of twenty-six paintings, of which two have since been lost. Of special interest is the fact that nine of the paintings show Africans as well as Indians, in their native costumes and with their native equipment. The greater number, however, present (with considerable skill and accuracy) different plants and fruits growing naturally in Brazil.[8]

Another donation received by Frederik III came from the Danish admiral Cort Sivertsen Adler. Adler had in his early days served in the Dutch merchant fleet, and as captain of the *Groote St Joris* he was hired by the Venetians to take part in several battles between Venice and the Ottoman Empire in the middle of the seventeenth century. In one of these battles the Venetians captured some Turkish standards, one of which Cort Adler later donated to Frederik III, who placed it in the *Kunstkammer* together with a sword which had also been taken from the Turks. This sword was later used by the Danish king Christian V during the war between Denmark and Sweden in the 1670s. Other Turkish weapons which were in the *Kunstkammer* as early as the 1670s might also have reached the collection through Cort Adler.[9]

A further example may be given of quite another kind of donation. The widespread piracy endemic in the Turkish-dependent Barbary States on the North African coast proved costly to Danish merchants; hence in 1746 Denmark was forced to sign a treaty with Algeria and, in 1752, entered into another agreement with Tunisia. These treaties were confirmed with exchanges of presents, and within a few years of receiving such gifts the King placed them in the *Kunstkammer*. They consisted mostly of riding equipment and weapons.[10]

The collection was further enriched by purchases, the most famous being the entire

[7] Ibid., pp. 107–13.
[8] Thomsen 1938. See also Berete Due and Torben Lundbæk in Dam-Mikkelsen and Lundbæk 1980, pp. 34–44 and Berete Due in Lundbæk and Dehn-Nielsen 1979, pp. 53–4.
[9] Anne Marie Flindt in Lundbæk and Dehn-Nielsen 1979, pp. 17–25.
[10] *Eadem*, in Dam-Mikkelsen and Lundbæk 1980, pp. 84–9.

Museum Wormianum which was incorporated into the Royal *Kunstkammer* in 1655.[11] Today about twenty objects from Ole Worm's collection have been identified in the National Museum, and surely more will be recognized.

Several items were bought for the *Kunstkammer* at auctions. Thus Christian V (1670–99) purchased in Copenhagen in 1684 the twelfth-century 'Gunhild Cross', made of the 'ivory of the North' – walrus ivory.

Some monarchs also bought items from abroad through certain highly trusted individuals. Agents in Nürnberg are known, and Frederik III used his minister to the States General, Peder Charisius, to seek out suitable accessions, especially in the Dutch ports.[12] It may have been through him that the *Kunstkammer* received certain of its great collections, such as the Japanese lacquers and Chinese porcelain, which were part of the collection by the end of the seventeenth century.

A third means of collecting is illustrated by a list from 1739, in which it is said that the King ordered the gathering of certain objects in Norway, which was at that time part of the Danish kingdom. The exercise resulted in 104 new accessions to the *Kunstkammer*, including ethnographical material, weapons and zoological specimens.

Finally one might mention increases in the collection by way of conquest. Denmark was the victor in the Northern War of 1700–21: the dispute was once more between Denmark on the one side and, on the other, Sweden and its ally the Duke of Gottorp. Defeat led to the incorporation of the ducal collection into the *Kunstkammer*, following a royal decree in 1742, although the actual transfer to Copenhagen did not take place until 1751.[13]

As well as the Gottorp *Kunstkammer*, the Danish king received the collection of Bernhard Paludanus, which, as mentioned above, had been bought in 1651. Some of the objects best documented in the history of museums, now in the Ethnographical Department of the National Museum in Copenhagen, come from this acquisition. They are of special interest to ethnographers since they are known to have been placed in the collection not later than 1617.[14]

CLASSIFICATION AND REGISTRATION

Our knowledge of the systems of classification and registration used in the *Kunstkammer* stems mainly from the various inventories. These were drawn up each time a new keeper was appointed, the retiring keeper (or his estate) being held responsible for the collection.

The earliest surviving inventory dates from 1674, when the *Kunstkammer* was situated at the Castle of Copenhagen. It is a brief list which, often with no more than one or two words, itemizes the contents of the *Kunstkammer*. It is evident, however, from the names of the rooms and from their respective contents that the collection was displayed according to distinct categories and following objective principles. The first room contained natural objects, the second artefacts, followed by the Gun Room with antiquities and weapons,

[11] Schepelern 1971, pp. 302–12.
[12] Liisberg 1897, pp. 64–77.
[13] Larsen 1941, p. 227.
[14] The following examples may be mentioned: from Brazil a side-blown wooden trumpet, a flute and a pendant both made of human bone, and, according to recent investigations by H. D. Schepelern, two aprons: these are women's aprons, one with shells from Central America and the other made of leather with mother-of-pearl from Mexico. All specimens published in Dam-Mikkelsen and Lundbæk 1980.

the Picture Room, the Mathematical Cabinet containing scientific instruments and clocks, the East India Cabinet with ethnographical specimens, the Medal Cabinet and the Model Cabinet.

The next inventory, of 1689, is unusual in that it was unconnected with a change of office. It is the first record made after the transfer from the Castle to the *Kunstkammer* building. The King had ordered its preparation in 1687 and it appeared two years later, becoming the basis of the first printed museum catalogue of the royal collection.[15] The *Museum Regium*, as it is called, was published in 1696 with numerous engraved illustrations. In 1710 a second, enlarged edition with new illustrations was published.

The third handwritten inventory from the seventeenth century followed the second by less than a year, due to the death of the keeper.

These seventeenth-century inventories, like that from 1737, show that the distribution of the objects around the *Kunstkammer* building followed principles similar to those applied within the Castle. Common to all the inventories from 1674, 1689, 1690, and 1737 is the fact that they list the whole collection room by room; in this they contrast with the three following inventories from 1775, 1807 and 1827 which were made as accession-lists. The objects in these latter inventories were listed according to category and not by their position in the collection.

All exhibits in the *Kunstkammer* were numbered in the decade from 1765 to 1775. Objects entered prior to 1737 were given a number consisting of two ciphers: the 1737 inventory page number and a serial number, for instance *862.84*. For objects acquired after the year 1737, a different numbering system was adopted. In the accession-inventories the objects were entered according to categories, each category being designated by a letter. Paintings had the letter *a*, antiquities the letter *b*, art objects *c*, Indian objects *d*, and natural objects *e*. Objects within each group were thus given both a letter and a serial number, for instance *d 179*. This method of numbering was used almost unchanged until the collection was dispersed.[16]

FROM *KUNSTKAMMER* TO THE MODERN MUSEUMS

Towards the end of the eighteenth century the collection became more and more crowded and a more systematic method of classification was needed. The lack of an inventory with proper descriptions became evident, and this factor, along with the development of new scientific ideas concerning special collections or museums, led to radical changes in the *Kunstkammer* (fig. 57).

The prime mover in these changes was the Lord Chamberlain and director of the *Kunstkammer*, Adam Hauch, who took office in 1802. As early as 1781 the coins and medals had been removed from the collection. The minerals were separated from the other natural objects in 1804 and were united with two similar collections elsewhere in Copenhagen, eventually being transferred to the Geologisk Museum (Geological Museum). At two auctions in 1811 and in 1824 some objects from the *Kunstkammer* were

[15] Hermansen 1951, pp. 32–3.

[16] Bente Dam-Mikkelsen [Gundestrup] in Dam-Mikkelsen and Lundbæk 1980, pp. xxv–xxvii.

sold, most of them in poor condition. In 1811 several of the northern antiquities were handed over to the Kongelige Commission til Oldsagernes Opbevaring (Royal Commission for the Preservation of Antiquities).

Unfortunately, the reorganization made slow progress. Nothing of significance happened until 1821, when six so-called scientific committees – groups of two or three leading experts – were appointed to supervise the classification of the remaining groups of objects. In this manner the way was finally cleared for a systematic classification of the *Kunstkammer* and for the creation of new collections and museums.

The following groups of items were removed from the *Kunstkammer* and in several cases united with public collections of similar character. The zoological objects entered the Kongelige naturhistoriske Museum (Royal Natural History Museum). The collection at Rosenborg, which from 1833 was called the Danske Kongers Kronologiske Samling (Chronological Collection of the Kings of Denmark) received nearly 550 exhibits. In return the *Kunstkammer* received some 100 items from the Rosenborg collection. Around 2,000 paintings were placed at the new Kongelige Billedgalleri (Royal Picture Gallery). The remainder, some 5,500 items consisting of classical and northern antiquities, ethnographical specimens, carved and turned pieces, together with what were called 'modern genuine polished stones and precious objects', were designated to remain in the *Kunstkammer*, but complications developed. The *Kunstkammer* rooms, carefully investigated, were found to be in such a poor state that new premises had to be found. The transfer of the objects to another building began in October 1823; by the end of 1824 the top floor of the *Kunstkammer* building had been emptied, and on 31 May 1825 the collection was inaugurated under a new name, the Kongelige Kunstmuseum (Royal Art Museum).[17]

Some years later, in 1839, Christian Jürgensen Thomsen was appointed curator of the Art Museum and another period of dissolution followed. The remainder of the northern antiquities were handed over to the Museum for Nordiske Oldsager (Museum of Northern Antiquities). The Ethnographisk Museum (Ethnographical Museum), the Antik-Cabinet (Cabinet of Antiquities, later the Royal Collection of Antiquities), and the Museum for Skulptur og Kunstflid (Museum of Sculpture and Handicraft) were all created at this time. The last-mentioned collection was dissolved in 1867, the objects then being shared between the Museum of Northern Antiquities and the Rosenborg collection.[18]

Most of the modern public museums in Copenhagen, therefore, contain a nucleus of objects from the Royal *Kunstkammer*. Attempts are currently being made to locate and identify those objects which have survived, and then, through the registers of the modern museums and the concordance lists, to trace these items in the old inventories and in other sources such as manuals and accession-lists, letters, accounts and inventories from incorporated collections. To date only the ethnographical items have been systematically examined. The full number of items formerly in the *Kunstkammer* has been estimated around 10,000 pieces (excluding coins and medals) and it should be possible to find and identify 90 per cent of the original royal collection.

[17] Andrup 1933, pp. 38–62. [18] Mackeprang 1929, pp. 8–13.

In a few years the registration of the whole *Kunstkammer* collection is expected to be completed and (it is hoped) published in the manner of the ethnographical items. Not until then will it really be known what exactly the founder and his successors were collecting: by that time the objects will no longer be mere descriptions in an old inventory but will have materialized in our hands and will thus provide the means for further and more detailed studies of the objects themselves and of the history of the early Danish museums.

APPENDIX: A NOTE ON THE ROSENBORG COLLECTION IN COPENHAGEN

Mogens Bencard

It is often said of the royal collections at Rosenborg Castle in Copenhagen that they, more than most, retain the atmosphere and tradition of the *Kunstkammer*. In the context of the theme of this publication it seems, however, important to stress that Rosenborg never was a *Kunstkammer* in the proper sense of the word. This assertion is of course dependent upon a definition of the term. The following is admittedly very broad, but will, I hope, suffice to prove my point: the *Kunstkammer* is a token of man's curiosity and delight in the surrounding world, mounted in a setting of prestige and/or education.

Rosenborg was built by Christian IV as a summer palace outside the city boundaries. It was used for about a hundred years until 1710, when a new summer palace was erected elsewhere. From then on it held, apart from the royal regalia and the crown jewels, furniture, paintings, royal costumes, and family heirlooms in general, considered for one reason or another too precious to be parted with. Most rooms were filled to capacity, and visits were allowed only to the very privileged few. A 'royal storehouse' seems a more appropriate description, with little prestige and certainly no educational value attached to it.

In 1833 the castle with its collections was turned into a public museum. The Lord Chamberlain, A. W. Hauch, a trained natural scientist, wrote in his memorandum to the King that since the major part of the collection had reference to the royal house, the best thing to do was to arrange the museum in *chronological order* according to the succession of kings.[1] In consequence the museum became a series of interiors relating to each monarch from Christian IV to the (then) present day.

The practical work was headed by two prehistoric archaeologists: firstly Christian Jürgensen Thomsen, a merchant turned scholar and internationally famous for having divided prehistoric times into the Stone, Bronze, and Iron Ages – again the chronological principle – and secondly J. J. A. Worsaae, a scholar and in his time head of most Danish historical museums.

When, in 1869, Worsaae was able to show the newly restored castle and its new displays to an international archaeological congress in Copenhagen, he proudly wrote of the unanimous acclaim it received, not only because of the chronological principle but also because of the attention paid to recent, even modern times.[2] Rosenborg, he added, was often copied by other European museums, and he was several times called out as a consultant.

[1] Andrup 1933, p. 9. Unfortunately only the first part of this interesting book, which deals with Danish museum history in the previous century, has been published. The unfinished manu- script is to be found in the archives at Frederiksborg Castle.

[2] Worsaae 1886, pp. 56 (the congress) and 77 (the consultant).

In 1879 the French scholar C. Charles Casati published his *Notice sur le Musée du Chateau de Rosenborg en Danemark concluant à la Création d'un Musée Historique de France*.[3] In order to find the best way in which to present a nation's history to its people, he had visited all the major historical museums in Europe. One of the most important and best organized, he found, was Rosenborg, where two centuries of Danish history were systematically represented in chronological order. He concluded that most other museums, by comparison, could be talked of only as *cabinets des curiosités*.[4]

Chronology was certainly not a basic organizational principle of the *Kunstkammer*, so Rosenborg, for all its old-world atmosphere, was ironically enough the first museum to break effectively with the *Kunstkammer* tradition and to point the way followed by all cultural-historical museums today.

A. W. Hauch had launched the chronological principle as early as 1812 in connection with plans for a National Portrait Gallery at Frederiksborg Castle.[5] Was he, I wonder, the first to put this idea into the heads of European museum keepers?

[3] Casati 1879.

[4] Ibid., p. 31.

[5] Andrup 1933, p. 31.

SOME NOTES ON SPANISH BAROQUE COLLECTORS[1]

Ronald Lightbown

The Baroque age was notable in Spain as in the rest of Europe for the great collections of paintings, works of art and curiosities accumulated by the king and the great nobility. In Spain as everywhere else the models for such collections were Italian: the collections of the Medici in Florence and of the Gonzaga in Mantua were celebrated throughout Europe, while the palaces of each successive generation of cardinals and Papal nephews showed that vast accumulations of paintings, antique statues and works of art could be assembled by powerful, wealthy and persistent men. The interests of the age, however, were universal: they extended beyond pictures and antique statues and medals to nature and to man, embracing the wonders of creation and the novelties of the exotic, as well as the monuments of antiquity and the medieval and the ingenious inventions of perfect works of the arts. The distinguishing feature of the Baroque collection, then, whether housed in the stately galleries and chambers of a prince or nobleman or the cluttered study of a lawyer or physician, is its reflection of a universal curiosity. It was, however, a curiosity still prone to be most stimulated by the rare, the marvellous, the strange and the exotic, by all in fact that was summed up in the term 'curious' itself. In taste it was apt to prefer elaboration and finish of workmanship in materials and techniques that required consummate skill and patience of hand, and to admire equally ingenuity and usefulness of contrivance.

We owe our liveliest picture of the collections of Madrid[2] in the early 1630s to the *Diálogos de la Pintura* of the Hispanicized Florentine painter Vicente Carducho. Published in 1633, the *Diálogos* embrace all aspects of the art of painting, 'its defence, origin, essence, definition, manners and differences'. In the eighth dialogue Carducho takes us to visit the great collections of his day. We go first

to a house where the discourse was of paintings, drawings, medals and statues, with much concerning all the originals of Raphael, Correggio, Titian, Tintoretto, Veronese, Palma, Bassano . . . and I was overjoyed to see that these subjects were treated and discoursed of with great taste, and very scientifically with the best artificers, who were present there, and many others, private wits, gentlemen and lords, who spend much good time in these diversions. Here were to be found, besides the paintings and sculptures I have spoken of, swords (by excellent masters), some for

[1] There is no published study of Spanish learned collections in the sixteenth and seventeenth centuries. The paper offered here is an excerpt from a longer study which the author hopes to publish elsewhere.

[2] For these collections in Madrid, see Carducho 1979, pp. 417–40. This edition has excellent illustrative notes.

wear on horseback, others for wearing on a gala ribbon or an everyday one, excellent damascened knives for hunting or for the table, fine shields and bucklers, works in rock crystal of a thousand fashions, carved and engraved with great art and delicacy. Here were also to be found escritoires, pyramids, balls of jasper and of glass and other curiosities for the oratory, the study or the cabinet. When we entered, the master of the house was adjusting an exchange he told us he had just made with the Admiral of Castile of an original by Titian, six heads by Antonio Mor, two statues of bronze and a small cannon for his chamber.

Next day we visit the house of Don Diego Felipe María de Guzmán, first Marquis of Legañés and General of the Spanish artillery as well as holder of other high offices. The Marquis owned a collection of almost 2,000 pictures, but he is perhaps of greatest interest because his collection of works of art and scientific instruments illustrates the practical purposes for which the scientific sections at least of Baroque collections were often assembled, becoming illustrations, even if sometimes unconscious illustrations, and aids to experimental philosophy. In his palace he had formed a sort of school of the mathematical and mechanical arts, especially as connected with his own artillery department and its special art of cannon-founding. He had had princely Italian predecessors in this practical involvement in the improvement of cannon, most notably Alfonso I d'Este of Ferrara (ruled 1505–34) and Emmanuel Philibert of Savoy (ruled 1559–80). Carducho invites us to admire 'the multitude of rich escritoires and buffets, extraordinary clocks and singular mirrors, the globes, spheres, mathematical and geometrical instruments skilfully arranged on large tables, all serving for the instruction of young men in mathematics and artillery'.

Carducho then passes on to the palace of the Conde de Benavente, which housed yet another great collection of pictures and also a number of precious relics, objects these for which the devout Carducho expresses even greater veneration, particularly for a crucifix still bespattered with the blood of San Pedro Bautista and the twenty-six blessed Franciscans who suffered martyrdom with him in Japan in 1597. So too at the house of the Principe de Esquilache, a lover of music as well as of painting, he reserves especial mention and adoration for the Miraculous Christ that spoke to St. Francis Borgia, the Prince's grandfather. Next he visits two noblemen who were also amateur artists. First comes the Roman Pietro Paolo Crescenzi (1577–1635), Marqués de la Torre, a typical figure of late Renaissance and Baroque culture as a gentleman deviser of spectacles and an amateur architect, who became Superintendent of the Royal Works. Crescenzi displays not only his collection of paintings but his model for the Panteón of the Escorial. We then visit Don Gerónimo Fures y Muñoz, just such another dilettante as Crescenzi. He is found designing and painting moral emblems. Emblems were one of the favourite forms of art with the aristocratic, the literary and the learned public of the later sixteenth and seventeenth centuries, for their ethical or philosophical content raised them to an equivalence or near-equivalence of import with literature, and delighted as well the general taste for ingenious and witty visual conceits. Don Gerónimo had a collection of pictures, of which Charles I of England had deigned to accept eight during the escapade of the Spanish marriage in 1623, receiving besides 'some swords, a great two-handed sword, and arquebuses of the best sort that the most excellent Artificers of such arms have

worked, both in Spain and outside it'. Fine weapons and armour were an interest of many Baroque collectors, but held a particular appeal for those of noble or princely birth, whose native profession was arms and whose ideals were still those of chivalry and military glory. Fine arms and armour therefore were the particular delight of Don Gerónimo, as a knight of Santiago and as a 'virtuous *caballero*'.

In Don Gerónimo de Villafuerte we meet a virtuoso of another type, one that made its first real appearance in the mid-sixteenth century, as usual in Italy, and was to become increasingly common there and elsewhere in the seventeenth. For he was a gentleman amateur who took delight in exercising the mechanical arts with his own hands. Carducho tells us that he had studied drawing, then and later the acknowledged foundation of the arts, for some years, and that his genius inclined him 'to make with his hands things that are scientific and of superior learning, and especially clocks, with such excellency that Ptolemy and Vitruvius might have improved their science had they had the good fortune to behold them'.

Carducho mentions a goodly number of other collections of paintings. He himself, as a Florentine, naturally favoured the Italian taste, but that for Flemish art still persisted: the pictures in the collection of the great satirist Quevedo, for example, were mostly Netherlandish. Carducho's account of the great collections of Madrid naturally culminates in his description of the architecture, decoration and paintings of the royal palace, as was only right and proper under a king like Philip IV, whose excellent taste as collector and patron ministered to his insatiable appetite for works of art. But more to our purpose is the last collection he describes, that of Don Juan de Espina, a learned ecclesiastic. Balthasar Gracián, who visited his museum in 1640, described him to his friend Lastanosa, a fellow-collector, as a Stoic, and lightly satirizes his credulity as a collector in the third part of *El Criticón* (1656). Espina owned two books of drawings by Leonardo – probably those recently discovered in the Biblioteca Nacional, Madrid – as well as many fine paintings. But Don Juan also delighted in that curious workmanship which as we have already noted was so dear to Mannerist and Baroque taste. 'He has things in ivory', exclaims Carducho, 'of such delicacy that the eye can scarcely perceive them, or the judgement of man divine the fashion that was used to make such tiny things, that seem to exceed what Galen wrote about having seen a Phaeton drawn by four horses carved in a ring, in which the reins, trappings and all other things pertaining to the car could be seen distinctly.' Yet in the end Carducho feels such curiosities to be works merely of skill with tools and of endless phlegm in the workman, but plainly Espina, like many other Baroque collectors, would never have agreed with him.

The various tastes in collecting illustrated from Carducho will readily be recognized as typical of the early seventeenth century throughout Europe. We have little information on collections elsewhere in Spain, except, as we shall see, in Aragon. Indeed if we turn to the 'Roolle des principaux cabinets curieux et autres choses remarquables qui se voyent en principales villes de l'Europe' at the end of Pierre Borel's *Antiquitez de Castres* (1649), we find hardly any Spanish collections mentioned. Borel cites the cabinets of the 'Hermit of Targos' in Catalonia – surely the most mysterious of all seventeenth-century collectors of curiosities – that of Alfonso Pérez, a professor of philosophy in the University of

Barcelona, and those of Don Francisco Ximenes de Urrea of Zaragoza and of a painter he calls Ribaldo of Valencia, perhaps the famous painter Francesco Ribalta or his son, both of whom, however, had died twenty years before.

The name of Ximenez de Urrea introduces us to that circle of erudite Aragonese gravitating around Zaragoza, the capital of Aragon, and Huesca, its second city, whose major distinction is that it produced in the Jesuit Balthasar Gracián one of the greatest figures of the European literary Baroque, and in Gracián's friend and patron Don Vicencio Juan de Lastanosa of Huesca (1607–84) the most interesting and remarkable collector of seventeenth-century Spain.[3]

The grand progenitor of this revival of antiquarian studies in Aragon was the inheritor of a family tradition of learning, Gaspar Galcerán de Gurrea Aragoń y Pino (14 November 1584–13 July 1638), Conde de Guimerá.[4] The grandson on the maternal side of Martiń de Gurrea y Aragón, Duque de Villahermosa, whose medals he seems to have acquired, he was of partly royal descent. As a young man of about twenty-three he founded in 1608 at his summer residence an Academy called *Pitima contra la ociosidad* (Plaster against Idleness) which he shortly afterwards transferred to Zaragoza. At its first session he read a discourse on Agustín's *Dialogos de Medallas*, which suggests that he had already begun his great collection of Celtiberian, Roman and Imperial coins and medals, of cameos, of pottery from Saguntum and elsewhere, of casts or models of ancient sculptures, and of fragments of mosaics. To the study of Aragonese and Catalan medieval coins he was ardently attached for the light they threw on the history of his native kingdom. In addition he had a fine collection of paintings and a large and important library of works on history and archaeology, including a copy of his grandfather's *Discursos de medallas y antiguedades*. He shared the consuming passion of every Spanish antiquary for genealogy and heraldry, especially for his own family's, and had a fine collection of illuminated heraldic manuscripts. According to his younger friend and follower Lastanosa, into whose hands many of his objects, books and manuscripts came by purchase after his death, 'he assembled the largest number of statues, inscriptions, coins and ring-stones that have ever been seen in the possession of a private person.' Guimerá applied himself with particular zeal to deciphering the inscriptions on Iberian coins, a task not satisfactorily completed even today. This pursuit which he passed on to Lastanosa, as we shall see, no doubt led to his general interest in alphabets of all kinds, another taste which Lastanosa certainly caught from him. Indeed Guimerá compiled a five-volume manuscript entitled *Cronografía y cosmografía de la invención de los inventores de las letras*. As an aid to his work of decipherment of Iberian inscriptions 'he assembled a huge number of ancient coins, written in the said language in unknown characters.'

His death at the age of fifty-three cut short the researches of an antiquary whose diligence in enquiry and collecting heralds a more scientific approach to the study of ancient and medieval Spanish antiquity. The only visible record of the impulse he gave to these studies is Lastanosa's publications on Celtiberian and medieval Aragonese coins. But in his lifetime he was an indefatigable antiquary, as the fifty-one letters he exchanged

[3] For learning and collecting in seventeenth-century Aragon, see Arco y Garay 1950.

[4] For the Conde de Guimerá, see Arco y Garay 1913.

with Lastanosa between June 1631 and November 1638 amply prove. From these we get a vivid impression of a world of primitive archaeology. In a letter of 1632 he notes that Lastanosa has got a sword from a tomb at Grañen: though broken by the peasants, Lastanosa was right to collect its pieces, and he regrets that he did not obtain the shield, which had begun to appear under the spade, and suggests that other tombs should be opened. He also collected eagerly on all his travels: thus in 1632 he mentions a large Roman búcaro he has purchased which is in perfect state, together with 'other things of great antiquity I have picked up on this journey.' Not content with purchases, he employed the painters Jusepe Martínez and Pedro Orfelin of Zaragoza to make drawings of antiquities and monuments in Aragon, and was perpetually badgering Lastanosa for views and plans of the monuments of Lastanosa's native city of Huesca. Indeed he was ardent in the pursuit of all antiquities that took his fancy: on hearing of a bronze Neptune which was for sale in Nîmes, and which had allegedly found its way to France from the Medici collections, he was at the expense of sending a gentleman of his household there for the sole purpose of acquiring it for his collection. Like so many Baroque virtuosi, he was a devotee of the emblem; he composed *Emblemas Morales*, which still survive in manuscript, and when Lastanosa devised an *impresa* (device) for himself in 1635, he treated it to some sharp criticism, as fitter for a Capuchin than a gentleman.

Many of his antiquities passed into the collection of Francisco Ximénez de Urrea (1589–1647), among them a red vessel found at Mallén 'in the form of a bowl, without handles, of a largish size, with different designs on it, and a band near its base with many hares all round it in relief, and inside were fourteen silver and copper medals of Vespasian, Titus and other Emperors'. Like Don Juan de Espina, Ximénez de Urrea was an ecclesiastic, and he spent his revenues just as eagerly on collecting a library and museum, corresponding with François Filhol, an antiquary of Toulouse greatly admired by all this learned circle of Aragonese, in an effort to procure books from France. His library reached a total of some 8,000 volumes, and his Punic, Greek and Roman medals, into which he absorbed the collections of Villahermosa and Guimerá, eventually numbered more than 6,000. He shared the interest of Guimera and Lastanosa in Iberian coins and their mysteries and wrote a discourse on them which was printed in Lastanosa's *Museo de medallas desconcidas* and is his only published work. He also owned mathematical instruments, but as official chronicler of Aragon from 1630 his interests were principally historical, and he compiled many manuscripts on the history and antiquities of Aragon.

This Aragonese circle of learned antiquaries pursued its studies independently of Madrid and sought no patronage from the court. It has been called a provincial circle, but Baroque culture, like that of the Enlightenment, possessed the power, not shared by all cultures, of igniting intellectual, learned and literary life even in quite small urban centres. Moreover a philosophy of retreat from the world, from its deceptions, perturbations and illusions, certainly inspired some of the circle, not least Lastanosa himself, for all that he formed the one Spanish collection which had something of a European reputation in its own day and the only one of which we possess detailed descriptions. In 1662 he told a monk who came to Huesca to see his collection that 'curiosity is a virtue and quality in gentlemen who profess to live a retired life, employed in

some honourable exercise.' Yet we should not exaggerate Lastanosa's retirement. In his day Huesca, though small, with a population of only some 5,000 souls, was not only the second city of Aragon, but had a more important university than Zaragoza, the capital. It also had a Jesuit college where Gracián resided from the summer of 1636 to the end of 1639 and again from late 1646 to late 1651, and a cathedral chapter which included men of learning and culture, among them Lastanosa's brother, Juan Orencio, himself an amateur artist. A literary academy in the city, already in existence in 1595, was revived by Lastanosa himself in the middle of the century.

Lastanosa was born in Huesca of a noble Aragonese family distinguished for its loyalty to the crown and by the high court offices it had held: his father was General de las Galeras under Philip III.[5] He was born in the family house, overlooking the Coso or principal street of Huesca, a house which his collections were to make famous in the seventeenth century. He seems to have imbibed his taste for literature, learning and the sciences from his tutor Canon Francisco Antonio Fuser, who was a preacher of repute in an age when pulpit oratory was a much appreciated form of eloquence, a poet, a musician, a mathematician and a gifted painter. Lastanosa's son Don Vicencio declares in a posthumous eulogy that his father's early accession to the obligations of head of his house on his own father's death wrenched him from his education and was adverse to his pursuit of the sciences. 'But they were unable to rob him of his affection for them', and in proof he cites the various books his father wrote. These show that for Lastanosa, as for all Spanish antiquaries, the study of antique coins and medals and gems was the prime branch of erudition, because of their importance as illustrations of antiquity, classical or national. As an ardent patriot his own preference went to the study of Spanish medals and coins. His first published work, the *Museo de las medallas desconocidas de España* (Huesca, 1645) is modest in its scholarly claims, pretending to do no more than publish the Iberian coins in his collections and in those of his friends in Zaragoza 'in order to present the Republic of letters with the ancient Trophies and certain memorials of Spain' and to incite 'learned and subtle wits' to take up their pens and 'illustrate the subjects presented to them'. The book then is essentially a collection of engraved plates of medals, with a text that is a series of catalogue entries. Nevertheless it has a signal importance because Lastanosa added details of provenance and notes on subject-matter, and because it was a prime step in defining a corpus of Iberian coins. Modestly but sensibly he refutes Worm and other Scandinavian scholars who had claimed a Gothic origin for the Iberian characters. The *Museo* seems to have been compiled from *c.*1643 onwards, contemporaneously with *La Dactylotheca* (now lost), a study of the ancient gems in his collection, of their use as talismans, and of the devices, portraits and figures cut on them.

[5] For Lastanosa, see Arco y Garay 1934. This is really an invaluable accumulation of materials rather than an analytical study, and reprints material and studies published earlier by Arco y Garay, notably in *Boletín de la Real Academia de la Historia* 56 (1910), pp. 301–37, 387–427, 506–24, which should also be consulted (reprinted as *Don Vicencio Juan de Lastanosa. Apuntes bio-bibliográficos*, 1911). Arco y Garay 1934 prints (pp. 199–215) the analysis of the catalogue of 1635 which was made in 1769 by the local antiquary Felix de Latassa y Orlín for his manuscript *Memorias literarias de Aragon*, an analysis of the description of 1639 (pp. 215–21), the *Descripciones de los jardines y casa de D. Vicencio Juan de Lastanosa*, by Andrés de Uztarroz (pp. 221–51) and Lastanosa's own *Narración de lo que le pasó a D. Vicencio Lastanosa a 15 de Octubre del año 1662 con un religioso docto y grave* (pp. 252–75). Lastanosa's description of 1639 is printed in full from the fragmentary manuscript in the Biblioteca Nacional, Madrid (1872745) by Coster, 1912. A catalogue of his library is printed in Selig 1960. Lastanosa naturally figures large in the literature of Gracián.

Lastanosa's only other published work, the *Tratado de la moneda jaquesa* (Zaragoza, 1681) is a product of his Aragonese patriotism, for it is a history of the coinage of Aragon illustrated with plates of coins in his collection made by an engraver of Huesca named Artiga. It was published at the request of the Diputados of Aragon, and in obedience to their urgent prayer Lastanosa gave all the manuscripts and all the coins which he had collected to illustrate the subject to the Archivio of Aragon.

Like a true Spanish antiquary he found the study of genealogy absorbing, and in 1631 compiled that of his own family. His one scientific work was a translation, now lost, of the *Elements de Chymie* of Jean Beguin, which was first published in Latin in 1610 as the *Tyrocinium chymicum*, and went through many editions in French from 1615 to 1665. Presumably Lastanosa made his translation from the edition of Rouen (1647) which was in his library. Its date is a pointer to that increased enthusiasm for alchemical and astrological studies and for enquiry into the secrets of nature which he seems to have begun to feel in the 1650s. Although Beguin's book has a leaning to alchemy, it is essentially an elementary manual of chemical remedies and receipts, and as such was in opposition to the traditional pharmacopeia of the Paris faculty of medicine. Originally Lastanosa must have been interested in it for its practical value and the 'secrets' which it contained, for although he owned a number of alchemical books, he disliked the art. His hostility to the practice of alchemy proceeded from the disinterestedness he thought proper to a gentleman, who ought to be above the pursuit of riches. Believing that pursuit to be the sole end of alchemy, 'I ever neglected it, scorning this means of heaping up treasures, though I have had great opportunities of coming to a knowledge of this prodigious art.' About 1658 his attitude was changed by the appearance of a learned Neapolitan alchemist Dr Natale Baronio, who came to Huesca especially to visit him. At first Lastanosa would have nothing to do with him, but when Baronio assured him that he was a priest, a theologian and a physician, and that the sole end of his chemistry was to improve health and prolong life though the use of his potable gold, his potable silver, his quintessence and his salts and compounds extracted from pearls, coral, amber and gold, Lastanosa took him into his household. He must have felt that he ran no risk of being duped, for Baronio declared that he would ask him for no gold, which he could get from the earth beneath their feet.

Besides being a collector, Lastanosa was a Maecenas, whose pride and pleasure was the encouragement of literature and learning. He offered to publish at his own expense any essays illustrating ancient Spanish medals which his *Museo* might inspire, and his sincerity in this offer is proved by his generous patronage of Gracián, nine of whose works he had printed and published in Huesca from 1637 to 1653, and of Juan Francisco Andrés, two of whose works he also had printed and published. His own taste in literature was what might be expected of an admirer of Gracián: he revered the *culteranismo* of Góngora, and the laconic *conceptismo* of Gracián himself. In other words he admired literary works in learned, pregnant, witty and conceited styles, written for an audience fit but few. He was himself an amateur painter, as was his daughter Ana, and paintings he had executed of 'various perspectives and ruins' and of works in miniature could still be seen in his house in the early nineteenth century. The painter Valentín Carderera, who records this, hints

politely that they were indeed the work of an amateur, but mentions with praise a self-portrait by Doña Ana and one by her husband Don Fernando Luis Climent which bore an inscription declaring that 'he too practised the art of painting'. Lastanosa and his circle shared then the enthusiasm of the cultivated Baroque gentleman for the exercise of painting. He was also a patron and a protector of artists, among them the painter Jusepe Martinez of Zaragoza and the local engraver and poet Jerońimo Aguesca and his family. In addition, he took into his house 'divers men who professed various sciences and arts, without scorning either the naked pilgrim or the barefoot traveller'.

His son adds that 'his love of letters and inclination to the arts and universal affection for all the mechanical arts and for curiosities' did not prevent him from serving his King and country. In reality Lastanosa seems to have interpreted his ideal of studious retreat as excluding all aspiration to high office or court favour, such as his family had so long enjoyed. But he did not conceive it as exonerating him from the local responsibilities to which he was called by his rank and standing in Huesca. He attended the Cortes of Aragon as a nobleman of Aragon, and served as a *regidor* of the *consejo* of Huesca, in which capacity he took command in 1641 of a company of infantry and bravely defended the approaches to Huesca against the invading French. In 1652 and 1653 he was *regidor* of the Hospital, an important office during which he had to take measures against a serious outbreak of plague. After 1654, however, he ceased to hold any municipal office, giving himself up wholly to his studies and to his collection.

To the great world and to its illusions, as we have seen, he was indifferent, probably by reason of the Neo-Stoicism which we know to have been his creed. Of a visit to Madrid in 1676 he writes: 'without listening to complaints, or taking notice of prognostics, monstrous abortions, political discourses or shameless libels, I betook myself to the conversation of men of virtuous inclinations.' Lastanosa generally appears in a most favourable light in the writings of his contemporaries. True it is that an anonymous Valencian, provoked by Gracián's satirical references to his native city in the third part of *El Criticón* (1657), insinuated in 1658 in reply that in the chapter of his novel describing the marvels of Lastanosa's collection Gracián had omitted to number among his patron's talents 'the art of executing wills, so that he who has not a penny of his own can raise prodigious fabrics'. But this seems to be nothing more than rancorous calumny or jealous small-town gossip: all his known actions reveal Lastanosa as generous and charitable, a loyal friend and patron, always happy to exhibit his collection and house to all who desired to see them. In an inscription composed in 1681 to honour him, his old friend Dr Diego Vincencio de Vidania, a professor of the University of Huesca calls him

'dedicated from infancy to the Muses, excellent in mathematics and painting, celebrated for the medals and unknown coins he has published and for those that together with antique rings, stones and cameos will give light to the shadows of the past, learned in alchemy and other arts, in peace a prudent Councillor and First Consul, in the wars of Catalonia a valiant Captain, in a time of plague and travail the first to assist his native place. He denied access to desire and ambition in his felicity. His house is a hospice for students and strangers. His liberality makes his riches common to all.

Already as a very young man Lastanosa must have conceived the notion of building a

splendid palace which was to be sumptuously furnished and decorated, to house a great collection of works of art and curiosities and to have beautiful gardens. The first step in this project of embellishing his retreat from the world seems to have been the reconstruction of his family house on the Coso. There are copies of the ground-plans in the description he wrote of it in 1639, and as he took a Neapolitan sculptor into his service in 1631 to make sculptures for the house and gardens we can assume that by that date the structure was more or less complete. Owing to the loss of the first pages of the description of 1639, we have to depend on a prose description by the historian Uztarroz, written *c*.1650, for an impression of its external appearance. Uztarroz tells us that it was of plastered brick and of two principal storeys. The façade was decorated on the first storey with projecting balconies, painted black and gold, and with stucco pilasters, ornamented with grotesques, supporting an architrave, frieze and cornice. In the south corner rose a square tower, topped by a colossal figure in sheet lead of Hercules supporting the globe, one of Lastanosa's devices and the theme of a *Romance jocoso a la desnudez de la estatua de Alcides* written by Uztarroz in 1646. The windows, Uztarroz notes with pride, were of glass. A curiosity of the house was its orientation to face the rising sun, so that in its course throughout the year its rays successively struck all the windows of the facade, marking each day the direction in which it would rise on the following day.

Lastanosa's house and collections had already achieved some celebrity by 1631, when Gaston d'Orléans, the brother of Louis XIII and himself an ardent collector of medals, pictures, and natural and artificial curiosities, wrote to him for the first time with a flattering request for drawings of the sculptures in his house. By 1635 it had become a typical learned Baroque museum, of which a library, let it never be forgotten, was a principal part – Lastanosa himself says of his medals in the *Museo* that they are kept in his Library. By now Lastanosa had compiled a catalogue of his collection, and thinking of perhaps printing it, sent it to his friend the Conde de Guimerá for his revision. The Conde sent him suggestions in a letter of 9 August 1635, adding that Lastanosa ought to incorporate them in the work 'since you are such a friend to having all things in perfection.' This catalogue or *Indice* is now known to us only from an analysis made by the eighteenth-century Aragonese antiquary Latassa.

In 1639 Lastanosa wrote a description of his house and collections, in itself a sign of the wide interest they were now exciting, an interest which the list of distinguished visitors proudly appended to it confirms. A few years later a verse description and eulogy of its marvels was composed by one of his greatest friends, Juan Francisco Andreas de Uztarroz (1605–53) the official chronicler of Aragon. This verse description was printed in 1647 and evidently served as a souvenir for visitors and to satisfy the requests from the curious for an account of the museum. For in 1682 Lastanosa's son Vicencio Antonio records that as the 2,000 copies printed were now exhausted he was proposing to print in its stead the long prose description of the collection composed by Uztarroz. This scheme never took effect. Finally Lastanosa himself wrote a second brief relation of it couched in the form of a conversation with a monk who came to visit it on 12 October 1662. In consequence of these descriptions we know more of the arrangement of Lastanosa's museum than of that of any other seventeenth-century museum.

How did Lastanosa accumulate his vast collections? Purchase from the collections of other, usually deceased collectors certainly accounted for many objects, and inheritance for others. The large sculptures were certainly direct commissions and this was probably true of a number of the paintings. Clearly quite a number of the books came from Paris, as they were proudly said to be in Parisian bindings. In 1633 we find Lastanosa negotiating for the purchase of books from the library of the lately deceased Don Gabriel Sora of Zaragoza, and buying maps, engravings, pictures and other things, apparently through the agency of Jusepe Martínez. For until the appearance of the scholar-connoisseur it was the custom to trust the judgement of artists in making purchases of works of art. And the role of gifts, always significant in Late Renaissance and Baroque diplomatic, courtly and formal exchanges, was as important in the formation of Lastanosa's collection as in that of other collections of the time. Sometimes collectors gave pieces: visitors to the collection who were possessed of objects of interest seem often to have presented them as a token of the pleasure they had received from what they saw or in order to add to its range, perhaps genuinely feeling that they would be seen and appreciated to better advantage in Lastanosa's house.

Thus on 8 April 1636 Don Bernardino Fernández de Velasco, Constable of Castile, writing to thank Lastanosa for a fifteen days' stay in his house, declared himself 'overwhelmed at having seen all the splendours of Your Lordship's house, as much in books as in jewels of the greatest richness, cupboards, statues, paintings, medals, arms, gardens, grottoes, pools.' He had spent most of his time in the library 'where there was so much to admire: even for a Monarch it would be a task to assemble such an accumulation of things from such remote parts, since many thousands of doubloons must have been spent on the carriage alone.' He announced that he was sending Lastanosa 250 gold medals, the latest in date being of the reign of Tiberius, and 325 silver ones for his collection. 'My father had them. I know not where he kept them. Here they are stored and no one sees them; in your house they will be seen by many of our countrymen and by strangers'. For the Armoury, a section of the collection in which Lastanosa took the greatest pride, he sent a coat of mail 'made of fine iron network, covered with ornaments of another in gold, making a most beautiful net' and 'a shield of cast steel with the arms of the royal house of Aragon' which had been won by Lastanosa's great-uncle, Don Pedro, Count of Varadin, at the battle of Mühlberg in 1547 when he captured Johann Friedrich, Duke of Saxony.

Others sent smaller gifts – from the Venetian nobleman Camillo Locauni came chemical and alchemical books, from the collector François Filhol of Toulouse bulbs and seeds, and from the Bolognese nobleman Vincenzo Marescotti, Roman medals and antiquities. On occasion the gifts were recent discoveries, like the 'three sherds of red ware and some medals' which were found in Tarragona while Gracián was rector of the Jesuit college there and sent by him to Lastanosa. Most prized of all were the gifts which had been sent by Gaston d'Orléans. Many of these gifts were in fact an expression of the network of friendships and mutual esteem which linked together the whole learned and antiquarian world of the seventeenth century. Into that network Lastanosa was very closely entwined: like all his kind, he depended heavily on correspondence with other

antiquaries, scholars and collectors for services of various kinds, drawings of monuments and objects, political news, the gossip of the learned and literary world. Correspondence was all-important to those who lived in provincial cities, where it was hard without it to keep abreast of new discoveries, new books, new thoughts. To men who felt themselves to be living in intellectual isolation, like the Andalusian antiquary Rodrigo Caro (1573–1647), letters brought refreshment and encouragement. In 1644 Caro wrote to Lastanosa from the once brilliant city of Seville lamenting that 'I know not if you will find here in these unhappy times three men who occupy themselves with these studies . . . of the glorious dust of antiquity.'

THE CABINET OF CURIOSITIES IN SEVENTEENTH-CENTURY BRITAIN

Arthur MacGregor

There can be no disputing the assertion that Continental collectors of rarities provided the setting against which corresponding collections in Britain were to develop. Yet there are difficulties in making very direct comparisons between the more-or-less rigorously ordered and hierarchical collections which account for many of those described elsewhere in this volume and the seemingly rather diffuse collections which are more characteristic of the British Isles. Whether this implies that British collectors were more simply 'curious' and less ambitious in their scientific or didactic purposes than their Continental counterparts, or whether the lack of recorded detail about most of them merely prevents the kind of close scrutiny which has been turned on the Continental cabinets, seems at least arguable. Again, while scholarly collectors can be found in Britain to match those on the Continent, there is a general absence of princely interest in the curious: the tastes of the earliest noble collectors in Britain were tuned to the fine arts rather than to rarities and curiosities of art and nature.[1] This is not to say that they led the way in what was later to become the norm, but they may claim to have been in the vanguard of the movement. Their apparent precociousness, however, was emphasized by the fact that by the time they responded to and became enthusiastic proponents of the Continental (and particularly the Italian) collecting fashion, the most enlightened of the Continental nobility were already turning their attention from the cabinet to the gallery. Nowhere in sixteenth-century England was there to be found any collection remotely comparable to those of Cosimo de' Medici, Ferdinand of Tyrol or Augustus of Saxony. When Horace Walpole applied the epithet 'the father of Vertu in England' to Thomas Howard, Earl of Arundel (1585–1646), his chronology was faultless.

The beginnings of curiosity collecting in Britain took shape lower down the social scale, and even there they came late. A nascent antiquarian interest can be detected in the foundation of the Elizabethan College of Antiquaries,[2] for example, and in the publication of William Camden's *Britannia*.[3] Camden himself is known to have been involved in collecting only to the extent that he accompanied his intimate friend, Robert (later Sir Robert) Cotton (1571–1631) on a tour to Carlisle and the northern counties of England in

[1] In 1599 Thomas Platter was shown at Windsor Castle a chest containing richly embroidered cushions, an entire bird of paradise, and a 'unicorn horn' (Williams 1937, pp. 214–15). Although the latter item (reputed to have been acquired from Arabia by Henry VIII) was of the greatest rarity, the chest and its contents can hardly be said to have constituted a cabinet.

[2] Norden 1946.

[3] Camden's pioneering survey was first published in 1586 and so well was it received that by 1600 it had reached its fifth edition. For an appraisal of the author and his work, see Piggott 1976, pp. 33–53.

1599, an expedition which resulted in a number of Roman and Pictish antiquities being carried off for Cotton's collection.[4] Although Cotton's cabinet contained numerous coins and medals as well as antiquities and natural curiosities,[5] his particular passion was undoubtedly for manuscripts: the vast numbers of items in his library far outweighed in significance the contents of his cabinet of rarities. Hence, although he is counted among the founders of the British Museum, Cotton ranks more strictly as a principal benefactor of the British Library.

Among Cotton's acquaintances was to be found a figure who represents more characteristically the earliest English collectors, namely Walter (later Sir Walter) Cope (d. 1614). Cope's collection is the first for which accounts survive in any detail. The earliest of these was left by the Swiss Thomas Platter in 1599,[6] who noted that although Cope was not the only collector then active in London, he was none the less by far the most superior for strange objects on account of an 'Indian voyage' which he had undertaken. Fifty items or categories of exhibit, mostly ethnological and zoological, were selected for particular note by Platter, all displayed in 'an apartment, stuffed with queer foreign objects in every corner'. A large part of the known world was represented: Virginian fire-flies and an 'Indian' canoe,[7] an African amulet made of teeth, cloaks and coats from Arabia, an Egyptian mummy, clothing, porcelain and other items from China, and a Javanese costume. There were numerous weapons and implements and a collection of saddles, musical instruments, holy relics and heathen idols.

Amongst the *naturalia* a strong preference for the more fabled specimens can be detected: alongside a hairy caterpillar, a sea mouse, and the horn and tail of a rhinoceros, were exhibited a unicorn's tail, a remora and a torpedo,[8] while Platter's account of the beak of a pelican is accompanied by reference to its alleged practice of killing its young and restoring them again with blood from its own breast. 'Old heathen coins, fine pictures, all kinds of coral and sea-plants in abundance' were added by Platter to his more detailed list of Cope's rarities, and further items were identified by a later visitor to 'Cope Castle'. This was Frederic Gerschow, who arrived in the company of his master, Philipp Julius, Duke of Stettin-Pomerania, in 1602, and who was charged by him to make careful note of all he saw.[9] Amongst the 'great many wonderful objects' which caught Gerschow's eye were 'some crowns worn by the Queen in America . . . a little Indian bird phosphorescent by night . . . many Indian manuscripts and books, a passport given by the King of Peru to the English, neatly written on wood, various strange cucumber plants . . .' Gerschow further mentions that Cope spent 'a good deal on artistic paintings; some of them had cost not less than fifty or eighty crowns.' If Cope himself felt that his collection

[4] Edwards 1870, p. 54; Mirrlees 1962, pp. 83–5.

[5] For Cotton's coins and medals, see Mirrlees 1962, p. 72. Cotton was also involved in founding a royal coin cabinet (Piggott 1976, p. 12). For mention of the antiquities in Cotton's collection, see below. Among his natural curiosities was a fossil 'fish' (sic.) 'near XX feet long, as was then conjectured', discovered on his estate at the edge of Connington Down (Mirrlees 1962, p. 76), and the 'toung of a fish which tyme hath converted into stone', sent from the Netherlands by Richard Verstegan (Ellis 1843, pp. 107–8). See also p. 207, below.

[6] Williams 1937, pp. 171–3. Thomas Platter was the brother of Felix Platter, whose collection is discussed on p. 65.

[7] Cope apparently witnessed a demonstration on the Thames in September 1603, when a number of 'Virginians' showed off their paces with a canoe (Quinn 1970). I am grateful to Dr George Hamel for this reference.

[8] The remora is described as 'a little fish which holds up or hinders boats from sailing when it touches them' and the torpedo is credited with the power of petrifying the crew's hands if it so much as touches the oars.

[9] Bülow 1892, pp. 2, 24–7.

had a weakness it was evidently in antiquities, for on the occasion of a third visit, from Christian IV of Denmark, he felt obliged to borrow some items from Cotton to boost his own holdings.[10]

In the diversity of its elements, Cope's collection reflects something of the character of contemporary Continental cabinets and foreshadows many standard features of later English collections, including that of the Tradescants at Lambeth.[11] It has been shown elsewhere[12] that John Tradescant the elder (d. 1638), founder of the famous collection known as 'The Ark' at Lambeth, knew Cope and probably knew his museum, which may have provided a model for Tradescant's own cabinet. Many points in common can be found between the two collections. The opportunity for personal enterprise in collecting, provided in Cope's case by his voyage to the Indies, came to Tradescant in the form of several visits to the Continental mainland. A number of these were to the Low Countries and to France and were principally concerned with the purchase of plants for the gardens of his various employers. Amongst the places visited on one of these occasions in 1611 was Leiden, where the cabinet of the Anatomy School may well have provided a further inspiration for the museum which Tradescant was later to found. In 1618 he was released from his employment to accompany an embassy to the Duke of Muscovy, sailing from Gravesend round the North Cape of Norway to Archangel. To judge from the diary kept by Tradescant on this occasion, his duties were negligible and there were ample opportunities for botanical fieldwork. No artificial rarities are recorded as having been brought back on that occasion, though some which still survive may have been collected then. Leave of absence was again granted to Tradescant in 1620–21, when he joined the British fleet sent to blockade the port of Algiers: we know from botanical records that he spent some time ashore on the Barbary coast, bringing back to England the Algiers apricot and no doubt much else besides.

In 1623 Tradescant transferred his allegiance to a new and powerful patron, George Villiers, the Duke of Buckingham. Under Buckingham's patronage Tradescant's horizons were expanded beyond the scope of his own travels, when the Duke himself seems to have been stimulated to take some interest in rarities. This at least is the implication of a letter written in Buckingham's name by Tradescant in 1625 and addressed to Edward Nicholas, Secretary to the Navy:[13]

Noble Sir

I have Bin Commanded By My Lord to Let Yr Worshipe Understand that It Is H Graces Plesure that you should In His Name Deall withe All Marchants from All Places But Espetially the Virgine & Bermewde & Newfownd Land Men that when they Into those Parts that they will take Care to furnishe His Grace Withe All maner of Beasts & fowells and Birds Alyve or If Not Withe Heads Horns Beaks Clawes Skins Fethers Slipes or Seeds Plants Trees or Shrubs Also from Gine or Binne or Senego Turkye Espetially to Sir Thomas Rowe Who is Leger At Constantinoble Also to Captain Northe to the New Plantation towards the Amasonians With All thes fore Resyted

[10] Mirrlees 1962, pp. 73–4.
[11] MacGregor 1983.
[12] Ibid., p. 18.

[13] Public Record Office, London, State Papers Domestic, Charles I, iv, 1625, nos. 155–6. The full text, together with an appended list giving more detailed requirements, is reproduced in MacGregor 1983, pp. 19–20.

Rarityes & Also from the East Indes Withe Shells Stones Bones Egge-shells Withe What Cannot Come Alive . . .

There appears to be no other record of any interest in material of this kind by the Duke of Buckingham, and it seems likely that he merely gave his name to the letter out of generosity to Tradescant. The effect appears to have been the same in any case, for among the recorded benefactors of Tradescant's museum are a great many with proven links with or indebtedness to Buckingham's circle.

Following Buckingham's assassination in 1628, Tradescant settled his family in the house at Lambeth which was to become internationally famous as The Ark. Even after Tradescant's appointment in 1630 as Keeper of His Majesty's Gardens, Vines and Silkworms at Oatlands Palace, he maintained the property at Lambeth and developed his museum there. By 1634 it had already reached such a size that a superficial examination of its contents took Peter Mundy a whole day.[14] To judge from Mundy's description, the character of the collection was already well formed, and he found himself 'almost persuaded a Man might in one daye behold and collecte into one place more Curiosities than hee should see if hee spent all his life in Travell.'

Four years later a more lengthy account of the collection was compiled by Georg Christoph Stirn, when he visited Lambeth in 1638.[15] From this we learn that 'the robe of the King of Virginia' – 'Powhatan's Mantle', the most important item surviving in the Tradescant collection – was already in the museum at this date. Stirn's visit to The Ark fell in the year of Tradescant's death, when the entire collection passed by bequest to his son of the same name. The younger Tradescant (1608–62), who had also trained as a gardener, seems to have augmented the museum with his own travels, for in 1637 he was reported to be in Virginia on the first of three such visits, 'to gather all rarities of flowers, plants, shells, etc.'.[16] Sadly, it is impossible to attribute with certainty to these visits any of the American items surviving in the Tradescant collection. Both the size and character of the Tradescant collection seems largely to have been determined by the father and there are few indications of what specifically was contributed by the son. In the preface to the catalogue, however, Tradescant the younger refers to 'those rarities and curiosities which my father collected and my selfe with continued diligence have augmented and preserved together'.[17] He also continued to display the rarities to the public and to attract foreign visitors such as Rasmus Bartholin who, in a letter to Olaus Worm dated 1647, compared what he saw at Lambeth unfavourably with Worm's own collection.[18]

More significant in some ways than these distinguished visitors were the ordinary people who flocked to see the collection for a fee – seemingly sixpence – for the Tradescants differed from the majority of their contemporaries – and indeed from every collector then known of in England – in the general accessibility of their collection. Most of these visitors no doubt saw the rarities in much the same light as had the founder of the collection – 'the Bigest that Can be Gotten . . . Any thing that Is strang'.

[14] Temple 1919, pp. 1–3.
[15] Bodleian Library, Oxford, MS Add. B67; Hager 1887; MacGregor 1983, p. 21.
[16] Public Record Office, London, State Papers, Colonial Series, 1574–1660, vol. 1, no. 11.
[17] Tradescant 1656, preface.
[18] Schepelern 1968, p. 273, no. 1536.

By the time a catalogue was prepared for publication in 1656, however, the utility as well as the richness of the collection was beginning to be acknowledged. In Tradescant the younger's introduction to the catalogue, he mentions that his collaborators, Elias Ashmole and Dr Thomas Wharton, had impressed him with the argument that 'the enumeration of these Rarities (being more for variety than any one place known in Europe could afford) would be an honour to our Nation, and a benefit to such ingenious persons as would become further enquirers into the various modes of Natures admirable workes, and the curious Imitators thereof.'[19] Tradescant was easily won over by this inducement, and so began 'many examinations of the materialls themselves', and an assessment of 'their agreements with severall Authors'. The sources cited in the text show that the compilers were conversant with the most significant and influential literature then circulating on the continent: classical writers such as Aristotle, Pliny and Dioscorides are quoted as authorities, but Aldrovandi, Rondelet, Bellon and Scaliger are also there; Piso and Markgraf's *Historia Naturalis Brasiliae* is extensively cited,[20] as is the enlarged second edition of Worm's catalogue, published only one year earlier.[21]

Two major divisions are recognized among the 'materialls' – the natural and the artificial. The first category is sub-divided into birds, four-footed beasts, fishes, shell creatures, insects, minerals and outlandish fruits. English names are given to these wherever possible: for others, notably the Brazilian specimens, no English term yet existed and local names are cited. Thus amongst the 'Divers sorts of strange Fishes' we find 'Guamajacu *ape* – Bras:*Margr*: 142', a specimen which still survives under the name *Ostracion trigonus* Bloch, the trigonal trunkfish (fig. 68).[22] Thirty pages are taken up by the *naturalia*, but the vagueness of some entries makes it impossible to estimate the precise numbers of specimens.

The second major category, the 'Artificialls', comprised utensils, household items, habits, instruments of war, rare curiosities of art, and coins and medals. Here are found many categories of material which were typical exhibits in Continental collections: cameos and intaglios, surgeons' implements made from the points of needles, a cherry stone holding 120 tortoiseshell combs, a nest of fifty-two wooden cups turned within each other, Egyptian, Roman and other antiquities, oriental calligraphy, American featherwork, and other ethnological material from every corner of the known world. The catalogue concludes with a hundred-page list of the plants growing in Tradescant's garden.

The utility of The Ark is again acknowledged in the records of specialist scholars who visited and made practical use of the collection. Thomas Johnson, for example, in revising Gerard's *Herball*, went there to view 'Indian morrice bells', made by inserting pebbles into the dried outer cases of fruits,[23] and John Ray's edition of Francis Willughby's *Ornithology* refers to rare birds examined in Tradescant's cabinet, including the dodo.[24]

The Tradescant collection achieved full recognition as a scientific resource after it was

[19] Tradescant 1656, preface.

[20] Dr Peter Whitehead has suggested (personal communication) that the relation of some specimens to Piso and Markgraf's *Historia* is so acute as to suggest that the Tradescants may have acquired the type specimens.

[21] Worm 1655.

[22] Gunther 1923–45, p. 366; see also below, p. 181.

[23] Johnson 1633, p. 1546.

[24] Ray 1678, p. 154.

inherited by deed of gift by Elias Ashmole (1617–92).[25] Ashmole was a man of considerable social standing: Comptroller of the Excise, Windsor Herald, an astrologer consulted by the King, author of several historical and alchemical works and a founder-member of the Royal Society. He was also a collector in his own right, principally of books, manuscripts, coins and medals, though he also possessed a number of rarities, including a collection of prehistoric flint implements.[26] When the Tradescant collection came into his possession, however, he resolved to make a gift of it to the University of Oxford, where he had studied briefly, had prepared a catalogue of the Roman coins in the Bodleian Library cabinet, and had been rewarded with a doctorate for his pains. His reasons for making the foundation gift for the Museum which was to bear his name (fig. 58), were set out in the preamble to the regulations for the museum of 1686:[27]

Because the knowledge of Nature is very necessarie to humaine life, health, & the conveniences thereof, & because that knowledge cannot be soe well & usefully attain'd, except the history of Nature be knowne & considered; and to this [end], is requisite the inspection of Particulars, especially those as are extraordinary in their Fabrick, or useful in Medicine, or applied to Manufacture or Trade: I Elias Ashmole, out of my affection to this sort of Learning, wherein my self have taken & still doe take the greatest delight; for which cause alsoe, I have amass'd together great variety of natural Concretes & Bodies, & bestowed them on the University of Oxford, wherein my selfe have been a Student, & of which I have the honor to be a Member.

Despite the fact that the Ashmolean continued to attract hostility for some years to come from those members of the University who were not adherents of the 'new philosophy', and notwithstanding that it contained all the curious miscellanea which the Tradescants had gathered together with less than critical discrimination, it quickly became the principal focus of scientific effort in Oxford.[28] It should be noted that it was not the mere acquisition of a collection – any collection – which ensured this galvanizing effect: there had been a cabinet of rarities in the Bodleian Library almost since its foundation and there were several others in schools and colleges which had failed to exert the same influence (see p. 160). Of crucial importance to the Ashmolean's success were the laboratory and lecture hall (occupying the basement and ground floor respectively), which undoubtedly claimed more scientific interest than the museum itself (housed on the first floor).

The first two curators of the Ashmolean, Dr Robert Plot (who also held the chair of chemistry) and Edward Lhuyd, used the museum as a base for their innovative work in natural philosophy, drawing on the natural rarities to illustrate their theories and augmenting the collections with numerous specimens of their own gathering. The pieces illustrated in Lhuyd's pioneering *Lithophylacii Ichnographica Britannici*, for example, were all deposited in the Ashmolean, where they earned the particular approval of von Uffenbach during a visit in 1710.[29]

[25] Josten 1966.

[26] Ibid., vol. 2, p. 683; vol. 4, p. 1635. One of these, a Neolithic axe from Oldbury, was illustrated by Dugdale in his *Antiquities of Warwickshire* (vol. 2, p. 1081).

[27] Bodleian Library, Oxford, MS Bodley 594, p. 111; Josten 1966, vol. 4, p. 1745.

[28] See, for example, MacGregor and Turner, forthcoming.

[29] Uffenbach 1753–4, vol. 3, p. 128; Quarrell and Quarrell 1928, p. 49. The Ashmolean always enjoyed popularity with the wider public (who were from its earliest days admitted for sixpence) as well as the academic community: Uffenbach was not at all pleased to find it crowded with ordinary country folk on the occasion of his first visit.

The *Lithophylacii* was published in the final year of the seventeenth century. While Cope and later Tradescant had dominated the collecting scene in the early decades, the situation had changed radically by the time of the opening of the Ashmolean. For popular appeal the most enterprising collection had been that amassed 'with Great Industry, Cost and Thirty Years Travel in Foreign Countries' by Robert Hubert, alias Forges, and displayed by him in a house near St. Paul's cathedral.[30] There, according to a catalogue published in 1664, could be seen every afternoon 'that which hath been seen by those that are admirers of God's works in Nature, with other things that hath been seen by Emperors, Empresses, Kings and Queens and many other sovereign princes'. Hubert clearly made little academic claim for his collection although, as shown elsewhere (p. 163), it was destined to achieve some learned significance. A large part of its appeal lay in the fact that other more illustrious eyes had already savoured the items on view to the beholder. Some of these estimable princes are also named as benefactors to the museum: several members of the ruling households of Scandinavia, Germany and France are mentioned as donors, and so are Charles I and Charles II of Great Britain. Others recorded as former owners of exhibits include James I, the King of France, Cardinal Richelieu, Johan Maurits of Nassau, and the Duke of Florence. A gloss of academic respectability was provided by named university professors from Strasbourg, Heidelberg, Prague and Utrecht, and by a list of material displayed in the Anatomy School at Leiden which Hubert appended to his own for comparison. On the matter of public appeal Hubert clearly had nothing to learn from the Tradescants: 'The Gentlemen of these rarities', says the catalogue, 'can show thousands of other rarities of Nature besides the things aforementioned, to those that are more curious, and will be at some more charge: on Mondays & Thursdayes things of the sea; Tuesdays and Fridays things of the land; Wednesdays and Saturdays things of sea land and air'. Private parties and foreign ambassadors were catered for 'in three or four tongues'.[31]

Hubert's museum was by no means typical in its exuberant appeal to the masses, and up and down the country the majority of collectors went about their business more soberly and in private. One cabinet recently brought to light at Canterbury perfectly preserves the character of the more modest collections built up by citizens through personal enterprise and maintained for private diversion. It belonged to John Bargrave (1610–80),[32] a canon of Canterbury Cathedral who had, in his earlier years, attended the King's School there with his contemporary, John Tradescant the younger. Following the loss of his fellowship at Peterhouse, Cambridge, due to the high-church complexion of his religion, Bargrave had become a travelling tutor to a succession of young gentlemen embarking on the Grand Tour. His itinerant lifestyle and modest financial means regulated the character of his purchases: portability, not splendour, is the principal characteristic of the curiosities in the collection, all of which are contained in two small cabinets (fig. 59). The prime importance accorded to Italy in the Grand Tour is reflected in the collection, which includes figurines, gems and other antiquities, rock samples and other *naturalia*, paintings and manuscripts, and devotional souvenirs. The high

[30] Hubert n.d.; 1664.
[31] Hubert n.d., pp. 25–7.

[32] Robertson 1867; Sturdy and Henig 1983.

proportion of fake antiquities reflects the consideration already taken by Italian suppliers to accommodate the appetites of hungry collectors. Other rarities were evidently acquired *en route* to Italy – a fossil from Saumur, the finger of a Frenchman from Toulouse, a crystal from Simplon, and other natural and artificial curiosities. Bargrave also possessed several hundred coins, some antique and others current issues collected on his travels, as well as lead copies of plaquettes and medallions which were again specially made for the acquisitive tourist.

Non-European items in Bargrave's collection are much less numerous. Some of them derive directly or indirectly from an extraordinary mission undertaken by Bargrave in 1662 when, with funds which he personally had helped to raise, he sailed to Algiers to redeem 162 English captives held there for ransom. Amongst the souvenirs originating from that occasion were a chameleon (which was preserved after dying on the voyage home) and a portrait of the Bey of Algiers, painted for Bargrave by an Italian slave painter during the negotiations. A later acquisition to Bargrave's cabinet was a set of porcupine quill ornaments from north-eastern America, sent to him in gratitude by a merchant who had been among those rescued from Algiers.

The interests of some other collectors were more catholic than those of Bargrave, or at least were not constrained to the same extent by personal experience. Ralph Thoresby of Leeds (1658–1725), for example, owned an extensive cabinet of some quality,[33] which attracted the attention of contemporaries in London as in Oxford, where attempts were made to recruit him as a donor to the Ashmolean.[34] His collection included human, zoological, botanical and mineral curiosities, as well as coins and medals, manuscripts and autographs. Thoresby himself judged his museum to be 'chiefly noted for the great variety of Roman and Saxon coins', and these account for the bulk of the published catalogue. The human and animal curiosities have every appearance of having been acquired for their rarity value and not on an encyclopaedic or scientific basis: hence the remains of Egyptian and Roman burials are classed along with kidney stones and human (cutaneous) horns, while the animals are dominated by specimens remarkable for their size or curiosity. Only the mineral section displays a conspicuous attempt at classification, having been drawn up on the model of Lhuyd's *Lithophylacii*. At the dispersal sale of Thoresby's collection the coins and medals alone took two days to auction.[35] Manuscripts, autographs and letters were sold the next day, along with curiosities including the almost obligatory cherrystone and hazel-nut carvings, mementoes associated with members of the royal family, and 'sundry Romish relics'.

For all its remoteness, Scotland has always been as receptive to Continental influence as England and there too the fashion for curiosity collecting took root and flourished. One of the earliest collectors was Sir James Balfour (1600–57) who, having compiled a library of some distinction and of antiquarian flavour, and appreciating 'that things and events involved in obscurity are often illustrated by ancient coins, rings, seals and other remains

[33] Thoresby 1715.
[34] Hunter 1830, vol. 2, pp. 498–9: 'I was exceedingly courted by Dr Plot for some of my coins, and almost won upon by his most

obliging carriage, but kept off promising till I see how it please God to dispose of me as to marriage, posterity, &c.'
[35] *Musæum Thoresbyanum* (1764). The sale prices are recorded in a copy in the Bodleian Library, Oxford (Mus. Bibl. III 8° 614).

of a former age,' he carefully collected this precious antiquarian material and arranged it in cabinets to supplement his library.

Sir James's younger brother, Sir Andrew Balfour (1630–94), returned to Scotland about 1667 after some fifteen years of foreign travel, bringing with him a collection which included costumes and weapons, scientific and medical instruments, and natural history specimens. Some open *Letters Written to a Friend*, published posthumously in 1700, contain hints given by the younger Balfour to the aspiring collector and a reference of some historical interest: describing some large and beautiful green lizards which he encountered on his travels, Balfour urges his reader that if he should meet with them 'I must intreat you wherever you find of them to cause preserve 1 or 2, to add to my *Tradescants*'.[36] It has been suggested that the Tradescants' name had been adopted by Balfour as the generic term for a natural history cabinet,[37] but the usage has not been noted elsewhere.

After Balfour's death the collection passed to his fellow-countryman Sir Robert Sibbald, founder of the College of Physicians in Edinburgh.[38] Sibbald was a distinguished antiquary and a collector in his own right, and also the author of the first systematic natural history of Scotland. From Sibbald the collection passed in 1697 to the University of Edinburgh which, sadly, failed to establish a lasting foundation on the Oxford model, so that the exhibits were almost entirely dissipated in the space of some fifty years.

Other collectors were more specialized in their interests. John Conyers shared something of Sir James Balfour's antiquarian tastes, being described by John Aubrey as possessing 'a world of antique curiosities found during excavations in the Ruines of London'.[39] He also made records of kilns discovered under St. Paul's Cathedral, producing drawings of the pottery found amongst them. His collections, built up over thirty years, were eventually bought by Dr John Woodward (1665–1728), whose most famous antiquarian specimen was a decorated iron shield to which he was much attached but which proved to be a false antiquity and thereby brought him the scorn of his contemporaries.[40]

Woodward's primary interest lay in minerals, fossils and petrifactions, however, and his cabinets, still preserved in Cambridge University where he founded the Woodwardian chair of geology, formed the basis of his scholarly research on the subject. Apart from his much-vaunted shield, Woodward's collections were notable for the attention they paid to the commonplace as well as to the extraordinary: in a set of instructions compiled for collectors, he wrote 'In the Choice of these Things, neglect not any, tho' the most ordinary and trivial: the Commonest peble or Flint, Cockle or Oyster-shell, Grass, Moss, Fern, or Thistle, will be as useful, and as proper to be gathered and sent, as any the rarest

[36] Balfour 1700, p. 24. Elsewhere (p. 65) Balfour requests some examples of box-wood combs 'to add to my Tradescants'.

[37] Caudill 1975, p. 159.

[38] Murray 1904, pp. 217–18; Simpson 1982.

[39] Bodleian Library, Oxford, MS Top. Gen. c24, fol. 244ᵛ, quoted in Munby 1977, p. 420. Some account of these discoveries was later published by Woodward: he laments that Conyers 'had not Encouragement to set forth some relation of them', explaining that the costs had proved prohibitive, 'he having only

the Returns of his Profession to depend upon' (Woodward 1713, p. 6).

[40] Levine 1977. Although Woodward may be considered most important as a natural scientist, his interest in collecting is reflected in the museum guides included in his library: as well as the catalogues of the Tradescant and Hubert collections, he owned those of Aldrovandi, Swammerdam, Worm and the Anatomy Theatre at Leiden (Bateman and Cooper 1728).

production of the Country.'[41] The universality of Woodward's interests clearly separates him from curiosity collectors such as the Tradescants: the ambitions he cherishes for his collection are by no means less discriminating but are, on the contrary, more encyclopaedic. His instructions also detailed the methods to be employed in drying and pressing plants, preserving worms and spiders in brandy, and impaling wasps and butterflies on pins in small boxes.

Sir Thomas Browne (1605–82) possessed in Norwich a house and garden which John Evelyn described as 'a Paradise and Cabinet of rarities, and that of the best collection, especially Medails, books, Plants [and] natural things', noting particularly his collection of birds' eggs.[42] In antiquarian circles he is best remembered for the publication of his *Hydriotaphia, Urne Buriall*, prompted by the recovery of some 'sepulchrall urnes' (fig. 60) from an Anglo-Saxon cemetery at Walsingham, Norfolk, *c.* 1658.[43]

A second East Anglian collection – that of the Pastons of Oxnead Hall – is best known from a painted record of some part of it dating from *c.* 1665 (fig. 61). The Dutch origin of many of the more costly pieces shown reflects the close links which then existed between (on the one hand) the Netherlands and (on the other) East Anglia in general and the Pastons in particular.[44] An extensive seventeenth-century inventory of 'Ornamental plate, &c. formerly at Oxnead Hall' records numerous vessels, boxes, figurines and other items in shell, crystal, amber and other media. From the locations recorded, it seems that the collection occupied the walls of an entire 'closset', taking up space all around the fireplace, door, windows, and the corners in between; other items lay on two sets of 'Hanging 5 shelfs . . . trimd with scarlett ribbin' on either side of the chimney breast.[45]

Botany, entomology and zoology were the primary interests of the London apothecary James Petiver (*c.*1663–1718) whose collections included many specimens from the East Indies and from the New World. Petiver himself never seems to have visited those parts, but in an appeal somewhat akin to that issued by Tradescant, Petiver circulated the following statement:[46]

I humbly entreat that all practitioners in Physick, Sea-Surgeons or other curious persons who travel into foreign countries will be pleased to make collections for me of whatever plants, shells, insects etc they small meet with, preserving them according to directions that I have made so easy as the meanest capacity is able to perform, the which I am ready to give to such as shall desire them.

From 1695 onwards, Petiver published a catalogue of his collection, issued as a series of ten fascicules, each listing 100 items and called *centuriae*.[47] Annexed to *centuriae* II-III is an 'Advertisement', giving instructions to intending contributors on the best methods of preserving natural rarities of all kinds; Petiver fulsomely acknowledges the 'curious

[41] Woodward 1696, p. 10.
[42] Evelyn 1955, vol. 3, p. 594. His collection included a 'fine green channelled egge' from a 'cassware, or emeu' which had belonged to Charles I (Wilkin 1852, vol. 3, pp. 469–70).
[43] Browne 1964, pp. 81–125.
[44] Sir William Paston (d. 1663) had joined the forces assembled by Henrietta Maria at Rotterdam in 1643. His son Robert, a friend of Charles II, was created first Earl of Yarmouth,

hence the painting's alternative title, 'The Yarmouth Collection'. For accounts of the painting see Bernsmeier *et al.* 1979, p. 438; Victoria and Albert Museum 1964, no. 80.
[45] *Gentleman's Magazine* 2nd new ser. 21 (1844), pp. 23–4, 150–2.
[46] Quoted in St John Brooks 1954, pp. 180–1.
[47] Petiver 1695–1703.

persons' who contributed to his cabinet and exhorts others who 'Travel to or Reside in Foreign Parts' to follow their example. John Ray considered Petiver 'one of the most skilful and active promoters of natural history, I will not say in England but in all Europe,'[48] although he seems to have made a less favourable impression on Dutch collectors (including Albert Seba and Frederik Ruysch) whom he met while on a buying trip to the Netherlands in 1711.[49] Unfortunately, it seems that he did not take equal care in keeping his specimens, but 'put them into heaps, with sometimes small labels of paper, where there were many of them injured by dust, insects, rain &c'. Von Uffenbach tells us that 'Everything he had was kept in true English fashion in prodigious confusion in one wretched cabinet and in boxes.'[50]

In time Petiver's collection was united under one roof with what may be regarded as one of the greatest of all seventeenth-century British cabinets, that belonging to William Charleton or Courten (1642–1702) and kept originally in ten rooms at the Temple in London. Although Charleton's collection lies chronologically at the end of the time span reviewed here, it preserved almost perfectly the character of the best English collections of the seventeenth century. It was built up over twenty-five years of Continental travel up to 1684. Visiting it some three years later, John Ray found it 'a repository of rare and select objects of natural history and art, so curiously and elegantly arranged that you could hardly find the like in all Europe'.[51] Thoresby concurred when he described it as 'perhaps the most noble collection of natural and artificial curiosities, of ancient and modern coins and medals, that any private person in the world enjoys . . . there is I think, the greatest variety of insects and animals, corals, shells, petrifactions etc that ever I beheld.'[52] In his *Numismata*, John Evelyn declared that some collectors had so distinguished themselves by their collecting activities that they personally deserved to have medals struck in their honour: Aldrovandi, Imperati, Settala, Cospi and Worm are singled out for special mention, so is John Tradescant, but above them all Evelyn (who was, it should be remembered, familiar with some of the best Continental cabinets) places 'the worthy Mr Charleton'.[53]

It has been mentioned that the collections of Petiver and Charleton were eventually joined together and they were so in the museum of Sir Hans Sloane (1660–1753), Charleton's cabinet being left to Sloane in a bequest and Petiver's being bought by him for £4,000.[54] Mention of Sir Hans Sloane, however, takes us beyond the end of the seventeenth century and beyond the point where the term 'cabinet of curiosities' has any useful meaning. There were over 100,000 specimens in this collection which came to form the foundation of the British Museum, in addition to those which had originated with Charleton and Petiver. A large number of these, notably 12,500 botanical specimens, were the result of Sloane's own collecting activities in the West Indies (which he visited in his capacity as physician to the Duke of Albemarle, Governor of Jamaica) and elsewhere.

[48] Petiver made many contributions to vol. 3 of Ray's *Historia* and the results of his researches are also incorporated in the appendix to his *Synopsis* of 1696 (Edwards 1981, p. 301). Whitehead (1971, p. 52) notes that Ray himself would undoubtedly have possessed a much greater collection had he not been crippled by poverty.

[49] Stearns 1952, pp. 282–5.

[50] Uffenbach 1753–4, vol. 2, p. 583; Quarrell and Mare 1934, pp. 126–7.

[51] Raven 1950, p. 229.

[52] Hunter 1830, pt. 1, p. 299.

[53] Evelyn 1697, p. 282.

[54] Altick 1978, p. 15; Brooks 1954, pp. 179–81; Whitehead 1971, p. 53.

Sloane's vast achievement did not, by any means, mark the end of private collecting in Britain, but it set a new bench-mark which no other collection was ever to match. Hubert and the Tradescants had their heirs in entrepreneurs like James Salter ('Don Saltero') (*fl.* 1723), at whose famous coffee house could be seen whimsical and extravagant rarities such as 'Pontius Pilate's wife's chambermaid's sister's hat',[55] and in more purposeful figures like Sir Ashton Lever (1729–88), whose truly remarkable cabinet of curiosities so impoverished its owner that he was forced to put it to lottery in 1785,[56] and William Bullock (*fl.* 1827), whose collection of over 7,000 exhibits, 'collected during several years of arduous Research and at an Expense of upwards of Twenty Thousand Pounds,' was exhibited first in Liverpool and later in Piccadilly, London.[57]

From the beginning of the eighteenth century, however, it was increasingly the connoisseurs of painting and sculpture, whose cultural ancestry can be traced back to Arundel and Buckingham, who came to dominate the collecting scene and who set new standards which ensured that matters of taste and aesthetics displaced curiosity as the common currency of the British collector.

[55] Altick (1978, p. 17) mentions that Salter had reputedly been a servant to Sir Hans Sloane, who had made him gifts of some of his duplicates.

[56] A view of the collection after it had passed out of Sir Ashton's hands is given in *A Companion to the Museum (late Sir Ashton Lever's) Removed to Albion Street, the Surry End of Black Friars Bridge* (London, 1790).

[57] Bullock 1809.

THE CABINET INSTITUTIONALIZED:
THE ROYAL SOCIETY'S 'REPOSITORY'
AND ITS BACKGROUND

Michael Hunter

Institutional collections in seventeenth- and early eighteenth-century England are worthy of study because they occupy an intermediate position between private cabinets and public museums. They therefore stand at a transitional point in the process of evolution which may be said to be the *raison d'être* of this volume. The significance of institutional collections is that – at least in theory – they had a potential for continuity which their private counterparts ordinarily lacked. Whereas cabinets accumulated and owned by individuals were vulnerable to dispersal after that person's death, institutions had a corporate life beyond the lives of their members, thus offering a potential guarantee of indefinite continuity and growth for collections vested in them. This advantage was something that was appreciated at the time: when the existence of the Royal Society's museum was announced in *Philosophical Transactions* in October 1666, potential benefactors to the collection were encouraged with the assurance that their gifts would there be preserved for posterity 'probably much better and safer, than in their own private Cabinets'.[1]

The most famous of such early public collections fall outside my terms of reference, namely the Ashmolean and the British Museum. Here I shall be dealing with a number of less august ventures: in fact, though included here because of their institutional status, some of the collections which I shall be covering proved as transitory as private cabinets, nor is the dividing line between these two types always easily drawn. In addition, institutional collections were often not very different in their content and its treatment from the private cabinets in Britain which have been dealt with elsewhere (pp. 147–58). As we shall see, this even applies to the Royal Society's museum, the most interesting and important of the collections with which I shall be dealing. But part of the reason why the Royal Society's 'repository' is the most interesting of them is that, although it showed similarities to earlier collections, this was in spite of ambitions to be qualitatively different from its predecessors, ambitions which I wish to survey. The context of these partially realized hopes was the grandiose Baconian programme of the early Royal Society, and the history of its repository reflects in microcosm the tension between ambition and actuality that characterizes the Society's early history as a whole.

[1] *Philosophical Transactions*, 1666, vol. 1, p. 321.

The commonest milieu for these early institutional collections was academic. A number of benefactors seem to have seen universities and colleges as appropriate recipients for miscellaneous curiosities, evidently as much because of the permanence accruing from their institutional status as because it was thought that such collections would serve a direct didactic function. Various gifts were made, which in some cases grew into collections sizeable enough to attract the attention of visitors. To some extent this applied to colleges. From the 1650s onwards, and particularly in the early years of the eighteenth century, we learn from travellers' accounts of rarities preserved at various colleges in both Oxford and Cambridge, including collections of coins, natural objects such as dried animals, and miscellaneous curiosities: the latter included (at Merton College, Oxford) 'the Thorn, which they say our Saviour was Crowned withal', a strange throwback to medieval relic-collecting.[2] Some of these accumulations were more extensive than others, while discrepancies between the reports of different travellers suggest a rather haphazard element about them. Indeed, in many cases these college cabinets were apparently hardly more formal or permanent than private ones.

Perhaps more impressive were the collections which the central institutions of the universities acquired, both at Oxford and Cambridge, though there was much more of a development towards an authentic 'museum' at the former than the latter. At Cambridge the University Library was presented with a collection of coins and other antiquities by Andrew Perne, Master of Peterhouse, as early as 1589. This was swelled by further donations during the seventeenth century, and the university accounts reveal that a cabinet was made for the coins in 1659–60 and repaired in 1660–1.[3] But during the seventeenth century hardly any more miscellaneous curiosities were on show, and the university seems to have acquired specimens of this kind on a significant scale only in the 1720s, with the bequests of George Lewis and John Woodward.[4]

At Oxford, on the other hand, sizeable collections existed at a much earlier date, perhaps connected with the greater degree of scientific endowment which Oxford acquired in the seventeenth century and especially in the 1620s and 1630s.[5] At this time rooms in the Schools Quadrangle was refurbished as an Anatomy School, and both here and at the Bodleian Library collections seem to have taken shape from this date: the earliest account of the collections comes from two travellers who visited Oxford in 1630 or 1631.[6]

The most important collection at the Bodleian was of coins. The core of this comprised five cabinets presented by Archbishop Laud in the 1630s. It was augmented by further gifts over the following decades, and between 1658 and 1666 was catalogued by Elias Ashmole.[7] In addition, however, the Bodleian also acquired more miscellaneous rarities, some from alumni and others from London merchants, who seem to have regarded the Bodleian as an appropriate repository for rarities acquired during their voyages. Hence

[2] Evelyn 1955, vol, 3, pp. 108–11; Gunther 1923–45, vol. 11, pp. 53, 193, 240–2; Hunter 1830, vol. 1, pp. 293–4; Mayor 1911, pp. 127, 129, 161, 169, 176–7; Quarrell and Quarrell 1928, pp. 17, 58; *British Curiosities* 1713, pp. 58–9, 62, 78, 80; Keynes 1966, pp. 273–5.

[3] Sayle 1916, pp. 56, 78, 90–2; Cooper 1880, vol. 3, pp. 68, 71.

The reference to the university accounts has kindly been supplied by David McKitterick.

[4] Oates 1961; Cooper 1880, vol. 3, pp. 72, 104–7; Sayle 1916, pp. 95–7.

[5] Frank 1973, pp. 239–40; Webster 1975, pp. 122–6.

[6] Frank 1980, pp. 45–6, 61; Macray 1890, pp. 74–5.

[7] Macray 1890, pp. 84, 125, 483; Josten 1966, vol. 1, pp. 123–4.

visitors were regaled with a miscellany of curiosities, mainly ethnographic items but also including such memorabilia as Guy Fawkes's lantern, presented in 1641.[8]

On the whole, a rough division of labour seems to have been imposed, so that natural rarities which were presented to the university went to the Anatomy School rather than the Bodleian even when their donor intended them for the Bodleian, as with items presented by the London alderman Sir Robert Viner in 1684.[9] The size and nature of the Anatomy School collection is revealed by catalogues of it made respectively in 1675 and between 1705 and 1709.[10] By the early eighteenth century the collection comprised some 400 items, thus constituting quite a serious museum. The collection seems to have been somewhat akin to that in the Anatomy School at Leiden, with which it was compared by one traveller.[11] Prominent among the exhibits were articulated skeletons and tables of muscles used for teaching purposes. In addition, Oxford could offer a pale reflection of the famous sequence of 'moralized skeletons' at Leiden, not least in the form of the skeleton of a woman who was said to have had eighteen husbands and to have been hanged for murdering four of them.[12] Beyond that, the collection comprised human and animal oddities, exotic birds, fishes and plants, ethnographic specimens and historical curiosities: the division of labour with the Bodleian does not seem to have been so rigorously applied that all 'artificial' things went to Bodley to compensate for the natural objects which were almost invariably sent from there to the Anatomy School.

In addition, no satisfactory division of labour from the point of view of content was worked out with the Ashmolean. The university apparently failed completely to comply with Ashmole's wish in setting up his museum that all rarities belonging to the university 'except such as are necessary for the Anatomy Lecture' should go to the Ashmolean.[13] It is interesting that his view was echoed by one of the visitors who gave an account of the Anatomy School, Zacharias Conrad von Uffenbach, who felt in 1710 that 'there are many [specimens] . . . which do not belong at all to an anatomical museum, but would be much more suitable to a *Kunstkammer* like the Ashmolean Museum'.[14] The university, however, does not seem to have agreed about the desirability of specialization; if anything, advantage was taken of Ashmole's benefaction to move lectures to the Ashmolean and make the Anatomy School more of a gallery, and by the mid-eighteenth century a further list of curiosities on show actually conflates the most memorable items in the two collections.[15]

Turning to London – and leaving on one side the menagerie, armouries and crown jewels at the Tower of London[16] – perhaps the most surprising institutional collection was that of the East India Company at its headquarters, East India House, a rather interesting phenomenon in view of the links between collecting and the opening up of

[8] Macray 1890, pp. 93, 133 and *passim*; Evelyn 1955, vol. 3, pp. 107–8; Magalotti 1821, p. 262; Quarrell and Quarrell 1928, pp. 11–14; Gunther 1923–45, vol. 3, pp. 249–51.

[9] Macray 1890, p. 154 and *passim*.

[10] Gunther 1923–45, vol. 3, pp. 258–60; Bodleian Library, Oxford, MS Rawlinson D 912, fols. 201, 203–4 (printed ibid., pp. 260–3), MS Rawlinson C 865, fols. 9–20 (partly printed in rearranged form ibid., pp. 264–74).

[11] Gunther 1923–45, vol. 3, p. 255; Leiden University 1683.

[12] Lunsingh Scheurleer 1975, esp. pp. 220–8; Gunther 1923–45, vol. 3, p. 265; *British Curiosities*, p. 63.

[13] Josten 1966, vol. 1, p. 248.

[14] Quarrell and Quarrell 1928, p. 24 (but 'Kunstkammer', which is there misleadingly translated, has been inserted from Uffenbach 1753–4, vol. 3, pp. 117–18).

[15] Gunther 1923–45, vol. 3, p. 256; Pointer 1749, pp. 156–61.

[16] *British Curiosities*, pp. 48–50; Magalotti 1821, pp. 175–7; Hunter 1830, vol. 2, p. 26.

contacts with the non-European world which others have stressed. Here, our sole informant is the Italian traveller Lorenzo Magalotti, who visited East India House in 1669 and reported that the rarities kept there 'to gratify the curiosity of the public' included various exotic birds, animals, fishes and plants from Egypt, Virginia and especially India. But nothing more is then heard of the collection, and, by the time a museum was begun afresh by the company in the late eighteenth century, the earlier venture had apparently been entirely forgotten.[17]

More important was the collection of the London College of Physicians. In 1651 William Harvey offered to build for the college a so-called 'Museum': this was opened in 1654 and architectural drawings survive of the structure, which was destroyed in the Fire of London.[18] In fact, 'Museum' is slightly misleading from our point of view, since what Harvey founded seems to have been primarily a library, 'Museum' being used in the more traditional meaning of a place for learned occupations and hence as appropriate a description of a library as of a cabinet.[19] When a catalogue of the contents of the 'Museum' was issued by Christopher Merrett, its keeper, in 1660, forty of its forty-three densely-packed pages were devoted to books. But the remaining three pages did list some 119 other items in the collection, forty-five entries detailing surgical instruments and seventy-four describing 'Res Curiosae & Exoticae'.[20] A few of these were skeletons and other anatomical specimens appropriate to the professional responsibilities of the college, but the collection – like the selection of books in the library – was broader. It contained things like armadillos, gourds and ostrich eggs – the standard natural *exotica* of virtuoso cabinets at the time – and it was particularly well stocked with fishes and marine curiosities, presumably due to a special gift.

As we have been reminded by the work of Charles Webster, in the 1650s the College of Physicians was a centre of non-medical as well as medical research.[21] At that time it served some of the functions for science in London which the Royal Society did after its foundation in 1660, and this collection is perhaps to be seen as one aspect of this, despite its limited scale. After 1660, however, with the new scientific society in existence, the College of Physicians seems gradually to have abandoned the overlapping territory between the two institutions and concentrated on its medical functions.[22] As far as its collection is concerned, this was apparently destroyed with the college buildings in the Fire of London, and that is the last we hear of it.

So we come to the Royal Society, founded in the year of the Restoration with the specific purpose of furthering scientific research by collaborative endeavour, with none of the responsibilities either for teaching or upholding professional standards which provided part of the *raison d'être* for the accumulation of exhibits at the Oxford Anatomy School and the College of Physicians. The Society began to accumulate experimental equipment and natural rarities from its earliest years: the largest single donation of such material of which

[17] Magalotti 1821, pp. 325–7; Desmond 1982, ch. 1.

[18] Munk 1878, vol. 3, pp. 323–6; Clark 1964–6, vol. 1, pp. 285–6, 298–9; Keynes 1966, ch. 42; Newman 1969, esp. pp. 303–7; Harris and Tait 1979, pp. 34–5 and pls. 57–62. On William Gilbert's 1604 bequest to the college, which included a cabinet of minerals, globes and instruments as well as books, see

Newman 1969, p. 299; none of these items are listed in Merrett's 1660 catalogue.

[19] See appendix below.

[20] Merrett 1660, pp. 41–3 and *passim*.

[21] Webster 1967; 1975, pp. 315–16. See also Frank 1979, pp. 84–92.

[22] Hunter 1981, p. 144.

we hear at this stage was made in the autumn of 1663 by John Wilkins, Dean of Ripon and the former convenor of the group of experimental philosophers at Oxford in the 1650s.[23] At much the same time Robert Hooke, the society's 'Curator of Experiments', was named as 'Keeper' of the 'Repository', a word first used to describe the collection in the Society's minutes on that occasion and habitually employed thereafter, with 'museum' being seen as the Latin equivalent of this.[24] So a nucleus already existed, but the museum received an artificial boost – which was retrospectively regarded almost as a foundation – early in 1666 when the Society purchased a substantial private cabinet, that of Robert Hubert (Anglicized in the Society's minutes as 'Mr Hubbard'), which had previously been publicly displayed in London.[25] This was bought for the bargain price of £100, a sum which was put up by the Society's Treasurer, the London citizen Daniel Colwall.

Quite why the collection was so cheap is unclear since, after the Tradescants', Hubert's was perhaps the most interesting collection of curiosities in England at that time, and it was the only one apart from the Tradescants' to merit a printed catalogue, of which various recensions had been issued in 1664 and 1665.[26] As this catalogue reveals, and as is made clear elsewhere in this volume (p. 153), Hubert's collection was typical of virtuoso cabinets of the day with its emphasis on the rare, the exotic and the marvellous, and in the element of social snobbery in its presentation: Hubert laid special stress on the gifts he had received from foreign potentates while displaying his collection on the continent during the Interregnum.[27] But in one respect his cabinet was unusual, and this does much to account for its appeal to the Royal Society: it was almost entirely limited to 'Natural Rarities' (to quote the title-page of the printed catalogue). It thus stood in marked contrast to the Tradescants' collection, completely lacking, for instance, the ethnographic curiosities, coins and other human artifacts which were so prominent a part of the Tradescant rarities,[28] and hence holding particular appeal for a society which specialized in research into natural history.

So, like the Ashmolean, the Royal Society's collection had its origins in a private cabinet, but from the first there were hopes that it would transcend these origins and 'be employed for considerable Philosophical and Usefull purposes', to quote the announcement of Colwall's benefaction in *Philosophical Transactions*.[29] The promise of continuity with which potential benefactors were urged on has already been cited, and there were also hopes that through such additions the collection could be transformed into a valuable tool for the reform of knowledge by collaborative endeavour to which the Society was committed. Thomas Sprat, in the polemical *History of the Royal Society* (1667) in which he expounded the aims of the fledgling institution, was rather disdainful of the cabinets of the

[23] Birch 1756–7, vol. 1, p. 324; see also, for example, pp. 23, 85.

[24] Ibid., vol. 1, p. 324; and see appendix below. For an earlier usage of the word to describe the Royal Society's collection in Evelyn's *Diary*, see Evelyn 1955, vol. 3, p. 334.

[25] Birch 1756–7, vol. 2, p. 64; Murray 1904, vol. 1, pp. 130–3 (who apparently first saw the connection).

[26] The earliest recension is evidently the undated catalogue of part of the collection (Hubert, n.d.) of which a copy survives in Bodleian Library, Oxford (MS Ashmole 967) (this deduction is based mainly on a collation of the lists of benefactors in the different versions); of the version dated 1664 there are two recensions, of which the later has an addendum describing new acquisitions (a copy of this will be found in British Library shelfmark 957.e.13); the content of the addendum is then incorporated in the text of the final recension, dated 1665, to which is appended a catalogue of the rarities on show at the university garden in Leiden.

[27] Hubert n.d., 1665; Major 1664, p. 63; 1683, pp. 109–112; *Calender of State Papers Domestic*, 1661–2, p. 390 (I am indebted to David Sturdy for this reference); Murray 1904, vol. 1, 127–8.

[28] Tradescant 1656.

[29] *Philosophical Transactions*, 1666, vol. 1, p. 321.

virtuosi but grandiloquent about the Society's museum, describing 'a General Collection of all the Effects of *Arts*, and the Common, or Monstrous *Works* of *Nature*' as 'one of the Principal Intentions' of the Society.[30] He and others aspired to 'complete' the collection,[31] and this urge to acquire a systematic rather than haphazard series of objects reached its climax in 1669, when the Society employed the botanical collector Thomas Willisel to perambulate the British Isles obtaining 'such natural things, as may be had in England, and were yet wanting in the society's repository'.[32]

Indeed, aspirations for the collection seem to have been linked to hopes that it might be possible to construct a universal taxonomy which would accurately mirror the order of nature. Such ideas were closely linked with another ambition of the time, to devise a new, rational language. Various Fellows of the Royal Society contributed to John Wilkins's famous work along these lines, *An Essay Towards a Real Character, And a Philosophical Language* (1668), by providing classified tables of natural phenomena which were intended to enable the language at the same time to describe and to define the components of the natural world, thereby serving an important taxonomic function as well as a linguistic one.[33] It is no coincidence that both Sprat and Wilkins referred to the repository in connection with these ambitions, thinking it appropriate for the collection to be arranged and its desiderata assessed according to this method, and catalogues of the museum according to the system of classification in Wilkins's *Essay* were actually begun by Robert Hooke in the 1660s and by John Aubrey in the 1670s, though neither has survived.[34]

A catalogue was ultimately compiled in the late 1670s by the botanist Nehemiah Grew, and published in 1681 as *Musæum Regalis Societatis, or a Catalogue & Description of the Natural and Artificial Rarities Belonging to the Royal Society And preserved at Gresham Colledge.* Contrary to what has sometimes been claimed,[35] this did not follow the classificatory scheme enshrined in Wilkins's *Essay*, the shortcomings of which had already been revealed by further investigations.[36] Grew's arrangement was in fact eclectic, but the integrity of his book to these taxonomic efforts is nevertheless clear, particularly in the section in which he deals with the shells in the collection: this includes a series of tables or 'Schemes' in which shells are classified according to their structural and decorative characteristics (fig. 62).[37]

Moreover, in his preface Grew also echoed the cry for comprehensiveness of authors like Sprat, aspiring to 'an Inventory of Nature' which would include 'not only Things strange and rare, but the most known and common amongst us'. Grew not only attacked the cult of rarity which informed many virtuoso collections; he also criticized the obscurantism of existing catalogues, advocating a fullness and precision of description which he then proceeded to exemplify through the entries in his text.[38] His citations

[30] Sprat 1667, pp. 251, 386.
[31] Ibid., p. 251; Wilkins 1668, sig. a1v. Cf. Sir John Hoskins to Aubrey, 25 March 1674, Bodleian Library, Oxford, MS Aubrey 12, fol. 214.
[32] Birch 1756–7, vol. 2, pp. 358, 378–9, 395, 398, 425–6, 431, 433.
[33] Slaughter 1982. See also Salmon 1972, esp. ch. 2; Knowlson 1975, ch. 3.

[34] Sprat 1667, p. 251; Wilkins 1668, sig. a1v; Hunter 1975, p. 45 and n. 8.
[35] Stimson 1948, p. 111; Slaughter 1982, p. 175.
[36] Raven 1942, ch. 8.
[37] Grew 1681, pp. 150–3.
[38] Ibid., preface and *passim*.

illustrate the breadth of his reading in relevant scientific literature – some of it specially bought by the Royal Society for his use[39] – and in his descriptions he was frequently able to use specimens in the collection to convict earlier writers of inaccuracy and mis-identification, while also rationalizing some of the strange phenomena which had preoccupied virtuosi like Hubert, such as the supposed power of the *Echeneis remora*.[40]

So the repository was central to the Royal Society's plan for the systematic reform of knowledge, but what was it actually like? In fact, the enterprise fell short of the grandiose ambitions for it in a manner which was typical of the early Royal Society. For one thing, the idea of a comprehensive series of common things as well as rare ones fell by the wayside, as is revealed by comparing the actual collection chronicled in Grew's *Musæum Regalis Societatis* with Hubert's catalogue. For though by 1681 the collection had been swollen by gifts to between two and three times the size of Hubert's cabinet, it remained similar to Hubert's in its basic physiognomy, dominated by the exotic and the monstrous at the expense of ordinary items. In the section on quadrupeds, for instance, some items were added, such as a beaver and fragments of a tiger; in other cases, as with a rhinoceros horn, the Royal Society could boast multiple specimens where Hubert had had only one; but much remained the same – a sloth, armadillos, chameleons, crocodiles and the like.[41] Throughout, exotic specimens greatly outnumbered native ones, while even things like 'A Cross of wood, growing in the form of Saint Andrews Cross', which Hubert had valued as a great curiosity, remained in the collection as catalogued by Grew, although Grew had a perfectly prosaic explanation of the process of grafting which had evidently occurred.[42] It is almost as if the 'scientific' characteristics of Grew's catalogue were imposed on a collection which remained inspired by the criteria of rarity and curiosity typical of virtuoso cabinets. Indeed, a comparison of Grew's and Hubert's catalogues reveals that the collection had actually become more like a normal virtuoso cabinet, since whereas Hubert's cabinet had been limited to natural rarities, well-intentioned gifts added a miscellaneous selection of man-made curiosities to the Royal Society's museum, such as a box of 100 turned cups one within the other and various ethnographic specimens.[43]

In this, the repository reflected the proclivities of the virtuosi who formed the staple of the Society's membership and whose gifts were the principal source of the additions which were made to the collection in the Society's early years. They clearly shared the preoccupation with the outlandish and the extraordinary, and the disdain for the commonplace, which is so marked in virtuoso collections like Hubert's. It is evident that only the unusual seemed to them appropriate as gifts – double eggs rather than ordinary ones, African birds rather than British – and these donors remained immune to the valuation of the ordinary urged by Grew and others.[44]

A collection of this kind undoubtedly had a certain value. Anatomical oddities could claim attention as illustrating nature 'erring' or 'out of course',[45] while the plethora of

[39] Birch 1756–7, vol. 3, p. 450; Royal Society MS Account books, s.v. 1679–81.
[40] Grew 1681, *passim* and p. 104; Hubert 1665, p. 24.
[41] Grew 1681, part 1, sect. 2; Hubert 1665, *passim*.
[42] Hubert n.d., p. 18; Grew 1681, p. 184.

[43] Grew 1681, part 4. This section also contains the Society's scientific apparatus.
[44] Ibid., pp. 4–5, 78–9 and *passim*. On virtuoso values, see esp. Houghton 1942.
[45] Bacon 1857–74, vol. 2, p. 102. See also Park and Daston 1981, pp. 43–51.

exotic items at least enabled naturalists to examine species which they would not otherwise have had an opportunity to see. It is clear that visitors too were mainly intrigued by unusual items of the kind which dominated the repository.[46] But what is significant is that – with the exception of the brief episode involving Willisel – the ideals of comprehensive accumulation advocated by authors like Sprat were never implemented, but succumbed to circumstances like other aspects of the Society's initial Baconian programme. Moreover, the haphazard nature of the collection and its stress on the exotic limited its value to the taxonomic effort of the day, as Grew noted at one point in his catalogue, regretting that a 'perfect' classification was not there feasible 'because as yet the Collection it self is not perfect'.[47]

So the repository was less different from virtuoso cabinets than had initially been intended. Equally revealing are the difficulties that the Society encountered in administering the collection: these are symptomatic of the Royal Society's institutional weakness, its lack of large-scale endowment and its vulnerability to fluctuations in the support of the virtuosi who made up the bulk of the membership.[48] Even the 'foundation' of the museum in 1666 can be seen in this context, since it is clear from remarks in the correspondence of leading figures in the Society that this was a deliberate gesture intended to reinvigorate activities after the dislocation caused by the Great Plague in 1665.[49]

Problems recurred almost immediately. In its earliest years the Royal Society held its meetings in the spacious milieu of Gresham College in the City of London and plans were afoot to display the rarities there when the Fire of London necessitated the Society's removal in 1667 to temporary quarters provided by the Howard family at Arundel House in the Strand.[50] Here there was evidently no space for the museum, which was left 'as in a storeroom', and only after the Society returned to Gresham College in 1673 was it possible to display the collection properly in one of the College's large galleries.[51]

Moreover, throughout its history the repository was dogged by the fact that, with limited resources at its disposal, the Royal Society could never afford sufficient staff to look after the collection properly. In the Society's early years the responsibility for it was given to Robert Hooke, despite the fact that he was expected to run the business of the weekly meetings virtually singlehandedly, in addition to his commitments outside the Society.[52] Things looked up while Grew was preparing his catalogue, but thereafter responsibility for the museum seems to have been left mainly to the Society's 'operators', who also had plenty of other functions to perform.[53] The result was a history of negligence. In the 1660s it was hoped that a register of benefactors should be kept, but the fact that in the early eighteenth century more than one attempt was made to compile such a list

[46] See Charleton 1668, pp. 84, 112, 113, 114, 115, 116, 186; Ray to Lister, 19 December 1674, in Lankester 1848, p. 112; Willughby 1686, sig. b1v, pp. 148, 154, 212, 216, appendix pp. 19–24, and pls. G9, I2, 7, 10, 20, 22–4, N13, O3–4, X11. For visitors, see, e.g., Quarrell and Mare 1934, pp. 99–101.

[47] Grew 1681, p. 124.

[48] See Hunter 1982a.

[49] Evelyn to Mrs G. Evelyn, 29 January 1666, in Sharp 1977, p. 256, n. 4; Hooke to Boyle, 3 February 1666, in Birch 1744, vol.

5, p. 545; Oldenburg to Boyle, 24 February 1666, in Hall and Hall 1965, vol. 3, p. 45.

[50] Birch 1756–7, vol. 2, pp. 96, 113–14.

[51] Middleton 1980, p. 140; Birch 1756–7, vol. 2, p. 300; vol. 3, pp. 191, 242, 310–11; Royal Society Miscellaneous Manuscripts, vol. 16, fol. 39.

[52] On Hooke's appointment, see below, pp. 210–11; Hunter 1982b, pp. 458–9.

[53] Simpson 1984.

retrospectively from the Society's minutes suggests that no such record ever existed.[54] Even the task of allocating new donations to the appropriate categories in the repository seems to have fallen behind, so that in the eighteenth century repeated efforts had to be made to reduce the collection to a better order.[55]

There were times when the museum was in quite a creditable state, and R. T. Altick was wrong to write it off virtually from the start.[56] When the Royal Society moved from Gresham College to Crane Court in 1710, a purpose-built gallery for it was erected, almost certainly to a design by Wren, and the objects were rearranged.[57] Further improvements occurred in the 1730s, when an elaborate new classification for the collection was devised by the Society's secretary, Dr Cromwell Mortimer.[58] But complaints of neglect preceded both episodes and recurred in the mid-eighteenth century, and it must have become increasingly apparent that the administration of a collection like this was really beyond the capacity of a voluntary body like the Royal Society. When the Society moved to rooms in Somerset House in 1779, the collection was offered to the British Museum, ostensibly because of lack of space but in fact probably because it was by now apparent that a museum was more of a burden than the asset which it had appeared to be in the 1660s.

Ironically, at this transitional stage a voluntary institution like the Royal Society may have been less able to look after a collection of rarities properly than an enthusiastic individual like Sir Hans Sloane with a burning commitment to the enterprise. It is symptomatic that during the revamping of the museum in the 1730s, Sloane's collection was held up as an example to the Society on one occasion,[59] and from this point of view it is interesting to note the impressions of von Uffenbach, whose high hopes of the Royal Society's repository were disappointed when he visited it in 1710, just as he compared the Ashmolean unfavourably with private cabinets.[60]

To an extent, institutional collections suffered from their status, which aroused expectations that were easily disappointed, whereas private cabinets stimulated fewer pre-existent expectations and were therefore likelier to please. More important is the relatively rudimentary evolutionary stage which institutions like the Royal Society had reached, since their lack of staff and dependence on voluntary effort presented difficulties in ensuring the continuity of care on which the well-being of a collection depended. As is well known, problems of a not dissimilar kind plagued the British Museum in its early years.[61] They are a reminder that, though the idea of an institutional museum was well established in Augustan England, the transition from private to public was by no means straightforward.

[54] Birch 1756–7, vol. 1, p. 344; *Philosophical Transactions*, 1666, vol. 1, p. 321; Royal Society Domestic MSS, vol. 5, fols. 85–9; MS 416.
[55] Royal Society MSS 413–17; Simpson 1984.
[56] Altick 1978, p. 14.
[57] Bennett 1972; Simpson 1984.
[58] Simpson 1984; Royal Society MSS CMB 63, MSS 414, 416, and esp. 415/2–5.
[59] Royal Society MSS CMB 63, minutes of meeting of 8 May 1733.
[60] Quarrell and Mare 1934, pp. 97–8; Quarrell and Quarrell 1928, p. 26. Cf. [Macky] 1714, p. 166.
[61] Miller 1973, ch. 3.

APPENDIX: A NOTE ON EARLY ENGLISH USAGE OF THE WORD 'MUSEUM'

Discussions of the early meaning and use of the word 'museum' will be found in Murray 1904, chapter 5, and Wittlin 1949, chapter 1; on the Latin usage of the word to denote 'a place for learned occupations', see Lewis and Short 1879, s.v. 'museum'. The usage of 'Museum' at the College of Physicians in 1654 is almost certainly to be seen in this connection, since it is apparent from the statutes drawn up for it that what was provided was primarily a library: although it is true that the college's Annals refer to both a library and 'a Repository for Simples and Rarities' and that the designs for the destroyed building show quite a sizeable room labelled 'Repository', the small size of the collection documented by Merrett in 1660 suggests that this part of the facility never made much headway.[62] It thus seems that Charles Webster is guilty of anachronism in seeing the college's 'Museum' as necessarily alluding to the collections of Worm and the Tradescants.[63]

As far as English words are concerned, 'repository' seems to have been the preferred name for a public collection of rarities at this stage. This was consistently used by the Royal Society to describe their collection, with 'museum' being seen as its Latin equivalent – as when Nehemiah Grew was ordered to 'take upon him the care of the repository under the name of *præfectus Musei regalis Societatis, &c.'*.[64] Even the Latin usage of 'museum' seems not to have been competely established: though Walter Charleton in his *Onomasticon Zoicon* (1668) usually describes the Royal Society's collection as its 'Musæum', he also refers to it variously as 'Gazophylacium', 'respositorium', 'Cimeliarchium' and 'Rerum Naturalium Thesaurus'.[65]

The Ashmolean seems to have represented something of a novelty in being called 'museum' in English and a reference to this institution in *Philosophical Transactions* in 1683 is the earliest example of the English usage of this word recorded in *The Oxford English Dictionary*, though an isolated parallel of slightly earlier date is found in the Epistle Dedicatory to Grew's *Musæum Regalis Societatis* (1681), where the word 'Musæum' is used in English in italics. That this meaning of the word only slowly established itself in English usage is suggested by the fact that the Ashmolean is almost invariably referred to as 'the Respository' in the accounts of the Vice-Chancellor of Oxford, while in John Kersey the younger's revised, sixth edition of Edward Phillips's *New World of Words: Or, Universal English Dictionary* (1706) '*Museum*' is defined as 'a Study, or Library; also a College, of Publick Place for the Resort of Learned Men', with 'The *Museum* or *Ashmole's Museum*' given as a separate, subsidiary usage meaning 'a neat Building in the City of *Oxford*, the lower part of which is a Chymical Laboratory, and the upper a Respository of Natural and Artificial Rarities, founded by *Elias Ashmole*, Esq.'[66]

[62] Keynes 1966, pp. 397, 401–2; Harris and Tait 1979, p. 34; and see above, page 162.

[63] Webster 1975, pp. 320–1. It should also be noted that Gunther 1937, p. 20, and following him, Hunter 1981, p. 142, were mistaken in presuming that the 'Musæum' abortively proposed at Cambridge in the 1670s was to be a repository: in fact, this word was used as a synonym for 'Commencement' House' or 'Theatre' (Willis and Clark 1886, vol. 3, p. 42).

[64] Birch 1756–7, vol. 4, p. 171.

[65] Charleton 1668, sig. a3v, pp. 96, 116, 186, 247, 113, 115, 246, 290.

[66] Clark 1891–1900, vol. 4, pp. 78–9; Phillips 1706, s.v. 'Museum'. For the usage of 'the Musæum' by Ashmole and Walker at the time when the regulations for the Ashmolean were being drafted in 1682, see Josten 1966, vol. 4, pp. 1707–10. For Ashmole's usage of 'Musæum' in the sense of a repository of rarities in 1674, see ibid., vol. 1, p. 197; vol. 4, p. 1395.

SOME CABINETS OF CURIOSITIES IN EUROPEAN ACADEMIC INSTITUTIONS

William Schupbach

Limitations of the author's knowledge and of space preclude the presentation here of an encyclopaedic account of academic cabinets of curiosities in Europe. The following allusive sketch of some aspects of seven cabinets in four countries may at best stimulate others to attempt a deeper study.[1] Such a study would be valuable because the culture of curiosity, of which the cabinet is one manifestation, is no longer readily intelligible even to many scholars, especially among English-speakers whose modern language, in other respects so rich, is demeaned by a narrow and historically perverse definition of the word 'science.' A typical example of *curioso* science such as the use of numismatic evidence to determine the number of Roman emperors called Gordian[2] would now be generally accepted as science if the coins were analysed by radiography, but not if analysed by epigraphy. To avoid anachronism the unfortunate word will be eschewed in the rest of this paper.

THREE UNIVERSITY MUSEUMS: PISA AND LEIDEN

The university museums to be discussed came into being not as independent entities but under the protection of two satellites of faculties of medicine: the physic garden (*hortus medicus, hortus simplicium*) and the anatomy theatre (*anatomia, anatomie, (amphi)theatrum anatomicum*). Botany and anatomy were respectively the summer and winter non-literary studies of medical students who, after qualification, would take up the post of inspector of pharmacies or civic anatomist in the cities in which they settled. As medicine was not a narrowly utilitarian subject but a discipline thoroughly integrated with philosophical and literary studies, visitors to these medical museums were rewarded with more than dry bones and plants.

The physic garden at Pisa dates from 1543[3] but evidence for the attachment of a gallery or museum is available only for the last decade of the century: the gallery may have been created on the orders of Grand Duke Ferdinando I de' Medici (reigned 1587–1605).[4] While the gallery always possessed items of pure information and record – drawings of plants and animals, a botanical library, herbs, seeds, animal remains and portraits of

[1] Basic bibliography includes Valentini 1704–14; Neickel 1727; Hirsching 1786–92; Murray 1904; Balsiger 1970; MacGregor 1983; and the present volume.

[2] Neveu 1966, pp. 481–2.

[3] Tongiorgi Tomasi 1979; *Livorno e Pisa* 1980; Tongiorgi Tomasi 1983. See also pp. 193–4 below. On the university in general, see Schmitt 1972, pp. 248–55.

[4] U. Aldrovandi, undated letter cited by Tongiorgi Tomasi 1980, p. 523 n. 16; *Ricettario Fiorentino* 1597, fol. †5ʳ.

botanists – it also contained an element of the *Wunderkammer*, in which objects were displayed to arouse wonder.[5] In 1596 a gift to the gallery from the estate of its late curator (the Fleming Giovanni Casabona or Goedenhuyse) contained Turkish manufactures as well as *naturalia*,[6] and in the following year the Florentine college of physicians described the Pisan gallery as containing 'innumerable things produced by nature as by a miracle . . . such a rich treasure as to detain and exercise for a long time any learned mind'.[7] As this last phrase shows, wonder was a proper reaction for the learned as well as for the uninstructed: wonder, paraphrased perhaps as inquisitive delight in novelty, mingled with awe and gratitude, was part of the natural history and natural philosophy of the time. The idea that it is the task of the scientist not to arouse wonder but to mortify it with the icy touch of reason[8] had no place in the 1590s. More typical would be the statement of one learned naturalist that 'the parts of nature are undoubtedly all marvellous, but more marvellous by far are those which it produces only rarely'.[9] Hence the Pisa gallery acquired rarities exotic, curious and bizarre as well as everyday utilities. From the natural world there were bezoars, amethysts, giants' bones, unicorn horns and a petrified human skull with coral growing out of it. Artificial marvels included engravings by and after the human prodigies Albrecht Dürer and Michelangelo, Mexican idols, distorting mirrors, bronzes and Flemish landscape paintings.[10] The gallery was one of the sights of Italy for foreign virtuosi such as Evelyn and de Monconys,[11] until the later seventeenth century when it fell into decline.[12]

Leiden university, founded in 1575, developed two museums, one in the *ambulacrum* of the physic garden and one in the anatomy theatre. The catalogues of the museum in the physic garden record a large number of exotic animals.[13] Brazilian specimens came from Prince Johan Maurits of Nassau and the naturalist Willem Piso. A hippopotamus was presented by the Dutch consul at the Cape of Good Hope. There was a polar bear from Greenland and a snake from Surinam marked on its back with what were believed (though not by everyone) to be Arabic characters.[14] A Sinhalese medical book and a banknote from the siege of Leiden (1574) were among the *artificialia* in the physic garden.[15] But the greater part of the Leiden collection was in the anatomy theatre constructed in 1591–3, where two successive professors of medicine, Pieter Paaw (1564–1617) and Otto van Heurn (1577–1652), created one of the most celebrated cabinets of curiosities in Europe.[16] Except during the winter months when the theatre was used for public dissections, the space was used to exhibit a collection of articulated skeletons, of which there were eighteen by 1601.[17] Exploiting the conceptual links between anatomy and death which were familiar from the contemporary moral literature of Calvinist Leiden, Paaw arranged the anatomical museum as a kind of Museum of Mortality. Six human skeletons standing

[5] Schlosser 1908; Tongiorgi Tomasi 1979, p. 23.
[6] *Livorno e Pisa* 1980, pp. 587–8.
[7] *Ricettario Fiorentino* 1597, fol. †5ʳ.
[8] Maccagni 1981, p. 302.
[9] Stelluti 1637, p. 5.
[10] Tongiorgi Tomasi 1979, p. 24; *Livorno e Pisa* 1980, pp. 593–6.
[11] Evelyn 1955, vol. 2, pp. 180–2 (1644), 408–9 (1645); Monconys 1665–6, vol. 1, p. 109 (1646).
[12] Tongiorgi Tomasi 1980, p. 522.

[13] Leiden University 1659; *idem* n.d. [1670?], reprinted with supplement in Valentini 1704–14, pp. 21–5; Leiden University 1688; *idem* n.d. [1697?] (1) and (2). Descriptions in Monconys 1665–6, vol. 2, p. 151 (1663); Hegenitius 1667, pp. 59–60; Neickel 1727, pp. 59–61; B[ockstaele] 1961. See also p. 194 below.
[14] Valentini 1704–14, p. 25; Misson 1699, vol. 1, p. 14 (1687).
[15] Valentini and Misson, ibid.
[16] Bibliography in Lindeboom 1975a, pp. 276–8.
[17] Rijksmuseum Amsterdam 1975, p. 100.

around the perimeter held pennants inscribed with admonitory mottoes: *memento mori*; *homo bulla*; *pulvis et umbra sumus*.[18] There were skeletons of a cow, cat, rat, ram and swan, and of an eagle with gilt talons. The pioneers of death, Adam and Eve, were represented by skeletons of a man and a woman beside a tree.[19] Just as Sir Thomas Browne picked curiosities from sundry antiquarian publications on disposal of the dead and marshalled them into a work of literary art,[20] so Paaw formed a work of visual art from the philosophical iconography of the Leiden anatomy theatre.

In 1617, after Paaw had died in office, Otto van Heurn took over responsibility for the anatomy theatre and began to turn Paaw's *Anatomiekammer* into a true, encyclopaedic cabinet of curiosities.[21] An inventory of 1620 records such exhibits as a Japanese teapot, Chinese scrolls and African plants,[22] and the theatre was adorned with engravings of philosophical, historical and literary subjects.[23] Excavated finds including Roman burial-urns were presented by Daniel Gysius of Nijmegen, and the Roman practice of cremation could be contrasted with Egyptian burial practices through the gift of Egyptian mummies, sarcophagi, and other objects by David Le Leu de Wilhelm (1588–1658), a Leiden alumnus seeking his fortune in the 1620s in Aleppo.[24] Three letters from van Heurn to Le Leu de Wilhelm reveal the impetus behind the donations.[25] In the first, dated 8 October 1621, van Heurn thanks Le Leu de Wilhelm for the gift of a mummy which he has placed in a case in the theatre with a descriptive label in Dutch (the Latin label being still in course of composition). After expressing the university's gratitude he laments, 'But the Anatomy, like Hades, is never full! I hunger ever . . . Since my blushes are invisible on paper, I am forced to request various gifts from the soil of Egypt.' There follows a list of twenty-three groups of items: Egyptian idols with animals' heads; hieroglyphic inscriptions; mummies 'particularly of those who have been wounded and in which one can see how the wound was afterwards closed'; local animals (ibis, hippopotamus) and vegetables (a pound of each of the vegetables eaten by the Egyptians with details of provenance and method of cooking); and above all details of arrangements in the burial chambers of Memphis and Saqqara.[26] In a second begging-letter (10 April 1622) van Heurn requested Egyptian surgical instruments different from the European ones already on display.[27] Van Heurn's description of Egypt as 'mother of all learning in the past and today a refulgence which lights up antiquity for all scholars'[28] provides the clue to his interest in *Ægyptiaca*.

The exhibits were housed all over the building: on the balustrades in the theatre, in cupboards lining the walls, stored in the basement and suspended from the ceiling. A guide was employed to show visitors around, and it may have been one of these guides, Hendrick Cramer, who first published a case-by-case catalogue of the exhibits.[29] It was well received: between 1669 and 1761 more than sixty-four editions were published in

[18] Lunsingh Scheurleer 1975; Schupbach 1982, pp. 96–7.
[19] Orlers 1614, pp. 147–9; Lunsingh Scheurleer 1975, p. 222.
[20] Browne 1964.
[21] Lunsingh Scheurleer 1975, p. 222.
[22] Ibid., p. 223.
[23] Ibid., pp. 223–77.

[24] Ibid., pp. 222–3; Rijksmuseum Amsterdam 1975, pp. 113–22.
[25] Stricker 1948.
[26] Ibid., pp. 45–7 (Latin text), 47–9 (Dutch translation).
[27] Ibid., p. 49.
[28] Ibid., p. 45.
[29] Witkam 1980, p. v.

Dutch, Latin, French and English.[30] Individual cases appear to have contained very miscellaneous assemblages: the thirty-two exhibits in the entrance hall, for example, included an elephant's head and a pair of skis ('A pair of stilts or skates with which the Norwegians, Laplanders and Finlanders run down high snowy mountaines, with almost an incredible swift pace').[31]

Numerous engravings of the central area of the Leiden museum carried a more or less accurate image of it to all parts of Europe (fig. 63).[32] A smaller version was established at Copenhagen where there were ten skeletons in the university's anatomy theatre by 1648;[33] the resemblance would have been closer if the intention of housing the Fuiren bequest of *naturalia* (1659) there had been carried out.[34] The anatomy museum at Altdorf university may also reflect the influence of Leiden.[35] At Altdorf the collection of skeletons spilled over into the library, and it was there that one could see the skeleton of a Croatian sitting on the skeleton of his horse, with a spear in his hand and a tobacco-pipe in his mouth: 'In 1646 he made the streets of Nuremberg very unsafe, and was pursued one night by certain citizens of Altdorf, and because bullets did not harm him he was shot down by gun-shot, together with his horse, near the hazel-nut tree.'[36] This piece embodied orthodox anatomy in the skeletons, a moral lesson in the mockery of the pipe, an *exoticum* in point of the origin of the culprit, a prodigy in his immunity to bullets, and an episode of local history – all in one exhibit.

THE CABINET OF A GUILD: THE CORPORATION OF SURGEONS AT DELFT

The Leiden cabinet was unique in the Netherlands by virtue of being in the anatomy theatre of a university, but other Dutch cities, notably Rotterdam[37] and Delft, displayed curiosities in the anatomy theatres of their surgeons' guilds. The Delft cabinet is described in detail in van Bleyswijck's description of the city in 1667, and his account can be filled out from surviving archival documents.[38] In 1657 the former St. Mary Magdalene convent was refurbished at municipal expense as the surgeons' meeting-place and anatomy theatre. It was surrounded by a physic garden which was cut off from the street by a high wall. The doors to the building were decorated in grisaille with a systematic programme which illustrated the avatars of medical genius[39] and was executed by Anthonie Palamedes (1600–73), better known now as a painter of musical and festive scenes.

Curiosities were shown both in the Great Chamber and in the anatomy theatre on the

[30] Ibid., p. vi.

[31] Ibid., p. 38.

[32] Wolf-Heidegger and Cetto 1967, nos. 301–4, 307; Witkam 1980 p. iii; Sawday 1983.

[33] Bartholin 1662, pp. 6–7.

[34] Ibid., pp. 40–7; Fuiren 1663. The silence of Maar 1916 suggests it was not.

[35] Richter 1936, pp. 52–3.

[36] Wolf-Heidegger and Cetto 1967, pp. 350–2, nos. 308 10.

[37] De Moulin 1972; Lieburg 1976.

[38] Bleyswijck 1667, pp. 572–85; Houtzager 1979, pp. 48–83.

[39] On the inner side of the door between the street and the garden was painted Apollo, the god of medicine. Facing him was the door to the vestibule, on which was painted his son Aesculapius, the legendary healer. On the back of the door was St. Damian who faced on the next door his brother physician St. Cosmas. On the inside of that door, facing into the Great Chamber where meetings and examinations were held, was Hippocrates, while facing him on the other side of the room was Galen painted on the outside of the door to the library. By a perhaps unintentional irony, the other side of this door, looking into the library, was adorned with a portrait of Andreas Vesalius (1514–64), the scourge of Galenic book-learning in anatomy. The shutters of the book-cabinets were decorated by Palamedes with books and a skull in grisaille.

first floor above it. In the Great Chamber 'everywhere one sees paintings and drawings of marvels of nature such as hermaphrodites, bearded women, strange tumours and diseases, most of which occurred in the city of Delft and were depicted for the instruction of the guild; also portraits, in paintings and prints, of famous Delft physicians.'[40] There were also a stuffed tiger and an ibex, a stuffed ostrich, a baby's body preserved in alcohol and the skeleton of a murderer which was used as a mannequin for American Indian feather-work. The chamber also housed two large group-portraits by Pieter and Michiel van Mierevelt (1617) and Cornelis de Man (1681; fig. 64), which depict members of the guild in the anatomy theatre upstairs.[41]

In the anatomy theatre were found still more macabre curiosities such as the skeleton of a horse ridden by the skeleton of a man equipped with an Indian (American?) war-harness, and numerous exotic animals presented by the Dutch East and West India Companies. Most remarkable of all was the great *renoster*, the rhinoceros acquired in 1662 and stuffed by two Amsterdamers in 1667.[42] Its silhouette is visible at the top of the de Man painting of 1681: it towers over the anatomy theatre as the *pièce de résistance*, a rarity unsurpassed by the older, richer and more famous collections of Leiden university, which had set the standard by which such a museum would be judged.

TWO RELIGIOUS HOUSES: THE ABBEY OF STE. GENEVIÈVE IN PARIS AND THE JESUIT COLLEGE IN ROME

A wealthy religious house with a taste for learning was an obvious place for the creation of a cabinet of curiosities. Some abbeys and monasteries were fertile fields of erudition, especially in Paris where the Maurist Benedictine scholars of St. Germain des Prés were *en plein éclat* in the late seventeenth century, and librarians, numismatists and learned secretaries formed an urban microcosm of the European republic of letters.[43] It may have been rivalry with St. Germain des Prés, in this as in other monastic activities,[44] that prompted the building of a new library and, with it, a cabinet of curiosities at the abbey of Ste. Geneviève in Paris in 1675,[45] though its creator, P. Claude du Molinet (1620–1687) offered simpler and purer motives for the addition of a cabinet: the new library, he states, would be much enhanced if accompanied by

a cabinet of rare and curious pieces which would have a bearing on learning and serve the literary arts. That is what I proposed to myself in the choice of these curiosities, and I tried not to look for, and not to have, any which would not be useful to the sciences: to mathematics, astronomy, optics, geometry and, above all, to history, whether natural, ancient or modern.[46]

The cabinet at Ste. Geneviève was rich in coins, medals and plaques; Greek and Roman sacrificial vessels, lamps, utensils, weights and measures; and Egyptian antiquities. Many items came from the collections of Nicolas Claude Fabri de Peiresc of Aix

40 Bleyswijk 1667, p. 579.
41 Houtzager 1979, pp. 84–100.
42 Ibid., pp. 73–7.
43 Neveu 1966.
44 Ultee 1981, pp. 171–5.

45 Bibliography in Cottineau 1935–70, vol. 2, cols. 2206–7. On the library and cabinet: Bougy 1847 and Franklin 1867–73, vol. 1, pp. 71–99.
46 Molinet 1692, preface.

(1580–1637), others from Achille de Harlay (1629–1712), *premier président* of the Paris parliament. A collection of engravings was bequeathed by one M. Accart.[47] There were exotic garments, optical instruments and pastel portraits of French kings from St. Louis. *Naturalia* played a minor part, being represented by corals, onyx, jade, shells and stuffed mammals and fishes. The published catalogue,[48] illustrated with neat engravings,[49] portrays an elegant, well-proportioned collection formed by a taste for order, clarity and sound learning, an abhorrence of the bizarre, and an indifference to gratuitous marvels.

Martin Lister visited the cabinet at Ste. Geneviève in 1698 and was struck by the value of the Roman liquid measures in interpreting the doses prescribed by ancient medical writers.[50] A coin stamped with Mercury's caduceus and with a shell might, he thought, illustrate the god's role in replacing primitive shell-barter with metallic coinage. Seeing a mummified leg, Lister suggested to a disbelieving canon that the medicine theriac would break the Lenten fast if its innumerable ingredients included (as they often did) a morsel of mummy, for mummy was flesh. Lister's comments remind us that a seventeenth-century cabinet of curiosities was meant to be seen through the eyes of a seventeenth-century *curioso* (or *curieux*).

The Musaeum Kircherianum was also formed within an academic religious house – the College at Rome of the Society of Jesus – but by a very different mind from that which created the cabinet of the canons of Ste. Geneviève. P. Athanasius Kircher (1602–80), an idiosyncratic German polymath,[51] was professor of mathematics and languages at the college in 1651 when a collection of antiquities was made over to the college by Alfonso Donnino.[52] Kircher, as a virtuoso who had received the encouragement of Fabri de Peiresc,[53] was appointed curator of the Donnino collection, and he used his position at the centre of the world-wide Jesuit order to enlarge it with *exotica* from Egypt, the Far East and the Americas as well as with mechanical, optical and acoustic instruments of his own devising.[54] The museum, though the property of the college and housed next to its library,[55] became a monument to Kircher's diffuse intellectual interests, which always tended towards obscure and inaccessible subjects such as the decipherment of hieroglyphics and the history of the Flood. Even when treating more orthodox problems of natural philosophy, such as the properties of sound, magnets, fossils or burning mirrors, Kircher exasperated more rigorous experimenters (who nevertheless revered his virtuosity) by his methodology, which he developed from a rich mixture of venerable occult traditions.[56]

A catalogue of Kircher's museum was published in 1678 by his assistant in mechanics, Giorgio de Sepi.[57] The engraved title-page (fig. 65) shows Kircher himself greeting some visitors and illustrates some objects in the collection. After Kircher's death in 1680 the museum was neglected: automatons fell into disrepair, organic materials rotted and

[47] Brice 1687, p. 32.
[48] Molinet 1692.
[49] MacGregor 1983, pl. CLXXXVI, reproduces two of them.
[50] Lister 1967, pp. 121–6.
[51] Kangro 1973; Reilly 1974.
[52] Villoslada 1954, pp. 183–4.
[53] Reilly 1974, pp. 41–3, 146–7.

[54] Pastine 1978; Rivosecchi 1982. On his correspondence, Gabrieli 1940.
[55] Reilly 1974, pp. 145–55.
[56] See, e.g., Thorndike 1923–58, vol. 7, pp. 568–9; vol. 8, p. 224; Allen 1949, pp. 182–3; Raven 1950, pp. 421, 439; Pastine 1978; Browne 1983, pp. 3–16.
[57] De Sepi 1678.

objects displayed to the public without supervision were stolen.[58] In 1698 P. Filippo Buonanni (1638–1725) was appointed curator, and though he claimed that 'the name of the museum is retained while the museum itself is wanting',[59] enough was left to provide a new reorganized display consisting of a vestibule hung with sepulchral inscriptions; a long L-shaped gallery lined on one side with windows and paintings and on the other with more paintings and secure cabinets; and three small rooms for hydraulic machines, manuscripts and illustrated books, and automatons.[60] Buonanni crowned his reorganization with a discursive catalogue of selected items (1709), in the preface to which he offered as Kircher's motive for forming the collection 'the glory of God and the advancement of the republic of letters'.[61] In illustration of the latter motive, one might mention Buonanni's discussion of a Roman tombstone with a relief of the rape of Proserpine (fig. 66): it leads to a consideration of Diodorus's and St. Augustine's interpretations of the myth, and hence provides matter for speculation on the theological significance of allegories of death in antiquity.[62]

THE ACADEMY AND THE CABINET

If one asks what cabinets comparable to the Royal Society's Repository[63] were established by European learned societies, the reply must regrettably be that any which did exist in our period have escaped this writer's search. The Accademia del Cimento at Florence (1657–67)[64] and the Académie Royale des Sciences at Paris (founded 1666)[65] possessed an abundance of 'curious' machines, but these were not placed on show (or not, in the case of the Cimento, until they had become antiques).[66] It commonly happened that the founder of an academy had a cabinet of curiosities while the academy itself did not: this was apparently true in the case of Federico Cesi (1585–1630), *principe* of the Accademia dei Lincei at Rome (1603–30);[67] of Johann Lorenz Bausch of Schweinfurt (1605–65), founder in 1652 of the peripatetic German Academia Naturae Curiosorum;[68] and of Giovanni Ciampini (1633–98),[69] guiding spirit of the Accademia Fisico-Matematica at Rome, founded in 1677.[70] But plans are no less part of history than accomplishments. The Lincei intended at first to have a museum,[71] and Cesi always intended to make over his collection to them,[72] though neither intention was fulfilled.[73] In 1690 the president of the Academia Naturae Curiosorum proposed to found at Jena 'a physico-medico-mathematical library

[58] Villoslada 1954, p. 185; Buonanni 1709, p. 1.
[59] Buonanni 1709, p. 1.
[60] Ibid., pp. 2–3.
[61] Ibid., p. 1 'ad divini Numinis gloriam, & Reipublicae litterariae emolumentum'.
[62] Ibid., pp. 87–90.
[63] See pp. 159–67 above.
[64] Middleton 1971.
[65] Académie des Sciences 1735–77.
[66] Hahn 1971, p. 123. Righini Bonelli 1968, pp. 38–9; Middleton 1971, pp. 328–9; p. 221 below. The contrary statements by Ornstein 1938, pp. 77, 158, are not borne out by the cited evidence (Monconys 1665–6, vol. 1, p. 130; Bertrand 1869, p. 37).

[67] Olmi 1981, p. 227; Gabrieli 1938–42, pp. 622–3; pp. 195–6 below.
[68] Bausch 1666, pp. 173, 183; Uschmann 1977, p. 23. On the academy, see Winau 1977 as introduction.
[69] Ansaldis 1689, p. 648; Grassi Fiorentino 1981, p. 141.
[70] Maylender 1926–30, vol. 3, pp. 11–17; Quondam 1981, pp. 48–9.
[71] Gabrieli 1938–42, pp. 28–30, 61, 110; Alessandrini 1978, p. 212.
[72] Gabrieli 1938–42, p. 348.
[73] Odescalchi 1806, p. 196; Alessandrini 1978, p. 18, citing Gabrieli 1938–42, p. 1217. For the contrary view, perhaps correct, that the Lincei had their own museum, see Bromehead 1947a, p. 21 and pl. I; Bromehead 1947b, p. 105; Maccagni 1981, p. 300; Krafft 1981, p. 448.

and a *theatrum naturae et artis* in which the rarer works of nature and technical inventions should be placed, after the example of the English Royal Society established in London',[74] but this proposal was not realized either, although a later generation of *Naturae Curiosi* did open a cabinet of natural history at Nürnberg in 1731.[75]

The political, financial and administrative problems which tended to reduce a seventeenth-century academy's life-expectancy to less than that of a man also worked to prevent the establishment of anything as permanent as a museum. Typical was the end of the Roman Accademia Fisico-Matematica: in 1698, when its founder Ciampini was asphyxiated by mercury fumes in the course of an experiment, the academy was extinguished also.[76]

One man who was never deterred by such problems was Gottfried Wilhelm Leibniz (1646–1716), who, as well as being a scholar, philosopher and librarian, was an indefatigable promoter of learned societies.[77] The various plans for such societies which he drew up for the Elector of Hanover in 1680,[78] for the Elector of Brandenburg in 1700,[79] for Peter the Great in 1708,[80] and for three Austrian emperors,[81] as well as an earlier plan of 1671,[82] allotted an important place to cabinets of medals, antiquities, instruments and anatomy, zoological and botanic gardens, and an *iconothèque*, all of which would illustrate 'the great works of art and nature.'[83] But like the academic cabinets dreamt up by J. V. Andreae (1586–1654) for his Utopian *Christianopolis* of 1619,[84] Leibniz's cabinets were fated to exist only on paper.

THE *NATURALIENKABINETT* OF THE HALLE ORPHANAGE

Leibniz's ideas did however find partial realization in the *Naturalienkabinett* formed at Halle in Saxony as part of the remarkable *Waisenhaus* or orphanage – really a cluster of charitable institutions – of August Hermann Francke (1633–1727).[85] Francke was a luminary of the Lutheran revivalist movement known as Pietism, and his educational foundations, like Leibniz's academies,[86] aimed at a combination of secular improvements and soul-saving. In general, both sets of institutions were intended to enhance mankind's stock of the God-like qualities of wisdom and power, and so promote universal harmony.[87] Specifically, they would arm missionaries with irrefutable knowledge of the natural world, and this knowledge in turn would make the heathens of Russia and China all the more willing to swallow mission-school teachings on supernatural matters.[88] The institutions at Halle which would accomplish these aims were built up between 1695 and

[74] Grulich 1894, pp. 4–6.
[75] Ibid., p. 10. For its troubled history, see Uschmann 1977, pp. 31–9.
[76] Grassi Fiorentino 1981, pp. 139, 141.
[77] Vennebusch 1966; Hammerstein 1981; for earlier bibliography, Müller 1967, nos. 752–93.
[78] Leibniz 1859–75, vol. 7, pp. 138–54.
[79] Harnack 1900, vol. 2, pp. 78–81.
[80] Leibniz 1859–75, vol. 7, pp. 470–8; pp. 55–6 above.
[81] Leibniz 1859–75, vol. 7, pp. 302–11, 373–382; Klopp 1869; Hamman 1973.
[82] Leibniz 1859–75, vol. 7, pp. 27–63.

[83] Ibid., vol. 7, p. 79.
[84] Andreae 1916, pp. 199–202.
[85] For Leibniz's proposal of a *Waisenhaus* c.1671, see Leibniz 1859–75, vol. 7, p. 52. On Francke, see Krämer 1880–2; Hertzberg 1898; Beyreuther 1957; Hofmann *et al.* 1965. Hinrichs 1971, pp. 1–125 is a good introduction to Halle Pietism.
[86] Schneiders 1977.
[87] On similarities between Leibniz's and Francke's ideas, see Hinrichs 1971, pp. 38–45.
[88] Leibniz c.1713 in Klopp 1869, p. 216. On missionaries from Halle, see below.

1700 and included the orphans' home proper, German school, Latin school, pharmacy, printing-press and *Naturalienkabinett*.[89]

The *Naturalienkabinett* already existed in some form in 1698 when it is mentioned in a printed prospectus as one of the attractions of Halle as a place for the studies of young noblemen.[90] But that it was still being expanded is shown by a begging-letter from Francke to Friedrich III, Elector of Brandenburg, probably of the same year. Francke describes the cabinet as containing 'all kinds of *naturalia* and *rariora* from the animal, vegetable and mineral kingdoms' which the pupils attend for one hour weekly for instruction, 'hoping to gain from it no little supplement to a sound education'. Then, since the Elector no doubt has 'many *naturalia* and *rariora* which are duplicates and superfluous', Francke would be grateful if the Elector would send them to Halle, which he did. The first printed inventory of 1701, containing 153 items, was obsolete by the next year when a coin cabinet and a manuscript collection were acquired, and donations began to flood in from ex-pupils who had been sent as missionaries to Sweden, Russia, the Far East and British colonies in North America. Donations from missionaries on the Malabar coast were often accompanied by reports on the languages, customs and natural history of the area, which were printed on the orphanage's press.

The value for publicity and fund-raising purposes of a visually striking museum was not lost on Francke, though his plan for moving the collection from an attic into a large hall formerly used as a dormitory was not realized until after his death in 1727. It must be accounted a success, for not only was the cabinet put to use in classes but it also attracted sixty visitors a day, and even more during the Leipzig fairs. Unusual items included two 8½-foot-high working models of the world systems of Copernicus and Tycho Brahe.[91] The classified catalogue of 1741 is outside our period and is mentioned here only to show that this cabinet, founded by A. H. Francke (d. 1727) and owing inspiration to the Utopianism of J. V. Andreae (b. 1586) and to the virtuosity of Leibniz (b. 1646),[92] formed a bridge between the world of the seventeenth-century *curioso* and the *siècle des lumières*.[93]

THE CABINET: AGAINST AND FOR

One should not infer from this survey that the cabinet of curiosities was considered an essential part of the house of learning. Some, like Descartes, disliked the whole business of curiosity.[94] Within the academy too there was vacillation and doubt. For one scholar, on the one hand cabinets were vitiated by fakes and misinterpretations, but on the other hand, in view of recent surprising discoveries, what should one not believe?[95] For another authority, cabinets enabled one to see *exotica* without travelling and therefore performed a useful service, but their exhibits were often unrepresentative or trivial fragments of nature which only wasted time.[96] Galileo ridiculed minor cabinets like that of Antonio Giganti,

[89] Storz 1962, p. 193; 1965.

[90] This paragraph is derived from Storz 1962, pp. 194–5, 198.

[91] Storz 1962, p. 195. The enlarged cabinet is described in Franckesche Stiftungen 1799, pp. 161–7, and illustrated in Sauerlandt 1911, pp. 136–9 and Schultze-Gallera n.d., pl. 65.

[92] Hinrichs 1971, pp. 45–7.

[93] Olmi 1978 on parallel developments elsewhere.

[94] Pomian 1982, pp. 550–6.

[95] Schelhammer in Conring 1688, p. 294, referring to Lebenwald 1684. On fakes in cabinets, see Maccagni 1981, pp. 300–2.

[96] Morhof 1714, vol. II, lib. 2, part 1, cap. i, para. 11, p. 132.

but only to praise major ones like that of Archduke Leopold Wilhelm.[97] The abbey of Ste. Geneviève in Paris had a cabinet[98] but the nearby abbey of St. Germain des Prés made do without one.[99] For many a scholar, his *museum* meant his library,[100] enhanced by no rarities but by dust and cobwebs.[101] Against these negative judgments must be set the actions of creators of cabinets such as Casabona, van Heurn, du Molinet and Francke, whose desire for certain knowledge was not so consuming as to kill their appreciation of the old, the fragmentary and the enigmatic.

[97] On Galileo: Panofsky 1954, p. 19; Micheli and Tongiorgi Tomasi 1982, p. 27. On Giganti: Fragnito 1982 and pp. 17–23 above. On Leopold Wilhelm: Distelberger, pp. 39–46 above.

[98] See pp. 173–4 above.

[99] Professor M. Ultee in conversation, 1983.

[100] Clemens 1635.

[101] Goetze 1712, p. 16.

ALIVE OR DEAD: ZOOLOGICAL COLLECTIONS IN THE SEVENTEENTH CENTURY

Wilma George

INTRODUCTION

After the exciting discoveries of the fauna and flora of the Americas and the East Indies in the sixteenth century and before the revolution in biological theory in the eighteenth century, the seventeenth century often seems to be a time of stagnation in natural history. But new plants and animals were pouring into Europe, their variety and number provoking endless questions. Why did collectors get birds of paradise only from the East Indies? Why armadillos only from South America? Should the armadillo be listed among the scaly reptiles or among the hairy viviparous beasts? Formal decisions were required on these matters, order was needed. In the seventeenth century, that ordering and decision-making began. It was a time when the foundations were laid for the first universal classification of Linnaeus in 1735; for the first zoogeographical glimmerings of Buffon in 1761 and 1766; and for the first great evolutionary theory of Lamarck in 1809.

To what extent did seventeenth-century cabinets of curiosities contribute to the systematization of natural history? To what extent were zoological collections affected by the new systematization?

THE COLLECTIONS

Catalogues of thirteen cabinets of dead specimens and two menagerie collections of live specimens have been analysed to answer five major questions. What sort of animals were in the collections? Where did the animals come from? Was there a national bias towards collecting from a particular part of the world? How did collectors get the animals? What use were the collections?

The criteria for choosing these particular collections were that they should have been accessible to the public and have had printed catalogues. The collections are listed in table 1. The Royal Society collection does not include the Hubert specimens which are treated separately. All together the collections contained 1,657 identifiable dead specimens – excluding shells, crustacea, echinoderms and so-called marine plants or corals – and 227 species of live specimens. The dead specimens vary from whole stuffed birds and mammals, dried trunkfish and pickled beetles to beaks, legs, horns, eggs and feathers. In many of the catalogues there are entries like 'gigantic tooth' (Worm) or 'animale incognito' (Cospi) and these have been ignored unless some indication is given

Table 1 The collections

The name of the collector is followed by the author and date of the printed catalogue. In brackets, the number of specimens used in this analysis.

Cabinets

England

J. Tradescant 1656 (285)
R. Hubert 1664 (181)
Royal Society: N. Grew 1681 (349)
J. Petiver 1695 (109)

Denmark

O. Worm 1655 (142)

Netherlands

J. van de Mere: Ray 1673 (46)
J. Swammerdam 1679 (178)

France

P. Borel 1649 (80)
Sainte Geneviève: G. du Molinet 1692 (39)

Germany

B. & M. Besler: J. Lochner 1716 (51)

Italy

F. Calceolari: B. Ceruti and A. Chiocco 1622 (62)
F. Cospi: L. Cremonese 1677 (72)
A. Kircher: P. Buonanni 1709 (63)

Menageries

Versailles seventeenth century: Perrault 1688, Loisel 1912 (188)
London seventeenth century: Pepys 1660–9, Willughby 1678, Bennett 1829 (39)

of the place of origin and the type of animal. Similarly, entries like '30 others' referring to bird beaks have been ignored.

In order to answer the first two questions, the specimens have been grouped according to type of animal and place of origin in tables 2 and 3. In some catalogues the place of origin is given. Where it is not, the specimens after identification can often be attributed to an area. For example, cassowaries come only from the East Indies, sloths from Central or South America. Atlantic fish might come from either side of the ocean so they have been classified as European unless a contrary indication is given. Other problem specimens have been treated equally arbitrarily. The Caribbean Islands and Central America have been included with South America. 'Reptiles' includes a few frogs and salamanders. 'Insects' includes such arthropods as spiders, scorpions, king crabs and centipedes but does not include crabs and shrimps.

WHAT SORT OF ANIMALS WERE IN THE COLLECTIONS?

The major groups of animals were represented in all the cabinets with the exception of that of James Petiver, who made a specialist collection of reptiles and insects. The menagerie catalogues contain neither fish nor insects. Taking the collections as a whole, the specimens are spread fairly evenly over the groups with only the live collections favouring birds and mammals above all others.

The most popular mammal was the armadillo (fig. 67). A scaly mammal was a valued

Table 2 Type and source of cabinet specimens

	Europe and Northern Asia		North America		South America		Africa		India and Siam		East Indies		Total
Mammals	215	56%	15	4%	45	12%	55	14%	41	11%	10	3%	381
Birds	122	42%	11	4%	50	17%	25	9%	30	11%	50	17%	288
'Reptiles'	118	40%	17	6%	62	21%	59	20%	27	9%	12	4%	295
Fish	239	71%	1	0%	59	18%	17	5%	16	5%	5	1%	337
'Insects'	264	74%	26	7%	30	8%	12	3%	4	1%	20	6%	356
Total	958	58%	70	4%	246	15%	168	10%	118	7%	97	6%	1,657

curiosity for the cabinet and its carapace easily dried and carried. It occurs in the catalogues of ten cabinets. Live armadillos do not seem to have been on show either at Versailles or London. All the cabinets except Petiver have antlers or horns and many had bits of hippos and bits of elephants. Whole live elephants, of course, were on show from time to time. The skull of the babyrousa pig from Celebes was often to be found – a 'monster' with its huge curling canine teeth (fig. 67). Rarities were Swammerdam's flying foxes (fruit bats).

By far the favourite bird was the fabulous bird of paradise, greater, lesser or king, with or without feet or wings (fig. 69). Bits of cassowaries from the same area were also popular: casques, legs, eggs and feathers turn up regularly. There were ostrich eggs in most collections and humming birds. The British collectors had a dodo. All these birds had been exhibited at Versailles or in St. James's Park, London.

Nearly every collection had crocodile skins or skeletons and dried chameleons. Over half had turtle carapaces. These animals, too, were to be seen alive at Versailles. But the prize reptiles were surely the flying lizards of the East in the collections of Swammerdam and Petiver.

The saw of the sawfish figures in nine collections and the easily dried trunkfish (fig. 68) and puffers were common. A rare specimen among fish was the garpike of North America attributed to Tradescant's collection[1] though not to be found in his catalogue. Half the collections could boast rhino beetles, king crabs and scarabs but butterflies were rarities except in Petiver's collection.

WHERE DID THE ANIMALS COME FROM?

Not surprisingly, the greatest number of specimens were local. South America was the next biggest source followed by Africa. North America contributed the fewest specimens.

There were European antlers and horns, birds of prey, tortoises, flying fish and beetles in almost all the collections. The now rare glutton had donated a leg to Tradescant's collection. The cabinet of Ste. Geneviève in Paris had some porcupine quills and both Versailles and London exhibited live bears.

[1] Gunther 1923–45, vol. 3, p. 364 and Davies 1983, p. 348.

South America had not lost its sixteenth-century fascination for collectors. Specimens ranged over all types of animals from tiny jewel humming birds and gaudy grotesque toucans (fig. 69) through weird iguana lizards to batfish (Tradescant, Swammerdam) and Peruvian lantern flies (Hubert).

Africa contributed reptiles and mammals, particularly live mammals. In addition to the crocodile and chameleon, the Egyptian skink and the big herbivorous dob lizard (*Uromastix*) came from Africa. African monkeys and gazelle were popular live exhibits.

India and the East Indies equalled South America in providing birds for the collections. This might be expected as South America and the East Indies have more unique families of birds than anywhere else in the world. Who could resist the birds of paradise and dark green cassowary eggs, extraordinary rhinoceros hornbills (fig. 69) and the peacock's feather (Worm and van der Mere)? Peacocks and Indian cranes strutted through the gardens of England and France.

Table 3 Type and source of menagerie specimens
V = Versailles; L = Tower of London and St. James's Park

		Europe and Northern Asia	North America	South America	Africa	India and Siam	East Indies	Total
Mammals	V	33	2	2	18	0	0	
	L	7	1	3	7	1	0	74
Birds	V	78	0	22	14	7	5	
	L	12	1	1	2	1	2	145
'Reptiles'	V	4	0	0	3	0	0	
	L	0	1	0	0	0	0	8
Total	V	115	2	24	35	7	5	
	L	19	3	4	9	2	2	227

The small contribution made by North America may seem surprising at a time when there were so many visitors from Europe and John Josselyn had studied the fauna of New England in detail by 1672. Rattles of rattlesnakes were occasional trophies but only Tradescant had any appreciable number of North American specimens. The younger Tradescant had made three journeys to North America and may have brought back a number of specimens like wild cats from Virginia, birds and insects.[2] Worm was given a live raccoon. The similarities of the North American and European faunas may have been the reason for the comparative lack of interest in North American specimens.

NATIONAL BIAS AND THE SPECIMENS

There was no distinct national preference for one sort of animal more than another among the collectors except that only the British collected large numbers of insects (table 4).

[2] Allan 1964, pp. 133, 173.

Table 4 Nationality of collectors and type of animal in collection

		Mammals	Birds	'Reptiles'	Fish	'Insects'
British	(4)	175	155	159	146	289
Danish	(1)	53	38	14	30	7
Dutch	(2)	56	42	47	54	25
French	(2)	25	25	25	37	7
German	(1)	10	12	15	13	1
Italian	(3)	62	16	35	57	27

Excluding Petiver's specialist collection, British collectors spread their interests the most evenly over animal types. The Dutch, too, spread their interests but had a preference for mammals and were least interested in insects. The Danish collection had a lot of mammals and very few insects. The Italians favoured mammals and fish, the French collections were rich in fish and poor in insects and the one German collection was almost devoid of insects. The two live collections showed mainly mammals and birds.

Predictably, the source of specimens differed according to the nationality of the collector (table 5). South America was the biggest source for the British and Danish collections after Europe. London exhibited a number of live African mammals. The Dutch drew heavily on the East while the Italian, French and German collections obtained the majority of their exotic animals from Africa. France had mainly live African mammals and South American birds on show. This distribution reflects the way in which the specimens were obtained: largely from traders.

Table 5 Nationality of collectors and sources of specimens

		Europe and Northern Asia	North America	South America	Africa	India and Siam	East Indies	Total
British	(4)	507	62	172	77	44	62	924
Danish	(1)	106	2	11	9	5	9	142
Dutch	(2)	106	3	24	19	55	17	224
French	(2)	80	1	17	14	4	3	119
German	(1)	31	0	5	9	3	3	51
Italian	(3)	128	2	17	40	7	3	197

HOW DID COLLECTORS GET THE SPECIMENS?

Many of the specimens can best be described as tourist junk. From the early sixteenth century, birds of paradise were sold to sailors who called at the Moluccas.[3] The birds were caught in New Guinea. They were skinned – often losing legs and wings in the process –

[3] Gilliard 1969, p. 15.

the skull removed, a stick run through and the specimen smoked in leaves (fig. 69). William Schouten bartered for two birds of paradise in 1616 and obtained a lesser and a greater.[4] 'The Holland pilots and ship-masters who are now wont to sail yearly into the East Indies, coming back from their voyages, do almost always bring home some of those birds.'[5] William Dampier's men bought sulphur-crested cockatoos and parakeets on the island of Bouru.[6] Ostrich eggs found their way from Africa and *Uromastix* lizards were sold as they are today: caught by little boys and led on strings to tourists. Dead specimens, too, were touted: stuffed with straw, grotesquely distorted but equally saleable. The illustration of *Uromastix* in the catalogues of Besler and Calceolari is very likely from such a stuffed specimen. Sometimes the sailors went straight to the collectors: a regular stream of sailors apparently went to the Ark at Lambeth with finds for Tradescant's museum which had become one of the sights of London.[7] Itinerant bagmen hawked their wares on spec in western Europe: 'a traveller from Palestine came', reported Thomas Platter, 'with his mule loaded with relics.'[8] Merchants, too, bought tourist trophies and, as Willughby reported, 'make great profit by selling them to others'.[9]

Some specimens were brought back to Europe alive or, at least, started their journey alive. Live animals were normal ship's cargo. Sheep, pigs, and poultry taken on board for food on the outward journey could be replaced by exotic animals on the return: both land and sea turtles were delicacies and many of them ended up in the pot and their carapaces in museums. In 1604, Jean Mocquet shipped an armadillo, a monkey and a sloth from South America and, on the same journey, snakes and alligators were taken on board for food.[10] Iguana skins and crocodile heads were often survivors of meals. Le Chevalier d'Hailley brought civets, a goat, partridges, guinea fowl and a crocodile from North Africa in 1671.[11] In the same year, sailors of the Dutch East India Company took a cassowary on board and sold it to the Governor of Madagascar. This bird eventually found its way to Versailles where it lived for four years.[12]

And there were gifts from friends and exchanges between collectors to enhance their museums. Hubert acquired his African electric ray from the collection of the King of France. St. James's Park received a gift of pelicans from the Russian ambassador in 1688.[13] Sir Hans Sloane gave Ray a Jamaican sulphur butterfly from his collection.[14] Walter Charleton gave Petiver a flying lizard which had been preserved in spirits.[15] It was only recently that specimens had been preserved in alcohol after Boyle had experimented with keeping a linnet in that way in 1663.[16] By 1689, Charleton was recommending: 'take Brandy, that of grain is as good as the other.'[17] Francisco Calceolari was given a live Egyptian chameleon which duly found its way into his collection.[18]

And there were the professional traders, such as Thomas Willisel who was commissioned by Ray and by the Royal Society to collect. He was a marksman and

4 Purchas 1625, p. 280.
5 Willughby 1678, p. 96.
6 Dampier 1697, p. 458.
7 Allan 1964, p. 145.
8 Platter 1963, p. 151.
9 Willughby 1678, p. 96.
10 Mocquet 1665, pp. 125–7, 142.
11 Loisel 1912, vol. 2, p. 113

12 Perrault 1688, p. 241.
13 Willughby 1678, p. 327.
14 Ray 1710, p. 112.
15 Petiver 1695–1703, p. 19.
16 Gunther 1925, p. 104–5.
17 Ibid.
18 Ceruti and Chiocco 1622, p. 673.

angler and, travelling with the simplers, brought in rare birds, fish and plants from all over the British Isles.[19]

The most enterprising of the professionals were undoubtedly those who hunted for the King's menagerie at Versailles. A Monsieur Gassion travelled regularly to the Levant and Tunisia in search of birds and mammals. Between 1671 and 1694 he made forty voyages and they were not without problems. The Turks saw an opportunity for exacting tax and many sea captains refused to take on board ostriches, pelicans and mongoose.[20] Monsieur Monier operated from Egypt and left details of the money he had to pay for specimens, for their food and for their transport. An ostrich cost more than ten times as much as a guinea fowl and five times as much as a demoiselle crane.[21]

Animals were regular cargo to Amsterdam. The Dutch East India Company had special warehouses and stables on the quayside to receive them. They were equally well provided for at the Cape.[22]

Sometimes the curiosity collectors went off themselves to collect in the field. The younger Tradescant is said to have brought back humming birds and beetles between 1637 and 1654.[23] Petiver caught butterflies and issued instructions to his friends: 'These must be put into your Pocket-Book, or any other small printed book as soon as caught, after the same manner as you dry plants.' But beetles 'may be Drowned altogether as soon as caught in a little wide mouth'd Glass or Vial of the aforesaid Spirits or Pickel, which you may carry in your pocket.'[24]

In Europe, Ray and Willughby acquired most of their specimens themselves. Willughby shot a dipper near Sheffield.[25] Ray assisted at a turtle catch in the Mediterranean.[26] They bought fish in the markets of Europe.[27] There were lamprey and sturgeon from Venice,[28] needlefish from Tenby,[29] swordfish from Reggio.[30] They picked up birds from the poulterers: swallows from Valencia,[31] kites and cranes from Rome.[32] There was a porcupine on sale in Rome.[33] Some specimens were dissected and drawn on the spot, others were dried and sent home. A consignment of German and Italian animals was sent from Italy in 1664 with the servant of Ray's friend Philip Skippon but, in the Mediterranean, the ship was captured by pirates and the cargo destroyed.[34] Thomas Platter had more luck when he sent rare fish successfully from the south of France to Basle in 1596.[35]

WHAT USE WERE THE COLLECTIONS?

For the most part, the cabinet of curiosities was just what it said it was: odds and ends to excite wonder. Almost every collection had 'monsters' in it: 'a monstrous calf with two heads' (Grew), 'a horned horse' and an 'ovum magicum' (Worm), 'calf with five feet'

[19] Boulger 1909, p. 497.
[20] Loisel 1912, vol. 2, p. 114.
[21] Ibid., vol. 2, p. 357.
[22] Ibid., vol. 2, p. 54.
[23] Allan 1964, p. 173.
[24] Petiver 1695–1703, p. 31.
[25] Willughby 1678, p. 149.
[26] Ray 1673, p. 290.
[27] Ray 1673, p. 362.
[28] Willughby 1686, p. 239.
[29] Lankester 1848, p. 175.
[30] Ray 1673, p. 316.
[31] Willughby 1678, p. 212.
[32] Ray 1673, p. 274.
[33] Ray 1673, p. 363.
[34] Raven 1942, p. 52.
[35] Platter 1963, p. 99.

(Cospi) and 'ova monstrosa' (Kircher). When the collection was displayed it rarely had any order in it. Stuffed birds stood on the top shelves of Calceolari's museum because there was room – mammals and fish hung from the rafters.

Collections could be advertisements: they attracted the public to the apothecary (Swammerdam, van der Mere) and the medical man (Besler, Borel) – rhino horn was good against poisons, elephant tusk helped conception. Collections improved social standing (Tradescant).

> I do remember an apothecary
> And in his needy shop a tortoise hung,
> An alligator stuff'd and other skins
> . . .
> Were thinly scatter'd to make up a show.[36]

The haphazard nature of the collections was manifest in the published catalogues.

Kircher's collection is divided into birds, marine animals and terrestrial animals for Kircher needed to know the number of birds and terrestrial animals which he must squeeze into the Ark he had designed.[37] Other catalogues segregate natural history objects into the obvious groupings of birds, beasts, fishes (which include whales and, often, turtles) and serpents, which often include insects (Tradescant). Lochner puts Besler's armadillo with lizards. Within the main categories the arrangement is often alphabetical (Tradescant, Swammerdam).

No one nationality and no one decade had a monopoly on chaos. Dutch, Italian, British, French and German – from 1656 to 1716 – follow, at best, the superficial traditional groupings of Gesner.[38]

But Ulisse Aldrovandi had not lived in vain. His influence on animal classification affected many of the seventeenth-century collections. For example, his breakdown of mammals into solid-hoofed, cloven-hoofed and clawed and the inclusion of whales with mammals[39] was followed by the Dane Worm (1655), the Italian Cospi (1677) and the Englishman Grew (1681). Grew explicitly rejects Gesner's classification and follows Aldrovandi with modifications.

Fishes, too, were sorted out and subdivided: Cospi separated cartilaginous from scaly (1677); Worm separated them into littoral, pelagic and freshwater (1655). Petiver used a geographical classification for the reptiles and insects of his collection (1695). Grew subdivided the Royal Society insects into those with naked wings, with sheathed wings and creeping insects (leeches, spiders, ants). And yet Swammerdam[40] had already demonstrated the importance of different types of insect metamorphosis. His discoveries were not reflected in Grew's classification nor in the catalogue which Swammerdam himself made of his father's collection.

The curiosity collectors did not contribute ideas to the revolutionary changes in plant and animal classification. A new classification of plants was being initiated by botanists and this soon affected animal classification.

[36] Shakespeare, *Romeo and Juliet*, act 5, scene 1, lines 37 ff.
[37] Kircher 1675, p. 108.
[38] Gesner 1551–8.
[39] Aldrovandi 1616, 1621, 1637.
[40] Swammerdam 1669.

Andrea Cesalpino[41] had arranged plants according to flower structure and almost all plants were given two names: a generic and a specific name. This binomial method of nomenclature was not unknown to the collectors of curiosities. Tradescant names the common scorpion *Scorpio terrestris*. Grew uses the form sporadically: *Capreolus moschi* the musk deer. Petiver is consistent though not very enlightening. All his butterflies are *Papilio*: some from Portugal; *lusitanicus*; and others from Java; *javanicus*. Most of Worm's fishes have two names – *Mustela laevis* the rough hound – as do some of the mammals, like the lemming *Mus norvegicus*. Almost all the collectors call the king crab *Cancer moluccensis* or *moluccanus* (fig. 70).

The first serious systematization of animals was made by John Ray and Francis Willughby.[42] 'We cannot claim to have discovered many new species,' Ray wrote. 'We have found some and can claim to have described, discriminated and classified more accurately.'[43] They had been asked to help John Wilkins with tables for his *Real Character* which was a systematization of language. Plants and animals were to be fitted into the system. Although the constraints were great it was an incentive to collect animals and plants all over Europe, to dissect fresh specimens and watch living animals and to group them.

Thus, in 1676, Willughby's *Ornithologia* was published posthumously. It divided birds into land fowl and water fowl. The first category of land fowl was the crooked-beak variety. This was subdivided into carnivorous and frugivorous kinds. They were either diurnal or nocturnal and after that greater or lesser. Greater and lesser were again divided into the more generous and the more cowardly. Within the lesser more generous groups were long-winged birds like falcons and short-winged like sparrowhawks.

In 1686 the *Historia Piscium* treated the fish to the same scrutiny. All possible characteristics were taken into consideration for a new classification of fish. *Synopsis Quadrupedum* (Ray 1693) and *Historia Insectorum* (Ray 1710) followed.

Although Ray and Willughby preferred to study living animals and fresh specimens, many of those which they described and classified were studied in cabinets of curiosities: of the Royal Society (an Indian antelope), of Tradescant (the dodo), of Petiver (insects); or in the descriptive catalogues of Worm (the crocodile), of Grew (turtles).

CONCLUSION

Cabinets of curiosities, although continuing as records of their owner's travels, as status symbols, as reflections of the general desire to collect odds and ends and pretty things, were, in their own ways, contributing to the ordering of the natural world. Some formed the basis of institutionalized collections, some provided information for those who were revolutionizing the studies of animal and plant geography and classification. In the seventeenth century many people were able to see a dodo, an ostrich and a bird of paradise alive or dead. They gaped, they admired, they wondered and they asked questions.

[41] Cesalpino 1583.
[42] Willughby 1678.

[43] Willughby 1686, supplement, p. 30.

CONCHOLOGY BEFORE LINNAEUS

Henry E. Coomans

INTRODUCTION

The founding collection of the Ashmolean Museum at Oxford contains several portraits of the John Tradescants senior and junior. On two of these paintings a number of shells can be seen. The four shells ornamenting one painting of Tradescant the elder must have been particularly dear to him because of their rarity, beauty and value. Nowadays you can buy the same four species for less than a pound each. Hence some *naturalia* from curiosity cabinets, which were priceless 350 years ago, can be obtained easily at the present time. Conversely, the art treasures which formerly adorned *Kunstkammern*, although bought for reasonable sums in the past are often priceless now, and in this respect they are different from animal, plant and mineral specimens.

Zoology has divided the animal kingdom into a number of classes, of which the insects are by far the largest group. Second in line are the molluscs with about 100,000 recent species. Amongst the molluscs are grouped together the snails, the bivalves (oysters and mussels) and the cephalopods (squids, octopus and nautilus). The mollusc body consists of two parts: the living animal and the hard shell, the main function of the shell being to protect the slow-moving mollusc against its enemies. The study of the animal – its anatomy, behaviour, physiology and so on – is called malacology ($\mu\alpha\lambda\alpha\varkappa\acute{o}\varsigma$, soft). The study of the hard shell is called conchology (*concha*, shell).

Molluscs can be found everywhere on earth: on land even up in the mountains, in freshwater, and from the sea shore to the depths of the oceans. The animals are edible, as was already known to primitive men; shell middens are found in many places and are studied by archaeologists. The hard shells were also used for tools and ornaments. At the present time the edible mussel and oyster, the Roman snail and the squid are appreciated by gourmets.

Shells consist of calcium carbonate or limestone, and therefore the shell may survive for thousands of years after the animal has died. For this reason, and because the molluscs are a very old group in the evolution of the animal kingdom, shells play an important role in palaeontology. The shell has two layers of limestone: the outer layer has a white ground, often with a beautiful pattern in colour; the inner layer is nacreous and made of mother-of-pearl, or it may resemble porcelain. It is because of the mother-of-pearl that shells are able to produce pearls. Thus the Chinese discovered hundreds of years ago how freshwater pearl mussels can be induced to make Buddha figures from mother-of-pearl. The two-layered shell is used to make shell cameos, distinct from the much harder stone cameos. The famous nautilus cups from the Renaissance were created with nautilus shells from which the outer layer had been removed, leaving only the mother-of-pearl.

With the Swedish naturalist Carolus Linnaeus, or Karl von Linné (1707–78), a new chapter in biology opened. He wrote the *Systema Naturae*; the tenth edition published in 1758 is considered the basis for systematic zoology and botany. To regularize the confusing nomenclature of animals and plants, he proposed that each species should have a binominal Latin name: the first is the name of the genus in which closely related species are grouped together; the second name distinguishes one species from its relatives.

This article will discuss conchology before the year 1758, at which time the Ashmolean Museum had already existed for seventy-five years. Conchology in those days included shell collecting, the collectors and their collections, and the literature which was published about shells.

SHELL COLLECTING

Shells are ideal objects to collect for several reasons: there are many species, both rare and common, so that no collection will ever be complete; they are beautiful and there is a great variety even within species; they are convenient in size; they are found everywhere and are easy to obtain.

Aristotle (384–322 BC), who is considered the founder of zoology, studied molluscs, but whether he possessed a collection is not known. The Roman author Pliny the Elder, who was killed by the eruption of Vesuvius in AD 79, probably knew some foreign shells as some have been found in the ruins of Pompei.

It seems that shell collecting started during the Renaissance, when European countries sent ships to the East and West Indies, and from these new lands treasures flowed back to Europe. Sea shells must have been picked up on far-away beaches by seafarers. The first collections were assembled in the Low Countries.[1] Desiderius Erasmus of Rotterdam (1467–1536) owned a shell collection; and we know from the journey of Albrecht Dürer (1471–1528) that shells were featured in cabinets in Antwerp. The hobby spread to other countries: the Swiss zoologist Conrad Gesner (1516–65) had a collection of animals including shells. Italy, Germany and France followed. In Britain John Tradescant (d. 1638) started a collection of *naturalia*, later enlarged by his son John Tradescant the younger. The collection eventually came to form the basis of the Ashmolean Museum.[2] None of these early collectors specialized in shells alone: they were interested in everything curious enough to merit collecting.

Shell collectors can be divided into two main groups, although there is no clear dividing line:
(a) The collection collector, to whom the objects are the main goal. The shells must be perfect; the collector may pay any price to get them, and their beauty and rarity must demonstrate his wealth.
(b) The scientific collector, who considers the shell as an object for study, and the collection as an aid to teaching; for him value lies in knowledge, not in price.

Shell collecting was often associated with certain specific categories of collectors: general scholars or naturalists (Erasmus, Gesner, Aldrovandi, the Tradescants),

[1] Dance 1966, p. 33. [2] MacGregor 1983.

physicians (Paludanus, Worm, Lister), apothecaries (Petiver, Seba), noblemen (Cospi, Imperato, Friedrich of Gottorp, Cosimo de' Medici). The relation between shell collecting and those people seems logical: scholar – teaching; physician – anatomy; apothecary – medicine; nobleman – money. We are perhaps inclined to suppose that the show collections of the nobility have a lesser value for science, but these wealthy people also wanted their collections described by naturalists. For this reason a number of illustrated books or catalogues were published.[3] In addition Worm[4] and Tradescant[5] described their own collections.

As well as the catalogues of the collectors, there were general textbooks on natural history in which molluscs were also discussed.[6] In these works fact and fancy were often mixed.

Not only collectors and scientists were interested in shells. Their beauty was also discovered by artists: in still-lifes, flower arrangements were often surrounded by shells, and silversmiths used the polished shell of the nautilus to create the nautilus-cups.

Because the shells of snails are asymmetrical, these were often figured in reversed position in engravings; a well-known example is the engraving of the marbled cone shell by Rembrandt (1606–65).

The first books devoted entirely to shells were published at the end of the seventeenth century. An Italian Jesuit priest, P. Fillipo Buonanni (1638–1725) produced a picture book on shells.[7] Because the author was not a scientist, the text is of rather low quality, but the shells are well illustrated (fig. 71).

The physician Martin Lister (1639–1712) published a book on British animals which included shells.[8] Subsequently he published a *Historia Conchyliorum* which comprised about 1,000 plates of shells but almost no text.[9] Many drawings (fig. 72) were prepared by Lister's two daughters, and the work is systematically arranged. Besides those from Lister's own collection, the shells figured were from the Ashmolean Museum and from the collection of William Charleton (or Courten). After this work was finished in 1692, a second edition was published, to be followed by a third edition in the succeeding century, prepared by William Huddesford, curator of the Ashmolean Museum. Apart from these systematic works, Lister also produced three publications on the anatomy of molluscs.

A third author of malacology is Georg Rumphius (1627–1702). Although born in Germany, he was employed by the Dutch East India Company on the island of Amboina from 1656, and his works were written in Dutch. Rumphius first published a book on the plants of Amboina, and later started one on the shells of the island. After he went blind in 1670, his son helped with the illustrations and the text. Another disaster for him was the great fire in Amboina in 1687, in which all the original plates were destroyed and had to be renewed. In 1699 the text and plates were sent to Holland, where the manuscript was prepared for publication by Simon Schijnvoet, who added some plates. The first Dutch

[3] Olivi (1584) described the collection of Calceolari; Olearius (1666) Gottorp's *Kunstkammer*; and Legati (1677) the museum of Cospi.

[4] Worm 1655.

[5] Tradescant 1656.

[6] The French biologists Pierre Belon (1517–64) and Guillaume Rondelet (1507–66) both wrote on aquatic animals.

Conrad Gesner (1516–65) from Basel published an encyclopaedic work on zoology.

[7] Buonanni 1681; many of the specimens were present in the collection of another Jesuit, Father A. Kircher.

[8] Lister 1678.

[9] Lister 1685–1692.

edition of *D'Amboinsche Rariteitkamer*[10] was followed by a Latin edition (fig. 73), the *Thesaurus Cochlearum* (1711) and by translations into English, French, German and Russian. The Royal Library at The Hague possesses forty-five original plates.[11] Rumphius's work is very important for conchology, as he was the first to observe tropical shells in the field; he gave accurate locality data; he wrote about the biology of the animals. He also gave much information on local applied conchology – the practical use of shells for food, ornaments, weapons, household articles and musical instruments like shell trumpets. In addition Rumphius gave a systematic classification; he often used a binominal Latin nomenclature (as was later officially introduced by Linnaeus). Although living on a remote island, Rumphius was familiar with the conchological literature of his time. He was in contact with the publisher Blaeu in Amsterdam, and also with collectors in Holland and Germany. He sent many shells to Europe, became a member of the Academia Curiosum Naturae in 1681, and was given the title of 'Plinius Indicus'. Rumphius sold a collection of shells to Cosimo de' Medici in 1682. Some of these shells are now preserved in the museum at Pisa, having been formerly in the collection of Gualtieri who received duplicates from Cosimo.

Rumphius's book appeared at the beginning of the eighteenth century. Meanwhile shell collecting continued to spread – even kings and queens were now shell collectors. In France the *Cabinet du Roi*, started by Louis XIII in 1635, became the largest collection in the eighteenth century. The Russian Tsar Peter the Great (1672–1725), when in Holland, bought large collections from Seba and Ruysch. Christian VI of Denmark was a shell collector, as were the kings of Poland and Portugal; in Sweden King Adolf Frederic and Queen Louisa Ulrica each had collections, many shells from their cabinets being described by Linnaeus.[12]

The literature of the eighteenth century was enriched with beautiful illustrated works. The Italian Niccolo Gualtieri (1688–1744) illustrated his collection in a book with almost no text;[13] he was physician to Cosimo III who had bought shells from Rumphius. The secretary of the French king, Antoine d'Argenville (1680–1765), wrote a *Conchyliologie*, of which the text is not of a high standard, but the plates are well engraved.[14] A Dutch apothecary in Amsterdam, Albert Seba (1665–1736), after selling his first collection to Peter the Great in 1717, started another collection which was described in four large volumes,[15] the third of which dealt with the shells. This work is scientifically arranged, although some figures are contrived in artistic arrangements (fig. 74).

The collections of James Petiver (1658–1718), also an apothecary, and Sir Hans Sloane (1660–1753) who collected in Jamaica, later formed the basis of the British Museum (Natural History).

An excellent illustrated book was published by F. M. Regenfuss (1713–80) in Copenhagen.[16] The work is of enormous size, but has no scientific arrangement, though it came out in the same year as Linnaeus' classic work.

[10] The work was published in 1705, three years after Rumphius's death.

[11] Benthem Jutting 1959, pls. 17–22.

[12] Linnaeus 1754, 1764.

[13] Gualtieri 1742.

[14] Argenville 1742.

[15] Seba 1734–65.

[16] Regenfuss 1758.

WHERE ARE THE ORIGINAL COLLECTIONS?

It is sometimes possible to trace the history of an old collection, but in most cases the shells are lost. Erasmus's collection from around the year 1500 was still extant in 1744, but is now lost.[17] The shell collection of Paludanus was brought to Gottorp and later transferred to Copenhagen. Only one single specimen from the Tradescant collection is known at present, namely *Strombus listeri* in the Hunterian Museum at Glasgow. Some specimens collected by Rumphius at Amboina are currently in the museum at Pisa. From the collection made by the Dutch clergyman F. Valentyn (1656–1727), who also worked in and wrote about Amboina,[18] a few shells were recently traced in the Zoological Museum at Amsterdam. The shell collection of Queen Ulrica of Sweden is still extant in the University of Uppsala.

One of the reasons that shells have disappeared lies in the fact that specimens without exact locality data are of no value to systematic zoology, and have sometimes been thrown away.[19] On the other hand, some museums contain parts of old collections, of which the original collector is unknown.

SHELL DEALERS, SOCIETIES AND AUCTIONS

Little is known about shell dealers in the sixteenth and seventeenth centuries, but in 1644 there was a shop in Paris known as 'Noah's Arke' which sold natural history objects. Rumphius sold shells and other *naturalia* from Amboina to collectors in Europe via his Dutch friends in Holland. With the money which he received he was able to buy the literature he needed. Exchanges of specimens also took place.

Starting in 1720 six shell collectors in Holland met once a month at Dordrecht to discuss their hobby. They called themselves the 'Lovers of Neptune's Cabinet'. This can be considered the first conchological society.[20]

Shell auctions started in the eighteenth century, and were very popular in Holland during the first half of that period.[21] Seba's second collection was auctioned in 1752 over several days, fetching about 25,000 guilders. This money was needed to finance the third and fourth parts of his *Thesaurus*.

During the eighteenth century the number of shells coming to Europe from overseas was so enormous that they were used sometimes as playthings. Shells were no longer kept merely in the drawers of cabinets – they were pasted all over them. There were shell grottoes in Italy, walls of rooms decorated with shells in England,[22] and a three-metre high clock in Holland covered with shells from top to bottom. When shells were used for purely decorative purposes like these, they were no longer curious objects. The end of the cabinet of curiosity had arrived.

[17] Engel 1939.
[18] Valentyn 1754.
[19] Davies and Hull 1976, p. 50.

[20] Engel 1937.
[21] Dance 1966, p. 61, referring to Gersaint 1736.
[22] Cameron 1972, p. 9.

'*CURIOSITIES* TO ADORN *CABINETS* AND *GARDENS*'

John Dixon Hunt

In sixteenth-century English the word 'cabinet' had a sense of 'summerhouse or bower in a garden',[1] and it continued to be so used at least until Miller's *Gardeners dictionary* of 1737. But fresh ideas of garden design and philosophy reaching England from Italy augmented the scope and idea of both a garden and a cabinet. These new attitudes are clearly suggested in John Evelyn's diary which, recording a visit to Sir Thomas Browne in October 1671, notes that Browne's 'whole house and garden' was 'a paradise and cabinet of rarities, and that of the best collection, especially medals, books, plants, and natural things'.[2] It is this new relationship between cabinets and gardens, traced first in its continental (chiefly Italian) manifestations and then in its deployment and declensions in England that is the subject of this essay.

The garden's association with the cabinet took various forms. The most obvious was simply that of physical proximity, though of course not all gardens were contiguous to cabinets nor were all cabinets linked to gardens. But many Italian Renaissance gardens were specifically dedicated to the display of objects which also featured in non-gardenist cabinets, and their designers accordingly made provision for those collections with galleries, loggias, special pavilions and grottoes. In the Orti Oricellari in Florence classical sculpture was displayed alongside every plant mentioned in classical literature.[3] At Mantua Isabella d'Este created in the Corte Vecchia of the ducal palace a small complex of spaces for the display of sculpture, paintings and precious stones which included a *studiolo*, a room known as the *grotta* as well as a *giardino segreto*.[4] And of course botanical gardens – by the very nature of their existence as places for study and teaching – usually incorporated buildings where natural rarities and curiosities were displayed. Such was the case with two of the earliest botanical gardens at Pisa and Leiden, founded respectively in 1543 and 1577.

At Pisa in the 1640s Evelyn remarked that the garden 'joynes a Gallery . . . furnish'd with natural rarities, stones, minerals, shells, dryed Animals . . . etc.'[5] The inventories of that Gallery show that by the time of his visit the collections included not only natural objects – what the Bolognese naturalist Aldrovandi called 'le cose sotterranee et le altre sopraterranee' – but pictures, engravings and drawings.[6] Some of these latter, still surviving at Pisa, are beautiful representations of flowers, animals and birds; but the

[1] *OED*, citing Spenser's *The Faerie Queene* (II.xii.83) among other sources. John Rea also describes a flower garden as a 'cabinet with several boxes fit to receive and securely keep Nature's choicest jewels', *Flora* (1665), quoted by Beck 1979, p. 50.

[2] Evelyn 1955, vol. 3, p. 594.

[3] Comito 1971, p. 486 note.

[4] See Fletcher 1982, pp. 51–63.

[5] Evelyn 1955, vol. 2, p. 181.

[6] See *Livorno e Pisa* 1980, especially for the drawings; Aldrovandi is quoted on p. 523.

collections included religious pictures, landscapes and portraits of European botanists, including Clusius. A similar conjunction of botany and natural history museum was made at Leiden, where the *Ambulacrum*, built in 1599, contained a museum of *naturalia*, curious examples of which decorate a well-known print of 1610. A drawing sixty years later (fig. 75) shows the addition of an orangery for the display and winter care of plants and a small house where chemistry experiments were conducted.[7]

Some botanical gardens, like Leiden and Florence, had a simple layout of their plant beds, readily accessible to the mind's categorizing and understanding as to the gardener's hands and care. But others, Pisa and Mantua for example, had far more elaborate designs, borrowed from shapes and decorations which artists and architects had devised for other projects.[8] These alert us to a familiar Renaissance theme, the debates of art and nature – sometimes a collaboration, sometimes a rivalry or *paragone*; this theme also made common ground between cabinet and garden in the Renaissance, though the latter was especially apt territory for it. Despite the objections of the Siennese writer, Giovan Battista Ferrari, who considered elaborately shaped beds 'quite unsuitable both for sowing seeds and for growing them', it became fashionable to arrange plants in what Agostino del Riccio called 'beautiful patterns in the forms, variously, of pyramids, maps, dragons, stars, and other *fantasie*'.[9] It was this kind of artifice which helped to register the affinities between garden and cabinet.

Evelyn's experience of gardens and cabinets and his sense of their congruence are everywhere apparent in his Italian diary.[10] From his first entry into Italy, at Genoa, he was impressed by the palaces and their gardens: his mind seems to make immediate connections between them and their collections or cabinets. At the Palazzo Doria he passed from the 'Achates, Onyxes, Cornelians, Lazulis, Pearle, Turquizes, & other precious stones' of the house into the three-tiered gardens where the 'rare shrubs' and fine marbles seem an extension of the rich interior. At the 'Palas of Negros' it was the terraced garden and its grottoes, similarly juxtaposed to 'rarest Pictures, & other collections', which he records. But he was struck also by the imitations of animals in stone, part of an elaborate metamorphic display of plants and flowers rendered in shells, stones and other precious materials. Just the same fascination with materials and their presentation was shown by Furttenbach in his *Newes Itinerarium Italiae* of 1627; but the ease and sophistication of Furttenbach's handling of these topics throws into relief Evelyn's relative inexperience of such wonders – in this he was typical of most English visitors before the middle of the century.[11]

However, by the time Evelyn had almost concluded his Italian itinerary and was in

[7] For an account of the Leiden Hortus Botanicus, see Karstens and Kleibrink 1982 and the relevant sections of Rijksmuseum 1975. For another Dutch botanical garden attached to an academy, see Museum 't Coopmanshus 1980, pp. 4–13.

[8] See Tongiorgi Tomasi 1983, pp. 1–34. Tongiorgi Tomasi illustrates various garden layouts, including the simple one at the Florentine Botanical Garden and the more intricate one at Mantua, significantly (for our purposes) designed by the man who was both antiquarian and herbalist to the Gonzagas, Fra Zanobi Bocchi.

[9] Ferrari 1638, p. 16; del Riccio, *Agricoltura teorica*, MS,

Biblioteca Nazionale, Florence, f. 50 recto. For further discussion and quotation, see Tongiorgi Tomasi 1983.

[10] Evelyn is used throughout this essay as providing representative evidence of both gardens and cabinets; other English travellers to Italy amply confirm his reactions. Evelyn's diary is not always a first-hand account, but even in its borrowings from other travel books it is usefully symptomatic.

[11] Evelyn 1955, vol. 2, pp. 173–5; the 'Palas of Negros' is now the Villa Rolla-Rasazza. On Furttenbach and the Genoese gardens' cabinet-like play with natural materials, see Magnani, 1978–9, pp. 113–29.

Rome for his second visit, his knowledge and assessment of these intricate relations between garden and cabinet were more assured. In some doggerel verses he tells the Eternal City that she 'Justly art term'd the *Worlds sole Cabinet*'.[12] That Rome should seem the epitome of cabinets is not surprising, and Evelyn's verses rehearse the wealth of its collections, the 'thousand wonders' of its buildings and its '*Villa's, Fountaines, & Luxurious Fields*'. But during his two stays in the city Evelyn had visited at least seven collections or cabinets and twice as many gardens. Some cabinets were unconnected with gardens: that belonging to Francesco Angeloni – 'divers good Pictures, many outlandish & Indian Curiosities & things of nature' was what Evelyn recorded; that of Cassiano dal Pozzo, who owned a 'choice Library', drawings, medals and a 'rare collection of Antique Bassirelievos'; and the medal collection and antiquities of the brothers Gottifredi.[13]

Other cabinets, like those of the Vatican, were closely linked to gardens, where some of the collections were displayed. Even when Evelyn does not go into details, the diary entries seem to imply a connection between cabinets and gardens; that this is not simply an accident of a journal's abbreviated structure is clear from Evelyn's more detailed visits. At the Vatican he proceeds from the Palatine Library, noting the frescoes by Domenico Fontana which record the raising of the obelisk, to the Armoury – a 'Library of Mars' – and out into the Belvedere courtyard, where the many famous statues were protected in shuttered alcoves, and finally to the Gardens, where it is the ingenuity of the water-works, 'divers other pleasant inventions' and its fruit trees that he notices.[14] All items in the Vatican collection elicit from him an equal attention, and the passage from inside to outside appears as natural as it does in his other visits. At the Villa Ludovisi, for instance, the kind and degree of his attention are the same whether outside in a garden where 'every quarter [is] beset with antique statues, and Walkes planted with Cypresse', or in the Casino dell' Aurora, a pavilion in the gardens decorated with paintings and displaying a clock 'full of rare & extraordinary motions', 'many precious Marbles . . . and other rare materials' as well as 'a mans body flesh & all Petrified, and even converted to marble', or inside the villa with its huge and diverse collections, some of them contained within what Evelyn specifically terms 'the Cabinet'.[15]

But gardens were used not simply as spill-overs for extensive collections, but as an integral part of the display system. The presentation of the Papal collection of sculpture in the Villa Belvedere had set a pattern which was imitated throughout the sixteenth century. One famous garden belonged to Cardinal Cesi; it was painted by Hendrick van Cleef III in 1584 (fig. 76). Although some liberties have been taken with the topography, the sense of a garden used as an open-air museum is strikingly conveyed; visitors are wandering around, some caught in admiring gestures, artists are sketching the antique figures scattered throughout the various compartments of the garden, while other items are being excavated and carried away, presumably for other collections.[16] The Cesi garden depicted by van Cleef did not survive long enough for Evelyn to see it, though he

[12] Evelyn 1955, vol. 2, p. 405.
[13] Ibid., pp. 236, 297, 391 respectively.
[14] Ibid., pp. 302–5.
[15] Ibid., pp. 234–6.
[16] The painting is discussed by Meulen 1974, pp. 14–24.

However, she confuses this Cesi garden with another, not this time in the Borgo Vecchio but under the Janiculum Hill: this other Cesi garden was famous for its fountains, for its *Antiquario* with adjacent supper room and covered loggia. For this garden, see Gnoli 1905, pp. 267–76.

would have seen many items from its former collections relocated at the Villa Ludovisi. But the idea of using a garden as museum did survive and was elaborated in innumerable villa designs which Evelyn did see. Loggias, especially, were invoked to display collections – useful because they offered protection while being still outside; and they were, too, an intriguing architectural feature, because so unfamiliar, to English visitors.[17] Besides loggias, gardens like those of the Villa Medici were provided with open galleries for the display of their collections: Evelyn recorded 'a Portico with Columns towards the Gardens' or 'the Arcado'. At both the Villa Medici and at the Villa Borghese he was impressed by the device of embedding antiquities, notably bas-reliefs, in the walls of both the galleries in the garden and the facades of the house – the garden 'facciata [of the Medici Villa] is incrusted with antique & rare Basse-relievis & statues', whereas 'the enterance of the [Borghese] Garden, presents us with a . . . dore-Case adorned with divers excellent marble statues.'[18]

Evelyn's botanical and horticultural enthusiasms are less frequently recorded, partly (I suspect) because the printed sources with which he refreshed his memory years later when he came to write up the Italian journal did not concern themselves with this aspect of gardens except in the most general terms. But his occasional notes on what he saw growing in Italian gardens are of a piece with his experience of them as cabinets of artificial and natural rarities. In the 'spacious Parke full of Fountaines' at the Villa Montalto he noted fish ponds, statues, inscriptions, ancient marbles and ('that which much surpris'd me') 'monstrous Citron-Trees'. At the Villa Aldobrandini he was impressed by the 'Citron trees . . . rarely spread [which] invest the stone worke intirely' as much as by the collections 'all for antiquity and curiosity'. At the Villa Borghese the garden, he wrote, 'abounded with all sorts of the most delicious fruit, and Exotique simples'; he continues with notes on 'Fountaines of sundry inventions' and the miniature zoo ('divers strange Beasts').[19] It is clear from pictorial records of the Borghese gardens that its flower beds were obviously designed to display such floral collections. Further north in Florence, where the Medici also took a lively interest in flower collecting, similar layouts can be seen in the series of lunettes of Medici villas which Gustave Utens painted in 1599.[20] Unfortunately, those images are scarcely explicit about the planting; indeed we are grievously short of adequate documentation on late sixteenth- and early seventeenth-century plants and planting. As Utens and other documents suggest, it was largely in the *giardini segreti*, private spaces to the sides of villas, where the visitors would not usually be admitted, that were to be found the plant collections to rival the antiquities, medals, precious stones and so on. Francis Mortoft is exceptional in his record of 'the little flowered garden' at the Villa Montalto in Rome; Evelyn writes only of its 'spacious park'. What records we do have of these small, private flower gardens confirms their contribution to the overall cabinet of a villa. Georgina Masson's pioneering article on Italian flower collectors' gardens gives ample testimony of owners' pride in displaying floral specimens, often new importations, which were prized as much as antiquities.

[17] See, for example, the surprise of Fynes Moryson (1907, vol. 1, p. 291) at the Villa Medici in Rome, or of Evelyn (1955, vol. 2, p. 288) at the Farnesina.

[18] Evelyn 1955, vol. 2, pp. 231 (Medici), 251 (Borghese).

[19] Ibid., pp. 240, 285, 251 respectively.

[20] An anonymous painting of the Borghese gardens is reproduced in Florence 1931, pl. 48; the Utens lunettes are finely reproduced in the first issue of *FMR* (March 1982), pp. 120–41.

Catalogues, published and in manuscript, further testify to the pride taken in such botanical collections.[21]

If the dozens of English visitors to Italy are not precise about the cultivated materials in gardens, they are none the less alert to the gardens as cabinets of rare *naturalia*; this was notably true when they were faced with oranges and lemons which, although by no means unknown in England in the seventeenth century, when encountered everywhere and in profusion seemed to travellers to be revivals of the mythic Hesperides. Thus the MS journal of Banister Maynard records outside Turin 'a most pleasant garden with Leamonds, Oranges, Pomegranads and many other sorts of Rich fruite'.[22] Maynard was travelling in the early 1660s; earlier travellers were more enthusiastic because more surprised – Fynes Moryson saw the gardens near Naples as rivalling the Hesperides.[23] Coryate was excited by citrous trees in the Valmarana gardens at Vicenza and saw plane trees for the first time (though he had read about them in Virgil) in the Botanical Gardens at Padua.[24] Necessarily, it was botanical gardens where visitors were specifically attentive to plant collections. Pury Cust, at Pisa aged twenty-one, is among the most explicit when he records: 'The Phisicke garden very fine and adorned with many simples, many fine smelling herbs, all manner of rare flowers, and aboundinge in all kinds of most rare oranges and limons . . . palm trees . . . pepper trees . . . Spanish allowes.'[25] Philip Skippon, travelling with John Ray, inspected a botanical garden in Messina where its creator, Dr J. P. Corvinus, had divided it into twelve plots named after the apostles, a hint of the unscientific motives which sometimes directed the display of these collections.[26] Ray himself, as we might expect, notices the botanical elements in these gardens/cabinets more frequently, but at least in the published *Observations, Topographical, Moral & Physiological* (1673) these tend to be fairly general: 'goodly flowers and choice plants' in the Boboli Gardens, and in the villas of Roman nobility 'gardens of flowers, groves and thickets, cut hedges of Cypress, Alaternus, Laurel, Bay, Phillyrea, Laurus tinus and other semper-virent plants'.[27] Ray, with his lively account of cabinets as well as gardens, is a prime spokesman for the relationship which English visitors perceived to exist between them in Italy. Not surprisingly perhaps, Evelyn's copy of Ray's *Observations* has marks in its margins most frequently against discussion of Italian cabinets of curiosity.

The sophisticated Italian garden and the cabinet shared several concerns. They both represented, by deliberate policy or casual effect, an image of the world's fullness. Evelyn's description of Rome as the 'Worlds sole Cabinet', beyond the claim that it was the biggest and best, also implied that in its various collections all the world was represented.[28] The use of the word 'theatre', in its sense of conspectus or collection, to describe gardens and their botanical contents also signals this sense of having achieved

[21] Masson 1972, pp. 61–80. The planting MS, mentioned by Masson (p. 74 n. 24), is being edited together with others related to it by Elisabeth MacDougall and will be appearing in a future issue of the *Journal of Garden History*.

[22] Bodleian Library, Oxford, MS Rawlinson D. 84, fol. 7 recto.

[23] Moryson 1907, vol. 1, p. 239.

[24] Coryate 1905, vol. 1, pp. 281, 292.

[25] Cust 1898, p. 342. He continues by noticing that 'By this garden is a fine Gallery adorned with many natural curiosityes.'

[26] 'An Account of a Journey . . .' in Churchill 1704–32, vol. 6, p. 613.

[27] Ray 1673, pp. 335 (Boboli), 364–5 (Roman villas). Evelyn's annotated copy of Ray's *Observations* is in the British Library, Eve. a. 44.

[28] The language of all travellers and collectors betrays a similar assumption: the repetition of 'all' in Cust's account of the Pisan Botanical Garden or Aldrovandi, both quoted above.

something of the world's fullness lost with the Fall. That point was made in the verses prefixed to *Musæum Tradescantianum*:

> Nor court, nor shop-crafts were thine ARTES, but those
> Which Adam studied ere he did transgresse,
> The wonders of the Creatures, and to dresse
> The worlds great Garden.[29]

But gardens were theatres in other relevant respects. Their collections of antiquities constituted a memory theatre of the classical past, while natural history exhibits (animals as well as plants) were a memory theatre of that complete world lost with Eden but recoverable by human skill. Evelyn assigns to the garden the task 'to comprehend the principal and most useful plants, and to be as a rich and noble Compendium of what the whole Globe of the Earth has flourishing upon her boosome'.[30] Furthermore, gardens were finally theatres in our modern sense by their organization of hydraulic displays and of grottoes into scenic shapes. This theatrical dimension of garden art is relevant to cabinets because the central theme of these Italian gardenist dramas was the co-operation or rivalry of Art and Nature. Cabinets of curiosities juxtaposed the natural with the artificial, not least with the intention of remarking how nature was herself ingenious and artful, and art was the ape of the actual world. We have already seen that the design of flower beds exploited this theme, but the *paragone* of art and nature was extended throughout the garden. Thus at Verona in the late 1650s Sir John Reresby recorded that 'The palace are many; the garden extraordinary . . . for not only great variety of plants, flowers, and greens, but for volories of birds, grottoes, fountains, from whence water throws itself by the turning of keys, in the shape of birds and beasts.' Not only the variety of nature itself, but the art of hydraulic contraptions created the illusion of that same nature.[31]

In the grottoes and waterworks of Italian gardens the ultimate congruence of garden and cabinet was achieved. Artificial animals were given real horns and tusks; natural rock, and sometimes precious stones and crystals, were shaped by art into illusionist caves; elements were confused, interchanged, even seemed to be in the very process of changing; water seemed carved as stone, stone flowed like water; statues moved by hydraulic machinery brought stones to life. The Villa Aldobrandini at Frascati seemed to most English travellers the paradigm of these rare and curious worlds: a natural hillside and rustic fountains were discovered behind a splendidly formal theatre; the art collection within the house was echoed by the natural materials in the alcoves of the exedra; the changefulness of the architectural repertoire throughout the water theatre was epitomized by the metamorphic imagery of the Hall of Parnassus, a cabinet built into one end of the terraced hillside. Its machinery provided rain, rainbows, music, birdsong, an

[29] Cf. Evelyn at the Villa Mondragone, Frascati, calling it a 'Theater for Pastimes' (1955, vol. 2, p. 393), or Parkinson 1640.
[30] In his MS *Elisium Britannicum*, bk I, chap. xvii; also quoted by Prest 1981, p. 47. Prest's short but well-illustrated book argues in more detail the point being made here.

[31] Reresby 1904, p. 50. When some years later William Acton saw the Chigi palace and collections (of which detailed inventories survive), he listed its 'pretty Armoury and many natural Curiosities, amongst the rest the Cockatrices were worth remark; His fine Garden, and the many Artifices by water' (1691, p. 37).

ingenious metal ball bounced on a stream of air, besides (as Evelyn put it) 'other pageants and surprising inventions'.

Coryate's account of his visit to the Giusti Gardens in Verona ('contrived with as admirable curiosity as ever I saw') puts him in mind of a similar English garden: Sir Francis Carew's in Middlesex, 'who hath one most excellent rocke there framed all by arte, and beautified with many elegant conceits, notwithstanding, it is somewhat inferiour unto this.'[32] Inevitably, English gardens suffered by comparison with Italian examples, though throughout the seventeenth century Italianate imagery and design were increasingly emulated. This development in garden art and design allowed the English gentleman and virtuoso to maintain significant connections between the cabinet and the garden.[33]

One of the most important ingredients for the English in the Italianate garden was the grotto.[34] Its design allowed the presentation in one room or cabinet of a collection of rocks and shells together with more or less elaborate hydraulic machinery. One such was that created by Thomas Bushell, a former associate of Francis Bacon, on his small estate of Enstone in Oxfordshire in the late 1620s (fig. 77).[35] Apart from automata, Bushell contrived many of the effects which were admired at Aldobrandini: rain, rainbows, a silver ball held up on a spout of water, birdsong, 'many strange forms of Beasts, Fishes and Fowls' – all in the rooms of a house adjoining a small terraced garden with 'a curious Walke, with neatly contriu'd Arbours'. Now Bushell's effects were presumably copied from Salomon de Caus's *Les Raisons des forces mouvantes* where many foreign inventions were reproduced and discussed. What is particularly interesting for our purpose is the evident use of an Italianate grotto by Bushell as a kind of laboratory (albeit one that earned him the scorn of contemporaries); what in Italy was a scene of marvels was annexed subsequently in Northern Europe to the rather unsteady beginnings of experimental science. De Caus himself built a house at the end of the garden at Heidelberg which probably contained cabinets and maybe even laboratories.[36] And if Evelyn's Italian journal notes only one garden with a laboratory (the Jesuits' in Rome), his later English diary records several gardens used for some scientific purpose. His own garden at Sayes Court he clearly considered in this light, for it was here that he built himself a study or cabinet in 1674 and where he kept the transparent beehive given to him by Dr Wilkins of Wadham College, Oxford, another scientist/virtuoso whose garden was the site of both botanical and hydraulic curiosities.[37]

The most intriguing of these garden-cabinets/laboratories was Charles Howard's 'Amphiteater Garden', where Evelyn was shown 'divers rare plants: Caves, an Elaboratory'.[38] John Aubrey fortunately gives us more details as well as a coloured plan of its layout in his MS 'Perambulation of Surrey'. Ever alert to the Italian style of gardening,

[32] Coryate 1905, vol. 2, p. 36.

[33] Though they focus little upon my specific subject, see Houghton 1942, pp. 51–73, 190–219; Webster 1975.

[34] See Strong 1979, pp. 138–43.

[35] One of the main sources is Plot 1677; see also Thacker 1982, pp. 27–48. When Aubrey came to design possible waterworks for his house and gardens at Easton-Piers, he seems to have copied one particular feature of Bushell's project, namely the Neptune with dog stalking a swimming duck: see 'Designatio de Easton-Piers in Com: Wilts: Bodleian Library, Oxford, MS Aubrey 17, fol. 16.

[36] Patterson 1981, pp. 97–8.

[37] Evelyn 1955, vol. 2, p. 230 (for Jesuits); vol. 4, p. 37 and vol. 3, p. 110 (for Sayes Court).

[38] Evelyn 1955, vol. 3, p. 154. Aubrey's account is quoted from Bodleian Library, Oxford, MS Aubrey 4, fols. 49–50.

Aubrey was struck by Howard's theatre-like valley, terraced and planted with 'twenty-one sorts of thyme' and 'many orange trees and syringas'; the 'pit' of this theatre was 'stored full of rare flowers and choice plants'; on the western side of the amphitheatre was the laboratory, where Howard dedicated himself to various scientific pursuits – cultivating saffron, tanning leather, growing and pressing wild flowers – on which he reported for a while to the Royal Society. He even had a scheme to tunnel through the back of the hill and thus fashion a sort of perspective tube.

The lack of any fanciful waterworks in Howard's grottoes, which were simply caves dug out of the sandy hillside, alerts us to a significant development in the English relationships of cabinet and garden. The earlier Italianate garden in England had imitated the vogue for elaborate, hydraulic equipment: John Aubrey's account of the gardens at Wilton, created in the 1630s, testifies to an especially rich set of waterworks where art or mechanics contrived miraculous natural effects (birdsong, rain, rainbows).[39] But such extravagances came to be far less practised; partly the expense, but partly a new distrust of the frivolity of such waterworks, contributed to their elimination. Something of both attitudes may be seen in John Bate's *The Mysteries of Nature and Art* (1634); in the tradition of earlier, Continental textbooks on hydraulics Bate sets out the working of various contraptions, but they are treated rather as toys, arousing curiosity and stimulating delight even after the spectator has discovered how they function. The work of Sir Samuel Moreland later in the century suggests how such effects would steadily lend themselves to more scientific enquiries and practical uses; although his own grounds at Vauxhall contained a room of mirrors with entertaining fountains (reported by both Aubrey and Evelyn) it was his work for Lord Arlington at Euston and also at Windsor with its pragmatic aims that seemed crucial to Evelyn.[40] Similarly, Henry Winstanley, builder of the Eddystone Lighthouse, had a house at Littlebury 'with abundance of fine Curiosityes all performed by Clockwork': these included both whimsical devices, such as a chair that ran backwards into the garden on rails, and more 'practical' machines which served tea and coffee in cups to the company.[41] Aubrey, as might be expected, is altogether more ambiguous in projecting the waterworks for Easton-Piers.[42]

The other Italianate feature of gardens which is of relevance to their English development as cabinets is, of course, the gallery, though this does not highlight as sharply as do grottoes the tensions between Baconianism and virtuosity. Galleries became a conspicuous element of English collections in the seventeenth century – the Matted Gallery beside the Privy Garden in Whitehall, for example, and its much more famous predecessor by a few years at Arundel House. Evelyn proposed a gallery for the display of the disintegrating statues and bas-reliefs of the old palace at Nonsuch.[43]

Arundel's sculpture garden beside the Thames was obviously created in emulation of such Roman examples as the Vatican Belvedere and the Cesi collections, in their turn Renaissance attempts to recreate the antique traditions of using gardens to display

[39] Bodleian Library, Oxford, MS Aubrey 2, fols. 50 ff. Partly published in Britton 1847, pp. 92–3.

[40] Vauxhall: Evelyn 1955, vol. 4, p. 257 and vol. 5, p. 221; Aubrey, 'A Perambulation of Surrey Anno Dio 1673', Bodleian Library, Oxford, MS Aubrey 4, fol. 32. Evelyn's other references to Moreland's work are vol. 3, p. 591; vol. 4, pp. 117, 317.

[41] See Morris 1982, p. 77 and n.

[42] See above, n. 35.

[43] Evelyn 1955, vol. 3, p. 427.

collections. Not only did Arundel's garden evidently put to good effect the sense of gardenist space which English designers were learning from Italy and which contributed to the exciting display of the sculpture,[44] but the sculpture garden impressed its visitors with its completeness: Christopher Arnold, afterwards Professor of History at Nürnberg, noted in 1651 his impressions of 'certain gardens on the Thames, where there are rare Greek and Roman inscriptions, stones, marbles: the reading of which is actually like viewing Greece and Italy at once within the bounds of Great Britain.'[45] The English vogue for decorating one's garden with classical fragments is registered by the inclusion of a chapter 'Of Antiquities' in the 1634 edition of Peacham's *The Complete Gentleman*, where it is specifically mentioned that antiquities have their place in 'gardens and galleries'.

Arundel's collection fell into decay during the Commonwealth. But it is not simply (if at all) the accidents of Civil War that are interesting but a whole congeries of new attitudes and developments in collecting and presenting what gardens and cabinets had hitherto managed to contain. Evelyn rescued many of Arundel's items for Oxford University, but only a few inscriptions were set up (at his suggestion) in a garden – within the holly hedge around the Sheldonian. The remainder became part of Ashmole's museum, while other items came to decorate country houses like Easton Neston in Northamptonshire or public pleasure gardens like Cuper's or Cupid's on the Thames: here later antiquaries like Stukeley found and sketched them. What has vanished along with Arundel's collection and garden is any ambition to present a conspectus of classical civilization; the garden uses of statuary may continue to provoke memories of the past, but they are above all discrete; the aesthetic pleasure in individual pieces predominates.

The same kinds of change are also apparent in the botanical and natural history side of gardens. The Tradescants' garden in Lambeth was remarkable for its wide range (for that time) of English wild flowers as well as of ever-increasing numbers of importations. A catalogue of some 750 species and varieties was issued in 1634, and this had more than doubled by 1656. As more and more species became available to gardeners, any ambition to recreate the fullness of the Garden of Eden was less and less practicable.[46] This seems to have been clear to Peter Mundy as early as 1634; when he called on the Tradescants he found a 'little garden with divers outlandish herbes and flowers' and he was *'almost perswaded* a Man might in one day behold and collecte into one place more Curiosities than hee should see if he spent all his life in Travell.'[47] It is clear that the extent of the collector's task was defeated by the spaces and methods then available to him. Similarly, I think, the equally famous museum of curiosities, probably housed in a 'purpose-built gallery in the garden',[48] must have been strained to absorb the many 'rarities of. . .shells' (among other trophies) which the younger Tradescant brought back from his visits to America.

The Tradescants, father and son, span the period of the closest collaboration between English garden and cabinet. The father worked for Cecil at Hatfield and therefore saw the establishment of its splendid, modern Italianate gardens as well as contributing his own

[44] See, for example, the description of the siting of the head of Jupiter quoted by Haynes 1975, p. 4. I discuss these spatial matters fully in a forthcoming publication.

[45] Cited by Masson 1881, vol. 4, p. 350. See a similar remark, this time Christianized, in Tenison 1679, p. 57.

[46] See Prest 1981.

[47] Temple 1919, pp. 1–2 (my italics); see MacGregor 1983, pp. 3–16, esp. 11. On the ever increasing profusion of species, see Thomas 1983, pp. 226–7 and *passim*.

[48] See Sturdy 1982, p. 11.

talents to what Evelyn would later call 'the more considerable rarity . . . the garden and vineyard'.[49] Some of the fruit trees which Tradescant found for Cecil during his visit to Holland and Belgium were recorded in the catalogue subsequently known as 'Tradescant's Orchard' (part of the Bodleian Ashmole MSS).[50] The son continued the search for more plants and natural objects by which to augment their own and others' collections. Yet their Ark, both garden and museum, which emulated the inclusiveness of Noah's divinely-inspired salvage operation, barely survived the death of the younger Tradescant in 1662. The inscription on their tomb in Lambeth celebrated their travels through Art and Nature as witnessed by 'A World of wonders in one closet shut'. That one closet already seemed inadequate to some contemporaries, their labours mere 'minims of art and nature'. The poet Cleveland registered that even 'Nature's whimsey . . . outvies/Tradescent and his ark of novelties'.[51] It would take the more ample spaces which Ashmole could supply as well as the more specialized skills which were starting to emerge – garden architect, garden plantsman, conchologist and so on – to attend adequately to the full range of the Tradescants' concerns. And, furthermore, there grew a need for more scientific attitudes: Sprat in the *History of the Royal Society*, though doubtless making some tactical capital on the Society's behalf, wrote that 'In every one of these *Transplantations* [of vegetables and living creatures], the chief Progress that has hitherto been made, has been rather for the Collection of *Curiosities* to adorne *Cabinets* and *Gardens*, than for the Solidity of *Philosophical Discoveries*.'[52]

So the late seventeenth century marks the effective separation of gardens from cabinets. In its turn this seems to have confirmed an earlier tendency to separate the design from the planting of gardens: a tourist of 1691 observed a distinction in Dr Uvedale's garden at Enfield between his 'delight and care lying more in the ordering of particular plants' (especially his 'greatest and choicest collection of exotic greens') than in the 'view and form of his garden'.[53] Such a division of interest had been apparent in the gardenist activities of the brothers Danvers: John, who, Aubrey claimed, had 'first taught us the way of Italian gardens', created the fine designs at Chelsea and West Lavington,[54] while his brother Henry, Earl of Danby, was responsible for the Oxford Botanical Garden. The creation of the latter in 1621 had the important, even if fortuitous, result that when Ashmole came to found his museum and received material from the Tradescant collection (among others) the garden part of those previous cabinets was already catered for elsewhere in Oxford. The two institutions of museum and botanical garden, as both Evelyn and Aubrey emphasized,[55] were able to dedicate themselves to the study and conservation of their special materials far more satisfactorily than when they were physically connected. Furthermore, since the Royal Society committed itself,

[49] Evelyn 1955, vol. 2, p. 80.
[50] See Leith-Ross 1984a, 1984b. Further examples of contemporary plant illustration may be seen in Blunt 1950 and Kaden 1983.
[51] Quoted in MacGregor 1983, p. 15.
[52] Sprat 1734, p. 386.
[53] 'A Short Account of Several Gardens near London', *Archaeologia*, 12 (1796), p. 188. Cf. Evelyn's the 'husbandry part' of gardening (1955, vol. 4, p. 121).

[54] Bodleian Library, Oxford, MS Aubrey 2, fol. 53 recto.
[55] For Evelyn on the extent and scope of even a specialized collection ('being an Universal Collection of the natural productions of Jamaica'), see his visit to Sloane: 1955, vol. 5, p. 48. For Aubrey urging Wood to put his rarities into the custody of Ashmole's new Museum ('for when he dies, it will be lost and torne by his nieces children'), see Hunter 1975, p. 87.

according to Sprat, to 'faithful records of all the Works of *Nature*, or *Art*',[56] it was increasingly clear that each had its own territory and that, say, a grotto was not the most effective theatre for studying their encounter. Bushell had discovered at Enstone 'a rock so wonderfully formed by nature, that he thought it worthy of all imaginable advancement by art'[57] and his grotto had accordingly the ambience of a magus's cave, where it was the privileged function of the 'artist' or hydraulist to control and manipulate natural elements. While that continued to be (*mutatis mutandis*) the role of the landscape gardener, the scientific spirit devoted itself more carefully to the purer observation of nature. In the eighteenth century such famous gardenist creations as Pope's grotto, Beckford's plantations at Fonthill or the imaginary sculpture garden in Joseph Spence's *Polymetis* may seem to perpetuate something of the alliance of garden and cabinet; but they were rather fossils of an older and outmoded tradition.

[56] Sprat 1667, p. 61. [57] Plot 1705, p. 240.

EARLY COLLECTING IN THE FIELD OF GEOLOGY

Hugh Torrens

He visits Mines, Colepits, and Quarries frequently, but not for that sordid end that other Men usually do, *viz.* gain; but for the sake of the fossile Shells and Teeth that are sometimes found there . . .

To what purpose is it, that these Gentlemen ransack all Parts both of *Earth* and *Sea* to procure these *Triffles?* . . . I know that the desire of knowledge, and the discovery of things yet unknown is the Pretence; but what Knowledge is it? What Discoveries do we owe to their Labours? It is only the Discovery of some few unheeded Varieties of Plants, Shells, or Insects, unheeded only because useless; and the Knowledge, they boast so much of, is no more than a Register of their Names, and Marks of Distinction only.[1]

Geological objects have been collected as curiosities by all civilizations and a particular folklore has grown up around such objects.[2] Apart from their basic curiosity value they served as ornaments, charms, fetishes or talismans. Many were regarded as endowed with a medicinal value either sympathetic[3] or sometimes surprisingly direct, as in the chalk fossil echinoids or Chalk Eggs which were so prized by seventeenth-century seamen.[4] The decorative and symbolic uses of the larger fossil vertebrates (or parts of them) were also legion:[5] for example fossil shark's teeth were incorporated into highly ornamental *languiers* or *Natternzungenbäume* and carefully treasured in aristocratic collections as antidotes to poison. Oakley, however, has rightly urged caution in the precise symbolic interpretation of such fossil and other objects – many may simply have had a directly aesthetic appeal as 'mere' curiosities.[6]

The connection between early geological collecting and pharmacy is also worth emphasis. The inventories of three collections of late seventeenth- and early eighteenth-century materia medica preserved at Cambridge with the original substances have been reprinted by Gunther[7] and include a large proportion of minerals and fossils. Such objects were also collected in the medical and anatomy schools of Europe such as Leiden and Oxford for the light they might shed on comparative anatomy, or as teaching aids. In museums open to the public, objects would be collected also for their appeal to visitors. In this contribution, however, I want to avoid the aesthetics and commerce of early geological collecting and to concentrate more on the scientific aspects.

Many minerals and fossils are highly indigenous to a particular vein or stratum which will have a limited outcrop. Local geological influences of this type are clearly seen in the

[1] Astell 1696.
[2] This is discussed by Oakley 1965 and Bassett 1982; and the particular folklore of ammonites by Skeat 1912 and Nelson 1968.
[3] Bromehead 1947a.
[4] Woodward 1729, pp. 7–8.
[5] Oakley 1975.
[6] Oakley 1965, p. 11.
[7] Gunther 1937, pp. 472–94.

first soundly based classification of 'Inanimate Subterranean Bodies' published by the German physician and mineralogist Georgius Agricola (1494–1555) in 1546.[8] Agricola was appointed as city physician and apothecary to the flourishing mining town of Joachimsthal (now Jáchymov) in Czechoslovakia in 1527. In 1531 he moved to another mining town, Chemnitz in Saxony.[9]

Such close connections with the then largest metalliferous mining areas in Europe gave Agricola an intimate knowledge of both mining technology and the products of such mining. In his *De Natura Fossilium* he classifies the constituents of the earth on the basis of their physical properties using such criteria as colour, weight, transparency, lustre, taste, odour, shape and texture. The mode of preservation of each object was crucial. He separates those 'de Natura eorum quae effluunt ex Terra' from those 'de Natura Fossilium' and classifies the last into a number of categories,[10] depending on whether the objects were simple or compound.

Agricola believed in *succi concreti*, fluids which circulated through the earth and which could turn various substances into stone by a process of petrification. This was a persistent sixteenth- and seventeenth-century view of the origin of many rocks, like stalactites or ores, and it was extended to explain the origin of many true fossils. It is important to realize the influence of both miners (who thought ores were constantly being replenished by such fluids) and apothecaries on Agricola's classification.

The next major attempt at a classification of the 'fossil' world appeared nearly twenty years later – the work of the Swiss physician Conrad Gesner (1516–65). His *De Rerum Fossilium Lapidum et Gemmarum* appeared in 1565. Gesner's great merit was to have illustrated his text with a large number of wood engravings which meant that for the first time in the history of geology a proper assessment of an object could be made on the basis of both text and illustration. His 'fossil objects' were classified into fifteen groups and comprised an extraordinary range of geological, archaeological and human artefacts. These were based on the supposed simplicity or complexity of the objects involved.

Gesner's classification appeared as one item in a compilation of eight short treatises on mineralogical subjects published together in Zurich in 1566. In this was also a small dissertation by a close friend of Gesner's called Johann Kentmann (1518–74). Kentmann was first in practice at Meissen for three years, but for the last twenty years of his life he was a physician at Torgau, north-west of Dresden. Here he had the opportunity to investigate the plant, animal and mineral wealth of the region.

It was the fruits of this latter that appeared in his 1565 treatise *Nomenclaturae Rerum Fossilium quae in Misnia praecipue et in allis quoque regionibus inveniuntur*. In this he classifies the 'fossil objects' that have been found in 'Meissen-land', and to placate Gesner used a classification based in part on those of Agricola and Gesner. The major novelty of Kentmann's book was an actual illustration of the 'Mineral cabinet' he had gathered, in which the twenty-six drawers and their contents are clearly shown (fig. 78). In fact Kentmann divided his 'Fossils' into thirty categories so there is no complete agreement between categories and drawers in the cabinet. The range of the collection is astounding

[8] Agricola 1546.
[9] Eyles 1955 and Prescher 1981.

[10] Agricola's categories and Gesner's classification are discussed by Adams 1938 and Accordi 1981a.

with a total of 1,608 specimens from 135 localities, which latter are accurately recorded for 472 of the specimens. The remainder of the collection can be assumed to come from Saxony.[11] The emphasis of the Kentmann collection is clearly on metals and their ores, as one would expect from the geology of an area like Saxony.

If we can thus show the beginning of scientific geological collecting by 1565 in Germany, we can demonstrate another surprisingly modern use of a geological collection soon afterwards, but this time in France, with the work of the potter Bernard Palissy (c.1510–90). In his *Discours Admirables* of 1580 – an embryonic textbook on geological matters – he demonstrates a keen interest in supporting his lectures (1575–84) with actual geological specimens available for inspection and study.[12] So with these two pioneers the importance of collecting to support both geological research (much of it economically directed) and teaching was well established in the sixteenth century.

At the same period Italian collectors were also very active and included large accumulations of geological objects among their vast collections which exhibited the whole range of the natural world.[13] Of these perhaps that of Ulisse Aldrovandi (1522–1605), Professor of Botany in Bologna, was the most distinguished.[14] His surviving collections were visited in 1664 by John Ray who was clearly impressed.[15]

Almost contemporary with Aldrovandi was the Verona collection formed by Francesco Calceolari (c.1521 – c.1606), a pharmacist. His collection had a pharmaceutical basis and included animals, plants and minerals which were thought to have curative powers – gradually it grew to include more curious and exotic objects.[16] It was among the most significant collections in Europe and again a place of pilgrimage for visiting naturalists.

In the 1560s Michele Mercati (1541–93), who had graduated in medicine at Pisa, was appointed as superintendent of the botanic garden at the Vatican. Here he too gathered together a large collection of rocks, minerals and fossils which he described as a *Metallotheca* and which became one of the most important of such collections in Europe. He had described over half of the collection, and over a hundred fine copper-plate engravings had been made, between 1572–1581, but all remained unpublished on his death. From about 1650 his work became available in manuscript to a number of other researchers including the Dane Niels Stensen who published one of the engravings in 1667. Mercati's work was finally published in 1717. His collection had been divided into seventeen cabinets of which ten were described by him in manuscripts. The arrangement was taken in part from Kentmann's of 1565, though much improved and with a particular contribution to the field of lithological classification. As one would expect from a collection built up in Italy, true fossils form a major part of the collection, but despite the size and fine preservation of much of this collection Mercati clung to the Aristotelian belief that such objects had been formed by heavenly influence and owed nothing to once-living animals. Mercati did however correctly identify the origins of flint

[11] Kentmann's work and classification, with an analysis of the Kentmann collection, have been meticulously analysed by Prescher, Helm and Franstadt 1980, who also compare his classification with that of Agricola. Prescher 1955 has also discussed in more detail the work of other sixteenth-century mineral collectors.

[12] Rocque 1957, pp. 15, 233–40.

[13] Morello 1979, p. 24, reviews Italian collections of natural curiosities of the sixteenth century and refers to the lists of such collections published by Buonanni in 1681 and Boccone in 1684.

[14] Schmitt 1975, p. 42.

[15] Ray 1738, p. 200, and Gunther 1928, pp. 211, 254.

[16] Accordi 1977.

arrowheads. An apparent omission in Mercati's sources is any reference to Conrad Gesner, but Accordi shows that although Mercati was forbidden to use such heretic Protestant sources, he certainly made direct if unacknowledged use of Gesner's work.[17]

Other Italian collections with significance as geological repositories include that of the pharmacist Ferrante Imperato (1550–1625) of Naples. He succeeded in publishing only one volume of a *Natural History* in 1599 with many plates of woodcuts, but from which his many contributions to the development of science in the field and laboratory can be judged.[18] The geological collections of the Museum of the Accademia dei Lincei in Rome, as they were about 1626, have also been analysed[19] on the basis of manuscripts now in the Royal Library at Windsor. The drawings are of an astonishing fidelity and, along with the work of one of the first Accademia members Fabio Colonna (1567–1640), clearly demonstrate a modern approach to the collection, investigation and depiction of geological objects. Colonna in 1616 published one of the first works in which the animal origin of fossil shark's teeth and shells was scientifically established. Morello has suggested that the close connections between him and the Imperato family and their museum in Naples – Colonna's birthplace – had stimulated Colonna's geological interests.[20] This is yet another example of the part collectors and museums played in the scientific development of geology.

It would be wrong however to see all Italian or other collecting in the sixteenth and seventeenth centuries as 'scientific'. Much of it was an activity which simply brought prestige to its protagonists and classifications used could as well reflect potential visitor appeal as scientific relations between objects. None the less the Italian contribution to geological collecting is pre-eminent before 1650. In the investigation of true fossils the Italians seem to have been particularly fortunate in having 'easy' fossils indigenous to their country, like the Caenozoic marine molluscs and shark's teeth. These were much easier to explain than the more 'difficult' (because, as we now know, of their being extinct) ammonites and belemnites. In addition Italian investigators had the advantage of a long and inviting coastal environment with which to compare directly fossil and recent processes and animals.

Collection and classification of geological objects in the few cabinets of British collectors[21] in the sixteenth and early seventeenth centuries were closely modelled on the European leads discussed above, but on a much more limited scale than in the prodigious collections right across the natural world to be found in Italy, Germany and Switzerland.

One museum collection which had an enormous influence across Europe, to judge by the number of times its published catalogue[22] is cited is that of Olaus Worm (1588–1654). This collection was particularly strong in what we would now call archaeological objects, a field in which Worm was also very influential.[23] It also contained large numbers of 'fossils – so called because most of them are wrested from the earth by digging, are called minerals by others who refer to diggings as mines, since they are, as it were, mine deposits

[17] Accordi 1980.
[18] Accordi 1981b.
[19] Bromehead 1947c.
[20] Morello 1981 and see Morello 1979, pp. 63–93, where Colonna's work of 1616 is analysed and reprinted.

[21] For the fossil ichthyosaur from Conington, Hunts., in Sir Robert Bruce Cotton's (1570/1–1631) collection, see above p. 148 n. 5; Torrens, forthcoming.
[22] Worm 1655.
[23] Piggott 1981, pp. 21–2.

of both fossils and metals.' He believed fossils were inanimate but created with a seminal power by which they could procreate and propagate. Worm divided his 'fossils' into *media mineralia*, stones and metals and then into many different subdivisions. True fossils and gems are found among the stones, one of whose categories was 'stones of various shapes without value'.

A figure in England with a particular interest in geology was Christopher Merret (1614–95), appointed curator in 1654 of the museum and library of the physician William Harvey (1578–1657). This museum was destroyed in the Fire of London in 1666,[24] but not before it had been visited by Robert Hooke (see below) and had served Merret in the compilation of his *Pinax Rerum Naturalium Britannicarum* of 1666. In this Merret made use of the published work of Joshua Childrey and the Royal Society's Repository to produce a valuable addition to what was then known of the geological objects of Britain.

Other museum catalogues issued in Britain at this time include the *Musæum Tradescantianum* of 1656.[25] This listed seven categories of 'Minerals' divided in accordance with a system like that of Agricola.[26] In such a classification preservation, and what an object was composed of, became crucial, and thus pyritized ammonites appear in the first category,[27] *Metallica*. The Repository of the Royal Society was also catalogued a little later by the anatomist Nehemiah Grew (1641–1712) in 1681. He divided the 'Minerals' into only three categories,[28] using a different system.[29]

The Royal Society Repository incorporated the earlier collection of Robert Hubert which also included 'Fossils' and which was donated by Daniel Colwall in 1665.[30] Thomas Willisel, who had been employed as a natural history collector by Merret,[31] was appointed as the Royal Society's official collector in 1668 and the material which he gathered for the Society in 1671 certainly included fossils.[32] His activities commenced, at least in Britain, the employment of paid field naturalists and fossil collectors. But the Repository was sadly neglected and in 1781 passed into the care of the British Museum where some of the palaeontological specimens are still preserved,[33] although none of the mineralogical material seems to have survived.[34]

Robert Plot (1640–96) was inspired with the idea of gathering materials for a natural history of English counties (of which the first volume appeared in 1677, covering Oxfordshire),[35] by the book published earlier by Joshua Childrey (1623–70).[36] Plot was based in Oxford from the 1660s and had made large collections of natural curiosities

[24] Raven 1947, pp. 305, 335.
[25] MacGregor 1983.
[26] The seven categories were:
 1 Metallic minerals
 2 Earths
 3 'Minerals' petrified by lean or thin fluids
 4 'Minerals' petrified by fatty or unctuous fluids
 5 Select stones
 6 Petrified objects
 7 Gems
[27] Gunther 1923–45, vol. 3, pp. 406–13.
[28] Smith 1978, p. 50.
[29] The divisions used were:
 1 Stones
 2 Metals

 3 Earths and materials formed from mineral solutions
Stones further included:
 i) True Fossils
 ii) Gems
 iii) 'Regular Stones' inc. minerals, crystals, fossils, arrow heads, etc.
 iv) 'Irregular Stones' inc. a variety of objects without any regular form.
[30] See Murray 1904 and Grosart 1880, p. 78.
[31] Raven 1947.
[32] Ray 1738, p. 98.
[33] Edwards 1967, p. 50.
[34] Smith 1978, p. 50.
[35] Wood 1731, vol. 2, p. 468, and Greenslade 1982, pp. 49–67.
[36] Childrey 1661.

including fossils by 11 July 1675 when John Evelyn (1620–1706) visited him in Oxford[37]

and saw that rare collection of natural curiosities of Dr. Plot's, of Magdalen Hall, author of 'The Natural History of Oxfordshire,' all of them collected in that Shire, and indeede extraordinary, that in one County there should be found such varietie of plants, shells, stones, minerals, marcasites, fouls, insects, models of works, chrystals, achates, and marbles.

Plot believed like many others before him that fossils and minerals were sports of nature produced by salts as an internal ornament to the earth,[38] by a plastic virtue or petrifying fluid.[39] In the same way other more familiar articles were produced such as hailstones, stalactites and kidney- and gall-stones. The latter were commonly found in seventeenth-century cabinets of curiosities and the analogy must then have seemed close. Thomas Sherley (1638–78) had discussed the origin of petrification and its connection with calculi in an influential book[40] published in 1672, a few years before Plot's *Oxfordshire* appeared.

In 1683 Plot was appointed first Keeper of the Ashmolean Museum (and also Professor of Chemistry) at Oxford. In 1686 his *Natural History of Staffordshire* appeared with beautiful engravings of rocks, minerals and fossils as in his *Oxfordshire*.[41] Since Plot considered true fossils to be mere 'formed stones', he was happy to record resemblances in the geological context even with physiological features, and plates and descriptions of accidentally or casually formed stones resembling parts of animals or men are to be found in both his county volumes. He gave no thought as to what had become of the rest of the animal or human skeleton because his view of their origin did not require him to. It is however surprising that Plot never examined the question of degrees of resemblance. He might have discovered that some formed stones were very inexact replicas and others wholly accurate reproductions. He might then have separated accidental resemblance from that due to another (biological) relationship.

Plot does deserve credit for separating human artefacts like arrowheads, spearheads and axeheads as 'Ancient British Products',[42] though William Dugdale (1605–86) had correctly identified such archaeological objects earlier.[43] Plot's collections of geological and other objects passed to the Ashmolean Museum and the Royal Society Repository in London[44] but are not known to have survived. Plot also deserves credit for the professional way in which he set about making these collections – making use of a number of printed questionnaires with the intention of encouraging others to help his collecting.[45]

Edward Lhwyd (1660–1709) succeeded Robert Plot in his Keepership of the Ashmolean Museum in 1691.[46] He had been born and educated in the Welsh borders, an area in which a number of extinct (and therefore particularly puzzling) fossil groups, like trilobites, are indigenous. Lhwyd became a most diligent investigator of natural curiosities as well as of philology and archaeology, and under his care the Ashmolean collection of geological objects – which he called a *Lithophylacium* – became widely

[37] Bray 1879, p. 385.
[38] Ray 1713, p. 124.
[39] Butler 1968.
[40] Sherley 1672.
[41] Their geological content is analysed by Gunther 1923–45, vol. 3, pp. 216–20, and Challinor 1945.

[42] Plot 1686, pp. 396–7 and pl. 33.
[43] Dugdale 1656, p. 778.
[44] Gunther 1923–45, vol. 12, pp. 349–60.
[45] Eyles 1973, p. 5.
[46] MacGregor 1983, p. 57.

celebrated.[47] He published a catalogue of the British objects in his collection in 1699, in a limited edition of 120 copies of which ten each were subscribed for by a group including Martin Lister, Isaac Newton and Hans Sloane. The book was designed by Lhywd to be 'of use for lithoscopists to carry with them into stonepits, gravelpits etc.', to help in the field.[48] It catalogued about 1,800 specimens from 294 localities of which thirty had provided over fifty per cent of the total.[49] More significantly for the development of palaeontology it illustrated a considerable proportion, including a number of trilobites, in a series of twenty-three folding plates.

Lhwyd, like Worm and others before him, explained true fossils as having been formed partly by seeds or spawn of marine animals which had been brought from the sea via evaporation and rain and carried down into the rocks where they were now found.[50] In this Lhwyd was to an extent swayed by the lack of any fossil land animals in those collections which he had made or seen. However, like many contemporaries he also vacillated in his opinions and was almost convinced that some of the fossils with which he was familiar were indeed spoils of once-living animals.[51] The 'figured stones' in Lhwyd's catalogue were placed in twelve classes, with an additional category for the highly anomalous belemnites.[52]

Geological material was among that scrutinized under the microscope by the London-based polymath and Keeper of the Royal Society Repository Robert Hooke (1635–1703),[53] who was, like his Danish contemporary Niels Stensen (1638–86), in advance of his times in seeking a biological origin for fossils.[54] In his *Micrographia* of 1665 he considered Cornish diamonds, Kettering oolite and fossil wood and other fossils.[55] The microscope gave Hooke that crucial insight into the degrees of resemblance between objects of the fossil and living worlds which Plot had lacked. This newly scientific approach is most noticeable in his detailed discussions and illustrations of extinct fossil ammonites in his *Lectures and Discourses of Earthquakes*, posthumously published in 1705, where he compared these and their septae with those of living *Nautilus* shells available to him in the Royal Society Repository. Hooke refers to fossil echinoids, ammonites and bivalves also in the Repository. This was not the only collection to which Hooke had had access in London, as he also records shells which he had seen in the museum formed by William Harvey.[56]

Hooke was born near the sea on the Isle of Wight where spectacular geological phenomena like the Needles were combined with the normal activity of present marine processes active on clearly stratified and very fossiliferous coastal exposures of rocks, ranging from the Chalk to the Oligocene, in the triangular western end of the island. Here, from at least 1665, Hooke made field observations, collected geological specimens and was able to interpret them with remarkable perspicacity.[57] In 1666 he was appointed one of the three City of London surveyors to rebuild London after the Great Fire. This also

[47] Jahn 1966.
[48] Gunther 1923–45, vol. 14, pp. 152, 282.
[49] Farey 1823.
[50] Ray 1713.
[51] Schneer 1954, p. 261.
[52] These are listed by Gunther 1923–45, vol. 14, p. 406.

[53] See Rossiter 1935; Oldroyd 1972.
[54] See Eyles 1958; Drake and Komar 1981.
[55] Hooke 1665, pp. 82, 93, 107–12.
[56] Hooke 1705, pp. 284–5, 342.
[57] Ibid., pp. 292, 297, 334–5, 342.

brought the Portland Stone of Dorset with its giant ammonites, which was chosen for the rebuilding, closely to his attention.[58]

Hooke's remarkable achievements in interpreting fossils so correctly, in postulating extinction as a working hypothesis and in realizing that a chronology, however constrained by contemporary thought, could be inferred from the fossil record, need emphasis. As Rudwick has pointed out,[59] Hooke in dealing with ammonites was interpreting a particularly 'difficult' group of geologically older fossils which were extinct and thus without living representatives. This makes his success all the more remarkable. Paradoxically, however, he did not seem to see the need to record the localities of fossils he described with any accuracy, and very few of the specimens which he figured are documented. He also had some important things to say about collections, of which his own was in existence at least by February 1666.[60] He encouraged the study of the common and most obvious as well as the strange,[61] and urged that because

without inspection of the things themselves, a Man is but a very little wiser or more instructed by the History, Picture, and Relations concerning Natural Bodys . . .

It were therefore much to be wishht for and indeavoured that there might be made and kept in some Repository as full and compleat a Collection of all varieties of Natural Bodies as could be obtain'd, where an Inquirer might be able to have recourse, where he might peruse, and turn over, and spell, and read the Book of Nature . . .

The use of such a Collection is not for Divertisement, and Wonder, and Gazing, as 'tis for the most part thought and esteemed, and like Pictures for Children to admire and be pleased with, but for the most serious and diligent study of the most able Proficient in Natural Philosophy . . . I could heartily wish that a Collection were made in this [Royal Society] Repository of as many varieties as could be procured of these kinds of Fossile-Shells and Petrifactions, which would be no very difficult matter to be done if any one made it his care: For *England* alone would afford some hundreds of varieties, some Petrify'd, some not.

It is a pity that the early Royal Society failed to follow Hooke's advice.

The English collector of greatest importance for his contributions to geological collecting and museology was John Woodward (1665/7–1728),[62] born at Wirksworth in Derbyshire. Woodward qualifies as the first truly scientific collector of geological objects, at least in Britain. He believed that fossils were the actual remains of once-living animals, but his rigid theorizing about their deposition by post-diluvian gravity settling, after a general dissolution during the Flood, which he invoked to explain the great depths at which fossils were found, has caused his more lasting contributions to be overlooked. In 1696 he issued his *Brief Instructions for making observations in all parts of the world*,[63] a twenty-page manual of instruction to collectors in natural history. This, with a special emphasis on geological activity, urges the use of the geological hammer *and* accuracy and detail in recording information about the objects collected.

Woodward also employed a number of agents to collect, who 'were obliged to be very exact in their searches' for him. It was for some of these agents that he drew up revised

[58] Ibid., pp. 284, 320, 342.
[59] Rudwick 1972, pp. 27–9.
[60] Boyle 1772, vol. 6, p. 504.

[61] Hooke 1705, p. 280.
[62] Porter 1979.
[63] Eyles 1973.

Directions relating to 'Fossils'. These were issued in manuscript from about 1700 to his collectors, but were published only posthumously together with a collection of earlier letters and essays.[64] These *Directions* at once established all the basic and special requirements for geological curators. They also for the first time urged the recording of stratigraphic information:

BRIEF DESCRIPTIONS
for making
Observations and Collections
and
For composing a travelling Register of all Sorts of Fossils.

1. Of keeping a Register of the Fossils as they are Collected.

By Means of Paste, Starch, or some fit Gum ought to be fix'd on each Sample collected, a bit of Paper, with a *Number upon* it, beginning with No. 1. and proceeding to 2, 3, and so on . . . Then in the Register, enter *Numbers*, answering those fix'd on the Fossils, and under each Note, 1°. *what Sort* of Fossil or Mineral 'tis reputed to be. 2. Where 'twas found. 3. Whether there were more of the same, and in what *Number* or *Quantity*. 4. Whether it was found on the *Surface* of the Earth: 5. Or, if it lay deeper, note at what *Depth*. 6. In what *Posture* or *Manner* it lay. 7. *Amongst what* Sort of terrestrial Matter 'twas lodged: 8. Whether in a Stratum, or perpendicular Fissure . . .

This is the fittest Conduct and Procedure I can pitch upon . . . To which Purpose that Register ought always to be *ready* at Hand . . . and the Observations entred upon the *Place*, for fear of Mistakes or Failure of Memory.

Woodward's catalogue of 600 pages is full of penetrating observations, and the four actual cabinets in which his collections of over 6,000 specimens were housed were acquired by the University of Cambridge in 1728. It is sad that they and the widespread collectors and localities which yielded them have been so little analysed – unlike his theories. But Woodward, by setting up through his will a chair in Woodwardian studies,[65] helped to guarantee that his activities as a collector[66] would inspire future generations.

At Oxford things were not taken so seriously. Funds were short, and in 1708 an advertisement had appeared in *Philosophical Transactions*:[67]

Whereas in the perusal of the late eminent Mr Ray's Physico-Theological Discourses, Dr. Lister's Treatise de Cochlites Angliae, Dr. Robert Plot's Natural Histories of Oxfordshire and Staffordshire, Dr. Woodward's Essay, some papers in the Philosophical Transactions, and several other books, the Discourses on Formed Stones and their Origin are not so clearly understood, for want of a competent knowledge of those Bodies: Notice is hereby given, that the Curious in that part of Natural History may for one Guinea, be supplied with Specimens of all the following figur'd fossils, by Alban Thomas, Librarian of the Ashmolian Repository in Oxford.

There followed a list of fifty-two different species.

Lhwyd died in 1709 and was replaced by David Parry under whom the collections

[64] Woodward 1728, pp. 93–119.
[65] Porter 1979.
[66] Levine 1977, pp. 93–113.
[67] Jahn 1966, pls. 2–3.

became seriously neglected.[68] Of the Oxford fossil collections made by Plot and Lhwyd, Gunther was informed in 1925[69] that only two specimens then survived and this has been repeated recently.[70] But in 1950 Edmonds had reported the rediscovery of over 130 of Lhwyd's originals,[71] and another, figured in a 1699 publication and which had subsequently acquired a type specimen status, has been found since, after a gap of 270 years.[72]

The history of the curation of collections has been even more ignored than the history of those collections. In geology it was Woodward's system which first called for security of the crucial link between an object and its documentation,[73] as well as for a remarkable amount of detail in both geographical and stratigraphic recording. But one cannot claim Woodward 'invented' such security since an archaeological specimen preserved in the Museo Egizio (reg. no. 2761) in Turin satisfies all the basic curatorial requirements for geological objects. This is an Eocene fossil sea urchin (fig. 79) found during archaeological excavations at Heliopolis in Egypt during 1903–6.[74] It dates from the old Kingdom of 2700–2200 BC and carries in hieroglyphic characters cut into the ambitus the name of the ancient collector *and* the name of the quarry where it was found. No data could be more securely attached to an object.

Some such system may have been in operation in the former Aldrovandi museum in Bologna, for a visitor in 1668 recorded that every object had a descriptive label attached to it.[75] The 1686 rules drawn up by Elias Ashmole for his museum specified that 'a number was to be fixed to every particular and accordingly to be registered in the Catalogue of them',[76] but it seems uncertain to what extent this was properly done.

Any review of such a vast subject[77] will reveal as much by what it omits as by what it considers. Despite this, it is clear enough that any eighteenth-century relapse in the earth sciences, at least in Britain,[78] should not be blamed on the lack of raw data provided by collectors. It is clear that the bases for the scientific collection, documentation and curation of geological objects had all been adequately lain by the end of the seventeenth century, however anachronistic the use of the word geological to this period may be.[79]

[68] Ibid.
[69] Gunther 1923–45, vol. 3, pp. 223, 374–5.
[70] MacGregor 1983, p. 69.
[71] Edmonds 1950.
[72] Dean 1974, pp. 97–8.
[73] Discussed by Palmer 1977.
[74] Scamuzzi 1947 and Socin 1947.

[75] Edwards 1967, p. 43.
[76] MacGregor 1983, p. 54.
[77] The vastness of which was already clearly recognized in 1667–8 by Hooke (1705, p. 279).
[78] Davies 1969, ch. 4.
[79] Dean 1979.

THE CABINET OF EXPERIMENTAL PHILOSOPHY

Gerard l'E. Turner

Human beings collect instinctively – first food, the means to survive; then tools and weapons, and other belongings which came to represent survival potential, status and, later, economic power. Grave goods, regarded as so important by many societies throughout the ages, represented the means to survive in the next world, and also symbolized the status of the dead. Property, as Thorstein Veblen has pointed out, began as booty from a successful raid, but soon became evidence of the power and status of its owner over other individuals within a community.[1]

The private collection, or cabinet, whatever its content, served a three-fold purpose: self-advertisement, economic advancement and utility, and intellectual satisfaction. The *Schatzkammer*, of jewels and precious metals, and the *Kunstkammer*, containing fine and decorative art, can be seen primarily as self-advertisement, part of the image-enhancing exercise which rulers throughout history have found it necessary to practise. It is part of the exercise and maintenance of any leader's power to ensure that his image is constantly before the people who count. In the past this has not, of course, been the mass of the population, but rather the ruler's immediate supporters, the courtiers and nobility, and his rivals in other states. One of the most successful of self-advertisers was Louis XIV of France, who wrote, in 1662, of his portrayal as the Sun King: 'It was then that I adopted the one [emblem] that I have retained ever since and that you see everywhere . . . Chosen as the symbol was the Sun, which . . . by never departing or deviating from its steady and invariable course, essentially makes a most vivid and a most beautiful image for a great monarch.'[2]

The Medici princes of Florence, like the other ruling families of Europe, made a business of splendour, surrounding themselves with artists and craftsmen of the finest calibre, so that their palaces became renowned and a magnet to the world.[3] Connoisseurs they might be, but they also appreciated to the full the commercial advantage of magnificence. There are many modern examples. That elaborate folly, St. Pancras Station in London, was built as a symbol of the economic achievement of Manchester business. Twentieth-century rulers know all about the use of elaborate displays in establishing the cult of the personality. In the National Museum in Bucharest, there is today a room devoted entirely to memorabilia and personal possessions of the living Head of State.

With the appearance of the *Wunderkammer* in the sixteenth and seventeenth centuries, another factor comes into prominence, namely economic advantage.[4] In this type of

[1] Veblen 1899, pp. 27–8.
[2] Sonnino 1970, pp. 103–4.
[3] Berti 1967; Hale 1977; Lensi Orlandi 1978; Taborelli 1980.
[4] Bedini 1965.

cabinet were included items of little or no beauty or intrinsic worth, except as rarities or curiosities. True, they were symbols of far-flung empire, but they were also used, and seen, as the means of development, the raw material of trade and prosperity. The small, crude abacus which Tradescant the elder brought back from Archangel may have been the forerunner of an amalgam of Napier's Bones and the abacus which was produced in England in the 1660s.[5] This and other rarities had an importance very similar to that of another category of objects brought home by seventeenth-century travellers: foreign trees, shrubs, fruit, flowers and seeds. The Tradescants rose to fame as gardeners, and the plant species which they and other travellers introduced into Britain were of great economic value.

The element of economic advancement is also strongly apparent in the cabinet of experimental philosophy, which reached its first flowering in the second half of the seventeenth century, though, as I shall show, its origins were much earlier. That these cabinets exemplified the intellectual preoccupation of the period with science is undoubtedly true, and this aspect has been the subject of considerable study by historians of scientific ideas. What has not received so much attention is the economic imperative which underlay the development of experimental philosophy. Galileo, Kepler, William Gilbert and Thomas Harriot were not simply theoreticians playing with new and exciting concepts; they were technologists, employed to solve practical problems, and for this they needed instruments. The most important of all these problems throughout the seventeenth and most of the eighteenth centuries was the problem of longitude.[6]

Before considering the composition and development of the cabinet of experimental philosophy, I propose briefly to discuss the way in which the expansion of exploration and commerce that began with the Portuguese voyages of discovery in the fifteenth century promoted experimental science and led to the establishment of a thriving European trade in scientific instruments.

Very broadly, the ancient requirement for time-telling and calendar-keeping created the astronomer and the mathematician; increasing population and the economics of landed property, as well as its military defence, produced the surveyor.[7] By the fifteenth century the economics of exploration and overseas trade forced into being instrumental deep-sea navigation.[8] This in its turn required the revision of astronomical tables to the point of a technical frontier that had to be broken through by the invention of new instruments, such as the telescope, the thermometer and the barometer.

The exploration of America had exposed the inadequacy of navigational technique. Charts were rudimentary; even the coast of Europe was poorly charted, and that of America scarcely at all.[9] This threatened the safety of men, ships and cargo. When out of sight of land, local time could be measured from the sun or stars, and the latitude estimated from the elevation of the Pole Star above the horizon. The problem was to work

[5] MacGregor 1983, p. 253, no. 193. There was no comparable instrument to this Russian *schety* in Western Europe at this time, computation being done by jettons on boards or cloths marked out for the purpose; see Barnard 1917. Robert Jole devised in about 1667 a calculator consisting of Napier's rods and an abacus, a complete example of which is in the Whipple Museum of the History of Science, Cambridge (no. 1587). See Bryden 1973.

[6] Waters 1958, *passim*; Taylor 1971; Howse 1980.

[7] Turner 1983.

[8] Deacon 1971.

[9] Waters 1958, esp. ch. 2; Morison 1971, especially pp. 136–42.

out the longitude. It was realized that a clock taken on board could keep the time at the port of departure, and so give the longitude by the difference between the time it gave and local time, longitude being fifteen degrees per hour. But there was no clock that could withstand the movement of a ship at sea, so this method did not become available to seamen until the invention of the marine chronometer in the mid-eighteenth century.[10] It was, therefore, necessary to use the Moon as a giant clock, which it is possible to do if the Moon's position against the background of the stars can be set out in tables. The measurement of the distance of the Moon from a range of selected stars was known as the lunar distance method of finding longitude.[11]

In the second half of the sixteenth century, the great Danish astronomer, Tycho Brahe (1546–1601), had laid the foundations for the new theoretical model of the universe formulated by Johannes Kepler (1571–1630). Long years of systematic observation with superb instruments enabled Tycho to increase the accuracy of astronomical measurement by a factor of between ten and twenty over his predecessors.[12] Kepler's name might well have been forgotten if he had not had access to Tycho's observations. They also made an important contribution to the new astronomical tables which Kepler published in 1627 and named after his patron, the Emperor Rudolf II, at whose court Tycho spent his last years. Under continual pressure to improve navigational techniques, the English Astronomer Royal, John Flamsteed (1646–1719), by using telescopic sights and pendulum clocks was able to improve on Tycho's achievement by a factor of five, with an accuracy of ten to fifteen seconds of arc.[13]

So it becomes clear that a new theoretical model of the universe, and more accurate tables to help in navigation, were both the result of improved accuracy of astronomical observation. This capability for accuracy itself produced an awareness of other areas of study. One of these was knowledge of the Earth's atmosphere. The point is that light travelling through the atmosphere becomes bent, or refracted, and so the correct position of the star or planet has to be calculated. This means that the nature of light and its behaviour have to be studied. The amount of refraction that occurs depends on temperature, pressure, and the degree of moisture in the atmosphere. It is for this reason that meteorological instruments have their origin in the early years of the seventeenth century.[14]

Tycho knew that the atmosphere refracted the light from the heavenly bodies, but he lacked the means to adjust for this effect. Thomas Harriot, of whom more will be said later, discovered the law of refraction and communicated his results on refraction angles to Kepler in 1606.[15] It is of interest, however, that Tycho kept daily weather records at his observatory for fifteen years.[16] His purpose in doing this was primarily as an aid to prognostication, for it was believed that the heavenly bodies and their conjunctions had a direct effect on the weather. Nevertheless, his records can also be seen as the beginnings of

[10] Quill 1966; Howse 1980, ch. 3.

[11] Howse 1980, appendix 1, where the technique is fully explained.

[12] Raeder, Stromgren and Stromgren 1946. For some comparisons between Tycho's instruments and extant instruments, see Mackensen 1979.

[13] Howse 1975; Chapman 1983a; Chapman 1983b.

[14] Middleton 1969.

[15] Rosen 1974, pp. 3–4; Shirley 1983, pp. 385–8.

[16] Hellman 1970, p. 410.

a systematic study such as would have been a necessary prelude to any theoretical model of weather.

In 1600 the great work of William Gilbert (1544–1603), physician to Queen Elizabeth I of England, was published under the title *De Magnete*.[17] It was the result of eighteen years of experiments on the properties of the natural magnet and the magnetic compass. Gilbert collected as many observations as he could from seafarers about the variation of the compass, and by combining this with a theory of terrestrial magnetism he hoped that he had solved the problem of finding longitude and latitude through the use of the horizontal compass needle and the vertical dipping needle. Gilbert also studied the theory of tides, and reported his findings in a book, *De mundo nostro*, making an analogy with magnetic attraction.[18] Thus for the first time since the Greeks, the movement of the oceans became a subject of serious study while, at the same time, practical information on tidal behaviour was being collected and tabulated, both for use at sea and as an aid to the theoreticians.

The telescope was invented by spectacle-makers of Middelburg (now part of the Netherlands), certainly by 1608 when a patent was sought.[19] In July 1609 Galileo heard about the invention and immediately had a telescope constructed for his own use. He demonstrated this first instrument to the *Signoria* of Venice by showing that, with its aid, ships could be clearly observed at a greater distance than was possible with the naked eye.[20] By the beginning of 1610 he had a more powerful telescope with which he was able to make astronomical observations. Great indeed must have been Galileo's excitement on 10 January 1610, the third day on which he had observed the bright stars close to the planet Jupiter, when he realized that they could not be fixed stars but were hitherto undiscovered satellites of the planet. On 13 January he observed a fourth 'moon', and he then spent several weeks making further detailed observations and calculations. The next important step was to publish his discovery, and this he did in March 1610 under the title *Sidereus nuncius*.[21] Galileo dedicated this work to Grand Duke Cosimo II, and named the newly discovered satellites *Medicea sidera*, after his hoped-for patron. The Grand Duke invited Galileo to Pisa so that he might make observations himself with Galileo's telescope. In the following July Galileo was appointed chief mathematician to the University of Pisa, and mathematician and philosopher to the Grand Duke Cosimo – and so for the first time in his life became financially extremely comfortable.[22]

There can be no doubt that Galileo's discovery of the four largest satellites of Jupiter, and his subsequent calculations on them, made an important contribution to the use of astronomical tables as a means of finding the longitude. He observed that the satellites alter their relative positions quite rapidly, and it occurred to him that if these motions could be accurately predicted, they would constitute a more satisfactory 'clock in the sky' to serve in determining the longitude.[23] In 1612 he actually proposed this techique as a viable one for seamen, using an instrument he had devised called a *Giovilabio*.[24] He was

[17] Gilbert 1600.
[18] Gilbert 1651.
[19] Waard 1906.
[20] Righini Bonelli 1974, pp. 13, 82.
[21] Galilei 1610; for a recent discussion, see Righini 1978.
[22] Righini Bonelli 1974, pp. 14, 105. Galileo's salary was 1,000

scudi. Assuming an equivalence of four shillings, the salary was £200, which may be compared with the £100 per annum paid to Flamsteed as Astronomer Royal, but who had to provide his own instruments.

[23] Righini 1978, p. 58; Waters 1958, pp. 299–300.
[24] Righini 1978, pp. 58–75.

motivated, as were other mathematicians and scientists of the time, by the commercial importance of solving the longitude problem. Philip III of Spain, whose father had been a strong supporter of applied science to increase the prosperity of his kingdom, offered in 1598 a substantial prize for such a solution.[25] Cosimo II of Florence appreciated the commercial potential of Galileo's scheme, and used it as a bargaining counter in negotiations for trading rights.[26] We must remember that the Royal Observatories, in Paris (built 1667–72) and at Greenwich (built 1675–6), were both founded for the explicit purpose of solving the longitude problem.[27] For Greenwich it could hardly have been more explicit: 'For rectifying the tables of the motions of the heavens, and the places of the fixed stars, so as to find out the so-much desired longitude of places for perfecting the art of navigation.'[28]

It is for his use of the telescope that Galileo is best remembered today by the average man. Less well known are his series of experiments concerning the laws of motion, and his jointed rule called the *compasso geometrico e militare*.[29] This could serve as a military architect's clinometer for erecting fortifications, and as a gunner's instrument to set the angle of elevation of a gun.

Galileo produced his thermoscope – an early form of the thermometer – which was made into a measuring device by Santovio in 1612, and which was developed by Torricelli and other of Galileo's pupils. As a result the thermometer and the barometer became capable of exact measurement, and the science of meteorology was launched.[30]

The Oxford-trained astronomer and mathematician Thomas Harriot (*c.*1560–1621) heard, like Galileo, of the invention of the telescope at Middelburg; indeed, the news would have reached England first, because of ease of communication. We know from Harriot's journal that he actually made observations of the Moon on 26 July 1609 (old style) with one of his own telescopes, three weeks before Galileo presented his telescope to the Venetians.[31] Harriot was employed to work on improving the accuracy of astronomical tables for the benefit of navigators. There was no incentive for him to publish his work, because he was already secure in his patronage, and was working on what was in effect an area of national security. Hence, what is probably the earliest astronomical use of the telescope by Harriot did not become generally known.

The invention of the printing press in about 1450 by Johann Gutenberg (?1397–1468) made much easier and more rapid the dissemination of knowledge, including scientific knowledge, stimulated enquiry, and in time produced a stock of skilled craft-workers in metal.[32] Books were illustrated first by woodcuts, and then by engravings on copper plates, which were also used in the printing of maps, charts and globes. A specially significant figure was the Flemish map-maker Gerard Mercator (1512–94). He studied mathematics at the University of Louvain, and became the maker of the finest charts for seamen, as well as producing instruments for surveying and navigation. It was he who

[25] Waters 1958, p. 223.
[26] Taborelli 1980, p. 45: 'Cosimo II, as a counter-exchange, offered the Council of the Indies "the way to measure longitude discovered by Galileo". This seems a very forward example of attempts at trading real rights for know-how.'
[27] Forbes 1975, pp. 6, 22–3.
[28] Waters 1958, p. 223, n. 1.
[29] Drake 1977, 1978.
[30] Middleton 1969.
[31] North 1974, p. 136.
[32] Eisenstein 1979.

perfected italic lettering for his maps, which he then used on his instruments, setting a style for instrument-makers in the subsequent century.[33]

The maker of scientific instruments was a new man, born around 1500. He could have learnt some of his skill from the goldsmith, but had he done so, there should be more evidence of elaborate decoration on early instruments. Far more crucial to this new craft than metal-working skill were literacy and numeracy. A sundial is easy to mark out; a tower clock is blacksmith's work. But to make instruments that depend on accurate angular measurement, on trigonometry when used in the field, and on spherical trigonometry when used at sea, narrows the field of potential craftsmen to near vanishing-point. This can easily be seen in England, where the scientific instrument-making trade came into being in the mid-sixteenth century, brought over by craftsmen and mathematicians from Louvain and Antwerp.[34] By 1590 there were no more than four men in London making 'mathematical instruments' in brass, and some ten using wood to produce the simpler quadrants, forestaves and plane-tables for the surveyor.[35]

The men who eventually mastered the mathematical as well as the technical problems of engraving brass scientific instruments for navigators and surveyors were, therefore, the product of the new printing industry. By the mid-sixteenth century the main centres of such craftsmanship were in the Low Countries and in Germany, particularly at Louvain and Augsburg. It was from these centres that the specialized skills spread to other parts of Europe.

As the seventeenth century opened, there was established an instrument-making trade to provide for surveyors, gunners and navigators, for weighing and measuring, for time-telling and astronomy. Because of the peculiar needs of deep-sea navigators, who had to know throughout a proposed voyage the lunar positions and the tides, accurate astronomical models had to be developed, based on ever more accurate measurements. It was this requirement that brought into being the so-called 'philosophical' instruments, what we today would call physical apparatus. The sciences of mechanics, optics, hydrostatics and hydraulics, pneumatics and atmospheric physics were now ready for development. Van Balen's *The Measurers* (fig. 80), painted *c.*1600, shows no philosophical or optical instruments for a very good reason – they did not exist at that date.

The princes of Europe were only too keen to become involved in the new scientific developments, because they saw them as generators of wealth. These rulers supported instrument-makers, theoreticians and teachers, and so the cabinet of experimental philosophy was an amalgam of laboratory experimental apparatus and teaching apparatus. Its true origin is firmly in the seventeenth century, and notable landmarks of its development are the Accademia del Cimento (founded 1657),[36] and later the Royal Society of London, founded in 1662, where one of the most brilliant physicists of all time, Robert Hooke, was Curator of Experiments.[37]

The desire for personal security and social prestige, curiosity and superstition, love of learning and the appreciation of beauty and fine craftsmanship – all these feelings were

[33] Osley 1969, esp. ch. 6.
[34] Taylor 1954, p. 18.
[35] Turner 1983.

[36] Middleton 1971.
[37] For the times, see Hunter 1981; for a specific aspect of Hooke's work, see Centore 1970.

satisfied by forming a collection. Notable collections were made by wealthy aristocrats as early as the end of the fourteenth century, but the golden age of the private collection, or cabinet, was the Renaissance. It was at this time that items of scientific interest began to be included. Many of these cabinets were maintained and augmented into the eighteenth century, and others were formed by learned societies, and as an aid to both institutionalized and private teaching. The eighteenth century saw a great many cabinets founded for teaching science; these contained a very wide range of instruments and apparatus, and this model continued through the nineteenth century and, of course, still exists. Any school or college charged with the teaching of science has to possess a large amount of apparatus.

The collector-patrons of the fifteenth and sixteenth centuries attracted to their courts both scholars and skilled artisans. One of the earliest of these was Jean de Berry, Duke of Burgundy (1340–1416), whose collection included clocks and mechanical and scientific instruments. A century and a half later the Landgrave Wilhelm IV of Hesse (1532–92), who was himself a distinguished mathematician and astronomer, had many instruments made for his own use in his observatory. This is claimed to be the first astronomical observatory in Europe, justifiably when considered from an organizational point of view; it was no mere casual observation point. The mechanical genius behind the design and construction of the instruments was Jost Bürgi (1552–1632), a Swiss clock-maker.[38] The Emperor Rudolf II (1552–1612) supported at his court in Prague many scholars and craftsmen, including Tycho Brahe, Johannes Kepler and the incomparable instrument-maker Erasmus Habermel (c.1538–1606),[39] whose instruments were mainly for surveying and time-telling, and would have been classified by Francis Bacon (1561–1626) as professional instruments. By Bacon's definition, science was a more all-embracing enquiry. A passage in one of his minor works refers to the creation of a philosophical cabinet. The work is *Gesta Grayorum*, an entertainment presented at Gray's Inn during the twelve days of Christmas 1594. On one of the days, 3 January, a number of 'philosophers' presented their views to a 'Prince' and his 'court'. One of these was called 'the Second Counsellor advising the study of philosophy', and it is he who recommends four means to further learning in this field: a library; a botanical and zoological garden; 'a goodly huge cabinet, wherein whatsoever the hand of man by exquisite art or engine hath made rare in stuff, form, or motion; whatsoever singularity, chance, and the shuffle of things hath produced; whatsoever nature hath wrought in things that want life and may be kept, shall be sorted and included'; and 'a still-house, so furnished with mills, instruments, furnaces, and vessels as may be a palace fit for a philosopher's stone.'[40]

In Spain, Philip II (reigned 1556–98) was opposed to the Reformation but not to science. He gathered round him mathematicians, engineers and physicians. In 1566 he ordered a complete survey of Spain, the mathematician in charge designing his own instruments.[41] In the 1580s a teaching institute was created on his orders for

[38] Mackensen 1979.

[39] Evans 1973, esp. ch. 5; Fučíková above (pp. 47–53); Eckhardt 1976.

[40] *Gesta Grayorum* is printed in the collected works edited by Spedding, Ellis and Heath 1862, vol. 8, pp. 332–42; the section spoken by the Second Counsellor is on pp. 334–5.

[41] Goodman 1983, p. 55.

cosmography, geography, navigation and hydraulic engineering; scientific instruments and appropriate books were purchased from Venice.[42] In Florence during the same period the Grand Duke Cosimo I (1519–74) began a collection of art objects, coins, and armour which formed a nucleus to which his descendants added according to their tastes. His successor, Francesco I (1541–87) put his collection of instruments in a special room, the ceilings of which were decorated in the grotesque style, the creatures holding and using several surveying and time-telling instruments.[43] Included were cartouches of mechanical contrivances.

Cosimo II (1590–1620) was first the pupil and then the patron of Galileo. His son Mattias (1613–77), on returning from the Thirty Years War in Germany, brought with him a fine group of the best instruments – from Augsburg, Nürnberg and Prague – which are still preserved in Florence.[44] Another son, Cardinal Leopoldo (1617–75), founded the Accademia del Cimento in 1657, composed of scholars and wealthy men who carried out organized experiments. The society disbanded in 1667, and the collection of instruments was carefully preserved in the Pitti Palace, to where all the other instruments in Florence were brought. They formed the nucleus of the Reale Gabinetto di Fisica e di Storia Naturale, which opened as a public museum in 1775. The director, Felice Fontana, was a biologist, and there were also a professor of mechanics and a workshop to produce apparatus.[45]

In England at about the time of the Accademia, the Royal Society was founded with the motto of the experimental scientist: *nullius in verba*. And in Oxford, in 1683, was opened the Ashmolean Museum, housed at the top of a specifically-designed building (fig. 81), which included a chemical laboratory in the basement and a lecture-room on the ground floor, as well as two libraries, one of chemistry and one of natural philosophy, so fulfilling some of Francis Bacon's requirements.[46] Another collection which found its way to Oxford was that of Charles Boyle, fourth Earl of Orrery (1676–1731), which was donated to Christ Church. The Earl's collection, which is a small one, was chiefly of mathematical and optical instruments amassed during the decades 1690–1710, and it is preserved in the Museum of the History of Science (fig. 82).[47]

King George III maintained a tutor, and a very large collection of experimental apparatus, and well over a thousand items are preserved in the Science Museum in London.[48] The King's close friend and adviser the third Earl of Bute (1713–92) is known to have had a similar vast collection – this is revealed by the catalogues of the auctions which dispersed his possessions on his death.[49] Sale catalogues also reveal the extent of the collection of the French amateur, Bonnier de la Mosson (1702–44), probably the largest ever made in this class of object,[50] and of the teaching collection of Petrus van Musschenbroek (1692–1761), Professor of Experimental Philosophy at Leiden

[42] Ibid., p. 56.

[43] Heikamp 1970a.

[44] Boffito 1929, p. 161; Righini Bonelli 1968, p. 28.

[45] Boffito 1929, pp. 171–3. Much of the apparatus is now in the Museo di Storia della Scienza; see Righini Bonelli 1968.

[46] Josten 1966, vol. 1, ch. 9.

[47] Gunther 1923–45, vol. 1, pp. 172, 378–82. For the context, see Turner 1973.

[48] Chaldecott 1951.

[49] Turner 1967.

[50] Gersaint 1744; Bourdier 1959. For short accounts and lists of eighteenth-century French collections, see Taton 1964, pp. 637–45 (physics), 647–52 (chemistry), 659–712 (natural history).

University.[51] Harvard University received in 1727 the endowment for the first scientific chair in America, and funds to purchase five chests of assorted philosophical apparatus.[52]

In Haarlem, Holland, the town received a considerable bequest to provide for a collection of apparatus, and a museum to house it. The benefactor was the silk merchant Pieter Teyler van der Hulst (1702–78), and the director appointed was Martinus van Marum (1750–1837), who began his purchases in the 1780s. The purpose was research and discovery, and emphasis was placed on the collection and construction of large, accurate equipment beyond the reach of private individuals. There were to be models of useful machines and demonstration apparatus, which would be used for lectures in experimental philosophy (fig. 83). Van Marum, interpreting the wishes of Pieter Teyler, proposed a scientific centre of unprecedented scope, a cabinet of natural philosophy that would also be a research and teaching centre, and an inspiration to technology appropriate to the needs of Holland.[53]

There were lecturers in experimental philosophy – some established, some teaching as private individuals – in many European universities, including Cambridge, Oxford, Glasgow, Leiden, Utrecht and Coimbra. From Cambridge originated the popular lectures held in coffee houses and provincial centres. William Whiston (1667–1752) succeeded Newton as Lucasian Professor at Cambridge in 1701. He devised a course in experimental philosophy in about 1705, and, following his dismissal from Cambridge in 1710 for heresy, he lectured in cooperation with an instrument-maker in London.[54] He and his imitators, some of whom travelled with their apparatus on what we would today call lecture tours, made a good living from the fees they charged their audiences.[55] Whiston's course included mechanics, hydrostatics, optics, pneumatics and electrics, and the illustrated syllabus issued by him shows apparatus that was copied extensively throughout the world for the next two centuries.

The cabinet of experimental philosophy had an essential part to play in the popularization of science which occurred during the eighteenth century throughout Europe, reaching many levels of society.[56] I have shown that the prince with his elegantly cased instruments, and the travelling lecturer with his showpieces piled into a cart, both were subject to an economic imperative as well as inspired by intellectual curiosity. The effects of this enthusiasm for science were to produce a well-supported, and therefore skilled and inventive, instrument-making trade, and much individual and institutional patronage for scientific investigation.

[51] Luchtmans and Luchtmans 1762; Crommelin 1926, pp. 19–20.

[52] Cohen 1950; Wheatland 1968.

[53] Turner and Levere 1973; see part II for a catalogue of the extant apparatus.

[54] Ibid., pp. 14–15.

[55] Millburn 1976.

[56] In addition to references already given, there may be added: Turner 1977 on the collection at Coimbra University; Brachner 1983, on the Bavarian Academy.

GREEK AND ROMAN ANTIQUITIES IN THE SEVENTEENTH CENTURY

Michael Vickers

That the material remains of Greece and Rome exerted a fascination over subsequent ages is a fact which does not require justification; but interesting questions arise when we come to consider the various ways in which the relics of classical antiquity have been regarded at different times. Perhaps the most radical change of attitude towards the legacy of Greece and Rome – whether material or intellectual – came about during the seventeenth century. Before, however, we examine developments in that century in any detail, it may be helpful to look briefly at prevailing attitudes towards classical antiquity before and after this period. J. S. Slotkin has well characterized the prevailing archaeology in the Renaissance in these terms: 'The earliest professional antiquarians are found in Italy, where their function was twofold: to discover a glorious past for the city states and thus give them ideological reinforcement, and to support humanistic secularisation by examples drawn from Greek and Roman cultures.'[1] The desire 'to discover a glorious past' in antiquity was not new. As early as the thirteenth century, Frederick II, self-styled Emperor of the West from 1220 to 1250, had not only closely modelled his regime on that of the Roman emperors, called himself *Imperator Fredericus Romanorum Caesar Semper Augustus*, but had clearly instructed a sculptor to adopt an Augustan prototype for his portrait, judging by the colossal portrait head found in the 1950s near Rome.[2] This was an early example in modern times of the political exploitation of archaeological material, but it was not by any means to be the last. Interest in Roman antiquities in particular was fostered in order to justify the claims of Holy Roman Emperors to be the rightful successors of the emperors of ancient Rome, and similar tastes were indulged by several Renaissance popes in order to make analogous statements regarding their temporal authority.

Emperors, popes and princes were not interested in the remains of classical antiquity for their symbolic value alone, however, for most such collections had considerable intrinsic value as well. Cardinal Pietro Barbo's cameos and intaglios were usually set on silver gilt tablets.[3] They included the Felix gem (now in Oxford) which was reckoned to be the most costly intaglio in Barbo's collection, being valued at 100 ducats.[4] Collections such as this could be, and were, used as convertible wealth. Gems could be taken into exile

[1] Slotkin 1965, p. x.
[2] Rowland 1963, pp. 128–32.
[3] Weiss 1969, p. 197.

[4] Dacos, Giuliano and Pannuti 1973, p. 104. The connection was first noted by Pollard 1977.

in case of political disturbance,[5] or they could serve as security for a loan.[6] Given their high market value in the Renaissance, it is scarcely surprising that many gems and ancient vessels made from semi-precious stones found their way into the collection of the owner-manager of the Medici Bank, Lorenzo de' Medici.[7] Sculpture, which had obvious architectural potential, was the other principal genre which appealed to collectors; ancient pottery, though presumably abundant, received far less attention than objects of intrinsic value at this period.[8] The humanists read their Greek and Latin texts carefully, and found a world in which wealth was expressed by means of gold, silver, jewels and costly perfumes and textiles, and a life lived against the background of magnificent architectural settings. This was the world which those who could afford to do so tried to emulate.

Those who were wealthy enough to enjoy a degree of leisure found the justification, and perhaps even the inspiration, for their hobbies in classical literature. A passage in Plutarch's *Life* of Demetrius Poliorcetes provides a perfect exemplum for princes with time on their hands: Aeropus the Macedonian, for instance, used to spend his leisure time in making little tables or lamp-stands. And Attalus Philometor used to grow poisonous plants, not only henbane and hellebore, but also hemlock, aconite and dorycnium, sowing and planting them himself in the royal gardens, and making it his business to know their juices and fruits, and to collect these at the proper season. And the kings of the Parthians used to take pride in notching and sharpening with their own hands the points of their arrows.[9]

It was the splendour of the Roman past which impressed local historians in Italy such as Flavio Biondo,[10] but since the relevant literary sources dealing with Germany and England were far less circumstantial, the authors of northern local histories written in imitation of Biondo's work laid rather less stress on ancient luxury.[11] Inscriptions were collected in Italy and soon afterwards in Germany where they began to be published and used as evidence for that country's Roman past.[12] Such interest should not, however, be regarded as disinterested scholarship: rather, it was politically motivated, for the more light that could be thrown on the Roman antiquities of Germany, the stronger the claims of the local gentry to be the lawful successors to the Romans who had ruled the country long before them.[13]

The seventeenth century was an age in which attitudes towards antiquity became far more complex. As an index of quite what happened in this century let us look at a document from a later period. In *The Antiquary* Sir Walter Scott describes with irony and insight two quite different views of the past. One recent critic has rightly observed: 'the real hero of the novel is the antiquary himself, Jonathan Oldbuck, who dominates the other characters in the novel . . . just as the middle class to which he belongs securely controls the town of Fairport and its environs.'[14] Oldbuck is proud of his descent from an

[5] Weiss 1969, p. 190.
[6] Brown 1983, pp. 102–4.
[7] Cf. Dacos, Giuliano and Pannuti 1973.
[8] Cook 1972, p. 287.
[9] Plutarch, *Demetrius* xx, 2.
[10] Biondo 1444–6, 1463.

[11] Celtis 1902 (written before his death in 1508) was intended to be part of a larger *Germania illustrata*: see Burke 1969, pp. 25–6; Camden 1586.
[12] Busch 1973, pp. 2–4, 227–230.
[13] Ibid., p. 4.
[14] Brown 1979, p. 48.

early Reformation printer, a descent which places him 'in his own eyes far above the status of hereditary aristocracy'.[15] It is, however, a member of the local hereditary aristocracy who serves as a foil to Oldbuck. Sir Arthur Wardour is also interested in the past, but in a wholly different way, one of his main concerns being to restore his greatly reduced family fortunes by searching for buried treasure in a ruined monastery with aid of an alchemist. His academic predilections are for 'old tomes containing lists of ancient dynasties; not only can he recite the full roll of mythical Scottish kings . . . he also defends their existence absolutely, sensing that the rights of inheritance themselves are in some way undermined by Oldbuck's objectionable scepticism on this subject.'[16] Wardour, moreover, complains that Oldbuck had 'a sort of pettifogging intimacy with dates, names, and trifling matters of fact' and 'a frivolous accuracy of memory which is entirely owing to his mechanical descent'.[17] Sir Arthur Wardour would clearly not have been out of place in earlier centuries: antiquity provided the authority for the existence of a hereditary aristocracy and all its rights and privileges (or at least appeared to do so). Oldbuck, by contrast, is an altogether new kind of animal, someone who looks at the past in quite a different spirit from that shown by the bankers and canons of Augsburg some three centuries earlier, for Oldbuck is a Whig, not an unquestioning supporter of the traditional establishment.

The room in which Oldbuck performed many of his antiquarian labours repays our brief attention for it contains a curious cabinet which deserves at least a passing glance.

One end of the room was entirely occupied by bookshelves, greatly too limited in space for the number of volumes placed upon them, which were, therefore, drawn up in ranks of two or three files deep, while numberless others littered the floor and the tables, amid a chaos of maps, engravings, scraps of parchment, bundles of paper, pieces of old armour, swords, dirks, and Highland targets. Behind Mr Oldbuck's seat . . . was a huge oaken cabinet, decorated at each corner with Dutch cherubs, having their little duck-wings displayed, and great jolter-headed visages placed between them. The top of this cabinet was covered with busts, and Roman lamps and paterae, intermingled with one or two bronze figures.

We do not, alas, learn what was inside the cabinet, though some of the objects on the table and elsewhere give a clue to their nature:

A large old-fashioned oaken table was covered with a profusion of papers, parchments, books and nondescript trinkets and gee-gaws, which seemed to have little to recommend them, besides rust and the antiquity which it indicates.

Amid this medley, it was no easy matter to fine one's way to a chair, without stumbling over a prostrate folio, or the still more awkward mischance of overturning some piece of Roman or ancient British pottery.[18]

All this, however, is a long way from the collection of Greek and Roman antiquities in the seventeenth century. By 1600 the central role of the classics in the intellectual life of Europe was being challenged, and travel and exploration had broadened men's cultural horizons in such a way that other civilizations might appear to be the equal of, if not

[15] Ibid., p. 49.
[16] Ibid., p. 51.
[17] Scott 1816, ch. 5; cf. Brown 1979, p. 51.
[18] Scott 1816, ch. 3.

superior to, those of ancient Greece and Rome. As a result classical civilization ceased to provide the only cultural mould within which the process of European civilization could occur.[19] This change took place very slowly, however, and what we might now provisionally distinguish as the 'aristocratic' approach to antiquity continued to exist, though it gradually ceased to be the only one. The different approaches can be illustrated by reference to the great English collector Thomas Howard, Earl of Arundel, on the one hand, and learned clerics such as Meric Casaubon or the Wiltheim brothers on the other.

Lord Arundel (1585–1646)[20] formed a deep affection for Italy, and when in Rome in 1613 he was allowed not only to excavate the ruins of several houses, but to take away the ancient Roman statues which he found.[21] The reason for this apparent act of generosity on the part of the Roman authorities was that in Arundel they hoped to have a friend at the English court. He was born a Roman Catholic and died in that faith, and it was presumably for reasons of state that Arundel was permitted to indulge his taste for the antique past in this way. Arundel's own motivation was to some extent political too. His family had been deprived of the Dukedom of Norfolk by Queen Elizabeth, and he devoted his whole career towards having the title restored. This is well illustrated by another interest, namely his collection of paintings by Holbein, an artist who might be regarded not simply as Arundel's link with the past, but with a past in which his own family had served with distinction and been duly honoured. Similarly, but less immediately personal reasons may underlie his interest in classical antiquity: it was the Roman quality of *gravitas* – 'a concern with order and propriety, with honour and nobility'[22] – which he seems most to have appreciated. Arundel's views regarding antiquity are doubtless reflected in the view of his librarian Franciscus Junius, that 'the arts inclined men to peace, consecrated the memory of the great, and showed virtue as the pattern of the glorious life.'[23]

Henry Peacham, a member of Arundel's household, wrote *The Compleat Gentleman*, a plodding remake of Castiglione's *Cortegiano*, in which his employer not surprisingly comes in for praise:

And here I cannot but with much reverence, mention the every way Right honourable Thomas Lord High Marshall of England, as great for his noble Patronage of Arts and ancient learning, as for his birth and place. To whose liberall charges and magnificence, this angle of the world oweth the first sight of Greeke and Romane statues, with whose admired presence he began to honour the Gardens and Galleries at Arundel House about twentie years agoe, and hath ever since continued to transplant old Greece into England.[24]

Arundel also transplanted contemporary Rome into England, and we can understand that in ordering new pieces of sculpture *all'antica* from the Roman *scarpellino* Egidio Moretti in 1614, he not only had the satisfaction of being a patron and of commissioning large-scale sculpture from a craftsman in Rome itself,[25] but was also furnishing his house

[19] Bracco 1979, pp. 107–8; cf. Nussbaum 1953, p. 27.
[20] Michaelis 1882, pp. 6 ff.; Hervey 1921; Haynes 1975; Howarth 1978; Fehl 1981.
[21] Dallaway 1800, p. 256.
[22] Sharpe 1978, p. 240.

[23] Ibid.; on Junius, see Fehl 1981.
[24] Peacham 1634, pp. 107–8.
[25] Hess 1950; Vickers 1979a. Later on Arundel was responsible for attracting a more accomplished sculptor from Rome to England: Vickers 1978.

in the manner in which the rich and the noble had been doing on the Continent for the past century and a half.[26] In so doing, he was in effect supporting his family's claim to ducal status by acquiring some of the outward forms of European nobility.

Arundel acquired statues in various ways apart from personal excavation or patronage. He appears to have bought in Italy a fragment of the Great Altar of Zeus at Pergamum, for the relief of a dead Giant with which it is adorned seems to have been used by Rubens as the model for the dead Christ in the *Descent from the Cross* in Antwerp in 1610,[27] and Arundel's own agent only visited Pergamum in 1625.[28] Another acquisition which probably followed a similar route from the Aegean to England via Italy is the so-called Arundel Homerus which Rubens, a friend of Arundel, used for the figure of Time in his *Gouvernement de la Reine* in the Louvre.[29] The services of Italian middlemen presumably did not come cheaply, and this is doubtless why Arundel copied the example of Venetian collectors and acquired sculpture directly from Greece and Turkey by means of his personal agent William Petty. From the fifteenth century until the beginning of the nineteenth the Greek world simply served as a quarry; Lord Elgin's speculative acquisition had an extremely long tradition behind it. Among the objects Arundel is thought to have acquired from this source are the metrological relief[30] and the famous Parian marble, a chronological table now virtually illegible.[31] He also received gifts of sculpture from diplomats, as presents from admirers and by exchange with other collectors.

How did Arundel display his antiquities? From a pair of portraits by Daniel Mytens of the Earl and his Countess, Alatheia Talbot,[32] we might be led to believe that the statues were exhibited along the walls of an upper gallery, each on a plinth, but, as David Howarth has observed,[33] we should probably regard these views as idealized, rather in the manner of a frontispiece. Another portrait of the Earl by Mytens shows sculpture in the garden, disposed regularly about the parterres,[34] a garden which Joachim Sandrart described in 1627 as 'resplendent with ancient statues in marble of Greek and Roman workmanship.'[35]

We have no direct information about where the inscriptions were housed, though since they were placed on a wall near the Sheldonian Theatre when they were given to Oxford University in 1667,[36] they probably enjoyed a similar location in the collection's heyday, on the south side of Arundel House. If so, they will have been exhibited in a tradition which we have met already in Rome and Augsburg, but of which there were other examples, notably in Florence, Padua, Vienne, Lyon, Cologne, Tarragona[37] and Luxemburg.[38] Contemporary German collections have been classified either as *Freiraumsammlungen* – usually local inscriptions in gardens – or as *Studiosammlungen* – coins, gems and sculpture, mostly from Italy, and housed indoors.[39] Arundel's collection

[26] Cf. Busch 1973.
[27] Vickers 1981.
[28] Haynes 1975, p. 6.
[29] Haynes 1974.
[30] Fernie 1981.
[31] Jacoby 1904.
[32] Millar 1972, pp. 12–13.
[33] Personal communication.

[34] Fehl 1981, p. 17, fig. 5.
[35] Trans. from Sandrart 1695, p. 41.
[36] Information from D. Sturdy, who will publish the evidence shortly.
[37] See chapter 17 of this publication.
[38] Busch 1973, pp. 9–36.
[39] Ibid., p. 8.

combined both, and his inscriptions were far from being local; very many of them were from Smyrna.[40] The inscriptions which had entered his collection by 1628 were published by John Selden in *Marmora Arundelliana*, a work which did much to establish Arundel's reputation as a man of learning on a European scale.

Arundel employed etchers to record the works of art in his collection. Noteworthy among these was Wenceslaus Hollar, an *émigré* Czech who entered Arundel's service while the latter was passing through Germany on an embassy to the Emperor Rudolf in 1636.[41] Hollar did very many etchings of the paintings and drawings which Arundel owned, but very few indeed of the classical sculptures. Some appear in a commemorative etching made after Arundel's death in 1646:[42] classical statues occupy the niches of the architectural background, and Roman portrait heads lie on the ground. They may have been intended to be Marcus Aurelius and Faustina, the Roman couple devoted to Stoic principles, and whose marriage might have been thought to prefigure that of Arundel and Alatheia Talbot.[43] In support of this idea, we might note that the only etching Hollar seems to have done of an Arundel statue in its own right was of a bust (in fact a seventeenth-century pastiche of two classical pieces) which was said to be a portrait of the Empress Faustina.[44] The etching was made at Antwerp, a centre of Neo-Stoic philosophy, in 1645, the year before Arundel's death, but after he had departed for Italy.

It was the Civil War which had driven Arundel abroad, but the fact that war broke out at all was due in no small part to the competitive spirit in which patronage and collecting were conducted in Caroline England. Arundel was far from being the only, or indeed the most prominent participant: Charles I and the Duke of Buckingham both had extensive collections, including many pieces of classical sculpture, some brought out of Turkey,[45] others bought from Italian collections whose owners had fallen on hard times. The Gonzaga court at Mantua was a principal source of material. Apart from the paintings and classical sculpture which entered the English royal collection,[46] the probability that the Felix gem was included in the cabinet of 263 cameos and intaglios which Arundel bought for the amazingly high sum of £10,000,[47] suggests that Mantua may have been the ultimate source of this cabinet. As a result of this and many other expensive purchases, Arundel's financial situation was dire towards the end of the 1630s.[48] The last official portrait shows the Earl 'with the chain of the Order of the Garter about his neck, pointing to the island of Madagascar where, in his last great (and abortive) bid for enduring political eminence, he hoped to establish a colony'[49] – and doubtless to restore his flagging fortunes on a palm-fringed island far from his creditors. In the event war intervened and Arundel died an exile at Padua. Much of his collection was eventually sold on the Continent in order to help the Royalist cause.[50] The Howards were restored to the

[40] Petzl 1982.

[41] Vickers 1979b.

[42] Parthey 1853, p. 466; Vickers 1979b, p. 132, fig. 9.

[43] Cf. Vickers 1979b, p. 130.

[44] Parthey 1853, p. 590; Vickers 1979b, p. 126, fig. 1.

[45] Sir Thomas Roe, English ambassador to the Porte, acted as Buckingham's agent: Michaelis 1882, pp. 18–19; Hervey 1921, p. 269.

[46] Luzio 1913.

[47] Bray 1818, p. 217. For further information on the Felix

gem and its influence, see Vickers 1976b; Pollard 1977; Sheard 1979, no. 8; Vickers 1983c; Brown 1983.

[48] Clarendon 1849, p. 78: 'His expenses were without any measure, and always exceeded very much his revenue.'

[49] Fehl 1981, pp. 21–2. The figure which Fehl interprets as Junius in the Knowle version of the Madagascar portrait (p. 22, fig. 11) is probably Aristotle, rendered in the tradition described by P. W. Lehmann (in Lehmann and Lehmann 1973, pp. 15–25).

[50] Weijtens 1971.

Dukedom of Norfolk after the Restoration, and from their point of view it might be thought that the English phase of the Renaissance had been worthwhile.

The other tradition, the antiquarian tradition to which Jonathan Oldbuck belonged, now holds our attention. Lacking the means to travel or to collect the more valuable relics of antiquity, and yet aware from their reading that much of civilized Europe had been occupied by the Romans in antiquity, its members applied their learning and ingenuity to the elucidation of the relics of the past which might be found in their locality. The most common material was pottery, a substance almost beneath contempt in days when the rich ate and drank from silver and the poor from pewter.[51] It would be a long time before pottery, even ancient pottery, would find a prominent place in a nobleman's collection.

Early evidence of antiquarian interest in Roman pottery and glass is supplied by the activities of Basilius Amerbach in excavating Augst in the late sixteenth century. Objects from these excavations were included in Amerbach's cabinet together with his other rarities.[52] It may be relevant to take note of the strong Erasmian traditions of the Amerbach cabinet, a topic discussed in general terms above (pp. 62–8). An early publication of Roman pottery was made by Meric Casaubon, a canon of Canterbury who, in an appendix to a translation of Marcus Aurelius which appeared in 1643, has an excursus dealing with some 'Roman pots and Urnes, almost of all seyzes and fashions, and in number very many' found in a field near Newington in Kent. He even published a sketch of some of the pots, which included a samian bowl of which 'such was the brightness and smoothness . . . that it rather resembled pure Corrall'.[53]

At much the same time two Jesuits in Luxemburg, the brothers Wilhelm and Alexander Wiltheim (1594–1636 and 1604–1694) were taking similar notice of the Roman antiquities of the region in which they lived. Their work *Luxemburgum Romanum* was conceived on a large scale, but has never been properly published. The contents of the manuscript are of interest, however, since they reveal how these two seventeenth-century antiquaries went about their business. Most of the field-work seems to have been carried out by the younger brother, Alexander, who realized the potential importance of Roman pottery, and drew and described potsherds and fragments of glass – objects which would have been dismissed as valueless by most people of that time.[54]

These two examples show the antiquarian tradition at its best, and it will have been as a result of the activities of the likes of Casaubon or the Wiltheims that Roman artefacts – bronzes, lamps, pots and glass for the most part, and perhaps a few gems – entered contemporary cabinets of curiosity. Greek pottery was exported in antiquity to Italy, and although there are a few references to pieces in fifteenth- and sixteenth-century collections, it was not until the mid-seventeenth century that writers and collectors began to take a consistent interest in it. It has been suggested by R. M. Cook that this delay was due to a stylistic repugnance;[55] more likely, since the material of which the pots were made was in no way valuable or even exotic, there was an understandable reluctance to collect it.

[51] Hatcher and Barker 1974, pp. 60–2.
[52] Information from Dr Ackermann.
[53] Casaubon 1643, appendix; cf. Vickers 1976a, pp. 45–6; Sturdy and Henig 1983.

[54] Ternes 1974, pls. 9–10; cf. Vickers 1976a, pp. 45–6.
[55] Cook 1972, p. 287.

When ancient lamps, pots and bronzes entered cabinets of curiosity, they were eventually studied as scientifically as shells, tomahawks and the rest. We should not, however, be misled into thinking that all such developments have necessarily given us a clearer understanding of what happened in antiquity, for in some important respects a concentration on what has actually been found, as opposed to the picture we receive in contemporary sources, has given rise to views of the past which, while apparently corresponding to the physical facts, may be wholly inaccurate. What we have termed for want of a better expression the 'aristocratic' approach to antiquity may, however, provide the necessary corrective.

Most professional students of antiquity have not only belonged to the 'antiquarian' as opposed to 'aristocratic' wing, but have also subscribed, no matter how unconsciously at times, to an intellectual tradition which has its roots not in ancient Greece or Rome, but in the New World. Early reports of America recounted that there were societies in that continent which 'held as nothing the wealth that we enjoy in this our Europe such as gold and jewels, pearls and other riches'.[56] Such reports influenced Thomas More, the inhabitants of whose imaginary state were systematically conditioned to despise precious metals: 'Inasmuch as they eat and drink from vessels fashioned out of clay and glass which, though handsomely shaped, are nevertheless of the cheapest kinds they . . . make night jars and all kinds of squalid receptacles out of gold and silver.'[57] W. S. Heckscher has recently discussed Alciati's emblem entitled *Adversus naturam peccantes*, an emblem of a naked man emptying his bowels into a golden vessel while close by him stand an earthenware pitcher and a glass goblet. Heckscher quotes J. Thuilius's commentary: ' . . . does a more scandalous abuse exist than to commit one's own excrements to gold, while drinking from simple glass and earthenware?'[58] This was a typically adverse reaction to More's philosophy. Others took a more favourable view, and none more so than William Morris, the inhabitants of whose earthly paradise could call in at a potter's workshop whenever the mood took them: 'It would be ridiculous', says Morris, 'if a man had a liking for pot-making that he should have to live in one place or be obliged to forgo the work he liked.'[59] It goes without saying that the existence of visionary literature of this kind has done much to make our world a more comfortable one, but it should not go unrecognized that there has been a marked tendency on the part of antiquaries to impose a Utopian view of society on the past, aided in large part by the abundant presence of pottery and the notable absence, broadly speaking, of precious metal. C. R. Dodwell has recently shown to general surprise that 'the survival pattern of the various crafts of the Anglo-Saxons has distorted our knowledge of their arts' and as a result 'it has also falsified our understanding of their visual tastes.'[60] Anglo-Saxons apparently preferred gold and silver to pottery and acquired as much precious metal as they possibly could.[61] A similar distortion has occurred with regard to antiquity,[62] and must exist in other areas of antiquarian study, and be all the more serious where there is no literary evidence to fill out the picture. It would seem to be incumbent on every scholar working on the material

[56] Vespucci 1893, fol. 4v.
[57] Trans. Heckscher 1981, p. 297.
[58] Ibid.
[59] Morris 1890, pp. 221–2.

[60] Dodwell 1982, p. 12.
[61] Ibid., *passim*.
[62] Vickers 1983a, 1983b, 1985.

remains of the past to ask himself just why there is so much pottery in our museums and at least to entertain the possibilities that aristocratic, or perhaps we should simply call them human, values prevailed in the past to the extent that the possession of precious metals was thought to be desirable in antiquity, and that until very recently there was every incentive to recover material objects of intrinsic value from the earth, but to ignore pottery completely.

NORTH AMERICAN ETHNOGRAPHY IN THE COLLECTION OF SIR HANS SLOANE

J. C. H. King

No full attempt has yet been made to identify and list ethnographic collections from North America made in the sixteenth, seventeenth and eighteenth centuries.[1] While many of the most famous artefacts in England, France and Scandinavia have been published in part, no systematic evaluation of North American artefacts has yet been made from the evidence which exists in the inventories of royal, scientific and gentlemanly cabinets of this period.[2] This is in contrast to the situation for Latin-American material where research into Mesoamerican writing systems and the generally more spectacular nature of Mexican artefacts has stimulated study of the inventories and published catalogues.[3] In addition it is obvious that while several parts of Latin-America were permanently colonized – making available large numbers of artefacts – in the sixteenth century, the first substantial colonization – and therefore collection of artefacts – in America north of the Rio Grande took place a century later.

This expansion into North America coincided with the first detailed records of English cabinets, three of which contained significant North American material. The most important cabinet of the seventeenth century is that of the Tradescants, recorded in the published catalogue of 1656. While the descriptions of artefacts are extremely brief we can estimate that there are twenty-nine entries of material likely to be from North America, although of course many of these entries included more than one object. The range of material is apparently broader than those of Continental collections, since it naturally includes items from Virginia and from Canada, as well as from Greenland, although these locations are not always mentioned.[4] The second important record of a catalogued English collection is that of the Royal Society published in 1681 by Nehemiah Grew. This collection contained fewer and less unusual items of possibly North American origin, but included the ubiquitous kayak, wampum and birchbark containers.[5] Less well known is the collection of Ralph Thoresby, the antiquary (1658–1725). In the catalogue published in the year of his death are some thirty items which may have originated in North America. These included a ball-headed club, a club with a pointed celt set transversely

[1] But see Hamell 1982 for a discussion of north-eastern North American material.

[2] Bushnell 1906, Dam-Mikkelsen and Lùndbæk 1980, Far-doulis-Vitart 1979.

[3] For instance Heikamp and Anders 1972.

[4] The Tradescant catalogue includes a list of donors, but since this is separated from the catalogue it is not as useful as it might be. See London 1983.

[5] King 1981, p. 24 discusses its transfer to the British Museum. No specimens have yet been identified. Feest (in MacGregor 1983, p. 122 n. 53) mentions wampum belts given to the Royal Society by Governor John Winthrop of Connecticut in 1669.

into the end of a shaft covered in wampum, of the type found in Scandinavian collections,[6] and a number of items associated with an Indian Queen of Maryland, Anna Sonam, and her daughter Elizabeth. This collection has unfortunately entirely disappeared.

The later collection of Sir Hans Sloane, born in 1660 in County Down, is altogether different in terms of its size, classification and in the preservation of a large volume of documentation. Sloane, as physician to the Duke of Albemarle and Queen Anne, Physician Extraordinary to George I, and President of the Royal Society and Royal College of Physicians, was in an excellent position to collect material, not only in the field on his visit to the West Indies while working for the Albemarles in 1687–9, but also from his association with the court and professional institutions.[7] It was perhaps this field experience, which had begun earlier with the collections made in France while working towards his degree, that trained Sloane to recognize the importance of the documentation of specimens. His collection grew in the late seventeenth and early eighteenth century to enormous proportions. At his death it contained some 79,575 specimens, of which 32,000 were coins and medals, 12,506 seeds, woods and roots, 5,439 insects and 5,843 shells. In addition he owned 334 volumes of dried plants, 50,000 printed books and 3,836 volumes of manuscripts. It is well known how this material came to form the basis of the British Museum founded in 1753.

The books, manuscripts and dried plants have survived rather well, while the whereabouts of much of the other collections are now unknown. Of the 10,484 mineralogical specimens, for instance, only 161 survived in 1933, and of these a substantial proportion were specimens of worked minerals outside the mineral categories of Sloane's cataloguing system.[8] At the time of his death this collection was listed in forty-six manuscript volumes. The ethnographic material is included in a catalogue of *Miscellanies*, that is a catalogue of artificial curiosities which fell outside the scope of his conception of antiquities. In lumping together unordered ethnographic material from all over the world, Sloane eschewed the by then common practice, followed by Tradescant for instance, of dividing collections into sections of clothing, household utensils, arms and idols. This had, however, one important effect for it appears as though the catalogue of *Miscellanies* was kept in chronological sequence, thus permitting reasonable propositions to be made about the dates on which specific specimens came into his possession.[9]

It is not possible to divide up the 2,111 miscellanies into exact places of origin, although eventually estimates of this nature will have to be made, taking into account some of the various possible origins and very non-specific listings especially in the early part of the catalogue. Braunholtz estimated that there were in the catalogue 350 items of ethnographic interest. Of the artefacts surviving in 1970, four were said to be of European origin, twenty of African origin and twenty-nine of American origin.[10] In addition there is material listed in this catalogue in other departments of the British Museum and in the

[6] Linné 1955, pl. 1b; Birket-Smith 1920, pl. 2 fig. 1. Thoresby's club was presented to him by S. Molineux of Dublin (Thoresby 1715, p. 473).

[7] Sweet 1935, pp. 49–64.

[8] Sweet 1935, p. 98.

[9] The surviving catalogue of *Miscellanies*, in the Museum of Mankind, lists 2,111 specimens; Sloane's will mentions 2,089. It seems likely that other material, perhaps specimens which had lost their labels, was added to the collection after his death. The surviving catalogue is a fair copy. Turner (1955, p. 60) discusses the chronology of the catalogue.

[10] Braunholtz 1970, pp. 20–1.

British Museum (Natural History). Other Sloane pieces have reappeared in the Department of Ethnography since 1970 (figs. 84–5). Of the 2,111 items listed some 210 are possibly of North American origin. These can be organized into simple categories, into those of native Indian, African and European origin, and also of place of origin. Whilst in the sixteenth century most North American artefacts recorded seem to have vague origins in northern Canada and Greenland, or Florida, and whilst in the seventeenth century Virginia becomes a prominent place of origin for artefacts, Sloane's catalogue adds, as one would expect, several additional colonies in which material was collected.

Of the 210 North American specimens, some forty are from Hudson Bay, Hudson Straits, Davis Straits and Greenland, although not all of them are of Inuit origin. The other large groupings are those of forty items from New England, twenty-five from the Carolinas and sixteen from Virginia. In addition there is one item from New York, and two items each from Pennsylvania and Georgia – the last is surprisingly modest since Sloane was personally involved in the setting up of Georgia and one might expect that his collection would have benefited more from this involvement. Of these things only eight are given tribal designations: three Iroquois items, three Huron, and one each designated as from the Eskimo and Cherokee. There are also eleven items of Euro-American and four of Afro-American origin. There are however substantial problems in the use of the term Indian, and also West Indian which appears alongside six North American items in the early part of the catalogue. Canada appears as the place of origin for nine items mostly in the very early part of the catalogue, presumably dating from the first decade of the century.

The types of artefact represented in the collection are perhaps typical: the fifty items of symbolic, ceremonial and religious significance include many items of wampum, a scalp, rattles and drums. The seventy-six items used for subsistence and domestic activities include numbers of bows and arrows, snow shoes, boats, baskets, and a model cradleboard. The nineteen items of clothing, consisting mostly of parkas, moccasins, and leggings, are complimented by thirty-two objects used as personal accoutrements and decorations, that is to say mostly garters, girdles and belts. The seven specimens of raw materials include moose hair for decoration, sinew for sewing, and a food made of goose flesh mixed with deer-bone marrow. The Euro-American artefacts reflect an interest in things derived from American raw materials such as candles, soap, a cigar and a nut-cracker for use with walnuts.[11] The Afro-American material consists of drums, a basket perhaps of African form and a noose made of cane for catching game or hanging runaway slaves, although this might be included amongst things of Indian or Euro-American origin.[12] The archaeological material, seventeen specimens, consists mostly of flaked stone points although it includes a grooved stone axe and several sherds (fig. 84).

More interesting than the division of the collection into source of origin is perhaps the

[11] The most famous Euro-American artefact is the bag of asbestos (Sl.1205), offered for sale by Benjamin Franklin in a letter to Sloane dated 2 June 1725, (Sl. MS 4047, p. 347), and now in the Department of Mineralogy, British Museum (Natural History).

[12] An Akan-type drum survives; Bushnell 1906, pl. xxxv.

association of 106 North American artefacts with twenty-three individuals, most of whom appear to have collected the material in the field. The majority of the artefacts for which we have the collectors' names comes from the later section of the collection which dates from the 1730s and 1740s. Of these twenty-three people it is possible to identify nineteen. Most significant of all is the manner in which Sloane preserved his correspondence, so that for more than half these things we have further information which indicates when and where a quarter of the total of North American specimens were collected. It is in this survival that the Sloane ethnography differs from collections which preceded it for, with the close documentation of some specimens, it becomes possible to think of Sloane as one of the first scientific collectors of ethnographic items.

The nineteen identified donors to Sloane can be roughly classified into professions,[13] though many had more than one professional and amateur interest, and moreover the categories overlap. In each case, therefore, it is the principal occupation which has been selected. The donors included six botanists,[14] four sea travellers including traders, explorers and naval captains,[15] two physicians,[16] three Americans,[17] one lawyer, one cleric,[18] one artist[19] and one general amateur.[20] It is not possible here to consider the collectors in detail, although one will be taken as an example to indicate the type of information available.

John Bartram (1699–1777; born Darby, Penn.) was a pioneer of American botany. He was a considerable correspondent, especially with Peter Collinson the horticulturalist, and had access through Collinson to wealthy patrons and collectors.[21] Bartram collected material widely, for instance in Pennsylvania in the 1740s and in Georgia, Carolina and Florida in the 1760s. He presented four Indian artefacts to Sloane; all are well recorded in Sloane's catalogue and the letter associated with the first survives in the Sloane correspondence. This is undated, but from the early 1740s. He thanks Sloane for material sent to him through Collinson. In return he sends him an Indian arrowhead of crystal (Sl. 2037) and an instrument, perhaps used to drill holes, and also discusses the use of a Jamaican celt which Sloane had sent him for identification.[22] Another letter of the same period, dated 14 November 1742, refers to other material. This included dried plant specimens, a box of insects and some fossils. He then goes on to say: 'when I read in thy second volume of thy extraordinary collection of curiosities I thought it would be difficult to send thee anything of that nature that would be new I have procured an indian pipe made of soft stone intire it was dug by chance out of an ould indian grave;' and he goes on

[13] The four people about whom we know little are: a Mr Standish who presented an Afro-American drum; Isaac Waldron who presented miscellaneous material; a Mr Wright who presented a pair of quilled beaver leggings and a Mr Villarmont who presented moosehair for embroidery, a twined hemp pouch decorated with moosehair and a pair of miniature moccasins with snow shoes (fig. 84).

[14] The six botanists are: John Bartram, Peter Collinson (1694–1768), Wiliam Darby (*fl.* 1696–1709), Nathaniel Maidstone (*fl.* 1698–1723), Philip Miller (1691–1771) and James Petiver (*c.*1658–1718).

[15] The explorers, naval officers and traders are Henry Elking (*fl.* 1726–9), Alexander Light (*fl. c.*1740–5), Christopher Middleton (*fl. c.*1720–45) and Thomas Walduck (*fl.* 1710–15).

[16] The two physicians are Richard Middleton Massey (1678?–1743), the antiquary, and a Mr Potts (*fl. c.*1735–45), active in the Hudson Bay trade.

[17] The three Americans are Benjamin Franklin, John Winthrop (1681–1747) and Sir Francis Nicholson, Governor of South Carolina (1721–3).

[18] The lawyer is Captain Thomas Walker (*fl.* 1701–5) and the cleric is a Mr Clerk (*fl. c.*1710–34).

[19] The artist is George Edwards (1694–1773).

[20] The general amateur is a Mrs Mary Dering (*fl.* 1725–30).

[21] Dandy 1958, pp. 88–9.

[22] Sl. MS 4069 fol. 90.

to include drawings of the pipe (fig. 87), a late prehistoric type of monitor pipe.[23] We do not know whether the pipe was sent to Sloane. However the significance accorded to pipes, one of the few easily available archaeological artefacts of considerable workmanship, is further suggested by the inclusion of a Creek(?) elbow pipe in one of the natural history drawings by John Bartram's son, William.[24] Bartram's interest in archaeology, and the status which he gave it, is further stressed by his catalogue comments on a number of sherds which he presented to Sloane (Sl. 2067–8). One sherd was from a stone pot which, according to Sloane, 'indureth fire well'; of the other pottery sherds Bartram made comments about the tempers used and particularly 'whether they be of shells, gravel, or some other hard matter'. Of the arrowhead he noted that 'it would push a European to make one wt only a couple of stones', a situation which has only recently changed.

The significance of Sloane's collection is that within it for the first time a substantial proportion of pedestrian descriptions are replaced with information copied directly from field informants. This is the significant factor which distinguishes Sloane's ethnography from that of preceding collectors. For in many other ways, such as in our lack of knowledge about how the collection was displayed and in Sloane's failure to classify his collection, it is more similar to the cabinets of the preceding century than to the museums which followed. In the second half of the eighteenth century the enormous increase of trade, and of wealth within Europe, resulted in ever-increasing numbers of ethnographic specimens, and perhaps also in reductions in their price or monetary value. It was only when there were sufficiently large numbers of specimens available that displays of comparative material culture from different peoples could be mounted. This innovation, which began perhaps with material said to have been assembled at the Hôtel de Sérent for the education of the young members of the French royal family, was by the end of the eighteenth century relatively commonplace in the form of commercial and public museums established especially in England. In a sense, in the eighteenth century the *Kunstkammer* exploded so that instead of a collection including one or two amber bottles, or a few Chinese vases, a whole room might be decorated with amber panels or with Chinese vases or with panels of locally made porcelain. In the same manner ethnographic displays came to be mounted in whole rooms, yet it was only after the form of the post-medieval museum had decayed and scientific specialization became again central to the idea of collecting that ethnographic displays took on anything approaching a modern form.

[23] The type of pipe is known from the Gaston phase, North Carolina: Willey 1966, p. 285. Sl. MS 4057, pp. 157–8. See fig. 87).

[24] Ewan 1968, pl. 26.

MEXICO AND SOUTH AMERICA IN THE EUROPEAN *WUNDERKAMMER*

Christian Feest

A survey of the surviving and/or documented specimens of Mexican and South American origin from sixteenth- and seventeenth-century collections is useful for a number of reasons. It will (1) demonstrate the importance of early modern collecting for the contemporary knowledge of extinct cultures; (2) provide clues for the selective principles involved in sixteenth- and seventeenth-century collecting; (3) underline the need for both better studies of individual pieces in terms of their documentation and their physical description, and also for better comparative and typological studies of certain artefact types; and (4) aid in the identification of other pieces which survive without adequate documentation.

MEXICAN FEATHERWORK

Only six Mexican feather items of the pre-Columbian tradition have survived until today out of the dozens which were brought to Europe in and soon after 1519.[1] Until recently, a circular fan with feather mosaic, now in Vienna (fig. 88), was the only serious contender among the six for having been on the first shipment of 1519 when no less than thirteen such fans were sent to Europe. The description of a similar fan in the possession of Archduke Ferdinand of Austria in 1524 does not fit the one preserved in Vienna which for the first time is recognizably described at Schloss Ambras in 1596. There are indeed two reasons why this fan is not one of those sent in 1519: both the butterfly shown in feather mosaic on the front side as well as the flower on the back are stylistically quite unlike any other such representations in Aztec art; and the butterfly mosaic seems to be dyed with several pigments unavailable before 1519 to Mexican craftsmen.[2] There are indications that the central sections of the fan both on its front and back sides were damaged and restored during the early colonial period. The core and fringe may thus be pre-Columbian, the restorations, however, must have been made in Mexico after 1519. The only surviving quetzal feather head-dress (popularly but erroneously called 'Montezuma's head-dress') may have shared the fan's history after 1524, but is certainly not on the list of 1519 (where similar but not identical items appear).[3] A feather mosaic shield, the third Mexican piece of featherwork now in Vienna, can also be identified at

[1] Anders 1978, pp. 67–8; Heger 1906.
[2] Nowotny 1960, pp. 34–7; Christian Duverger, personal communication, 1984.
[3] Nowotny 1960, pp. 42–53.

Ambras in 1596, but it probably came from Spain (where it may have arrived in 1522) to Austria in the 1560s or 1570s. Of the other three pre-Columbian items, all of them shields, one was in a Habsburg collection in Schloss Laxenburg near Vienna before being returned to Mexico by Emperor Maximilian in 1864. Its previous history is as badly understood as that of the other two, which were removed in 1808 from the secularized monastery of Weingarten and are now in Stuttgart.[4] Only one major Mexican feather-piece listed in the 1596 Ambras inventory – a coat – has not come down to us (hence we cannot be sure it was Mexican, since like the rest it was referred to as 'Moorish').[5] We may infer, therefore, that most losses of featherwork brought to Europe probably occurred at an early date, before such items entered *Kunstkammer*-type collections.

A much greater number of pieces of colonial Mexican featherwork has survived in European collections, partly because their Christian content and European-derived artistic conventions made them more acceptable pieces for the average collector than items which could be suspected of having to do with heathen idolatry.[6] Of more than a dozen remaining and documented sixteenth- and seventeenth- century feather pictures of saints of Tarascan workmanship, six are in Viennese collections (of which two are on the 1596 Ambras list, and three were in Prague in 1607).[7] Dated sixteenth-century pieces (including a triptych of 1544) are now at the Museo de America in Madrid, another triptych is at the Real Armeria in Madrid together with a Spanish buckler with featherwork of Mexican origin made for King Philip around 1580.[8] Sir Walter Cope's featherwork Madonna seen by Platter in 1598 is now lost, as is Aldrovandi's St. Jerome.[9] More feather pictures with seventeenth-century documented dates may be found at Loreto.[10]

The other major type of colonial Mexican featherwork is the bishop's mitre. Coming in almost identical pairs, there are seven of these now – in Vienna (Ambras 1596) and Toledo, in Florence (two documented for 1587) and the Escorial (1576), in Milan and Lyon, and formerly in a private collection in Germany (now in a New York museum).[11]

MEXICAN MOSAIC

While the total number of surviving Mexican mosaics (twenty-three) is smaller than that of the featherwork, all of them represent a pre-Columbian stylistic tradition.[12] On the other hand, only about a third of the mosaics has any attested early history. Of the two shields, the Vienna example was at Ambras in 1596 and may go back to 1519 when sixteen such shields were sent to Europe.[13] The London shield comes from Turin but has no history before 1866.[14]

[4] Nowotny 1960, pp. 54–6, Anders 1978; Hochstetter 1884, pp. 4–5, taf. IV; Fleischhauer 1976, pp. 139–40.

[5] Nowotny 1960, p. 19; cf. Heger 1906, pp. 310–11.

[6] Anders *et al.* 1970. Some of these have also survived in Mexico.

[7] Anders 1978, pp. 74–5.

[8] Anders *et al.* 1970; Heikamp and Anders 1972; Heikamp 1982.

[9] MacGregor 1983, p. 17; Laurencich-Minelli 1982a.

[10] Heikamp 1976, p. 436.

[11] Anders 1978, pp. 71–5; Anders *et al.* 1970; Heikamp 1982, pp. 129–32.

[12] Oppel 1896; Lehmann 1906.

[13] Nowotny 1960, pp. 38–41.

[14] Carmichael 1970 for all the London mosaic pieces.

Of six mosaic-encrusted masks, Rome has one which was documented in Florence in 1533 (where a second was lost after 1556) and another from Aldrovandi's collection.[15] Copenhagen, on the other hand, obtained its two masks in 1856 reputedly from an ultimately Roman source.[16] Both London masks have only nineteenth-century histories, even though they come from different directions (Florence and Paris). The same is true of the two inlaid skulls now in London and Berlin, but formerly in Bruges and Brunswick.

Two knife handles with mosaic published in the seventeenth-century publications of Aldrovandi and Liceti must be considered lost, while the two which were in the Cospi collection are now in Rome.[17] The third surviving example is said to have come to London from Florence around 1830. Of six animal heads or figures, only Vienna's dog's head-shaped mirror frame has a history extending to the sixteenth-century (Ambras 1596), although it is of early colonial manufacture.[18] Of the other five, two have traditionally an Italian origin (Rome in the case of an item in Gotha, Northern Italy in the case of one of the London pieces). The second London piece is associated with Joseph Mayer of Liverpool, the past owner of Codex Fejervary-Mayer. One Berlin mosaic puma comes from Alexander von Humboldt, the other from Brunswick; none has a pre-nineteenth-century documented history. The same is likewise true of the remaining three Mexican mosaics, which were probably *Kunstkammer* pieces: the London helmet formerly in Paris, the London snake previously in Rome, and the bone rattle transferred from Bologna to Rome in 1878.[19]

OTHER MEXICAN OBJECTS

Stone sculpture is represented in early collections by a number of masks and figurines. Some of these are from archaeological cultures (such as an Olmec mask which has been in Munich since at least 1611, and a Teotihuacan mask in Florence), others are of Aztec origin (Florence, or the green stone idol in Stuttgart described in 1616). Most of them as well as two small prehistoric stone figurines in Florence have been mounted to fit sixteenth-century or seventeenth-century European taste. Other small figurines illustrated in the 1648 Aldrovandi catalogue must now be considered lost.[20]

An interesting group is formed by stone pendants in the shape of axe blades and animal heads. Two inlaid bird's heads (a duck, a parrot), from the Ambras collection, are now in Vienna, but are not in the 1596 list; three analogous pieces in Florence, however, may have originally been part of the same lot, and have a history going back to 1553. Vienna also received from Ambras a cylindrical piece of stone, and three blade-shaped pendants.[21] A presumably Aztec bird figure of amber can be tied to the 1677 catalogue of the Cospi collection,[22] and is as unique as the very fine small wooden figure of the god Xolotl now in Vienna and reasonably well documented at Graz from 1595 into the

[15] Heikamp 1976, pp. 458–9; Laurencich-Minelli 1982a, p. 149.

[16] Lehmann 1907.

[17] Heikamp 1976, pp. 459–60, 469–70, 474.

[18] Nowotny 1960, pp. 60–1. An identical piece is described in the Fickler catalogue of the Munich *Kunstkammer* in 1598.

[19] Lehmann 1906; Andree 1888; Laurencich-Minelli 1983a, p. 200.

[20] Heikamp 1976, pp. 457, 460–2, 464–7; Heikamp 1982, pp. 136–9; Fleischhauer 1976, p. 18.

[21] Nowotny 1960, pp. 57–9; Heikamp 1982, pp. 128–9.

[22] Laurencich-Minelli and Filipetti 1981, p. 227.

seventeenth century.[23] Of three spear-throwers, only the one in Rome, coming from the Aldrovandi/Cospi lot, has an early date while the two in Florence appeared without previous history in 1902.[24]

An early colonial obsidian mirror in Vienna came from the Vienna *Schatzkammer* (where it was thought to be Chinese), but the pre-Columbian-style obsidian mirror used by John Dee during the late sixteenth century has a better documented early history.[25]

Besides the items of Mesoamerican tradition, there is a possible northern Mexican skin apron from the Gottorp collection (1666) now in Copenhagen,[26] as well as several lots of colonial pottery, among them several of a style today associated with Tonalá in Jalisco.[27] One of the most commonly found native Mexican artefacts in sixteenth and seventeenth century Europe are native pictorial manuscripts, but most of them were in libraries rather than *Kunst-* and *Wunderkammern*. The Codex Cospi may be mentioned as an example of one which was part of a general collection.[28] To be mentioned among the Mexican items which have not survived from early collections are weapons, which is surprising in view of the number of Brazilian clubs and of weapons from other regions in the European *Wunderkammern*. The absence of material from peripheral Central America, on the other hand, is not so unexpected.

TAINO ARTEFACTS FROM THE WEST INDIES

Extremely few objects have come down to us from the area hit first and hardest by Spanish colonization. Vienna has a beautifully preserved cotton and shell-bead belt (fig. 89), an early sixteenth-century item from Ambras which lacks any documentation prior to 1877. It is closely related to a little figurine of the same materials now in Rome but formerly in the Cospi collection.[29] Turin has a big cotton idol or *zemi*,[30] and Florence a wooden bowl and a necklace made of carved shell.[31] A virtually identical necklace is found in the Weickmann collection in Ulm which dates from the seventeenth century (but the item itself does not appear in old catalogues).[32] Identification of all of these items was made only after comparative archaeological material has become available in the late nineteenth century.

BRAZILIAN WEAPONS

Six bows in Copenhagen which in 1689 were referred to as Japanese or East Indian, as well as one bow in the Tradescant collection listed in 1656 as part of a lot of bows from different areas, may be as much or little Brazilian as those mentioned a little later in the 1725 Gottorp catalogue.[33] Most of the types are not unexpectedly very simple and extremely hard to identify as to their exact provenance. No identification without both a good

[23] Nowotny 1960, pp. 62–8; Merian 1677, p. 41.
[24] Heikamp 1976, pp. 463–4; Bushnell 1905.
[25] Nowotny 1960, p. 69; Tait 1967.
[26] Dam-Mikkelsen and Lundbæk 1980, p. 22.
[27] Heikamp 1982, pp. 143–4.
[28] Glass 1975, esp. p. 113.

[29] Schweeger-Hefel 1952; Vega de Boyrie 1973; Laurencich-Minelli 1983a, p. 200.
[30] Ripley 1980.
[31] Giglioli 1910.
[32] Andree 1914, pp. 31–4.
[33] Dam-Mikkelsen and Lundbæk 1980, pp. 32–3; MacGregor 1983, pp. 120–1.

analysis of the wood and a documentation which is reasonable beyond any doubt should be accepted, as similar bows could be of much later date or from a different region.

There can be no such doubt in the case of Tupinamba clubs, an early and often-illustrated type of weapon from Brazil.[34] This is fortunate as the documentation of many of the surviving pieces leaves something to be desired. While the existence of only two such surviving clubs is generally known, at least ten have in fact have come down to our time. One of the better known two, the Paris club, comes from the Musée d'Artillerie collection and is believed to have been brought to France by André Thevet. Since there were four other such clubs in the post-revolutionary Cabinet d'Histoire naturelle de Paris at the Louvre, and a further one in the Peiresc collection at the Bibliothèque Ste. Geneviève in Paris in 1688, this undocumented assertion cannot be accepted. The four clubs last reported in the Louvre in the 1880s were transferred in 1908 to Saint Germain-en-Laye where they were rediscovered only in 1983.[35] The sixth Tupinamba club, very similar to the one at the Musée de l'Homme, was transferred to the American department of the Berlin museum from its Oceanian department in the late nineteenth century. It is assumed to have originally been acquired with Georg Forster material, but this is not certain.[36] Similarly undocumented is the club in Vienna (fig. 90) which came from the Ambras collection but cannot be traced back earlier than the 1870s. Its length is unusual when compared with other surviving specimens, but it fits some early illustrations as well as Hans Staden's description of the Tupinamba ceremonial club.[37] Dresden has a specimen donated in 1652, which has a typical cotton-and-feathers fringe, but an unusual spatula-shaped blade; another and more standard Dresden club may have come from the same source at the same time, but has 1832 as its earliest documented date.[38] Finally, there is a club of this group in Florence which may be the only one that can be traced back to the sixteenth century.[39] Obviously, there is a need for a closer look at typology and for a better explanation of the existing differences in the future.

Although mentioned only in early eighteenth-century catalogues of the Gottorp collection, two Tarairiu clubs from Brazil are probably related to the collecting activities of Johan Maurits of Nassau and thus date from the seventeenth century.[40] The only other known example of this type is in Munich where it was acquired in 1913 as being from the 'South Seas'.[41] Another type of club characterized by highly stylized low-relief carving is assumed to have originated somewhere near the Brazilian/Guyana borderlands. The two pieces at Bibliothèque Ste. Geneviève (presumably from the Peiresc collection),[42] the four in the Tradescant collection (as well as one which may have originated in the Tradescant collection but which is now at the British Museum), and the four in Copenhagen with

[34] For some early illustrations, see Sturtevant 1976.

[35] Métraux 1932, pp. 9, 13–16: MacGregor 1983, pl. clxxvi a, Meyer and Uhle 1885, pl. 9 and accompanying text. Musée des Antiquités Nationales, Saint Germain-en-Laye, cat. nos. 84.462–84.465, seen February 1984.

[36] Métraux 1928, pp. 80–3; 1932, p. 13 n. G. Hartmann, personal communication, 1983. Both the Berlin and the Musée de l'Homme clubs have hitherto unnoticed annotations on their blades which may help to elucidate their collection histories.

[37] Museum für Völkerkunde Wien, cat. no. 10440; Staden 1557; Sturtevant 1981, p. 71, fig. 9.

[38] Meyer and Uhle 1885, Taf. 9 and accompanying text. Another possibly early Tupi club in Dresden of different shape and design, illustrated by Meyer and Uhle 1885, taf. 9, fig. 1, cannot be safely designated to the 1652 lot; its earliest date is again 1832.

[39] Seen in March 1983.

[40] Dam-Mikkelsen and Lundbæk 1980, p. 32.

[41] Zerries 1961.

[42] Seen in February 1982.

seventeenth-century dates are all rather long when compared with a distantly related type of club later much collected in Guyana.[43] A piece in Munich from the old Erlangen[44] collection is rather similar, and so is a presumably early piece in Florence.[45] The clubs located in an earlier comparative analysis (like the one in Florence, or another one in Paris) should be looked at once more in terms of their documentation.[46]

The last Brazilian type of weapon present in early collections is the anchor axe, usually attributed to Gê people of eastern Brazil who continued to make them in variant forms into the twentieth century. Three of these can be firmly documented for the pre-1700 period, and a good case for an early date can be made for several others. The oldest documented specimen is that referred to as 'Montezuma's battle axe' in the Ambras collection, now in Vienna. It is listed in 1596 and had a note (now lost) attached identifying it as having been given by Cortés to the Pope. This axe is clearly Brazilian, but the source for Ambras was ultimately Italian: it was given to Archduke Ferdinand in 1577 by Count Jakob Hannibal of Hohenems, who was married to a Medici; and the Pope may have been Pius IV rather than Clement V. A second and more lavishly decorated axe in Vienna has no early history (beyond the fact that it was in the Ambras collection), but is decorated with the cotton-and-feathers fringe otherwise typical for Tupi clubs. The two Vienna axes (fig. 91) form a clear sub-type in having straight and cylindrical shafts.[47]

The other sub-type is not only thicker at the point where the blade is hafted, but also markedly smaller, yet longer than the specimens collected in the nineteenth century.[48] The oldest documented piece in this group is the one from the Aldrovandi and Giganti collections, now in Rome,[49] closely followed by the one at Bibliothèque Ste. Geneviève (Peiresc collection).[50] Those in Dresden were found in 1832 in the same Turkish tent as the 1652 Tupinamba club.[51] No old dates are documented for the axes in Brunswick and Stockholm, while a piece from Zwolle in the Netherlands can be traced to at least 1787.[52]

BRAZILIAN FEATHERWORK

Another extensive group of early Brazilian Indian artefacts comprises items made of feathers. Approximately two-thirds of these have survived in Copenhagen where most of them can be traced as far back as 1689 (and in one instance to 1674). Most of them seem to derive from the activities of Johan Maurits of Nassau in Brazil.[53]

Four feather items have an Italian background. One going back to the Settala collection is still preserved, however fragmentarily, in Milan.[54] Of the three feather capes which can be documented in Florence as early as 1539, one was traded to Berlin in 1892 to

[43] MacGregor 1983, pp. 115–20; Dam-Mikkelsen and Lundbæk 1980, pp. 32–3.

[44] Zerries 1967, pp. 404, 406–7.

[45] L. Laurencich-Minelli, personal communication, 1983.

[46] Stolpe 1896. To these should be added the ones now in the Musée des Antiquités Nationales in Saint Germain-en-Laye.

[47] Hochstetter 1884, pp. 8–9, 19–24; Welti 1954, pp. 281–2.

[48] Giglioli 1896, Rydén 1937.

[49] Colini 1891; Laurencich-Minelli 1982a.

[50] Seen in February 1982.

[51] Meyer and Uhle 1885, pl. 10 and accompanying text. Fig. 7 may actually be a later piece.

[52] Andree 1894; Schmeltz 1890; Rydén 1937, pp. 60–2.

[53] Dam-Mikkelsen and Lundbæk 1980, pp. 27–30; Métraux 1927; Due 1980; Stemann Petersen and Sommer-Larsen 1980.

[54] Michele *et al.* 1983, pp. 20–3; Laurencich-Minelli and Ciruzzi 1981, pp. 138–9 n. 8.

be lost during the Second World War; the remaining two have only recently been published for the first time.[55]

The history of the Brazilian feather cloak in Paris is less well recorded, although Métraux was able to point out that a similar piece had been given in 1555 by André Thevet to the collection of a courtier of the French king.[56] Another cloak in Brussels, traditionally known as 'Montezuma's mantle' but of Brazilian origin, cannot safely be traced further back than 1782, although it must have been in a European collection a century or two earlier.[57] Even less impressive is the documented history of the Basle feather cape which was obtained by the Museum für Völkerkunde in 1918 from the Geographic-Commercial Society of Aarau where it had been used in carnival parades.[58] Another 'Brazilian' feather mantle which is mentioned in the literature without ever having been published is supposed to exist in Frankfurt. It may be assumed that this actually refers to the nineteenth-century Californian feather mantle existing there.[59] On the other hand, several pieces which are indeed Brazilian have been illustrated in old manuscript or printed catalogues but have not survived; the attribution of some of these to Florida may be placed in doubt.[60]

Even more than in the case of the Brazilian weapons, a closer inspection of the literature makes apparent the need for an adequate typology and for better detailed studies.

OTHER SOUTH AMERICAN ARTEFACTS

Of Brazilian objects other than featherwork and weapons, there is only a limited number that has come down to us from sixteenth- and seventeenth-century collections. Copenhagen has the widest range, including a trumpet, bone flute and bone pendant (all from at least 1617 and the Paludanus collection) as well as a comb, broom, and a necklace of beetles' wings documented in the late seventeenth century.[61]

Hammocks from various parts of South America seem to have occurred frequently in early collections, and at least one of those listed in Tradescant's 1656 catalogue is still extant. The Gottorp hammocks in Copenhagen are also possibly early even though they appear only in mid-eighteenth-century catalogues.[62] We will probably never be certain whether Tradescant's Brazilian tobacco pipe really was from Brazil. The 1655 Worm catalogue describes in some detail another Brazilian pipe which survives in Copenhagen and turns out to be from north-eastern North America.[63]

Unique in terms of its documentation for the period is a ceremonial baton at the Bibliothèque Ste. Geneviève.[64]

Especially noteworthy is the almost complete absence of early collections from the Andean highlands, especially from Peru. A few pieces of Mexican origin have

[55] Laurencich-Minelli and Ciruzzi 1981.
[56] Métraux 1932, pp. 3–12.
[57] Hirtzel 1928.
[58] Seiler-Baldinger 1974.
[59] Métraux 1932, p. 5; 1928, p. 140; Vatter 1925, pp. 96, 99–102.
[60] Laurencich-Minelli 1982a.
[61] Dam-Mikkelsen and Lundbæk 1980, pp. 20–7.
[62] MacGregor 1983, pp. 138–9; Dam-Mikkelsen and Lundbæk 1980, pp. 22–3.
[63] Tradescant 1656; Dam-Mikkelsen and Lundbæk 1980, pp. 18–19.
[64] Lehmann 1958.

occasionally and mistakenly been identified as Peruvian, while on the other hand the only documented seventeenth-century collection (1691) from the Sierra Nevada de Santa Marta in Colombia was later thought to be Mexican and has only recently been rediscovered.[65]

[65] Bischof 1974.

AFRICAN MATERIAL IN EARLY COLLECTIONS

Ezio Bassani and Malcolm McLeod[1]

It is well known that the historian of African art faces great difficulties in his research, for, by and large, his material has little time depth. Comparatively few African artefacts were made of durable materials or were intended to last, and few were deliberately preserved. Indeed it can be argued that the roles such objects played in African systems of thought militated against their long preservation. To put it at its simplest, such artefacts were used to create an ideal present by countering, or absorbing into the pattern of time, contingent or unexpected factors in human existence and the disruption of ideal states which these caused. Objects used in this way, to re-establish the correct form of the present, could not, therefore, serve to create a sense of the passing of time or of linear or cyclical movement from a fixed point in past time. Consequently it was neither necessary nor desirable for such objects to be preserved in many African societies.

Whether or not this general view is accepted, it is clear that few African artefacts survive from before that great burst of collecting which accompanied the European expansion into the interior parts of Africa during the nineteenth and twentieth centuries. To rescue from comparative oblivion what survives, we are therefore inevitably drawn to those royal, noble and bourgeois collections which contained even small numbers of African items.

The earliest published document indicating African artefacts in a European collection is the often quoted account whereby Duke Charles the Bold paid, in 1470, 'A Alvare de Verre, serviteur de Messire Jehan d'Aulvekerque, chevalier portugalois . . . 21 livres . . . quant nagaires il luy a presenté une espée et aucuns personnages de bois comme ydoilles.'[2] Unfortunately these objects are lost, as are those which Francis I admired in 1527 in the possession of the Dieppe ship-builder Jean Ango. It is recorded that Ango had collected material from the Indies, Brazilian curiosities and 'ivory points, strange idols, ostrich feathers and skins of wild animals, brought home on his ships that had touched land along the coasts of Africa'.[3]

There are other tantalizing glimpses of such early African material, for example in the collection of the son of André Tiraqueau, Rabelais's friend and protector, in the early part of the sixteenth century,[4] but once again the items are now lost or destroyed. A few years after the purchase by Charles the Bold, African artefacts were among the presentations brought in 1489 from the mouth of the Congo to the King of Portugal. These

[1] I would like to make it clear that my contribution to this paper is a small one and the paper owes most to my co-writer's researches.

[2] Olbrechts 1941, p. 8.
[3] Besson 1944, cited in Laude 1968, p. 542.
[4] Ibid.

included ivory sculptures and 'muitos panos de palma bem tecidos e com finas coores'.[5]

Although, as we shall show, a certain number of such early exports still survive, and can sometimes be traced back to early sixteenth-century owners, it is virtually impossible to gain a clear picture of what came to Europe from Africa in the first two or three centuries of contact between the continents. The surviving documentary sources are few and not particularly helpful, and many of the items which we know to have been imported have since disappeared. It is not always possible to identify the exact origin of items which survive. Finally we are forced to accept that what survives may be unrepresentative of what came to Europe, since objects which were judged to be of exceptional rarity or quality, or which were made of highly esteemed materials, may have been especially protected against neglect and destruction. A number of published references and shipping documents indicate some of the African objects which were carried to Europe, but these have rarely, if ever, survived. For example it is recorded that in 1502 the Portuguese fetched from the Gold Coast about 2,000 ounces of gold 'all in manillas and jewels which the natives are accustomed to wear';[6] presumably this was all melted down. Later accounts similarly record great sums of gold fetched 'in trinkets and gold pieces'.[7] Equally in John Lok's account of a voyage of 1554–5 Lok notes that gold items and worked ivory, worn by local people, were obtained in exchange for European manufactured goods and he stated: 'I myself have one of their bracelets of ivory, weighing 2 lbs and and 6 ounces of troy weight.' He added: 'Among other things of golde that our men bought of them . . . were certaine dog chaines and collers.'[8] Making gold dog-collars and hat-bands for European visitors seems to have continued on the Gold Coast until the end of the seventeenth century.

Despite the comparative paucity or vagueness of much of the evidence, it is clear that the artefacts fetched from Africa fall into three broad categories: things made for local use and collected because Europeans found some aspect of them interesting (though probably evaluating them very differently from their native makers and users); things of local use which were valued primarily because of the materials from which they were made (e.g. gold castings from the Gold Coast); and, finally, things produced in Africa with indigenous materials but after a Western model. (We would also make the very obvious point that in most such transactions Europeans were in an overwhelmingly superior economic position.)

The range of the artefacts collected in Africa seems to have been restricted to eminently portable objects, as one would expect: weapons, basketry, textiles, shoes or sandals, representational carvings and musical instruments. There is no record, as far as we know, of pottery (or pipes), non-anthropomorphic representations of powers ('fetishes') or such large objects as canoes or parts of house structures.

It is quite clear that within a few decades, at the most, of sea-contact with West Africa, Europeans were utilizing indigenous skills and materials for European ends. The most spectacular products of this approach are the so-called Afro-Portuguese ivories. These were made in two main areas on the West African coast: in Benin City and in the Bulom

[5] Pina 1792, p. 148.
[6] Blake 1942, vol. 1, p. 93.

[7] Ibid., p. 237.
[8] Ibid., vol. 2, p. 343.

or Sherbro areas of what is now Sierra Leone. It is now difficult to estimate accurately the relative importance of these ivories in the total of objects which were fetched from Africa. As we shall see, the high value and quality of these objects led to them being recorded occasionally in shipping records, to their use as diplomatic gifts and to their later preservation.

The history of these horns, vessels and spoons indicates something of their quasi-diplomatic status. The number of such ivories which survive is considerable, perhaps as many as two hundred. They are mentioned in numerous documents and there are ambiguous references which may also refer to such items. Among the latter, for example, is the note in Dürer's diary in February 1521: 'I paid three florins for two salt-cellars from Calicut.'[9]

There were three ivory horns of African workmanship in the collection of Cosimo I de' Medici.[10] The first is partly covered by stamped leather which bears the quartered armorial bearings of the Medici and Toledo houses under a crown. It may therefore be linked to the wedding between Cosimo I and the Spanish princess Eleonora of Toledo, daughter of the Naples viceroy, in 1539. It is first recorded in 1553. The other two horns are mentioned in the same document. Their decoration allows an attribution to the Kongo peoples. It is known that Pope Leo X (1513–21) received an embassy from the King of the Kongo (newly a Christian) and this embassy may have been the source of the horns. Equally 'cousas de marfim lavradas'[11] were among the first gifts sent to the King of Portugal from the Kingdom of Kongo: some may have been passed to the Pope. Another, similar horn, now in the Museo Pigorini, formerly belonged to the Museo Nazionale of Naples; in the light of the aforementioned relationship between Tuscany and Naples, a similar origin may be supposed. Two almost identical horns, therefore of the same origin and date, are also extant. Cosimo I also owned five ivory spoons of Benin-Portuguese origin; these survive.[12] Two large Bulom-Portuguese ivories, formerly in Cosimo's collection, are now in Paris and Leningrad; they were first published in 1643 in Worm's *Monumenta Danicorum*.[13]

The dating of these elaborate ivory items is now fairly certain: most of them seem to have been made at the very end of the fifteenth century and in the first few years of the next century. Armorial decorations help this dating: three horns and a powder flask (fig. 92) bear the arms of the house of Aviz, which reigned in Portugal from 1385 to 1580, the cross of Beja and an armillary sphere, and the arms of Ferdinand V, King of Aragon and Castile from 1474 to 1514, who was connected by a double marital alliance with Emmanuel I of Portugal. In 1497 Emmanuel married Isabel of Castile and then, after her death, Maria, the King of Spain's third daughter, in 1500. The 'hunting set' of horns and flasks seem likely to have been made as a gift to mark one of these alliances.[14]

Once these items had reached Europe it is clear that they continued to be held in high regard and some continued to circulate among, or to find their way into, royal treasuries and collections. In 1590 Prince Christian of Saxony is recorded as buying 'twelve ivory

[9] Dürer 1918, p. 74.
[10] Bassani 1975, no. 143, pp. 69–80; no. 144, pp. 8–23.
[11] Pina 1792.
[12] Bassani 1975.

[13] Worm 1643, pp. 432–5.
[14] Bassani 1979. In the article are illustrated two of the horns; a third was in a private Spanish collection and the powder flask is in the Instituto Valencia de Don Juan, Madrid.

spoons made in Turkey'.[15] These are to be identified with the fifteen spoons of Benin origin now in Dresden. According to an inventory of 1658 a Bulom-Portuguese horn, also now in Dresden, was acquired by the Elector of Saxony.[16]

A third sixteenth-century collection which contained African material was that formed by Ferdinand of Habsburg, Grand Duke of Tyrol, at Ambras. In 1596, after his death, an inventory indicates it contained six Bini-Portuguese spoons, a Bulom-Portuguese salt and a side-blown trumpet.[17] A trumpet, similar to that described at Ambras, is illustrated in Michael Praetorius's *Theatrum Instrumentorum* of 1619.[18]

It is possible that Emperor Rudolf II, who held court in Prague, may have owned Afro-Portuguese oliphants which, like comparable materials, were mis-described in contemporary lists. Thus he is described as possessing, in an inventory of 1619, 'five ivory hunting-horns from India' and 'two Indian horns'.[19] Also in the second half of the sixteenth century a collection formed by the Archduke Albrecht IV of Bavaria contained Afro-Portuguese material and this seems a source of such items now in Munich. In the catalogue of the Munich *Kunstkammer* by Fickler in 1598 there is a record of an ivory horn with a crocodile decoration, probably the one now in the Museum für Völkerkunde in Munich and possibly from Calabar.[20] Also listed in the Fickler catalogue is what must be an Afro-Portuguese oliphant with the Latin inscription *Da pace Domine in diebus nostris* — just such an inscription is found on a horn now in Dresden and another in a private French collection.

An inventory of 1694 records a Bini-Portuguese ivory spoon as being in the collection of Gustavus Adolphus of Sweden. The spoon is now in University of Uppsala.[21]

In England, as we have already been told, Tradescant sought African ivory trumpets or 'flutes'. A letter of 1625 from the Duke of Buckingham addressed 'to the Marchants of the Ginne Company and the Gouldcost' requests 'Ivory Long fluts'. The Tradescant collection, bequeathed by the son to Ashmole in 1659, is described in a printed catalogue of 1656 and in a manuscript of 1685.[22] It contained an ivory horn, a drum, possibly from Zaire, two Afro-Portuguese spoons and a sandal, possibly Nigerian. (The horn is described as Indian in the 1685 list.)

Three important early collections in Italy are recorded as containing African materials. The first was founded in Milan around the mid-seventeenth century by Canon Manfredo Settala. Two catalogues (1664 and 1666) exist as well as five out of seven volumes of coloured illustrations made before 1666.[23] The latter show two Kongo rafia-pile cloths, a Kongo basket and two ivory side-blown horns, one probably Kongo, the other probably Calabar. On a drawing of one cloth Settala wrote 'of rare beauty'. Similar cloths, as noted previously, are earlier recorded as among the gifts sent in 1489 to the King of Portugal.[24] Some were also in the possession of Alvaro Borges who died in Sao Tome in 1507 where the word 'enfulla', a corruption of the native term, is first used.[25]

[15] Wolf 1960, pp. 410–25.
[16] Inventar der Kunstkammer, no. 10 (1732), p. 83.
[17] Heger 1899, pp. 101–9.
[18] Pl. XXX.
[19] Herold 1977, pp. 51–4.
[20] Bayerische Staatsbibliothek, MSS cgm 2133–4, no. 725.
[21] Böttiger 1909–10, appendix, p. 17.

[22] MacGregor 1983, pp. 145–9.
[23] Bassani 1977, no. 151, pp. 151–82 and nos. 154–6, pp. 187–202. Two printed catalogues of the collection are available: Terzago 1664; Scarabelli 1666.
[24] Pina 1792.
[25] Personal communication by the late Admiral Avelino Teixeira da Mota to E. Bassani.

A watercolour of two horns in the Settala Collection (fig. 94) helps confirm the early dating of related examples – one now in Paris and one now in Ambras, which was probably the one mentioned in the 1659 inventory of Archduke Leopold Wilhelm, Governor of the Low Countries.[26]

The second major Italian collection was that of Marchese Ferdinando Cospi of Bologna.[27] The Bulom-Portuguese salt now in Bologna undoubtedly comes from this collection and, probably, ten of the Kongo cloths now in the Museo Pigorini. The third collection, of the Jesuit Museo Kircheriano, was founded at Rome in 1630, the collections descending eventually to the Pigorini.[28] The Kircher collection almost certainly contained a Bulom-Portuguese salt, eight Kongo cloths and a Kongo hat. The salt may have earlier been in the collection of Cardinal Flavio Chigi who knew Kircher. An inventory of 1706, made by Chigi's heirs, described 'an ivory vase with two heads on the top of the carved lid' which can possibly be identified with the salt in the Pigorini.[29] Four textiles and a decorated and illustrated Bulom-Portuguese horn (fig. 95) (formerly lost, but now reappeared in a private collection) are described in a printed catalogue of the Kircher museum of 1709.[30]

The Ulm collection of the merchant Weickmann is well known. The printed catalogue of 1659 *Exotico phylacium Weickmannianum* lists a number of African items. Among these are five Afro-Portuguese spoons, two decorated Yoruba ivory bracelets, a divination tray, an Akan sword and scabbard, a rafia bag from Benin, a gourd covered with plaited fibre, a lidded basket, a West African cloth, a Kongo rafia cloth and two West African tunics. A bow and some Akan and Gabon spears, listed in the catalogue, cannot now be located.[31]

African items were also present in the various Danish royal collections, surviving parts of which are now in the Nationalmuseum in Copenhagen.[32] From the first such collection, of Christian IV (1588–1648), only two lances survive. The collection formed by Olaus Worm also contained African objects, some of which are illustrated in the printed catalogue of 1655.[33] In the collection were two baskets, possibly from Kongo, one of which is illustrated. A similar basket appears in one of Eckhout's paintings, done in 1654, as does an Akan sword. An Akan sword is now in the Nationalmuseum, Copenhagen, having previously been noted in the 1674 list of Gottorp material. A similar Akan sword appears in a Rembrandt painting of 1630.[34]

In 1751 the King of Denmark acquired the collection from Gottorp which owed much to Adam Olearius, librarian to the Dukes of Schleswig-Holstein, and to this was added in 1651 the collection of the Dutch physician Paludanus (p. 125). In 1666 Olearius published a catalogue of the augmented collection.[35] From these sources probably come two lower parts and a lid of a Bulom-Portuguese salt, two Bulom horns, two horns from Calabar, and a Kongo cloth (possibly two more), a dagger with scabbard, a wicker shield (fig. 96) and twelve spears.

26 Bassani 1982, pp. 5–14; Berger 1883, p. clxxii.
27 Bassani 1977; Legati 1667; Anon. 1680, p. 29.
28 Bassani 1977.
29 Incisa della Rocchetta 1966, p. 180.
30 Buonanni 1709, p. 235, pl. 299.
31 Zeiler 1659; Andree 1914.

32 Dam-Mikkelsen and Lundbæk 1980, pp. 40–62.
33 Worm 1655.
34 *St. Paul in meditation*, Oil on canvas, 1630, Germanisches Nationalmuseum, Nürnberg.
35 Olearius 1666.

From the collection of Frederik III, about 1650 or slightly earlier, and his successors derive a large group of African pieces: a Bulom-Portuguese ivory spoon, a Bini salt and three Bini-Portuguese spoons, three ivory bracelets, a Bini leather fan, a bracelet of glass, one side-blown ivory Bulom horn, one from the Kongo kingdom and six others of unknown origin, an Akan sword in a ray-skin scabbard, a Benin sword, a dagger, a Central African throwing knife, eighteen spears, ten Kongo pile cloths, a woven cap, two other caps, two mats and two bags from Madagascar, two other bags, a drum and five wooden bells. Some of these are not listed until the late eighteenth century and none can be traced in the written sources to before 1689.[36]

Between 1700 and 1730 the doctor and naturalist Antonio Vallisnieri formed a collection in Padua.[37] He owned two Kongo cloths and two wood carvings (fig. 97) from Zaire which are now in the Museo Pigorini. The last two items were probably collected in the Kwango area between 1690 and 1695 by the Capuchin Francesco da Collevecchio. Another early eighteenth-century collection was that of the Jesuit Ferdinand Orban at Ingolstadt in Bavaria, from which a Bulom-Portuguese ivory trumpet passed eventually to the Munich Museum für Völkerkunde.[38]

The Sloane collection contained items of undoubted African origin: those surviving include two ivory bracelets from West Africa, a strip of woven cotton with polychrome geometric decoration, a Kongo cloth, a Malagasy textile, a leather thong (possibly South African) and a woven vegetable fibre cap. It also contained an Akan-type drum made in a wood of North American type and listed as from 'Virginie'.[39]

It is clear that there were considerable numbers of African items in Europe in the fifteen, sixteenth and seventeenth centuries which do not appear in dateable records until long after their arrival. It is not possible to list all of these in the space available. Typical of such items are, however, the Bulom-Portuguese ivory horn listed in the 1753–4 inventory of the royal Württemberg collections[40] and two ivory vessels, probably those described in a list of 1803 which may have been in the collection at Catajo Castle near Padua, a collection begun in the seventeenth century. Similarly the Städtisches Museum of Brunswick has five Bini-Portuguese spoons, the lower part of a Bulom-Portuguese salt and a horn, probably from Calabar – these are first listed in 1805 but must have been acquired by their ducal owners long before.[41] Similar examples could be repeated for items now in Berlin, London, Turin and many other places.

The above brief account will give some idea of the histories of certain types of African material in the centuries since Europeans first made direct contact with Africa. It does not, of course, deal with objects which must have been collected by nameless sailors, traders and adventurers, of which items almost all trace has now disappeared.

[36] Jacobaeus 1696.
[37] Bassani 1978; Bontinck, 1979.
[38] Muller 1980.

[39] Braunholtz 1970, pp. 33, 35.
[40] Fleischhauer 1976, p. 123.
[41] Andree 1901.

EXOTICA FROM ISLAM

Julian Raby

The cabinets of curiosities were not the first European collections to include objects from the Muslim world. From the 'Veil of St. Anne' to the 'Baptistère de St. Louis' and other less celebrated items, the religious treasuries of medieval Europe were stocked with Islamic artefacts. Ivories and inlaid metalwork were less frequent perhaps than rock crystal and enamelled glass, but the predominant medium was textiles – silks especially and, from the fifteenth century onwards, carpets. None of these had been designed for the Christian church: many of the rock crystals and enamelled glass beakers were therefore converted to liturgical use by the addition of European metal mounts, and the silks were readily transformed into vestments. Once transported from the Islamic world and before 'conversion' such objects were emotively neutral, so that the same range and quality of items could be found in fifteenth- and sixteenth-century secular treasuries in Europe, such as that of Jean Duc de Berry, or the *Guardaroba* of the Medici, or the treasury of the Habsburgs, although the latter was enriched by the Muslim-Sicilian imperial regalia of Roger II.[1]

How similar, in type and provenance, to the Islamic objects in the princely and religious *Schatzkammern* were those in the virtuoso's cabinet? Julius von Schlosser's long-held theory maintains that there was a linear development from the *Schatzkammern* to the *Kunst-* and *Wunderkammern*. This implies a similarity of contents, typologically if not qualitatively. On the other hand, it has been argued by Balsiger that there was a fundamental divide, in concept and hence in material, between the *Schatzkammern* and the cabinet of curiosities. The contents of the *Schatzkammern* were inventoried, the inventory being no more than a utilitarian tally of its contents. What distinguished the cabinet was its catalogue, which in principle at least was a conceptual organization of its material intended as a *theatrum mundi*. The contrast was marked by the publication of Quiccheberg's *Inscriptiones* in 1565. It lay between the empirical accumulation and the ideal collection, although the *idea* was often more apparent in the catalogue than in the physical reality of the cabinet, as the *Museum Wormianum* well exemplifies. The question arises whether the collections of *Islamica* can throw any light on this supposed distinction between the *Schatzkammern* and the *Wunderkammern*.[2]

[1] The most convenient summary of this topic is Ettinghausen 1974, with a useful bibliography, pp. 316–20. On the *orientalia* in the Medici collections, Bassani 1980; Spallanzani 1980a, 1980b. In general, Müntz 1888. For the recent discovery of two important carpets from the Medici collection, Boralevi 1983.

[2] Schlosser 1908; Balsiger 1970, vol. 2, pp. 508, 512 ff., 597.

Balsiger points out, however, that the transition from treasury to museum was first manifest in princely collections, such as those of the Habsburgs, where catalogues were drawn up of individual sections although never of the whole. The distinction, therefore, between the two types of collection is not always easy to establish in practice; cf. Lach 1970, p. 9.

ISLAM AND THE PRINCELY *SCHATZKAMMERN*

Many of the Islamic items in princely hands in the fifteenth, sixteenth and seventeenth centuries were acquired as direct gifts from their Muslim counterparts. A sufficient example is the exchange of embassies between Iran and Europe at the beginning of the seventeenth century. Under the leadership of Husayn Ali Beg and the Englishman Sir Anthony Sherley, Shah Abbas's mission visited Prague (11 October 1600–early February 1601) and then Rome, with a dual political and economic objective. An alliance between Europe and Iran was to be formed against the common enemy, the Turk, while the Persian silk trade was to be rerouted via Russia in order to circumvent the Ottoman middlemen. Rudolf II responded with a return embassy to Iran. In 1604 another Persian embassy under Zeynal Khan Shamlu arrived in Prague bringing gifts of figural and gold brocades, silks and *un bel tapeto di seta* which, as Kurz has suggested, might refer to the Habsburg silk 'hunting carpet'. Textiles were not the only gifts, and the same envoy gave the Medici two horse armours which were given pride of place in the Tribuna degli Uffizi, Caravaggio being commissioned to paint his Medusa shield as an apotropaic pendant.[3]

In June 1600 another Persian envoy, Efet Bey, presented the Doge with a figural hanging depicting the Annunciation. This was intended for the Sala del Consiglio dei Dieci, and shows that on rare occasions Islamic items bound for Europe could have Christian iconographies and specific destinations. Three years later, on the 5 March 1603, another Persian mission presented Doge Pasquale with a highly prized gold garment, the only other example of which was said to be owned by the Great Moghul; a carpet with silk and gold thread of the so-called Polonaise type for the Basilica di San Marco; and a velvet brocade depicting the Madonna and Child, which is now in the Museo Correr. A comparable brocade can be seen on a kaftan worn by Sir Robert Sherley, brother of Sir Anthony, who was likewise a Safavid envoy, in the portrait painted in Rome in 1622 by Van Dyck.

Further embassies were exchanged between Prague and Isfahan, while in 1636 Duke Friedrich of Holstein-Gottorp attempted to renew the textile agreement with Persia; and it is possible that the Persian silks which are now in Rosenborg Castle were originally gifts to Duke Friedrich. However, not all the textiles received in Europe as gifts from the Muslim world were of Persian manufacture. Envoys to the Sublime Porte in Istanbul were regularly invested with robes of honour, presumably of Ottoman origin, and in 1609 Archduke Matthias was given a gold brocade kaftan by Ali the Ottoman Pasha of Buda. Duke Friedrich further enriched his holdings at Gottorp with gifts from the Bey of Algiers, and Suleiman the Magnificent's present of textiles to Count Lastanosa is discussed elsewhere in this volume.[4]

From these and numerous similar examples we learn how European dignitaries received direct gifts from Muslim rulers which were invariably of the highest quality and

[3] Kurz 1966; Heikamp 1966a.
[4] Kurz 1966; Gallo 1967, pp. 260–5. On Tunisian and other textiles in the Munich *Kunstkammer*, cf. Seelig, pp. 76–89 above.

For the Lastanosa collection, cf. Lightbown, pp. 136–46 above. For a recent description of the military as well as the mercantile aims of the Holstein embassy, see Floon 1983.

preponderantly textile.[5] Before considering whether the cabinets shared this textile bias, it may be useful to ask what rationale prompted the choice of *Islamica* in cabinet collections.

The rationale of the cabinet of curiosities can be seen as an attempt to establish a microcosm intended to demonstrate, on the one hand, God's ingenuity as a creator in the form of *naturalia* and, on the other, man's creative ingenuity in the form of *artificialia*.[6] (Ferrante Imperato's publication of 1599 discusses the processes by which man can transform *naturalia* into works of art.)[7] Let us speculate on the possible motives which would have prompted a virtuoso collector to select illustrative items from the Islamic world, mostly restricting ourselves however to *artificialia* and omitting natural items which often attracted great interest, such as the tulip. The prime motive must have been to find types of objects unavailable in Europe in terms of either material or technique, the latter including structure, decoration or virtuosity of craftsmanship. Alternatively, an object could attract by virtue of its historical association.

MATERIAL

One need only cite the collections of Ferrante Imperato, Moscardo, Cospi, Balthasar Künast of Strasbourg, Olaus Worm, Sir Hans Sloane, the Royal Society and the royal *Kunstkammer* in Copenhagen to realize that most cabinets contained a section of medicinal clays, the most celebrated of which was *terra lemnia*. This came from the island of Lemnos, which had fallen to the Ottomans during the reign of Mehmed the Conqueror (1451–81). Some *terra lemnia* was acquired in the form of tablets, often stamped with the legend *Tin-i makhtum*, which was an Ottoman calque of *terra sigillata*. Some, however, was fashioned into pottery which was believed to act as a febrifuge or more potently as a specific against the plague. It was highly valued by the Ottomans and European visitors, and specimens were given to viziers and foreign ambassadors. Pottery examples could be found in Aldrovandi's collection, in Worm's museum and in the collection of Rudolf II, who also owned a European version modelled on the Turkish, a drawing of which occurs in the 1607–11 catalogue of his collection.[8]

Alongside the clays were displays of *conchilia*, and the combination of the two was believed by many in the sixteenth century to be the substantive secret of porcelain. Indeed, the debate on the fabric of porcelain was conducted by several owners of cabinets. Hard-paste porcelain in the sixteenth and seventeenth centuries was the monopoly, it is

[5] There were exceptions, of course, and some gifts may have been neither contemporary products nor even of Islamic manufacture. The *Tazza Farnese*, for example, is recorded in the Medici collection in the last quarter of the fifteenth century, but it must have been in the Timurid treasury earlier in the century, because a drawing of it was made by one of Baysunghur's artists, Muhammad Khayyam: Blanck 1964. On Ottoman gifts and booty in Vienna, cf. Distelberger, pp. 39–46 above. That there was no great difference conceptually or even in terms of content between Muslim princely treasuries and their European counterparts was realized by Valentini who included a description of the Mughal and Safavid treasuries as well as that of Ibrahim Pasha, the vizier of Suleiman the Magnificent: Valentini 1704, pp. 34–6, 55.

[6] Balsiger 1970, vol. 2, pp. 540 ff., 560 ff.
[7] Imperato 1599; cf. Balsiger 1970, vol. 1, pp. 274 ff.
[8] On the collections cited, Balsiger 1970, *passim*; and, e.g., Legati 1677, pp. 266–72. For Sloane's medicinal chest, St. John Brooks 1954, pp. 96–7. For the *Museum Regium*, Jacobaeus 1696, p. 39. The functional, pharmaceutical bias of many of the Italian collections is discussed by Olmi, pp. 5–16 above. On *terra lemnia*, J. Raby, 'Terra Lemnia and the potteries of the Golden Horn' (in preparation). Meanwhile, Hasluck 1909–10. Aldrovandi 1648, p. 265, and Valentini 1704, pp. 1 ff. have excursuses on *terra lemnia*. For Rudolf II's specimens, Bauer and Haupt 1976, p. 57 and p. xxii for the drawing (cf. Boström, pp. 90–101 above, on *terra sigillata* items in Hainhofer's *Kunstschränke*).

true, of the Far East, but numerous examples first acquired by Europeans came via the Levant or India, and the shell fable seems to have been first promulgated among Europeans by Muslims.[9]

Semi-precious stones from the Middle East and India were also popular items in cabinets, often in the form of amulets. Another favoured form was the archer's thumbring; twelve, for example, were owned by Antoine Agard of Arles in the first half of the seventeenth century, made of semi-precious stones from the Indies or of white carnelian 'from Turkey'. The undecorated stone thumbrings in the Tradescant collection underline how an item was collectable for the rarity of its material even if its craftsmanship was undistinguished.[10] Vice versa, an item of unexceptional material such as wood could appeal by the virtuosity of its craftsmanship, as the wooden spoon from Iran in the Tradescant collection illustrates. Such delicate work was unusual in Islamic portative items of this period and other Islamic woodwork seems hardly ever to occur in cabinets.[11]

HISTORICAL ASSOCIATIONS

European virtuosi had little interest in Muslim history except in so far as it touched upon European affairs. Thus it is rare to find objects with a strictly Muslim historical association, although the royal *Kunstkammer* in Copenhagen contained a Koran which was described in the catalogue as *Liber pseudodogmaticus*.[12] However, mistaken Christian or classical associations could account for the presence of Islamic objects. Rudolf II owned an object described as one of the vases from the marriage feast of Cana. In reality it was the fourteenth-century Hispano-Moresque lustre 'Alhambra' vase which had been captured by the Ottomans in Cyprus in 1571 and which is now in Stockholm.[13]

An example of a classical misassociation is also provided by Hispano-Moresque lustre ware. In the Cospi catalogue Legati illustrates a typical wing-handled fifteenth-century vase and makes the magisterial pronouncement that 'La qual sorte di lavoro [sc. the handles] esendo Greca, cospira colla materia, ad autenticar questi per vasi samii.' On the basis of this attribution other lustre pottery, presumably Spanish, is also catalogued as Samian.[14]

Despite such errors, it is often striking how little *Islamica* is included in the cabinets. If Islamic objects were collected primarily as ethnographic exemplars, the paucity is indeed surprising. If, on the other hand, they were acquired as illustrations of man's ingenuity, it

[9] J. Raby, 'Islamic and European accounts of the manufacture of Chinese porcelain' (in preparation). Meanwhile, Lightbown 1969, pp. 229 ff. Legati (1677, pp. 273 ff) includes a discussion of the porcelain controversy. On Europe's earliest acquisitions of Chinese porcelain Davillier 1882; Whitehouse 1972; Spallanzani 1978. Lach 1970, p. 26, raises the interesting question of whether Ferdinand of Austria acquired his blue-and-white mostly via Turkey, since it contains no figurines, whereas Philip II of Spain acquired his from Lisbon and owned numerous figurines. Shells were also used for intarsia and marquetry work, Gujarati caskets being much appreciated in Europe, cf. Skelton, pp. 274–80 below. Although the etymology of 'intarsia' is probably derived from the Arabic *tarsiʿ*, examples from the Ottoman world seem rarely to have been imported during the

sixteenth and seventeenth centuries. But cf. n. 27 below.

[10] Balsiger 1970, vol. i, p. 39; MacGregor 1983, pp. 173–4, nos. 60–2.

[11] MacGregor 1983, p. 176, cat. no. 69; cf. Murdoch-Smith n.d., pp. 75–6 and cf. n. 9 above on intarsia woodwork.

[12] Jacobaeus 1696, p. 53.

[13] Kurz 1975; for a drawing of the vase in Rudolf II's inventory of 1607/11, Bauer and Haupt 1976, p. xxiii. Jacobaeus 1696, p. 270. A dagger in San Marco was at first identified as that used by Saint Peter to cut off Malco's ear, and later as that used by Christ at the Last Supper: Gallo 1967, pp. 229–31; cf. Valentini 1704–14, p. 196, pl. 37.

[14] Legati 1677, p. 266, cf. pp 268–9. Legati's ignorance of ceramic types was long ago criticized by Davillier 1882, p. 49.

is considerably less surprising. The reason is that the sixteenth and seventeenth were the crucial centuries which witnessed a shift in the scales of the technological balance. They were the centuries when many Islamic arts and crafts went into decline and when technical borrowing from Europe began to increase appreciably.

Let us take a few examples from portative objects. In ceramics the distinctive lustre technique died out in Syria and Egypt, although it enjoyed a brief revival in seventeenth-century Persia. Technical brilliance was achieved in the sixteenth century by the Ottoman potters of Iznik, and Iznik ware could be found in some European cabinets, such as that of Walter Cope in London (d. 1614); and it exerted an influence on Francesco de' Medici's soft-paste porcelain experiment. In the seventeenth century, however, Iznik pottery went into a sad decline and Islamic pottery ceased to be of interest to a Europe receiving large cargoes of Chinese and, later, Japanese porcelains. Persian pottery was even produced in imitation of Chinese blue-and-white and sometimes falsely sold in Holland as Chinese work.[15] Glass production suffered a more disastrous collapse; from the fifteenth century onwards there seems to have been no production in the Levant or Iran to rival the enamelled splendours of the thirteenth and fourteenth centuries, and the period is marked by imports from Venice and Bohemia.[16] Ivory working was a restricted industry, but here standards were often excellent, as the Ottoman ivory dagger-handle in the British Museum testifies. Islamic ivory of this period was rare, however, in the West, and it is perhaps indicative that the ivory casket in the Settala collection was an 'antique', dating from the fourteenth century.[17]

Fine metalwork continued to be produced under the Ottomans and Safavids; but it was the method rather than the quality of craftsmanship which restricted its interest for European collectors, because its decorative techniques – bejewelling, repoussé and engraving – were practised to a high standard in the West. Safavid and Ottoman methods were not, therefore, technically distinctive, and the great Islamic contribution to the metalworker's decorative repertoire – silver and gold inlay – fell into oblivion in Iran and the Ottoman Empire in the first decades of the sixteenth century, at precisely the time it was being practised with such distinction in 'Veneto-Saracenic' wares.[18] Consequently references in the cabinets to metal 'tablewares' from the Islamic world are rare. When they do occur, they tend to be antiques, such as the thirteenth-century ewer in the Cospi collection.[19]

[15] On later Islamic pottery, Lane 1957a. On Iznik exports to Europe, Lane 1957b, pp. 278–80. On the Iznik in Cope's cabinet, Lane 1957b, p. 280; cf. Lach 1970, pp. 34–5, on the general importance of this cabinet. On Iznik and the Medici porcelains, Liverani 1936; Lightbown 1981, pp. 461 ff. Cospi, however, owned 'Vasi aperti di Porcelanotto di Turchia coloriti con fiori, e oro', which probably refers to a seventeenth-century gilded Iznik ceramic: Davillier 1882, p. 49, n. 1. cf. n. 14 above for reservations about Legati's ceramic descriptions. For such a gilded piece, Butler 1926, pl. xv. Persian pottery was owned by Lorenz Hoffmann of Halle (d. 1630): Balsiger 1970, vol. 1, pp. 263–4; and 'vases from Cairo' by Moscardo of Verona (1672, p. 442, and accompanying engraving). These were unglazed wares, which Moscardo commends for their ability to keep water cool.

[16] On medieval Islamic glass, Lamm 1930; cf. Ettinghausen 1974, pp. 308–10. On European exports to Turkey and Iran, Charleston 1964, 1966; cf. Eyice 1967.

[17] For the ivory handle see Dalton 1909, no. 573, where it is wrongly described as 'Hispano-moresque'; cf. Çağman 1983, pp. 161–3, nos. E 86, 88–9. The casket recently appeared on the London art market, *Persian and Islamic Art*, Sale Exhibition, Spink & Son Ltd., London 21 April–6 May 1977 (London 1977), no. 84. On Settala see Fogolari 1900; Terzago 1664; Scarabelli 1666. For similar caskets, Dalton 1909, pp. 173–4.

[18] On Ottoman metalwork, Allan and Raby 1982; on Safavid, Melikian-Chirvani 1982, pp. 260 ff. For Veneto-Saracenic wares, Melikian-Chirvani 1974; Huth 1970; Ettinghausen 1974, p. 305; Lightbown 1981, pp. 465 ff.

[19] Legati 1677, p. 259. On the ewer, Scerrato 1966, p. 120, pls. 53–4.

The scarcity in 'tablewares' was compensated for, however, by arms and armour. Daggers in particular were popular and many catalogues devoted a special section to knives and daggers in which Turkish specimens figured prominently. (Three such collections were those of Settala in Milan, Moscardo in Verona and Vecchietti in Florence.)[20] Three principal reasons for their popularity can be adduced. The first was a conceptual factor, for it was frequent to include an independent section in the catalogues on weaponry. The second was availability, a point to which we shall return. The third was technical virtuosity. This manifested itself in damascening in its twin senses of watered steel and gold-on-steel decoration. The fascination which such techniques could hold for Renaissance Europe is perhaps best illustrated by Benvenuto Cellini's comments:

There fell into my hands some little Turkish poniards; the handle as well as the blade of these daggers was made of iron, and so too was the sheath. They were engraved by means of iron implements with foliage in the most exquisite Turkish style, very neatly filled in with gold. The sight of them stirred in me a great desire to try my own skill in that branch, so different from the others which I practised; and finding that I succeeded to my satisfaction, I executed several pieces. Mine were far superior.[21]

It is interesting that the appeal of inlaid metal was just as lively in the Far East, to judge from the words of a Chinese connoisseur writing in 1387, who relates that 'I have seen a pair of scissors of this kind [damascened watered steel] with chased and gilt patterns on the outside and silver inlaid Muhammadan characters on the inside. It was beautifully made.'[22]

The availability of Turkish daggers and other weaponry was due to the quantities of Turkish booty. Cospi's collection, for example, contained Ottoman standards and weapons seized by Carlo Cignani at the capture of Clissa and the siege of Zomonico in 1647; the royal Kunstkammer in Copenhagen contained spoils from a naval battle in 1658.[23] Ottoman guns were included in many collections, such as that of Beutel, secretary to the Elector of Saxony in Dresden in the second half of the seventeenth century. As Ottoman cavalry was often splendidly caparisoned, captured horse-trappings also occur in cabinets, John Evelyn owning a bridle 'to which hung half a moon'. Military spoils often comprised miscellaneous items too, and thus Cospi owned Turkish copper bowls, two items of women's headgear, as well as the finial from the mosque of Clissa.[24]

The topic of availability raises the problem of the geographical distribution of *Islamica*, in terms of both countries of origin and countries of collection. Establishing provenance, however, is complicated by inaccuracies of attribution in the catalogues, most *Islamica* being identified as Turkish or Indian, although it is frequently unclear whether the reference is to the East or West Indies. Inaccuracies notwithstanding, the majority of

[20] Moscardo 1672, p. 444; on Vecchietti, cf. Lach 1970, p. 39; Lightbown 1969, p. 238; cf. *idem*, p. 256, for a description of several gold-inlaid daggers, mostly it seems of Indian origin, once in the Settala collection.

[21] Cellini 1949, pp. 54–5. Legati 1677, p. 259, describes the thirteenth-century ewer from Cospi's collection as 'uno sforzo dell'Artefice, *per dimostrare l'eccellenza dell'ingegno, e la finezza dell'Arte*' (Legati's italics).

[22] David 1971, p. 137.

[23] Legati 1677, bk. III, sect. 15, pp./229 ff., 250 ff.,; on p. 250 there is an engraving of some of these objects. Balsiger 1970, vol. 1, pp. 303 ff.; Jacobaeus 1696, p. 52. On Turkish booty at Ambras, cf. Scheicher, pp. 29–38 above.

[24] For Beutel, Balsiger 1970, vol 2, pp. 631–4. For the Clissa miscellanea, Legati 1677, pp. 250–1, 260.

Islamic objects were Ottoman. This was due, on the one hand, to Turkish forays into Europe, which resulted in the *Türkenbeute* already referred to, and to European forays into the Ottoman Empire, on the other. Apart from diplomacy and trade we can posit three main incentives for European travel to the Ottoman world, and all three allowed for incidental or additional acquisition of *Turkica*.

The first was the archaeological pilgrimage to Greece and especially Asia Minor. The archaeologist/traveller was rarely blind to contemporary Turkish life; many in the seventeenth century seem to have enjoyed dressing up in Turkish costume and living *à la Turque*. An alternative, or supplementary, attraction was Ancient Egypt, and pharaonic detritus, ranging from small-scale ushabtis to complete mummies, was avidly collected. One need only cite the cabinets of Settala, Foucquet (1615–80), Michel Bégon (1638–1710), Calceolari, John Evelyn and the Royal Society, not to mention the celebrated Egyptian collection of Athanasius Kircher.[25] Mummies formed part of the *animalia* section. Moreover, mummy flesh enjoyed the reputation of having a medicinal curative power when ingested, and Egyptian Jews are said to have conducted a lively trade in fake mummies. The *disjecta membra* of recently executed criminals were steeped in bitumen to age them and sold to unsuspecting Europeans. Doubtless many ended up in either the stomachs or the cabinets of virtuosi.[26]

The third incentive to eastern travel was the religious pilgrimage to the Holy Land, and souvenirs of such trips include intarsia models of the Holy Sepulchre in Jerusalem and the Church of the Nativity in Bethlehem formerly in the Bodleian collections.[27] As Greece, Anatolia, Egypt, Syria and Palestine were all in Ottoman hands in the sixteenth and seventeenth centuries, the preponderance of Ottoman items in European cabinets is understandable. Persian artefacts were less commonly owned by bourgeois collectors, who did not reap the benefits like some princes, of receiving Persian embassies or of sending envoys to Persia in return.[28] North African items are also rare, while Indo-Muslim artefacts are dealt with elsewhere in this volume.

The distribution of *Islamica* falls into an understandable pattern: *Türkenbeute* was uncommon in France, England and Spain, and more frequent in other countries of Northern Europe and in Italy, which were protagonists in the armed struggle.[29] Most objects seem to have been of contemporary or recent date, and Italian collections seem to have been the only ones to include antiques.[30]

[25] Balsiger 1970, *passim*. For a few examples of Europeans dressing in oriental costume, Naderzad 1972.

[26] Murray 1904, vol. 1, pp. 50 ff., esp. pp. 52, 83.

[27] Now in the Ashmolean Museum, loan nos. 302–4. One was presented to the Bodleian Library by a London merchant, Aaron Goodyear, in 1681. Tradescant's 'modells of the Sepulcher at Jerusalem; one in wood: the other in plaister' (Tradescant 1656, p. 40) no longer survive. For other examples see Regteren Altena 1967, pp. 20–1; Dalman 1920.

[28] Adam Olearius, for example, who catalogued the *Kunstkammer* of Friedrich von Holstein-Gottorp, went to Persia in 1633 and 1635 as ambassadorial secretary.

[29] In the first half of the sixteenth century the Low Countries benefited from the presence of Portuguese factors who assured

the import of *exotica* from the East Indies: Lach 1970, pp. 16 ff., 22 ff.

[30] On antique items, see, e.g. Legati 1677, p. 259. The preponderance of Ottoman artefacts may explain why Islamic miniature painting rarely occurs in cabinets, since high-quality painting was restricted to court circles under the Ottomans. Rudolf II seems to have been exceptional in his interest in the art of the Islamic book: Lach 1970, p. 29; Chytil 1904, p. 15; Kurz 1966. Indian paintings were owned by Lorenz Hoffmann: Balsiger 1970, vol. 1, p. 262; and Indian books by Moscardo (1672, p. 303). The Ottomans did, however, produce *Trachtenbücher* as souvenirs for visiting Europeans, and the influence of one of these can be seen in Rubens's *Costume Book* in the British Museum. The same book contains copies after Safavid Persian miniatures: Kurz and Kurz 1972; Ingrams 1974; Belkin 1980.

We can thus conclude that the Islamic items in the *Wunderkammern* consisted in the main of Ottoman objects. Secondly, many of the objects illustrated Islam at war. That there were few to illustrate Islam at prayer perhaps reflects more on Islam than on Europe, because Muslim religious art places an insistence on calligraphy, and is neither pictorially nor plastically demonstrative. Yet calligraphy is less universally accessible than figural imagery and tends to restrict access to the initiate.[31] Thirdly, the collections of *Islamica* were random and piecemeal, and made no attempt at a comprehensive ethnographic conspectus. Fourthly, they differed markedly in their typology from those of the mediaeval religious treasuries. The difference, however, was perhaps less a question of destination and more a problem of supply, considering the shift in the technological balance between Europe and the Middle East already mentioned.

If, lastly, we compare the virtuoso's cabinet and the prince's treasury, we find that the prince benefited from direct gifts – which must have assured a higher quality of item – and that he owned a higher proportion of Persian items. The most striking contrast, however, is in textiles. As rich as the treasuries were in Islamic textiles, the cabinets were poor. Of course, there were carpets *in* the cabinets, as can be seen in numerous seventeenth-century Dutch paintings, but they were not *of* the cabinet.[32] In other words they were regarded as utilitarian items like the chairs in the Munich *Kunstkammer*, and they were not included in the catalogue. Islamic silks and velvets appear incidentally as items of costume but never as bolts of material – never, that is, as *exempla* of man's ingenuity as a creator.[33]

Thus, whatever we may think of the conceptual divide between the *Wunder-* and the *Schatzkammern*, there was a clear material divide, at least as regards *Islamica*.

[31] Examples of Arabic and Turkish script were owned by the Royal Society, Cospi and Settala among others: Balsiger 1970, vol. 1, pp. 243, 246; Legati 1677, p. 193. For Settala, Lightbown 1969, p. 257. It seems, however, that they were collected as specimens of script rather than as illustrations of Muslim religious practice. Legati's introduction to Cospi's exotic scripts discusses the evolution of the Latin alphabet and China's role in printing, but has nothing on the Arabic alphabet. One medium where Arabic script was used which was influential in Europe was paper-cuts. It remains to be established, however, the number of cabinets which contained examples, although Rudolf II is known to have owned a specimen: Kurz 1972, esp. pp. 244 ff.

and n. 25. Louis XIV assembled a large collection of Oriental manuscripts: *Collections* 1977. Islamic coins appeared in the collections of, e.g., Elias Backenhoffer of Strasbourg (1618–82), Worm and Hoffmann: Balsiger 1970, vol. 1, p. 262.

[32] E.g. Speth-Holterhoff 1957.

[33] Valentini 1704, ch. xlii, pp. 512 ff., has a section, however, entitled 'Von der rohen Seiden und deren Zubereitung'; and Moscardo 1672, pp. 440–1, an excursus on the history of silk, but without citing specimens in the museum. For a selection of Asian shoes from the Tradescant collection, MacGregor 1983, pp. 170–3. On Turkish leather bottles see Legati 1677, p. 296.

THE EARLY CHINA TRADE

John Ayers

The theme of my paper is China, its exported arts and artefacts, and their place in the earlier collections of Europe. The surviving Chinese items, if less numerous perhaps than some others, are varied and often intriguing in character, and their story is probably as strange as any when considered in relation to their time. One has of course to remember the extent to which ignorance and myth about the East abounded throughout this period, and even in the sixteenth century the real possibility of acquaintance with China was still extremely slight. Those who made the long journey – and they were few enough – seldom got more than a distant and ill-informed view of the country because foreigners could not travel about freely there, and were mainly confined to the ports on the southern coast. It is hardly surprising therefore that even as late as the sixteenth century the references to Asiatic objects in western inventories and accounts are so often vague or misleading, with Chinese, Japanese and South-East Asian objects labelled alike as 'Indian'.

It is well known how much work still remains to be done in fields such as this, and this brief paper makes no pretence to be a comprehensive analysis. There is an obvious need for more publication of all kinds, and for fuller systematic studies of both collections and records; for only then can the scattered strands be drawn together within the various disciplines. In this connection I would cite as a model example the publication of the Royal Danish *Kunstkammer* in Copenhagen,[1] where each object is not only classified, described, dated and illustrated, but also identified with relevant passages in the dated inventories. Such work is of quite inestimable value.

In the period which mainly concerns us direct trade with the Far East was still a very recent thing; it had begun only with the entry of the Portugese into the Indian Ocean early in the sixteenth century, and their decision to oust the Muslim traders from Malacca in 1511.[2] A trans-Asiatic trade had flourished in the time of the Romans, conducted mainly along the immensely long overland routes. But in subsequent times the sea route round southern Asia was increasingly favoured, not least because it avoided the middlemen of Central Asia; and throughout the early centuries of Islam – as archaeological studies in Egypt, Mesopotamia and the Persian Gulf area have underlined – traffic flowed by sea on a considerable scale. This was carried on mainly by Persians, Arabs and Indians, and fed the markets of Baghdad, Cairo and Damascus in medieval times with a variety of Chinese goods which included silks and also pottery, as well as a whole range of perishables, among which spices from the East Indian islands were always prominent. As

[1] J. Hornby, in Dam-Mikkelsen and Lundbæk 1980.
[2] For the literature of early relations between China and the West, see Hudson 1931; Bretschneider 1910; Boxer 1969; Volker 1954.

archaeological finds at various Middle Eastern sites indicate, it was probably in the ninth century that the first true porcelain was imported there.

European lands were brought within closer reach of this trade by the Crusades in the twelfth and thirteenth centuries, which led to trading colonies being established in the Levant; but if this resulted in acquisitions of Chinese rarities, few, if any, of these have survived, and it was not until the Mongols spread their grip across Asia that the situation radically altered. Then, for a hundred years or so the land route was once again safe for travellers, making possible missions such as those of John de Plano Carpini and William of Rubruck to the Mongol court in the mid-thirteenth century, or of traders like the Polos from Venice soon afterwards.

All this is well known; and from this period a few things have been preserved such as the rare silks in various churches which have been published by Agnes Geijer[3] and others, and a handful of porcelains; while in the fourteenth century, as Davillier noted,[4] porcelains also began to figure in princely inventories. Since advances in the study of Chinese ceramics now enable us to look at these porcelains with a more informed eye than in the past, it may be worth reviewing briefly a few of them.

A small, whitish porcelain vase (fig. 99) belonging to the Treasury of San Marco in Venice, for example, has the quite unsubstantiated repute of having been brought from China by Marco Polo himself. This would make it the earliest of all surviving Chinese ceramics in the West: its early history, however, is quite unknown.[5] What can be said is that it represents a rather coarse type of porcelain made in the southerly province of Fujian, and not far from Dehua – the place where the later *blanc-de-Chine* was produced; and it is probably of Mongol Yuan date. There is a reference in Polo's *Travels* to a place in China where porcelain was made, called Tinju: one not certainly identifiable now, but clearly from the context situated in this province. It is the only piece of its sort known from an early western collection, although similar wares have been excavated recently in South-East Asia. Marco Polo could quite well therefore have brought this back from China about AD 1292, but nothing apart from its presence in San Marco either proves, or even suggests, that he did so. Nevertheless, it is among the most perfect of all candidates for a cabinet of curiosities: the relic of a fabulous event, and made of a unique and exotic substance.

Another very rare and much-discussed piece of porcelain is shown in a drawing representing the so-called Gaignières-Fonthill ewer: a treasure which was lost from view in the nineteenth-century, but eventually rediscovered about 1952 in the National Museum of Ireland in Dublin.[6] It is a bottle of what we call *ying-qing* porcelain, fitted once with metal mounts which transformed it into a ewer; these were decorated in enamel work with mottoes and the arms of King Louis the Great of Hungary and others, from which it is deduced that he presented it to Charles I of Durazzo in 1381. Unfortunately the historic mounts have disappeared, but the piece itself is still handsome, with its pale bluish-green glaze, and curious decoration of relief-work panels of flowers framed in pearl beading. This type of ware has been simply dated to the early fourteenth century in the past, but

[3] Geijer 1951.
[4] Davillier 1882.
[5] Raphael 1931–2.
[6] Lane 1961.

can now I think be placed more precisely between about 1320 and 1340. How it reached Europe remains a mystery; and it is curious that nothing else of the kind survives in the vast collections of Istanbul or Ardebil. Mazerolle[7] thought it was brought from China by a mission of Nestorian Christians who came to visit the Pope in 1338, but he did not explain adequately why.

A third very early porcelain to place beside these is a fine dish belonging to the Museo degli Argenti in Florence: a typical piece of Longquan celadon ware, which has recently been published by Professor Spallanzani.[8] Its interest is heightened by inscriptions on the base which show, firstly, that it was sold from the collections of the Medici in 1773, and, secondly, state that it formed part of the celebrated gift to Lorenzo by the Sultan of Egypt in 1487. The porcelain has been dated as late fourteenth or early fifteenth century, but I believe recent studies enable us to place it earlier: as early as the second quarter of the fourteenth century.[9]

Although these three porcelains antedate our main interest, there are I think good reasons for reviewing them: firstly, because they illustrate well the problem of deciding how such unfamiliar objects can have travelled here from China. Sometimes, it seems, this may have been through purchase by traders in the Middle East, although proof of this is not easily found, while in other cases, as we have seen, objects may have come from that region as diplomatic gifts. Alternatively, as suggested but not proven in two of these instances, items may have arrived directly from the Far East, through the medium of a trader or missionary legate. A further point of interest concerns less the objects themselves than the overall situation created by the Mongol conquest, and the peculiar contribution which it made to that broadening of curiosity and comprehension in Europe which inspired a new element in these collections. For there is no doubt that the reports of travellers and traders at this time, as well as the goods and treasures with which they returned, both heightened and sharpened speculation about the nature of the eastern world, and encouraged and fed the coming maritime expansion, with all that that implied.

Turning to the later fifteenth and early sixteenth centuries, as Ronald Lightbown showed in his very original published paper,[10] and as the contributions of Professors Olmi and Minelli in this publication have underlined, it seems especially in Italy that the idea of the cabinet or *studiolo* as an instrument of scientific study was nurtured in late Renaissance times. A lively debate was pursued there concerning the nature of porcelain and attempts at making it followed – although we should not perhaps forget that it was at Dresden, a century later, that such experiments were finally brought to a wholly successful conclusion. Meanwhile Chinese objects, still it seems mainly porcelain and silks, came in increasing numbers to Italy by the routes already described. The fine blue-and-white porcelain of the early fifteenth century, which was such a feature of the princely collections of Iran and Turkey, was certainly known in Italy, as has been shown by Dr Spriggs's study of porcelains represented in European paintings,[11] which included

[7] Mazerolle 1897.
[8] Spallanzani 1978.
[9] Compare for example dishes with similar incised cloud scrolls in the cavetto which were recovered from a sunken ship wrecked off Sinan, South Korea in about the third decade of the fourteenth century (National Museum of Korea 1977).
[10] Lightbown 1969.
[11] Spriggs 1964–6.

some striking examples by major artists – such as Giovanni Bellini's *Feast of the Gods*. Several collections which included porcelain are recorded around 1530, while in Rome and Florence the collections of the Medici, as Professor Spallanzani has shown, were outstanding. Thus in 1545 we find Cosimo de' Medici still commissioning the purchase of porcelains and carpets from a visitor to Egypt – the source also, with Istanbul, of some notable early gifts. The 1553 inventory of his collection numbered already 400 pieces, including 59 celadons and 289 blue-and-white wares. Unfortunately its dispersal later was remarkably complete, so that apart from the celadon dish already mentioned and a large vase in the Museo degli Argenti dating from about 1500, only one or two other pieces are still recognizable as having belonged to it.[12]

In the inventory these wares are sometimes described in quite an informative manner, and the 'vase two feet high', the 'vase with two handles one foot high' and 'ewers one foot high', vague though these entries might seem, are in fact descriptions of celadon wares all readily matched by groups of items in the Topkapi Saray and elsewhere. As for the one 'red and green' piece – clearly an enamel-decorated porcelain – this is the earliest record of such a ware appearing in Europe. By the end of the century this collection, with its more than one thousand pieces, was undoubtedly unique. According to an inventory of the possessions of Philip II of Spain made in 1611–13 after his death, the King had as many as 3,000 porcelains – a staggering figure, which may however be discounted when one reads their further classification as 'porcelains of crystal, of agate, and of stone', which casts serious doubt on the competence of the cataloguer.

Earlier than this two more remarkable pieces of celadon ware had already found their way to northern Europe. One is the celebrated bowl in Kassel with silver-gilt mounts bearing in enamel work the arms of Count Phillipp of Katzenelnbogen, which were added to it before 1453.[13] According to one later account he brought it back from the Orient himself in 1433. The other celadon is the famous bowl preserved in the Treasury of New College, Oxford, to which it was given by Archbishop Warham in 1532; this too appears to date from the late fourteenth or early fifteenth century.[14] Both these bowls, it will be noted, where honoured with mounts of precious metal, which indicates their rarity and the respect which such things aroused in their own day: and both no doubt arrived in Europe via the Near East.

For much of the sixteenth century the arrival of the Portuguese in the Far East meant greatly improved opportunities for obtaining goods from China. The foremost emporium was Malacca, and there Chinese merchants came regularly to trade; but it was not until 1557 that the Portuguese were allowed to take over Macao near Canton for this purpose. Neither records of this trade nor surviving collections in Portugal or elsewhere paint an adequate picture for us, but a handful of earlier porcelains provide some measure of their success. Among them is the blue-and-white bowl, now in the Museo Civico, Bologna, with an engraved silver mount which records its gift by King John III of Portugal to the papal legate Zambeccari in 1554. This is a handsome, characteristic and datable piece.[15]

[12] Spallanzani 1978; for these inventory descriptions see p. 187; see also Lightbown 1969, p. 232.

[13] Above, p. 102; see also Lunsingh Scheurleer 1980, taf. 1 (in colour) p. 9, with bibliographical note. See also fig. 37.

[14] Lunsingh Scheurleer 1980, p. 10, Abb. 4.

[15] Home 1935–6.

There are others however which show it was already possible to get pieces made to order in China – or, at least, inscribed to order – by sending a specification to the factories. Quite soon there were to be pieces decorated with the arms of Portuguese families or other such features; and such is the bowl in a Portuguese collection with an inscription translatable as 'in the time of Pedro da Faria in 1541' written round the inside by a Chinese hand, which is the earliest of all such dated wares.[16] Da Faria was Governor of Malacca at that time. Two small handles at the rim of this bowl also indicate Chinese willingness to provide forms as well as decoration to order if this was requested.

There are porcelains which illustrate not only the Portuguese involvement, in the form of the royal arms and emblem of the armillary sphere, but also avowedly Christian subjects such as the monogram 'IHS' set within a crown of thorns; and, oddly enough, the type is one which somehow found its way to the very stronghold of the Infidel in Istanbul.[17]

The Jesuits were to become important gatherers of information about China and no doubt also of objects; and from the end of the century they enjoyed a unique foothold on the mainland of China itself. Indeed, if the Italian *cognoscenti* retained the lead in the serious study of China in the seventeenth century as has been stated, it was owing not a little to these contacts, which brought an acquaintanceship with Chinese books and learned sources; although these were not unknown at the north European courts either. On a more mundane level, it is another Italian, Filippo Sassetti, who in fulfilment of a commission from the Medici reports in some detail on the trade at first hand, first from Lisbon and later from India.[18] Chinese silks were probably now available in Europe in quantities as greatly increased as were those of porcelains: but these had destinations other than the *Kunstkammer*, and have consequently seldom survived outside the church treasuries. Much sought-after luxury items were sets of silk bed-hangings, and Sassetti records ordering one of these for his Medici client. They continue to crop up in wills and inventories throughout the seventeenth century.

Much of the porcelain and other Chinese objects which came into the northern *Kunstkammern* in the later sixteenth century probably derived from Portugal, but contacts with Italy were still important, and in 1582 and again in 1588 gifts of porcelains to the Duke of Bavaria from the Grand Duke of Tuscany reflect the degree of their mutual interest – at the very time, it may be noted, when the so-called 'Medici porcelain' was being produced in Florence.[19] In 1590 followed the Grand Duke's gift to the Elector Prince Christian of Saxony, on which Spallanzani has recently published an improved commentary.[20] Apart from fourteen porcelains, this also included two Chinese paintings, which were rare items at any time. Of the porcelains which, still survive at Dresden, there are four polychrome-glazed items of unusual type which must have been greatly prized. One is a ewer in the form of a phoenix; while another in the form of a crayfish is a piece repeated in Philipp Hainhofer's *Kunstschrank* at Uppsala. A third example of this from the Collections Baur in Geneva shows the crayfish rising above a sea of waves, while the filler

[16] Keil 1942.
[17] Jenyns 1964–6.
[18] Lightbown 1969, p. 235.

[19] Spallanzani 1978.
[20] Spallanzani 1979.

is a lotus pod, its stem forming the handle.[21] They are remarkable pieces for their date, which must be in the 1570s or 1580s; and even if such porcelains are not of the finest by Chinese standards, among men with a taste for the curious and ingenious, such pieces can hardly have failed to touch some chord of sympathy with the Chinese artistic imagination.

The rare green bowl in that group at Dresden is almost identical with one at Schloss Ambras; over the glaze is a floral decoration in thin gold foil, in the style which the Japanese call *kinrande*. Six bowls of this type in various colours still remain at Ambras;[22] but although they do not stand out among the 250 or more porcelains in the 1596 inventory, there could well once have been more of them. The type was made for a rather short time around the 1570s. A further, red-glazed example in the Victoria and Albert Museum, one of two bowls mounted in this way in silver-gilt, adds a footnote to the story for it has a dated inscription.[23] This tells us that a certain Count von Manderscheidt, who was an ecclesiastic, brought them back from Turkey in 1583 and had them both mounted before presenting them to his brother. The Topkapi Saray includes many such *kinrande* pieces, and it may be that the Middle East was their principal common source.

Turning away from porcelain, the durability of which ensures it perhaps a somewhat undue prominence in my paper, we may examine another of the Chinese paintings at Schloss Ambras, inventoried in 1596, which have already been mentioned by Dr Scheicher.[24] The scene is an ideal landscape with palace buildings and figures, reflecting some golden age of the past, and perhaps somewhat akin in spirit to the work of Claude Lorrain. Although studio work, it reflects a design of no mean quality while the illustration of architecture, gardens, dress and a variety of Chinese customs, not to mention its refined artistic style, make it highly revealing concerning the unfamiliar culture of the Middle Kingdom.

Other objects at Ambras fall more closely in line with the local taste in collecting: for example, a number of carvings in such materials as rhinoceros horn, ivory and soapstone. A horn cup (fig. 100), the sides of which are beautifully carved with a spray of hibiscus[25] seems once to have been mounted up in some way, judging from the hole cut in the bottom; a cup of very similar type is in the Tradescant collection at the Ashmolean Museum. The Ambras cup is not certainly identifiable in the 1596 Inventory, but may well date from that time. Two or three ivory figures also at Innsbruck may be from this period. They are typified by a standing statuette apparently representing the Daoist Immortal Lan Caihe playing the flute, although his instrument does not in fact survive. One is struck first by the extraordinarily fine state of preservation of the ivory, which is fine and white, although unfortunately the right arm and part of the head are also now missing; the face and draperies however are refined and delicate work, in which the details are picked out in bright and harmonious pigments.

At Ambras too are a large number of carved soapstone figures, some representing Daoist and some Buddhist subjects. A fairly typical example of these works with their

[21] Ayers 1969, no. A.209.

[22] Garner 1975, pls. 2–7.

[23] Garner 1975, pl. 9 and colour frontispiece.

[24] See p. 37. Three such paintings are referred to in the inventory but in fact four exist today, although two of these are now at the Kunsthistorisches Museum in Vienna. See Whitfield 1976, fig. 1; this article discusses and illustrates all four works.

[25] Reproduced by Garner 1975, pl. 16, with the Tradescant cup on pl. 17.

finely-engraved surface details is one which bears an artist's signature and also a date, under the Chinese cyclical system, which may be read as corresponding to the year 1568 or 1628 (fig. 101).[26] This princely collection in Austria also includes a few examples of oriental lacquerwork, an art which, whether Chinese or Japanese, was to exert a very considerable influence on the European interior in the course of the next century or two. One unusually early red-lacquered cup with decoration in gold of plants and birds employs a gold-foil technique similar to that employed on the *kinrande* porcelain bowls previously mentioned, and again seems likely to date from this period. It is ascribed by Garner[27] to factories in the Ryukyu Islands, halfway between China and Japan, which played their own small part in this exotic trade.

It would be impossible to say anything very worthwhile here about the changing means of supply by which the *Kunstkammern* of northern Europe were furnished with items such as these, but some of the links between them have undoubtedly been further illuminated by contributions to this book. A fresh factor as we enter the seventeenth century is the new supremacy of the Dutch in the Far East, and at a lower level the participation of the English, among others.[28] The Dutch East India Company and its lesser rivals tended to be hard-headed commercial enterprises and the volume and value of their imports, especially those of porcelains, was now greatly increased; indeed very soon these porcelains ceased to be curiosities, and in Holland in particular they were widely used as tableware. At the Catarina sale in Amsterdam in 1604, it is said that the King of France acquired an entire 'dinner service' of porcelain.[29]

Another growing import from China in the seventeenth century was tea. It is notable that from 1637 onwards, according to Volker, porcelain teacups were included in every single shipment from the Dutch base in Batavia. There is a fine double-spouted teapot in the Royal Danish *Kunstkammer* which was first inventoried there in 1656 – the earliest documentation of the ware in Europe, I think; another teapot from that collection (fig. 102) has been traced back to 1665.[30] It too, is made of the red stoneware pottery of Yixing in Central China, which was soon taken as a model by potters in both Holland and England, and indeed early in the eighteenth century by Böttger at Meissen, shortly before his success in making porcelain. Teapots such as these, which represent the introduction of an entirely new vessel-form in Europe and of a new and civilizing custom in daily life, are very properly to be regarded as curiosities.

No collection in Europe is more illuminating about seventeenth-century imports from the East than that in Copenhagen; and the furniture and lacquerwork there are as important, or even more important for Japan than they are for China. The most imposing Chinese furnitures of the second half of the century are the large folding screens and chests of so-called Coromandel lacquer, carved and painted in bright colours; not a few have survived in our great houses. The screen in Copenhagen, however, like many another, was at some stage cut up into smaller panels and used as wall decoration; and the fashion

[26] Three other soapstone figures from this group are reproduced by Garner 1975 pl. 18.

[27] Garner 1975, pl. 14.

[28] Volker 1954 provides a most revealing account of the trade in porcelain and much else.

[29] Volker 1954, p. 22.

[30] J. Hornby in Dam-Mikkelsen and Lundbæk 1980, p. 171, nos. EBc88 and EBc90.

for creating miniature *Kunstkammern* or 'porcelain rooms' adorned in this way is demonstrated in a number of places and countries.[31]

Apart from this, improved access to China now made possible an increasing flow of objects which facilitated the study of Chinese life and customs of a more purely ethnographic kind; and this is represented to a notable extent at Copenhagen. This and other collections now began to represent in a more or less systematic way such things as Chinese writing equipment, brushes, inks and seals; chopsticks and other table utensils; tools and weapons; fans, lamps and lanterns; boxes, baskets and other basketwork in various materials, often partly lacquered; the abacus; the compass; and so on. Soon also there would be instructive models of Chinese buildings, and figures of men and women in dress typical of the various ranks of society; and without doubt there were at one time many actual items of dress as well.

The wealth of the Orient and the enlargement of vision which came through the trade with exotic lands remained a source of wonder in Europe for a long time yet, and is very effectively celebrated in the works of the Dutch still-life painters. In a picture which is ascribed to Willem Kalf, for example, we see just such an assemblage of wonders: in which rare blue-and-white porcelain of the preceding century, still in the rich mounts of that time and by now already counted as 'antique', is displayed alongside a nautilus shell and a fine near Eastern carpet.[32] Clearly, collecting was on the way to assuming some of its more modern connotations.

In the same way, but on a much more ample scale, the Elector of Brandenburg's palace of Charlottenburg celebrated in the first years of the eighteenth century the more extreme passions of the princely porcelain collector – or in this case his wife, Sophie Charlotte. Chinese and Japanese porcelains line the walls here from floor to ceiling, relieved only by great expanses of mirror glass.[33] Elsewhere possibly the spirit of the early *Kunstkammer* lived on in a diminished or altered form; but here it is abundantly clear that the best exports of China have now made possible the decorative modes of the *Porzellanzimmer* and *Spiegelkabinett*.

[31] Eadem, pp. 199–200.
[32] A number of such paintings are examined by Spriggs 1964–6.

[33] Reidemeister 1934.

JAPAN: TRADE AND COLLECTING IN SEVENTEENTH-CENTURY EUROPE

Oliver Impey

Vague reports of Xipangu had reached European ears before the middle of the sixteenth century. It is even possible that a few Japanese goods were known to Europeans in eastern waters or even in Europe before Europeans 'discovered' Japan. If so, then these things must have been bought from Chinese or Japanese merchants in eastern ports other than in Japan. For Europeans (the Portuguese) first reached Japan in 1542. Trade between the Portuguese and the Japanese began in 1544. A clear distinction will later have to be made between trade-goods and curious objects, but in the early periods of trade even the meanest trade-goods could become 'curious' and be treated as such in Europe.

The commerce which is of concern to us here can be divided into two periods:

(a) Firstly, the period up to 1639, at which date Japan almost closed its doors to trade.[1] In this period the Portuguese and the Chinese were the most important traders, the English and Dutch less so.

(b) Secondly, the years after 1639 (until 1854) when the monopoly of the Japanese trade was shared between the Dutch and the Chinese.

Distinction can also be made between the routes by which objects could reach Europe, which to some extent cut across these time divisions.

There were five nations dealing directly in Japanese goods at various times during the seventeenth century:

(i) The Japanese themselves could trade throughout Asia officially until the 1620s. After that time a licensing system (the Red Seal system) curtailed trade abroad, while after 1639 – the famous 'Closure of the Country' – no Japanese person or ship was allowed abroad. In spite of extreme punishment, some unofficial trade existed.

(ii) The Chinese continued to trade with Japan throughout both periods, but were severely restricted in the second period; from them European traders could buy Japanese goods.

(iii) The Portuguese arrived in Japan in 1542 and traded in Japan on an annual basis until 1638. By 1550 the Portuguese Crown had established a monopoly which it gave or sold annually to a Captain-Major. Until 1618 one Great Ship per annum went to Japan; after that date and until 1638 several smaller boats went each year; no Portuguese boats were allowed to land thereafter.[2]

(iv) The Dutch arrived in Japan in 1600 and set up a 'factory' in Hirado a few years later. In 1641 they were forced to move their factory to Deshima Island, a reclaimed mud-flat in Nagasaki

[1] For this critical closure of the country – *sakoku* – see Iwao 1963; Boxer 1951. [2] Boxer 1959.

harbour. After the expulsion of the Portuguese, they shared the monopoly of trade with the Chinese.[3]

(v) The English came in 1613 but closed their factory as unprofitable in 1623.[4]

Trade between Japan and Europe was rarely direct. The Portuguese and then the Dutch were middlemen; they bought silver (later copper) in Japan with silk bought in China, they bought spices with Indian cotton goods which had been bought with gold bought in China and so on. Some cargoes were destined for Europe, but Japanese goods were, at first, not much sought after in Europe.[5]

The annual Great Ship – and it was great, up to 1600 tons before 1618 – was, of course, very important to the Japanese as well as to the Portuguese.[6] Not only was it the main source of Chinese silk, but also of the European imports – Christianity and the smooth-bore musket. The great military successes gained by the use of the musket revolutionized Japan; Christian missionaries were, at first, welcomed and made numerous converts (this was all to go in 1637).[7]

In 1584 the Jesuit Father in Japan, Alessandro Valignano, sent an 'embassy' of four Japanese converts, young men of the minor nobility, to Europe.[8] They brought with them presents. Some of these must have been Japanese. They gave to Philip II of Spain, for instance, some screens, two suits of armour, a bamboo desk with drawers, a varnished wooden basin decorated with a gold border and some other trinkets. They gave to the apothecary Calceolari of Verona some 'feather works'.[9] It is very interesting that they should have visited Calceolari (of whom Professor Olmi has written): it shows not only how highly such persons were regarded, but also, perhaps, some dry Jesuit humour in taking living curiosities to see a collection of dead curiosities. In addition, they gave to the Pope two screens which had been given to Valignano by Oda Nobunaga. Several of these things can be tentatively described.

The suits of armour present no problem: although no suit of this date exists in Europe, armours sent to James I by Tokugawa Ieyasu in 1613 are still in the Tower of London. The varnished wooden basin was almost certainly a lacquer bowl in so-called Namban style. The screens were said to depict the 'King's' castle (Nobunaga was in fact military dictator) which was called Azuchi. A contemporary engraving by van Winghe[10] depicts part of it and shows it to have been a screen of a type related to the 'in and around Kyoto' screens. Some of these are known to have been painted by Nobunaga's official painter Kano Eitoku.[11]

There is a piece of Japanese lacquer which is inventoried in the collection of the Archduke Ferdinand of Tyrol in 1596 – the Ambras cabinet (fig. 103).[12] This is in Namban style, with pearl-shell inlaid into coarse lacquer, and with gold lacquer

[3] Boxer 1965: for the porcelain trade, Volker 1954: for the lacquer trade, Impey 1982.

[4] For the voyage of the *Clove*, see Satow 1900. For the later period, Boxer 1951.

[5] Boxer 1969 gives an excellent summary of the intra-Asian trade.

[6] Boxer 1959.

[7] Boxer 1951.

[8] Abranches Pinto, Okamoto and Bernard 1942; Lach 1970.

[9] A remarkable picture made of feathers, within a Namban-style lacquer frame enclosed by doors was sold by Christies in New York on 28 January 1982. No other sixteenth- or seventeenth-century Japanese 'feather works' appear to be recorded.

[10] Lach 1970 illustrates van Winghe's engravings pls. 50, 51.

[11] See the screens firmly attributed to Kano Eitoku (1543–1590) in Tokyo National Museum 1979, no. 109.

[12] Illustrated in Boyer 1959, pl. lvii, 57.

overpainting.[13] In 1569 the Jesuit Luis Frois had mentioned that Nobunaga had some 'chests like those of Portugal' – perhaps they were like the Ambras cabinet; it is a European shape.[14] So also is the other common shape in this style, the coffer. Here, too, there is an early inventoried piece, the coffer at Gripsholm Castle presented to Gustavus II Adolphus of Sweden in 1616 by the States General.[15]

Meanwhile other mentions of Japanese lacquer can be found. In 1605 Louis XIII of France received, among 'ouvrages de la Chine', 'un parquet de bois, peint et doré par dedans, rapporté de Flandres'.[16] In 1609 the Camer of Zeeland had some unspecified lacquer, and William Kick made presentation furniture 'after the fashion of China'.[17]

In 1610 a Dutch East India Company ship landed at Texel with nine chests of lacquer.[18] In 1613 the English ship the *Clove* went to Japan to open a factory for the Honourable East India Company.[19] On the return journey Captain Saris wrote that he had 'some japan wares as ritch Scritoiries; Trunckes, Beoubes, Cupps and Dishes of all sorts, and of a most excellent varnish'. The scriptors were presumably like the Ambras chest, but with a fall-front – these are not at all uncommon. The 'Beoubes' were screens (*byobu*) and were presumably not lacquered. When they were sold they were described:

'Biobee or skreene guilded and painted with some
resemblances of warfare' £6
Another 'Biobee . . . portrayde full of horses'
 £4:13:0 and another £4:11:0
Three other 'Biobees of warfare' £5:12:0
 £5:13:4 and £6:15:0
Two 'portrayde with fowles' £3:3:0 and £4: 7:0
Three 'of huntinge' £10, £8:1:0 and £8: 5:0

All of these subjects for screen paintings are typical of the late Momoyama and early Edo periods.

These were sold because they were not good enough to serve as presents for the King – the Company already had better ones. This presupposes some considerable trade, probably with Portugal, in Japanese goods. These are still presents, destined to become collectors' items, not ordinary trade-goods.

So probably also were the Japanese swords, knives, paintings and pictures in the King's chamber seen by Prince Christian of Anhalt at Rosenborg Castle in 1623. He also saw 'an Indian carrier . . . built like a bed in which they carry their queen about'[20] which may well have been a Japanese palanquin (a *norimon*) such as those seen in Macao by Peter Mundy in 1637; 'The better sort [of women] are carried in hand chairs like the Sidens at London, all close covered, off which there are very Costly & ritche brought from Japan'.[21] A model of one is inventoried in the royal collection in Copenhagen in 1690.[22] Little else at this

[13] Irwin 1953; Impey 1982.
[14] For a fuller account see Impey 1977, pp. 111–26.
[15] Boyer 1959; pl. xxxii, 27; Gyllensvärd 1966, pp. 62–6.
[16] Lunsingh Scheurleer 1941, p. 58.
[17] Huth 1971, p. 14.
[18] Lunsingh Scheurleer 1941, p. 56.
[19] Satow 1900, p. 202, p. lxxiii.
[20] Quoted in Lach 1970, p. 24 n. 110.
[21] Temple 1919. Vol. 3, part 1, pp. 269–70.
[22] J. Hornby in Dam-Mikkelsen and Lundbæk 1980, p. 233, EAc140.

date seems to be identifiable as Japanese, though Saris had got into trouble for bringing home 'certaine lascivious books and pictures . . . which was held to be a great scandal unto this Companye and unbeseeminge their gravitie to permit'.[23]

Real trade seems only to have become securely established in the early years of the seventeenth century. Trade in lacquer, which was to be an important commodity throughout the seventeenth century, began in earnest in the 1620s, though porcelain was not exported from Japan to Europe until the 1650s.[24]

Although some Namban lacquers were for Christian (Jesuit) purposes, most of the lacquer was furniture; chests or coffers, scriptors or cabinets. Orders for these appear repeatedly in the Dutch documents until the 1680s. Fortunately we are able to see a progressive change of style which can be dated with some precision by the use of inventoried items and by documentary evidence. On the whole one can see a reduced use of pearl-shell inlay in favour of a painted lacquer decoration at first in a cartouche and then extending over the whole surface. Unusual shapes of furniture sometimes occur. But by the middle of the century, the commonest shapes are still the coffer (though it now usually has a flat top) and the scriptor or cabinet (fig. 104), whose doors now open at either side instead of as a fall front. These pieces are true trade-goods: they were made in Japan to European orders (nearly always, of course, Dutch orders), in European shapes for use in a European house.

There are, however, two other categories of lacquer wares which must be considered. The first of these is the special order made by a European, of which a few examples are:

(a) The van Diemen box, a special order of exceptionally high quality made as a gift for the wife of the Governor of Bantam probably between 1636 and 1639.[25]

(b) A lacquered shield bearing the arms of Constantijn Ranst who was chief merchant in Japan in 1668 and Governor of Bengal from 1669 to 1673.[26] Bengal had often ordered shields (since 1656) and had sent the leather to Japan to be lacquered.[27]

(c) In 1680 the Siam office ordered for Constant Phaulkon, the Greek adventurer who ruled Siam, 'two pairs very costly large Japanese dishes'.[28] These were to be presents to the Court of Louis XIV to which Phaulkon sent embassies in 1684 and 1686. Two dishes now in the Musée Guimet, about 35cm in diameter, bear labels from the time of the Revolution which read 'Emigré Condé'. It seems very likely that these are the dishes ordered in 1680.

Secondly, there are the pieces which arrived by chance. By far the best example is the famous picnic-set in Copenhagen which is inventoried from 1674 but which may well date from thirty years earlier.[29] Associated with it somewhat tenuously is a lacquer teabowl imitating raku pottery which is documented for 1665. Neither of these could be special orders for Europeans or trade-goods. There are other examples also in the Danish Royal Collection which do not conform to European shapes. Elaborate partitioned boxes and a

[23] Satow 1900, p. lxvii.

[24] For a general account of the porcelain and lacquer trade, see Impey 1977, pp. 89–99, 111–26; 1984. For detailed documentation of the porcelain trade, see Volker 1954, 1959. For a fuller account of the lacquer trade, see Lunsingh Scheurleer 1941; Impey 1982.

[25] A detailed discussion of this important piece is given by Earle 1984.

[26] See Impey 1983.

[27] Lunsingh Scheurleer 1941, p. 64.

[28] For these dishes, see Impey 1982, p. 139, pl. 8b.

[29] See J. Hornby in Dam-Mikkelsen and Lundbæk 1980, pp. 236–7.

lacquered pillow – inventoried for 1673 – do not seem more than curiosities. The four beautiful trays (of 1689) are easier to understand, and the saké cups of the same year may well be listed in the shipping documents as small dishes.

The trade in Japanese lacquered furniture came to an end in the 1680s:[30] the Chinese had undercut the price (and also, of course, the quality) and exported much lacquered furniture to Europe.

Of the other trade-goods in Europe which come from Japan before the eighteenth century, the most important are paper and porcelain. Japanese paper has always been of high quality, and was much in demand in Holland, where it was used, for example, by Rembrandt for etchings. Porcelain is another matter.

The Japanese had begun to make porcelain only in the first years of the seventeenth century,[31] having previously imported it from China. By the middle of the seventeenth century the porcelain factories of Arita achieved a considerable technical competence, and when the supply of Chinese porcelain dried up in the 1640s (owing to the collapse of the Ming dynasty and consequent civil war and disorder), the Dutch East India Company turned to Japan for their supplies. The first purchase (jars for the apothecary's shop in Batavia) was in 1650 (cf. fig. 105); the first order in 1653 and the first large order (56,700 pieces) in 1659. Thereafter pieces (sometimes thousands of pieces) were shipped to Europe (as well as around South East Asia) by the Dutch almost every year. This is fairly well documented in the papers of the Dutch East India Company,[32] but two other considerations have to be taken into account.

Firstly there was very considerable private trade in porcelain by members of the Company either as 'perks' or illegally.[33] Secondly, the Chinese merchants also bought Japanese porcelain to sell to Europeans other than the Dutch in other eastern ports. Thus old collections in Holland do not look quite like old collections in England, France or Germany. These latter had been bought from the Chinese and not from the Dutch.

These considerations also make it difficult to estimate the quantities of porcelain exported from Japan. There are no records of the quantities of Japanese porcelain bought by the Chinese, though they must have been considerable. Nor are the Dutch figures reliable as they (obviously) ignore the private trade. Where there are Japanese records[34] to compare with the Dutch (only for the years 1709–11), then the quantities recorded as purchased by the Dutch are sometimes smaller than the quantities recorded as sold to the Dutch by the Japanese by a factor of fourteen.[35]

The types of porcelain exported to Europe were those made at Arita – blue-and-white (usually called Arita in Europe) – the enamelled wares usually called Imari after the port through which they were shipped to Nagasaki and hence abroad, and the specially fine Kakiemon wares.[36] In all of these wares (which are of course very closely related) we can see developments of style, colours and techniques. As substitutes for Chinese porcelain they nevertheless achieved their own identity, and, indeed, when the Chinese again

[30] Jörg 1981, p. 59.
[31] Jenyns 1965.
[32] Volker 1954, 1959.
[33] Nishida 1974.

[34] *Toban Kamotsu Cho* reprinted 1971.
[35] For figures, see Impey 1984, p. 694.
[36] Jenyns 1965; Impey 1977.

competed in the export porcelain market in the 1720s, one type which was made was in imitation of Japanese Imari.

As far as dates go, the heyday of the Japanese export porcelain trade was from 1659 to about 1730. Some pieces are securely datable by inventories, imitations and depictions. The inventory taken by Burghley House[37] in 1688 mentions several pieces which are easily identifiable for they are still in the house – for instance two large elephants, two blue-and-white birds, and two China boys wrestling (fig. 106). On the ceiling of the Oranienburg in Berlin, now destroyed, was a painting of a jar done by Terwesten before 1695, which is a copy of a well-known type.[38] The greatest of all collections is at Dresden, where Augustus the Strong, King of Poland and Elector of Saxony, accumulated a vast collection of Chinese and Japanese porcelain, mostly inventoried and marked between 1723 and 1730.[39]

But still we are talking of trade-goods. However, in Dresden there are some oddities – two pairs of Kyoto pottery hanging flower-vases.[40] This is not an export ware, nor a shape much used in Europe – it is the ceramic equivalent of the Copenhagen picnic set.

One thing that is noticeable is the occurrence in old collections of identical pieces which are not common. Thus, three great country-house collections in England have marked similarities. I refer to Burghley House of the Cecils, Welbeck Abbey of the Cavendish–Bentincks, and Drayton House of the Stopford–Sackvilles. This similarity occurs both in lacquer and in porcelain and suggests purchases from the same dealer or from auctions of the same shipment, over a considerable period of collecting. Whether or not this is collecting, as opposed to the mere furnishing of a house, is debatable. But we do know how highly porcelain was regarded in the late seventeenth century from two documents in Burghley House; the 1688 inventory[41] drawn up by Culpepper Tanner and the will of Elizabeth, dowager Countess of Devonshire (1690), in which she bequeathed to her daughter Anne, Countess of Exeter, the contents of her bedroom and closet which included over 150 pieces of porcelain, listed in some detail.

In the eighteenth century, one of the Duchesses of Portland is described as a 'fanatical' collector[42] – but this term was to be even more appropriately applied to William Beckford.

Beckford collected, *inter alia*, fine Japanese lacquer;[43] in this he followed the French example, for Japanese lacquer had been collected by such persons as the Duc de Lorrain and Mme de Pompadour. These collections were not of export lacquer; they were more of the finer, later lacquers which were not made for export, but were nevertheless imported in relatively small numbers by the Dutch, mostly as items of private trade.

One pair of objects can perhaps sum up the Japan trade. The van Diemen box and its pair, the Buys box.[44] These pieces were of exceptional quality, made, possibly in the Koami workshops, as gifts to the wives of two high officials of the Dutch East India

[37] Burghley House 1983 identifies several pieces in the inventories, still in the house.
[38] See Nishida 1974; for an illustration, see Jenyns 1965 pl. 57B.
[39] For a discussion of the Dresden collection, see Jenyns 1965 and Reichel 1981, who include many pictures of securely datable items.

[40] Impey 1974.
[41] Burghley House 1983.
[42] Jenyns 1965.
[43] See Watson 1963.
[44] Earle 1984.

Company. In the eighteenth century they belonged to Mme de Pompadour from whom they passed indirectly to William Beckford. Beckford had one, the Buys box, carefully dismembered, and the pieces inlaid into two pieces of furniture by Vulliamy; these are now in a private collection. The other, the van Diemen box, is one of the treasures of the Victoria and Albert Museum.

INDIAN ART AND ARTEFACTS IN EARLY EUROPEAN COLLECTING

Robert Skelton

Before beginning to consider Indian objects which reached European collections during the sixteenth and seventeenth centuries, one must remind oneself of the danger into which a naïve orientalist might fall if he is unwise enough to start floundering among those hallowed texts to which devotees of the *Wunderkammer* pay such reverence. Whereas to the innocent the term 'Indian' applies only to things originating in India, this was certainly not the case when inventories of the early European collections were compiled. In these, as is well known, the word has a much wider meaning, so instead of puzzling over those enigmatic lists the present paper will be confined to a consideration of particular objects in European collections which are reasonably believed to have arrived from India or Ceylon by the beginning of the eighteenth century.

One celebrated object, which has long been considered to fall within this brief, is a rock crystal elephant supporting a bowl which is now in Vienna.[1] It perhaps seemed natural to suppose that this was an Indian object because of its subject matter, but there is one very simple rule of thumb by which such an attribution can be tested.[2] Does it really look like an elephant? The answer is no and that means it is not from India or Ceylon. If this seems a crude way of solving this problem, one only has to look at the end of a famous sixteenth-century ivory box from Munich[3] where an elephant is shown moving forwards with stately and rhythmic grace. By contrast with the ungainly and misproportioned form of the crystal, the outline of the ivory carving is defined by bounding curves suggesting both volume and movement, and the head is correctly proportioned in relation to the trunk.

It now appears that Wolfgang Born, who published the elephant with other hardstones from the Habsburg collections, was rather unlucky with his attributions to India since none were correct. For example, the jewelled thumb-rings in Vienna are not Mughal but Turkish.[4] It is only very recently that we have learned to distinguish between Mughal and Turkish hardstone carvings[5] and all that one can say about the elephant is that it is neither Mughal nor Turkish. It is possibly European.

About the Munich ivory casket there is no such difficulty. The *Schatzkammer* has two of these and as Dr Seelig shows (p. 83) they came to Duke Albrecht V direct from the agents of Marx Fugger in Lisbon and were in the inventory by 1598. The other of these two

[1] Born 1936, pl. IID.
[2] The test applies mainly to objects made by skilled professionals under court or bourgeois patronage.

[3] Thoma and Brunner 1964, p. 46.
[4] Born 1940, fig. 3.
[5] Skelton, 1978.

superb caskets is documented further by two scenes on the front depicting an historical event. Unusually, however, this event had not yet happened when the casket was made.

In 1521, the Kingdom of Kotte in Ceylon was partitioned and King Bhuvaneka Bahu, who got the richest portion, was in danger of being ousted by his ambitious younger brother. Although the king had descendants, his sons were born to a junior queen so he wanted the succession to go to the son of his daughter by the senior queen. This would have provided his brother with a perfect excuse to interfere so Bhuvaneka Bahu sent ambassadors to Lisbon in 1540 with various presents, including this box, which showed the king of Portugal what he wanted. On the left, ambassadors introduce a golden statue of the grandson to the King of Portugal, who is shown to the right crowning the statue and thus assuring the young heir of Portuguese protection.[6] The crowning took place in 1543.

These caskets in Munich are not only two of the finest documented examples of *exotica* to have reached Europe by the middle of the sixteenth century; they are also very rare examples of Sri Lankan ivory carving. Until recently only four other such caskets were known.[7] Recently another has been acquired by the Victoria and Albert Museum. Something is known of its history because in 1888 it was displayed at a meeting of the Society of Antiquaries by Sir J. C. Robinson,[8] who had played a major role in building up the Museum's collections in its early days. Robinson acquired this casket in Portugal and, although we know nothing about its origins, the fitted case covered with early eighteenth-century Italian silk suggests that it had already reached a European collection by this time. Unlike the caskets in Munich it has Christian subject matter and may have been designed as a gift for some dignitary of the Church.

Another type of ivory object which reached European collections at an early date is represented by a group of priming flasks in Copenhagen.[9] These were there by 1737 and in one case by 1690. Their origin is specified by an inscription on one: 'This powder horn is made in East India by the blacks.'[10] There is an even earlier record of one of these at Dresden, which was in the collection of Johann Georg II by 1658.[11] Judging from the Mughal costume of figures on the side, it was made during the early seventeenth century and thus travelled to Europe soon after its manufacture. An ivory horn mentioned to me by Ronald Lightbown[12] is possibly from this group also.

Continuing with this topic of objects connected with war and the chase, it is quite clear from the inventories and accounts of collections that Indian weapons reached Europe both direct and via the Turks. Daggers are often mentioned but it is not always certain whether they really were Indian except for one type, which is very distinctive. This is the characteristic Indian 'punch dagger' or *katar*, which is found in some numbers in, for example, both Copenhagen[13] and Oxford. As these went on being made with very little change of form or decoration over a long period, it is extremely helpful for us to know that the Copenhagen ones all appear to have been in Gottorp by 1743 and one of those in

[6] Brunner 1970, pl. 78.

[7] Two in the Kunsthistorisches Museum, Vienna (inv. nos. 4743, 4745): Born 1936, pl. III; one formerly on London art market: Ashton 1950, pl. 73; one in the Völkerkunde Museum, Berlin: Keil 1938, figs. 10–14.

[8] Robinson 1888, pp. 267–8.

[9] Dam-Mikkelsen and Lundbæk 1980, pp. 111–12.

[10] Ibid., p. 112, EDb62.

[11] Skelton *et al.* 1982, p. 135, no. 439.

[12] Lightbown, personal communication.

[13] Dam-Mikkelsen and Lundbæk 1980, pp. 106–7.

Oxford may be the 'Indian square-pointed Dagger, broad and flat' of the Tradescant catalogue.[14]

Four swords, also in Copenhagen,[15] include two Nepalese *korahs*, which presumably came via Bengal and are believed to be from a group of seven East Indian scimitars listed in 1674. Another of this group illustrates the re-export of European manufactures traded to the East. Although the hilt is Indian, the blade is Danish and bears the mark of Christian V.[16] A necessary defence against weapons such as these are shields such as the 'Targets' listed in Tradescant's catalogue.[17] He had 'East India' examples of 'Reeds, Leather, Skins, and Crocodill-skin'. However, those which we can see in Oxford today are not Indian and to find an early import from Europe we may go to the Bargello where there is a very fine Indian shield which perhaps formed part of the Medici collections in the sixteenth century.[18]

This shield introduces us to an important group of Indian decorative artefacts, which are referred to by a number of sixteenth-century and later writers and have reposed in several old collections without attracting the attention of Indian art historians until very recently. The pioneer of this subject, Mr Simon Digby, has very kindly let me consult his paper being published in the proceedings of a symposium held in London in 1982.[19] Most of these objects share a technique which uses mother-of-pearl set in black lac on a wooden carcass, and the Bargello shield is dated by Mr Digby to between 1540 and 1570. The centre of production was Gujarat, and besides satisfying an important demand in India itself, the local industry exported examples of the technique to the Near East – especially Turkey – and also to East Africa. The earliest recorded example was 'a bedstead of Cambay wrought with gold and mother-of-pearl' which was given to Vasco da Gama on his second outward voyage in 1502 by the East African King of Melinde.

Examples of overlaid mother-of-pearl work still surviving in historic collections include a charming pair of sandals[20] which were in Gottorp by 1710 and the casket[21] which was seen by Wolfenbüttel at Dresden in 1629. A similar casket can be seen in the Ashmolean Museum[22] but this is a recent acquisition whose early history is not known. As Mr Digby has shown, a great variety of objects were decorated in this technique for both the home and export markets, and one class which was particularly exported to Europe was the drop-fronted cabinet or *scrutori*. These were also decorated in other techniques in Western India and a large number reached England during the seventeenth and eighteenth centuries. Later examples, such as a painted cabinet from Sind of the late seventeenth century, have doors which open sideways.[23] This example, which was repainted on the outside at a later date, has descended in the English family of its early owner, John Fotherley (1652–1702) of The Bury, Rickmansworth, but it is not clear how it entered his possession. A larger example of *c.*1700 inlaid in ivory also remained in the family of its original owner, who was a British merchant trading in the East.[24] Most of such cabinets

[14] Tradescant 1656, p. 45.
[15] Dam-Mikkelsen and Lundbæk 1980, pp. 106–9, ECb2, ECb4, EDb105–6.
[16] Ibid., pl. 108, EDb106.
[17] Tradescant 1656, p. 45.
[18] Digby forthcoming.

[19] Ibid.
[20] Dam-Mikkelsen and Lundbæk 1980, p. 123, EDc1–2.
[21] Menzhausen 1968, pl. 43.
[22] Skelton *et al.* 1982, p. 162, no. 551.
[23] Ibid., p. 162, no. 547.
[24] Ibid., p. 163, no. 556.

were produced in Gujarat or Sind but in this case the figure drawing indicates that it was made in the Deccan.

Two much more celebrated pieces of furniture are the chair and chest in Uppsala, which were published in 1934 by Slomann who argued[25] that they were Mughal work of about AD 1580. Whatever they are, they are not Mughal and perhaps the closest parallel to their rather feeble decoration is a small group of boxes which appear to be South Indian work of the eighteenth century.[26] There is, however, a difficulty. According to Slomann, the chest has the arms and initials of Clas. Fleming (married 1573, died 1579) and his wife Ebba Stenboch (d. 1614). The chair has an inscription giving the name of Ebba Stenboch's sister, the Queen Catherina Stenboch, who died in 1624, sixty-four years after her husband Gustavus I (Vasa). Slomann admits that this last inscription has been doubted[27] and, taking the style of decoration into account, it seems that these two pieces may not be quite what they pretend to be.

Two chairs associated with another Queen, Catherine of Braganza, in the Founder's Collection of the Ashmolean, create less of a problem because there is no reason to question their date. They belong to a vast series of chairs made under Portuguese and Dutch influence in Ceylon during the late seventeenth century. Such furniture is well known in Holland and for some reason, as yet unknown, it appears very plentifully in English country houses. Eighteen chairs and two tables in highly carved ebony were at Strawberry Hill and some of them can be seen in engravings of the Holbein Chamber and other parts of the house.[28] Similar chairs are seen in an illustration of the interior of Fonthill.[29] Both the collectors, Horace Walpole and William Beckford, found such furniture very much to their taste and Walpole was convinced that the pieces were Tudor. He bought them at Lady Conyers' sale at Staughton in Huntingdonshire in 1763 and in a letter about the purchase he states that there was virtually nothing but ebony in the house.[30] Unfortunately we do not know how this furniture came into the possession of the Conyers family.

Turning now to the topic of soft furnishings, one moves even further from the arcane mysteries of the microcosm which obsessed the eccentrics of the *Wunderkammer* to the mundane sphere of trade and domestic comfort. When Europeans intervened in the Asian spice trade, they soon discovered the need to use Indian cotton-paintings as barter goods and from this they proceeded to discover a market in Europe itself.[31] The famous chintz from Ashburnham House in Sussex[32] illustrates the type of textile exported in the late seventeenth and eighteenth centuries, which were greatly in vogue and were shipped here in their thousands. Although they were much sought after and are esteemed greatly now, we can hardly call them rarities in the sense that has dominated our discussions. The acquisition of a fine carpet, however, was rather more difficult.

In 1630 Robert Bell, one of the founding merchants of the East India Company, commissioned a colleague sailing to India to order a carpet bearing his own device and the

[25] Slomann 1934, pp. 119–20.
[26] Haags Gemeentemuseum 1967, no. 58.
[27] Slomann 1934, p. 120.
[28] Mordaunt Crook 1973, p. 1601, pl. 7.
[29] Britton 1823, pl. X and p. 57.

[30] Toynbee 1927, p. 121. I am grateful to Mr Clive Wainwright for this reference.
[31] Irwin and Brett 1970, p. 3.
[32] Ibid., p. 67, no. 7.

arms of the Girdlers' Company to whom he intended to present it. Eventually, after some delay, the work was completed in Lahore and the carpet reached England in 1634.[33] Another carpet commissioned in similar circumstances bears the arms of the East India merchant William Fremlin and is now in the Victoria and Albert Museum.[34]

Carpets – like the Girdlers' carpet, which was inkstained – are known to have been used on tables and the seventeenth-century use of Indian imports for this purpose is seen in a painting made for the Sheriff of Cheshire, Sir Thomas Ashton, on the occasion of his wife's death in 1635.[35] The table cover depicted in this painting has been identified as a chintz, but the motifs resemble those of a group of Indo-Portuguese embroideries, which may now be attributed to Sind.[36]

A more princely heirloom is the gold brocade with rows of flowers, which has come down in the family of the Earl of Northesk.[37] According to family tradition this was the christening cloth of a Stuart prince. Gold brocades with floral diaper appear on the evidence of paintings to have been rare when the traveller Mandelslo reported from Ahmedabad in 1638 that related brocades were reserved for Imperial use.[38] In view of this it seems not impossible that the cloth was sent as a diplomatic gift to Charles I. The more certain gift of a manuscript to this unfortunate monarch is mentioned below. Meanwhile two other Indian textiles with royal associations are the tusser silk embroideries which belong to the Swedish Royal Collection and Schloss Ambras.[39] The latter is reputed to have been the bed-cover of Phillipine Welser, the wife of Archduke Ferdinand. Such textiles were certainly made in her lifetime but it appears that there is no evidence for the association of the coverlet with her. However, these embroideries in yellow tusser silk on cotton were made in Bengal for the Portuguese during the sixteenth century, so in view of the Welser family's connections with Indo-Portuguese trade the undocumented association with Phillipine is not entirely implausible.

To conclude with a brief discussion of paintings and sculptures one may mention an album of portraits which are thought to have belonged to the Dutch scholar and travel writer Nicholas Witzen, who was at one time Burgomaster of Amsterdam.[40] They are typical of several known sets of portraits of Mughal and Deccan rulers and nobles painted in Golconda in about 1680.[41] According to Hermann Goetz, they were probably brought back from Golconda by the Dutch ambassador Laurens Pit in 1686 just before the Mughal conquest of the city. Soon after this a similar album, now in Paris,[42] was acquired by the Italian traveller Nicolao Manucci while travelling with the Mughal camp. Hermann Goetz conjectured that Witzen also came into the possession of Indian paintings which in Sarre's opinion were among the pictures of costumes sold by Rembrandt in 1656 together with items of Indian dress.[43]

Whether or not Rembrandt actually owned these, we know that more than twenty Indian miniatures were copied by him and that some of these can now be found on the

[33] Irwin 1962.
[34] Irwin 1965, pp. 18–19.
[35] Collins Baker 1928, p. 132, no. II; p. 133, no. III.
[36] Unpublished.
[37] Skelton *et al.* 1982, p. 86, no. 218.
[38] Mandelslo 1719, col. 80.
[39] Geijer 1951, p. 119, no. 120; Irwin 1952, fig. 15.
[40] Goetz 1936, pp. 11 ff.
[41] E.g. Titley 1977, pp. 12–14, nos. 26, 29.
[42] Bibliothèque Nationale, Paris, MS O.D. 45, see Manucci 1907–8, vol. I, pp. liii–lv.
[43] Sarre 1904, pp. 143–58.

walls of the *Millionenzimmer* of the Schönbrunn in Vienna.[44] A drawing of four learned Muslim shaykhs is directly copied from a Mughal miniature of 1627 which we see at the bottom left of a composite panel in Vienna.[45] The Emperor Jahangir receiving an officer appears in the centre of another rococco frame[46] and a drawing of Akbar and Jahangir seated together is related to another drawing copied from a divided Mughal miniature in Vienna, which shows Tamburlane and his descendants with Akbar and Jahangir in the foreground.[47]

In actual fact the clouds and putti above the two great Mughals show that Rembrandt had access to a picture of them in apotheosis such as one now in the Bodleian Library.[48] This is also confirmed by a pair of paintings by the seventeenth-century Dutch artist Willem Schellinks which depict the Emperor Shah Jahan watching his four sons parade on a stage riding Arcimboldesque animals.[49] A comparison between Rembrandt's drawing and the detail of the same Emperors in apotheosis in Schellinks's painting in the Victoria and Albert Museum shows that both Dutch masters borrowed from the same Mughal source.

The subsequent history of Rembrandt's drawings is interesting in relation to an Indian painting of two lovers very recently acquired by the Ashmolean Museum, which bears the stamps of John Richardson senior (1665–1745), his son John Richardson junior and also the initials of John Barnard, who died in 1784.[50] Eighteen of Rembrandt's Indian drawings were in Richardson's sale of 22 January 1747 and an album of twenty-five Indian drawings was sold on the following day.[51]

If Oxford has only just acquired this Indian miniature from a distinguished early collection, others came to the city even before the Ashmolean was founded. These are an album of provincial Mughal paintings donated by Archbishop Laud to the Bodleian Library in 1640.[52] We know of Laud's interest in oriental studies which bore fruit when he founded the chair of Arabic in Oxford, but the source of his Indian album is not known.

In another slightly earlier case, however, we know the source but the whereabouts of the paintings, if they still exist, is unknown to us. The two, or possibly three, pictures were engraved by Purchas in his celebrated compilation of travel narratives.[53] The engraving appears as an illustration to the account by Edward Terry, who visited India as chaplain to Sir Thomas Roe, the first British Ambassador to Jahangir. The figure on the right of this engraving is Jahangir himself and the Persian inscription engraved below after what was clearly the Emperor's own handwriting states that 'it was painted by Manohar in the town of Mandu in 1026 Hijri [i.e. AD 1616] when I was in my fiftieth year'. Roe and Terry were both with the Emperor in Mandu when the picture was painted there.

Whether or not this was a royal gift to the ambassador or his monarch we shall never know, but we are on firmer ground with a manuscript in the Chester Beatty Library, which was bound with the royal coat of arms of George IV and sent as a gift to the ruler of

[44] Strzygowski and Goetz 1923.

[45] Ibid., pl. 6E; Benesch 1954–7, vol. 5, pp. 335–6, no. 1187, fig. 1411.

[46] Benesch 1954–7, vol. 5, pp. 337–8, no. 1190.

[47] Ibid., pp. 336–7, no. 1188, fig. 1413; Strzygowski and Goetz 1923, pl. 55F.

[48] Bodleian Library, Oxford, MS Douce Or. a.1, fol. 19r.

[49] In Musée Guimet, Paris (Auboyer 1955), and Victoria and Albert Museum, London, inv. no. I.S. 30–1892.

[50] David and Soustiel 1983, pp. 74–5.

[51] Benesch 1954–7, vol. 5, p. 336.

[52] Bodleian Library, Oxford, MS Laud. Or. 149; see Stooke and Khandalavala 1953, pp. 8–9.

[53] Roe 1899, f. p. 114, p. 562.

Persia in 1827.[54] How it entered the British Royal Collection is revealed by a note in the hand of Jahangir's son, Shah Jahan, who wrote on the flyleaf in AH 1048 (AD 1638) that he sent it as a gift to 'the glorious and exalted King of England'. We know that this was not the only Indian object in Charles I's collection because of a note in the 1638 inventory of the Royal Collection which reads: 'Item in the same window an East Indian Idoll of black brasse which was sent by my Lord Denby taken out of there churches from there altar.'[55]

Although there are other references to Indian images in early inventories, little survives to suggest that much of real importance arrived before the eighteenth century, when missionaries sent bronzes and other images to countries such as Italy and Denmark.[56] One conspicuous exception to this is the Ashmolean's fine medieval Pala image of Vishnu which, as Dr Harle has recently shown,[57] was listed in the Book of Benefactors as the gift in 1695 by Sir William Hedges of 'an Indian image called Gonga' acquired by him from a pagoda on the island of Saugar in the Ganges delta. Although Ganga is really the name of the goddess Ganges, Dr Harle has been able to demonstrate that the four-armed god was elsewhere given this misappellation during the period and thus we may conclude with him that this is 'the first important piece of Indian sculpture in the West whose acquisition by a museum is recorded and which can be identified today'.[58]

[54] Wilkinson 1957.
[55] Millar 1958–60, p. 94.
[56] Dam-Mikkelsen and Lundbæk 1980, pp. 114–15; Cimino 1982, pp. 97, 102.

[57] Harle 1983.
[58] I am indebted to my colleagues Veronica Murphy and Timothy Wilcox for some of the information incorporated in this paper.

BIBLIOGRAPHY

MANUSCRIPT SOURCES

Augsburg
Staats- und Stadtbibliothek
MS Cim.66

Bologna
Biblioteca Universitaria
Aldrovandi MSS 6, 21, 26, 70, 136
[U. Aldrovandi] 'Tavole di Animali I'

Archivio di Stato
Fondo Ranuzzi-Cospi, 'Vita del Sig. March.ᵉ Balì
Ferdinando Cospi Senat.ʳᵉ di Bologna Scritta
Dal Sen.ʳᵉ Co. Ferdinando Vincenzo Ranuzzi
Cospi'

Copenhagen
Royal Library
G1.k.S. 3467, 8 [Inventory of Paludanus's collection at Enkhuizen]

Dresden
Staatsarchiv
MS Loc.9835 [G. Kaldemarck, 'Bedenken, wie
eine Kunst-Cammer aufzurichten seyn
möchte' (1587)]

Florence
Biblioteca Nazionale
MS Targioni Tozzetti 56 [A. del Riccio, 'Agricoltura teorica']
MS Targioni Tozzetti 56² [A. del Riccio, 'Agricoltura sperimentale']

Leningrad
Central Archive of Ancient Acts
Fond IX, list 2, bk. 62

Hermitage Library
No. 20005

London
British Library
MSS Sloane 4047, 4057, 4069 [Sloane Letter Books]

Museum of Mankind
MS 'Catalogue of Miscellanies'

Public Record Office

State Papers, Colonial Series, 1574–1660, vol. 1
State Papers Domestic, Charles I, iv, 1625, nos. 155–6
Royal Society
Account Books
Domestic MSS vol. 5
Miscellaneous MSS vol. 16
MSS 413–17, CMB 63

Madrid
Biblioteca Nacional
MS 1872745 [V. J. de Lastonosa, description of his house and garden]

Milan
Biblioteca Ambrosiana
MS S 85 sup. M [Indice del museo di Antonio Giganti]
MSS Z 387–9 sup. ['Il museo Settala']

Modena
Biblioteca Estense
MSS Campori y H 1.21–2

Munich
Bayerische Verwaltung der staatlichen Schlösser,
Gärten und Seen
Inv. nos. 31, 128–34

Bayerisches Hauptstaatsarchiv
MF 55794/2 [building records of the Munich
Kunstkammer]
Kurbaiern Äusseres Archiv 4851, 4853

Bayerische Staatsbibliothek
MSS cgm 2133, 2134 [J. B. Fickler, Inventory of
the Munich Kunstkammer (1598)]
MS Mus. A I [S. Quiccheberg, Commentary on
the penitential psalms of Orlande de Lassus]

Oxford
Bodleian Library
MS Add. B 67
MSS Aubrey 2, 4, 12, 17
MS Bodley 594
MS Douce Or. a.I.
MS Laud Or. 149
MSS Rawlinson C865, D84, D912
MS Top. Gen. c24

Christ Church College Library
MS Evelyn 45 [J. Evelyn, 'Elysium Britannicum']

Paris
Bibliothèque Nationale
MS O.D. 45

Wolfenbüttel
Herzog August Bibliothek
Cod. Guelf. 17.23 Aug.4°; 17.24 Aug.4°; 17.27 Aug.4°; 60.9 Aug.2°; 60.22 Aug.4°; 83 Extrav. 2°

PRINTED SOURCES

Abranches Pinto, J. A., Okamoto, Y. and Bernard, H., 1942. *La première ambassade du Japon en Europe, 1582–1592* (Tokyo).

Académie des Sciences (Paris), 1735–77. *Machines et inventions approuvées par l'Académie royale des Sciences, depuis son établissement jusqu'à présent* (Paris).

Accordi, B., 1977. 'The Musaeum Calceolarium (XVIth century) of Verona illustrated in 1622 by Ceruti and Chiocco', *Geologica Romana* 16. 21–54.

—— 1980. 'Michele Mercati (1541–1593) e la Metallotheca', *Geologica Romana* 19. 1–50.

—— 1981a. 'Tentativi di classificazione delle pietre e delle gemme nei secoli XVI e XVII', *Physis* 23. 311–24.

—— 1981b. 'Ferrante Imperato (Napoli 1550–1625) e il suo contributo alla storia della geologia', *Geologica Romana* 20. 43–56.

Ackerman, J. S., 1954. *The Cortile del Belvedere* (Vatican).

Acton, W., 1691. *A New Journal of Italy* (London).

Adams, F. D., 1938. *The Birth and Development of the Geological Sciences* (London).

Agricola, G., 1546. *De ortu et causis subterraneorum* (Basle).

Aimi, A. 1983. 'Il Museo Settala: i reperti americani di interesse etnografico', *Archivio per l'Antropologia e l'Etnologia* 113. 167–86.

Aimi, A., de Michele, V. and Morandotti, A., 1984. *Musaeum Septalianum. Una collezione scientifica nella Milano del seicento* (Florence).

Alberici, C., 1983. 'Un automa del Museo Settala', *Rassegna di Studi e notizie* 10. 37–67.

Alberti, L. B., 1911. *Zehn Bücher über die Baukunst* (trans. and ed. M. Theuer) (Leipzig).

Aldrovandi, U., 1602. *De Animalibus Insectis Libri septem* (Bologna).

—— 1616. *De Quadrupedibus Solidipedibus* (Bologna).

—— 1621. *De Quadrupedibus Bisulcis* (Bologna).

—— 1637. *De Quadrupedibus digitatis viviparis* (Bologna).

—— 1642. *Monstrorum Historia* (Bologna).

—— 1648. *Musaeum Metallicum* (Bologna).

Alessandrini, A., 1978. *Cimeli Lincei a Montpellier* (Rome).

Alfter, D., 1981. 'Die Geschichte des Augsburger Kabinettschranks' (unpublished typescript).

Alifer, I. A., 1680. *Manfredo Septalio Academia Funebris publice habita* (Milan).

Allan, J. W. and Raby, J., 1982. 'Metalwork', in Y. Petsopoulos (ed.), *Tulips, Arabesques and Turbans* (London), pp. 17–71.

Allan, M., 1964. *The Tradescants, their Plants, Gardens and Museum 1570–1662* (London).

Allen, D. C., 1949. *The Legend of Noah* (Urbana).

Altick, D., 1978. *The Shows of London* (Cambridge, Mass., and London).

Anders, F., 1965. 'Der Federkasten der Ambraser Kunstkammer', *Jahrbuch der Kunsthistorischen Sammlungen in Wien* 61. 119–32.

—— 1978. 'Der altmexikanische Federmosaikschild in Wien', *Archiv für Völkerkunde* 32. 67–80.

Anders, F., *et al.*, 1970. 'Tesoros de Mexico. Arte plumario y de mosaico', *Artes de Mexico* 137.

Andreae, J. V., 1649. *Seleniana Augustalia* (Ulm).

—— 1916. *Christianopolis* (trans. F. E. Held) (New York).

Andree, R., 1894. 'Brasilianische Ankeraxt im Herzoglichen Museum zu Braunschweig', *Globus* 65. 17–19.

—— 1888. 'Die altmexikanischen Mosaiken'. *Internationales Archiv für Ethnographie* 1. 214–15.

—— 1901. 'Alte westafrikanische Elfenbeinschnitzwerke im Herzogl. Museum zu Braunschweig', *Globus* 79. 156–9.

—— 1914. 'Seltene Ethnographica des Städtischen Gewerbe-Museums zu Ulm', *Baessler-Archiv* 4. 29–38.

Andrup, O., 1933. *Den Kongelige Samling paa Rosenborg gennem Hundrede Aar* (Copenhagen).

Anon., 1680. *Inventario semplice di tutte le materie esattamente descritte che si trovano nel Museo Cospiano. Non solo le notate nel libro già stampato e composto dal Sig. Dottore Lorenzo Legati ma ancora le aggiuntevi dopo la Fabrica* (Bologna).

—— 1888–9. 'Inventar des Nachlasses Erzherzog Ferdinands II. in Ruhelust, Innsbruck und Ambras vom 30. Mai 1596', *Jahrbuch der Kunsthistorischen Sammlungen des Allerhöchsten Kaiserhauses* 7. cclviii–ccxiii; 10. i–x.

Ansaldis, A. de, 1689. *De commercio et mercatura discursus legales* (Rome).

Arco y Garay, R. del, 1913. *Revista de Historia y genealogía espagñola* (n.p.).

—— 1934. *La erudición española aragoñesa en el siglo XVII en torno a Lastanosa* (Madrid).

—— 1950. *La erudición en el siglo XVII y el cronista de Aragon Andres de Uztarroz* (Madrid).

Argenville, A. J. D. d', 1742. *L'histoire naturelle, la Lithologie et Conchyliologie . . . de la Société Royale des Sciences de Montpellier* (Paris).

Ashton, L. (ed.), 1950. *The Art of India and Pakistan* (London).

Astell, M., 1696. 'Character of a Vertuoso', in *An Essay in Defence of the Female Sex*, 2nd edn. (London).

Auboyer, J., 1955. 'Un maitre hollandais du XVIIᵉ s'inspirant des miniatures mogholes', *Arts Asiatiques* 2. 251–73.

Ayers, J., 1969. *The Baur Collection. Chinese Ceramics, II: Ming Porcelains* (Geneva).

Baader, B. P., 1943. *Der bayerische Renaissancehof Herzog Wilhelms V.* (Leipzig and Strasbourg).

Bachtler, M., Diemer, P., and Erichsen, J., 1980. 'Die Bestände von Maximilians I. Kammergalerie. Das Inventar von 1641/1642', *Quellen und Studien zur Kunstpolitik der Wittelsbacher vom 16. bis zum 18. Jahrhundert* (Munich), pp. 191–252.

Bacon, F., 1857–74. *Works* (eds. J. Spedding, R. L. Ellis, and D. N. Heath) (London).

Baklanova, N. A., 1947. *Velikoe posolstvo za granitzej v 1697–1698, Petr Velikij* (Moscow and Leningrad).

Balfour, Sir A., 1700. *Letters Written to a Friend . . .* (Edinburgh).

Balsiger, B. J., 1970. 'The Kunst- und Wunderkammern. A Catalogue Raisonné of Collecting in Germany, France and England 1565–1750' (Ph.D. thesis, University of Pittsburg).

Baltische Studien, 1834. *Baltische Studien* 2 (Stettin).

Baltrušaitis, J., 1956. 'L'anamorphose à miroir à la lumière de documents nouveaux', *La Revue des Arts* 6. 85–98.

—— 1969. *Anamorphoses ou magie artificielle des effets merveilleux* (Paris).

Bapst, G., 1889. *Les Joyaux de la Couronne de France* (Paris).

Bär, M. (ed.), 1895. 'Lupold von Wedels Beschreibung seiner Reisen und Kriegserlebnisse 1561–1606', *Baltische Studien* 45. 573–7.

Barbaro, D., 1568. *La practica della prospettiva* (Venice).

Barnard, F. P., 1917. *The Casting-Counter and the Counting Board: A Chapter in the History of Numismatics and Early Arithmetic* (Oxford) [reprinted Castle Cary, 1981].

Bartholin, T., 1662. *Domus anatomica hafniensis* (Copenhagen).

Bassani, E., 1975. 'Antichi avori africani nelle collezioni medicee', *Critica d'Arte* 143. 69–80; 144. 8–23.

—— 1977. 'Oggetti africani in antiche collezioni italiane', *Critica d'Arte* 151–3. 151–82; 154–6. 187–202.

—— 1978. 'Les Sculptures Vallisnieri', *Africa-Tervuren* 1.

—— 1979. 'Gli olifanti afroportoghesi della Sierra Leone', *Critica d'Arte* 163–5. 175–201.

—— 1980. 'Il collezionismo esotico dei Medici nel Cinquecento', *Le Arti del Principato Mediceo* (Florence), pp. 55–72.

—— 1982. 'The rediscovery of an ancient African ivory horn from the King's Cabinet described by Daubenton', *Res* 3. 5–14.

Bassett, M. G., 1982. *'Formed Stones', Folklore and Fossils* (National Museum of Wales, Geological Ser. 1) (Cardiff).

Bate, J., 1634. *The Mysteryes of nature and art* (London).

Bateman, C., and Cooper, J., 1728. *A Catalogue of the Library, Antiquities, &c. of the late Learned Dr. Woodward* (London).

Bátori, I., 1969. *Die Reichsstadt Augsburg im 18. Jahrhundert, Verfassung, Finanzen und Reformversuche* (Veröffentlichungen des Max-Planck-Instituts für Geschichte 22) (Göttingen).

Bauer, R., and Haupt, H. (eds.), 1976. 'Das Kunstkammerinventar Kaiser Rudolfs II, 1607–11', *Jahrbuch der Kunsthistorischen Sammlungen in Wien* 72.

Bausch, J. L., 1666. 'De unicornu fossili schediasma', in J. M. Fehr (ed.), *Anchora sacra* (Jena), pp. 169–204.

Bayerische Akademie, 1893. 'Die Bildnisse der herzoglich bayerischen Kunstkammer nach dem Ficklerschen Inventar von 1598' (ed. F. von Reber), *Sitzungsberichte der philos.-philol. und histor. Classe der kgl. bayerischen Akademie der Wissenschaften zu München* (Munich).

—— 1921. *Sitzungsberichte der philosophisch-philologischen und der historischen Klasse der Bayerischen Akademie der Wissenschaften zu München, Jahrgang 1920* (Munich).

Bayerisches Nationalmuseum, 1909. *Denkmale und Erinnerungen des Hauses Wittelsbach im Bayerischen*

Nationalmuseum (Kataloge des Bayerischen Nationalmuseums 11) (Munich).

—— 1955. *Kunst und Kunsthandwerk. Meisterwerke im Bayerischen Nationalmuseum* (Munich).

Bayerische Staatsbibliothek, 1979. *Die Karte als Kunstwerk* (Munich).

—— 1982. *Orlando di Lasso. Musik der Renaissance am Münchner Fürstenhof* (Wiesbaden).

Beck, H., and Decker, B., 1981. *Dürers Verwandlung in der Skulptur zwischen Renaissance und Barock* (Frankfurt-am-Main).

Beck, T., 1979. *Embroidered Gardens* (London).

Bedini, S. A., 1965. 'The evolution of Science Museums', *Technology and Culture* 6. 1–29.

Beger, L., 1696–1701. *Thesaurus Brandenburgicus selectus* (Coloniæ Marchicæ).

Beljaev, O., 1800. 'Kabinett Petra Velikogo', *Otdelenie* (St. Petersburg).

Belkin, K., 1980. *Corpus Rubenianum Ludwig Burchard part XXIV. The Costume Book* (Antwerp).

Belloni, L., 1958. 'La medicina a Milano fino al seicento', *Storia di Milano* 11 (Milan).

[Bellori, G. P.], 1664. *Nota delli Musei, Librerie, Galerie, et ornamenti di Statue e Pitture Ne' Palazzi, nelle Case, e ne' Giardini di Roma* (Rome).

Belon, P., 1553. *De Aquatilibus* (Paris).

Bendiscioli, M., 1957. 'Politica, amministrazione e religione nell'età dei Borromeo', *Storia di Milano* 10 (Milan).

Benesch, O., 1954–7. *The Drawings of Rembrandt* (London).

Bennett, E. T., 1829. *The Tower Menagerie* (London).

Bennett, J. A., 1972. 'Wren's last building?', *Notes and Records of the Royal Society* 27. 107–18.

Benthem Jutting, W. S. S. van, 1959. 'Rumphius and malacology', in H. C. D. de Wit (ed.) *Rumphius Memorial Volume* (Baarn), pp. 181–207.

Berger, A., 1883. 'Inventar der Kunstsammlungen des Erzherzogs Leopold Wilhelm von Österreich', *Jahrbuch der Kunsthistorischen Sammlungen des Allerhöchsten Kaiserhauses* 1 (2). lxxxvi–clxxvii.

Berliner, R., 1926. *Die Bildwerke des Bayerischen Nationalmuseums. Die Bildwerke in Elfenbein, Knochen, Hirsch- und Steinbockhorn* (Kataloge des Bayerischen Nationalmuseums 13/4) (Augsburg).

—— 1928. 'Zur älteren Geschichte der allgemeinen Museumslehre in Deutschland', *Münchner Jahrbuch der bildenden Kunst* new ser. 5, pp. 327–52.

Bernsmeier, U. *et al.*, (eds.), 1979. *Stilleben in Europa* (Münster and Baden-Baden).

Berti, L., 1967. *Il principe dello Studiolo: Francesco I dei Medici e la fine del Rinascimento Fiorentino* (Florence).

Bertrand, J., 1869. *L'Académie des Sciences et les Académiciens de 1666 à 1793* (Paris).

Besson, M., 1944. *L'influence coloniale sur le decor de la vie française* (Paris).

Bethe, H., 1937. *Die Kunst am Hofe der pommerschen Herzöge* (Berlin).

Beutel, T., 1671. *Chur-Fürstlicher Sächsischer stets grünender hoher Cedern-Wald . . .* (Dresden) [reprinted Leipzig, 1975].

Beyreuther, E., 1957. *August Hermann Francke und die Anfänge der ökumenischen Bewegung* (Leipzig).

Biblioteca del Cinquecento, 1979. *La scienza a corte. Collezionismo eclettico natura e immagine a Mantova fra Rinascimento e Manierismo* (Biblioteca del Cinquecento 7) (Rome).

Biondo, F., 1444–6, 1559. *Opera, Roma instaurata* (Basle).

—— 1463, 1559. *Opera, Italia illustrata* (Basle).

Birch, T. (ed.), 1744. *The Works of the Hon. Robert Boyle* (London).

—— 1756–7. *The History of the Royal Society of London* (London).

Birket-Smith, K., 1920. 'Some ancient artefacts from the eastern United States', *Journal de la Société des Américanistes de Paris* new ser. 12. 141–69.

Bischof, H., 1974. 'Una Colección Etnografica de la Sierra Nevada de Santa Marta (Colombia), Siglo XVII', *Atti del XL Congresso Internazionale degli Americanisti* 2. 391–8.

Blake, J. W., 1942. *Europeans in West Africa 1450–1560* 1 (London).

Blanck, H., 1964. 'Eine persische Pinselzeichnung nach der Tazza Farnese', *Archäologischer Anzeiger*, cols. 307–12.

Blendinger, F., 1966. 'Hainhofer (Ainhofer), Philipp', in *Neue deutsche Biographie* 7 (Berlin), pp. 524–5.

Bleyswijck, D. van, 1667. *Beschryvinge der stadt Delft* (Delft).

Blunt, W., 1950. *The Art of Botanical Illustration* (London).

Boccone, P., 1684. *Osservazioni naturali ove si contengono materie medico-fisiche e di botanica* (Bologna).

B[ockstaele], P., 1961. 'De "Hortus botanicus" en het "Theatrum anatomicum" te Leiden gezien door een Poolse jezuïet', *Scientiarum historia* 3. 45.

Boehm, L., and Raimondi, E. (eds.), 1981. *Università, accademie e società scientifiche in Italia e in Germania dal Cinquecento al Settecento* (Bologna).

Boerlin, P. H., 1976. *Leonhard Thurneysser als Auf-*

traggeber. Kunst im Dienst der Selbstdarstellung zwischen Humanismus und Barock (Basle and Stuttgart).

Boffito, G., 1929. *Gli Strumenti della Scienza e la Scienza degli Strumenti* (Florence) [reprinted Rome 1982].

Bolzoni, L. 1980. 'L' "invenzione" dello Stanzino di Francesco I', in *Le Arti del Principato Mediceo* (Florence), pp. 255–99.

Bontinck, F., 1979. 'La provenance des sculptures Vallisnieri', *Africa-Tervuren*.

Boralevi, A., 1983. 'The discovery of two great carpets: the Cairene carpets of the Medici', *Hali* 5, no. 3. 282–3.

Borel, P., 1649. *Les Antiquitez, Raretez, Plantes, Mineraux et autres Choses considerables de la Ville et Comté de Castres d'Albigeois* (Castres).

Born, W., 1936. 'Some eastern objects from the Hapsburg Collections', *Burlington Magazine* 69. 296–76.

—— 1940. 'Small objects of semiprecious stone from the Mughal period', *Ars Islamica* 7. 101–4.

—— 1942. 'Ivory powder flasks from the Mughal period', *Ars Islamica* 9. 93–111.

Borsieri, G., 1619. *Il supplimento della Nobiltà di Milano* (Milan).

Boscius, J. L., 1580. 'Oratio secunda de Serenissimo Principe Alberto V . . .', *Orationes funebres in exequiis . . . Alberto . . . celebratis* (Ingolstadt).

Boström, H. O., 1982. 'Philipp Hainhofer och Gustav II Adolfs konstskåp', *En värld i miniatyr, Kring en samling från Gustav II Adolfs tidevarv* (Skrifter från Kungl. Husgerådskammaren 2) (Stockholm), pp. 13–48.

Böttiger, J., 1909–10. *Philipp Hainhofer und der Kunstschrank Gustav Adolfs in Upsala* 1–4 (Stockholm).

—— 1913. *Gustaf II Adolfs konstskåps öden i Upsala* (Uppsala Universitets Årsskrift 1913, program 2) (Uppsala).

—— 1923. 'Försök till en konturteckning av Philipp Hainhofers personlighet', *Tillägg till Philipp Hainhofer und der Kunstschrank Gustav Adolfs in Upsala* (Stockholm).

Boucher, B., 1981. 'Leone Leoni and Primaticcio's moulds of antique sculpture', *Burlington Magazine* 123. 23–6.

Bougy, A. de, 1847. *Histoire de la bibliothèque Sainte Geneviève* (Paris).

Boulger, G. S., 1909. 'Thomas Willisel', in *Dictionary of National Biography* 21 (London), pp. 497–8.

Bourdier, F., 1959. 'L'extravagant Cabinet de Bonnier', *Connaissance des Arts* (August), pp. 52–60.

Boxer, C. R., 1951. *The Christian Century in Japan 1549–1650* (Los Angeles and London).

—— 1959. *The Great Ship from Amacon, Annals of Macao and the old Japan Trade 1555–1640* (Lisbon).

—— 1965. *The Dutch Seaborne Empire 1600–1800* (London).

—— 1969. *The Portuguese Seaborne Empire 1415–1825* (London).

Boyer, M., 1959. *Japanese Export Lacquers from the Seventeenth Century in the National Museum of Denmark* (Copenhagen).

Boyle, R., 1772. *The Works of . . . Robert Boyle* (London).

Bracco, V., 1979. *L'archeologia classica della cultura occidentale* (Rome).

Brachner, A. (ed.), 1983. *G. F. Brander 1713–1783: Wissenschaftliche Instrumente aus seiner Werkstatt* (Munich).

Braun, A., and Hogenberg, F., 1965. *Civitas Orbis Terrarum 1572–1618* (Kassel).

Braunholtz, H. J., 1970. *Sir Hans Sloane and Ethnography* (London).

Bray, W. (ed.), 1818. *Memoirs illustrative of the Life and Writings of John Evelyn* 2 (London).

—— 1879. *The Diary of John Evelyn Esq. FRS from 1641–1705*, 6 (London).

Bredekamp, H., 1982. 'Antikensehnsucht und Maschinenglauben', in H. Beck and P. C. Bol (eds.) *Forschungen zur Villa Albani, Antike Kunst und die Epoche der Aufklärung* (Berlin).

Brenninkmeyer-de Rooij, B., 1982. 'Notities betreffende de decoratie van de Oranjezaal in het Huis ten Bosch', *Oud-Holland* 96.

Bretschneider, E., 1910. *Mediaeval Researches from Eastern Asiatic Sources* (London).

Brice, G., 1687. *Description nouvelle de ce qu'il y a de plus remarquable dans la ville de Paris* (Paris).

British Curiosities, 1713. *British Curiosities in Nature and Art* (London).

Britton, J., 1823. *Graphic and Literary Illustrations of Fonthill Abbey, Wiltshire* (London).

Britton, J. (ed.), 1847. *John Aubrey, Natural History of Wiltshire* (London).

Bromehead, C. N., 1947a. 'Aetites or the eagle-stone', *Antiquity* 21. 16–22.

—— 1947b. 'Bottle imps', *Antiquity* 21. 105–6.

—— 1947c. 'A geological museum of the early seventeenth century', *Quarterly Journal of the Geological Society of London* 103. 65–87.

Brown, C. M., 1983. 'Cardinal Francesco Gonzaga's collection of antique intaglios and cameos:

questions of provenance, identification and dispersal', *Gazette des Beaux-Arts*, 102–4.

Brown, D., 1979. *Walter Scott and the Historical Imagination* (London).

Brown, E., 1677. *An Account of Several Travels through a great part of Germany in Four Journeys* (London).

Browne, J., 1983. *The Secular Ark* (New Haven).

Browne, Sir T., 1964. *Religio Medici and other works* (ed. L. C. Martin) (Oxford).

Brückmann, F. E., 1747. *Centuriae secundae epistolaria itineraria LXX, sistens Cimeliothecam, Mus. Antiquitatum, nec non Nummophylacium Regium Berolinense* (Wolfenbüttel).

Brunner, H., 1966. *Chinesisches Porzellan im Residenzmuseum München* (Munich).

—— 1970. *Katalog der Schatzkammer der Residenz München* 3rd edn. (Munich).

—— 1977. *Die Kunstschätze der Münchner Residenz* (Munich).

Bryden, D. J., 1973. 'A didactic introduction to arithmetic. Sir Charles Cotterell's "Instrument for Arithmeticke" of 1667', *History of Education* 2. 15–18.

Budde, H., 1981. 'Studien zum "Thesaurus Brandenburgicus" (1696–1701) von Lorenz Beger' (Magisterarbeit, Technische Universität, Berlin).

Buffon, G. L. L., 1761 and 1766. *Histoire Naturelle* 9 and 14 (Paris).

Bullock, W., 1809. *A Companion to the Liverpool Museum . . . now open for Public Inspection in the Great Room, No. 22, Piccadilly, London* (London).

Bülow, A. von, 1892. 'Diary of the journey of Philip Julius, Duke of Stettin-Pomerania, through England in the year 1602', *Transactions of the Royal Historical Society* new ser. 6. 1–67.

B[u]onanni, P., 1681. *Ricreatione dell' occhio e della mente* (Rome).

—— 1709. *Musaeum Kircherianum sive Musaeum a P. Athanasio Kirchero incoeptum nuper restitutum, auctum, descriptum, et iconibus illustratum a P. Philippo Bonanni* (Rome).

Burckhardt, J., 1864. 'Ueber die Goldschmiederisse der Oeffentlichen Kunstsammlung zu Basel', *Basler Taschenbuch 1864*, pp. 99–122.

Burckhardt, R. F., 1917. 'Ueber den Arzt und Kunstsammler Ludovic Demoulin de Rochefort aus Blois', *Historisches Museum Basel, Jahresbericht 1917*, pp. 29–60.

Burghley House, 1983. [*Catalogue of an exhibition of Japanese and Chinese porcelain*] (ed. G. Lang) (London).

Burke, P., 1969. *The Renaissance Sense of the Past* (London).

Busch, R. von, 1973. 'Studien zu deutschen Antikensammlungen des 16. Jahrhunderts' (Diss. phil., University of Tübingen).

Bushnell, D. I., 1905. 'Two ancient Mexican atlatls', *American Anthropologist* new ser. 7. 218–21.

—— 1906. 'The Sloane Collection in the British Museum', *American Anthropologist* new ser. 8. 671–85.

Butler, A. J., 1926. *Islamic Pottery, A Study Mainly Historical* (London).

Butler, H. K., 1968. 'The Study of Fossils in the last half of the Seventeenth Century' (Ph.D. thesis, University of Oklahoma).

Çağman, F., 1983. 'Ottoman art', in *The Anatolian Civilisations* 3 *Seljuk/Ottoman* (Istanbul).

Camden, W., 1586. *Britannia. Siue florentissimorum regnorum, Angliæ, Scottiæ, Hiberniæ, et Insularum adiacentium ex intima antiquitate Chorographica descriptio* (London).

Cameron, R., 1972. *Shells* (London).

Campori, A., 1866. *Lettere artistiche inedite* (Modena).

Cardano, G., 1663. *Opera omnia* (Lyon).

Carducho, V., 1979. *Diálogos de la Pintura* (ed. F. Calvo Sevraller) (Madrid).

Carmichael, E., 1970. *Turquoise Mosaics from Mexico* (London).

Casati, C. C., 1879. *Notice sur le Musée du Château de Rosenborg en Danemark concluant à la Création d'un Musée Historique de France* (Paris).

Casaubon, M., 1643. *M. Antonini Imp. de seipso et ad seipsum libri xii* (London).

Casparson, W. J. C., 1785. *Allgemeine Beschreibung des Museum Fridericianum zu Cassel* (Hessische Beiträge zur Gelehrsamkeit und Kunst 1) (Kassel).

Caudill, R. L. W., 1975. 'Some Literary Evidence of the Development of English Virtuoso Interests in the Seventeenth Century with Particular Reference to the Literature of Travel' (D.Phil. thesis, University of Oxford).

Cellini, B., 1949. *The Life of Benvenuto Cellini written by himself* (London).

Celtis, C., 1902. *De origine, situ, moribus et institutis Norimbergae* (Nuremberg).

Centore, F. F., 1970. *Robert Hooke's Contributions to Mechanics: A Study in Seventeenth-Century Natural Philosophy* (The Hague).

Ceruti, B., and Chiocco, A., 1622. *Musaeum Francisci Calceolari Veronensis* (Verona).

Cesalpino, A., 1583. *De Plantis* (Florence).

Chabod, F., 1961. 'L'epoca di Carlo V', *Storia di Milano* 9 (Milan).

Chaldecott, J. A., 1951. *Handbook of the George III Collection of Scientific Instruments* (London).

Challinor, J., 1945. 'Dr. Plot and Staffordshire Geology', *Transactions of the North Staffordshire Field Club* 79. 29–67.

Chambers, D., and Martineau, J. (eds.), 1982. *Splendours of the Gonzagas* (London).

Chapman, A., 1983a. 'The accuracy of angular measuring instruments used in astronomy between 1500 and 1850', *Journal for the History of Astronomy* 14. 133–7.

—— 1983b. 'The design and accuracy of some observatory instruments of the seventeenth century', *Annals of Science* 40. 457–71.

Charleston, R., 1964. 'The import of Venetian glass into the Near East – 15th–16th centuries', *Annales du 3° Congrès des Journées Internationales du Verre Damas 1964* (Liège), pp. 158–68.

—— 1966. 'The import of western glass into Turkey: sixteenth–eighteenth centuries', *The Connoisseur* 162, no. 651. 18–26.

Charleton, W., 1668. *Onomasticon Zoicon* (London).

Chastel, A., 1978. *Fables, formes, figures* (Paris).

Childrey, J., 1661. *Britannia Baconia* (London).

Christ, W., 1866. 'Beiträge zur Geschichte der Antikensammlungen Münchens', *Abhandlungen der philos.-philol. Classe der kgl. bayerischen Akademie der Wissenschaften* 10 (Denkschriften 39), pp. 359–96.

Churchill, A., and Churchill, J., 1704–32. *A Collection of Voyages and Travels* (London).

Chytil, K., 1904. *Die Kunst in Prag zur Zeit Rudolf II* (Prague).

Ciardi, R. P., 1968. *Giovan Ambrogio Figino* (Florence).

Cimino, R. M., 1982. 'Il Museo Borgia di Velletri e la sua sezione indiana', *Bollettino d'Arte* 13. 97–105.

Clarendon, Earl of, 1849. *The History of the Great Rebellion* (London).

Clark, A. (ed.), 1891–1900. *The Life and Times of Anthony Wood 1632-1695* (Oxford).

Clark, Sir G., 1964–6. *A History of the Royal College of Physicians of London* (London).

Clemens, C., 1635. *Musei sive bibliothecae tam privatae quam publicae extructio, instructio, cura, usus* (Leiden).

Coffine, D., 1972. *The Italian Garden* (Washington, D.C.).

Cohen, I. B., 1950. *Some Early Tools of American Science* (Cambridge, Mass.).

Colini, G. A., 1891. 'Une autre hache en pierre du Brésil', *Internationales Archiv für Ethnographie* 4. 257–8.

Collections, 1977. *Collections de Louis XIV, dessins, albums, manuscrits* (Orangerie des Tuileries 7 Oct. 1977–9 Janvier 1978) (Paris).

Collins Baker, C. H., 1928. 'John Souch of Chester', *Connoisseur* 80. 131–3.

Comito, T., 1971. 'Renaissance gardens and the discovery of Paradise', *Journal of the History of Ideas* 32. 483–506.

Comune di Verona – Direzione dei musei, 1982. *Il Museo Maffeiano riaperto al pubblico* (Verona).

Conring, H., 1688. *In universam artem medicam . . . introductio* (with additions by G. C. Schelhammer) (Speyer).

Cook, R. M., 1972. *Greek Painted Pottery* 2nd edn. (London).

Cooper, C. H., 1880. *Memorials of Cambridge* (Cambridge).

Coryat[e], T., 1905. *Coryat's Crudities* (Glasgow).

Coster, A., 1912. 'Une description inédite de la demeure de Don Vicencio Juan de Lastanosa', *Revue Hispanique* 26. 566–610.

Cottineau, L. H., 1935–70. *Répertoire topo-bibliographique des abbayes et prieurés* (Mâcon).

Cremonese, L. L., 1677. *Museo Cospiano annesso a quello del famoso Ulisse Aldrovandi* (Bologna).

Crommelin, C. A., 1926. *Beschrijvende Catalogus der Historische Verzameling van Natuurkundige Instrumenten in het Natuurkundig Laboratorium der Rijks-Universiteit te Leiden* (Leiden).

Cust, E., 1898. *Records of the Cust Family* (London).

Dacos, N., Giuliano, A., and Pannuti, V., 1973. *Il Tesoro di Lorenzo il Magnifico* (Florence).

Dallaway, J., 1800. *Anecdotes of the Arts in England* (London).

Dalman, G., 1920. 'Die Modelle der Grabeskirche und Grabeskapelle in Jerusalem als Quelle ihrer ältesteren Gestalt', *Palästina Jahrbuch* 18. 23–31.

Dalton, O. M., 1909. *Catalogue of the Ivory Carvings of the Christian Era . . . of the British Museum* (London).

Dam-Mikkelsen [Gundestrup], B., and Lundbæk, T. (eds.), 1980. *Etnografiske genstande i Det kongelige danske Kunstkammer 1650-1800. Ethnographic Objects in the Royal Danish Kunstkammer 1650-1800.* (Copenhagen).

Dampier, W., 1697. *A New Voyage round the World* (London).

Dance, S. P., 1966. *Shell Collecting: An Illustrated History* (London).

Dandy, J. E., 1958. *The Sloane Herbarium* (London).

David, M. C. and Soustiel, J., 1983. *Miniatures orientales de l'Inde 3* (Paris).

David, Sir P., 1971. *Chinese Connoisseurship* (London).

Davies, G. L., 1969. *The Earth in Decay: A History of British Geomorphology 1578–1878* (London).

Davies, K., 1983. 'Zoological specimens in the University Museum attributed to the Tradescant Collection', in A. MacGregor (ed.) *Tradescant's Rarities* (Oxford), pp. 346–9.

Davies, K. C. and Hull, J., 1976. *The Zoological Collections of the Oxford University Museum* (Oxford).

Davillier, J. C., 1882. *Les origines de la porcelaine en Europe* (Paris and London).

Deacon, M., 1971. *Scientists and the Sea 1650–1900: A Study of Marine Science* (London and New York).

Dean, D. R., 1979. 'The word "geology"', *Annals of Science* 36, 35–43.

Dean, W. T., 1974. *The Trilobites of the Chair of Kildare Limestone (Upper Ordovician) of Eastern Ireland. Part 2.* (Palaeontographical Society Monograph) (London).

Demiandt, K. E., 1939. 'Der spätmittelalterliche Silberschatz des hessischen Fürstenhauses', *Hessenland* 50. 21–31.

Desmond, R., 1982. *The India Museum, 1801–1879* (London).

Diemer, P., 1980. 'Materialien zu Entstehung und Ausbau der Kammergalerie Maximilians I. von Bayern', *Quellen und Studien zur Kunstpolitik der Wittelsbacher vom 16. bis zum 18. Jahrhundert* (Munich), pp. 129–74.

Dierauer, U., 1977. *Tier und Mensch im Denken der Antike. Studien zur Tierpsychologie, Anthropologie und Ethik* (Amsterdam).

Distelberger, R., 1975. 'Die Saracchi-Werkstatt und Annibale Fontana', *Jahrbuch der Kunsthistorischen Sammlungen in Wien* 71. 95–164.

—— 1978. 'Beobachtungen aus den Steinschneidewerkstätten der Miseroni in Mailand und Prag', *Jahrbuch der Kunsthistorischen Sammlungen in Wien* 74. 79–152.

—— 1979. 'Dionysio und Ferdinand Eusebio Miseroni', *Jahrbuch der Kunsthistorischen Sammlungen in Wien* 75. 109–88.

Dodwell, C. R., 1982. *Anglo-Saxon Art: A New Perspective* (Manchester).

Doeplerus, J., 1697. *Theatrum Poenarum oder Schau-Platz derer Leibes- und Lebens-Strafen* (Leipzig).

Doering, O., 1894. 'Des Augsburger Patriciers Philipp Hainhofer Beziehungen zum Herzog Philipp II von Pommern-Stettin, Correspondenzen aus den Jahren 1610–1619', *Quellenschriften für Kunstgeschichte und Kunsttechnik des Mittelalters und der Neuzeit* new ser. 6 (Vienna).

—— 1901. 'Des Augsburger Patriciers Philipp Hainhofer Reisen nach Innsbruck und Dresden', *Quellenschriften für Kunstgeschichte und Kunsttechnik des Mittelalters und der Neuzeit* new ser. 10 (Vienna).

—— 1904. 'Hainhofer', *Allgemeine Deutsche Biographie* 49, *Nachträge bis 1899* (Leipzig), pp. 719–21.

Dollinger, H., 1968. *Studien zur Finanzreform Maximilians I. von Bayern in den Jahren 1598–1618. Ein Beitrag zur Geschichte des Frühabsolutismus* (Schriftenreihe der historischen Kommission bei der Bayerischen Akademie der Wissenschaften 8) (Göttingen).

Drach, C. A. von, 1888. *Ältere Silberarbeiten* (Marburg).

—— 1893. 'Die Casseler Weissglashütte von 1583', *Bayerische Gewerbezeitung* 5. 97–106; 6. 121–32.

Drake, E. T., and Komar, P. D., 1981. 'A comparison of the geological contributions of Nicolaus Steno and Robert Hooke', *Journal of Geological Education* 29. 127–34.

Drake, S., 1977. 'Tartaglia's squadra and Galileo's compasso', *Annali dell'Istituto e Museo di Storia della Scienza* 2. 35–54.

—— 1978. *Galileo Galilei Operations of the Geometric and Military Compass 1606* (Washington, D.C.).

Dreier, F. A., 1961. 'Zur Geschichte der Kasseler Kunstkammer', *Zeitschrift des Vereins für Hessische Geschichte und Landeskunde* 72. 123–42.

—— 1964. 'Unbekante Arbeiten von Leonhard Kern und zwei Reliefs aus der Drehbank des Landgrafen Carl von Hessen', *Pantheon* 22. 96–106.

—— 1968. *Glaskunst in Hessen-Kassel* (Kassel and Basle).

—— 1970. 'Franz Gondelach – Anmerkungen zum Leben und Werk', *Zeitschrift des Deutschen Vereins für Kunstwissenschaft* 24. 101–40.

—— 1981. 'Die Kunstkammer im 19. Jahrhundert', in Staatliche Museen Preussischer Kulturbesitz, *Die Brandenburgisch-Preussische Kunstkammer. Eine Auswahl aus den alten Beständen* (Berlin), pp. 35–44.

Drossaers, S. W. A., and Scheurleer, Th.H. Lunsingh, 1972. *Inventarissen van de inboedels in de verblijven van de Oranjes* 1 (The Hague).

Due, B., 1980. 'A shaman's cloak?' *Folk* 21–2. 257–61.

Dugdale, Sir W., 1656. *The Antiquities of Warwickshire* [2nd edn., 1730] (London).

Dülmen, R. von, 1978. *Die Utopie einer christlichen Gesellschaft, Johann Valentin Andreae (1586–1654)* 1 (Stuttgart).

Dürer, A., 1918. *Albrecht Dürer Niederländische Reise* 1 *Die Urkunden über die Reise* (eds. J. Veth and S. Muller) (Berlin and Utrecht).

Earle, J. V., 1984. 'Genji meets Yang Guifei; a group of Japanese export lacquers', *Transactions of the Oriental Ceramic Society* 47. 45–75.

Eckhardt, W., 1976 and 1977. 'Erasmus Habermel: zur Biographie des Instrumentmachers Kaiser Rudolfs II', *Jahrbuch der Hamburger Kunstsammlungen* 21. 55–92; 22. 13–74.

Edmonds, J. M., 1950. [Comments on specimens catalogued by Edward Lhwyd] *Quarterly Journal of the Geological Society* 106, Proceedings pp. vi–vii.

Edwards, E., 1870. *Lives of the Founders of the British Museum . . . 1570–1870* (London).

Edwards, P. I., 1981. 'Sir Hans Sloane and his curious friends', in A. Wheeler and J. H. Price (eds.), *History in the Service of Systematics* [Papers from the Conference to celebrate the Centenary of the British Museum (Natural History)] (London), pp. 27–35.

Edwards, W. N., 1967. *The Early History of Palaeontology* (London).

Egg, E., 1962. *Die Glashütten zu Hall und Innsbruck* (Innsbruck).

Eichler, F., and Kris, E., 1927. *Die Kameen im Kunsthistorischen Museum. Beschreibender Katalog* (Vienna).

Eisenstein, E. L. 1979. *The Printing Press as an Agent of Change* (Cambridge).

Ellis, H. (ed.), 1843. *Original Letters of Eminent Literary Men of the Sixteenth, Seventeenth and Eighteenth Centuries* (Camden Society 23) (London).

Engel, H., 1937. 'De Liefhebbers van Neptunus-Cabinet. De eerste malacologische Vereeniging?', *Basteria* 2. 64.

—— 1939. 'Alphabetical list of Dutch Zoological cabinets and menageries', *Bijdragen tot de Dierkunde* 27. 247–346.

Ertl, A. V., 1703. *Churbayerischer Atlas* 3rd edn. (Nuremberg).

Ettinghausen, R., 1974. 'The impact of Muslim decorative arts and painting on the arts of Europe', in J. Schacht and C. E. Bosworth (eds.), *The Legacy of Islam*, 2nd edn. (Oxford), pp. 292–320.

Evans, R. J. W., 1973. *Rudolf II and his World: a Study in Intellectual History 1576–1612* (Oxford).

Evelyn, J., 1697. *Numismata. A Discourse of Medals, Ancient and Modern* (London).

Evelyn, J., 1955. *The Diary* (ed. E. S. de Beer) (Oxford).

Ewan, J. (ed.), 1968. *William Bartram: Botanical and Zoological Drawings, 1758–1788* (Philadelphia).

Eyice, S., 1967. 'La verrerie en Turquie de l'époque byzantine à l'époque turque', *Annales du 4ᵉ Congrès des Journées Internationales du Verre (Ravenne-Venise 1967)* (Liège), pp. 162–82.

Eyles, J. M. 1955. 'Georgius Agricola (1494–1555)', *Nature* 176. 949–50.

Eyles, V. A., 1958. 'The influence of Nicolaus Steno on the development of geological science in Britain', *Acta Historica Scientiarum Naturalium et Medicinalium* 15. 167–88.

Eyles, V. A. (ed.), 1973. [Reprint of J. Woodward's *Brief Instructions for making observations in all parts of the world* (1696)] (London).

Falk, T., 1979. *Kunstmuseum Basel/Kupferstichkabinett, Katalog der Zeichnungen III. Die Zeichnungen des 15. und 16. Jahrhunderts* pt. 1 (Basle and Stuttgart).

Fardoulis-Vitart, A., 1979. 'Le Cabinet du Roi et les anciens Cabinets de Curiosité dans les collections du Musée de l'Homme' (Diplôme de l'Université de Paris).

Farey, J., 1823. 'Some particulars regarding the Ashmolean Catalogue of Extraneous Fossils, published in Latin by Mr Edward Luid', *Annals of Philosophy* ser. 2, 5. 378–80.

Fehl, P. P., 1981. 'Franciscus Junius and the Defense of Art', *Artibus et Historia* 3/2. 9–55.

Fernie, E., 1981. 'The Greek metrological relief in Oxford', *Antiquaries Journal* 61. 255–63.

Ferrari, G. B., 1638. *Flora overo la Cultura di fiori* (Rome).

Fink, A., 1955. 'Das Augsburger Kunsthandwerk und der dreissigjährige Krieg', in H. Rinn (ed.), *Augusta 955–1955, Forschungen und Studien zur Kultur- und Wirtschaftsgeschichte Augsburgs* (Augsburg), pp. 323–32.

Fischer, O., 1936. 'Geschichte der Oeffentlichen Kunstsammlung', *Festschrift zur Eröffnung des Kunstmuseums Basel* (Basle), pp. 7–118.

Fleischhauer, W., 1976. *Die Geschichte der Kunstkammer der Herzöge von Württemberg in Stuttgart* (Veröffentlichungen der Kommission für geschichtliche Landeskunde in Baden-Württemberg ser. B, 87) (Stuttgart).

Fletcher, J. M., 1982. 'Isabella d'Este, patron and collector', in D. Chambers and J. Martineau (eds.), *Splendours of the Gonzaga* (London), pp. 51–63.

Floon, W., 1983. 'New facts on the Holstein embassy to Iran (1637)', *Der Islam* 60.

Florence,1931. *Mostra del Giardino Italiano* (Florence).

Fludd, R., 1617. *Utriusque cosmi historia* (Oppenheim).

—— 1979. *Robert Fludd and His Philosophical Key, being a Transcription of the manuscript at Trinity College, Cambridge* (New York).

Fock, C. W., 1982. 'Het zogenaamde kunstkabinetje van Rudolf II', *Leids Kunsthistorisch Jaarboek* 1. 199–209.

Fogalari, G., 1900. 'Il Museo Settala', *Archivio Storico Lombardo* 14. 58–126.

Forbes, E. G., 1975. *Greenwich Observatory: The Royal Observatory at Greenwich and Herstmonceux 1675–1975* 1 *Origins and Early History* (London).

Forster, L. W., 1944. *Georg Rudolf Weckherlin, Zur Kenntnis seines Lebens in England* (Basler Studien zur deutschen Sprache und Literatur 2) (Basle).

Fragnito, G., 1982. 'Il museo di Antonio Giganti da Fossombrone', in Istituto Nazionale di Studi sul Rinascimento, *Scienze, credenze occulte, livelli di cultura* (Florence), pp. 507–33.

Franchini, D., *et al.*, 1979. *La scienza a corte. Collezionismo eclettico, natura e immagine a Mantova fra Rinascimento e Manierismo* (Rome).

Franckesche Stiftungen, 1799. *Beschreibung des Hallischen Waisenhauses und der übrigen damit verbundenen Franckischen Stiftungen* (Halle).

Frank, R. G., 1973. 'Science, medicine and the universities of early modern England: background and sources', *History of Science* 11. 194–216, 239–69.

—— 1979. 'The physician as virtuoso in seventeenth-century England', in B. Shapiro, and R. G. Frank, *English Scientific Virtuosi in the Sixteenth and Seventeenth Centuries* (Los Angeles), pp. 57–114.

—— 1980. *Harvey and the Oxford Physiologists* (Berkeley and Los Angeles).

Frankenburger, M., 1923. *Die Silberkammer der Münchner Residenz* (Munich).

Franklin, A., 1867–73. *Les anciennes bibliothèques de Paris* (Paris).

Franzoni, L., 1975–6. 'L'opera di Scipione Maffei e di Alessandro Pompei per il museo pubblico veronese', *Atti e memorie dell'Accademia di agricoltura, scienze e lettere di Verona* ser. 6, 27. 193–218.

—— 1979. 'Il collezionismo dal Cinquecento all'Ottocento', in G. P. Marchi (ed.), *Cultura e vita civile a Verona. Uomini e istituzioni dall'epoca carolingia al Risorgimento* (Verona), pp. 597–656.

Frey, K. H. W., 1930. *Der literarische Nachlass Giorgio Vasaris* (Munich).

Frosien-Leinz, H., 1980. 'Das Antiquarium der Residenz: erstes Antikenmuseum Münchens', in K. Vierneisel and G. Leinz (eds.), *Glyptothek München 1830–1980* (Munich), pp. 310–21.

Fuchs, L. F., 1959. 'Das Glück von Edenhall', *Weltkunst* 29, no. 8, p. 8.

Fučíková, E., 1972. 'Umělci na dvoře Rudolfa II. a jejich vztah k tvorbě Albrechta Dürera', *Umění* 20. 149–66.

Fuiren, T., 1663. *Rariora musaei Henrici Fuiren . . . quae Academiae Regiae Hafniensi legavit* (Copenhagen).

Gabrieli, G., 1938–42. 'Il carteggio linceo della vecchia Accademia di Federico Cesi (1603–1630)', *Memorie della Reale Accademia Nazionale dei Lincei* classe di scienze morali [etc.], ser. 6, 7 (Rome).

—— 1940. 'Carteggio kircheriano', *Atti della Reale Accademia d'Italia. Rendiconti della classe di scienze morali e storiche*, ser. 7, 2. 9–17.

Galilei, G., 1610. *Siderius nuncius . . .* (Venice).

Gallo, R., 1967. *Il Tesoro di S. Marco e la sua Storia* (Fondazione Cini, Civiltà Veneziana Saggi 16) (Venice).

Galluzzi, P., 1980. 'Il mecenatismo mediceo e le scienze', in C. Vasoli (ed.), *Idee, istituzioni, scienza ed arti nella Firenze dei Medici* (Florence), pp. 189–215.

Gamber, M., and Thomas, B., 1958. 'L'arte milanese dell'armatura', *Storia di Milano* 11 (Milan).

Gandolfo, F., 1978. *Il 'Dolce Tempo'. Mistica, Ermetismo e Sogno nel Cinquecento* (Rome).

Ganz, P., and Major, E., 1907. 'Die Entstehung des Amerbach'schen Kunstkabinetts und die Amerbach'schen Inventare', *Jahresbericht der Oeffentlichen Kunstsammlung Basel*, pp. 1–68.

Garas, K., 1967. 'Die Entstehung der Galerie des Erzherzogs Leopold Wilhelm', *Jahrbuch der Kunsthistorischen Sammlungen in Wien* 63. 39–80.

—— 1968. 'Das Schicksal der Sammlung des Erzherzogs Leopold Wilhelm', *Jahrbuch der Kunsthistorischen Sammlungen in Wien* 64, 181–278.

Garner, Sir H., 1975. *Chinese Export Art in Schloss Ambras* (Second Hills Memorial Lecture, Oriental Ceramic Society) (London).

Geijer, A., 1951. *Oriental Textiles in Sweden* (Copenhagen).

Gerje, V., 1871. *Otnoschenije Leibnitza k Rossii i Petru Velikomu* (St. Petersburg).

Gerland, O., 1895. *Paul, Charles und Simon Louis du Ry, eine Künstlerfamilie der Barockzeit* (Stuttgart).

Gersaint, E. F., 1736. *Catalogue raisonné de Coquilles, et autres Curiosités Naturelles* (Paris).

—— 1744. *Catalogue Raisonné d'une Collection considerable de diverses Curiosités en tous Genres, contenues dans les Cabinets de feu Monsieur Bonnier de la Mosson, Bailly & Capitaine des Chasses de la Varenne des Thuilleries & ancien Colonel du Regiment Dauphin* (Paris).

Gerszi, T., 1975. 'Les attaches de Paulus van Vianen avec l'art allemand', *Bulletin du Musée Hongrois des Beaux-Arts* 44. 71–90.

—— 1982. *Paulus van Vianen: Handzeichnungen* (Leipzig).

Ges[s]ner, C., 1551–8. *Historiae Animalium* (Zurich).

Getto, G., 1969. *Barocco in prosa e in poesia* (Milan).

Giannessi, F., 1958. 'La letteratura dialettale e la cultura', *Storia di Milano* 11 (Milan).

[Gibson, J.], 1796. 'A short account of several gardens near London', *Archaeologia* 12. 181–92.

Giganti, A., 1595. *Carmina Exametra, Elegiaca, Endecasillaba* (Bologna).

—— 1598. *Appendix ad Volumen Poematum anno MDXCV* (Bologna).

—— 1797. 'Vita di Monsignor Lodovico Beccadelli Arcivescovo di Ragusa', in G. Morandi (ed.), *Monumenti di varia letteratura tratti dai manoscritti originali di mons. Lodovico Beccadelli, arcivescovo di Ragusa* 1 (Bologna), pp. 1–68.

Giglioli, H. H., 1896. 'On rare types of hafted stone battle-axes', *Internationales Archiv für Ethnographie, Supplement* 9. 25–34.

—— 1910. 'Intorno a due rari cimelî precolombiani dalle Antille, molto probabilmente da San Domingo, conservati nel Museo Etnografico di Firenze', *Verhandlungen des XVI. Internationalen Amerikanisten-Kongresses* 2. 313–20.

Gilbert, W., 1600. *De magnete, magneticisque corporibus, et de magno magnete tellure . . .* (London).

—— 1651. *De mundo nostro sublunari philosophia nova* (Amsterdam).

Gilliard, E. T., 1969. *Birds of Paradise and Bower Birds* (London).

Gilly, C., 1977–9. 'Zwischen Erfahrung und Spekulation. Theodor Zwinger und die religiöse und kulturelle Krise seiner Zeit', *Basler Zeitschrift für Geschichte und Altertumskunde* 77. 57–137; 79. 125–223.

Girgensohn, J., 1912. 'Eine Beschreibung der Stadt Kassel aus dem Jahre 1606', *Hessische Chronik* 1. 137–8.

Giusti, A. M., Mazzoni, P., and Pampaloni Martelli, A., 1978. *Il museo dell'opificio delle pietre dure a Firenze* (Milan).

Glass, J. B., 1975. 'A census of native Middle American pictorial manuscripts', *Handbook of Middle American Indians* 14. 81–252.

Gnoli, D., 1905. 'Il giardino e l'antiquario del Cardinal Cesi', *Mitteilungen Deutsches Archaeologisches Institut Rom* 20. 267–75.

Gobiet, R. (ed.), 1984. *Der Briefwechsel zwischen Philipp Hainhofer und Herzog August d. J. von Braunschweig-Lüneburg* (Forschungshefte, Bayerische Nationalmuseums München 8) (Munich and Berlin).

Godwin, J., 1979. *Robert Fludd, Hermetic Philosopher and Surveyor of Two Worlds* (Boulder).

Goetz, H., 1936. 'Notes on a collection of historical portraits from Golconda', *Indian Art and Letters* 10. 10–21.

Goetze, G. H., 1712. *Museum eruditi variis memorabilibus conspicuum, vel die Denck-Würdige Studier-Stube* (Lübeck).

Goltz, H., 1557. *Vivae omnium fere Imperatorum imagines . . .* (Antwerp).

—— 1574. *Caesar Augustus sive historiae Imperatorum Caesarumque Romanorum . . .* (Brugge).

Goodman, D., 1983. 'Philip II's patronage of science and engineering', *British Journal for the History of Science* 16. 49–66.

Gorlaeus, A., 1601. *Dactyliotheca seu annulorum sigillorumque quorum apud priscos tam Graecos quam Romanos usus promptuarium . . .* (Delft).

Götz, W., 1964. *Deutsche Marställe des Barock* (Munich and Berlin).

Grassi Fiorentino, S., 1981. 'Giovanni Giustino Ciampini', *Dizionario biografico degli italiani* 25. 136–43.

Greenslade, H. W., 1982. *The Staffordshire Historians* (Stoke-on-Trent).

Grew, N., 1681. *Musæum Regalis Societatis, or a Catalogue & Description of the Natural and Artificial Rarities Belonging to the Royal Society And preserved at Gresham Colledge* (London).

Grosart, A. B., 1880. *The Poems etc. of Richard James B.D. (1592–1638)* (London).

Gröschel, S.-G., 1981. 'L. Beger, Thesaurus Brandenburgicus selectus Band I–III', in Staatliche Museen Preussischer Kulturbesitz, *Die Brandenburgisch-Preussische Kunstkammer. Eine Auswahl aus den alten Beständen* (Berlin), pp. 96–7.

Grulich, O., 1894. *Geschichte der Bibliothek und Naturaliensammlung der Kaiserlichen Leopoldinisch-*

Carolinischen Deutschen Akademie der Naturforscher (Halle).

Gualtieri, N., 1742. *Index Testarum Conchyliorum* (Florence).

Günderode, J. F. von, 1781. *Briefe eines Reisenden über den gegenwärtigen Zustand von Cassel mit aller Freiheit geschildert* (Frankfurt-am-Main and Leipzig).

Gunther, R. T., 1923–45. *Early Science in Oxford* (Oxford).

—— 1928. *Further correspondence of John Ray* (London).

—— 1937. *Early Science in Cambridge* (Oxford).

Gyllensvärd, B., 1966. 'Old Japanese lacquer and japanning in Sweden', in *Opuscula in Honorem C. Hernmarck* (Stockholm), pp. 62–93.

Haags Gemeentemuseum, 1967. *Zilver uit de tijd van de Vereenigde Oost-indische Compagnie* (The Hague).

Habich, G., 1913. 'Bayerische Medaillen. Nachträge und Berichtigungen', *Mitteilungen der Bayerischen Numismatischen Gesellschaft* 31. 128–31.

Haeutle, C., 1881. 'Die Reisen des Augsburgers Philipp Hainhofer nach Eichstädt, München und Regensburg in den Jahren 1611, 1612 und 1613' *Zeitschrift des Historischen Vereins für Schwaben und Neuburg* 8. 55–148.

Hager, H., 1887. [Appendix II to review of Schaible, K. H., *Geschichte der Deutschen in England* (1885)], in *Englische Studien* 10. 445–53.

Hahn, R., 1971. *The Anatomy of a Scientific Institution: the Paris Academy of Sciences (1666–1803)* (Berkeley).

Hajós, E. M., 1958. 'The concept of an engravings collection in the year 1565: Quicchelberg, "Inscriptiones vel tituli theatri amplissimi"', *Art Bulletin* 40. 151–6.

—— 1963. 'References to Giulio Camillo in Samuel Quicchelberg's "Inscriptiones vel tituli theatri amplissimi"', *Bibliothèque d'Humanisme et Renaissance* 25. 207–11.

Hale, J. R., 1977. *Florence and the Medici* (London).

Hall, A. R., and Hall, M. B. (eds.), 1965. *The Correspondence of Henry Oldenburg* (Madison, Milwaukee and London).

Hallo, R., 1983a. 'Hessischer Kristall- und Steinschnitt des Barock' in G. Schweikhardt (ed.), *Schriften zur Kunstgeschichte in Kassel* (Kassel), pp. 174–207.

—— 1983b. 'Von der Kasseler Kunstkammer und den Museumsverlusten in Westfälischer Zeit', *Schriften zur Kunstgeschichte in Kassel*, pp. 63–73.

Hamel, G. R., 1982. 'One Culture's "Truck" is another Culture's Treasure: Cabinets of Curiosities and Northeastern Native American Ethno-logical Specimens of the 16th through 18th Centuries' (unpublished typescript).

Hamman, G., 1973. 'G. W. Leibnizens Plan einer Wiener Akademie der Wissenschaften', *Studia leibnitiana supplementa*, 12. 205–27.

Hammermayer, L., 1976. 'Barock und frühe Aufklärung. Zur Wissenschafts- und Geistesentwicklung Bayerns (circa 1680–1730)', *Kurfürst Max Emanuel, Bayern und Europa um 1700 I* (Munich), pp. 428–48.

Hammerstein, N., 1981. 'Accademie, società scientifiche in Leibniz', in L. Boehm and E. Raimondi (eds.), *Università, accademie e società scientifiche in Italia e in Germania dal Cinquecento al Settecento* (Bologna), pp. 395–419.

Hansmann, L., and Kriss-Rettenbeck, L., 1966. *Amulett und Talisman, Erscheinungsform und Geschichte* (Munich).

Hantzsch, V., 1902. 'Beiträge zur älteren Geschichte der kurfürstlichen Kunstkammer in Dresden', *Neues Archiv für Sächsische Geschichte und Alterumskunde* 23. 220–96.

Harle, J., 1983. 'An Indian "Gonga"', *The Ashmolean* 2. 6–7.

Harnack, A. von, 1900. *Geschichte der königlich preussischen Akademie der Wissenschaften zu Berlin* (Berlin).

Harris, J., and Tait, A. A., 1979. *A Catalogue of the Drawings by Inigo Jones, John Webb and Isaac de Caus at Worcester College, Oxford* (Oxford).

Hartig, O., 1917. 'Die Gründung der Münchener Hofbibliothek durch Albrecht V. und Johann Jakob Fugger', *Abhandlungen der kgl. bayerischen Akademie der Wissenschaften, Philos.-philol. und histor. Klasse* 28, 3 (Munich).

—— 1924. 'Unbekannte Reisen des jungen Hainhofer nach München und Stuttgart 1603–1607', *Der Sammler, Unterhaltungs- und Literaturbeilage der München-Augsburger Abendzeitung* 118.

—— 1931. 'Münchner Künstler und Kunstsachen III', *Münchner Jahrbuch der bildenden Kunst* new ser. 8. 322–84.

—— 1933a. 'Der Arzt Samuel Quicchelberg, der erste Museologe Deutschlands, am Hofe Albechts V. in München', *Bayerland* 44. 630–3.

—— 1933b. 'Die Kunsttätigkeit in München unter Wilhelm IV. und Albrecht V. 1520–1579', *Münchner Jahrbuch der bildenden Kunst* new ser. 10. 147–225.

Hartmann, A., and Jenny, B. R., 1942–82. *Die Amerbach-Korrespondenz* (Basle).

Hartmann, F., and Vierhaus, R. (eds.), 1977. *Der*

Akademiegedanke im 17. und 18. Jahrhundert (Bremen and Wolfenbüttel).

Hartt, F., 1958. *Giulio Romano* (New Haven).

Haskell, F., 1963. *Patrons and Painters. A Study in the Relations between Italian Art and Society in the Age of the Baroque* (London).

Haskell, F. and Penny, N., 1981. *Taste and the Antique* (New Haven and London).

Hasluck, F. W., 1909–10. 'Terra Lemnia', *Annual of the British School at Athens* 16. 220–31.

Hassencamp, J. H., 1783. *Briefe eines Reisenden über Pyrmont, Cassel, Würzburg, etc.* (Frankfurt-am-Main and Leipzig).

Hatcher, J., and Barker, T. C., 1974. *A History of British Pewter* (London).

Hausmann, T., 1959. 'Der Pommersche Kunst-schrank, Das Problem seines inneren Aufbaus', *Zeitschrift für Kunstgeschichte* 22. 337–52.

Haynes, D. E. L., 1974. 'The Arundel "Homerus" rediscovered', *J. Paul Getty Museum Journal* 1. 73–80.

—— 1975. *The Arundel Marbles* (Oxford).

Hayward, J. F., 1976. *Virtuoso Goldsmiths and the Triumph of Mannerism 1540–1620* (London).

Heckscher, W. S., 1981. 'Pearls from a dungheap: Andrea Alciati's "offensive" emblem, "Adversus naturam peccantes"', *Art the Ape of Nature, H. W. Janson Festschrift* (New York), pp. 295–319.

Hegenitius, G., 1667. *Itinerarium frisio-hollandicum* (Leiden).

Heger, F., 1899. 'Alte Elfenbeinarbeiten aus Afrika in den Wiener Sammlungen', *Mittheilungen der Anthropologischen Gesellschaft in Wien* 29.

—— 1906. 'Verschwundene altmexikanische Kostbarkeiten des XVI. Jahrhunderts, nach urkundlichen Nachrichten', *Anthropological Papers written in Honor of Franz Boas* (New York), pp. 306–15.

Heikamp, D., 1963. 'Zur Geschichte der Uffizien-Tribuna und der Kunstschränke in Florenz und Deutschland', *Zeitschrift für Kunstgeschichte* 26. 193–268.

—— 1964. 'La Tribuna degli Uffizi come era nel Cinquecento', *Antichità Viva* 3. 11–30.

—— 1966a. 'La Medusa del Caravaggio e l'armatura dello Scià Abbàs di Persia', *Paragone* 199. 62–76.

—— 1966b. 'Reisemöbel aus dem Umkreis Philipp Hainhofers', *Anzeiger des Germanischen National-museums, Nürnberg*, 91–102.

—— 1969. 'Les Merveilles de Pratolino', *L'Oeil* 171. 16–27, 74–5.

—— 1970a. 'L'antica sistemazione degli strumenti scientifici nelle collezioni Fiorentini', *Antichità Viva* 9. 3–25.

—— 1970b. 'Mexikanische Altertümer aus süddeutschen Kunstkammern', *Pantheon* 28. 205–20.

—— 1976. 'American objects in Italian collections of the Renaissance and Baroque: a survey', in F. Chiapelli (ed.), *First Visual Images of America* (Berkeley, Los Angeles and London), pp. 455–82.

—— 1982. 'Mexico und die Medici-Herzöge', in K.-H. Kohl (ed.), *Mythen der Neuen Welt* (Berlin), pp. 126–46.

Heikamp, D., and Anders, F., 1972. *Mexico and the Medici* (Florence).

Helbig, G. 1900. *Russkije izbranniki* (Berlin).

Hellman, C. D., 1970. 'Tycho Brahe', in *Dictionary of Scientific Biography* 2 (New York), pp. 401–16.

Heninger, S. K., 1977. *The Cosmographical Glass: Renaissance Diagrams of the Universe* (San Marino, California).

Hennin, J. de, 1681. *De zinrijke gedachten toegepast op de vijf sinnen van 's mensen verstand* (Amsterdam).

Henry, J., 1805. *Algemeines Verzeichnis des Königlichen Kunst-, Naturhistorischen und Antiken-Museums* (Berlin).

Heres, G., 1977. 'Die Anfänge der Berliner Antiken-Sammlung: zur Geschichte des Antikenkabinetts 1640–1830', *Staatliche Museen zu Berlin, Forschungen und Berichte* 18. 93–130.

—— 1980. 'Die Anfänge der Berliner Antiken-Sammlung. Addenda et Corrigenda', *Staatliche Museen zu Berlin, Forschungen und Berichte* 20–1. 101ff.

Hermansen, V., 1951. 'Fra Kunstkammer til Antik-Cabinet', in *Antik-Cabinettet 1851* (Copenhagen), pp. 9–56.

Hernmarck, C., 1977. *The Art of the European Silversmith 1430–1830* 1 (London and New York).

Herold, E., 1977. 'Afriká móda renesanční Evropy', *Umění a řemesla* 2/77.

Hertzberg, G. F., 1898. *August Hermann Francke und sein Hallisches Waisenhaus* (Halle).

Hervey, M. F. S., 1921. *The Life, Correspondence and Collections of Thomas Howard, Earl of Arundel, 'Father of Vertu in England'* (Cambridge).

Hess, J., 1950. 'Lord Arundel in Rom und sein Auftrag an den Bildhauer Egidio Moretti', *English Miscellany* 1. 197–220.

Heuser, H. J., 1961. 'Drei unbekannte Risse H. Collaerts d. Ä.', *Jahrbuch der Hamburger Kunstsammlungen* 6. 29–53.

Heym, K., 1913. 'Aus den Fremdenbüchern der

Kunstkammer', *Mitteilungen aus den sächsischen Kunstsammlungen* 4.

Himmelheber, G., 1975. 'Ulrich und Melchior Baumgartner', *Pantheon* 33. 113–20.

—— 1980. 'Augsburger Kabinettschränke', *Welt im Umbruch* 2 (Augsburg), pp. 58–62, 472–4.

Hinrichs, C., 1971. *Preussentum und Pietismus* (Göttingen).

Hirn, J., 1885–8. *Erzherzog Ferdinand II von Tirol* (Innsbruck).

Hirsching, F. K. G., 1786–92. *Nachrichten von sehenswürdigen Gemälde- und Kupferstichsammlungen . . . in Teutschland* (Erlangen).

Hirtzel, J. S. H., 1928. 'Le manteau de plumes dit le de "Montézuma" des Musées Royaux du Cinquantenaire de Bruxelles', *International Congress of Americanists* (New York), Acts pp. 649–51.

Hochstetter, F. von, 1884. 'Über mexikanische Reliquien aus der Zeit Montezuma's in der k. k. Ambraser Sammlung', *Denkschriften der philosophisch-historischen Klasse der kaiserlichen Akademie der Wissenschaften* 35.

Hofmann, F., *et al.*, 1965. *August Hermann Francke. Das humanistische Erbe des grossen Erziehers* (Halle).

Holger, J., 1696. *Museum Regium rerum tam naturalium quam artificialium . . .* (Copenhagen).

Holtmeyer, A. (ed.), 1923. *Die Bau- und Kunstdenkmäler im Reg. Bez. Cassel* 6 (Kassel).

Home, Sir J., 1935–6. 'A Ming bowl at Bologna', *Transactions of the Oriental Ceramic Society* 13. 30–1.

Hooke, R., 1665. *Micrographia* (London).

—— 1705. 'Discourses of Earthquakes', in R. Waller (ed.), *The Posthumous Works of R[obert] H[ooke]* (London), pp. 210–450.

Houghton, W. E., 1942. 'The English virtuoso in the seventeenth century', *Journal of the History of Ideas* 3. 51–73, 190–219.

Houtzager, H. L., 1979. *Medicyns, vroedwyfs en chirurgyns* (Amsterdam).

Howarth, D. J., 1978. 'Lord Arundel as a Patron and Collector 1604–1646: A Study in Motive and Influence' (Ph.D. thesis, University of Cambridge).

Howse, D., 1975. *Greenwich Observatory: The Royal Observatory at Greenwich and Herstmonceux 1675–1975* 3 *The Buildings and Instruments* (London).

—— 1980. *Greenwich Time and the Discovery of the Longitude* (Oxford).

Hubert, R., n.d. *A Catalogue of part of those Rarities Collected in thirty years time with great deal of Pains and Industry, by . . . R. H. alias Forges* (London).

—— 1664. *A Catalogue of the Many Natural Rarities, with Great Industry, Cost and thirty Years travel in Foraign Countries, Collected by Robert Hubert* (London) [another edn. 1665].

Hudson, G. F., 1931. *Europe and China: a survey of their relations from the Earliest Times to 1800* (London).

Hunter, J. (ed.), 1830. *The Diary of Ralph Thoresby, F.R.S., author of The Topography of Leeds (1677–1724)* (London).

Hunter, M., 1975. *John Aubrey and the Realm of Learning* (London).

—— 1981. *Science and Society in Restoration England* (Cambridge).

—— 1982a. *The Royal Society and its Fellows 1660–1700: the Morphology of an Early Scientific Institution* (Chalfont St. Giles).

—— 1982b. 'Reconstructing Restoration science: problems and pitfalls in institutional history', *Social Studies of Science* 12. 451–66.

Huth, H., 1970. '"Sarazenen" in Venedig', in *Festschrift für Heinz Ladendorf* (Cologne and Vienna), pp. 58–68.

—— 1971. *Lacquer of the West* (Chicago).

Hutin, S., 1971. *Robert Fludd (1574–1637), alchimiste et philosophe rosicrucien* (Paris).

Imperato, F., 1599. *Dell'Historia Naturale di Ferrante Imperato Napolitano Libri XXVIII Nella quale ordinatamente si tratta della diversa condition di miniere, e pietre. Con alcune historie di Piante, et Animali; sin' hora non date in luce* (Naples).

Impey, O. R., 1974. 'Kyoto ware hanging wall vases in the Johanneum', *Oriental Art* 20. 431–5.

—— 1977. *Chinoiserie: the Impact of Oriental Styles on Western Art and Decoration* (Oxford).

—— 1982. 'Japanese export lacquer of the seventeenth century' in W. Watson (ed.), *Lacquer-work in Asia and Beyond* (Colloquy on Art and Archaeology in Asia 11) (London), pp. 124–58

—— 1983. 'A lacquered shield', *The Ashmolean* 2. 8–9.

—— 1984. 'Japanese export art of the Edo period and its influence on European Art', *Modern Asian Studies* 18. 685–97.

Incisa della Rocchetta, G., 1966. 'Il museo di curiosita del Card. Flavio I Chigi', *Archivio della Società Romana di Storia Patria* 89. fasc. I–IV.

Ingrams, R. A., 1974 'Rubens and Persia', *Burlington Magazine* 116. 190–7.

Irwin, J., 1952. 'Indo-Portuguese embroideries of Bengal', *Journal of the Royal India, Pakistan and Ceylon Society* 24.

—— 1953. 'A Jacobean vogue for oriental lacquer ware', *Burlington Magazine* 95. 193–4.

—— 1962. *The Girdlers Carpet* (London) [reprinted *Marg* 18, no. 4 (1965), pp. 15–17].

—— 1965. 'Fremlin carpets', *Marg* 18, no. 4, pp. 18–19.

Irwin, J., and Brett, K. B., 1970. *Origins of Chintz* (London).

Iwao, S., 1963. 'Sakoku', *Nihon no Rekishi* 10.

Jacobaeus, O., 1696. *Museum Regium seu Catalogus rerum tam naturalium quam artificialium* (Hafnia).

Jacoby, F., 1904. *Das Marmor Parium* (Berlin).

Jahn, M. E., 1966. 'The Old Ashmolean Museum and the Lhwyd collections', *Journal of the Society for the Bibliography of Natural History* 4. 244–8.

Jamnitzer, W., 1568. *Perspectiva Corporum Regularium* (Nuremberg).

Janáček, J., 1962. 'Francouzský cestovatel v Praze roku 1597', *Kniha o Praze* 79–91.

Janson, H. W., 1952. *Apes and Ape Lore* (Studies of the Warburg Institute 20) (London).

Jenyns, S., 1964–6. 'The Chinese porcelains in the Topkapu Saray, Istanbul', *Transactions of the Oriental Ceramic Society* 36. 43–72.

—— 1965. *Japanese Porcelain* (London).

Jöcher, C. G., 1751. *Allgemeines Gelehrtenlexicon* 3–4 (Leipzig).

Johnson, T., 1633. *The Herball or Generall Historie of Plantes gathered by John Gerarde . . . very much Enlarged and Amended by Thomas Johnson* (London).

Jörg, C. J. A., 1981. 'Japanese lacquerwork decorated after European prints', in *Collection of Essays in Commemoration of the 30th Anniversary of the Institute of Oriental and Occidental Studies, Kansai University* (Osaka), pp. 57–80.

Josselyn, J., 1672. *New-England's Rarities discovered in Birds, Beasts, Fishes, Serpents and Plants of that Country* (London).

Josten, C. H., 1966. *Elias Ashmole, 1617–1692* (Oxford).

Kaden, V., 1983. *The Illustration of Plants and Gardens 1500–1850* (London).

Kagan, J., and Neverov, O., 1982. 'Sud'ba petrovskoj relikvii', *Soobschenija Gos. Ermitaga* 47. 19 ff.

Kangro, H. 1973. 'Kircher', in *Dictionary of Scientific Biography* 7. 374–8.

Karstens, W. K. H., and Kleibrink, H., 1982. *De Leidse Hortus, een Botanische Erfenis* (Zwolle).

Kaufmann, T. DaCosta, 1978. 'Remarks on the collections of Rudolf II: the *Kunstkammer* as a form of *representatio*', *Art Journal* 38. 22–8.

Keil, L., 1938. *Alguns exemplos da influencia Portuguesa de arte indianes do seculo XVI* (Lisbon).

—— 1942. 'Parcelanos Chinesas do Seculo XVI com iscricoes em Portugues', *Bolttim da Academia Nacional de Belas-Artes* 10. 18–69.

Kemp, W., 1973. *Natura, Ikonographische Studien zur Geschichte und Verbreitung einer Allegorie* (Frankfurt-am-Main).

Kentmann, J., 1565. *Nomenclaturae Rerum fossilium* (Dresden).

Keutner, H., 1958. 'The Palazzo Pitti Venus and other works by Vincenzo Danti', *Burlington Magazine* 100. 427–31.

Keynes, Sir G., 1966. *The Life of William Harvey* (Oxford).

Kienast, R., 1926. *Johann Valentin Andreae und die vier echten Rosenkreutzer-Schriften* (Palaestra 152: Untersuchungen und Texte aus der Deutschen und Englischen Philologie) (Leipzig).

Killing, M., 1927. *Die Glasmacherkunst in Hessen* (Marburg).

King, J. C. H., 1981. *Artificial Curiosities from the Northwest Coast of America* (London).

Kircher, A., 1675. *Arca Noë in tres libres digesta* (Amsterdam).

Kirchvogel, P. A., 1953. *Index zur Geschichte der Medizin, Naturwissenschaft und Technik* (Munich and Berlin).

Klein, D., 1977. 'Der Münzhof in München', *Oberbayerisches Archiv* 102. 226–34.

Klemm, F., 1973. *Geschichte der naturwissenschaftlichen und technischen Museen* (Deutsches Museum. Abhandlungen und Berichte Jahrgang 41, 2) (Munich and Düsseldorf).

Klemm, G., 1837. *Zur Geschichte der Sammlungen für Wissenschaft und Kunst in Deutschland* (Zerbst).

Klinckowstroem, C. von, 1922. 'Von Kunst- und Raritäten-Kammern', *Geschichtsblätter für Technik und Industrie* 9. 12–25.

Klopp, O., 1869. 'Leibniz' Plan der Gründung einer Societät der Wissenschaften in Wien', *Archiv für österreichische Geschichte* 40. 157–255.

Knips Macoppe, A. 1822. *Aforismi medico-politici del celebre Alessandro Knips Macoppe volgarizzati col testo a fronte da Giuseppe Antonio del Chiappa* (Pavia).

Knowlson, J., 1975. *Universal Language Schemes in England and France, 1600–1800* (Toronto and Buffalo).

Köhler, J. D., 1788. *Anweisung zur Reiseklugheit für junge Gelehrte* (Magdeburg).

Köhler, W., 1906–7. 'Aktenstücke zur Geschichte der Wiener Kunstkammer in der herzoglichen Bibliothek zu Wolfenbüttel', *Jahrbuch der Kunsthistorischen Sammlungen des Allerhöchsten Kaiserhauses* 26 (2). i–xx.

König, A. B., 1793–8. *Versuch einer historischen Schilderung der Hauptveränderungen der Religion, Sitten, Gewohnheiten, Künste, Wissenschaft etc. der Residenzstadt Berlin seit den ältesten Zeiten, bis zum Jahre 1786* (Berlin).

Krafft, F., 1981. 'Luoghi della ricerca naturale', in L. Boehm and E. Raimondi (eds.), *Università, accademie e società scientifiche in Italia e in Germania dal Cinquecento al Settecento* (Bologna), pp. 421–60.

Krämer, G., 1880–2. *August Hermann Francke. Ein Lebensbild* (Halle).

Krčálová, J., 1975. 'Poznámky k rudolfínské architektuře', *Umení* 23. 499–523.

—— 1979. 'Die Kunst zur Zeit der Renaissance und Manierismus', in J. Horejsí *et al.*, *Die Kunst der Renaissance und Manierismus in Böhmen* (Prague), pp. 49–147.

—— 1982. 'Die rudolfinische Architektur', *Leids Kunsthistorisch Jaarboek* 1. 271–308.

Krempel, U., 1967. 'Augsburger und Münchner Emailarbeiten des Manierismus aus dem Besitz der bayerischen Herzöge Albrecht V., Wilhelm V. und Maximilian I.', *Münchner Jahrbuch der Bildenden Kunst* ser. 3, 18. 111–86.

—— 1968. 'Die Orbansche Sammlung, eine Raritätenkammer des 18. Jahrhunderts', *Münchner Jahrbuch der Bildenden Kunst* ser. 3, 19. 169–84.

—— 1978. 'Die herzogliche Kunstkammer in München', in J. von Schlosser, *Die Kunst- und Wunderkammern der Spätrenaissance* new edn. (Braunschweig), pp. 142–50.

Kris, E., 1926. 'Der Stil "Rustique", die Verwendung des Naturabgusses bei Wenzel Jamnitzer und Bernard Palissy', *Jahrbuch der kunsthistorischen Sammlungen in Wien* new ser. 1. 137–208.

—— 1929. *Meister und Meisterwerke der Steinschneidekunst in der italienischen Renaissance* (Vienna).

—— 1932. *Goldschmiedearbeiten des Mittelalters, der Renaissance und des Barock, Erster Teil, Arbeiten in Gold und Silber* (Publikationen aus den Kunsthistorischen Sammlungen in Wien 5) (Vienna).

Kugler, F., 1838. *Beschreibung der in der Königlichen Kunstkammer zu Berlin vorhandenen Kunst-Sammlung* (Berlin).

Kühnel, E., 1924. *Maurische Kunst* (Berlin).

Kunisch, J., 1982. *Der dynastische Fürstenstaat* (Historische Forschungen 21) (Berlin).

Kunsthistorisches Museum, Vienna, 1964. *Katalog der Sammlung für Plastik und Kunstgewerbe 1 Mittelalter* (Führer durch das Kunsthistorische Museum 10) (Vienna).

—— 1966. *Katalog der Sammlung für Plastik und Kunstgewerbe 2 Renaissance* (Führer durch das Kunsthistorische Museum 11) (Vienna).

—— 1977. *Sammlungen Schloss Ambras. Die Kunstkammer* (Führer durch das Kunsthistorische Museum 24) (Innsbruck).

—— 1978. *Das Kunsthistorische Museum in Wien* (Vienna).

—— 1981. *Sammlungen Schloss Ambras. Die Rüstkammern* (Führer durch das Kunsthistorische Museum 30) (Vienna).

Kurz, O. 1966. 'Künstlerische Beziehungen zwischen Prag und Persien zur Zeit Kaiser Rudolfs II. und Beiträge zur Geschichte seiner Sammlungen', *Umĕní* 14. 461–89 [in Czech] [reprinted in Kurz (1977), no. xiv, in German].

—— 1972. 'Libri cum characteribus ex nulla materia compositis', *Israel Oriental Studies* 2. 240–7 [reprinted in Kurz (1977), no. xxi].

—— 1975. 'The strange history of an Alhambra vase', *al-Andalus* 40. 205–12 [reprinted in Kurz (1977), no. xvii].

—— 1977. *The Decorative Arts of Europe and the Islamic East. Selected Studies* (London).

Kurz, O., and Kurz, H. S., 1972. 'The Turkish dresses in the Costume-Book of Rubens', *Nederlands Kunsthistorisch Jaarboek* 23. 275–90 [reprinted in Kurz (1977), no. xv].

Küster, G. G., 1756. *Beschreibung des Alten und Neuen Berlin in 5 Teilen III Abtheilung* (Berlin).

Lach, D. F., 1970. *Asia in the Making of Europe 2 A Century of Wonder Book 1 The Visual Arts* (Chicago).

Laet, J. de, 1648. *Historia Naturalis Brasiliae Guilielmi Pisonis et Georgii Marcgravii* (Amsterdam and Leiden).

Lamarck, J. B. P. A. de M. de, 1809. *Philosophie Zoologique* (Paris).

Lamm, C. J., 1930. *Mittelalterliche Gläser und Steinschnittarbeiten aus dem nahen Osten 1* (Berlin).

Landolt, E., 1972. 'Materialien zu Felix Platter als Sammler und Kunstfreund', *Basler Zeitschrift für Geschichte und Altertumskunde* 72, 245–306.

—— 1978. 'Künstler und Auftraggeber im späten 16. Jahrhundert in Basel', *Unsere Kunstdenkmäler* 29. 310–22.

Lane, A., 1957a. 'The Ottoman pottery of Isnik', *Ars Orientalis* 2. 247–81.

—— 1957b. *Later Islamic Pottery* [2nd edn. 1971] (London).

—— 1961. 'The Gaignières Fonthill Vase: a Chinese porcelain of about 1300', *Burlington Magazine* 103. 124–31.

Lankester, E. (ed.), 1848. *The Correspondence of John Ray* (London).

—— 1866. *Memorials of John Ray . . . with his Itineraries* (London).

Larsen, H., 1941. 'Ancient specimens from Western and Central Polynesia', *Ethnographical Studies, Etnografisk Raekke* 1. 223–50.

Larsson, L. O., 1967. *Adrian de Vries* (Vienna and Munich).

Laude, J., 1968. *La peinture française (1905–1914) et 'l'Art Nègre'* (Paris).

Laurencich-Minelli, L., 1982a. 'Bologna und Amerika vom 16. bis zum 18. Jahrhundert', in *Berliner Festspiele. Mythen der Neuen Welt* (Berlin), pp. 147–54.

—— 1982b. 'Dispersione e recupero della collezione etnografica Cospi', *Deputazione di Storia Patria della provincia di Romagna* 33. 185–202.

—— 1983. 'Oggetti Americani studiati da Ulisse Aldrovandi', *American Objects in European collections of XVI–XVIII centuries* (Archivio per l'Antropologia e la Etnologia 113) (Florence) pp. 187–206.

—— 1984. 'L'indice del Museo di Antonio Giganti. Interessi etnografici e ordinamento di un museo cinquecentesco,' *Museografia Scientifica* 2.

Laurencich-Minelli, L., and Ciruzzi, S., 1981. 'Antichi oggetti americani nelle collezioni del Museo Nazionale di Antropologia e Etnologia di Firenze: due mantelli di penne dei Tupinamba', *Archivio per l'Antropologia e la Etnologia* 111. 121–42.

Laurencich-Minelli, L., and Filippetti, A., 1981. 'Il Museo Cospiano e alcuni oggetti americani ancora a Bologna', *Il Carrobbio. Rivista di studi bolognesi* 6. 220–9.

—— 1983. 'Per le collezioni americanistiche del Museo Cospiano e dell'Istituto delle Scienze. Alcuni oggetti ritrovati a Bologna', *American Objects in European collections of XVI–XVIII centuries* (Archivio per l'Antropologia e la Etnologia 113) (Florence), pp. 207–25.

Lebenwald, A. von, 1684 (published 1685). 'De admiranda calculi curatione', *Miscellanea curiosa sive ephemeridum . . . decuriae II* 3. 158–61.

Ledebur, L. von., 1831. 'Geschichte der Königlichen Kunstkammer in Berlin', *Allgemeines Archiv für die Geschichtskunde des Preussischen Staates* 6.

—— 1833. 'Wanderung durch die Königliche Kunstkammer Berlin mit besonderer Rücksicht auf Errinerungen an das Hohe Herrscherhaus', *Allgemeines Archiv für die Geschichtskunde des Preussischen Staates* 12.

—— 1844. *Leitfaden für die Königliche Kustkammer und das ethnographische Cabinet zu Berlin* (Berlin).

—— 1871. *Königliche Museen, Abtheilung der Kunstkammer, umfassend die Sammlung kleinerer Kunstwerke des Mittelalters und der Neueren Zeit, sowie der historischen Merkwürdigkeiten* (Berlin).

—— 1875. 'Friedrich I. und die Kunstkammer', *Der Bär* 1 no. 13, l.x. 121ff.

Leeman, F., Elffers, J., and Schuyt, M., 1975. *Anamorphosen, Ein Spiel mit der Wahrnehmung, dem Schein und der Wirklichkeit* (Cologne).

Legati, L., 1667. *Breve descrizione del Museo di F. Cospi* (Bologna).

—— 1677. *Museo Cospiano annesso a quello del famoso Ulisse Aldrovandi e donato alla sua Patria dall'Illustrissimo Signor Ferdinando Cospi* (Bologna).

Lehmann, H., 1958. 'Un bâton de cerémonie du XVIIe siècle', *Miscellanea Paul Rivet* 2. 297–304.

Lehmann, P. W., and Lehmann, K., 1973. *Samothracian Reflections. Aspects of the Revival of the Antique* (Princeton).

Lehmann, W., 1906. 'Altmexikanische Mosaiken und die Geschenke König Motecuzomas an Cortés', *Globus* 90. 318–22.

—— 1907. 'Die altmexikanischen Mosaiken des ethnographischen Museums in Kopenhagen', *Globus* 91. 322–35.

Leibniz, G. W., 1859–75. *Oeuvres de Leibniz publiées pour la première fois d'après les manuscrits originaux* (ed. A. Foucher de Careil) (Paris).

Leiden University, 1659. *Res curiosae & exoticae, quae in Ambulacro Horti Academiae Leydensis curiositatem amantibus offeruntur Anno 1659* [Leiden].

—— n.d. [1670?]. *Res curiosae et exoticae, in Ambulacro Horti Academici Lugdano-Batavi conspicuae* [Leiden].

—— 1683. *A Catalogue of all the cheifest Rarities In the Publick Theater and Anatomie-Hall of the University of Leiden* (Leiden).

—— 1688. *An index to the Indian Closset . . . to be seen in the Garden of the Academy of Leyden* (Leiden).

—— n.d. [1697?] (1). *Musaei indici index exhibens varia exotica animalia & vegetabilia . . . prosantia apud Jacobum Voorn* (Leiden).

—— n.d. [1697?] (2). *Musaei indici index exhibens varia exotica animalia & vegetabilia . . . conspicienda in Horti Academici Ambulacro Lugduni Batavorum* [Leiden].

Leithe-Jasper, M., 1970. 'Der Bergkristallpokal Herzog Philipps des Guten von Burgund', *Jahrbuch der Kunsthistorischen Sammlungen in Wien* 66. 227–42.

Leithe-Jasper, M., and Distelberger, R., 1982. *The Kunsthistorische Museum, Vienna. The Treasury and the Collection of Sculpture and Decorative Arts* (London).

Leith-Ross, P., 1984a. *The John Tradescants: Gardeners to the Rose and Lily Queen* (London).

—— 1984b. 'Two notes on the Tradescants', *Journal of Garden History* 4.

Lencker, H., 1567. *Perspectiva Literaria* (Nuremberg).

Lensi Orlandi, G., 1978. *Cosimo e Francesco de' Medici, Alchimisti* (Florence).

Lessing, J., and Brüning, A., 1905. *Der Pommersche Kunstschrank* (Berlin).

Levine, J. M., 1977. *Dr Woodward's Shield. History, Science and Satire in Augustan England* (Berkeley, Los Angeles, and London).

Lewis, C. T., and Short, C., 1879. *A Latin Dictionary* (Oxford).

Lhotsky, A., 1941–5. *Festschrift des Kunsthistorischen Museums in Wien 1891–1941* 2 *Die Geschichte der Sammlungen* (Vienna).

—— 1974. 'Die Ambraser Sammlung, Umrisse und Geschichte einer Kunstkammer', in A. Lhotsky (ed.), *Aufsätze und Vorträge* 4 (Vienna), pp. 127–8.

Liebenwein, W., 1977. *Studiolo. Die Entstehung eines Raumtyps und seine Entwicklung bis um 1600* (Frankfurter Forschungen zur Kunst 6) (Berlin).

—— 1982. 'Die Villa Albani und die Geschichte der Kunstsammlungen', in H. Beck and P. C. Bol (eds.), *Forschungen zur Villa Albani. Antike Kunst und die Epoche der Aufklärung* (Berlin), pp. 461–505.

Lieburg, M. J. van, 1976. 'Het eerste theatrum anatomicum van Rotterdam (1642–1759)', *Rotterdams Jaarboekje* pp. 210–27.

Lightbown, R. W., 1969. 'Oriental art and the Orient in Late Renaissance and Baroque Italy', *Journal of the Warburg and Courtauld Institutes* 32. 228–79.

—— 1981. 'L'esotismo', *Storia dell'Arte Italiana* 10 (*Conservazione, falso, restauro*) (Turin), pp. 445–87.

Liisberg, H. C. Bering, 1897. *Kunstkammeret* (Copenhagen).

Lindeboom, G. A., 1975a. *A Classified Bibliography of the History of Dutch Medicine 1900–74* (The Hague).

—— 1975b. *The Letters of Jan Swammerdam to Melchisédec Thévenot* (Amsterdam).

Link, E. M., 1975. *Die landgräfliche Kunstkammer Kassel* (Kassel).

Linnaeus, C., 1735. *Systema Naturae* (Leiden).

—— 1754. *Museum Regis Adolphi Friderici* (Holmiae).

—— 1764. *Museum Reginae Ludovicae Ulricae* (Holmiae).

Linné, S., 1955. 'Drei alte Waffen aus Nordamerika im Staatlichen Ethnographischen Museum in Stockholm', *Baessler-Archiv* new ser. 3. 85–7.

Linschoten, J. van, 1596. *Itinerarium ofte schip-vaart naer Oost ofte portugaels Indien* (Amsterdam).

—— 1599. *Navigatio ac Itinerarium Johannis Hugonis Linschoten* (Hagæ Comitis).

Lister, M., 1678. *Historiae Animalium Angliae* (London).

—— 1685–92. *Historia Conchyliorum* (London).

—— 1967. *A journey to Paris in the year 1698* (ed. R. P. Stearns) (Urbana).

Liverani, G., 1936. *Catalogo delle porcellane dei Medici* (Faenza).

Livorno e Pisa, 1980. *Livorno e Pisa: due città e un territorio nella politica dei Medici* (Pisa).

Lloyd, H. A., 1958. *Some Outstanding Clocks over Seven Hundred Years* (London).

Lochner, J. H., 1716. *Rariora Musei Besleriani* (Nuremberg).

Logan, A. M. S., 1979. *The 'Cabinet' of the Brothers Gerard and Jan Reynst* (Amsterdam and New York).

Loisel, G., 1912. *Histoire des Ménageries* (Paris).

Lomazzo, G. P., 1584. *Trattato dell'arte de la pittura* (Milan).

London, A., 1983. '*Musæum Tradescantianum* and the Benefactors to the Tradescants' Museum', In A. MacGregor (ed.). *Tradescant's Rarities* (Oxford), pp. 24–39.

Losman, A., 1980. *Carl Gustaf Wrangel och Europa, Studier i kulturförbindelser kring en 1600-talsmagnat* (Lychnos-Bibliotek 33) (Stockholm).

—— 1982. 'Minnets teater', in *En värld i miniatyr, Kring en samling från Gustav II Adolfs tidevarv* (Skrifter från Kungl. Husgerådskammaren 2) (Stockholm), pp. 5–12.

Luchner, L., 1958. *Denkmal eines Renaissancefürsten. Versuch einer Rekonstruktion des Ambraser Museums von 1583* (Vienna).

Luchtmans, S., and Luchtmans, J., 1762. *Collectio exquisitissima Instrumentorum, in primis ad Physicam experimentalem pertinentium, Quibis, dum vivebat, usus fuit vir celeberrimus Petrus van Musschenbroek* (Leiden).

Lugli, A., 1983. *Naturalia et Mirabilia. Il collezionismo enciclopedico nelle Wunderkammern d'Europa* (Milan).

Lundbæk, T., and Dehn-Nielsen, H. (eds.), 1979. *Det Indianske Kammer* (Copenhagen).

Lunsingh Scheurleer, D. F., 1980. *Chinesisches und japanisches Porzellan in europäischen Fassungen* (Braunschweig).

—— 1981–2. 'De triomftocht met geschenken uit de Oost en de West door Jacob van Campen', *Oud Nieuws* 15.

Lunsingh Scheurleer, Th.H., 1941. 'Aanbesteding en verspreiding van Japansch lakwerk door de Nederlanders in de zeventiende euwe', *Jaarverslag van het Koninklyk Ondheidkundig Genoetschap*.

—— 1969. 'De woonvertrekken in Amalia's Huis ten Bosch', *Oud-Holland* 84.

—— 1975. 'Un amphithéatre d'anatomie moralisée', in Th.H. Lunsingh Scheurleer and G. H. M. Posthumus Meyjes (eds.), *Leiden university in the 17th century* (Leiden), pp. 217–77.

—— 1979. 'The Mauritshuis as Domus Cosmographica', in E. van den Boogaart, H. R. Hoetink, and P. J. P. Whitehead (eds.), *Johan Maurits van Nassau-Siegen 1604–1679* (The Hague), pp. 143–90.

Luschin von Ebengreuth, A., 1899. 'Die ältesten Beschreibungen der kaiserlichen Schatzkammer zu Wien', *Jahrbuch der Kunsthistorischen Sammlungen des Allerhöchsten Kaiserhauses* 20 (2).

Luyendijk-Elshout, A. M., 1970. 'Death enlightened', *Jama* 212.

Luzio, A., 1913. *La galleria dei Gonzaga venduta all'Inghilterra nel 1627–28* (Milan).

Maar, V., 1916. 'The Domus Anatomica at the time of Thomas Bartholinus', *Janus* 21. 339–49.

Maccagni, C., 1981. 'Le raccolte e i musei di storia naturale e gli orti botanici come istituzioni alternative e complementari rispetto alla cultura delle università e delle accademie', in L. Boehm and E. Raimodi (eds.), *Università, accademie e società scientifiche in Italia e in Germania dal Cinquecento al Settecento* (Bologna), pp. 283–310.

MacGregor, A. (ed.), 1983. *Tradescant's Rarities: Essays on the Foundation of the Ashmolean Museum 1683 with a Catalogue of the Surviving Early Collections* (Oxford).

MacGregor, A., and Turner, A. J., forthcoming. 'The Ashmolean Museum', in *The History of the University of Oxford* 5: *The Eighteenth Century* (Oxford), pp. 639–58.

Mackensen, L. von, 1979. 'Die erste Sternwarte Europas mit ihren Instrumenten und Uhren', in Staatliche Kunstsammlungen Kassel, *400 Jahre Jost Bürgi in Kassel* (Schriften zur Naturwissenschaft und Technikgeschichte 1) (Munich) [new edn. 1982].

Mackeprang, M., 1929. 'Fra Nationalmuseets barndom', *Nationalmuseets Arbejdsmark*, pp. 5–14.

[Macky, J.], 1714. *A Journey through England* [1] (London).

Macray, W. D., 1890. *Annals of the Bodleian Library, Oxford* 2nd edn. (Oxford).

Magalotti, L., 1821. *Travels of Cosmo III, Grand Duke of Tuscany, through England (1669)* (London).

Magnani, L., 1978–9. 'Uno "Spazio Privato" nella cultura Genovese tra XVI e XVII secolo', *Studi di Storia delle Arte* 11. 113–29.

Major, E., 1908. 'Das Fäschische Museum und die Fäschischen Inventare', *Jahresbericht der Oeffentlichen Kunstsammlung Basel* 1–69.

—— 1926. *Erasmus von Rotterdam* (Basle).

Major, J. D., 1664. *Dissertatio Epistolica de Cancris et Serpentibus Petrefactis* (Jena).

—— 1683. *See-Farth nach der Neuen Welt ohne Schiff- und Segel* (Hamburg).

Mandelslo, J. A. de, 1719. *Voyages celèbres et remarquables faits de Perse aux Indes orientales* (Leiden).

Manucci, N., 1907–8. *Storia do Mogor* (ed. W. Irvine) (London).

Mariani Canova, G., 1975–6. 'Il museo maffeiano nella storia della museologia', *Atti e memorie dell'Accademia di agricoltura, scienze e lettere di Verona* ser. 6, 27. 177–91.

Masson, D., 1881. *Life of Milton* (London).

Masson, G., 1972. 'Italian flower collectors' gardens in seventeenth-century Italy', in D. Coffine (ed.), *The Italian Garden* (Washington, DC), pp. 61–80.

Maurice, K., 1976. *Die deutsche Räderuhr* (Munich).

Maylender, M., 1926–30. *Storia delle Accademie d'Italia* (Bologna).

Mayor, J. E. B., 1911. *Cambridge under Queen Anne* (Cambridge).

Mazerolle, F., 1897. 'Un vase oriental en porcelaine orné d'une monture d'orfévrerie du XIVe siècle', *Gazette des Beaux-Arts* 17. 53–8.

Meitinger, O., 1970. *Die baugeschichtliche Entwicklung der Neuveste* (Oberbayerisches Archiv 92) (Munich).

Melikian-Chirvani, A. S., 1974. 'Venise, entre l'Orient et l'Occident', *Bulletin des Études Orientales* 27. 109–26.

—— 1982. *Islamic Metalwork from the Iranian World 8–18th centuries* (London).

Menzelius, P., 1579. *Threnos in Serenissimum et illustrissimum principem . . . Albertum* (Ingolstadt).

Menzhausen, J., 1968. *The Green Vaults* (Leipzig).

—— 1977. *Dresdener Kunstkammer und Grünes Gewölbe* (Leipzig).

Mercati, M., 1717. *Metallotheca. Opus Posthumum. Auctoritate et Munificentia Clementis Undecimi P.M. e tenebris in lucem eductum: Opera autem et studio Ioannis Lancisii Archiatri Pontificii illustratum* [another edn. 1719] (Rome).

Merian, M., 1677. *Topographia Provinciarum Austriacarum: Steiermark* 2nd edn. (Frankfurt-am-Main).

Merrett, C., 1660. *Catalogus Librorum, Instrumentorum Chirurgicorum, rerum curiosarum, Exoticarumque Coll. Med. Lond. Quae Habentur in Musaeo Harveano* (London).

—— 1666. *Pinax Rerum Naturalium Britannicarum, continens Vegetabilia, Animalia et Fossilia* (London).

Métraux, A., 1927. 'Nationalmuseets fjerprydelser fra Tupinamba'erne', *Geografisk Tidsskrift* 30. 258–74.

—— 1928. *La Civilisation Matérielle des Tribus Tupi-Guarani* (Paris).

—— 1932. 'A propos de deux objets tupinamba', *Bulletin du Musée d'Ethnographie du Trocadéro* 3. 3–18.

Metz, P., *et al.*, 1966. *Bildwerke der christlichen Epochen von der Spätantike bis zum Klassizismus. Aus den Beständen der Skulpturenabteilung der Staatlichen Museen, Stiftung Preussischer Kulturbesitz, Berlin-Dahlem* (Munich).

Meulen, M. van der, 1974. 'Cardinal Cesi's antique sculpture garden: notes on a painting by Hendrick van Cleef III', *Burlington Magazine* 116. 14–24.

Meyer, A. B., and Uhle, M., 1885. 'Seltene Waffen aus Afrika, Asien und Amerika', *Königliches Ethnographisches Museum zu Dresden* 5 (Leipzig).

Meyer, E., 1959. 'Romanische Bronzen und ihre islamischen Vorbilder', in R. Ettinghausen (ed.), *Festschrift für Ernst Kühnel* (Berlin), pp. 317–22.

Meyer, F., 1966. 'Andreas Ryff (1550–1603), Der Rappenkrieg', *Basler Zeitschrift für Geschichte und Altertumskunde* 66. 5–31.

—— 1972. 'Andreas Ryff (1550–1603), Reisebüchlein', *Basler Zeitschrift für Geschichte und Altertumskunde* 72. 5–135.

Michaelis, A., 1882. *Ancient Marbles in Great Britain* (Cambridge).

Michele, V. de, 1973. 'Un'illustrazione inedita della meteorite caduta a Milano nel secolo XVII', *Atti Società Italiana di Scienze Naturali* 114. 43–50.

Michele, V. de, Cagnolaro, L., Aimi, A., and Laurencich-Minelli, L., 1983. *Il Museo di Manfredo Settala nella Milano del XVII secolo* (Milan).

Micheli, R., and Tongiorgi Tomasi, L., 1982. 'Galileo critico d'arte di Erwin Panofsky', *Dimensioni* 2. 9–42.

Michelspacher, S., 1615. *Cabala. Spiegel der Kunst und Natur: in Alchymia* (Augsburg).

Middleton, W. E. Knowles, 1969. *Invention of the Meteorological Instruments* (Baltimore).

—— 1971. *The Experimenters: A Study of the Accademia del Cimento* (Baltimore).

—— (ed.), 1980. *Lorenzo Magalotti at the Court of Charles II: his 'Relazione d'Inghilterra' of 1668* (Waterloo, Ontario).

Millar, O. 1958–60. 'Abraham Van der Voorts catalogue of the collections of Charles I', *Journal of the Walpole Society* 37.

—— 1972. *The Age of Charles I; Painting in England 1620–1649* (London).

Millburn, J. R., 1976. *Benjamin Martin: Author, Instrument-Maker and 'Country Showman'* (Leiden).

Miller, E., 1973. *That Noble Cabinet. A History of the British Museum* (London).

Miller, P., 1724. *Gardeners and florists dictionary, or a complete system of horticulture* [another edn. 1737] (London).

Mirandola, F. Pico della, 1513. *De Venere et Cupidine expellendis* (Rome).

Mirrlees, H., 1962. *A Fly in Amber, being an extravagant biography of the romantic antiquary, Sir Robert Bruce Cotton* (London).

Misson, M. T., 1699. *A new voyage to Italy* (London).

—— 1702. *Nouveau voyage d'Italie* 4th. edn. (The Hague).

—— 1743. *Voyage d'Italie. Edition augmentée de remarques nouvelles et interessantes* (Amsterdam).

Mocquet, J., 1665. *Voyages en Afrique, Asie, Indes Orientales et Occidentales* (Rouen).

Molinet, C. du, 1692. *Le Cabinet de la Bibliothèque de Sainte Geneviève* (Paris).

Moller, D. W., 1704. *Commentatio de technophysiotameis sive germanice von Kunst- und Naturalien-Kammern* (Altdorf).

Monatliche Unterredungen, 1696–7. *Monatliche Unterredungen einiger guten Freunde von allerhand Büchern und andern annehmlichen Geschichten* (Leipzig).

Monconys, B. de, 1665–6. *Journal des voyages* (Lyons).

Montfaucon, B., 1724. *L'antiquité expliquée* 5 (Paris).

Montgomery, J. W., 1973. *Cross and Crucible, Johann Valentin Andreae (1586–1654), Phoenix of the Theologians* 1 (The Hague).

Morandi, G. B., 1797. *Monumenti di varia letteratura tratti dai manoscritti originali di mons. Lodovico Beccadelli, arcivescovo di Ragusa* 1 (Bologna).

Morandotti, A., 1983a. 'Il nimfeo delle Villa Borromeo, Visconti Borromeo, Litta, Toselli di Lainate: nuove tracce per il tardo Rinascimento italiano' (forthcoming).

—— 1983b. 'Pirro Visconti Borromeo mecenate milanese di une fortuna economica, sociale e politica nelle Milano delle fine del XVI secolo', *Archivio Storico Lombardo* (forthcoming).

—— forthcoming. 'Le lettere di Giovan Battista Clarici e Pietro Antonio Tolentino al naturalista Ulisse Aldrovandi', *Atti Società Italiana di Scienze Naturali*.

Morávek, J., 1932–3. 'Nově objevený inventář rudolfinských sbírek na Hradě Pražském', *Památky archeologiché, skupina historická* 2. 69–82; 3. 74–94 [first part].

—— 1933. Ibid. 3. 74–94 [second part].

—— 1934–5. Ibid. 4–5. 98–103 [third part].

Mordaunt Crook, J., 1973. 'Strawberry Hill revisited', *Country Life* 153. 1598–1602.

Morello, N., 1979. *La Nascita della Paleontologia nel Seicento* (Milan).

—— 1981. 'De Glossopetris Dissertatio: the demonstration by Fabio Colonna of the true nature of fossils', *Archives Internationales d'Histoire des Sciences* 31. 63–71.

Morhof, D. G., 1714. *Polyhistor literarius philosophicus et practicus* (Lübeck).

Morigia, P., 1619. *La Nobiltà di Milano* (Milan).

Morison, S. E., 1971. *The European Discovery of America: The Northern Voyages* (New York).

Morris, C., 1982. *The Illustrated Journey of Celia Fiennes* (London and Exeter).

Morris, W., 1890. *News from Nowhere* (London) [reprinted in A. Briggs (ed.), 1962. *William Morris, Selected Writings and Designs* (Harmondsworth)].

Moryson, F., 1907. *An Itinerary* (Glasgow).

Moscardo, L., 1656. *Note overo memorie del Museo di Lodovico Moscardo nobile veronese* (Padua).

—— 1670. *Note overo Memorie del Conte Lodovico Moscardo nobile veronese . . .* (Verona) [new edn. 1672].

—— 1672. *Note overo Memorie del Museo del Conte Lodovico Moscardo* (Verona).

Motta, E., 1892. *Il Museo di un letterato milanese* (Bellinzona).

Moulin, D. de, 1972. 'De natuurhistorische verzameling in het voormalige theatrum anatomicum te Rotterdam', *Rotterdams Jaarboekje*, pp. 129–39.

Mraz, G., and Haupt, H., 1981. 'Das Inventar der Kunstkammer und der Bibliothek des Erzherzogs Leopold Wilhelm aus dem Jahre 1647', *Jahrbuch der Kunsthistorischen Sammlungen in Wien* 77. i–xlvi.

Muchka, I., 1969. 'Stylové otázky v české architektuře kolem roku 1600' (D.Phil. thesis, Charles University, Prague).

Muller, C. C., 1980. *Wittelsbach und Bayern. 400 Jahre Sammeln und Reisen. Aussereuropäische Kulturen* (Munich).

Müller, J. J., 1714. *Entdecktes Staats-Cabinet* 2. Eröffnung (Jena).

Müller, K., 1967. *Leibniz-Bibliographie* (Frankfurt-am-Main).

Muller, P. E., 1937. *De dichtwerken van Philibert van Borsselen* (Groningen and Batavia).

Müller, R. A., 1976. 'Friedrich von Dohnas Reise durch Bayern in den Jahren 1592/93', *Oberbayerisches Archiv* 101. 301–13.

Munby, J., 1977. 'Art, archaeology and antiquaries', in J. Munby and M. Henig (eds.), *Roman Life and Art in Britain* 2 (British Archaeological Reports 41) (Oxford), pp. 415–30.

Mundt, B., 1974. *Die deutschen Kunstgewerbemuseen im 19. Jahrhundert* (Studien zur Kunst des 19. Jahrhunderts 22) (Munich).

Munk, W. R., 1878. *The Roll of the Royal College of Physicians* new edn. (London).

Müntz, E., 1888. *Les collections des Médicis au XV siècle: Le Musée, La Bibliothèque, Le Mobilier* (Paris and London).

Murdoch-Smith, R., n.d. *Persian Art* 2nd (enlarged) edn. (London).

Murray, Sir D., 1904. *Museums: their History and their Use* (Glasgow).

Musæum Thoresbyanum, 1764. *Musæum Thoresbyanum. A catalogue of the genuine and valuable collection of . . . the late Ralph Thoresby . . . all of which will be sold by auction . . . at . . . Charing Cross, on Monday March 5th and the Two following Days* (London).

Musei Imperialis Petropolitani, 1741. *Musei Imperialis Petropolitani* (St. Petersburg).

Museum 't Coopmanhus, Franeker, 1980. *Het Botanisch Kabinet, Herbaria Houtversamelingen, Aquarellen & Bocken uit Vier Eeuwen* (Franeker).

Naderzad, B., 1972. 'Louis XIV, La Boulaye et l'exotisme persan', *Gazette des Beaux Arts* 79. 29–38.

National Museum of Korea, 1977. *Special Exhibition of Cultural Relics found off Sinan Coast* (Seoul).

Neickel [Jenckel], C. F., 1727. *Museographia oder Anleitung zum rechten Begriff und nützlicher Anlegung der Museorum* (Leipzig and Breslau).

Nelson, C. M., 1968. 'Ammonites: Ammon's horns into cephalopods', *Journal of the Society for the Bibliography of Natural History* 5. 1–18.

Neumann, E., 1961. 'Die Tischuhr des Jeremias

Metzker und ihre nächsten Verwandten', *Jahrbuch der Kunsthistorischen Sammlungen in Wien* 57. 89–122.

—— 1966. 'Das Inventar der rudolfinischen Kunstkammer von 1607–11', *Queen Christina of Sweden: Documents and Studies* (Analecta Reginensia 1) (Stockholm), pp. 262–5.

Neverov, O., 1977. 'Pamjatniki antichnogo iskusstva v Rossii Petrovskogo Vremeni', *Kultura i iskusstvo Petrovskogo Vremeni* (Leningrad).

Neveu, B., 1966. 'La vie érudite à Paris à la fin du XVIIe siècle d'après les papiers du P. Léonard de Sainte-Catherine (1695–1706)', *Bibliothèque de l'École des Chartes* 124. 432–511.

Neviani, A., 1936. 'Ferrante Imperato speziale e naturalista napoletano con documenti inediti', *Atti e Memorie Accademia di Storia dell'arte sanitaria* ser. 2, 2. 57–74; 124–45; 191–210; 243–67.

Newman, C. E., 1969. 'The first library of the Royal College of Physicians', *Journal of the Royal College of Physicians* 3. 299–307.

Nickel, H., 1983. 'Über einen ritterlichen Siegelring in der Schatzkammer der Residenz München', *Studien zum europäischen Kunsthandwerk. Festschrift Yvonne Hackenbroch* (Munich), pp. 39–43.

Nicolai, F., 1769. *Beschreibung der königlichen Residenzstädte Berlin und Potsdam* [3rd edn. 1786] (Berlin).

Nishida, H., 1974. 'Japanese Export porcelain of the 17th and 18th century (D.Phil. thesis, University of Oxford).

Norden, L. van, 1946. 'The Elizabethan College of Antiquaries' (Ph.D. thesis, University of California at Los Angeles).

North, J., 1974. 'Thomas Harriot and the first telescopic observations of sunspots', in J. W. Shirley (ed.), *Thomas Harriot: Renaissance Scientist* (Oxford), pp. 129–65.

Notzing, J. Schrenck von, 1601. *Augustissimorum imperatorum . . . regum . . . principum . . . verissimae imagines, quorum arma . . . in . . . Ambrosinae . . . Armanentario . . . conspiciuntur* (Innsbruck). [German translation by N. von Campenhouten (Innsbruck, 1603), new edn. by J. D. Köhler (Nuremberg, 1735)].

Nowotny, K. A., 1960. *Mexikanische Kostbarkeiten aus Kunstkammern der Renaissance* (Vienna).

Nussbaum, F. L., 1953. *The Triumph of Science and Reason 1660–1685* (New York).

Nyholm, E., 1977. *Arte e teoria del Manierismo, 1. Ars Naturans* (Odense University Studies in Art History 2) (Odense).

Oakley, K. P., 1965. 'Folklore of fossils', *Antiquity* 39. 9–16, 117–25.

—— 1975. *Decorative and Symbolic uses of Vertebrate Fossils* (Pitt Rivers Museum Occasional Papers on Technology 12) (Oxford).

Oates, J. C. T., 1961. 'An old book at Cambridge', *The Book Collector* 10. 291–300.

Occo, A., 1579. *Imperatorum Romanorum Numismata a Pompeio Magno ad Heraclium* (Antwerp).

Odescalchi, B., 1806. *Memorie istorico-critiche dell'Accademia de' Lincei* (Rome).

Oechelhäuser, A. von, 1891. 'Philipp Hainhofers Bericht über die Stuttgarter Kindtaufe im Jahre 1616', *Neue Heidelberger Jahrbücher* 1. 254–335.

Olbrechts, F. M., 1941. 'Bijdrage tot de kennis van de chronologie der Afrikaansche plastiek', *Mémoires de l'Institut Royal Colonial Belge, Section des Sciences Morales et Politiques* 10, pt. 2. 1–36.

Oldroyd, D. R., 1972. 'Robert Hooke's methodology of science as exemplified in his "Discourse of Earthquakes"', *British Journal for the History of Science* 6. 109–30.

Olearius, A., 1666. *Gottorfische Kunst-Kammer. Worinnen Allerhand ungemeine Sachen. So theils Künstliche Hände hervor gebracht* (Schleswig) [2nd edn. 1674].

Olivi, G. B., 1584. *De reconditis et praecipuis collectaneis ab honestissimo et solertissimo Francisco Calceolario Veronensi in Musaeo adservatis* (Venice).

Olmi, G., 1976. *Ulisse Aldrovandi. Scienza e natura nel secondo Cinquecento* (Trento).

—— 1977a. 'Osservazione della natura e raffigurazione in Ulisse Aldrovandi (1522–1605)', *Annali dell'Istituto storico italo-germanico in Trento* 3. 105–81.

—— 1977b. 'Farmacopea antica e medicina moderna. La disputa sulla Teriaca nel Cinquecento bolognese', *Physis* 19. 197–246.

—— 1978. 'Alle origini della politica culturale dello stato moderno: dal collezionismo privato al Cabinet du Roy', *La Cultura* 16. 471–84.

—— 1981. '"In essercitio universale di contemplatione, e prattica": Federico Cesi e i Lincei', in L. Boehm, and E. Raimondi (eds.), *Università, accademie e società scientifiche in Italia e in Germania dal Cinquecento al Settecento* (Bologna), pp. 169–235.

—— 1982. 'Arte e Natura nel cinquecento bolognese: Ulisse Aldrovandi e la raffigurazione scientifica', in A. Emiliani (ed.), *Le arti a Bologna e in Emilia dal XVI al XVII secolo* (Bologna), pp. 151–71.

—— 1983. 'Dal "Teatro del mondo" ai mondi inventariati. Aspetti e forme del collezionismo

nell'età moderna', in P. Barocchi and G. Ragionieri (eds.), *Gli Uffizi. Quattro secoli di una galleria* (Florence), pp. 233–69.

Oppel, A., 1896. 'Die altmexikanischen Mosaiken', *Globus* 70. 4–13.

Orlers, J. J., 1614. *Beschrijvinge der stad Leyden* (Leiden).

Ornstein, M., 1938. *The Rôle of Scientific Societies in the Seventeenth Century* (Chicago).

Osley, A. S., 1969. *Mercator: A Monograph on the Lettering of Maps, etc. in the 16th Century Netherlands with a Facsimile and Translation of his Treatise on the Italic Hand and a Translation of Ghim's* Vita Mercatoris (London).

Österreichische Nationalbibliothek, 1965. *Ambraser Kunst- und Wunderkammer. Die Bibliothek* (Vienna).

Pallavicino, R., 1667. *I trionfi dell'Architettura nella sontuosa Residenza di Monaco* (Munich).

Palmer, C. P., 1977. 'Data security in scientific objects', *Newsletter of the Geological Curators' Group* 1 (9). 446–9.

Panofsky, E., 1954. *Galileo as a critic of the arts* (The Hague).

Pantaleon, H., 1570. *Teutscher Nation Heldenbuch* (Basle).

Park, K., and Daston, L. J., 1981. 'Unnatural conceptions: the study of monsters in sixteenth- and seventeenth-century France and England', *Past and Present* 92. 20–54.

Parkinson, J., 1640. *Theatrum botanicum, the theatre of plants* (London).

Parshall, P. W., 1982. 'The print collection of Ferdinand, Archduke of Tyrol', *Jahrbuch der Kunsthistorischen Sammlungen in Wien* 78. 139–84.

Parthey, G., 1853. *Wenzel Hollar: beschreibendes Verzeichnis seiner Kupferstiche* (Berlin).

Pastine, D., 1978. *La nascita dell' idolatria. L'oriente religioso di Athanasius Kircher* (Florence).

Pastorini, G. B., 1680. *Orazione Funebre Per la morte dell' Ill. Sig. Can. Manfredo Settala* (Milan).

Patin, C., 1695. *Relations historiques et curieuses de voyages en Allemagne, Angleterre, Hollande, Bohème, Suisse* (Amsterdam).

Patterson, R., 1981. 'The "Hortus Palatinus" at Heidelberg and the Reformation of the World', *Journal of Garden History* 1. 67–104; 179–202.

Peacham, H., 1634. *The Compleat Gentleman* 2nd edn. (London).

Pechstein, K., 1983. 'Aus fürstlichen Kunstkammern, Unbekannte Visierungen für Philipp Hainhofers pommersche Kunstaufträge', *Kunst und Antiquitäten* 1. 44–53.

Pekarskij, P., 1862. *Nauka i Literatura pri Petri Velikom* 1 (St. Petersburg).

Peltzer, A. R. (ed.), 1925. *Joachim von Sandrarts Academie der Bau-, Bild- und Mahlerey-Künste von 1675* (Munich).

Pepys, S., 1660–9. *The Diary* 3 (ed. R. C. Latham and W. Matthews) (London).

Perrault, C., 1688. *Memoirs for a Natural History of Animals* (trans. A. Pitfield) (London).

Petiver, J., 1695–1703. *Musei Petiveriani* (London).

Petzl, G., 1982. *Die Inschriften von Smyrna* 1 (Bonn).

Pevsner, N., 1979. *A History of Building Types* (London).

Philippovich, E. von, 1966. *Kuriositäten, Antiquitäten* (Braunschweig).

Phillips, E., 1706. *The New World of Words: or Universal English Dictionary* 6th edn. rev. J. Kersey (London).

Piacenti Aschengreen, C., 1968. *Il Museo degli Argenti a Firenze* (Milan).

Piggott, S., 1976. *Ruins in a Landscape* (Edinburgh).

—— 1981. 'Vast perennial memorials', in J. D. Evans, B. Cunliffe, and C. Renfrew (eds.), *Antiquity and Man* (London), pp. 19–25.

Pina, R. de, 1792. *Chronica d'El Rey Dom Joao II* (Lisbon).

Planiscig, L., 1924. *Die Bronzeplastiken* (Publikationen aus den Sammlungen für Plastik und Kunstgewerbe 4) (Vienna).

Platter, T., 1963. *Journal of a Younger Brother* (trans. S. Jennett) (London).

Plot, R., 1677. *Natural History of Oxfordshire* (Oxford) [2nd edn. 1705].

—— 1686. *The Natural History of Staffordshire* (Oxford).

Pointer, J., 1749. *Oxoniensis Academia* (London).

Pollard, G., 1977. 'The Felix gem at Oxford and its provenance', *Burlington Magazine* 119. 574.

Pomian, K., 1982. 'Collection-microcosme et la culture de la curiosité', in Istituto Nazionale di Studi sul Rinascimento, *Scienze, credenze occulte, livelli di cultura* (Florence), pp. 535–57.

Porro, G., 1591. *L'Horto de i Semplici di Padova* (Venice).

Porta, G. B. della, 1569. *Magiae naturalis libri XX in quibus scientiarum naturalium divitiae et deliciae demonstratur ec.* (Naples).

Porter, R., 1979. 'John Woodward: "A droll sort of a philosopher"', *Geological Magazine* 116. 335–43.

Prescher, H., 1955. 'Von Sammlern und Sammlungen des Mineralreiches im XVI Jahrhundert',

in Deutsche Akademie der Wissenschaften, *Agricola Gedenkschrift* (Berlin), pp. 320–38.

—— 1981. 'Leben und Werk des Georgius Agricola', *Neue Bergbautechnik* 11 (4). 243–5.

Prescher, H., Helm, J., and Franstadt, G., 1980. 'Johannes Kentmanns Mineralienkatalog, aus dem Jahre 1565', *Abhandlungen des Staatlichen Museums für Mineralogie und Geologie zu Dresden* 30. 5–152.

Prest, J., 1981. *The Garden of Eden. The Botanic Garden and the Re-Creation of Paradise* (New Haven and London).

Prodi, P., 1959–67. *Il cardinale Gabriele Paleotti* (Rome).

Prohaska, W., 1984. *The Kunsthistorische Museum, Vienna. The Gallery* (London).

Pühringer-Zwanowetz, L., 1966. *Matthias Steinl* (Vienna).

Purchas, S., 1625. *Hakluytus Posthumus or Purchas His Pilgrimes* 2 (London).

Putscher, M., 1974. *Ordnung der Welt und Ordnung der Sammlung* (Circa Tiliam, Studia Historiae Medicinae Gerrit Arie Lindebom Septuagenario oblata) (Leiden).

Quarrell, W. H., and Mare, M. (eds.), 1934. *London in 1710 from the Travels of Zacharias Conrad von Uffenbach* (London).

Quarrell, W. H., and Quarrell, W. J.C. (eds.), 1928. *Oxford in 1710 from the Travels of Zacharias Conrad von Uffenbach* (Oxford).

Quicche[l]berg, S., 1565. *Inscriptiones vel tituli theatri amplissimi, complectentis rerum universitatis singulas materias et imagines eximias . . .* (Munich).

Quill, H., 1966. *John Harrison, the Man who found Longitude* (London).

Quinn, D. B., 1970. 'Virginians on the Thames', *Terra Incognitae* 2. 7–14.

Quirino, G., 1676. *De Testaceis Fossilibus Musaei Septalliani* (Venice).

Quondam, A., 1981. 'La Scienza e l'Accademia', in L. Boehm and E. Raimondi (eds.), *Università, accademie e società scientifiche in Italia e in Germania dal Cinquecento al Settecento* (Bologna), pp. 21–67.

Rabiosus, A. [W. L. Weckherlin], 1778. *Reise durch Ober-Deutschland* (Salzburg and Leipzig).

Raeder, H., Stromgren, E., and Stromgren, B. (eds.), 1946. *Tycho Brahe's Description of his Instruments and Scientific Work as given in* Astronomiae instauratae mechanica *(Wandesburgi 1598)* (Copenhagen).

Raphael, O., 1931–2. 'Chinese porcelain jar in the Treasury of San Marco, Venice', *Transactions of the Oriental Ceramic Society* 10. 13–15.

Rathgeber, J., and Herrenberg, H. Schichard von, 1603–4. *Wahrhaffte Beschreibung zweyer Raisen . . . herausgegeben durch Erhard Cellius* (Tübingen).

Rave, P. O., 1959. 'Paolo Giovo und die Bildnisvitenbücher des Humanismus', *Jahrbuch der Berliner Museen* [*Jahrbuch der Preussischen Kunstsammlungen*, new ser.] 1. 119–54.

Raven, C. E., 1942. *John Ray Naturalist* (Cambridge) [2nd edn. 1950].

—— 1947. *English Naturalists from Neckam to Ray* (Cambridge).

Ray, J., 1673. *Observations made in a Journey through Part of the Low-Countries, Germany, Italy and France* (London).

—— 1678. *The Ornithology of Francis Willoughby* (London).

—— 1693. *Synopsys Methodica Animalium Quadrupedam et Serpentini Generis* (London).

—— 1710. *Historia Insectorum* (London).

—— 1713. *Three Physico-Theological Discourses* 3rd edn. (London).

—— 1738. *Travels through the Low-Countries – Germany, Italy and France* 2nd edn. (London).

Rea, J., 1665. *Flora: seu, de florum cultura* (London).

Reber, F. von, 1892a. 'Die Gemälde der herzoglich bayerischen Kunstkammer nach dem Fickler'schen Inventar von 1598', *Sitzungsberichte der philos.-philolog. und hist. Classe der kgl. bayerischen Akademie der Wissenschaften* (Munich), pp. 137–68.

—— 1892b. *Kurfürst Maximilian I. von Bayern als Gemäldesammler. Festrede (Nr. 34) gehalten in der öffentlichen Sitzung der kgl. bayerischen Akademie der Wissenschaften zu München am 15. November 1892* (Munich).

Regenfuss, F. M., 1758. *Auserlesne Schnecken Muscheln und andre Schaalthiere* (Copenhagen).

Regione Toscana – Giunta Regionale, 1981. *Il giardino storico italiano. Problemi di indagine – Fonti letterarie e storiche* (ed. G. Ragionieri) (Florence).

Regteren-Altena, I. Q. van, 1967. 'Hidden records of the Holy Sepulchre', in D. Fraser *et al.* (eds.), *Essays in the History of Architecture presented to Rudolf Wittkower* (London), pp. 17–21.

Reichel, F., 1981. *Early Japanese Porcelain* (London).

Reidemeister, L., 1934. 'Die Porzellankabinette der brandenburgisch-preussischen Schlösser', *Jahrbuch der Preussischen Kunstsammlungen*, pp. 44–9.

—— 1935. 'Philipp Hainhofer und die ostasiatische Kunst', *Adolph Goldschmidt zu seinem siebenzigsten Geburtstag am 15. Januar 1933* (Berlin), pp. 109–12.

Reilly, P. Conor, 1974. *Athanasius Kircher S.J. Master of a hundred arts* (Wiesbaden and Rome).

Reindl, P., 1973. 'Basler Frührenaissance am Beispiel der Rathaus-Kanzlei', *Historisches Museum Basel, Jahresbericht 1973*, pp. 54–6.

Reinhardt, H., 1945. 'Basler Münzsammler', *Historisches Museum Basel, Jahresbericht 1945*, pp. 33–44.

—— 1958. 'Unscheinbare Kostbarkeiten aus dem Amerbach-Kabinett', *Historisches Museum Basel, Jahresbericht 1958*, pp. 27–35.

Reitzenstein, A. von, 1967. *Die alte bairische Stadt in den Modellen des Drechslermeisters Jakob Sandtner* (Munich).

Reresby, J., 1904. *Memoirs of Sir John Reresby* (London).

Rettenbeck, L., 1953. *Feige, Wort–Gebärde–Amulett, Ein volkskundlicher Beitrag zur Amulettforschung* (Munich).

Reznicek, E., 1983. 'De achtste tronie van de schelpenverzamelaar', in *Essays in Northern European Art Presented to Egbert Haverkamp-Begemann* (Doornspijk), pp. 209–12

Ricettario Fiorentino, 1597. *Ricettario Fiorentino di nuovo illustrato* (Florence).

Richter, G., 1936. *Das Anatomische Theater* (Berlin).

Richter, J. P., 1880. 'Über Kunst, Archäologie und Cultur in Italien', *Repertorium für Kunstwissenschaft* 3. 288–300.

Rieber, A., 1968. 'Das Patriziat von Ulm, Augsburg, Ravensburg, Memmingen, Biberach', *Deutsches Patriziat 1430–1740* (Büdinger Vorträge 1965) (Limburg-an-der-Lahn), pp. 299–351.

Righini, G., 1978. *Contributo alla Interpretazione Scientifica dell'Opera Astronomica di Galileo. Monografia N.2* (Florence) [supplement to *Annali dell'Istituto e Museo di Storia della Scienza*].

Righini Bonelli, M. L. 1968. *Il Museo di Storia della Scienza a Firenze* (Milan).

—— 1974. *Vita di Galileo* (Florence).

Rijksmuseum, Amsterdam, 1952. *Catalogus van meubelen en betimmeringen* (Amsterdam).

—— 1975. *Leidse universiteit 400. Stichting en eerste bloei 1575–ca.1650* (Amsterdam).

Ripley, G., 1980. 'El Cemi Taino de algodon', *Boletin del Museo del Hombre Dominicano* 13. 115–24.

Rittershausen, J. S. von, 1788. *Die vornehmsten Merkwürdigkeiten der Residenzstadt München* (Munich).

Rivolta, A., 1914. 'L'umanista Gian Vicenzo Pinelli studiato nella Biblioteca Ambrosiana di Milano', *Scuola Cattolica* 1 (Milan).

—— 1939. *Catalogo dei codici pinelliani latini dell' Ambrosiana* (Milan).

Rivosecchi, V., 1982. *Esotismo in Roma barocca. Studi sul padre Kircher* (Rome).

Robertson, J. C. (ed.), 1867. *Pope Alexander the Seventh and the College of Cardinals by John Bargrave, D. D., Canon of Canterbury (1662–1680) with a Catalogue of Dr. Bargrave's Museum* (Camden Society 92) (London).

Robinson, J. C., 1888. [Exhibition of Indo-European ivory caskets], *Proceedings of the Society of Antiquaries of London*, ser. 2, 12. 267–9.

Rocque, A. La, 1957. *The Admirable Discourses of Bernard Palissy* (Urbana).

Roden, J. Limberg von, 1690. *Denckwürdige Reisebeschreibung durch Teutschland, Italien, Spanien, Portugall, Engeland, Franckreich und Schweitz* (Leipzig).

Rodriquez, F., 1956. *Il Museo Aldrovandiano nella Biblioteca Universitaria di Bologna* (Bologna).

Roe, T., 1899. *Embassy of Sir Thomas Roe to the Court of the Great Mogul, 1615–19* (ed. W. Foster) (London).

Rohde, A., 1937. *Bernstein* (Berlin).

Rommel, C. von, 1828–58. *Geschichte von Hessen* (Kassel).

Rondelet, G., 1554–5. *Libri de piscibus marinis* (Lugduni).

Rosa, G., 1957. 'Le arti minori dal 1530 al 1630', *Storia di Milano* 11 (Milan).

Rosen, E., 1974. 'Harriot's science, the intellectual background', in J. Shirley (ed.), *Thomas Harriot: Renaissance Scientist* (Oxford), pp. 1–15.

Rossi, F., 1969. *Malerei in Stein, Mosaiken und Intarsien* (Stuttgart, Berlin, Cologne and Mainz).

Rossiter, A. P., 1935. 'The first English geologist', *Durham University Journal* 29. 172–81.

Rowland, B., 1963. *The Classical Tradition in Western Art* (Cambridge, Mass.).

Rückert, R., 1982. *Die Glassammlung des Bayerischen Nationalmuseums München* (Munich).

Rudwick, M. J. S., 1972. *The Meaning of Fossils* (London).

Rumphius, G. E., 1705. *D'Amboinsche Rariteitkamer* (Amsterdam).

—— 1711. *Thesaurus Cochlearum, Concharum, Conchyliorum et Mineralium* (Lugduni Batavorum).

Ryden, S., 1937. 'Brazilian anchor axes', *Ethnological Studies* 4. 50–83.

St. John Brooks, E., 1954. *Sir Hans Sloane: the Great Collector and his Circle* (London).

Salerno, L., 1963. 'Arte, scienza e collezioni nel

manierismo', *Scritti di storia dell'arte in onore di Mario Salmi* (Rome), pp. 193–214.

Salmon, V., 1972. *The Works of Francis Lodwick* (London).

Sammler, Fürst, Gelehrter, 1979. *Sammler, Fürst, Gelehrter, Herzog August zu Braunschweig und Lüneburg 1579–1666, Ausstellung der Herzog August Bibliothek in Wolfenbüttel* (Wolfenbüttel).

Sandrart, J., 1675. *Teutsche Akademie* (Nuremberg).

Sandrini, A., 1982. 'Il "Lapidarium veronense" e le origini dell' architettura museale', *Studi Storici Luigi Simeoni* 32. 153–60.

Sarre, F., 1904. 'Rembrandts Zeichnungen nach indisch-islamischen Miniaturen', *Jahrbuch der Königlich Preussischen Kunstsammlungen* 25. 143–58.

Satow, Sir E. M. (ed.), 1900. *The Voyage of Captain John Saris to Japan 1613* (Hakluyt Society 5) (London).

Sauerlandt, M., 1911. 'Die Naturalienkammer des Halleschen Waisenhauses', *Museumskunde* 7. 133–46.

Sawday, J., 1983. 'The Leiden anatomy theatre as a source for Davenant's "Cabinet of Death" in *Gondibert*', *Notes and Queries* new ser. 30. 437–9.

Sayle, C., 1916. *Annals of Cambridge University Library, 1278–1900* (Cambridge).

Scalesse, T., 1982. *Dizionario Biografico degli Italiani* 26 (Rome).

Scamuzzi, E., 1947. 'Fossile eocenico con iscrizione geroglifica rinvenuto in Eliopoli', *Bolletino della Societa Piemontese di Archeologia e di Belle Arti* new ser. 1. 1–4.

Scarabelli, P. F., 1666. *Museo ò Galeria Adunata dal sapere, e dallo studio del Sig. Canonico Manfredo Settala* (Tortona) [new edn. 1677].

Scarisbrick, D., 1981. 'Companion to a Russian princess. Martha Wilmot's green book', *Country Life* 169. 76–8.

Scerrato, U., 1966. *Metalli Islamici* (Milan).

Scheicher, E., 1979. *Die Kunst- und Wunderkammern der Habsburger* (Vienna, Munich and Zürich).

—— 1982a. 'Korallen in fürstlichen Kunstkammern des 16. Jahrhunderts', *Weltkunst* 52. 3447–50.

—— 1982b. 'Schloss Ambras', in O. Trapp (ed.), *Tiroler Burgenbuch* 6 (Bozen), pp. 139–86.

Scheller, R. W., 1969. 'Rembrandt en de encyclopedische kunstkamer', *Oud-Holland* 84.

Schenckelius, L., 1614. *Exemplvm speciminis artis memoriae* (Augsburg).

Schepelern, H. D., 1968. *Breve fra og til Ole Worm 1607–1654* (Copenhagen).

—— 1971. *Museum Wormianum, dets Forudsætninger og Tilblivelse* (Odense).

—— 1981. 'Naturalienkabinett oder Kunstkammer. Der Sammler Bernhard Paludanus und sein Katalogmanuskript in der Königlichen Bibliothek in Kopenhagen', *Nordelbingen: Beiträge zur Kunst und Kulturgeschichte* 50. 157–82.

Schierbeek, A., 1947. *Jan Swammerdam, zijn leven en zijn werken* (Lochem).

Schlee, E. (ed.), 1965. *Gottorfer Kultur im Jahrhundert der Universitäts-gründung* (Schleswig).

Schlosser, J. von, 1908. *Die Kunst- und Wunderkammern der Spätrenaissance. Ein Beitrag zur Geschichte des Sammelwesens* (Leipzig) [new edn. Braunschweig, 1978]

Schmeltz, J. D. E., 1890. 'Ein neuer Beitrag zur Geschichte der Verwischung der Herkunft ethnographischer Gegenstände', *Internationales Archiv für Ethnographie* 3. 195.

Schmin[c]ke, F. C., 1767. *Versuch einer genauen und gründlichen Beschreibung der Hochfürstlich Hessischen Residenz- und Hauptstadt Cassel* (Kassel).

Schmitt, C. B., 1972. 'The faculty of arts at Pisa at the time of Galileo', *Physis* 14. 243–72.

—— 1975. 'Science in the Italian universities in the 16th and early 17th centuries', in M. Crosland (ed.), *The Emergence of Science in Western Europe* (London), pp. 35–56.

Schneer, C., 1954. 'The rise of historical geology in the seventeenth century', *Isis* 45. 256–68.

Schneiders, W., 1977. 'Gottesreich und gelehrte Gesellschaft. Zwei politische Modelle bei G. W. Leibniz', in F. Hartmann and R. Vierhaus (eds.), *Der Akademiegedanke in 17. und 18. Jahrhundert* (Bremen and Wolfenbüttel), pp. 47–61.

Schtelin, J., 1787. *Podlinnyje anekdoty Petra Velikogo* (St. Petersburg).

Schultze-Gallera, S. von, n.d. [after 1924]. *Das alte Halle* (ed. E. Neuss) (Leipzig).

Schupbach, W., 1982. *The Paradox of Rembrandt's Anatomy of Dr Tulp* (London).

Schweeger-Hefel, A., 1952. 'Ein rätselhaftes Stück aus der alten Ambraser Sammlung', *Archiv für Völkerkunde* 6/7. 209–28.

Schwindratzheim, H., 1937. 'Eine Portraitsammlung Wilhelms IV. von Hessen und die "Güldensaal"', *Marburger Jahrbuch für Kunstwissenschaft* 10. 263–78; Cat. I and II; 279–306.

Scott, Sir W., 1816. *The Antiquary* (Edinburgh).

Seba, A., 1734–65. *Locupletissimi rerum naturalium thesauri accurata descriptio* (Amsterdam).

Seelig, L., 1980. 'Die Ahnengalerie der Münchner

Residenz', *Quellen und Studien zur Kunstpolitik der Wittelsbacher vom 16. bis zum 18. Jahrhundert* (Munich), pp. 253–327.

Seiler-Baldinger, A., 1974. 'Der Federmantel der Tupinamba im Museum für Völkerkunde Basel', *Atti del XL Congresso Internazionale degli Americanisti* 2. 433–8.

Selig, K. L., 1960. *The Library of Vicencio Juan de Lastanosa, patron of Gracián* (Travaux d'humanisme et de Renaissance 43) (Geneva).

Seling, H., 1950. 'Die Entstehung des Kunstmuseums als Aufgabe der Architektur' (Diss. Phil., University of Freiburg i. Br.).

—— 1967. 'The genesis of the museum', *Architectural Review* 131. 103–14.

—— 1980. *Die Kunst der Augsburger Goldschmiede 1529–1868* (Munich).

Sepi, G. de, 1678. *Romani Collegii Societatis Jesu Musaeum Celeberrimum* (Amsterdam).

Sharp, L. G., 1977. 'Sir William Petty and Some Aspects of Seventeenth-century Natural Philosophy' (D. Phil. thesis, University of Oxford).

Sharpe, K. A., 1978. 'The Earl of Arundel, his circle and the opposition to the Duke of Buckingham, 1618–1628', in K. A. Sharpe (ed.), *Faction and Parliament: Essays on Early Stuart History* (Oxford), pp. 209–44.

Sheard, W. S., 1979. *Antiquity in the Renaissance* (Northampton, Mass.).

Sherley, T., 1672. *A Philosophical Essay: declaring the probable Causes whence stones are produced* (London).

Shirley, J. W., 1983. *Thomas Harriot: A Biography* (Oxford).

Simonsfeld, H., 1902. 'Mailänder Briefe zur bayerischen und allgemeinen Geschichte des 16. Jahrhunderts', *Abhandlungen der kgl. bayerischen Akademie der Wissenschaften, Hist. Klasse* 22 (Denkschriften 72) (Munich).

Simpson, A. D. C., 1982. 'Sir Robert Sibbald – the founder of the College', *Proceedings of the Royal College of Physicians of Edinburgh Tercentenary Congress (6–11 September) 1981* (Edinburgh), pp. 59–91.

—— 1984. 'Newton's telescope and the cataloguing of the Royal Society's repository', *Notes and Records of the Royal Society* 38. 187–214.

Skeat, W. W., 1912. 'Snakestones and stone thunderbolts as subjects for systematic investigation', *Folklore* 23, 45–80.

Skelton, R., 1978. 'Characteristics of later Turkish jade carving', in G. Fehér (ed.), *Fifth International Congress of Turkish Art* (Budapest), pp. 795–807.

Skelton, R., *et al.*, 1982. *The Indian Heritage* (London).

Skippon, P., 1732. 'An account of a journey made thro' part of the Low-Countries, Germany, Italy and France', in A. Churchill and J. Churchill (eds.), *A Collection of Voyages and Travels* 6 (London), pp. 361–736.

Slaughter, M. M., 1982. *Universal Languages and Scientific Taxonomy in the Seventeenth Century* (Cambridge).

Slomann, V., 1934. 'The Indian period of European furniture', *Burlington Magazine* 65. 113–26, 157–71, 201–4.

Slotkin, J. S. (ed.), 1965. *Readings in Early Anthropology* (London).

Smith, W. C., 1978. 'Early mineralogy in Great Britain and Ireland', *Bulletin of the British Museum (Natural History), Historical Series* 6. 49–74.

Socin, C., 1947. 'Fossile eocenico con iscrizione geoglifica rinvenuto in Eliopoli', *Atti della Societa Toscana di Scienze Naturale Memorie* 53. 3–11.

Somers Cocks, A. G., 1980. 'The status and making of jewellery 1500–1630', *Princely Magnificence. Court Jewels of the Renaissance 1500–1630* (London), pp. 1–7.

Sonnino, P. (trans.), 1970. *Louis XIV King of France and of Navarre, Mémoires for the Instruction of the Dauphin* (New York and London).

Spallanzani, M., 1978. *Ceramiche Orientali a Firenze nel Rinascimento* (Florence).

—— 1979. 'Le porzellane cinesi donata a Cristiano di Sassonia da Ferdinando I de' Medici', *Faenza* 65. 382–90.

—— 1980a. 'Ceramiche nelle raccolte medicee da Cosimo I a Ferdinando I', *Le Arti del Principato Mediceo* (Florence), pp. 73–94.

—— 1980b. 'Metalli islamici nelle collezione medicee dei secoli XV–XVI', *Le Arti del Principato Mediceo* (Florence), pp. 95–116.

Spallanzani, M. F., forthcoming. 'Le "Camere di storia naturale" dell' Istituto delle Scienze di Bologna nel Settecento', in *Scienza e letteratura nella cultura italiana del Settecento* (Bologna).

Spedding, J., Ellis, R. L., and Heath, D. D. (eds.), 1862. *Works of Francis Bacon* (London).

Speth-Holterhoff, S., 1957. *Les peintres flamands de cabinets d'amateurs au XVIIᵉ siècle* (Brussels).

Spicer, J. A., 1970. 'Roelandt Savery's studies in Bohemia', *Umění* 18. 270–5.

Sporhan-Krempel, L., 1970. 'Georg Forstenheuser aus Nürnberg 1584–1659, Korrespondent, Bücherrat, Faktor und Agent', *Börsenblatt für den*

deutschen Buchhandel, Frankfurter Ausgabe 26. 705–43.

Sprat, T., 1667. *The History of the Royal Society* (London) [4th edn. 1734; new edn., ed. J. I. Cope and H. W. Jones, London, 1959].

Spriggs, A. I., 1964–6. 'Oriental porcelain in Western paintings', *Transactions of the Oriental Ceramic Society* 36. 73–87.

Springell, F. C., 1963. *Connoisseur & Diplomat, The Earl of Arundel's Embassy to Germany in 1636 as recounted in William Crowne's Diary, the Earl's letters and other contemporary sources with a catalogue of the topographical drawings made on the journey by Wenceslaus Hollar* (London).

Staatliche Münzsammlung, Munich, 1982. *Vom Königlichen Cabinet zur Staatssammlung 1807–1982* (Munich).

Staatliches Museum für Völkerkunde, Munich, 1980. *400 Jahre Sammeln und Reisen der Wittelsbacher. Aussereuropäische Kulturen* (Munich).

Staden, H., 1557. *Warhaftige Historia und Beschreibung eyner Lantschafft* (Marburg) [reprinted Frankfurt-am-Main, 1925].

Stadtmuseum, Munich, 1980. *Klassizismus in Bayern, Schwaben und Franken. Architekturzeichungen 1775–1825* (Munich).

Staniforth, M. (ed.), 1982. *Marcus Aurelius, Meditations* (Harmondsworth).

Stanjukovitch, T., 1953. *Kunstkamera Petersburgskoj Akademij Nauk* (Moscow and Leningrad).

Stearns, R. P., 1952. 'James Petiver, promoter of natural science, *c.*1663–1718', *Proceedings of the American Antiquarian Society* new ser. 62. 243–365.

Steinruck, J., 1965. *Johann Baptist Fickler. Eine Laie im Dienste der Gegenreformation* (Reformationsgeschichtliche Studien und Texte 89) (Münster).

Stelluti, F., 1637. *Trattato del legno fossile minerale nuovamente scoperto* (Rome).

Stemann Petersen, K., and Sommer-Larsen, A., 1980. 'Techniques applied to some feather garments from the Tupinamba Indians, Brazil', *Folk* 21–2. 263–70.

Stetten, P. von, 1778. *Lebensbeschreibungen zur Erweckung und Unterhaltung bürgerlicher Tugend* (Augsburg).

Stimson, D., 1948. *Scientists and Amateurs: A History of the Royal Society* (New York).

Stockbauer, J., 1874. *Die Kunstbestrebungen am bayerischen Hofe unter Herzog Albrecht V. und seinem Nachfolger Wilhelm V.* (Quellenschriften für Kunstgeschichte und Kunsttechnik des Mittelalters und der Renaissance 8) (Vienna).

Stöcklein, H., 1911. 'Naturgeschichtliche Raritäten

des 16. Jahrhunderts in der Münchner Staatssammlungen', *Bayerland* 22. 513–14.

Stolpe, H., 1896. *Studier i Amerikansk Ornamentik* (Stockholm).

Stooke, H. J., and Khandalavala, K., 1953. *The Laud Ragamala Miniatures* (Oxford).

Storz, J., 1962. 'Das Naturalien- und Kunstkabinett der Franckeschen Stiftungen zu Halle an der Saale', *Wissenschaftliche Zeitschrift der Martin Luther-Universität Halle-Wittenberg, Gesellschafts- und Sprachwissenschaftliche Reihe* 11. 193–200.

—— 1965. 'Hauptbibliothek, Archiv und Naturalien-kabinett der Franckeschen Stiftungen', in F. Hofmann, *et al.*, *August Hermann Francke. Das humanistische Erbe des grossen Erziehers* (Halle), pp. 96–108.

Stricker, B. H., 1948. 'De correspondentie: van Heurn – Le Leu de Wilhelm', *Oudheidkundige Mededelingen uit het Rijksmuseum van Oudheden te Leiden* new ser. 29. 43–54.

Strong, R., 1979. *The Renaissance Garden in England* (London).

Strzygowski, J., and Goetz, H., 1923. *Die indischen Miniaturen im Schlosse Schönbrunn* (Vienna).

Sturdy, D., 1982. 'The Tradescants at Lambeth', *Journal of Garden History* 2. 1–16.

Sturdy, D., and Henig, M., [1983]. *The Gentle Traveller. John Bargrave, Canon of Canterbury, and his Collection* (n.p.).

[Sturm, L. C.], 1697. *Die geöffnete Raritäten- und Naturalien-Kammer . . .* (Der geöffnete Ritter-Platz pt. 3) (Hamburg).

Sturtevant, W. C., 1976. 'First visual images of native Americans', in F. Chiapelli (ed.), *First Visual Images of America* (Berkeley, Los Angeles and London), pp. 417–54.

—— 1981. 'The Ethnographical illustrations', in H. Wallis (ed.), *The Maps and Text of the Boke of Idrography presented by Jean Rotz to Henry VIII* (Roxburghe Club) (Oxford), pp. 67–72.

Swammerdam, J., 1669. *Historia generalis Insectorum ofte Algemeene Verhandeling van de Bloedeloose Dierkens* (Utrecht).

—— 1679. *Catalogus Musei Instructissimi* (Amsterdam).

—— 1737. *Biblia Naturae* 1 (Leiden).

Sweet, J. M., 1935. 'Sir Hans Sloane: life and mineral collection', *Natural History Magazine* 5. 49–64, 98–116.

Taborelli, G. (ed.), 1980. *The Medici in Florence, a Workshop of European Culture* (trans. C. Foster) (Milan).

Tait, H., 1967. '"The Devil's Looking-Glass": the magical speculum of Dr John Dee', in W.H. Smith (ed.), *Horace Walpole – Writer, Politician, and Connoisseur* (New Haven and London), pp. 195–212, 337–8.

—— 1981. *The Waddesdon Bequest, The Legacy of Baron Ferdinand Rothschild to the British Museum* (London).

Taton, R. (ed.)., 1964. *Histoire de la Pensée 11 Enseignement et Diffusion des Sciences en France au XVIII^e siècle* (Paris).

Tavernari, G., 1976. 'Manfredo Settala, collezionista e scienziato milanese del '600', *Annali dell'Istituto e Museo di Storia della Scienza di Firenze* 1. 43–61.

—— 1979. 'Il Museo Settala 1660–1680', *Critica d'arte* 164–5. 202–20.

—— 1980. 'Il Museo Settala. Presupposti e storia', *Museologia* 7. 12–46.

—— forthcoming. 'Lettere di Manfredo Settala ad Atanasio Kircher, Francesco Redi ed Antonio Magliabechi', *Atti Società Italiana di Scienze Naturali* (in press).

Taylor, E. G. R., 1954. *The Mathematical Practitioners of Tudor and Stuart England* (Cambridge).

—— 1971. *The Haven-Finding Art: A History of Navigation from Odysseus to Captain Cook* (London).

Tea, E., 1959. 'Arti minori', *Storia di Milano* 12 (Milan).

Temple, Sir R. C. (ed.), 1919. *The Travels of Peter Mundy, in Europe and Asia, 1608–1667* 3 (Hakluyt Society ser. 2, 45–6) (London).

Tenison, T., 1679 *Baconiana* (London).

Ternes, C.-M., 1974. *Das römische Luxemburg* (Zürich).

Terzago, P. M., 1664. *Musaeum Septalianum Manfredi Septalae Patritii Mediolanensis industrioso labore constructum . . .* (Tortona).

Tesauro, E., 1675. *Il Cannocchiale Aristotelico, O sia, Idea dell'arguta, et ingegnosa elocutione, che serve a tutta l'Arte oratoria, lapidaria et simbolica . . . Settima impressione. Accresciuta dall'Autore di due nuovi Trattati, cioè, De' Concetti Predicabili, & Degli Emblemi* (Bologna).

Thacker, C., 1982. 'An extraordinary solitude', in S. Butler *et al.* (eds.), *Of Oxfordshire Gardens* (Oxford), pp. 27–48.

Theuerkauff, C., 1963. 'Kaiser Leopold, im Triumph wider die Türken . . .', *Hamburger mittel- und ostdeutsche Forschungen* 4. 60–83.

—— 1981. 'Zur Geschichte der Brandenburgisch-Preussischen Kunstkammer bis gegen 1800', Staatliche Museen Preussischer Kultur-besitz, *Die Brandenburgisch-Preussische Kunstkammer. Eine Auswahl aus den alten Beständen* (Berlin), 13–33.

Thoma, H., and Brunner, H., 1964. *Schatzkammer der Residenz München. Katalog* [3rd edn. 1970] (Munich).

Thomas, K., 1983 *Man and the Natural World. Changing Attitudes in England 1500–1800* (London).

Thomsen, T., 1938. *Albert Eckhout* (Copenhagen).

Thoresby, R., 1715. *Ducatus Leodiensis: or the Topography of the Ancient and Populous Town and Parish of Leedes* (London).

Thorndike, L., 1923–58. *A History of Magic and Experimental Science* (New York).

Titley, N., 1977. *Miniatures from Persian Manuscripts* (London).

Toban Kamotsu Cho (1971). *Toban Kamotsu Cho* (Tokyo).

Tokyo National Museum, 1979. *Painting of the Kano School* (Tokyo).

Tomba, T., 1978a. 'Gli astrolabi della Collezione Settala nella Pinacoteca Ambrosiana', *Atti della Fondazione Giorgio Ronchi* 2. 297–314.

—— 1978b. 'Gli astrolabi della Collezione Settala nella Pinacoteca Ambrosiana', *Atti della Fondazione Giorgio Ronchi* 4. 636–47.

Tongiorgi Tomasi, L., 1979. 'Inventari della galleria e attività iconografica dell' orto dei semplici dello Studio pisano tra cinque e seicento', *Annali dell' Istituto e Museo di storia della scienza di Firenze* 4.21–7.

—— 1980. 'Il giardino dei semplici dello studio pisano. Collezionismo, scienza e immagine tra cinque e seicento', in *Livorno e Pisa: due città e un territorio nella politica dei Medici* (Pisa), pp. 514–26.

—— 1983. 'Projects for botanical and other gardens: a 16th-century manual', *Journal of Garden History* 3. 1–34.

Toynbee, P., 1927. *Strawberry Hill Accounts* (Oxford).

Tradescant, J., 1656. *Musæum Tradescantianum: or, a Collection of Rarities, preserved at South-Lambeth neer London* (London) [reprinted London, 1980].

Tugnoli-Pattaro, S., 1977. 'La formazione scientifica e il "Discorso naturale" di Ulisse Aldrovandi', *Università di Trento. Quaderni di Storia e Filosofia della Scienza* 7.

—— 1981. *Metodo e sistema delle scienze nel pensiero di Ulisse Aldrovandi* (Bologna).

Turner, A.J., 1973. 'Mathematical instruments and the education of gentlemen', *Annals of Science* 30. 51–88.

Turner, G., 1955. *Hair Embroidery in Siberia and North America* (Oxford).

Turner, G. L'E., 1967. 'The auction sales of the Earl of Bute's instruments, 1793', *Annals of Science* 23. 213–42.

—— 1977. *Apparatus of Science in the Eighteenth Century* (*Revista da Universidade de Coimbra* 26) (Coimbra).

—— 1983. 'Mathematical instrument-making in London in the sixteenth century', in S. Tyacke (ed.), *English Map-Making 1500–1650: Historical Essays* (London), pp. 93–106.

Turner, G. L'E., and Levere, T. H., 1973. *Van Marum's Scientific Instruments in Teyler's Museum* (R. Forbes *et al.* (eds.), *Martinus van Marum: Life and Work* 4) (Haarlem and Leiden).

Uffenbach, Z. C. von, 1753–4. *Merkwürdige Reisen durch Niedersachsen, Holland und Engelland* (Ulm).

Ultee, M., 1981. *The Abbey of St. Germain des Prés in the Seventeenth Century* (New Haven).

Uschmann, G., 1977. 'Kurze Geschichte der Akademie', in *Deutsche Akademie der Naturforscher Leopoldina 1652–77 (Acta Historica Leopoldina, suppl.* 1) (Halle), pp. 9–61.

Valentini, M. B. 1704, *Museum Museorum oder Vollständige Schau-Bühne aller Materialien und Specereyen* (Frankfurt-am-Main).

—— 1704–14. 'Anhang von verschiedenen Kunst- und Naturalien-Kammern, welche entweder rar zu bekommen, oder noch gar nicht im Druck sind', in his *Museum Museorum* 2 (Frankfurt-am-Main), separate pagination, 1–116.

Valentyn, F., 1754. *Verhandeling der zee-horenkens en zee-gewassen in en omtrent Amboina en de nabijgelegene eilanden* (Amsterdam).

Vatter, E., 1925. 'Ein bemaltes Büffelfell und andere seltene amerikanische Ethnographica im Städt. Völkermuseum zu Frankfurt a. M.', *Abhandlungen zur Anthropologie, Ethnologie und Urgeschichte* 2. 75–112.

Veblen, T., 1899. *The Theory of the Leisure Class: An Economic Study in the Evolution of Institutions* (New York).

Vega de Boyrie, B., 1973. 'Un cinturon tejido y una careta de madera de Santo Domingo, del periodo de transculturacion Taino-Español', *Boletin del Museo del Hombre Dominicano* 3. 199–226.

Vegetti, M., 1979. *Il coltello e lo stilo. Animali, schiavi, barbari e donne alle origini della razionalità scientifica* (Milan).

—— 1981. 'Lo spettacolo della natura. Circo, teatro e potere in Plinio', *Aut-Aut* 184–5. 111–25.

Veldman, I. M., 1983. 'De macht van de planeten over het mensdom in prenten naar Maarten de Vos', *Bulletin van het Rijksmuseum* 31. 21–53.

Vennebusch, J., 1966. *Gottfried Wilhelm Leibniz. Philosopher and Politician in the Service of a Universal Culture* (Bad Godesberg).

Verga, E., 1931. *Storia della vita milanese* (Milan).

Vespucci, A., 1505–6, 1893. *The First Four Voyages* (London).

Vicecomes, I. M., 1680. *Exequiae in Templo S. Nazarii Manfredo Septalio . . .* (Milan).

Vickers, M., 1976a. *The Roman World* (Oxford).

—— 1976b. 'The "Palazzo Santacroce Sketch-book", a new source for Andrea Mantegna's "Triumph of Caesar", "Bacchanals", "Battle of the Sea Gods",' *Burlington Magazine* 118. 824–34.

—— 1978. 'Rupert of the Rhine, a new portrait by Dieussart and Bernini's Charles I', *Apollo* 107. 161–9.

—— 1979a. 'Lord Arundel's Roman patronage: two "lost" statues by Egidio Moretti rediscovered', *Apollo* 110. 224–5.

—— 1979b. 'Hollar and the Arundel Marbles', *Städel Jahrbuch* new ser. 7. 126–32.

—— 1981. 'A new source for Rubens's "Descent from the Cross" in Antwerp', *Pantheon* 2. 140–2.

—— 1983a. [Review of R. D. Barnett, *Ancient Ivories in the Middle East*], *Burlington Magazine* 126. 303.

—— 1983b. 'Les vases peints, image ou mirage?', *Actes de la Table Ronde, Image et céramique grecque* (Rouen), pp. 29–42.

—— 1983c. 'The Felix gem at Oxford and Mantegna's triumphal programme', *Gazette des Beaux-Arts* ser. 6, 101. 97–102.

—— 1985. 'Artful crafts: the influence of metalwork on Athenian painted pottery', *Journal of Hellenic Studies* 105.

Victoria and Albert Museum, 1964. *The Orange and the Rose. Holland and Britain in the Age of Observation 1600–1750* (London).

Villoslada, R. G., 1954. *Storia del Collegio Romano dal suo inizio (1551) alla soppressione della Compagnia di Gesù (1773)* (Rome).

Vismara, G., 1958. 'Le istituzioni del patriziato', *Storia di Milano* 11 (Milan).

Volbehr, T., 1909. 'Das "Theatrum Quicchebergi-cum", ein Museumstraum der Renaissance', *Museumskunde* 5. 201–8.

Volk, P., 1980. 'Satyrköpfe mit Geweihen in Maximilians Kammergalerie', *Quellen und Studien zur Kunstpolitik der Wittelsbacher vom 16. bis zum 18. Jahrhundert* (Mitteilungen des Hauses der Bayerischen Geschichte I) (Munich), pp. 175–8.

Volker, T., 1954. *Porcelain and the Dutch East India Company* (Mededelingen van het Rijksmuseum voor Volkenkunde, Leiden 11) (Leiden)

—— 1959. *The Japanese porcelain trade of the Dutch East India Company after 1683* (Mededelingen van het Rijksmuseum voor Volkenkunde, Leiden 13) (Leiden).

Volk-Knüttel, B., 1976. *Wandteppiche für den Münchener Hof nach Entwürfen von Peter Candid* (Munich and Berlin).

—— 1980. 'Maximilian I. von Bayern als Sammler und Auftraggeber. Seine Korrespondenz mit Philipp Hainhofer 1611–1615', *Quellen und Studien zur Kunstpolitik der Wittelsbacher vom 16. bis zum 18. Jahrhundert* (Mitteilungen des Hauses der Bayerischen Geschichte 1) (Munich and Zürich), pp. 83–98.

—— 1981. 'Jan de la Groze, ein Brüsseler Tapissier am Hof Wilhelms V. von Bayern', *Documenta Textilia. Festschrift für Sigrid Müller-Christensen* (Munich and Berlin), pp. 234–50.

Voltelini, H. von, 1899. 'Urkunden und Regesten aus dem k. und k. Haus, Hof- und Staats-Archiv in Wien', *Jahrbuch der Kunsthistorischen Sammlungen des Allerhöchsten Kaiserhauses* 20 (2).

—— 1928. 'Ein Familienfideikommiss im Hause Habsburg', *Festschrift zum 70. Geburtstage Oswald Redlichs* (Jahrbuch für Landeskunde von Niederösterreich new ser. 21) (Vienna), pp. 164–71.

Waal, H. van de, 1967. 'The linea summae tenuitatis; Pliny's phrase and its interpreters', *Zeitschrift für Aesthetik und Allgemeine Kunstwissenschaft* 12.

Waard, C. de, 1906. *De Uitvinding der Verrekijkers: Eene Bijdrage tot de Beschavingsgeschiedenis* (The Hague).

Waters, D. W., 1958. *The Art of Navigation in England in Elizabethan and Early Stuart Times* (London).

Watson, F. J. B., 1963. 'Beckford, Mme. de Pompadour, the Duc de Bouillon and the taste for Japanese lacquer in eighteenth-century France', *Gazette des Beaux Arts.* ser. 6, 61. 101–27.

Watson, W. (ed.), 1982. *Lacquerwork in Asia and Beyond* (Percival David Foundation of Chinese Art, Colloquy on Art and Archaeology in Asia 11) (London).

Webster, C., 1967. 'The College of Physicians: "Solomon's House" in Commonwealth England', *Bulletin of the History of Medicine* 41. 393–412.

—— 1975. *The Great Instauration: Science, Medicine and Reform, 1626–1660* (London).

Weihrauch, H. R., 1956. *Die Bildwerke in Bronze und in anderen Metallen* (Bayerisches Nationalmuseum Kataloge 13/5) (Munich).

Weijtens, H. E., 1971. *De Arundel-Collectie: Commencement de la fin, Amersfort 1655* (Utrecht).

Weiss, R., 1969. *The Renaissance Discovery of Classical Antiquity* (Oxford).

Welt im Umbruch, 1980. *Welt im Umbruch* 1–2 (Augsburg).

Welti, L., 1954. *Graf Jakob Hannibal I. von Hohenems, 1530–1587* (Innsbruck).

Wheatland, D. P., 1968. *The Apparatus of Science at Harvard, 1765–1800* (Cambridge, Mass.).

Whitehead, P. J. P., 1971. 'Museums in the history of zoology', *Museums Journal* 70. 50–7, 155–60.

Whitehouse, D., 1972. 'Chinese porcelain in medieval Europe', *Medieval Archaeology* 16. 63–79.

Whitfield, R., 1976. 'Chinese paintings from the collection of Archduke Ferdinand II', *Oriental Art* new ser. 22. 406–15.

Wilckens, L. von, 1978. *Das Puppenhaus. Vom Spiegelbild des bürgerlichen Hausstandes zum Spielzeug für Kinder* (Munich).

Wilkin, S., 1852. *The Works of Sir Thomas Browne* (London).

Wilkins, J., 1668. *An Essay Towards a Real Character, And a Philosophical Language* (London).

Wilkinson, J. V. S., 1957. 'An Indian manuscript of the Golestan of the Shah Jahan period', *Ars Orientalis* 2. 423–5.

Willey, G. R., 1966. *An Introduction to American Archaeology* 1 North and Middle America (Englewood Cliffs).

Williams, C., 1937. *Thomas Platter's Travels in England 1599* (London).

Willis, R., and Clark, J. W., 1886. *The Architectural History of the University of Cambridge* (Cambridge).

Will[o]ughby, F., 1678. *The Ornithology* (London).

—— 1686. *De Historia Piscium Libri Quatuor* (Oxford).

Winau, R., 1977. 'Zur Frühgeschichte der Academia Naturae Curiosorum', in F. Hartmann and R. Vierhaus (eds.), *Der Akademiegedanke im 17. und 18. Jahrhundert* (Bremen and Wolfenbüttel), pp. 117–37.

Winkelmann, J. J., 1697. *Gründliche und wahrhafte Beschreibung der Fürstentümer Hessen und Hersfeld* (Bremen).

Witkam, H. J., 1980. *Catalogues of all the Chiefest Rarities in the Publick Anatomie Hall of the University of Leyden* (Leiden).

Wittlin, A. S., 1949. *The Museum: its History and its Tasks in Education* (London).

Woldbye, V., and Meyenburg, B. von (eds.), 1983. *Konkylien og Mennesket* (Copenhagen).

Wolf, S., 1960. 'Afrikanische Elfenbeinlöffel des 16. Jahrunderts im Museum für Völkerkunde Dresden', *Ethnologica* new ser. 2. 410–25.

Wolf-Heidegger, G., and Cetto, A. M., 1967. *Die anatomische Sektion in bildlicher Darstellung* (Basle).

Wood, A. à, 1731. *Athenæ Oxonienses* 2nd edn. (Oxford).

Woodward, J., 1696. *Brief Instructions for Making Observations in All Parts of the World, as Also for Collecting, Preserving and Sending Over Natural Things* . . . (London) [reprinted London, 1973].

—— 1713. *Remarks upon the Antient and present State of London, Occasion'd by Some Roman Urns, Coins, and other Antiquities, Lately discover'd* (London).

—— 1728. *Fossils of all kinds, digested into a Method* (London).

—— 1729. *An attempt towards a natural history of the fossils of England in the collection of J. Woodward M.D.* (London).

Worm, O., 1643. *Danicorum moumentorum libri sex* (Copenhagen) (*Additamenta*, 1651).

—— 1655. *Museum Wormianum, seu Historia rerum rariorum, adornata ab Olao Wormio, med. doct.* . . . *Variis et accuratis Iconibus illustrata* (Lugdunum Batavorum).

Worsaae, J. J. A., 1886. *Optegnelser om Rosenborg Samlingen i 25 aar, 1858–1883.* (Copenhagen).

Yates, F. A., 1969. *Theatre of the World* (London).

—— 1972a. *The Art of Memory* (London and Henley).

—— 1972b. *The Rosicrucian Enlightenment* (London and Boston).

Yrissarri, A. B. de, 1681. *Compendio de la vida de Manfredo Settala* (Milan).

Zangheri, L., 1979. *Pratolino, il giardino delle meravig-lie 1: testi e documenti* (Documenti Inediti di Cultura Toscana 2) (Florence).

Zedler, J. H., 1962. *Grosses vollständiges Universal-Lexikon* (Photomechanischer Nachdruck) 37 (Graz).

Zeil[l]er, M., 1640. *Itinerarii Germaniae Continuatio darin das Reyssbuch durch Hoch und Niederteutschland 50 anno 1632 aussgangen* (Strasbourg).

—— 1659. *Exoticophylacium Weickmannianum* (Ulm).

Zerries, O., 1961. 'Eine seltene Keule von den Otschukayana (Ostbrasilien) im Staatlichen Museum für Völkerkunde in München', *Tribus* 10. 143–4.

—— 1967. 'Einige alte ornamentierte Keulen aus Guayana im Staatlichen Museum für Völkerkunde zu München', *Folk* 8/9. 403–8.

Zimmer, J., 1971. *Joseph Heintz der Ältere als Maler* (Weissenhorn).

Zimmermann, H., 1888. 'Acten und Regesten aus dem Archiv des k. k. Ministeriums des Inneren', *Jahrbuch der Kunsthistorischen Sammlungen des Allerhöchsten Kaiserhauses* 7 (2).

—— 1889. 'Inventare, Acten und Regesten aus der Schatzkammer des Allerhöchsten Kaiserhauses', *Jahrbuch der Kunsthistorischen Sammlungen des Allerhöchsten Kaiserhauses* 10 (2).

—— (ed.), 1905. 'Das Inventar der Prager Schatz- und Kunstkammer vom 6. Dezember 1621', *Jahrbuch der Kunsthistorischen Sammlungen des Allerhöchsten Kaiserhauses* 25. xiii-lxxv.

Zimmermann, M.G., 1895. *Die bildenden Künste am Hof Herzog Albrechts V. von Bayern* (Studien zur deutschen Kunstgeschichte 5) (Strasburg).

Zinner, E., 1956. *Astronomische Instrumente* (Munich).

Zwollo, A., 1968. 'Pieter Stevens, ein vergessener Maler des rudolfinischen Kreises', *Jahrbuch der Kunsthistorischen Sammlungen in Wien* 64 (new ser. 28). 119–80.

INDEX

Note: parentheses denote editorial as opposed to textual matter.

Aarau, Geographic-Commercial Society of 243
abacus 215, 266
abnormalities, *see* monsters
Abondio, A. 51
Academia Naturae Curiosorum 175, 191
Accart, M. 174
achates, *see* agates
Acton, William 198 n. 31
Adam and Eve 171
adders' tongues 43, *see also Natternzungenbaüme, Natternzungenkredenz*
Adler, Cort Sivertsen 130
Adlersheim, Christian Lorentzen von 112
Adriatic Sea 33
Aeropus the Macedonian 224
Aesculapius 172 n. 39
Aesslinger, Hans 84, n. 120
Africa 2, 34–5, 111, 130, 181–4
 (items from) ch. 29 *passim*, 26, 35, 83, 118–19, 171, 233–4, figs. 93–8
Agard, Antoine 254
agates (achates) 116, 194, 209 (items of) 30, 41–4, 67, 76
agents 25, 38, 77, 90–1, 131
Agricola, Georgius 205, 208
agricultural implements, miniature 96
Aguesca, Jerónimo 143
Agustín 139
Ahmedabad 278
Akan artefacts 234 n. 12, 249–50
Akbar, Emperor 279
alabaster 71, 86, 99
Alaternus 197
Albemarle, Duke of 157, 233
Albrecht VII, Archduke of Austria 40
alchemy 142
Alciati, Andrea 230
Aldrovandi, Ulisse 1, 5–11, 17–22, 25, 122–3, 126, 151, 157, 169, 174, 186, 189, 193, 197 n. 28, 206, 213, 238–40, 242, 253
Aleppo 102
Alexius, Tsar of Russia 54
Algeria, items from 130
Algiers 149, 154
 Bey of 252
Alhambra vase 254
Ali, Pasha of Buda 252
alligator 186
allowes (alloes) 197
alpine objects 86
Altdorf 172
Altdorfer, Albrecht 64

Althann, Count Gundaker 46
Altötting, provost of 84
Amazonian axes 20–1
ambassadors' gifts 55
amber 14, 26, 43, 52, 58–9, 64, 95, 107, 112–13, 119, 156, 236, 239
 (with enclosures) 14, 112
ambergris 79
Amberg 80 n. 55
Amboina 190–2
Ambras, Schloss, ch. 4. *passim*, 15, 39–40, 43, 81, 83, 85–6, 91–2, 99, 237–40, 242, 248–9, 256 n. 23, 264, 268, 278, figs 11–14, 88–91, 100, 101, 103
Ambraser Liederbuch 37
ambulacrum 170
Amerbach, Basilius 63–8, 229
Amerbach, Bonifacius 62–3, fig. 24
Amerbach, Johannes 62
America 2, 18, 34, 43, 47, 119 n. 46, 156, 179, 181–2, 201, 215, 222, 230
 items from 20, 24, 26, 65, 117–18, 173–4, figs. 84–92
 Central and South ch. 28, *passim*, 85, 131 n. 14, 179–83, 232, 240
 North ch. 27, *passim*, 177, 234, 243, 250
 South 91, 117–18, 130, 170
ammonites 207–8, 210–11
Amsterdam 54, 117, 185, 191, 265
 (collections in) 56, 110, 117, 119, fig. 47
 Rembrandt's house 118
 Rijksmuseum 93
 Zoological Museum 192
amethysts 170
amulets 97, 148, 204, 254
anamorphoses 97–8
Anatolia 257
anatomie moralisée 120
anatomical specimens 10, 55, 58–60, 107, 119, 154, 161–2, 165, 173, 176, figs. 49, 64
 see also Bones
anatomists 56, 119–20
anatomy collections, schools and theatres 69, 107, 119, 169–73, 204, figs. 63–4
Andean highlands 243
Andreae, J. V. 176–7
Andrés, Juan Francisco 142
Angeloni, Francesco 195
Ango, Jean 245
Anhalt, Christian, Prince of 128, 269
 Elizabeth of fig. 26,
 Johann Moritz, Duke of 103
animals chs. 21, 22, 24 *passim* 1, 6–10, 14, 20, 22, 32–3, 52,

FIGURES

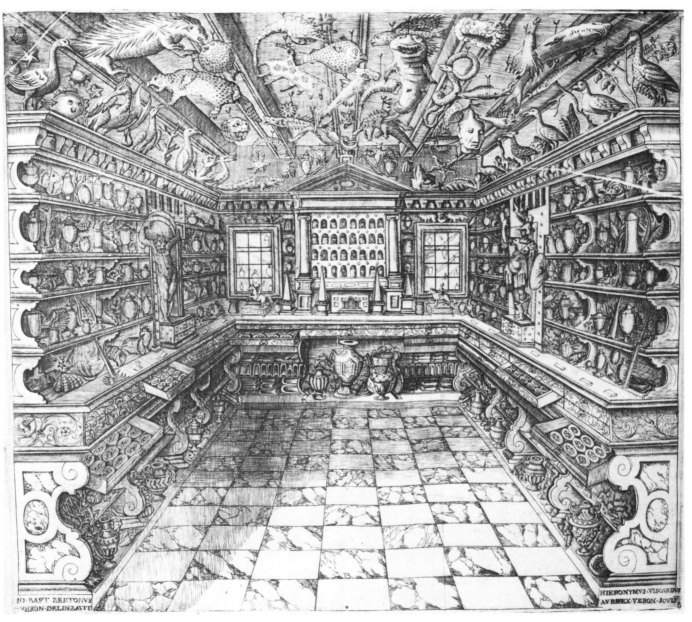

1 The Museum of Francesco Calceolari in Verona, from Ceruti and Chiocco 1622.

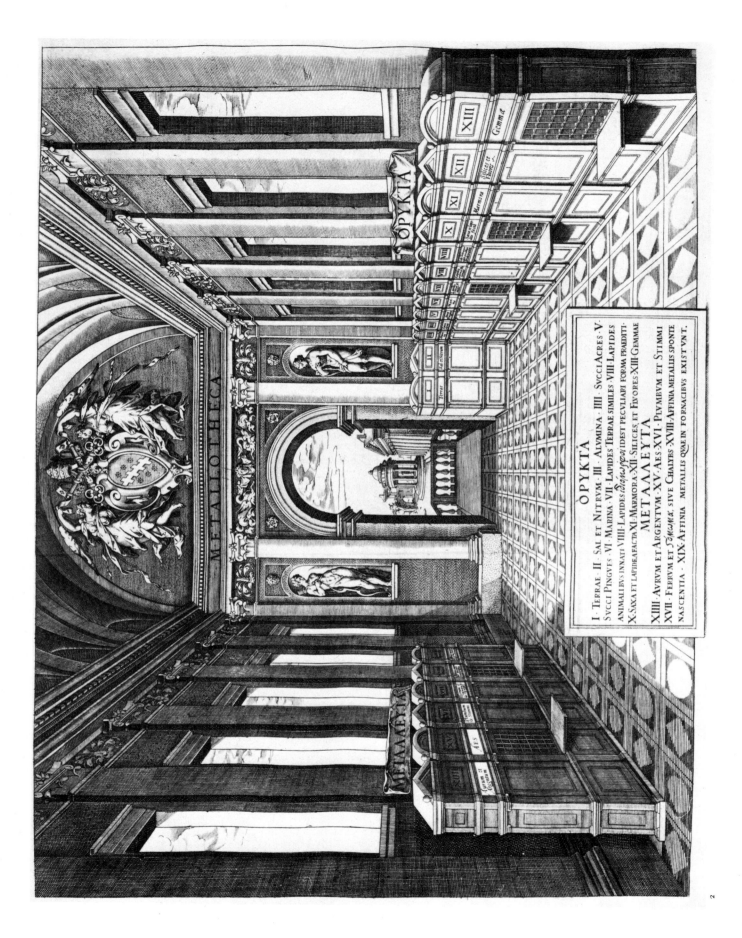

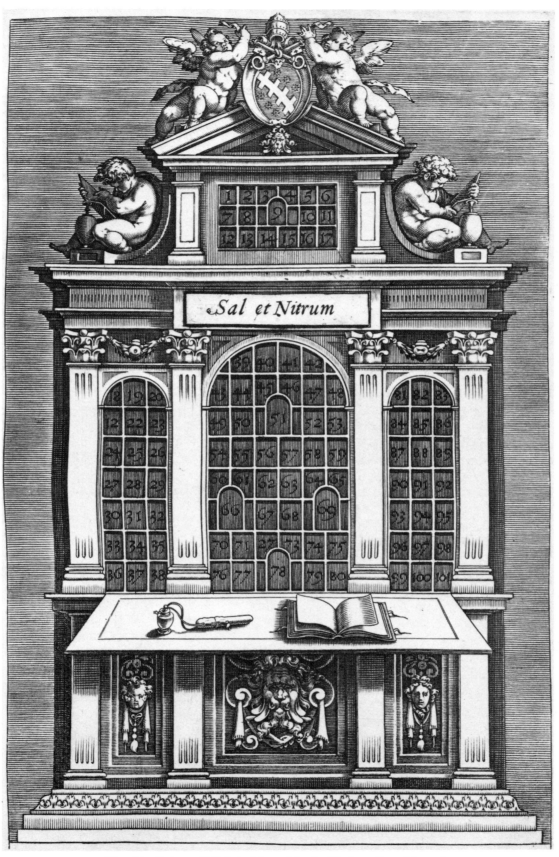

2–3 The *Metallotheca* of Michele Mercati in the Vatican, from Mercati 1719.

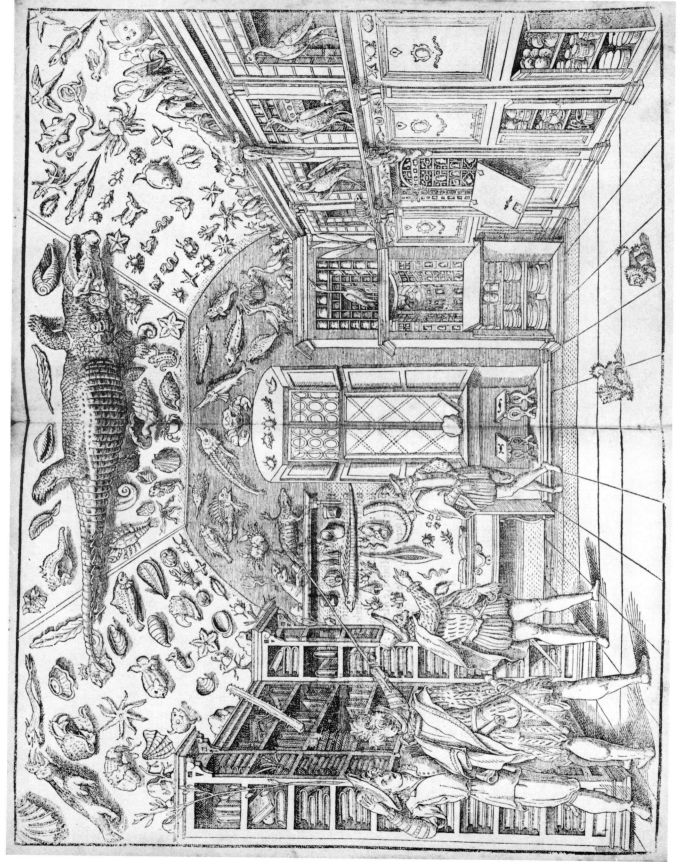

4 Ferrante Imperato's museum in Naples, from Imperato 1599.

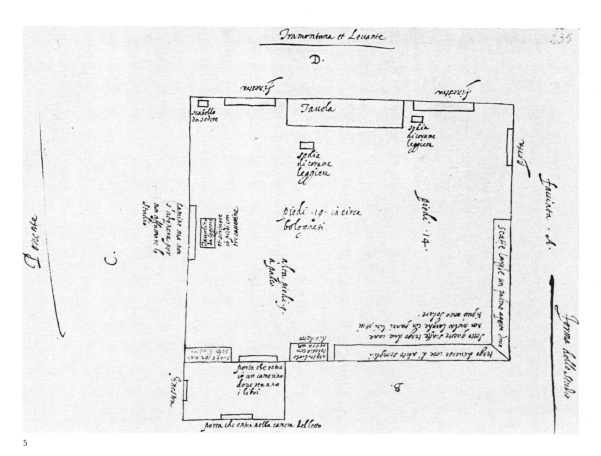

5

6 5–6 The museum of Antonio Giganti in Bologna: plan and elevation.
From Biblioteca Ambrosiana, Milan, MS 85 sup.

7 The *nymphaeum* of the Villa Visconti Borromeo, Milan.

8 A grotto in the Villa Visconti Borromeo, Milan.

9 Portrait of Manfredo Settala, by Daniele Crespi.
Pinacoteca Ambrosiana, Milan.

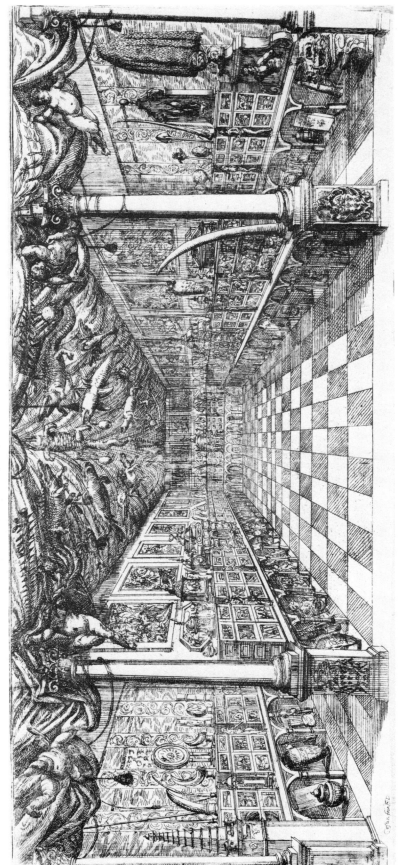

10 (*below*) The museum of Manfredo Settala, Milan.
From Scarabelli 1666.

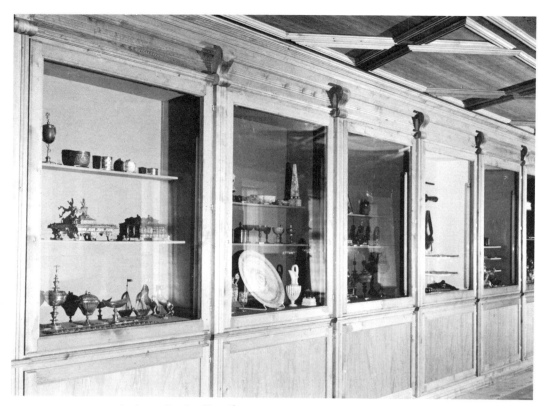

11 Ambras Castle, *Kunstkammer*, row of cases (1–5), northern part.

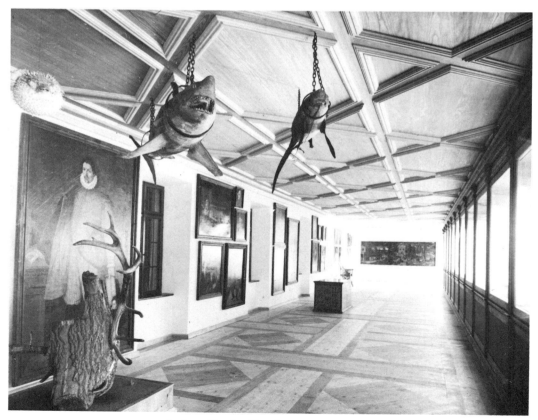

12 Ambras Castle, *Kunstkammer*, southern part.

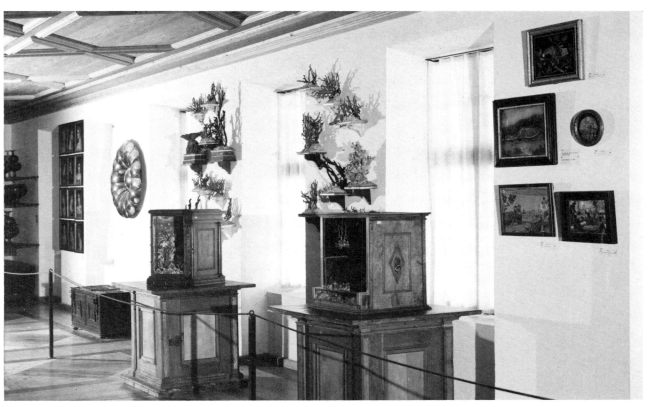

13 Ambras Castle, *Kunstkammer*, view of the northern wall.

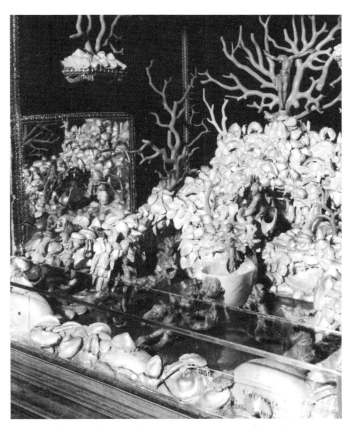

14 Ambras Castle, *Kunstkammer*, interior of a cabinet.

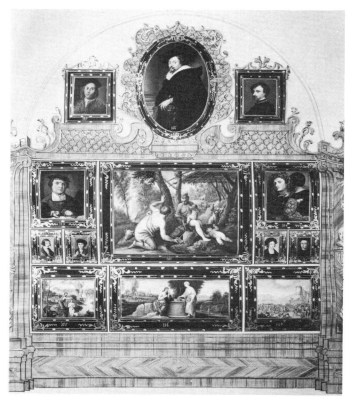

15

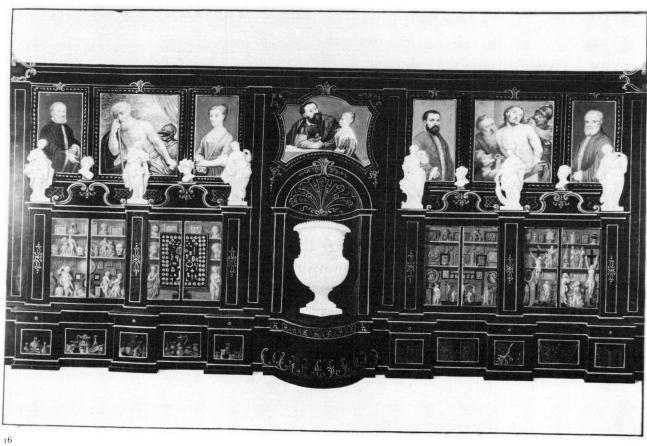

16

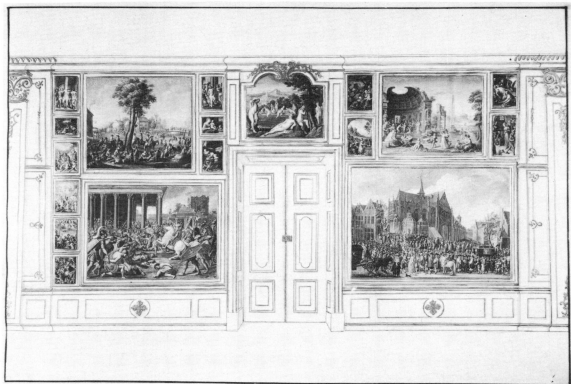

17

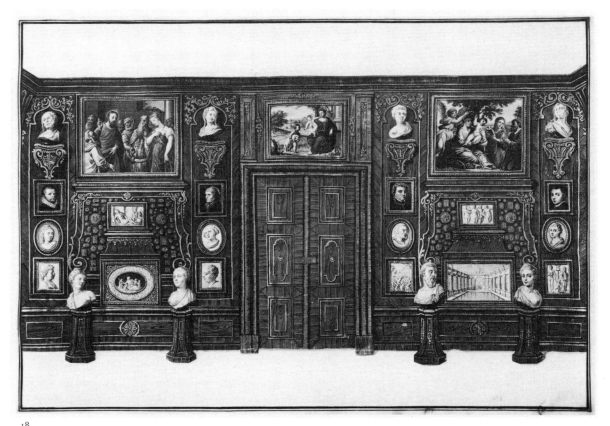

18

15–18 Four walls of four different rooms in the Stallburg Gallery and *Kunstkammer* in the Vienna Hofburg after the picture inventory by Ferdinand Astorffer dated 1720–33. This display was set up between 1720 and 1728.

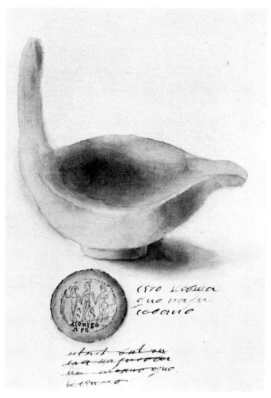

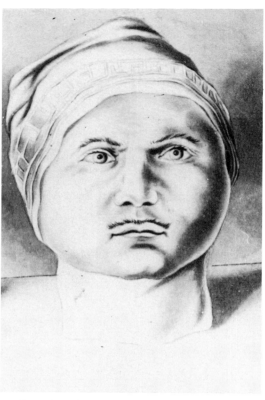

19 Drawing of a Roman lamp from the *Kunst-kammer* of Peter I. Archives of the Academy of Sciences, Leningrad.

20 Drawing of a head of Tsar Peter I in coloured wax, from the tsar's *Kunstkammer*. Russian Museum, Leningrad.

21 Lead plaquette of Venus and Adonis, by Paul van Vianen. Hermitage Museum, Leningrad.

22 Drawing of a silver disc of second century B.C., showing the Bactrian goddess Khvaninda. Hermitage Museum, Leningrad.

23 Foma, one of the living rarities from the *Kunstkammer* of Peter I.

24 Cabinet made in 1539 for Bonifacius Amerbach. Historisches Museum, Basle.

25 Detail of intarsia cabinet with the arms of Andreas Ryff, dated 1592. Historisches Museum, Basle.

26 Wax portrait from the collection of Remigius Faesch, showing
Margrave Johann Georg of Brandenburg with his third wife, Elizabeth
von Anhalt. Historisches Museum, Basle.

27 Cabinet made in Basle in 1619 for Remigius Faesch. Historisches Museum, Basle.

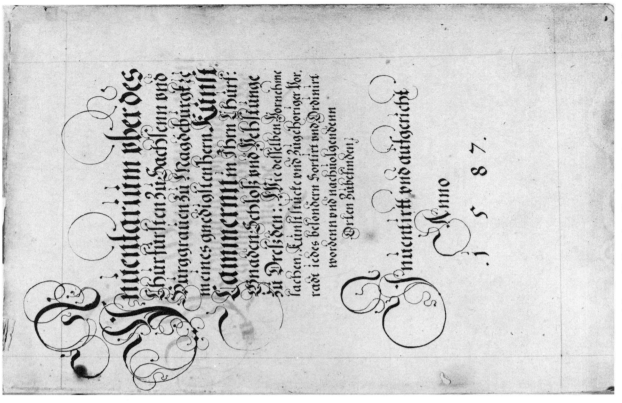

29 First page of the 1587 Dresden *Kunstkammer* inventory, written by Kunst-kammerer David Uslaub. Grünes Gewölbe, Dresden.

28 Inventory of the Dresden *Kunstkammer* of 1587. Leather cover with electoral coat of arms; above, the letters C.H.Z.S.C. (Christian Herzog zu Sachsen, Churfürst); below, 1588. In the manner of Jacob Krause. Grünes Gewölbe, Dresden.

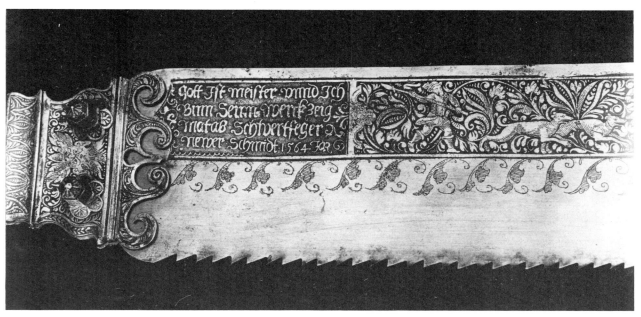

30 Coping or veneer saw-blade of steel, etched with blackened background, parcel gilt. Inscribed 'God is master and I am his tool. Matass [Mattheus] Schwertfeger, new smith year 1564'. Historisches Museum, Dresden.

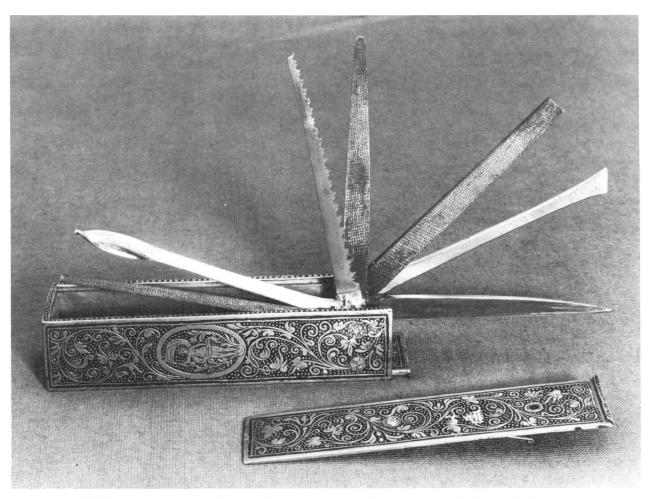

31 Folding multi-purpose tool, iron etched with blackened background, by Balthasar Hacker, c.1565. Historisches Museum, Dresden.

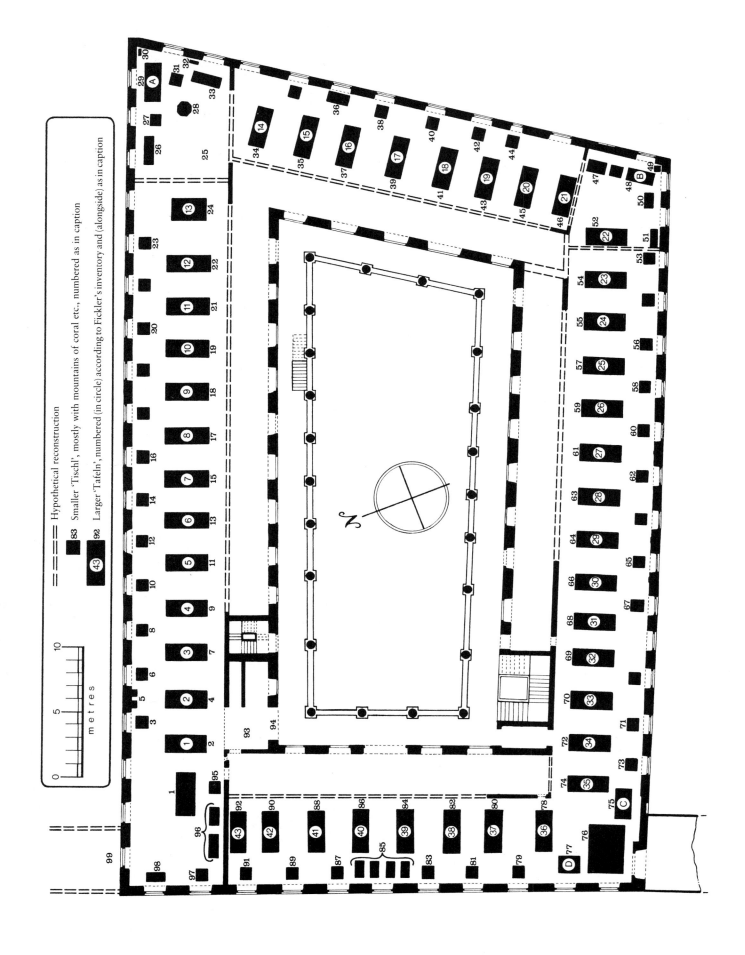

Hypothetical reconstruction

83 Smaller 'Tischl', mostly with mountains of coral etc, numbered as in caption

92 Larger 'Tafeln', numbered (in circle) according to Fickler's inventory and (alongside) as in caption

32 Schematic reconstruction of the Munich *Kunstkammer*. The plan is based on a drawing signed by Gärtner in 1807 and incorporating information from Fickler 1598 and Hainhofer 1611. Gärtner's plan of the first floor of the *Marstall* and *Kunstkammer* building was compiled directly before the remodelling of the building into the Royal Mint; the Kunstkammer was probably installed at that time on the second floor, which was laid out in a similar manner but for which no corresponding drawing exists. Due to slight discrepancies between Sandtner's town model and Gärtner's drawing some uncertainty remains over the precise arrangement of the objects and certain constructional details such as the original shape of the north-west corner room. The distinction between original walls and those dating from the remodelling of 1807, marked by different shading on Gärtner's original, is not shown in this reconstruction.

Note: In the following key the numbers referred to are those given *alongside* each 'Tafel' or 'Tischl'; the sans serif numbers within white circles on the plan are those given in the Fickler inventory.

1 Books.
2 Graphic works.
3 Malformed calf's head; statuettes of terracotta; Marsyas (?) and Actaeon.
4 Books, maps, graphic representations of abnormalities.
5 Two glass-protected chests with turned wooden superstructures and chamois horns (also on most of the other mullions of the north side).
6 Marine plants.
7 'Jewish' metal religious utensils.
8 Aurochs head; malformed horns.
9 [above] 'Indian' vessels and textiles; [under] 'Indian' arms; [drawer] lead castings.
10 Veined wood pieces with the appearance of bread.
11 [above] Ivory vessels and sculptures; 'Indian' and 'Moscovian' wooden vessels; [under] historic apparel (William IV).
12 Copper fountain.
13 Mother-of-pearl works; historic articles of clothing; [drawer] lead castings.
14 Mother-of-pearl chest with male and female jointed dolls.
15 Miniature portraits of princes, popes and cardinals; [drawer] micro-carvings.
16 Three male and female joint-dolls; wooden bowl support.
17 [above] Small chests, writing-utensils; bridal shirt of Empress Eleonore; [under] shoes.
18 [above] Swords, daggers, knives; [under]: sticks.
19 [above] Cutlery; rosaries; objects from the Holy Land; natural castings; bezoars; [under] animal horns.
20 Nun's belt with silver ornamentation.
21 Reliefs, esp. portraits; Egyptian images; micro-carvings, 'subtle works'.
22 European and exotic turned and carved ivory; wooden vessels.
23 Duchess Jacobaea's wooden receptacle.
24 Coins in a coin cabinet.
25 'ENCLOSED ROOM'
26 Sideboard with four steps with *tazze*, basins, ewers, candlesticks in silver gilt.
27 Sinhalese ivory casket esp. with rings and cameos.
28 Florentine *pietra dura* table with a celestial globe.
29 [above] Objects (esp. vessels) in gold, silver, rock crystal, semi-precious stones; [under] targets.
30 'Persian' weapons.
31 Sinhalese ivory casket with twelve cameos of Roman Emperors; 'Golden Table.'
32 Mirror.
33 Sideboard with four steps with ungilded silver objects.
34 Religious sculptures; [under] 'Turkish' and 'Indian' textiles and feather works.
35 [above] Metal sculptures; animal horns, claws and teeth; [under] tin.
36 'Indian' desk.
37 Ironwork: locks, torture instruments, printing blocks.
38 Chest with miniatures.
39 Porcelain.
40 Chests with cutlery, dagger pommels, signets, intaglios.
41 Marine snails and shells, some of them encrusted with precious stones.
42 [above] Camouflaged telescope; [under] two alabaster bowls.
43 [above] Alabaster vessels; [under] whale-ribs.
44 Sepulchral urns from Carinthia; bones of a giant.
45 [above] Stone vessels and sculptures; [under] majolica.
46 Sculptures, [above] in alabaster, [under] in marble and plaster of Paris.
47 Desk with *lapides manuales*.

48 [above] Two sepulchral urns; [under] five whale fins.
49 Mine of *lapides manuales*, made by Duke Ferdinand of Bavaria.
50 Crucifix with precious stones; coral chaplet; Caritas.
51 Sideboard; [above] rosaries; [drawer] lead castings and copper plates.
52 [above] Glasses, mirrors; [under] crocodile.
53 Marble pyramids and columns.
54 Coral cabinet; plaster of Paris castings of human arms and animal feet.
55 Plaster of Paris castings of meals and deformations.
56 [under] Plaster of Paris castings.
57 Marine wonders; unknown animals.
58 [under] Plaster of Paris castings.
59 'Turkish' objects
60 [under] Plaster of Paris castings.
61 Feather and fine textile works.
62 [under] Plaster of Paris castings.
63 [above] Wax portraits; [under] 'Indian' textiles.
64 'Turkish' and exotic objects (esp. textiles).
65 Four heads of marine wonders.
66 'Indian' objects (esp. from Latin America).
67 [above] Ceramics (finds from Luben in Lusatia); [under] feather fan; malformed pig's trotter.
68 [above] Wood carvings; [under] textiles, esp. of silk.
69 Etched stones; stone and wood reliefs.
70 Mathematical, physical, geometrical and geographical instruments.
71 Fine wood works; [drawer] 'Turkish' and 'Indian' textiles.
72 Globes; astronomical instruments; [drawer] 'Turkish' textiles.
73 [above] Astronomical instruments; [drawer] 'Tunisian' and 'Indian' textiles; cloak and sword of Francis I; doublet and trousers of the Provost of Nußdorf.
74 Models of Juelich and of Frauenchiemsee Monastery; [drawer] exotic and historic textiles (Francis I).
75 Model of Burghausen Castle.
76 [above] Models of Munich, Ingolstadt, Landshut; [under] model of fortifications of Ingolstadt; triumphal arch of Emperor Maximilian I.
77 Models of Jerusalem and Straubing.
78 Printing blocks of the Bavarian map by Apian and of Bavarian coat-of-arms.
79 Alabaster jug, historic card decks.
80 [above] Tortoiseshell vessel; [under] books from Taufkirchen Castle of the Fugger family
81 [above] Wooden galley; [under] wax works.
82 Natural wonders; petrifications; rock crystal.
83 *Lapides manuales*; turned ink-stand.
84 Marble pieces; wax works.
85 Four trunks with *lapides manuales*, minerals and metals.
86 *Lapides manuales* and stone growths.
87 *Mirabilia* (corn fallen from the sky etc.); mandrakes.
88 Mines and *lapides manuales*.
89 'Indian' table, folding-chair and draughts-board with mother-of-pearl marquetry.
90 Game boards.
91 Spring-gun (trick toys).
92 Plaster of Paris reliefs; wax works; glass mixture; Limoges enamels; silver.
93 ANTECHAMBER ('TENNELEIN').
94 ENTRANCE TO THE KUNSTKAMMER.
95 Table painted by Bocksberger.
96 Table and trunk with simple implements.
97 Table with stone-etched map of Bavaria.
98 Chest with simple moulds etc.
99 COURT GALLERY TO THE NEUVESTE.

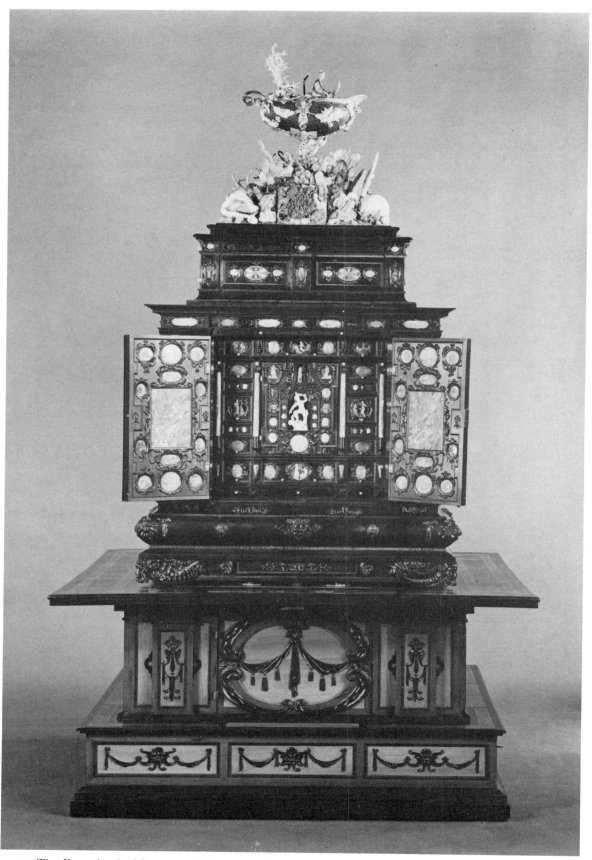

33 The *Kunstschrank* of Gustavus Adolphus, made 1625–31 by Philipp Hainhofer. University of Uppsala.

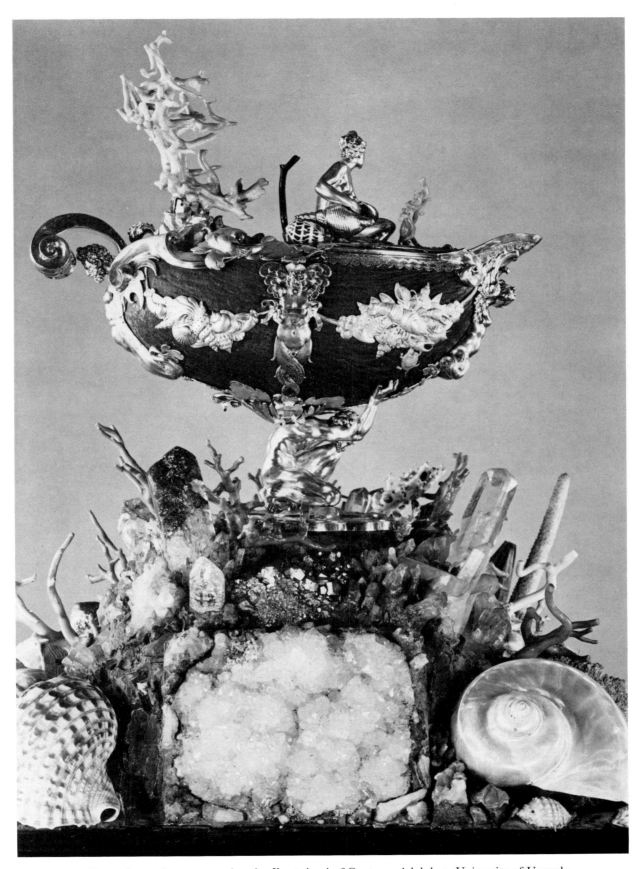

34 Ewer of coco-de-mer crowning the *Kunstschrank* of Gustavus Adolphus. University of Uppsala.

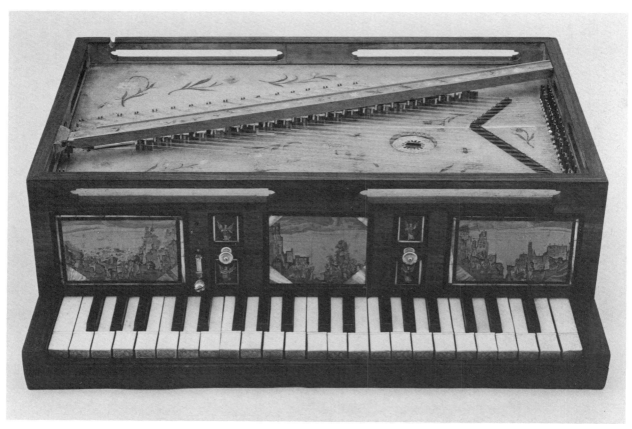

35 Virginal from the *Kunstschrank* of Gustavus Adolphus. University of Uppsala.

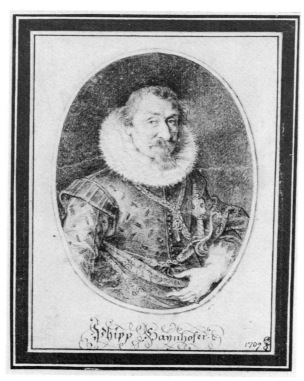

36 Portrait of Philipp Hainhofer by Lucas Kilian.
Nationalmuseum, Stockholm.

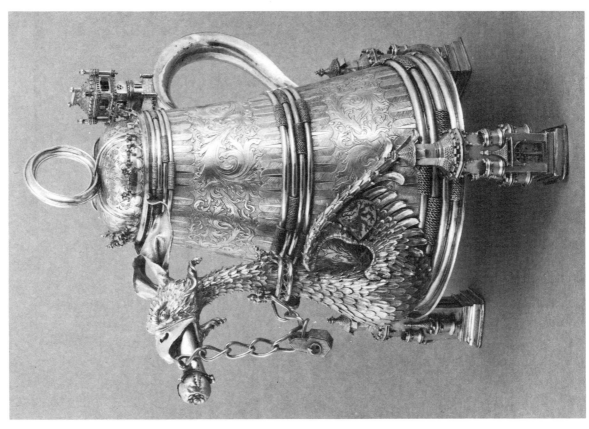

38 'Katzenelnbogischer Willkomm', silver-gilt, central Rhineland, mid-fifteenth century. Staatliche Kunstsammlungen, Kassel.

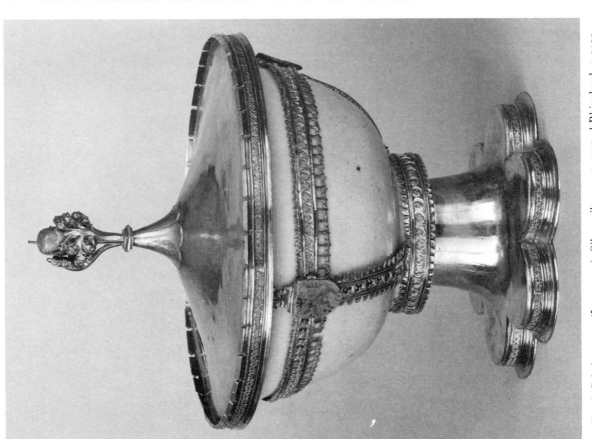

37 Bowl, Celadon ware (Longquan). Silver-gilt mount: central Rhineland, c. 1435. Staatliche Kunstsammlungen, Kassel.

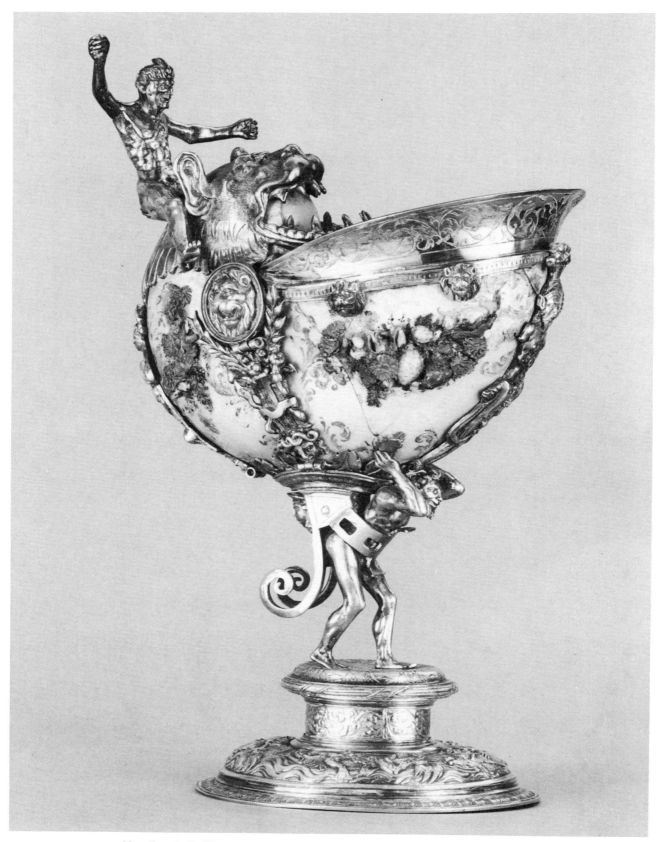

39 Nautilus shell. Silver-gilt mount: Antwerp (?), last quarter of the sixteenth century.
Staatliche Kunstsammlungen, Kassel.

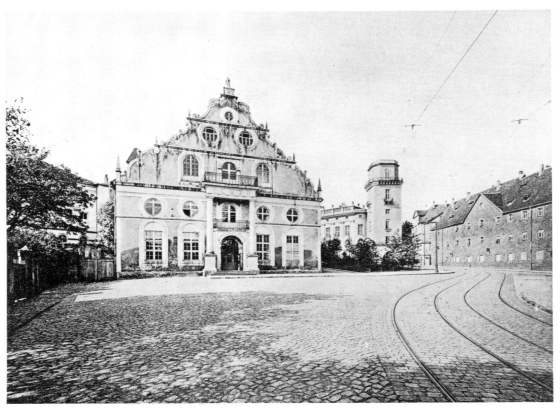

40 *Kunsthaus* of the Landgrave Carl of Hesse-Kassel, inaugurated in 1709.
Staatliche Kunstsammlungen, Kassel.

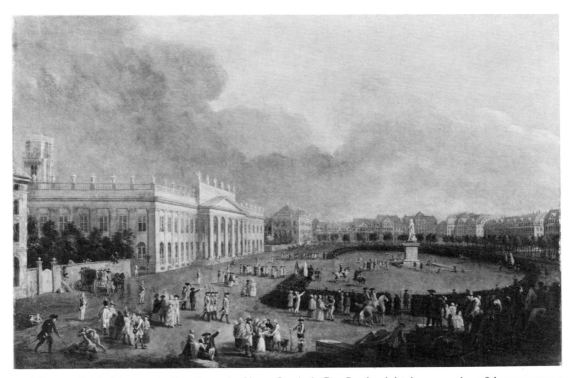

41 Museum Fridericianum, built 1769–79 by Simon Louis du Ry. On the right, inauguration of the monument
of the founder Landgrave Friedrich II of Hesse-Kassel. Painting by Johann Heinrich Tischbein the Elder.
Staatliche Kunstsammlungen, Kassel.

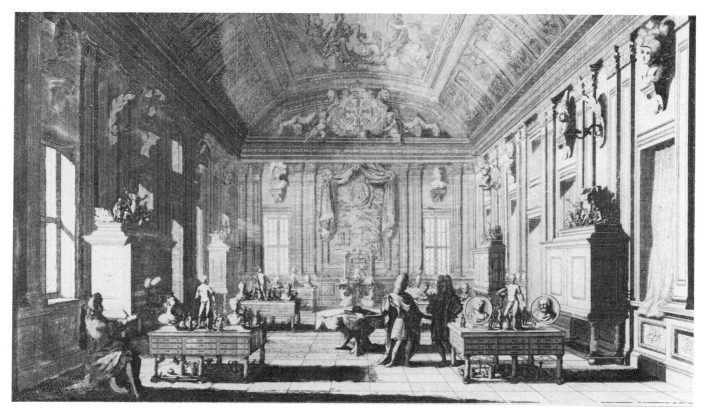

42 View of the Brandenburg *Kunsthammer* by S. Blesendorf, from Beger 1696–1703.

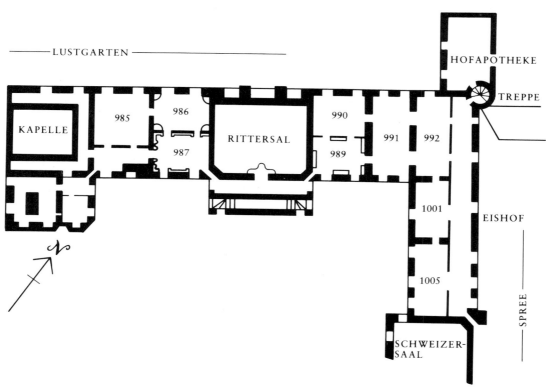

43 Plan of part of the fourth floor of the Berlin Stadtschloss. Nos. 985–7, three rooms of the antique and medal cabinet; 989, ivory room; 990, naturalia room; 991, instrument room; 992/1001, model rooms.

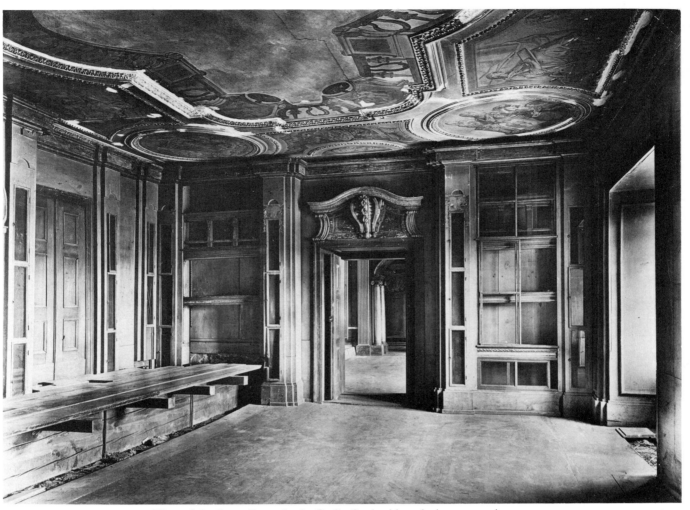

44 View of the Ivory Room in the Berlin Stadtschloss during restoration *c.*1930.

45 Pyramidal showcases in the Berlin *Kunstkammer*, from Beger 1696.

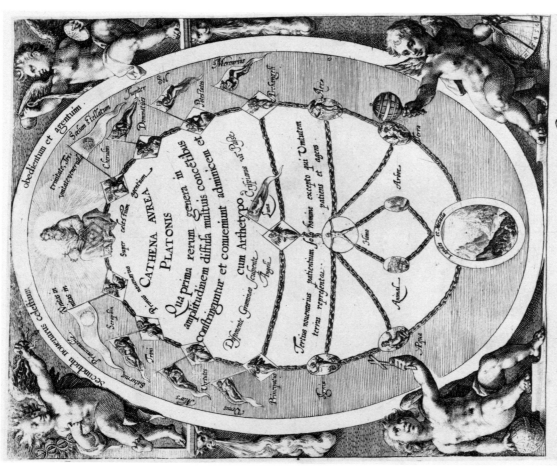

46 Title-page of a series representing the Seven Planets, entitled *Cathena aurea Platonis*, by
Crispin de Passe after Maarten de Vos. Rijksprentenkabinet, Amsterdam.

47 Title-page of a volume showing a selection of antique sculptures from the
Reynst collection, Amsterdam, by Gerard Lairesse.

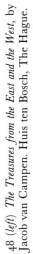

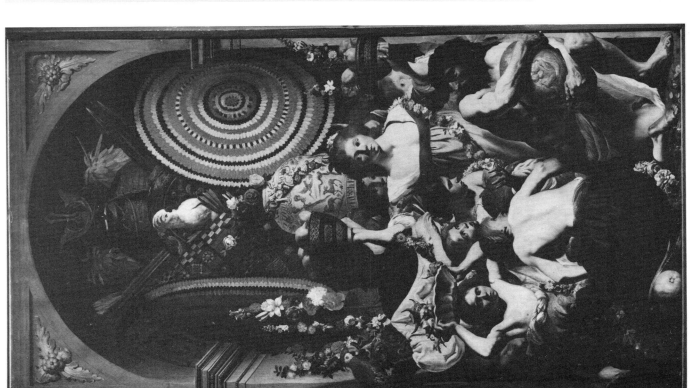

48 (*left*) *The Treasures from the East and the West*, by
Jacob van Campen. Huis ten Bosch, The Hague.

49 (*above*) Anatomical group composed by Frederick
Ruysch as a *vanitas mundi*, engraved by C. Huyberts.
From Ruysch's *Opera Omnia*.

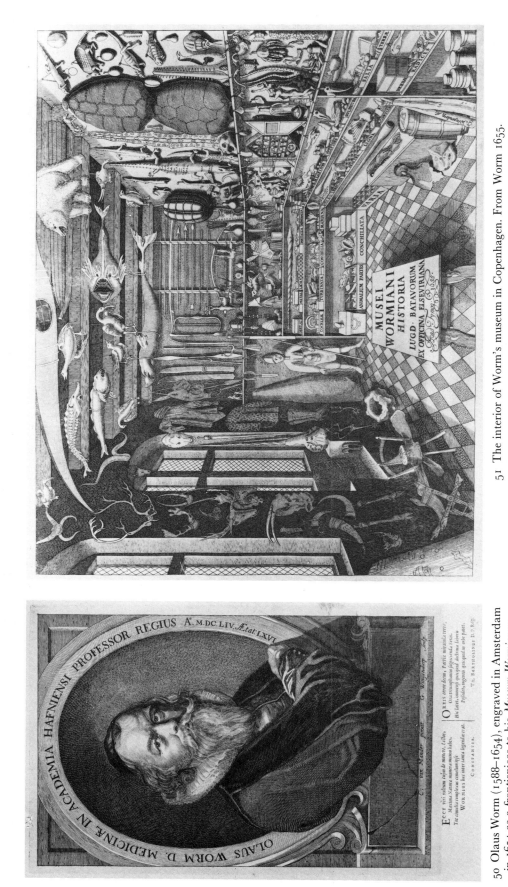

51 The interior of Worm's museum in Copenhagen. From Worm 1655.

50 Olaus Worm (1588–1654), engraved in Amsterdam in 1654 as a frontispiece to his *Museum Wormianum*.

53 Bernhard Paludanus (1550–1633) of Enkhuizen, by Hendrick Gerritsz Pot.
Frans Hals Museum, Haarlem.

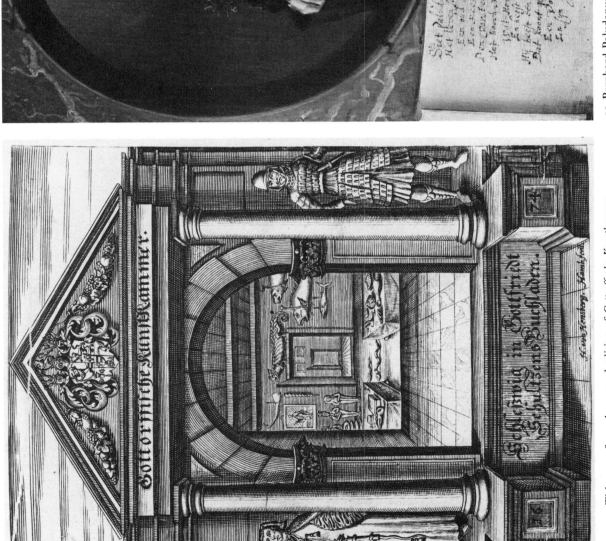

52 Title-page from the second edition of *Gottorffische Kunstkammer*
by Adam Olearius (1674).

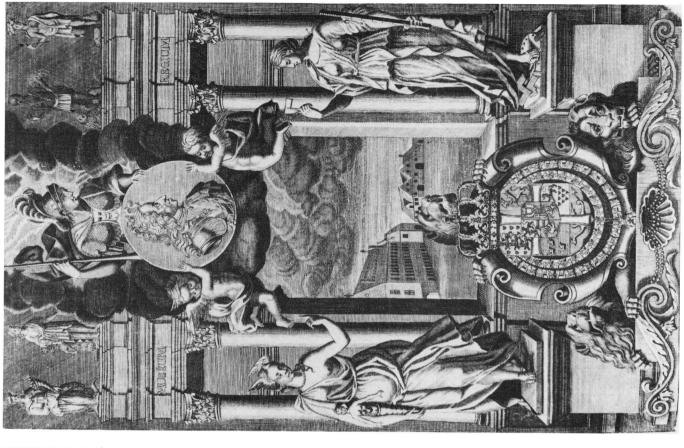

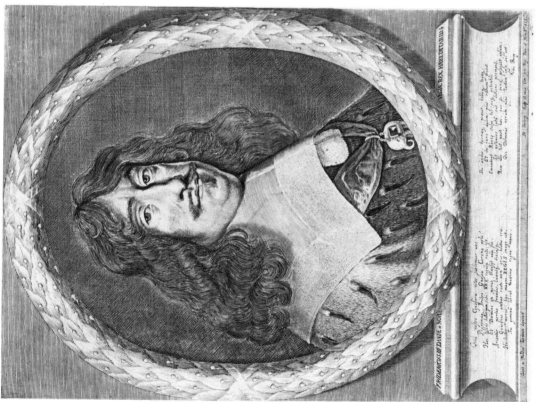

54 (*above*) King Frederik III of Denmark (1609–70). Engraving by Albert Hadwegh after a painting by Karl van Mander. Frederiksborg Museum.

55 (*right*) The oldest known picture of the Royal *Kunstkammer* and library building, seen at left in the central field. The frontispiece of the *Museum Regium* (1696).

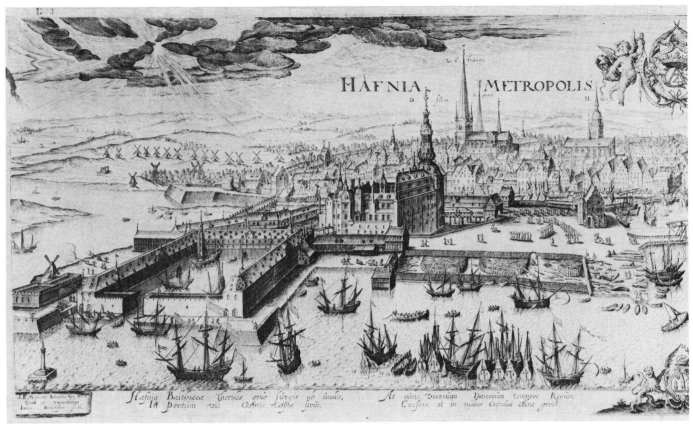

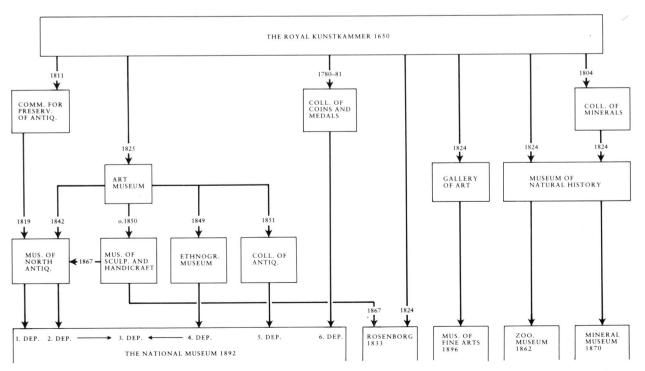

56 View of Copenhagen in 1611. In the centre is the Royal Palace of Copenhagen and in the foreground the south wing where Frederik III installed his *Kunstkammer*. Detail of an engraving after a lost painting by Jan van Wijck. National Museum of Denmark.

57 Schematic representation of the development of those parts of the Danish royal collections connected with the *Kunstkammer*.

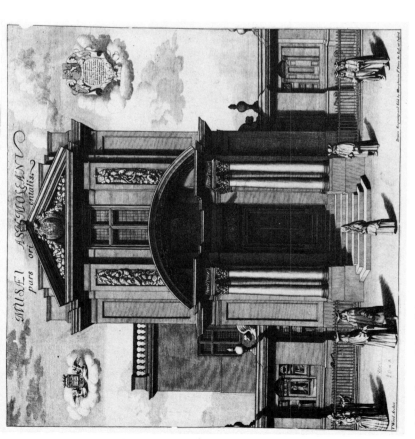

59 One of two cabinets housing the smaller rarities in the Bargrave collection at Canterbury, thought to date from the 1660s. In addition to eight flat drawers and a deeper ninth drawer in the centre, it incorporates thirteen coin trays grouped at the top and bottom. The doors are thought to have been added in the nineteenth century. Photograph, John Webb.

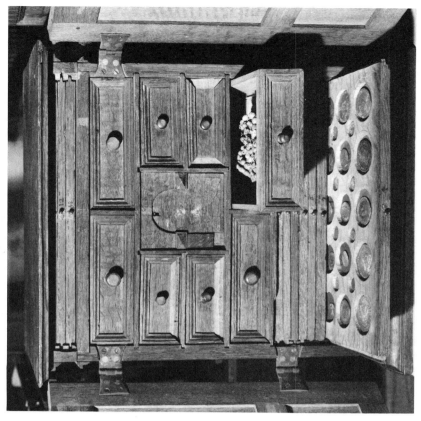

58 East front of the original Ashmolean Museum, Britain's earliest purpose-built museum building. The exhibition galleries were at first limited to the upper floor, the ground floor being given over to a lecture room and the basement to a 'chemical laboratory'. The engraving is by Michael Burghers, c.1685.

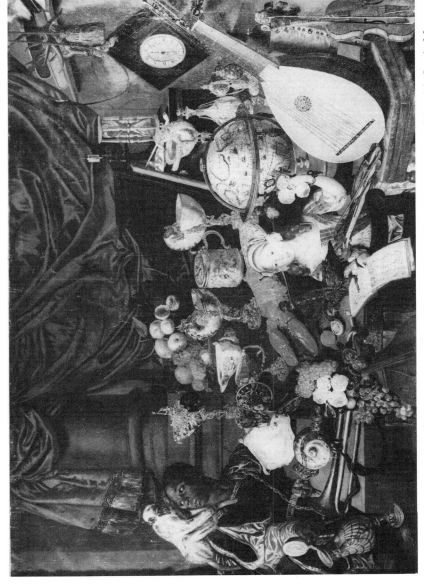

61 The 'Paston Treasure', from Oxnead Hall, Norfolk, c.1665. Norfolk Museums Service (Norwich Castle Museum).

60 Anglo-Saxon urns (mistaken for Roman) from Sir Thomas Browne's *Hydriotaphia* (1658).

En Sum quod digitis Quinque Levetur onus propert

Scheme 3.

Scheme 4.

Scheme 5.

62 Sample page from Grew's *Musaeum Regalis Societatis* (1681), concerning the classification of shells.

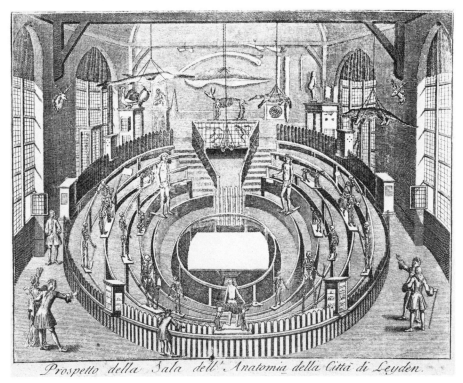

63 The anatomy theatre of Leiden University, built in 1593, with some curiosi examining the exhibits. Italian engraving, early eighteenth century. Wellcome Institute Library, London.

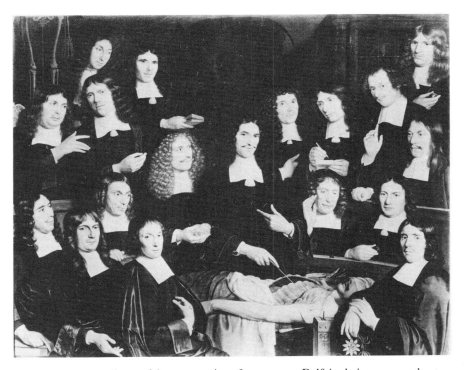

64 Members and officers of the corporation of surgeons at Delft in their anatomy theatre, 1681. In the background, visible in this old photograph of the painting, are (left to right) a human skeleton, the stuffed rhinoceros and the skeleton of an ostrich. Painting by Cornelis de Man 1681, in the Oude en Nieuwe Gasthuis, Delft. Wellcome Institute Library, London.

66 Engraving of a Roman tombstone with relief of the rape of Proserpina by Pluto, formerly in Kircher Museum of the Collegio Romano. From Buonanni 1709, pl. XXVI, p. 116. Wellcome Institute Library, London.

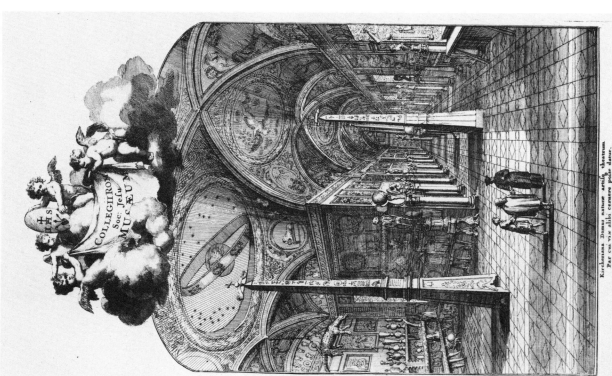

65 Idealized view of the museum built up by P. Athanasius Kircher in the Roman College of the Society of Jesus. Engraved title-page to De Sepi, 1678. Wellcome Institute Library, London.

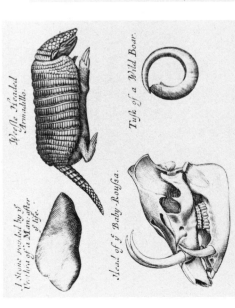

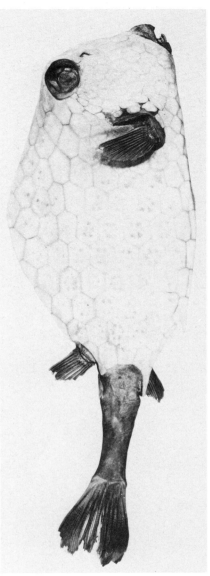

67 Weasel-headed armadillo and babyrousa pig skull from Grew 1681, pl. 1.

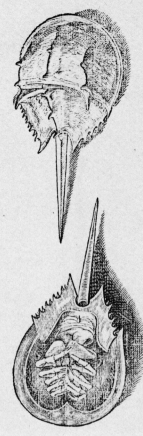

68 Trunkfish from a surviving specimen of Tradescant's collection in the University Museum, Oxford.

C A P. V.
De Cruſtatis Rotundis.

QUamvis inter Cruſtata oblonga & rotunda ambigere videatur, quem primo loco hic proponimus, Cancer, quia tamen, caudam ejus acutam ſi exceperis, totum ejus corpus ad rotunditatem accedit, locun ei hic tribuere placuit.

Dicitur verò à Carolo Cluſio Exot lib. 6. cap. 14. CANCER MOLUCANUS, co quod circa Inſulas Molucas copioſè capiatur, & ad naturam Cancri accedere videatur. Clariſſ. Vir D. Joh. de Laet in deſcriptione Indiæ Occidentalis lib. 2. cap. 19. Araneum Marinum vocat; Americani Signoc vel Siguenoc.

70 King crab from Worm 1655, pl. 249.

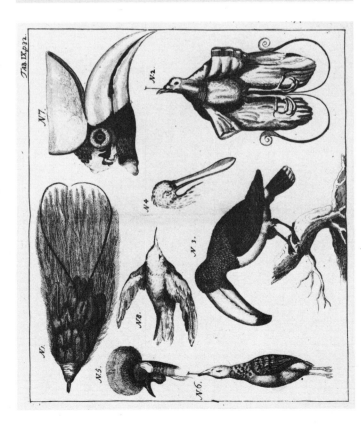

69 1, Greater bird of paradise; 2, king bird of paradise; 3, toucan; 4, spoonbill; 5, African crowned crane; 6, eider duck; 7, rhinoceros hornbill; 8, humming bird. From Lochner 1716, pl. IX, p. 32.

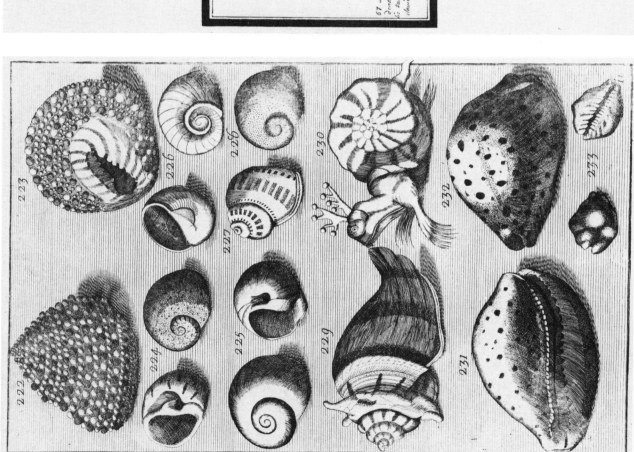

71 A plate, including figs. 222–33, from Buonanni 1681. The fantasy animal of fig. 230 shows that the living mollusc was not studied.

72 Figures 838–40 from Lister 1685–1692.

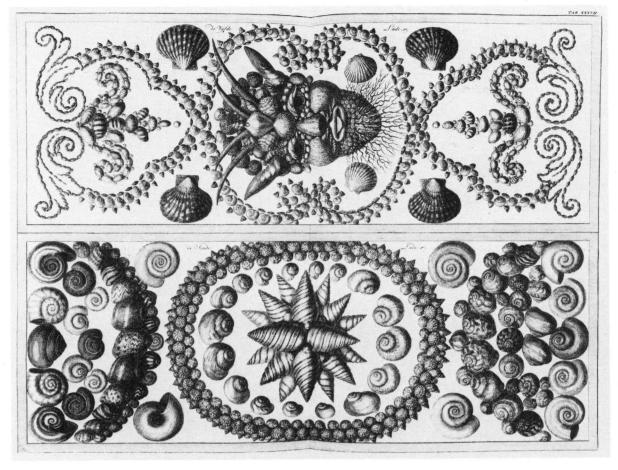

74 Plate 37 from Seba 1734–65, vol. 3, showing two artistically arranged drawers from his shell collection.

73 Title plate of Rumphius 1711.

KRUYTHOFF

C. Hagen fecit

75 Engraving (c.1670) of the *Hortus Botanicus* at Leiden.
Leiden City Archives.

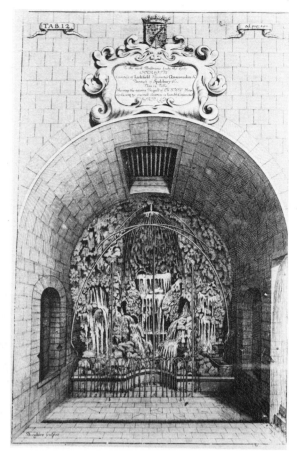

TAB. 12

77 Thomas Bushell's grotto at Enstone. Plot 1677.

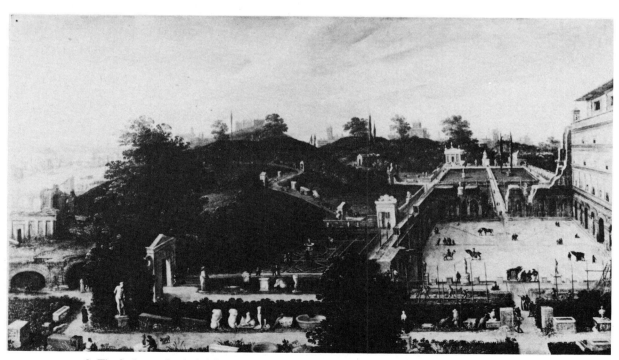

76 *The Sculpture Garden of Cardinal Cesi*, by Hendrick van Cleef III. National Gallery, Prague.

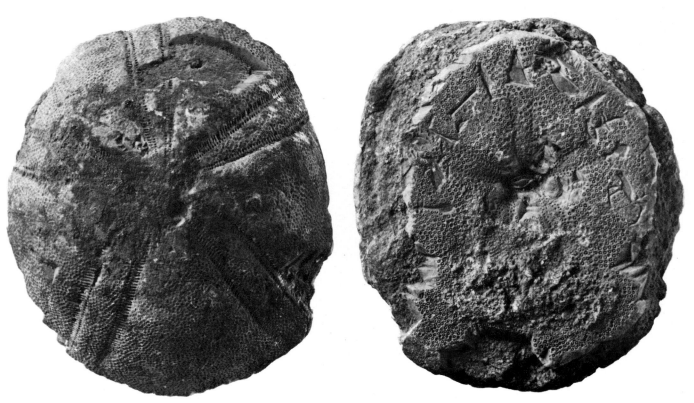

ARCA RERVM FOSSI
lium Ioan. Kentmani.

1	TERRAE	* 2	SVCCI NA-TIVI.
		*	
3	EFFLORE-SCENTES	* 4	PINGVES
		*	
5	LAPIDES	* 6	LAPID. IN A-NIMALIBVS
		*	
7	FLVORES	* 8	SILICES
9	GEMMAE	* 10	MARMORA
		*	
11	SAXA	* 12	LIGNA IN Saxa corporata.
		*	
13	ARENAE	* 14	AVRVM
15	ARGENTVM	* 16	ARGENTVM VIVVM
		*	
17	AES SEV CV-PRVM	* 18	CADMIA MET PLVMBAGO
		*	
19	PYRITES	* 20	PLVMBVM NIGRVM
		*	
21	CINEREVM	* 22	CANDIDVM
23	STIBI	* 24	FERRVM
25	STOMOMA	* 26	MARINA VARIA
		*	

Quicquid terra sinu, venúsq; recondidit imis,
Thesauros orbis hæc breuis arca tegit.
Læta magna est tacitas naturæ inquirere vires,
Maior in hoc ipsum munere nosse Deum.
Georg. Fabricius. C.

78 Johann Kentmann's 'mineral cabinet' from his *Nomenclaturae Rerum Fossilium*, 1565.

79 Eocene fossil sea urchin from Heliopolis, Egypt. Egyptian Museum, Turin.

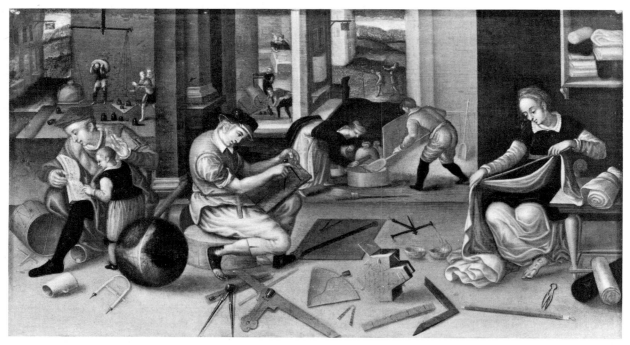

80 *The Measurers*. Oil by Hendrick van Balen (1560–1632), *c*.1600. Museum of the History of Science, Oxford.

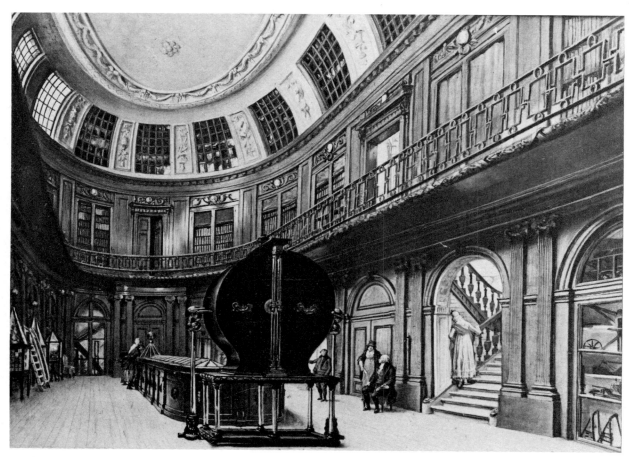

81 *De Ovale Zaal*. Oil by Wijbrand Hendriks (1744–1831), *c*.1810. The room was ready for use in 1784. The glazed cabinets were subsequently filled with scientific apparatus, and the island case with minerals. The view remains almost unchanged today. Teyler's Museum, Haarlem.

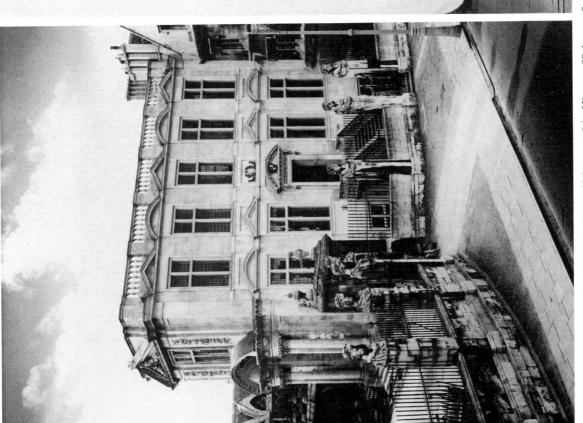

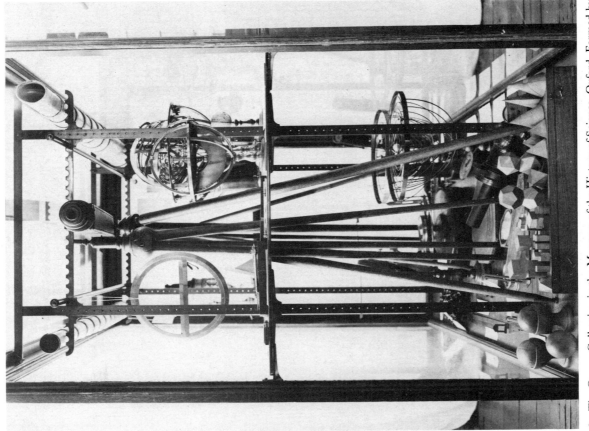

82 The Old Ashmolean building, built 1679–83. Museum of the History of Science, Oxford.

83 The Orrery Collection in the Museum of the History of Science, Oxford. Formed by Charles Boyle, fourth Earl of Orrery between 1690 and 1710. Deposited by Christ Church College, Oxford.

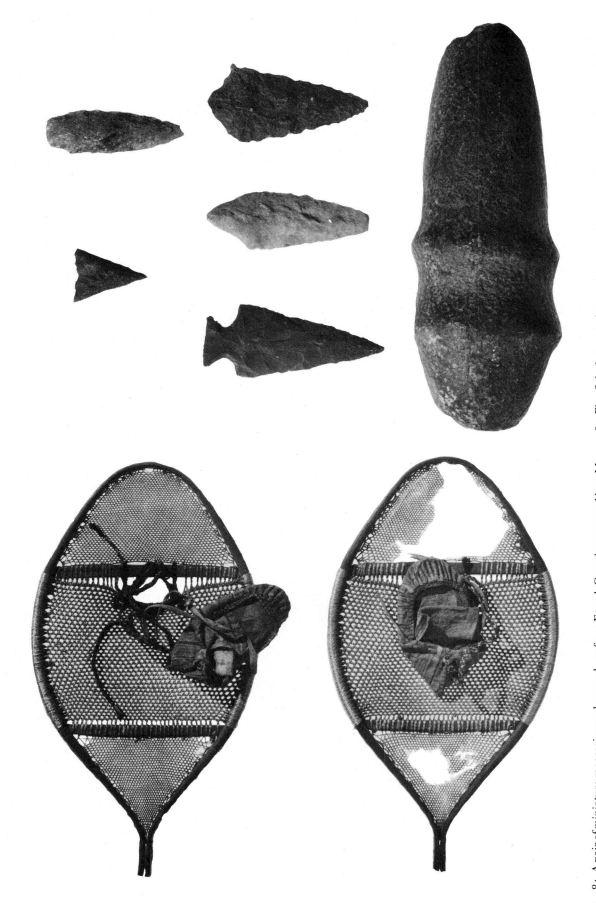

85 Five flaked stone points and a grooved stone axe. These constitute one of the first groups of archaeological specimens from North America. British Museum.

84 A pair of miniature moccasins and snow shoes from French Canada presented by a Mr Villarmont. British Museum.

86 A series of folded sheets of birchbark inscribed 'A Booke Made in New found Land of the Barke of Trees by Mr William Clerk Surgeon A.D. 1710'. Clerk contributed substantial botanical material to Sloane's collection *c.*1699–1710. British Library.

87 John Bartram's drawing of an early historic monitor pipe offered to Sloane in a letter of November 14th 1742. British Library.

88 The rarely illustrated back view of a fan with feather mosaic, probably sent by Cortes from Mexico in 1519. Museum für Völkerkunde, Vienna (formerly Schloss Ambras collection).

89 Shell-bead and cotton fibre belt of the Taino Indians of Hispaniola, early sixteenth century. Museum für Völkerkunde, Vienna (formerly Schloss Ambras collection).

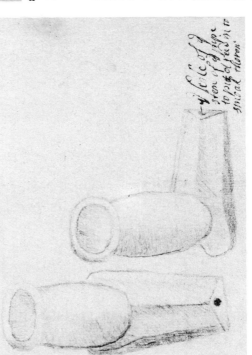

88

89

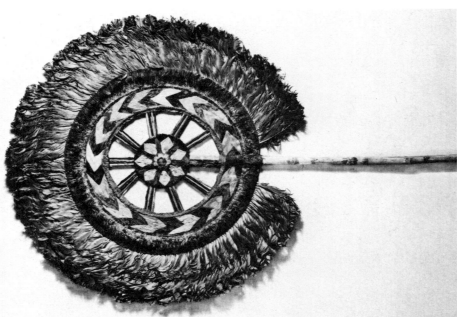

86

87

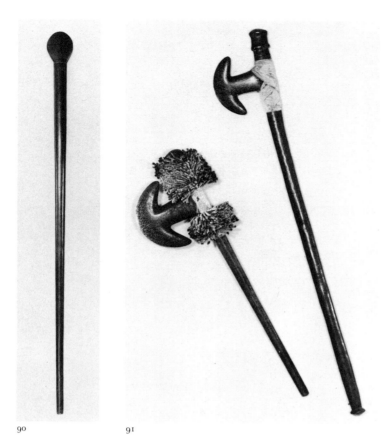

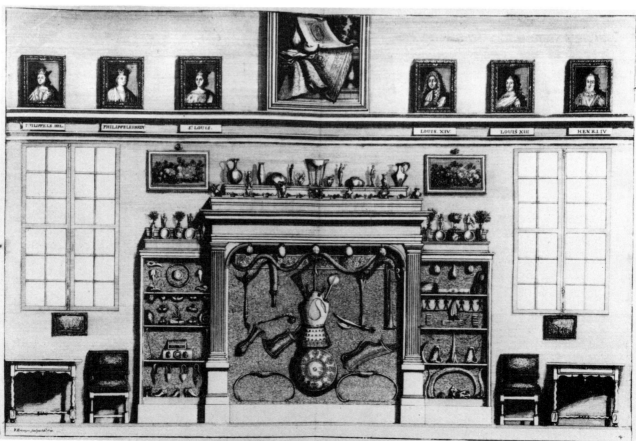

90 Tupinamba wooden club from Brazil, probably sixteenth century. Museum für Völkerkunde, Vienna (formerly Schloss Ambras collection).

91 Two Brazilian anchor axes: right, 'Montezuma's battle axe', documented before 1596; left, probably sixteenth century. Both Museum für Völkerkunde, Vienna, formerly Schloss Ambras collection).

92 Cabinet of Bibliothèque Sainte Geneviève, Paris, in 1688. Central case includes Brazilian anchor axe, low-relief carved club from northern Brazil, ceremonial baton, as well as a now lost Tupinamba club, all probably from the collection of Claude-Nicolas Fabri de Peiresc. From C. du Molinet 1692.

90

91

92

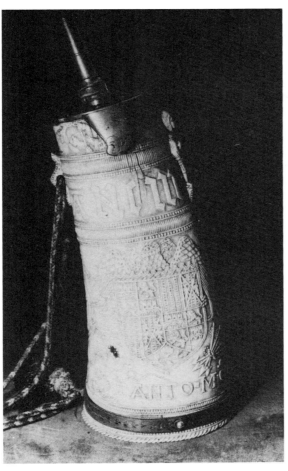

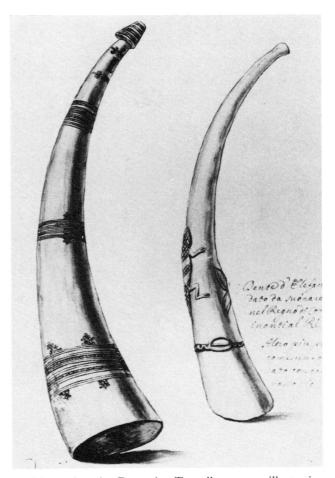

93 Powder flask (from a fragment of an ivory horn) with the arms of Ferdinand V, King of Aragon and Castille. Bulom-Portuguese, Sierra Leone, sixteenth century. Height 29 cm. Instituto de Valencia de Don Juan, Madrid.

94 Watercolour by Domenico Tencalla, c.1500, illustrating two ivory horns in the Settala collection in Milan. Ms.Z 388 Sup. no. 58, Biblioteca Ambrosiana, Milan.

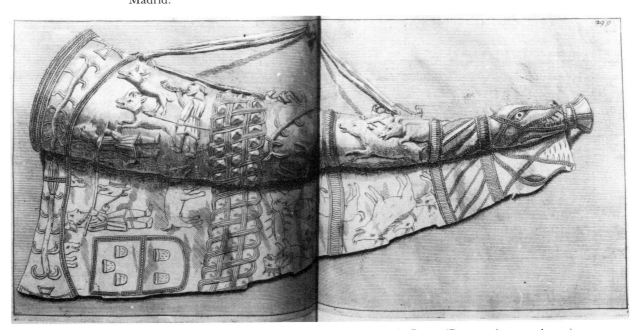

95 Afro-Portuguese ivory horn, once in the Museo Kircheriano in Rome (Buonanni 1709, pl. 299).

96 Shield from Central Africa. Reed, height 50 cm. Danish National Museum. From the Gottorp collection, before 1710.

97 Female figure. Zaire, Angola. Wood, height 24.8 cm. Collected in Africa before 1695. Museo Pigorini, Rome.

98 Anonymous watercolour illustrating a Kongo rafia cloth. Painted in Angola about 1665. *Manoscritti Araldi*, private collection, Modena.

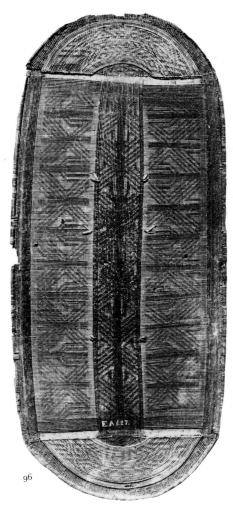

96

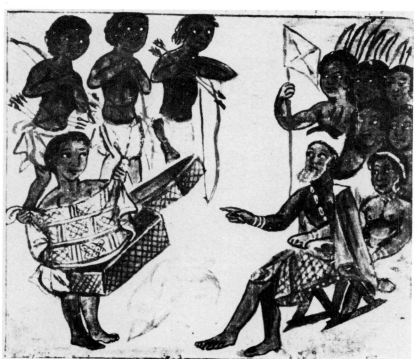

98

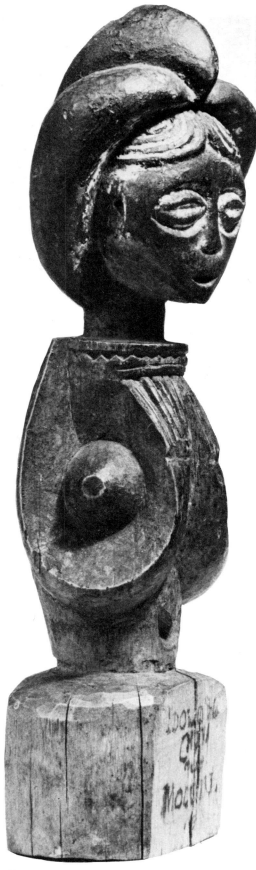

97

99 The 'Marco Polo' vase, porcelain. Chinese; thirteenth to fourteenth century. San Marco, Venice.

100 Bowl, rhinoceros horn. Chinese. Sixteenth to seventeenth century. Schloss Ambras, Innsbruck.

101 A Bodhisattva, soapstone. Chinese; cyclical date, perhaps 1568. Schloss Ambras, Innsbruck.

102 Teapot, Yixing stoneware. Chinese; before 1665. National-museet, Copenhagen.

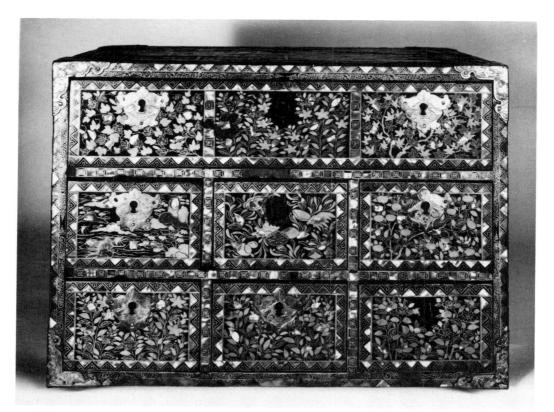

103 The Ambras cabinet, inventoried for 1597. Japanese export lacquer in Namban style. Schloss Ambras.

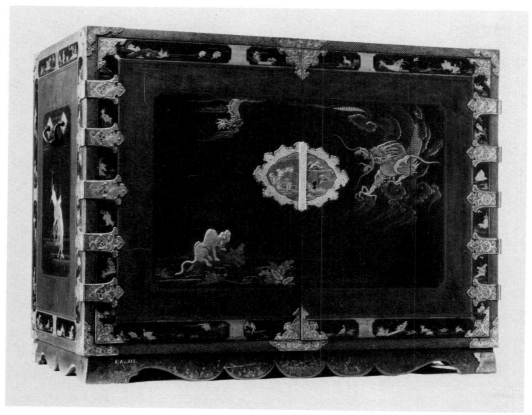

104 Japanese export lacquer cabinet, inventoried for 1668. Nationalmuseet, Copenhagen.

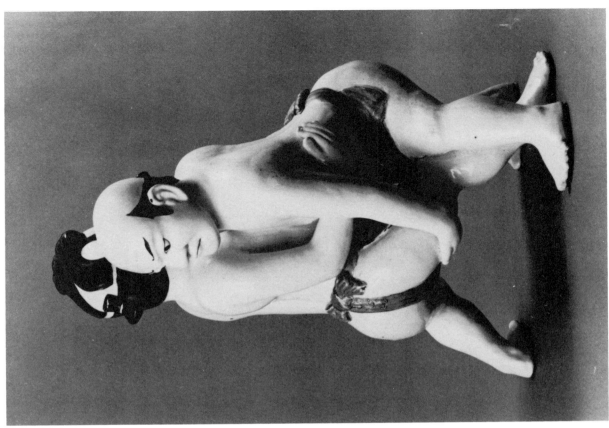

106 '2 China boys wrestling', porcelain figure made at Arita, Japan, and decorated in Kakiemon style, inventoried for 1688. Burghley House, Stamford.

105 Apothecary's jar, blue-and-white porcelain made at Arita, Japan, in imitation of European style, possibly dating from the 1650s. Photograph Spink and Son.

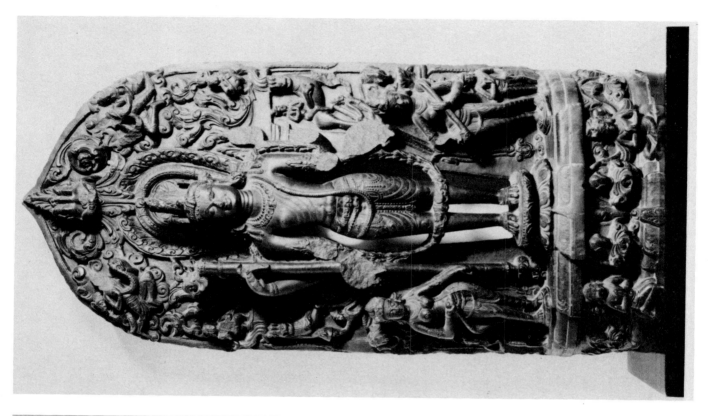

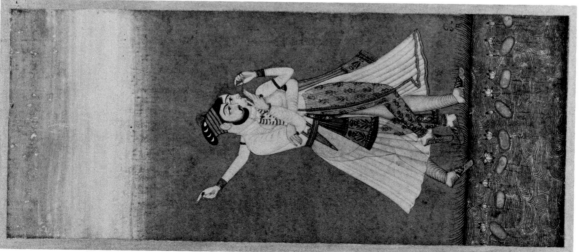

107 (*above*) Lovers. Miniature painting, bearing the stamp of John Richardson Senior. India seventeenth century. Ashmolean Museum, Oxford. 108 (*right*) Vishnu. Black Schist sculpture, listed in the Ashmolean Book of Benefactors in 1690. Pala, eleventh century. Pitt-Rivers Museum, on loan to the Ashmolean Museum, Oxford.